NORMAN ROCKWELL

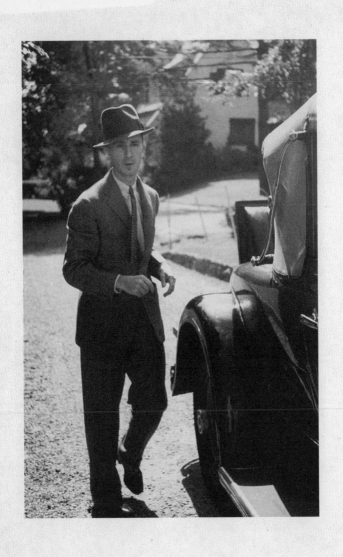

NORMAN ROCKWELL

A Life

Laura Claridge

THE MODERN LIBRARY

NEW YORK

LIBRARY OF CONGRESS CATALOGING-IN-PUBLICATION DATA
Claridge, Laura P.
Norman Rockwell: a life / Laura Claridge.
p. cm.
Includes bibliographical references and index.
ISBN 0-8129-6723-2 (pbk.)
1. Rockwell, Norman, 1894–1978. 2. Painters—United States—Biography.
3. Illustrators—United States—Biography. I. Title.
ND237.R68 C59 2001
759.13—dc21
[B] 2001019784

Modern Library website address: www.modernlibrary.com

Printed in the United States of America

2 4 6 8 9 7 5 3 1

Book design by Caroline Cunningham

Frontispiece: Norman Rockwell and his beloved Packard, late 1920s

For my parents,

Mary Wilson Powell and

William Harney Powell (1922–1973)

and

For my parents-in-law,

Fay Friedman Oppenheimer and

Samuel Leon Oppenheimer (1924–1999)

What is truly revolutionary is the secret signal of what is to come that speaks from the gesture of the child.
—Walter Benjamin

ABOU BEN ADHEM

Leigh Hunt

(Norman Rockwell's favorite poem, recited at his funeral)

Abou Ben Adhem, may his tribe increase!
Awoke one night from a deep dream of peace,
And saw, within the moonlight in his room,
Making it rich, and like a lily in bloom,
An angel writing in a book of gold:—

Exceeding peace had made Ben Adhem bold,
And to the presence in the room he said,
"What writest thou?"—The vision raised its head,
And with a look made of all sweet accord,
Answered, "The names of those who love the Lord."
"And is mine one?" said Abou. "Nay, not so,"
Replied the angel. Abou spoke more low,
But cheerly still; and said, "I pray thee then,
"Write me as one that loves his fellow men."

The angel wrote and vanished. The next night
It came again with a great wakening light,
And showed the names whom love of God had blessed,
And lo! Ben Adhem's name led all the rest.

1834

Contents

❧

Introduction and Acknowledgments

⸎

Let us not take it for granted that life exists more fully in what is commonly thought big than in what is commonly thought small.
—Virginia Woolf

A confession, since such is the stuff of biographies: I began this project keenly interested in the cultural history encompassed by Norman Rockwell's life and career but equally unsure if spending years on the illustrator himself would sustain my interest. I needn't have worried: this major-league player of twentieth-century America stepped up to the plate deftly, deflecting my fastballs, my curves, my sliders—sometimes obvious in his moves, more often wily. To my surprise and chagrin, I ended up falling half in love with my subject—and then dumping him in disgust the next day. A fickle romantic, I nonetheless decided that it was not my fault, this confusion, but Norman Rockwell who thwarted constancy instead. No wonder he kept me spinning. No wonder that he kept me coming back.

And therein lies a major theme that emerges from the near century of Rockwell's life: he was a master at creating desire in others. Highly intelligent man that he was, he early on figured out the basic economy that would keep people coming back for more: he had to withhold something while he appeared to give in excess. Mastery of this dy-

namic allowed him to remain an intensely private person even as his extraordinary celebrity spawned the illusion that he shared himself completely and intimately with his public.

Norman Rockwell, illustrator, was no different from most artists fully focused on their talent, and this meant putting his art ahead of his family. In fact, he often appropriated the emotional marrow of his relationships with his three wives and three sons (from his second marriage) in order to feed an audience always clamoring for more. As far as many Americans were concerned, however, Norman Rockwell exemplified the country's heartland; he was its "everyman." It is true that Rockwell did not seek deliberately to counter such an image; still, he also did nothing to hide the far more dramatic texture of his domestic life. He spoke openly and surprisingly often about his private demons. Probably to his detriment, his gentle self-revelation developed into a means of unconsciously manipulating others into taking care of him; and the important truth of his chronic depression went untended until he was an old man.

But I came to this biography through Norman Rockwell's work, not his life. It was the summer of 1995, and my husband and I took our two youngest children to the National Baseball Hall of Fame in Cooperstown, New York. Adjacent to the memorabilia exhibit was a small room of sports paintings, where I drifted somewhat aimlessly, my interest in representations of all things athletic long exceeded. Suddenly I was riveted by a canvas whose saturated color and fine draftsmanship were put to truly democratic use: the painting gently and lovingly mocked the seriousness with which baseball was regarded. Aggressively strong horizontal and vertical lines, the depth of field imaginatively multiplied by three parallel planes on which separate actions were taking place—who could this be? Glancing at the artist's name, I was shocked: *Calling the Game,* by Norman Rockwell. *This* was Norman Rockwell? Growing up, I'd heard of Rockwell mostly through magazine pages touting the Famous Artists' School, and I'd seen his work reproduced on countless calendars and ceramic plates. I had no idea that he possessed the technique and painterly so-

phistication to render such an oil—ignorance on my part that, I quickly discovered, typified the attitude of many of my generation.

Now in front of me was a painting with colors that were bracingly clean, the palette fastidiously chosen. Its intelligent negotiation of figure and space as well as the consummate painterly qualities bespoke values prior to those of Modernism. I was flummoxed, to risk a Rockwellian locution.

Back home, involved in completing a biography of a different sort of figural painter, I found myself sneaking breaks from my current project to take peeks at Rockwell's complete portfolio. From Internet forays to purchases at the local bookstore to interlibrary loan requests for out-of-print books, a catalogue of this man's life's work began to take shape in my mind. The size of his output alone—more than four thousand pieces—was dizzying, but even more impressive was his diversity of illustrative styles. Early sketches in *Boys' Life* were broad, loosely painted; and years later, after decades of not using this technique, he could still invoke it at will. During that same initial stage of his career, his work frequently seemed indebted to the fashionable illustrations that depended on romanticized yet sinewy, elegant, often two-dimensional figures. Within a few years, however, Rockwell had mastered a brushstroke of such control that the oil seemed to tighten on the canvas as you looked at it—at times, too much—and he exploited this talent in pursuit of the one last, perfect detail that would make his painting great.

I knew within months of that day in Cooperstown that opinion was not only wildly mixed on the proper way to appreciate Norman Rockwell but that, more surprising to me yet, the art world had been reacting in just this way since the beginning. I had expected to find a reception history that lauded his work until, say, the early fifties, when Abstract Expressionism had left little room even in the popular imagination for domestic painters such as Rockwell. Instead, the same arguments still raging today served as the backdrop to many articles on the artist in the 1920s. Is illustration worthy of comparison to fine art? Are such categories viable anyway? Is subject matter, formal execu-

tion, or historical innovation most important? Was it just his senti-
mentality, or was there more that kept Norman Rockwell from canon-
ical status in the modern art world? The battles currently being waged
over Rockwell in newspapers and journals began almost at the incep-
tion of his career, as surprising as that seems in light of the mythology
of his Arcadian past, before modern art supposedly snubbed him out
of existence. In truth, Rockwell began working at the height, not in
the aftermath, of America's education in Modernism; he attended the
landmark 1913 New York Armory Show, an exhibition of more than
sixteen hundred pieces of modern painting and sculpture, while in art
school in Manhattan.

A few professional voices, such as the *Washington Post* critic Paul
Richard, reminded me that they'd been on the record decades ago as
appreciating Rockwell's talent, when such praise incurred the con-
tempt of other journalists. And Ferdinand Protzman, Richard's col-
league at the *Post,* recalled how he'd admired Rockwell since his early
adulthood spent in Italy, where the Europeans taught him to under-
stand Rockwell's particular mastery.

Equally significant, there have been notable artists who voiced
their genuine appreciation of Rockwell's painterly talent before such
an assessment was even remotely fashionable. But when John Updike
and Tom Wolfe added their praise of Rockwell to that of the abstract
expressionist Willem de Kooning, the social realist Ben Shahn, and
the pop artist Andy Warhol, the celebrity supporters tended to be dis-
missed as eccentric exceptions among the cognoscenti. Their judg-
ments were, for the most part, tolerated as their right—they had
earned the ability to hold the aberrant opinion. Later, when Steven
Spielberg explained that without Rockwell he couldn't have produced
his cinematic view of life, there was no great gasp, no shock of recog-
nition. Indeed, Rockwell's own productions assimilated all too easily
the charge of sentimentality leveled against the filmmaker.

And yet: the times, they are a-changin'. When I started hearing
from my artist stepson in Berkeley that it was cool to "get" Rockwell,
and when my lazy Saturday wanderings in Manhattan and Washing-

ton galleries produced enthusiastic assays by young comers to the effect that they not only *liked* Rockwell, they felt themselves influenced by his attention to form and color in the name of a story—well, then I began to believe that the art world had belched forth a new template. I had actually become optimistic about the resurgence of figural painting in 1988, when Alex Katz won wide acclaim for his show at the Brooklyn Museum (where Rockwell had received his first major retrospective): maybe the heralding of this artist who had traveled his own idiosyncratic, noncategorical way for so many years meant that audiences were going to be offered a more capacious palette from which to choose the pleasures they preferred.

I reflected upon such decade-old optimism while working in the Rockwell Museum archives at Stockbridge, Massachusetts, where I quizzed the energetic, deeply engaged Ph.D. students camping out beside me, following their own critical theses that centered upon Norman Rockwell's art. One of their professors, art historian Robert Rosenblum, had reminded me that just as twentieth-century thinkers seriously revisited Victorian culture only when that era became remote enough to lack threat, so Rockwell had needed to fade in time before modern scholarship could risk immersion in his aura. These hip, intellectually engaged graduate-school scholars seemed proof positive of such a chronology of engagement.

No soothsayer, I don't pretend to know what such changes portend. I read better the suggestions of actual experience—the fact that many of society's best-educated people whose paths I cross in daily life had started sharing with me, almost defiantly (before the exhibition of 1999 made such admissions acceptable), that they had loved Rockwell *all these years.* Now they felt liberated to confess such allegiance to me without fear of censure. Patronized if they professed any serious admiration and delight, they had felt intimidated by that vague thing called institutional or critical opinion, what the knowing "they" thought and said. Indeed, this very need for "experts" to guide them in matters of aesthetics—the difficulty for many of enjoying, untutored, the abstraction of so much great twentieth-century art—had

bred unfortunate suspicions about the art being touted. Too often, it seemed mandatory that to merit value, a painting had to be remote from the shared experiences most commonly the subject of narrative art. Though a longtime devotee of modern art, I agreed with such assessments: something is wrong when we reach a stage where art that does not require the mediation of a schooled critic lacks value because of its accessibility to the masses.

. . .

Energized by the tumult, I began to reconsider Norman Rockwell, both the impact that the man had on the twentieth century, and the value of his art. Unknown to me when I started, the Norman Rockwell Museum in Stockbridge, Massachusetts, had long been working on convincing prominent institutions across the country to support a major retrospective tour of Rockwell's career. As a result of the unflagging efforts of museum director Laurie Norton Moffat and curators Maureen Hart-Hennessey, Anne Knutson (High Museum of Art), and Judy Larson (Art Museum of Western Virginia), Rockwell took front and center stage throughout much of 1999, with art critics scrambling to weigh in with their judgments of the illustrator's place inside (or outside) their discipline. A few, such as Robert Rosenblum, Dave Hickey, Paul Richard, and, to some extent, Peter Schjeldahl and Arthur Danto—those who had long been on record as (unfashionably) respecting, beyond the acceptable limit, Rockwell's work—repeated their thoughtful and sometimes qualified admiration, this time to a more interested audience. The middle ground was occupied by reviewers who praised the plurality of the current art scene, one that permits us to appreciate Rockwell's technical skills while abjuring his sentimental (nonartistic) vision and values; others, like Deborah Solomon, went further, but in a different direction, celebrating in *The New York Times Magazine* that expanded room in the marketplace for the best of bad art, the triumph of kitsch—the Rockwellian cheeseburgers we sometimes prefer to a steady diet of haute cuisine. A few, Hilton Kramer among them, maintained their judgments that Rockwell was not art, and that there the matter should end.

We Americans have, it appears, mastered the lessons of Modernism. And after Modernism won the right to create its own traditions, the need to oppose anything that might chip at its defensive self-righteousness disappeared. Those battles over, the majority of us seem to believe that there is room for everyone at the table, at least temporarily, until the manners are judged, until the napkins are crumpled at the end of the meal, and the host decides who will be invited back.

Still, one might grumble that the Museum of Modern Art's 1990–91 High & Low exhibit, touted as containing more than three hundred examples of art that confounded the old hierarchy, should have included a Rockwell or two. But though pages from children's books and fan belts from Cadillacs greeted the eager spectators bent on seeing the new amalgams of culture, Rockwell didn't fit in here, either. Neither high nor low, Rockwell's proximity to either world made him a near miss in both. The demise of Marxism aside, the twentieth-century view that art should scrutinize a culture's dominant values has basically held the day. Where was the salutary effect of Rockwell's art, where was its attempt to defamiliarize the dominant culture, in order to make us see anew; where was the critique?

One way that some critics have elected to back into the problem, so to speak, has been to manipulate Rockwell into escaping the whole dilemma. The nation's first father of popular culture was, it turns out, conveniently called "Pop" by his sons, a delicious coincidence that anticipates the postmodern culture that today would claim him as its own. Earnest art critics, eager to determine a respectable way to include him anew in the art histories of the twentieth century, find themselves mesmerized by the prospect of wedding popular to postmodern: perhaps Norman Rockwell's decades of sentimental, narrative painting prophesied the postmodern brilliance of marrying high and low culture; maybe Rockwell was pomo in spite of himself. If nothing else, Rockwell's art clearly was meant to be disposable (a good thing) versus monumental (negative), finding its temporary home on the cover of magazines that were discarded weekly.

This biography engages in such theoretical questions more by implication than directly. I have sought to offer one interpretation of the

complicated, fascinating long life of a major modern American figure. The very lack of a full-length biography of a man of Norman Rockwell's long-term fame intrigued me, especially as the reasons for such a rude omission are implicated in the shifts of aesthetic tastes and social values that the march of the twentieth century demanded. My account is limited in the way that all historical assessments are, by the lack of a bird's-eye view. "Biographies are but the clothes and buttons of the man—the biography of the man himself cannot be written," Mark Twain wrote in his own self-history.

I console myself that most readers nowadays hold truth to be a complicated achievement, and few among us believe anyone's telling of a life to be the final word, the only way of its telling. Because those of us in the twenty-first century are close to Rockwell's times—seeing them, quite rightly, as the context from which our own lives emerge— we mine such lives as a means to understand the families that spawned us and the selves we've become.

It obviously wasn't all that incongruous for me to wed my initial interest in Norman Rockwell's *Calling the Game* with the more academic interests I'd long been pondering, theoretical questions about biographies, histories, and other narrative art forms. I decided I wanted to know all about the man who lived his own life grounded in the power of narrative, of telling stories. Over the countless trips I made to Stockbridge to work in the extensive Rockwell archives, capped by a writing fellowship at the International Ledig House in Hudson, New York, I came to trust my first aesthetic instincts. The shock of recognition that I had first felt when seeing Rockwell anew—really, for the first time—back in Cooperstown, remained true to the place where I ended.

And it proved especially fortunate that I wrote the first draft of *Norman Rockwell* during my idyllic retreat among poets, novelists, reporters, and visual artists from Sweden, Bangladesh, Spain, Germany, Poland, and England. These colleagues helped me think about the differences between the intimidation of Americans by institutional criticism and the greater freedom abroad to stand by one's sensuous

reaction to art as a valid criterion for its worth. The Catskill Mountains at sunset, the autumnal colors competing against the sun's defiantly brilliant nocturne, painted an almost too perfectly clichéd backdrop for many intense international discussions about Rockwell's talent. After all, Rockwell's Massachusetts and Vermont homes were both an easy drive from here, their Berkshires and Green Mountains mere variations on our local Hudson Valley panorama.

But I also realized how Norman Rockwell's presence was recorded in my life even closer to home. A few months earlier, writing yet another thank-you note to an acquaintance of Norman Rockwell generous with his time, I found my afternoon's work at a Brooklyn waterfront café interrupted by the antics of two art students laughing over their sodas and onion rings. After they filled their straws with cola, they expertly squirted the stream of liquid to imaginary lines on the street below, deciding that whoever hit closest to the East River was destined to make a six-figure sale first. Probably because my project was drawing to a close, nostalgia overtook me, and I was transported vividly, if for only a minute, to the similar scenes that must have occurred around 1915, when Norman Rockwell shared studio space with his art school friends in this same neighborhood. The landscape has remained fairly constant, but Rockwell and his buddies were talking about where they could gain exposure: money, they scoffed, wasn't meant for real artists, a position Rockwell took pains in later years to disavow. I wondered what he would think of these students, so comfortable admitting that their ambitions included monetary success. At the very least, he would have found them interesting, his curiosity one of his most salient features.

Over the years, Rockwell's celebrity has proved cumbersome to his three sons, and it took but a few interviews for me to see the potential barrier it would erect for me as well. Americans, especially those whose lives he personally graced with a way he had of making people feel important, believed they owed him his hero's status, and that too much information might tarnish the mythology. As a result of his fans' reluctance to commit potential sacrilege, the family's cooperation and

the precedents they established turned out to be especially important in the research for this biography. All three sons, of strikingly different temperaments but sharing a communal decorum, graciousness, and goodwill toward others, promoted publicly their hard-won belief that it was time to make peace with their father's humanity—that he was weak as well as strong, and there was nothing to be ashamed of in that. Jarvis Rockwell, the artist's eldest son, made himself available whenever and however I wanted to talk, in spite of illness and pressing professional concerns. His interest in the mind's processes and his years of scrupulous introspection made him a particularly rich source of informed speculation. Tom Rockwell inconvenienced himself without hesitation every time I asked for help, and he delivered that help with a gentle humor, lively wit, and modesty that surely hinted at his father, as well as attesting to his own strengths as a writer. Often I left his farmhouse feeling a bit more in touch with the affection the illustrator had so effortlessly bred in others. Peter Rockwell, the youngest of the three, met me everywhere—literally as well as psychologically in this case, since we conversed in Atlanta, Stockbridge, and Tuscany, where he even gave me a free lesson in stone carving. The precision demanded in his art reverberated in his conversations about his father: Peter repeatedly and carefully fine-tuned his reflections so that I felt him a real ally in my search for some kind of truth. These men—not coincidentally artists all—as well as their lively, thoughtful wives, Nova, Gail, and Cinny, provided physical hospitality in addition to allowing me the material support of their memories and personal archives. Jarvis, Tom, and Peter Rockwell proved extraordinary resources and exemplary sons: alternately skeptical, proud, loving, unsure of their father, they were both loyal and honest about him—a difficult combination—though it was clear that these emotions proved costly at times.

The museum built around Norman Rockwell, where the archives contain everything from the illustrator's four pairs of eyeglasses to more than thirty boxes of his business correspondence alone, was an idyllic place to study my subject. Its director, Laurie Norton Moffatt,

ensured that the repository was open to my intrusions, its collection easily accessible to my sometimes overreaching curiosity, in spite of the inconvenience my presence frequently caused. But in terms of sheer impact on this biography, no book or individual has approached the influence of Linda Pero, curator of the museum's archives. With her encyclopedic and learned grasp of her subject, her quiet and strong sense of Rockwellian duty—meaning that for her, hard work and graciousness go hand in hand—she is every researcher's dream. For such as us mere mortals, she tethers her creative intelligence to the fastidious world of archival documents, numbers, and other artifacts of "hard" history. Not only her practical advice but the sagacity of her insights enriched my own a hundredfold. I thank her for enabling this project to see daylight.

Although it is true that when I began my research no comprehensive biography yet existed of Norman Rockwell, there were dozens of immeasurably useful and often well-informed books about various aspects of his art and person. Particularly helpful for my purposes were Arthur Guptill's pioneering study of Rockwell's technique, *Norman Rockwell, Illustrator,* especially significant because the artist cooperated with the author during its composition; Thomas Buechner's invaluable *Norman Rockwell, Artist and Illustrator;* Christopher Finch's *Norman Rockwell: 322 Magazine Covers,* with some of the most trenchant and on-target evaluations of Rockwell's major oils that exist, in spite of too many factual errors; Jan Cohn's *Covers of the Saturday Evening Post;* Donald Walton's chatty *A Rockwell Portrait;* Susan Meyer's books on Rockwell's models and on great illustrators in general; and Laurie Norton Moffatt's *Definitive Catalogue,* an indispensable tool for any student of Rockwell. More recently, by going back to the drawing board themselves—by refusing too easy classifications and categorizations—the social and art historians Dave Hickey, Karal Ann Marling, Wanda Korn, and Michele Bogart have elevated the discourse surrounding Rockwell, brilliantly nudging the vocabulary used to explore his work into one of serious—not to say solemn—cultural respectability. Students of Rockwell today are heavily in their debt;

they were there first. Also fortunate for Rockwell scholars is the plethora of good "picture books" that exists; their first-rate quality ensures that readers of this biography have easy access to much of Rockwell's oeuvre. Given his substantial output, any severely edited selection ends up somewhat capricious and personal, but in general I have tried to provide examples of different periods, different genres, and most of all, of his finest painting per se, the oils that could be at home in any thoughtful collection of twentieth-century art.

Humility—the acknowledgment that no one creates alone—is one of the first lessons taught by the demands of this particular genre. To complete the project in a timely fashion, sustaining along the way the same enthusiasm with which I began, I have relied over the past several years on a handful of people who patiently allowed me to talk or to research Rockwell with them again and again, as I tried to absorb into myself their own special knowledge of the subject: Robert Berridge, John Favareau, Wayne Kempton, Virginia Loveless, and Dick Rockwell. Others tended my project in far less direct ways that probably I alone recognize: Bruce Fleming, Phil Jason, Elizabeth Langland, Dori Sless, Joseph Wittreich, and Arnold Dino Rivera, whose expansive knowledge of the human body and its possible ailments, in concert with a humanity that, cliché though it may be, shines forth from his eyes, makes him a surgeon I'd choose any day.

For advice about the ever-elusive psyche, mental health specialists Sue Erikson Bloland, Robert Coles, Kaye Redfield Jamison, and Jennifer Naidich provided wise observations and cautious clues that helped me understand Norman Rockwell far better than I could have on my own. In varying degrees, they blended friendship with professionalism, a nexus that yielded yet more bounty during the biographer's hunt.

I have learned that during the writing of any book, certain individuals bear an importance disproportionate to their actual involvement with the project. Arthur Danto, Robert Rosenblum, and Michel Witmer hold pride of place for *Norman Rockwell*: the first two learned professors took time to encourage my vision even when they bore weighty demands on their own schedules, and the notoriously gener-

ous art dealer shared his near encyclopedic knowledge of art histori-cal moments with me, week after week, year after year.

Others with me on a near daily basis were my invaluable research assistants. Lulen Walker and Elizabeth Ann Parker worked fast and furiously early on, before leaving for curatorial positions. Devin Org-eron proved an adroit, intuitive interviewer in California as well as places East. Ingrid Satelmajer's sharp intellect prompted my rethink-ing every time she read a chapter of the manuscript, and her natural warmth smoothed more rough corners than texts alone. The burden of assistance, however, was borne by Tracey Middlekauff and Marsha Orgeron, and if I had a wish list for the future, they'd be near the top of it. Whenever I needed them (often), wherever (all over the coun-try), whatever (from redoing three hundred endnotes to translating Latin marriage certificates), they delivered. They saved me from countless errors; they went the extra mile to assuage my fears. I am deeply grateful for their presence.

There were other people at my side throughout this project: Linda Chester, my agent, and her associate, Julie Rubenstein, eased my way professionally and personally. Their enthusiasm, friendship, and af-fection buoyed my spirits whenever they were flagging. At Random House, I was lucky to have Caroline Cunningham design a beautiful interior, Casey Hampton a perfect series of photo inserts, and Dan Rembert a handsome jacket; and Benjamin Dreyer, the production editor, with the assistance of the sharp eyes of John McGhee and proofreaders Michael Burke and Maria Massey, magnificently put the pages through their paces until they came out a book. Matt Thornton helped us all, one way or another. Early on, Ann Godoff's support and Jonathan Karp's editorial sponsorship had convinced me that I'd found the right home for Rockwell's biography. Then, when Susanna Porter edited the manuscript, I decided that this home was very heaven. Her intelligence and sensitivity to language saved me from every possible kind of mistake; she did so with utmost grace and tact-fulness; and she pulled it all off creatively, sometimes working in un-conventional methods in order to avoid the delays common to biographies. She is, in short, every writer's dream editor.

Many individuals bound not to my text but to Norman Rockwell himself gave selflessly when I turned to them for help—most of them strangers to me until their efforts bridged that gap: Betty Parmelee Aaronson, Barbara Alan, Mary Best Alcambra, Elizabeth Aldred, Lyn Austin, Joanne Bartoli, Jonathan Best, Terry Bragg, Sue Bronstein, Thomas Buechner, Paul Camp, Stephanie Cassidy, Ardis Clark, Christopher Clark, Rachel Clark, Jan Cohn, Sally Hill Cooper, Barbara Davis, Kara Dowd, Amy Edgerton, Bud Edgerton, Joy Edgerton, Kai Erikson, Barclay Feather, Peter Franck, Ilene Frank, Joy Freisatz, Lawrence Friedman, Elizabeth Fuller, Bill George, Shelley Getchell, Dalia Giladi, Jim Gilkinson, Tom Glazier, Judy Goffman-Cutler, Leah Schaeffer Goodfellow, Jennifer Gould, Douglas Greenberg, Trevor Hall, Lauren Henkley, Bradford and Kay Hertzog, Dave Hickey, Charles and Maren Hobson, Tom and Jeannette Hochtor, Helen Hutchinson, Gary Jaffe, Nancy Jarman, Timothy V. Johnson, Clemens Kalischer, Deane Keller, Fran Kessler, David Knowles, Pam Koob, Matt Kuhnert, Terry Lehr, Barry Lewis, Susan Lyman, Constance Malpas, Donald March, Allison Marchese, Karal Ann Marling, Margaret McBurnie, Pam Mendelsohn, David Ment, Susan Merrill, Susan Meyer, David Michaelis, Melissa Mosqueda, Francis Murphy, Kenneth John Myers, Chris Niebuhr, William Nordling, Tim O'Brien, Pat O'Donnell, Mary Amy Orpen, Robert Orpen, Anka Palitz, Barbara Davis Pappas, Dean X. Parmelee, Fred Paulmann, Anne Pelham, Gene Pelham, Elizabeth Peters, Steve Pettinga, Yvette Cohen Pomerantz, Gloria Pritts, Ferdinand Protzman, Mary Quinn, Tom Range, Cris Raymond, Azra Raza, Sugra Raza, Walt Reed, Paul Richard, Bea Rockwell, Daisy Rockwell, Mary Rockwell, Peigi Rockwell, Michael Rubenstein, Cecelia A. St. Jean, Steve Schlein, Ron Schweiger, Eric Segal, Richard Seigman, Theresa Sharp, Maryann Smith, Janet Solinger, Leo Spinelli, William Stauffer, Ann Stokes, Nan Timmerman, Betsey Travis, Kathleen Triem, Miriam Tuba, Agata Tuszynska, John Updike, Leonard Verrastro, Ida Washington, Mary Welsh, Ess White, Nancy White, Jonathan Witte, Nancy Barstow Wynkoop, David Wood, and Mitchell Yockelson.

Institutions that extended their resources for *Norman Rockwell* include the following: American Illustrators Gallery; Art Students League (New York City); Austen Riggs; Bureau of Vital Statistics, Yonkers; Blessed Sacrament Catholic Church (New Rochelle, New York); Brooklyn Remembered; Coveleigh Club; Corcoran Museum of Art, Washington D.C.; *Esquire* magazine; Hudson River Museum; Church of Jesus Christ of Latter Day Saints Family History Center (Kensington, Maryland); Larchmont Yacht Club; Ledig House International Artists' Colony; Special Collections at the Milbank Memorial Library, Teachers College, Columbia University; Hagley Art Museum; Houghton Special Library Collections, Harvard University; Institute for Living (Hartford, Connecticut); McLean Hospital; Mamaroneck Public Library; Mamaroneck Historical Society; Massachusetts State Police; Massena Public Library; Metropolitan New York Library Council, Hospital Library Services; Motor Vehicle Administration of Vermont; National Academy of Art (New York City); National Academy of Design (New York City); National Archives; New Rochelle Public Library; New-York Historical Society; New York Public Library (research librarians); New York Academy of Medicine, Historical Collections; Otis Art Institute, Los Angeles; Parrish Art Museum; Potsdam Public Museum; *The Saturday Evening Post* (Curtis Publishing archives); St. John's Episcopal Church, Yonkers; St. John's–Wilmot Episcopal Church, New Rochelle; St. Paul's Episcopal Church, Yonkers; University of Iowa Libraries; University of South Florida Library; United States Department of Justice; United States Naval Academy, Annapolis; Village of Norwood (New York); Westchester County Surrogate's Court; Westchester Historical Society; Yonkers Public Library; Yonkers Historical Society.

During the gestation of a book, amid the clamor of the new, the solace of a few old friends proves vital. For *Norman Rockwell,* I reached out to three people who have traveled my path long enough to teach me much about loyalty, love, and generosity of spirit: Suzanne Ford, Lorraine Miller, and Abbas Raza.

Finally, with that turn toward the inevitable that every writer an-

ticipates as the journey's reward, I thank my family. My parents and parents-in-law, to whom I dedicate this book, for their nurturance and faith; my sister and sister-in-law and loving brothers these women have given me, Marybeth and Steve and Anita and Tommy, for their unwavering support. To another brother, Michael, and to Donna and Shane for opening their hearts to me about complicated, shared family. And to my children, Devon and Colin, whose never-failing patience, pride, and encouragement have urged me on when I was awfully tired; to Geof Oppenheimer, whose sanction from the art world proper reassured me. Even with all that support, however, it has been Ian Claridge, my philosopher-son from his earliest years, who has physically and mentally boosted this project most: his incisive queries, his imaginative ruminations, his bibliographic references, his balanced critique—all have invigorated the quality of my own thought. It is a particularly deep pleasure to get such nourishment back from one's child.

My husband, Dennis Oppenheimer, first suggested this book, and he has quietly, steadfastly, pragmatically shored me up throughout its birth. If I have been guilty at moments of entering into the Rockwellian vignette too hopefully, his is the blame: he has made our home as near an ideal as I ever imagined possible. This book salutes him, as husband, father, and man.

Part I

NEW YORK

1

※

Narrative Connections,
the Heart of an Illustrator

We tell ourselves stories in order to live.
—Joan Didion, *The White Album*

Norman Rockwell was not sadistic. He was, however, expert at creating desire, both in his public and in his private life. His family, who too often felt themselves to be "living out the cover of a *Saturday Evening Post*," as his oldest son, Jarvis, once expressed it, were routinely seduced by his invitations of intimacy, though the artist established a subtle but impermeable distance when they tried to respond. His real sensitivity was reserved for his art, his empathy lavished on his easel, day after day, for over six decades. As do many artists, he tended to exorcise his internal tensions in his paintings, so that the energy that might have been expended on the work of rearing three sons born within six years of each other exploded into the narrative stories on his canvas instead. In the summer of 1954, for instance, at the height of his powers, Rockwell undertook a *Saturday Evening Post* cover of an aspiring artist studying master works in a museum, *The Art Critic,* published on April 16, 1955. The cover shows a young man scrutinizing a woman's décolletage in the head-and-shoulders portrait in front of him, while on the adjacent wall, prosperous Dutch burghers

in an Old Master painting appear to start with indignation and amusement as they watch the impudent student. The model for the student was Rockwell's son Jarvis (named after the illustrator's father); for the portrait the young critic studies so assiduously, Rockwell used his wife (and Jarvis's mother), Mary.

The timing of this particular painting, in terms of familial harmony, was way off. Mary had been struggling valiantly against alcoholism and depression—possibly a bipolar illness—for at least five years. The family had been racked by the demise of their formerly predictable upper-middle-class home, as the mother, previously the anchor of their household, suddenly needed all the tending. Boarding school plans had been upended in an attempt to rally round her, trips were rescheduled, tremendous amounts of money were poured into treatments, and finally, a permanent move was undertaken from Arlington, Vermont, where the family had lived since 1939, to Stockbridge, Massachusetts, when it became clear that Mary's treatments at the Austen Riggs Center would be long-term. Unknown to the family, as they struggled to adjust to Mary's illness Rockwell suffered a simultaneous spate of suicidal thoughts.

Jarvis, however, could give both his parents a run for their money, and in terms of expensive sessions with mental healthcare specialists, he did exactly that. From his earliest years, he was a particularly complicated member of the family: "I never caught on to what you're supposed to do in school," he remembers. "So it kind of never made sense to me, from the beginning." Born in 1931, by 1938 Jarvis had been displaced by two younger brothers, and as he approached second grade, his parents were contemplating yet another major dislocation in his young life. The next year, they would decide to leave the sophisticated enclave of New Rochelle, New York, to make their home in Arlington, Vermont. A greater contrast is hard to imagine, at least on the face of it. New Rochelle fed on the overspill from Manhattan, seeing itself as a haven for worldly artists, entertainers, and intellectuals who wanted to be within commuting distance of the city, while enjoying the yacht club environment of what many treated as a wealthy distant suburb of

the city. Even at his young age, Jarvis would feel the shock of adjusting to a bucolic life after the faster pace of his earlier years.

Between the move at age nine and posing for *The Art Critic* immediately prior to his twenty-third birthday, Rockwell's eldest son retrod many of his father's steps, though too often, to Jarvis, they seemed to be missteps. He, too, had dropped out of high school; he, too, attended not only art school but his father's own, the Art Students League in New York City. And though "Pop," the name the boys conferred on their father when they became adolescents, ostensibly encouraged Jarvis's efforts, praising lavishly to others his son's work, the young artist grew up feeling distant from the father whose somewhat vague friendliness left his son desperate for a closer connection.

By 1954, Jarvis had been in and out of art schools, the Air Force, and psychiatric treatment. He was, in the lingo of a later age, trying to find himself. And he was trying hard to understand how to position himself as an aspiring artist in an art world that rejected as inconsequential the achievements of his father, whose technique Jarvis at least deeply appreciated, but whose storytelling in oils found expression, after all, only on mass-reproduced magazine covers. As soon as he was finished posing for Pop this time, Jarvis planned to head off for the Boston Museum of Art School, a more competitive program than any his father had attended.

No account exists of Rockwell's inspiration for *The Art Critic*. Preparing even more feverishly than he did for most of his covers, however, he went through dozens of charcoal sketches, color renderings, and redirection of the mise-en-scène. The flirtatious, attractive woman for whom Mary Rockwell posed took the form of at least ten variations alone, from an early frowning hausfrau to the beautiful damsel that preceded the final image. More impressive still was the illustrator's long indecision over what to place in the frame on the museum's right wall. He completed two detailed paintings in contrasting Dutch styles; in addition to the group portrait of the men, he executed fully a landscape genre scene.

Until the last moment, Rockwell alternated between the two

pieces, unsure which effect he preferred. In the charcoal on board that he drew immediately prior to his oil sketch, the painting to the right of the student critic is the Dutch landscape, with windmill, elaborate forestry, and tiny figures in the background. But in the end, he chose the parody of a Dutch group scene, which historically implied the weight of patriarchal authority. Vacillating between a genre that suggested a domestic tranquillity and one that invoked the power of his fathers, Rockwell went with the idea of ancestral censure and brought down the full force of his family and aesthetic pedigree on the poor befuddled art student, hapless in the ways of the world and of art.

The student himself metamorphosed from an initially disheveled outsider into a more suave Easterner: "Finally, my father changed my face so much it hardly looks like me," the model remembers. In one of Rockwell's earliest pen-and-charcoal sketches, Jarvis is given long uncombed hair, a soft, almost nonexistent jawline, and made to appear nearly myopic, his glasses sliding down his nose, as he stands within an inch of a startled-looking housewife in order to study her portrait. He is, in other words, presented as a sloppy, unkempt beatnik, an identity he had in fact been fostering.

The finished painting consists instead of a slender, well-groomed, slightly droopy-lidded young man, painterly accoutrements of his trade under his arm, standing in front of a portrait in the Netherlandish section of a museum. This eager neophyte, seen only in profile—in contrast to the frontal views of the Dutch group portrait—exhibits a supercilious facial expression and an aristocratic sharp chin, accentuated by his proprietary leaning in toward the woman's portrait. The ersatz sophistication is offset by the childlike way that he nearly squeezes his legs together, his feet perfectly aligned on the tile floor, their toes almost pushed upward by their owner's rigid lower body. Rockwell's frequent device of exaggerating the subject's derriere is employed here to undercut any authority the young art critic might have claimed otherwise; instead, the viewer of the cover is invited to assume the superior, knowing position: benign, wise interpreter of the scene.

The finished painting positions the oddly disruptive parody of the Dutch Masters group scene to the right of the voyeuristic student, in

the pictorial plane of his palette and easel, perpendicular to his open art history book with its reproduction of the woman's portrait. Rockwell's deliberately formulaic Old Master painting, its antecedents the famous group portraits by both Frans Hals and Rembrandt, revisited his own earlier family romance. His admiration for seventeenth-century Netherlandish painters was one of the few passions he shared with his parents, with whom he continued to live for several years while he went to art school. His father's own not inconsequential sketches clearly were modeled on studies of the Dutch and English countryside; and the domestic painting that lost out to the group portrait in *The Art Critic* was strikingly similar to the older man's homey sketches.

Father-son issues not resolved in their own time passed down to Jarvis and Norman Rockwell. What part mockery versus a more gentle condescension plays in the psychodrama of *The Art Critic* remains incalculable to its principal model. It was not entirely clear to Rockwell's oldest son how much his father really respected his progeny's work. Rockwell could slide from speaking of "Jerry's" terrific modern art one minute to referring to his son's local installation piece as the "string mess up on the hill" the next. Probably both attitudes were real, given Rockwell's lifelong ambivalence toward abstraction. And Jerry, since late adolescence, had begun to deprecate his father's painting, his newfound superiority hard to hide from Pop. The son's claim to know, his right even to judge his father, takes shape in *The Art Critic* in the proprietary posture of the student, bending over the detail of the portrait with his magnifying glass in one hand, his easel, palette, and reproduction of the painting in the other. A slightly weary expression, something between smugness and an unguarded absorption, captures the poseur's incoherence, the lack of an authentic center. His innocence is further compromised by the hint of pursed lips, as if ready to kiss the painting. Worse still, the young artist is magnifying the brooch perilously close to the woman's décolletage; the smirk she has assumed seems a cross between an admonishment and a come-on.

Jarvis Rockwell does not like to talk about this painting. "It was very unpleasant for me," he says. "It's true that my mother and I never

posed together for this piece. But that's why I realized that there was all this stuff going on, and that my father, on some level, was too polite or too timid to force our faces in it literally. As usual, we were living on the cover of a magazine." Jarvis was embarrassed to contribute to the painting's ribald implications, since his mother's bosom was the object of his gaze. "My father made it very plain that the sexual joke was important to the painting," he remembers. What Mary Rockwell thought of the whole thing goes unnoted; loyal wife of a prominent artist, she buried any conflicts she had at the time with alcohol and pills. The millions of readers who welcomed that April 16, 1955, *Saturday Evening Post* cover into their homes didn't realize the family drama writ large that the cover shared with them, Rockwell's other— and at least equally important—family. Questions of influence, of talent, of generation, of authority, and of the vexed center of family love all reverberate as one painting within the painting relates to the other, and the parodies and substitutions and historical references feast on one another.

What tale would Rockwell have claimed to be telling in *The Art Critic*? Norman Rockwell told stories. That was his job as an illustrator, and over the decades he stressed that, for him, the hardest part of his work always was coming up with ideas to narrate in the absence of a text written by others. And *Post* covers, as he said on more than one occasion, had to be read within a few seconds, the manifest meaning laid out through the artful accretion of details. Given those thematic elements of the painting that remained unchanged from his earliest pencil sketch, *The Art Critic* asks to be understood as, at the least, a young, earnest, overconfident art student yielding up his professionalism to female pulchritude. In the process, his artistic and historical elders gently show their superiority, through their mock outrage and hints of laughter that acknowledge this normal misguided stage of youth. Themes of looking, illicit views and presumptuous vantage points among them, knit together the young art critic, daring to judge, and the Dutch ancestors—woman and man, the old and the young, the new and the dated. Final authority is granted to the viewer—the

wise spectator looking in on the picture who is expected, surely, to smile at the too-earnest artist who is still miles, decades, ages away from the achievements of his father(s).

Did Rockwell actually reflect upon the template of family desire and ambition embedded in this painting too fraught for his sons to enjoy? Of course not. But we know that by 1954, Norman Rockwell had been put through the wringer in terms of delving into his own psyche. At least as important, he had always developed his narrative line through accretive yokings, visual puns, and meaning that begot meaning, an almost classical, psychoanalytically oriented process of free association.

In the late 1940s, for instance, he explained for the benefit of the students he was then teaching that "in a picture which tells a story, the idea itself probably is the most important element of the entire illustration." For an instructor who insisted on the primary importance of technique, of mastering the principles of traditional draftsmanship and color, this was an illuminating statement. And it is a position that he reiterated over the decades, usually adding wryly, as he did here, that he had always found this the hardest part of his profession—coming up with a good idea. After all, he expounded, it wasn't enough to come up with something that the artist alone found meaningful; for an illustrator, a narrative idea had to possess near instant recognition for the audience. "Usually I get my best ideas as I shave in the morning," Rockwell repeated throughout the years. "I draw them on three-by-five squares of paper, then discard them until I get one I think I can go with."

That crucial next stage—developing a nugget into a narrative gold mine—involved a long associative habit of thinking, free ranging and unlimited in the directions in which it took the artist. He shared with the students enrolled at the Famous Artists' School an example of this process, in which to begin the sequence he sketched a lamppost, "which always gets me started," although "where I will end I never know." Rockwell travels through ten more vignettes before that end point arrives, and, along the way, he plays with a drunken soldier, who

morphs into a dutiful one sewing his pants, to a picture of the sailor's mother mending them instead—with the family dog at hand; to the sailor transformed into a boy who tends to his sick dog, to a vet and dog, to doctors braving blizzards, to a sick girl missing out on a dance, to a square dance, to a cobbler fixing shoes, to a lone cowboy—"shoes recall cowhide, cowhide recalls cows, cows recall cowboys. Still no idea so I must keep going until I finally do get one." At this point, he stops, assuming that the students get the point.

The clarity of Rockwell's narrative covers is hard-won, that much is sure. Still, his free-associative method of deriving the thesis surely became second nature to him, given the number of stories he needed to create. And many of those covers tell more stories than one, if only we know where to look. It must have been emotionally costly at times for Rockwell to stir up silt, sift through it, and never stay around long enough to see it settle. But the benefit of such a strategy is clear, too: messy connections that began to surface inconveniently could be put down at once, unexamined further, and remixed later for additional use.

The Art Critic appears to be just this kind of achievement. In spite of the obvious family dramas played out in the painting, the complex emotions that motivated it were, the sons agree, probably too subterranean to rise to the level of consciousness in the man who welded them into a witty representation instead. "I think the painting is cruel, though my father was not a cruel man," Jarvis's youngest brother, Peter Rockwell, states today. Rockwell refused to get bogged down in the depressions he seemed always to hold at bay with more work. Beset by his own anxieties and constant professional comparisons, he often acted out his denials of the tensions in front of him through the "overkill" for which he became famous—the one detail too many, the picture never allowed to be finished, sent off still wet to the *Post,* nonetheless so finely articulated that it looked destined for the ages, not for an ephemeral magazine cover.

Through the supposedly impersonal theme of looking at art, *The Art Critic* rehearses the central love and commitment of Norman Rockwell's life: his work. In the final cover, a balance has been estab-

lished among the various acts of viewing, even of over-looking, or voyeurism, that the scene comprises. The young artist and the object of his fascinated study appear to be in a symbiotic relationship of sorts—her flirtatious, welcoming smile is familiar, and his scrutiny proprietary. It is the Dutch Masters to the side who disrupt the relationship between subject and object; theirs is the intervention of those who would dare judge. The painting had as its thematic antecedents works such as *Fireman,* from 1944, in which a distressed, even disgusted firefighter looked down from the inside of the portrait onto a burning cigar left on the bottom of the frame. In Rockwell's reference to his own carelessness that a year earlier had caused his entire studio to burn to the ground, he raised the notion of authority, of who has the final say when looking at art. In *Man Carrying Frame,* painted two years after *Fireman,* he anticipated his bracketing in *The Art Critic* of an "innocent" whose self-regarding activity takes place between two museum masterpieces, the subjects of which stare out of their own frames in amazement at his presumption. The protagonist in *Man Carrying Frame* actually removes a frame from a painting in such a way that he ends up looking framed himself.

As the art historian Michael Fried points out in *Absorption and Theatricality,* painting that calls attention to itself, a common theme of the seventeenth century, became a staple of Modernism as a means of talking about art. Rockwell's interest in self-reference was grounded only partially in philosophical questions about looking, being looked at, and the painter's relationship to his audience, especially pertinent as those ideas were for someone whose artistic mainstay was producing covers for *The Saturday Evening Post.* His less theoretical text in the pictures about pictures spoke to the need for tolerance, for capaciousness, for an awareness that as soon as we judge others, we will find ourselves coming up short as well. In the end, Rockwell's paintings about painting remind us that to presume superiority is to risk inevitable comeuppance oneself; that the act of seeing outside the frame must allow for difference. From this perspective, it is no stretch to see two paintings as disparate on most lev-

els as *The Art Critic* and the 1960s civil rights piece, *The Problem We All Live With,* as sharing a common concern.

That Rockwell would sometimes draw from the murky regions of his unconscious to engender his covers is surely, upon reflection, no surprise. Most artists work on a very limited number of images at one time, as opposed to complete narratives that must stand on their own. Rockwell confronted a major challenge in inventing so many stories for the *Post* covers. Only months before he began *The Art Critic,* for instance, he painted the hauntingly beautiful *Breaking Home Ties,* which was published as the September 25, 1954, *Post* cover. The recent efforts of just about the entire Rockwell household to move away—including Mary's frequent trips to the Riggs psychiatric institution—were mimed in this bittersweet representation of father and son taking their leave of each other. Family connections—and their breaking—were much on Rockwell's mind in those days. And they had been for the past three years, since Mary had suggested that they divorce as a remedy for her unhappiness—Rockwell's second wife to seek this solution.

Such themes accommodated thoughts that lay too deep for tears, to borrow from another Romantic poet of the quotidian, William Wordsworth. *The Art Critic* rehearsed the intertwined, emotionally fraught motivations that had funded Norman Rockwell's career; and it reminded him that familial traits underwrote his right to such a destiny, much as he assumed was true for his eldest son. Markers from several generations had indicated to the illustrator even before he learned to write that art could be his way to compete among men. If painterly talent had not inspired emotional closeness among his relatives, it had funded much of the family pride in achievement, especially on his mother's side. Even the connection he shared with his own rather browbeaten father, lacking as it was, came through their early shared love of telling stories through the pen and palette. Art and family, painting and love, loss and renewal: not the conventional dialogue of an illustrator. But for Norman Rockwell, they were the very substance of his life and his career.

2

Family Ties That Bind

Two Thomas Hills, born in England during the late 1820s, unrelated except by such coincidence, similarly staked out their futures in the New World: they were artists intent on specializing in landscapes, portraits, and even animal paintings. Both would produce artist sons named Thomas Hill as well, and the confluence of names and professions would engender confusion up to the present day. But in the mid-1860s, just as the more hapless of the shared-name patriarchs immigrated to the United States, the other and more fortunate senior Hill, who had already lived in Massachusetts for more than ten years, decided to go west. There he would become a highly successful, respected landscape painter, joining Albert Bierstadt and Thomas Moran among artists renowned for their aesthetic mastery of the American wilderness. Our newly arrived Thomas Hill, never as lucky in the fine arts as his talent probably deserved, would soon dig his heels into Yankee soil and paint portraits of beloved neighborhood animals one day, the peeling clapboard walls of neighborhood houses the next. His descendants would joke that his masterpiece legacy was

his grandson, the heir whose domestic genre paintings would give voice to Middle America's unarticulated yearnings better than the other successful Hill's homage to the western sublime ever did.

Given the option, Norman Rockwell would probably have been ambivalent about which Thomas Hill to choose for his grandfather. Without a doubt, the great western painter would have anchored his progeny to a more elegant pedigree, worthy of envy even by that magnificent illustrator of the West, N. C. Wyeth. But Rockwell's delight in the presence of well-meaning if larger-than-life men; his love of a good prank and his sly pleasure at the ribald suggestion; and his vivid rootedness in all things northeastern legitimize as an equally appropriate forebear the colorful, various, ill-behaved extrovert, Thomas Howard Hill.

Rockwell's grandfather, fated to be the Thomas Hill that history forgot, sailed to America in the early 1860s, settling for the first few years in Hoboken, New Jersey, where his mother and father, Susannah and Thomas, had immigrated earlier. Hopeful that the career he had barely taken up in England would bear fruit in the new land, Thomas Hill, Jr., tried for several years to support his family by plying his art. But by 1866, the local directory reflects an adjustment in Hill's expectations; his job, previously listed as "artist," changes now to "painter"—of houses—matching the description of his father's career. For reasons unclear, in 1867 or 1868, the peripatetic painter chose to relocate his family and his parents to Yonkers, New York, where he would begin to call himself by his middle name, Howard; city records reveal at least six Thomas Hills in Yonkers alone, and Thomas Howard Hill, however absurd his self-assessment, always liked to think of himself as distinguished.

Although family anecdotes reveal a restlessness on Hill's part that sought relief in frequent moves, his English wife, Anne Elizabeth Patmore, the three children they'd brought with them from London, and the two born subsequent to the family's immigration prevailed in their wish to retain Yonkers as their home base, the town where they had ended up burying Hill's mother soon after their relocation. Regardless

of the comings and goings of their head of household, the rest of the family sought psychological as well as physical stability. The descendants bequeathed the nation by Anne and Howard Hill would, within two generations, disperse around the country in typical immigrant fashion, but their identity as Americans was rooted in one of the first suburbs of New York City.

Both of his Hill grandparents were dead before Norman Rockwell was born. Depending on whose account and which calculation you accept, Anne and Howard Hill produced four daughters, Susan, Kate, Amy Elizabeth, and Anne Mary, and two sons, Percevel and Thomas Jr. Still, mid-nineteenth-century American mores supported a strong tradition of taking in the orphaned children of one's siblings, cousins, and in-laws and raising them as one's own, and the Hills were generous in this regard. Throughout the years, the size of their household ranged from six to thirteen children, variations that account for Rockwell's claim that his mother was one of twelve siblings.

Anne Elizabeth Patmore Hill claimed royal ancestry on both sides of the family for her large brood, often citing her sister's marriage to Captain Norman Spencer Perceval as the maternal evidence. According to family lore, in 1605 Captain Perceval's grandfather encountered Guy Fawkes, the instigator of Catholic insurrection, in the House of Commons, whereupon he promptly pushed the rebel down the stairs. Furthermore, Anne explained, Howard Hill was a direct descendant of Lady Elizabeth Howard, whose name was the source of his own. Finally, the proud Mrs. Hill confided, Howard Hill's original surname was Jenkin, a link to another royal family; but his early bad temper had caused him to be adopted by an aunt named Hill, whose name he then assumed. Vague family connections had led Thomas Howard Hill to sing a solo for Her Majesty when he was a child, while Anne herself, when a young lady, had been presented at Queen Victoria's court.

However illustrious her ancestors might have been, Anne Elizabeth Hill's life with her husband was hardly queenly. Experiencing living conditions that varied radically year to year, and bearing and

caring for many children while at the whim of her artist husband's moods, Mrs. Hill was given little opportunity even to dream of her old life. By turns generating periods of prosperity and poverty, Thomas Howard Hill haphazardly earned his living by selling a painting, resting a while on those laurels, then seeking housepainting under assumed names when the family had completely run out of resources. When he painted seriously, the results were more than competent renderings of usually outdoor scenes, typically alternating between the landscapes and animal pictures that were endemic to the popular tastes of the time. He exercised extreme attention to the brushstroke, using clear, small, carefully controlled motions, a quality that, Rockwell would later jest, must have been passed along the bloodline. New York City's prestigious National Academy of Design hung four of Hill's paintings in its 1865 exhibition: *The Warblers, Babes in the Woods, Winter Scene,* and *Three Chicks.* Two were accepted the following year as well: *Rural Felicity* and *Haunt of the Partridge.* During this period, the yearly National Academy shows functioned as the private American equivalent of the annual state-sponsored salon exhibitions in Paris.

Hill, who had arrived in the States with real hopes of adding his name to the Hudson River School, did achieve a modicum of artistic respectability through several commercial commissions, and at least two prominent Manhattan hotels—the Murray Hill and the Union Square—owned several of his paintings. But what Rockwell remembered most about his grandfather's talent was that he squandered it.

Recklessness as well as restlessness inhabited the heart of the artist-patriarch. As Howard Hill cobbled together a family life of plenty that was in danger of being supplanted by a complete reversal of fortune at any moment, uncertainty became the only constant of the Hill household. With a Yonkers boardinghouse for their home, the first-generation Americans grew up not knowing whether the week would rain down the rich array of clothes and culinary treats from Manhattan typical of a particularly lucrative painting commission, or if they'd be divvying up a dozen pairs of identical shoes, all the same

size, that their father, in the aftermath of a drunken night of despair, had bought for next to nothing off the street.

The joie de vivre that Howard Hill manifested led his eldest son to follow his romantic lead. In 1875, Tom Hill daringly sailed to Mexico and Cuba on a boat that carried both passengers and cargo loaded along the journey. His diary tells of adventures ranging from hurricanes to government insurrections, where, as two boats braced to battle, he "hoped to see blood flow." Tom's importance as the oldest son comes through in the letters he sends and receives during the trip. His interest in the "children" left behind—his two youngest siblings, nine-year-old Nancy and the baby, Percevel—is keen, and the older girls, his sisters Amy, Kate, and Susie, take pains to keep him up-to-date on their little brother "Percy" especially. Their letters to him center on church and Sunday school; the entire family, except for Howard Hill, was deeply religious, and Tom's diary records the hours that he spent reading his Bible every Sunday. Most significant, the sisters' correspondence reveals that he was probably his mother's favorite, and that his relationship with his father was at best vexed. "Father misses you and often talks very kindly of you, he feels your absents [sic] very much. . . . he has quite surprised us by thinking so much about you," his sister Susie earnestly informs him. She wistfully alludes to the young man's cheerful nature: "We all miss you very much every time a boy goes by in the evening whistling we think it is you." Tom, in return, writes mostly of the head winds and the sharks that he encounters, but he does add thoughtful bits about the gifts such as tortoiseshell combs he is bringing home for the girls.

Judging from the weary, often inarticulate communication that the apparently uneducated Mrs. Hill sent to her Mexico-bound son in 1875, she carefully marshaled her energies to run her household and contribute to the church, the latter ranking higher in her order of commitments than the former. Family anecdotes about Howard Hill's irrational behavior during days of drunken rampages reflect communal amusement at the wildly incongruous accusations of infidelity he would level against his devout and devoted wife and dismay at the suf-

fering his erratic actions caused her. From the few surviving pictures of Norman Rockwell's maternal grandmother, Anne Hill was a perpetually tired, anxious woman. The face that peers cautiously out of one photograph from the early 1880s seems fine-tuned into a permanent tension—perhaps an alert apprehension ready to defend against Howard's periodic tirades.

But she did adore her husband, and she must have appreciated that a life of adventure was in the cards for his sons, at least from the way she accepted with equanimity Tom's daring ventures. Although he had been coughing up blood and running high fevers for years, Tom believed that the fresh air would serve him well, and he continued to sail any chance he could get, fatiguing himself in the process. In between his forays into the sea, he pursued a career as an artist, admirably earning enough through easel sales and design work to support himself comfortably, although his flat, childish representations of kittens and butterflies evince little evidence of his father's technical skill.

Nonetheless, the young man gained a fairly substantial local reputation for himself so that he was able to rent a studio at 40 Warburton Street, where he taught drawing and painting. By the beginning of 1884, Alexander Smith's carpet works in Yonkers, a major producer of high-quality rugs, had hired him as one of their many designers. On November 18 of that same year, armed with a good salary and dashing looks, Tom married Lallie Newlin from Elizabeth, New Jersey. According to nineteenth-century church records, Lallie's uncle, the Reverend Richard Newlin, performed the ceremony at the Hills' parish church, St. Paul's. The wedding invitations were elegant and expensive; Tom's marriage to someone of good family suggests he had trustworthy prospects, as well as a religious pedigree.

But if even one member of the Hill family was able to enjoy this wedding with equanimity, such pleasure would have been a triumph of hope over every probable cause to despair of the couple living happily ever after. Only six months earlier, Tom's older sister Amy and her husband, Harold Milner, had died of consumption, leaving their three young children, John, Eva, and Amy, to be shuffled among family

members. The irritating cough that had become both Tom's and his mother's inconstant companion must have sounded ominously like an insistent murmur: proceed with caution.

But Tom and Lallie decided that his frequent fevers and occasional bloody sputum were just constitutional weaknesses, and on November 25, 1886, the Hills had a baby. "Harold" probably spent little time in his grandmother Hill's arms, since by his birth, she had begun suffering from lung congestion that left her breathless after the slightest exertion. When her new grandson was three months old, Anne Elizabeth Hill died—within a few weeks of the consumptive death of her two-year-old grandson by her daughter Susie.

Perhaps as a partial effort to regain his naturally optimistic nature, and probably as a supposed fresh-air curative for his respiratory illness, four months after he had helped bury his mother and nephew, Tom Hill set out to sail around Manhattan. He ran into a terrible summer storm that dashed ships and waterfront property to pieces. Two weeks after that flirtation with disaster, and determined to enjoy more domestic pleasures, Tom took his wife and baby to Coney Island. Within hours of their arrival, Tom began hemorrhaging from the throat. The next day he was dead.

Obituaries for the twenty-nine-year-old new father emphasized how he had already positioned himself within the Yonkers community, no doubt largely through the easy affability he had copied from his father's habits outside the home: "He was genial and amiable by nature, and made friends of all who knew him." Another local paper praised him for being "a genial, whole-souled, unpretentious gentleman." Furthermore, "Mr. Hill had resided here so long and was so well and favorably known for his many excellent qualities as a man, and his abilities as an artist . . . that his death in early manhood seemed doubly sad." For Tom's little sister Nancy, the sadness was compounded by the wide swath that consumption, as tuberculosis was poetically but appropriately called at the time, cut in her family's midst that year. She couldn't know who would be next to die; and alongside her grief, she had to wonder about her own mortality.

Nor had the solicitous attention paid to Tom Hill throughout his

long bout with tuberculosis escaped his sister, who appropriated the theme of suffering for the rest of her life as a way to be recognized. Born on March 6, 1866, in Hoboken, New Jersey, Nancy—or Anne Mary, until she began using her nickname—was the youngest girl in the Hill brood, and she learned early to whine effectively and often in order to gain attention from her volatile household. Countervailing such self-pity, however, was the love of adventure she shared with her father and her brother Tom. Although, for the most part, Nancy's spiritedness assumed the conventionally feminine form of fantasy life—living through magazines, books, and tales told in church by missionaries—the otherwise pious daughter of the even more religious Anne Elizabeth Hill would encourage in her own children an openness to excitement, reserving her highest praise for accomplishments that marked her sons as intrepid men of the world, like her brother and her father before them. She could be an invalid; they would be the outlet for her needs that went otherwise unaddressed.

Whatever emotions were stirred by her masculine but gentle brother's death, Nancy Hill registered its impact most tellingly by becoming engaged, the year Tom died, to a man who bore a striking physical resemblance to him. And she implied the values she held dear in a man through her choice of a husband whose character contrasted completely with the frivolous father she was said to detest.

In later years, though her sisters granted more weight to Howard Hill's charm than to the chaos he created, Nancy could only repeat darkly that he was a "street angel and a house devil." If his name emerged in family conversation, she railed against his drunkenness. Nancy's great-niece, Mary Amy Orpen, admits that "enough people in the room always agreed with her assessment that I guess she must have been on target." Norman Rockwell assumed instead that Nancy's demanding personality led her to judge her father too harshly. Typical of a tendency to give the benefit of the doubt to characters whose peccadilloes struck him as harmless, Rockwell emphasized in his family accounts that he'd heard that Howard Hill wasn't really so bad. He tended to discount his mother's opinions as self-interested

anyway, and so thought Nancy was probably being typically unfair in her condemnation. In truth, the public conviction that poverty bred consumption led to the Hill family's deep sense of humiliation at being silently stigmatized as consumptives, and Nancy Hill associated her father's failure to earn a decent living with the shame-filled death her closest relatives had endured.

She was proud, however, of the artistic lineage she felt she had inherited, and that she exhibited primarily through the elaborate embroidery designs she created for her family and for church functions. And she enjoyed sharing with her own children the childhood anecdote about Howard Hill lining up his eight or nine (depending on who was at home) progeny along a stair-rail or kitchen table, where he then passed a painting in progress along their paths, each girl or boy tasked with a particular assignment: one might have been taught to paint a certain kind of stump, one to shade leaves. Nancy was asked to perfect the moon as her contribution to such "potboilers," as Norman later called them. Hardly the first artist to use his children to fill in the less important moments on his canvas, Hill nonetheless ingeniously engineered an aesthetic production line.

On March 7, 1888, at age sixty-five, Howard Hill, having outlived his wife by two years, died of what the newspapers called an "epileptic fit" at the Yonkers boardinghouse where the widower lodged. Medical examiners called it heart failure. Whether the convulsion was brought on by a high fever from the tuberculosis he may well have shared with his son and wife was not noted; St. Paul's registry of funerals also records Hill's cause of death as heart failure, though the church sometimes substituted that vague phrase for less attractive possibilities. Given the contrast between the registry's multitude of references to his wife's and children's attendance at church functions and the complete absence of any mention of Howard Hill, Hill's funeral might well have been the only time the painter made it to church. In his obituary, the local paper declared him "an artistic painter by profession, [whose] abilities brought him considerable reputation." Over one hundred years later, Hill's paintings infrequently

would show up for auction at Sotheby's and Christie's; and, by the turn of the next century, those few collectors interested in his work could find three landscapes available at Florida and New York galleries, ranging in price from $4,000 to $20,000. The dealers did not realize that Thomas Howard Hill was Norman Rockwell's grandfather; indeed, the only name connection that has inflated Hill's prices has been the periodic, ever-present confusion with "the" Thomas Hill.

Although Howard Hill would be dead before his grandson was born, he lived on emphatically in the daughter who held him in contempt, Norman Rockwell's mother. Nancy Hill had grown into a petite woman who, in spite of her ladylike ways, was a "real character," as Mary Amy Orpen chuckles. "Yes, she acted like she hated her father, saying he was a bum, but she was so colorful herself, it's hard not to think she was deeply influenced by him." If the five-foot-two-inch-tall woman raged against her father's outrageous behavior, she was no stranger to such extremes herself. By the age of twenty-two, around the time she moved in with her married sister, Susan Hill Orpen, Nancy Hill had developed into a complicated young adult. Often extraordinarily demanding—"she got what she wanted"—she was soft and decoratively feminine, strong-willed and active, victimized and anxious. She also suffered from depression, what she and others called her "nerves." As she aged, she regaled visitors with stories of her miserable childhood, or, depending on her mood, entertained them by pulling out the fur collar her mother had worn to be presented at court. More than one person believed her to be very lucky to find a man like Waring Rockwell to make of her his almost pet.

Professions of English blue blood aside, Nancy Hill's family did not come close to enjoying the prestigious pedigree of the one she married into. A genealogist who has thoroughly researched the Rockwell family tree reflects, "It's almost as if Norman Rockwell had been created to represent America—it's amazing how many towns have a Rockwell as their founder." If historian David Hackett Fischer is correct to claim that of the four major English migrations to the United States, the first wave of Puritans to reach the American shores in the

1630s and '40s encapsulated the values of what would become the American standard, then the country could do worse than anoint Rockwell its representative. "A people of substance, character, and deep personal piety," the initial immigrant tide was remarkably homogenous compared to the groups that followed. These early pioneers traveled in family units, typically with "exceptionally literate, highly skilled, and heavily urban" heads of household. This Yankee strand, with its potent mixture of tolerance, liberality, emotional distance, and judicial standards, with its Abrahams and Rachels and Jonathans who pushed their way across Connecticut and Massachusetts, finally stopping in New York, would brand America, for better and worse, with habits of mind and body that triumphed as the substance of a democracy.

And in 1862, even as Thomas Howard and Anne Elizabeth Hill arranged their passages to the United States of America, John William Rockwell and Phoebe Boyce Waring, both of Yonkers, New York, were on the verge of combining two great Yankee families through their marriage.

John Rockwell's father and mother—Norman's great-grand-parents—were Samuel and Oril Sherman Rockwell. Born in 1810 to well-to-do farmers in Ridgebury, Connecticut, "whose Christian fidelity made a happy home," according to a history of Westchester County, Samuel was apprenticed when he was fifteen years old to a watchmaker and jeweler in Manhattan. After twelve years of applying "more than ordinary natural aptitude for the business," the twenty-seven-year-old man bought the modest establishment and developed it into a "flourishing and profitable business." In 1844, Samuel built a modest cottage on a plot of land he bought in Yonkers, and the next year he converted the little house into the family homestead and began traveling back and forth each morning and night to his job in Manhattan. Until the Hudson River Railway was built, he took a horse-drawn carriage along what was then called Harlem Road, becoming one of Yonkers's first daily commuters.

The original small cottage evolved into a "fine country seat" before

long, and Samuel Rockwell worked so hard that he was soon able to sell his watch shop in "the crowded city" of New York to establish a real estate business in the "pure air" of Yonkers, which at this point contained only three thousand inhabitants. He cofounded the Yonkers Savings Bank and helped organize the first Presbyterian church in the community. Known as a man of "enlarged views," Samuel Rockwell was deemed by a late-nineteenth-century historian of Westchester County to hold the best possible claim "to be considered a representative man of the city."

Samuel was proud of his New England heritage, the lineage and traditions of which he sought to pass down through his children: Samuel Sherman (who died at the age of four), John William (Norman Rockwell's grandfather), George Sigourney, Frances Elizabeth, and Julius Talcott. He named his second son, born in 1838, after the covey of sixteenth-century John Rockwells who were among the early wave of Pilgrims first settled in Hartford, Connecticut. Born in Somerset, England, in 1588, John Rockwell and his wife, Wilmet Cade, had seeded the Rockwell lineage in the New World through their son and daughter, John and Mary. By 1703, when John's son Jonathan married a Ridgefield country girl, Abigail Canfield, the Rockwells were sufficiently well established that three years later Jonathan could pack up his loom and head west with his wife to help her family develop their land. Predictably, the relocated Rockwells were successful with their farming and weaving, which their son Abraham and his wife Esther Riggs continued to expand. By the time that Abraham and Esther's firstborn, Runa Rockwell, and his wife, Rachel Darling, were rearing the son who would establish the Rockwell presence in New York—Samuel Darling Rockwell—the town of Ridgebury, Connecticut, had been inhabited by Rockwells for more than 150 years. And at least a few Rockwell boys fought in 1779 against Benedict Arnold's troops, who tried to burn down Ridgebury and Danbury in their attempt to stem the American Revolution.

Most important of the traditions that Norman Rockwell would absorb from his own father was the ancestral assumption that the son

should model his character on his male parent—with the corollary that the parent was supposed to earn such emulation. Runa Rockwell had patterned himself upon what archival family records call Abraham's "habits of industry and frugality," the example of which enabled the weaver and part-time farmer not only to provide well for his own family but to contribute heavily to the local "cause of Religion" and to the needy in the community. "The good will and respect of his townsmen" that this type of behavior had won for his forebears, proudly noted in the old histories of the Rockwell family, were not lost on Samuel Rockwell, who earned great admiration in Yonkers, largely due to a lifetime of steady, reliable labor.

Samuel's son John only increased his family's pride in its American lineage when he married Phoebe Boyce Waring, who brought her own dowry of Yonkers nobility to their union. Born in 1841, Phoebe came from an English family that had left Liverpool with the great wave of early-seventeenth-century religious refugees who migrated to Norwalk, Connecticut. A New York contingent was led by Phoebe's great-grandfather, John Waring, who by the next century had made his way to Yonkers, where his offspring—twelve grandchildren produced by Waring's fourth child, Peter—would convert the country town into a center of industry. Peter's son William initiated the brothers' string of successes when he rented an old gristmill in order to start up a small hat manufacturing company, restructured in 1834 because his family and Yonkers's prominent Paddock clan decided to unite in marriage and in business. Another of Peter's children, Aurelia Waring, wed Isaac Paddock, and "Paddock and Waring" would expand for the next decade, until, in 1844, the buildings burned to the ground.

Although the reconstruction took several years, by 1857 it was a thriving small business again, and Peter's son John T. Waring, who had worked with his brother William for the ten years prior to the fire, bought the entire factory and enlarged it until it employed over eight hundred men to make ninety-six hundred hats a day. In 1861, Phoebe's uncle John was elected president of Yonkers, while the next year, her uncle William cofounded Underhill and Waring molasses

house, the town's first sugar refinery. By 1868, John T. Waring was rich enough to buy the buildings that Robert Getty, one of the wealthiest businessmen in Yonkers, had constructed on the corner of Main Street and Broadway, and within eight more years, John's capital would grow to almost a million dollars. But during the previous decade, lulled into a false sense of security because of his company's unprecedented success, Phoebe's uncle had bought thirty-three acres of land on North Broadway overlooking the Hudson River, where he erected a magnificent mansion known as "Greystone." When sudden reverses in his business caused him to lose everything the same year that he gained his first million dollars, he went bankrupt and ended up selling Greystone for a tenth of what it had cost to build.

More impressive than John T. Waring's earlier success, however, was the courageous way in which he handled the severe setback, and the generosity with which the community welcomed him home rather than censuring his failure. Waring moved to Boston, hired convicts to help him build his business anew, and, triumphant, returned to Yonkers in 1884, where he set to work reconstructing his hat industry. Phoebe's own father, Jarvis Augustus Waring, himself a respected local businessman until he died in 1872, through his can-do work ethic inspired among his descendants, John T. included, the belief that failure was ignoble only if its victims refused to seek success anew. When the history of Westchester County was written in 1896, it would celebrate the Waring family's prominent identification with the social life of Yonkers, their connection with St. John's Episcopal Church, and their energy in conducting business affairs—all of which tethered them to the very founding of Yonkers's history.

Phoebe Waring and John Rockwell appeared well positioned to contribute to the vitality of the city their forebears had helped create, through yet another prominent union of Yonkers's best families. They had three children, who grew up in Yonkers, where, eleven years after their marriage, John and Phoebe had purchased "a beautiful residence on Locust Hill," according to local histories. Their firstborn—a daughter, Grace Waring Rockwell—dutifully attended Drew Semi-

nary, a girls' school in Carmel, New York, where she was graduated in 1882. The middle child, and the paternal grandfather's namesake, Samuel Darling, born in 1866, was later encouraged to work with his father at the family business—when he deigned to work at all. A charming scoundrel, Samuel would assume an afterlife as the Rockwell family skeleton. And on December 10, 1867, Jarvis Waring Rockwell was born, as serious as his brother was frivolous. The youngest child would seem, temperamentally, the fusion of the stock he had come from, as if his name symbolized the merging of his parents' pasts as well as their persons. In spite of his aura as an insignificant but ethical businessman and an honorable, caring father, Waring, as he was called, was an everyman worthy of respect, even if the circle who recognized him was small compared to the admirers of his father, John, and his grandfather Samuel.

In truth, John Rockwell's station in life had been somewhat of a comedown for Phoebe Waring. The Rockwells had done well, but the Warings had gotten rich, and they preferred that money marry money. Still, Phoebe's husband worked hard, that much was clear to everyone in Yonkers—a good thing, since the grinding daily commute between Yonkers and New York City required his kind of industrious nature. John Rockwell was a minor executive in the Manhattan coal industry, his office located at 1 Broadway in the Wall Street district along the waterfront. During the early period of their marriage, the demands of the Civil War more than kept the new husband in business: John felt a particularly keen responsibility to supply the Union troops efficiently because of the fate of his younger brother George, a sergeant of Company B, 23rd Regiment Wisconsin Volunteer Infantry. Gallant George had been captured and "mortally wounded" on December 29, 1862, the final day of the battle at Stone River. Only two months before his death, John had experienced the good fortune of marrying Phoebe Waring, and now wanted to prove himself in the name of his dead brother as well as for the glory of his young wife.

Of this pantheon of illustrious forebears that Norman Rockwell could legitimately claim, he chose to remember that "my grandmother

[Phoebe Waring] was related to Robert Getty. . . . otherwise, we have nothing to brag about," an odd contortion of ancestral history. Not only had the Rockwells and Warings themselves achieved admirably and gained renown, but their connection to the Gettys was distant at best. Phoebe Waring's sister, Anne Marie Waring, had married Walter Halsey Paddock, whose sister in turn had married Samuel E. Getty, Robert's son. Their merger was only the latest of several between the Paddocks and the Gettys during the preceding fifty years, none of which changed the fact that any connections to the Rockwells were through marriage, not bloodlines. Furthermore, in complete contrast to the English blood that comprised Norman Rockwell's own heritage, Robert Getty was from Londonderry, Ireland, his ancestors Scottish. But Robert Getty had been respected as one of the first prominent citizens to speak out against slavery, and Rockwell would have loved laying claim to such a liberal tradition, one that he had probably heard admiringly discussed. Getty's great wealth as well must have awed Rockwell, who referred frequently to his own family's financial straits. It is nonetheless startling that in spite of the fact that Rockwell had at his disposal an ideally constructed middle-class Yankee genealogy, made to order for the values promulgated by *The Saturday Evening Post,* he chose to dispatch that history with a few brief references. Instead, he identified either with the "name brand" nonrelative or with the less directly connected ancestors who lent themselves best to kindly caricature, characters such as his underappreciated artist grandfather, whose traits retained dramatic life from his childhood memories.

To be sure, the romance that blossomed between Nancy Hill and Waring Rockwell would yield plenty of theatrical fodder for their creative son. How the couple met.is unclear, especially as Nancy was Episcopalian and Waring a Presbyterian in an age when courting often occurred at church functions. Nancy, however, was looking for a good man. "Apparently she was considered a bit of an old maid by the time she married at age twenty-five," Mary Amy Orpen explains. Nancy and Waring got engaged the year that her mother and brother

died, in spite of the young woman's reservations about being three years older than her fiancé. Hard work had become an ancestral badge of honor by the time that Rockwell's grandfather was building his coal business, and Waring appeared to be as steadfast and energetic as his father. He also proved malleable: two years after their engagement, Nancy convinced Waring to be confirmed in the Episcopal faith. He had already started receiving communion at Nancy's modest St. Paul's parish. Episcopalians trumped Presbyterians on the social pecking order; but the lifelong adoration Waring Rockwell held for his spouse suggests that society played little part in his embrace of her religion. All her life, according to Norman Rockwell, Nancy would believe that Waring had married down in taking her for his wife.

Almost three years after the couple became engaged, Nancy's father died. Howard Hill was as itinerant in death as he had been in life. Inexplicably, it took his surviving children almost two years to arrange for his burial in St. John's cemetery, and even then, his grave lay conspicuously separated from those of his wife and son. Nancy, twenty-three years old, was already living in Crompton, Rhode Island, with her older sister Susan and Susan's husband, Samuel, when her father died, and she and "Susie" may have used their distance as a convenient excuse for failing to arrange for the patriarch's interment. An Episcopal minister, Susie's husband, Samuel Orpen, had recently been appointed rector of St. Philip's, the first Episcopal church to have been erected in the Pawtuxet Valley, and his home provided a temporary oasis for his wife's rootless sister. Two years after Hill's death, Nancy achieved a respite from her insecure life. "She spoke often of having had 'only' a five-year engagement to Waring," Mary Amy Orpen remembers. "'I didn't believe in long engagements' is what she would explain. The truth is, in those days she was getting rather old to be a first-time bride, so instead of the ten years not uncommon for engagements then, she hurried things up a bit." Local church records show that Anne Mary Hill and Jarvis Waring Rockwell, with his striking resemblance to the bride's handsome dead brother, Tom, were wed at St. Philip's on July 22, 1891. Samuel

Orpen, Nancy's brother-in-law, performed the ceremony at the Episcopal church, and he sponsored the wedding breakfast held in the rectory afterward. In attendance were ten-year-old Frances Anne Orpen (Susan's daughter) as maid of honor and Samuel D. Rockwell, Waring's brother, as best man. Nancy's younger brother, Percevel Howard Hill, gave the bride away; her other sisters and adopted siblings had scattered throughout the country. Phoebe and John Rockwell, the groom's parents, were present, as were Waring's sister and her husband, and his great-aunt Anne Waring Paddock and her husband, Walter. The absence of parents on the bride's side poignantly bespoke the devastation tuberculosis had visited upon the Hills; nor had its reign ended, as the wedding party would discover soon enough.

The beauty of the ceremony and the "prettily decorated" church, festooned with "palms and flowers," served to remind everyone that although Nancy Hill was marrying into one of Yonkers's most reliable and well-established families, her own background enabled her to ennoble the surroundings with her inherited artistic (and aristocratic) taste. Having her sister's husband perform the Episcopal rites also suggested that Waring Rockwell was marrying his equal. Nancy ensured that the wedding conveyed an "agreeable fascination," as the local paper termed it: "The bride and maid of honor were attired in white, the bride carried a posy of duchess roses and the maid of honor a posy of white daisies. . . . The bridal party approached the chancel amid the quiet strains of the 'Bridal Chorus.' It was a beautiful and impressive scene—the solemnity of the occasion, the fragrance of the artistically arranged bridal blossoms, the grace of the bride and groom. . . ."

The couple moved into their modest spousal apartment at 206 West 103rd Street, near the northwestern boundary of Central Park, an area that had blossomed when the Ninth Avenue El brought it to life in 1880. Waring's job as a clerk with the Manhattan regional branch of Philadelphia's George Wood and Sons textile company provided him ample opportunities for promotion. In spite of the troubled economy of the early 1890s, considered by some experts to have en-

compassed the second-worst depression in American history, the fin de siècle beckoned from the horizon of Manhattan's Upper West Side, with its promise of a fully functioning I.R.T. subway, a completed world-class cathedral, and further blossoming of academic institutions and residential expansions along Riverside and Morningside parks. Innovation and progress, replete with rewards for hardworking citizens like Waring Rockwell, heralded the decade ahead. And the newlyweds inherited a ready-made community: John Rockwell, for one, had traded his daily commute from the Yonkers homestead for an apartment in Manhattan, probably because his own fortunes had been damaged during the recent downturn in the economy. Cousins lived in the city as well, and Nancy's own relatives were all within visiting distance. Following the lead of her pious mother, however, the new bride established as her first social circle the committees of the local Episcopal church, St. Luke's.

So it was that on September 29, 1892, the Rockwells' first child was born a native New Yorker. Jarvis Waring Rockwell, Jr.—called "Jerry" during his childhood—took his place as firstborn and father's namesake. For the next year and a half, Waring, as conscientious and sober as his hapless father-in-law had been unreliable, worked doubly hard to accommodate the family's growing financial needs, while Nancy responded to the seemingly never-ending demands of a new baby. In spite of Jerry's age, she even forced herself to take him to Crompton to see her sister and brother-in-law, because the Orpens were making sounds about moving somewhere warmer that might improve the minister's lingering cough. In the summer of 1893, amid great concern that the cotton business would be affected by the recent stock market crash on June 29, a loving but plaintive wife informed her already diligent husband that his efforts would need to increase, since it appeared that they were to have another child early the following year.

3

City Boy, Born and Bred

By midnight on February 2, 1894, snow was predicted for the following day. At least a month earlier, Waring Rockwell had dutifully informed his boss that any time now he might fail to show up at work; his wife, convinced she had a sickly constitution, insisted that her husband be prepared for a premature delivery. Instead, pretty much on schedule, she had gone into labor that evening, and now Waring awaited anxiously the appearance of Dr. Grant, who arrived in plenty of time to assist Norman Percevel Rockwell, feet first, into the world at two A.M. on February 3, hours before the first snowflake fell. The elaborate miniature bedclothes Nancy had expertly embroidered in hopes of fitting them to a girl this time seemed a bit frilly in the (slightly horsey) face of this gangly infant, she had to admit. Nevertheless, incongruous or not, he would wear them. The newborn's eighteen-month-old brother was quickly sent away to Waring's sister's large country home in Nyack, where Grace and Sherman Johnson had two older boys to keep young Jerry amused.

Pictures of Norman Rockwell dating from his first few years reveal

a wary child whose gaze seems preternaturally fearful and impatient at the same time. In more ways than this, the child was truly father of the man. Rockwell would consistently narrate his feelings far more expressively through his face than through his conversation. Consider this experiment: cover the top half of any photograph of the adult, then reverse the trick and look at the eyes only, bereft of the inevitably upcurved lips. Impossibly, the heavily hooded eyes stare forth boldly and tentatively at the same time. Rarely does their emotion match the implication of the smiling mouth. Pleasant though wary, provocative if emotionally removed, happy but sad: these are the paradoxes that defined the man as well as the boy. Apparently, the personality they reflect was laid down early and irrevocably.

The tension that even the toddler wears on his face seems part of what would prove his mother's mixed legacy. By default as much as design, Nancy Hill yoked her sons to stereotypes: Jerry represented the masculine ideal in the household, and Norman the effete nobleman. Somewhat reminiscent of British primogeniture, where the firstborn son inherits the manor, Jerry, named after his father, was to be successful in business, and a "real man" besides; Norman, tasked by his names to represent the royal as well as the feminine side of the family tree, would develop his artistic talents. Accordingly, Nancy projected the appropriate behavior onto each son: she encouraged Jerry to be aggressive, strong, and fearless, while she reassured Norman that he was weak, like she was, and therefore probably entitled to protection as a result—though she quickly turned the equation around so that he was meant to succor her.

Through the names she bestowed on her sons at birth, Nancy hinted at the duality she would use to guide their development. Rockwell ruminated aloud that "My mother, an Anglophile . . . and very proud of her English ancestry, named me after Sir Norman Perceval ('Remember, Norman Percevel,' she'd say, 'it's spelled with an e; i and a are common'). . . . The line from Sir Norman to me is tortuous but unbroken, and my mother insisted that I always sign my name Norman Percevel Rockwell. 'Norman Percevel,' she'd say, 'you have a

valiant heritage. Never allow anyone to intimidate you or make you feel the least bit inferior. There has never been a tradesman in your family. You are descended from artists and gentlemen.' "

The strained stories about their royal heritage that Nancy repeated to Lord Perceval's New York namesake (she seems to have been quite mistaken about the spelling of the name) sounded dubious to Rockwell even when he was young, contributing to a lifelong gentle scorn toward his mother. He felt diminished, not elevated, by bearing so patently inappropriate a name as this sign of his mother's misplaced pride, and he "darn near died" when a boy called him "Mercy Percy" in his youth. It was Jerry, named after one of the family's true Yankee aristocrats, Jarvis Waring, who got handed the real identity, as far as the younger son could see. Somewhat gratifying to the competitive older child, such classification encouraged Rockwell to believe from an early age that his own masculinity was never the given that his brother's was—"I had the queer notion that Percevel (and especially the form Percy) was a sissy name, almost effeminate"—and he lived "in terror" of being ridiculed because of it. His idea was not queer; it was an accurate reflection of his times. At this point in American culture, media use of the name Percevel functioned as a kind of shorthand for pretentious, effete old-worldisms. The crusty H. L. Mencken even warned parents that giving their sons such a "sissy" name was tantamount to ensuring a childhood of playground fights for Percevel to defend his masculine honor. Rockwell would always feel himself falling short of the model American male, and having to stave off the identity attached to *Percevel,* a part of his name until he left home, contributed to his insecurity.

Oddly, in light of such perceptions and his relatives' own observations to the contrary, Norman (as well as Jerry) confusedly believed that he had been the favorite son, a complicated assessment buttressed by Nancy's unfortunate edicts to her friends that "Norman and I are so alike, we might as well be Siamese twins." In spite of evidence suggesting that she did in fact favor Jerry, her oppressive attention to Norman conferred benefits as well as caused distress. Although it does seem that she was generously possessed of hypochondria, self-centeredness, and intellectual banality, Nancy Hill also displayed a

startling flexibility, a sometimes charming eccentricity, close attention to detail, and a resolute will to get whatever she wanted—this last characteristic closely observed by her younger son. An unpredictable sense of fun coexisted with her often rigid propriety, and her pleasure in the ribald seems the probable source of Rockwell's own famously naughty humor: "I know that I was shocked when my aunt Nancy thought nothing of my going skinny-dipping with a mixed group of young people in the 1940s," Mary Amy Orpen recalls. "She saw the sketch I made of the event, and she said, 'I'm appalled.' When I asked her why, she said, 'It is too early in the season; in May you can still catch your death of cold.' "

In all fairness, the stress Nancy labored under shortly after Norman's birth would have weakened the most determined mother's resolve to tend cheerfully a newborn and a toddler not yet two years old. Her brother-in-law, the Reverend Samuel Orpen, had become so ill that he had resigned from St. Philip's. In spite of the signs that consumption once again preyed on her family, Susan Orpen optimistically agreed that the strain of running what were essentially two parishes had caused her husband's exhaustion. The young minister and his family stayed on at the rectory until Samuel felt recovered enough to travel to Welden, North Carolina, to take on a new church job. Susan remained behind to oversee the packing of the household, and to visit with her sister's new baby, she hoped, before leaving for the rectorate in the South.

Instead, she received a telegram stating that her husband was stricken yet again—with "apoplexy." According to rectory accounts, their loyal Crompton physician traveled all the way to Welden to bring the minister back to Rhode Island, where he could recover among friends and family. By mid-July, Samuel appeared strong enough to set out again, but it was felt that he needed a vacation to recuperate fully. Frances, their nineteen-year-old daughter, moved in with Nancy and Waring, and the Orpens departed for Europe.

Frances, who had been Nancy's youthful maid of honor nine years before, was a favorite of Waring's as well. Now she would prove helpful with the younger charges. Still, Nancy was all too aware of what

her brother-in-law's fevers and coughs signaled, and by now she would have surmised the threat that contaminated family members posed to one another. She had already observed the symptoms of consumptive tuberculosis up close five times in the past fifteen years; the disease was wiping out her relatives. She knew how to interpret Susan's own increasing fragility and recurring colds; if Samuel had tuberculosis, his wife would most likely die not too long after him.

Nancy Rockwell understood that lives entwined with the Hill family proved more provisional than most. Her distant affection for her own children must have stemmed not only from her mother's example but from, at the very least, an unconscious fear of losing them. She didn't know the epidemic pattern of the disease, which would have depressed her further: the bacterial tuberculosis that had not finished its sweep through her family had most likely left its calling card with every person in continual close physical contact with the Hills. The lucky ones would escape its activation, though the germs would live in their host until death, ready for activation if the immune system failed. Poverty, poor nutrition, and overcrowding were conditions that ensured the disease a stranglehold; alternations of feast and famine in Howard Hill's household must have weakened many of the inhabitants, making his family perfect incubators for the unwelcome guest. Consumption was not yet a rare condition by the end of the nineteenth century, but the degree to which it ravaged Nancy's family seems more characteristic of the garrets of *La Bohème* than the boardinghouses of Yonkers.

The Hills' mode of moving from one communal home to another depending on Howard's work status had raised hope as often as it dashed expectations. Nancy had accepted such varying domestic rhythms as the norm, and the frequent relocations that she grew up with soon began to punctuate her married life. Around 1896, when Norman was two years old, the family moved to a railroad apartment at 789 St. Nicholas Avenue, near 149th Street, a sign that their financial resources were improving, especially since they had weathered the market crash and assimilated the costs of a second child comfortably.

In later years, the illustrator remembered the fourth-floor walk-up as dark and gloomy but, however modest the apartment, its location farther uptown where real estate cost more and new buildings were being planned around anticipated mass transit stations marked a rise in his family's fortunes. Whatever his parents believed, however, he stockpiled memories of a "pitifully genteel" neighborhood, composed of monolithic four- and five-story apartment buildings with a few private houses scattered in their midst. The residential area was actually a typical one for low-level white-collar workers at the turn of the century, and in fact most of the apartment buildings were erected after 1904, when the subway opened, but Rockwell cast the far Upper West Side peremptorily as "lower middle-class with a smattering of poorer families." Most of all, he never forgot that "the tough slum districts were east of us toward Third Avenue."

Nancy and Waring depended on Jerry to defend their younger child against the dangers they carefully detailed for both sons. By the time Jerry turned five or six, the athletic, confident, bright child functioned as a useful guide into boyhood society for his little brother. Allowed to tag along, primarily because the pecking order was so apparent, Norman learned to socialize easily with the friends that Jerry effortlessly gathered around him. And Norman felt safe with his strong older brother at his side, since disaster awaited him at every street corner, according to the warnings his nervous mother issued daily. But the fraternal closeness always on the verge of emerging was smothered under the pressure of Nancy's awkward maternal gestures. Continuing to send Jerry to "have fun" with relatives in the country when her own nerves were frayed, Nancy clumsily tried to reassure her firstborn that his family would be there when he returned, emphasizing instead his dethroning: "Little Norman didn't feel well again yesterday, so he crawled into bed and slept with me," she once cheerfully wrote the young boy, a message he would recount to his own children years later, in wonder.

Jerry created his own defenses against his childhood. A personal memoir that he penned after his sibling had become famous recalls,

perhaps defensively, his pity for poor Norman's plight: while the older boy got to go play with cousins his own age in Providence, Rhode Island each summer—"I considered myself very lucky as I had a bicycle there"—his little brother was stuck at home. "I always felt sorry for Norman," he wrote. In truth, Jerry grew up resentful of his brother, their relationship tainted from the start by his parents' insensitive handling of baby Norman's displacement of the little toddler. Shipping the eighteen-month-old off to relatives whenever Nancy felt overtaxed was hardly designed to assuage his fears. Norman, as the baby, had to stay with "Mama," but Jerry could temporarily become a cousin's responsibility. "My father said that Norman was always sick," Jerry's son, Dick Rockwell, remembers. And Jerry himself admitted that "I have very little memory of him as a baby. He was always frail, quite thin and I considered him delicate. I was rather rough I'm afraid and did not play very gently with my young brother."

Norman, striving to emulate his brother and gain his approval, sought opportunities to join in the older boy's activities. Luckily, when Jerry began grammar school at P.S. 46, Norman quickly discovered a sure way to increase his own currency: he learned to draw. Although his father had actually been copying pictures from magazines for years, Jerry's obviously important homework—completed at the dining room table under his father's watchful eyes—goaded Norman into joining the fraternity. After a few days of boredom, Norman asked "Papa" to teach him how to draw too, and then all three Rockwell "men" began a routine of working together every evening after dinner.

Motivation aside, the inspiration was divinely directed, that much seems clear. Waring was no mean draftsman. A pencil sketch from around 1900 of a Northern European countryside shows his fine mastery of perspective, form, and detail. Although a nightly routine of copying magazine illustrations is nearly unimaginable a hundred years later, at the beginning of the twentieth century the hobby was popular in many households, especially those of an artistic bent. Night after night, Waring sat with his two sons, his wife calmly embroidering on the nearby sofa, the glow of soft maize-colored gaslight casting

warm shadows that Rockwell would call upon years later when paint-
ing his own Dutch-inspired domestic scenes.

By the time Norman was sharing magazines with his father, the
Golden Age of Illustration, roughly the period from 1880 to 1930, was
peaking. Well represented by such artists as Howard Pyle, Charles
Dana Gibson, Howard Chandler Christy, Harrison Fisher, James
Montgomery Flagg, Frederic Remington, Arthur Frost, and Edward
Kemble, the period around the turn of the century was a watershed
for illustration, proving that the mass production of extraordinarily
high-quality art was possible and profitable. Artistic talent put to use
in magazines was no longer new, for sure: Winslow Homer had illus-
trated the New Year of 1869 in *Harper's Weekly*, showing 1870 riding
in on a velocipede, an early bicycle. *Scribner's* and *Harper's* both pio-
neered the use of wood engravings, and, by 1884, *Century* and
Harper's were both reserving a full 15 percent of their space for pic-
tures. Although the production methods of the past quarter century
had produced an overabundance of lackluster illustration alongside
the outpourings of first-rate artists, the last years of the nineteenth
century coincided with a revivified period of quality magazines set to
exploit improved technologies.

When Rockwell was born, the American magazine had finally tri-
umphed over its close competition from England; *Judge* and *Life* were
finally outselling *Punch* in the United States. Ushered into lower-class
homes through the reduced prices caused by the financial panics of the
1890s, magazines would play a part in forming the national conscious-
ness until the end of World War I, superseded only by radio and televi-
sion. This visual/verbal venue of mass circulation seemed to symbolize
America's new strength as an industrial, muscular, modern country—its
mission nothing less than to become a world leader. By association, the
art that appeared in such periodicals was assumed worthy of study. It
was this forum overladen with all things American, progressive, and
communal that anchored the nightly bonding of the Rockwell males.

Imagining the family scene where Norman Rockwell undertook
his first drawing proves irresistible. Slightly churlish throughout his

life, little Jerry must have lorded over his pesky brother the importance of his own real work. At the turn of the century, the curriculum
of New York City primary grades depended heavily upon drawing the
answers to questions, whatever the subject. Norman, those intelligent, restless eyes signaling that he thought he could do just as well as
his brother, quickly realized that he could do even better. The praise
emanating from his father and his mother established the strongest
sense of self and worth yet available to the son whom Nancy called
"Snow-in-the-Face," because he was so pale.

Norman's desire to imitate his father was sanctioned by his parents, who both quickly grew proud of their son's obviously inherited
abilities. Erik Erikson, the psychoanalyst who wrote on adolescence
and stages of human development (and later Rockwell's close friend)
believed such approval pivotal to any boy's development. In terms that
shed light on the Rockwells' father/son hobby hour, Erikson, in *Childhood and Society,* reflected upon the determining role that a father
often plays in his son's choice of a career. By "sharing his admiration
for a particular ideal"—in this case, illustrations good enough to be
mass reproduced, and worthy of replication yet again by the paternal
hand—without positioning himself as a professional competitor, Waring allowed Norman to "play" with him by identifying with the same
fantasy, the successful commercial artist. Waring enacted his passion
in the amateur realm only, but the next generation had the chance, at
least, to reproduce competitively the source of the nightly bonding,
outperforming the teacher in the process.

About the same time that Norman and Waring practiced their
drawing from as many illustrated magazines as the (according to
Rockwell) lower-middle-class family could afford, one hundred miles
to the southwest, George Horace Lorimer was working sixteen-hour
days to revivify the flagging *Saturday Evening Post.* The weekly *Post*
proudly traced its lineage to Ben Franklin's *Pennsylvania Gazette,*
launched in 1729. One hundred years later, circulation had climbed
to an astounding ninety thousand, due in part to a stable of writers including Edgar Allan Poe, Harriet Beecher Stowe, and James Fenimore

Cooper. But after the Civil War, the English pattern of monthly mag-
azines influenced the American publishing world so much so that the
triumvirate of *Harper's, Scribner's,* and *The Atlantic Monthly* began to
dominate the local market. By 1898, even the all-American *Post* aped
the higher-brow practice of culling snippets from English newspapers
and magazines. Its fiction now rarely signed, the entire magazine was
sustained by the ludicrously low advertising revenues of $290.00 per
issue; subscription had, predictably, deteriorated to 10,473.

Philadelphia publisher Cyrus Curtis, who had made his *Ladies'
Home Journal* a huge success, perceived the need for a weekly that
would leave news to the newspapers, and that would establish for it-
self an entirely separate niche. Intending it to be aimed primarily at
men, he bought the foundering *Post,* and after the first year, during
which Lorimer worked under someone else, Curtis fired the first-in-
command and appointed Lorimer as acting editor in chief. Within
weeks, Lorimer had convinced the owner that he could turn the *Post*
around.

Which he did. In the process, he expanded the pragmatic vision of
its founder, packaging smartly and stylishly an irresistible myth predi-
cated on American unity, its art and literature—its destiny—finally in-
dependent of Europe.

By the turn of the twentieth century, New York City counted more
than 70 percent of its public school students from foreign-born par-
ents. The common progressive view, held by humane educators and
government officials alike, perceived the need for acculturation, or
Americanization, which included immersing the immigrant in the
"language, customs, and political ideals" of the country. No strong
voices were raised in defense of a pluralistic society; instead, the very
youth of the United States seemed to argue for the need to establish a
unified, incontestable image of "being American," the achievement of
which the multitudes of immigrants could then make their goal. In
curricular reform that reflected education across the country, the New
York Board of Education began emphasizing a formal study of history
that celebrated a mythic America of a decidedly Protestant-Puritan

bent, an account distorted, as one teacher of the era recalled, by "omission" more than commission: "They left out all the terrible things that happened." Such a focus on the country's manifest destiny implied that the torch of civilization had passed from the (corrupt) Old World to America's virtuous shores, an ideal picture thought sustainable only if the image of America was writ bold and clear and unified.

George Horace Lorimer used the *Post* as an instrument of such "Americanization." Worried that the country would be caught up in global concerns best deferred until the national identity of the United States had congealed, he urged his countrymen (and, later, women) to see their business as that of building a new nation, one where hard work, fair treatment of others, and rigorous if imaginative thinking would triumph against an effete intellectualism tainted with European elitism and decadence. Most important, he celebrated the ideal of an American community made safe by a shared vision of right and wrong. If he challenged readers to live a virtuous and informed life, he also encouraged them to look to their own backyards first and foremost. The *Post* aimed its advertising at an inchoate ruling class in search of an identity. The message found its audience among the country's aspiring middle-class, largely Protestant population, which could consistently afford to buy the modestly priced magazine.

Waring Rockwell typified the kind of customer targeted by the new *Post*. He liked its unpredictable mix of worldly cover drawings and the occasionally vivid illustration; the magazine was clearly undergoing major changes, and he was eager to see what would happen each week. And in spite of its slight sheen of sophistication, it still met family standards of modesty and decorum. Why, even the subjects that captivated the Rockwell boys showed up in this adult forum: the famous illustrator J. C. Leyendecker's first cover for the *Post* appeared on May 20, 1899, a black-and-white drawing for a story on the Spanish-American War, around the time that Jerry bribed his talented brother into making him a paper fleet of ships.

And, by 1900, Norman was already taking advantage of any opportunity to increase his skills and his repertoire of recognizable pictures. He had quickly realized that his brother would allow him to hang

around his friends as long as the younger boy kept reproducing the various ship models that celebrated Admiral Dewey's recent feats, cardboard pictures of which were now included in cigarette boxes. The child took meticulous care with each picture, effort that went utterly disregarded when Jerry and his latest buddy engaged in instant warfare once the objects were handed over. The older kids would take scissors and see who could cut up the other's ship first, a too quick end to his art, even the six-year-old artist felt. A scorched-earth policy ruled, so that after ten minutes, hours of Norman's craft crumbled to the ground. Years later, he still rued the contrast between his efforts and the disposable commodity he had brought forth: "It was sort of a frustrating form of art for me: five minutes after I had drawn the fleets, laboriously copying with much smudgy erasing, Jarvis and his friends would have cut them to shreds." The memories the brothers later recounted of the mock war games speak loudly of the division between their sensibilities. One tended toward action, the other, contemplation: "I do recall playing sham battle in a vacant lot across the street," Jerry writes during the same period that Norman reconstructs in his memory in terms of the artist's role, meant to curry favor. "The Spanish-American War made us kids quite warlike."

His ability to draw whatever others asked him gained Rockwell a place in the neighborhood, and it became his identity mark among a group who were all considered gifted in equal but different ways: "My ability was just something I had, like a bag of lemon drops. Jarvis could jump over three orange crates; Jack Outwater had an uncle who had seen a pirate; George Dugan could wiggle his ears; I could draw. I never thought much about it. A bunch of us kids would be sitting around on the stoop and somebody would say, 'Let's go up to Amsterdam Avenue and look in the saloons.' 'Naw, we did that yesterday.' Silence. 'Say, Norm, draw something.' So I'd draw a lion or a fire engine on the sidewalk with a piece of chalk. But it was just as likely that someone would ask George Dugan to wiggle his ears."

Although Norman and Jerry had plenty of friends in the neighborhood, the boys generally went to others' houses to play. Their mother found it taxing to have visitors, and her frequent sick spells, which in

later years she herself would call her "nerves," benefited from quiet. "Whenever I think of my parents a certain scene invariably presents itself, a scene which was repeated day after day during my childhood," Rockwell recalled at age sixty-five. "It is late afternoon. I am playing on the stairs or in the hallway of the apartment house. The front door opens and closes and my father comes up the stairs, worn out from his day at the office and his hour ride on the trolley. He goes into the apartment and I can hear him ask my mother: 'Well, now, Nancy, how are you?' 'Oh, Waring, I've had such a hard day. I'm just worn out.' 'Now, Nancy, you lie down on the couch there and I'll get a cold towel for your head.' And then he'd shut the door and all I could hear would be my mother complaining, interrupted at long intervals by my father in tones of gentle sympathy and concern." The neighbors told Norman that his father was "a saint," a "wonderful, wonderful man" for treating Nancy this way.

Nancy's neurasthenia routinely reached fever pitch when her doting husband returned every evening, and the boys learned that this was the best time of day to grant their parents some privacy. Her constant spells of feeling ill demanded most of the emotional resources of her household. In spite of being told that there was "nothing wrong," she was always sending for doctors to diagnose the physical ailments that accompanied what we would today call depression. The sympathy that such chronic suffering normally elicits was forestalled by her demanding attitude; whatever she wanted, it was Waring's duty to procure—a position he unfailingly accepted with good grace. From pictures of this period, the married couple seem romantically bound; in one, for instance, Nancy cuddles in Waring's lap while the sons stand, somewhat uncertainly, behind and to the side of their parents. Family lore holds that Nancy Hill was an enviably skilled coquette, though her overt use of conventional feminine wiles struck many people as dated and cloying rather than charmingly coy.

The parents' closed little circle of spousal devotion left little energy for their sons, and staying away until dinnertime was no hardship from the boys' point of view. From the loud omissions in Rockwell's

autobiography, we understand that he welcomed diversions from his home life. His mother, with good reason, was more often frenzied than controlled during early 1900. Mere months after welcoming in the new century with fervid hopes for good health, Nancy had confronted the deaths of her beloved sister and brother-in-law, Susan and Samuel Orpen. During the five years that the couple battled consumption, a tacit understanding had developed that in the event of their deaths, Nancy and Waring would house at least one of the children that the Orpens were raising. In addition to Frances, their own daughter, the kindly minister and his wife had informally adopted John, Amy, and Eva Milner, the three children orphaned several years earlier by the consumptive deaths of Nancy and Susan's sister Amy Hill Milner and her husband. Over the next ten years, at least one of the two girls lived with the Rockwells, and sometimes both Amy and her mentally retarded younger sister, Eva, were under Aunt Nancy's care. Nancy's grief over the Orpens' death, and her fear of the additional responsibilities she incurred upon their demise, tended to find expression in a compelling though inconsistent neediness that confused and frightened her younger son: "I was never close to my mother. . . . When I was a child, she would call me into her bedroom and say to me: 'Norman Percevel, you must always honor and love your mother. She needs you.' Somehow that put a barrier between us."

Unfortunately, school did not provide for Rockwell the escape from an oppressive home life that it has for many children. In the early 1900s, the primary years curriculum depended heavily on drawing and coloring, activities that might have been congenial to the young boy. But the rigid structure of the classes and the rewards for doing things the teacher's way played to a nascent imperiousness that would characterize the adult artist as well. Unwittingly replicating the behavior of his mother, Rockwell refused to exert himself for any activity he felt not in his self-interest. And he could not convince himself that school was of much benefit. Even walking back and forth four times a day (the boys ate lunch with Nancy) grew tedious, so Norman and Jerry got roller skates that made the seven-

block trip between their apartment and the school on 157th Street more fun.

Skating enabled Norman to get home in ten minutes, time spent in dreaming up schemes to make up for the day's lost hours. The boredom of school was a spur to being "bad" in the afternoons, in the determinedly subversive mode common to restless city boys. His buddies dug holes to China under any tiny plot of ground they could find; they raced to the top of telegraph poles; and they huddled around the *National Geographic*s one lucky lad ferreted out of his parents' hiding place, in order to look at the naked native women. Race and class mattered, Rockwell remembered: "There was . . . a lot of racial prejudice in New York City in those days [a "nasty, stupid business" as he notes]—we called Italians wops, Frenchmen frogs, Jews kikes—and class feeling was strong." In the 1940s, when asked to define his "boiling point," Rockwell responded: "I was born a white Protestant with some prejudices which I am continuously trying to eradicate. I am angry at unjust prejudices, in other people or in myself." In the far Upper West Side of Manhattan, Norman befriended a boy who would ordinarily have been beneath the notice of Rockwell's group because his mother took in laundry. The lad would do anything to be allowed to join in the boys' activities, the illustrator remembered, slightly ashamed, so the poor child volunteered to be the subject of the group's experiment one day: how many encyclopedias could you drop on someone's head before he passed out? "Ewald" collapsed after four books hit him, but he made up for his weakness by taking his friends to the police station in the paddy wagon when he had to identify his dead uncle, a "drunkard" whose corpse Ewald promptly vomited all over, making him a real hero to the boys.

Waring sought to be the weighty, somber family head his wife seemed to desire (even those aunts who had liked Howard Hill agreed he'd been "very dictatorial and stern," values Nancy apparently imbibed as patriarchal duties). He tried to tame the neighborhood boys' exploits into more decorous pleasures. When allowed to give way to his own impulses, however, he exposed a less obvious side of his per-

sonality, one that relished the activities of childhood. One escapade recalled by several of his nephews consisted of running up and down the fire escape outside his apartment. Especially given the kinds of stunts Rockwell pulled with his own sons later on, it is easy to imagine what pleasure Waring's playfulness provided his boys. He wanted his sons to have a "normal" boyhood, and he tried, sometimes clumsily, to match theirs to what his had been in Yonkers. "I do remember one Fourth of July disaster," Jerry reminisced. "Pa had bought us a lot of fire crackers. We were allowed to shoot them off one at a time—not in packs as lots of the other boys did. Somehow the box we had them in took fire and our entire celebration was banging off in about five minutes. I am sure we both cried."

But Waring's attraction to things childlike, including his capitulation to his wife's babyish coquetry, all too often merely highlighted a certain ineffectiveness that his sons later associated with him. Even his earnest work ethic, which enabled him to rise from office boy to manager of the New York branch of George Wood's cotton firm, sometimes verged on the pathetic in his zeal to impress his boss. His sister Grace had married a doctor who made a handsome living; his brother Samuel lived luxuriously off wealthy women; and his cousins all made more money than he did as well. On the infrequent occasions when George Wood appeared in Waring's Manhattan branch office, the excited employee would hurry home in the evening to share the great news with his family. At a young age, the boys recognized that Waring needed their affirmation, if only to compensate for their mother's failure to give him the praise he obviously courted: "He was intensely loyal to the firm. Every so often he would come home from the office beaming with pleasure. Then we all knew what had happened that day—Mr. Wood had been in the office. At dinner after my mother had said grace he would unfold his napkin and arrange it carefully across his knees. Then he would lean back in his chair and say: 'Mr. Wood was in the office today.' My mother would continue eating, but Jarvis and I would beg him to tell us what Mr. Wood had said. And he would recount his conversation with Mr. Wood verbatim."

Waring's pleasure at satisfying his boss boded well for the financial stability Nancy sought, but his easy acceptance of the paternal order worked against the excitement and change the demanding woman equally valued. At least Waring came by his living honestly, we can almost hear his frequently bored wife avowing self-righteously, when she learned of the rapscallion Sam Rockwell's remunerative marriage to a prominent heiress.

It had so happened that when Sam, Waring, and their sister Grace were young, Phoebe and John Rockwell owned a modest country house in Stamford, Connecticut, near the lavish estate of the wealthy banker and philanthropist Francis A. Palmer. Especially since Susan Lewis, the ward of her uncle Francis, had been a "chum" of Grace Rockwell at Drew Seminary and later at Wells College, the young woman had on several occasions interacted with Grace's suave younger brother, Sam. After her graduation from Wells, Susan Lewis married Miller Crampton, whose own investments in western mines had netted him a handsome income. Crampton unexpectedly died in 1896, leaving behind a young, very wealthy widow and their two sons. Mrs. Crampton spent the next two summers at Trumansburg, New York, her birthplace, where Sam Rockwell was also vacationing. He believed that his "sciatic rheumatism," probably the syphilis that would later kill him, responded particularly well to the spa treatments at Sheldrake resort on Cayuga Lake. At the time of Miller Crampton's death, Sam Rockwell was apparently married (sketchy extant records strongly suggest the presence of a wife) and living in Warehouse Point, Connecticut; two years later, inexplicably, he was once again a single man, whereupon he promptly wed the Crampton widow at a private wedding at the Cayuga Lake House.

But there was a serious problem from the beginning: Susan Crampton Rockwell's eccentric uncle and guardian, Francis Palmer, had warned her not to remarry or she would risk disinheritance from one of the largest personal fortunes in New York City. The couple commanded family and friends to keep their marriage silent, a pact sustained, amazingly, for three years. Waring and Nancy, averse to anything that publicly compromised one's moral stature, undoubt-

edly clucked in disapproval at the slick older brother's methods. And they would have seen him often; Sam worked daily with his father at the coal business on 1 Broadway. He lived, however, in an elegant brownstone residence at 10 West Seventy-first Street that his wife's uncle had given her (in addition to a country house) at the time of her first marriage, and such handsome surroundings would have caused his relatives, whom he frequently invited over, to forgive him much.

Although jewels and gifts of money had been lavished on the Cramptons seventeen years earlier, banker Francis Palmer felt differently about this second marriage of his beloved niece when he finally found out about it. It appears from his carefully worded response to reporters hounding him for a statement that he sniffed a gold digger; Samuel Rockwell's reputation as a ladies' man, his work in the coal industry, and the contrast between the playboy's elegant slimness and Susan's matronly appearance all cast suspicion upon the union. Publicly, Palmer stated that because his niece had married without his consent and then deliberately deceived him, he had disinherited her from the $5,000,000 reported to be previously promised her.

Publicity raged. The November 26, 1901, *New York Journal* deemed the event worthy of a bold headline on its front page: "WED FOR THE SECOND TIME IN SECRET," followed by the subtitle "NIECE OF F. A. PALMER LOSES FORTUNE." The article claimed that "millionaire Philanthropist and Bank president discovers his selected heir married again and decides to leave his millions to charity and Education Institutions—niece kept marriage secret three years and is 'happy though married.'" *The New York Times* reported that after Palmer "accidentally" heard about the marriage, he obtained a "confession" from his adored grandniece, who for the entire period of her marriage had been leaving her own house by six in the morning in order to breakfast with her uncle at seven, then shop with him daily before returning to her home on Seventy-first Street, where a reporter claimed to have seen the "slender, delicate-looking" young Samuel Rockwell.

Indeed, he was slender. A picture from 1902 would reveal a substantially overweight bride with a scarecrow of a husband at her side,

the couple surveying "their" property at the Lamertine Mine in Idaho Springs, Colorado.

Samuel gave the newspaper his own self-serving version of the uncle's actions: "The marriage was kept from Mr. Palmer because he is an old crank, a perfect fanatic. He does not believe in second marriages, and we feared the news of ours might kill him." Shifting his tactics totally, the young groom continued energetically: "He says that I cannot support Mrs. Rockwell. He has only gone on this tangent because I am showing I am able to do so. He is angry because his niece has not been compelled to eat humble pie and because when our marriage was announced a short time ago [after Palmer found out first] our friends in society rallied loyally to our support and Mrs. Rockwell's social position has not suffered. The anonymous letter to Mr. Palmer, telling of our marriage, was written by a scheming relative who wanted to get his money." Not to be deterred in his self-righteous anger, Samuel continued: "If Mr. Palmer keeps on talking about the affair he will hear from me. I will show him up. We are married and are happy. We have been happy ever since our wedding three years ago. We are not worrying about the future, or the loss of Mr. Palmer's millions."

The embarrassing publicity did not inspire Nancy and Waring to cut off contact with their relative; not only would family gatherings have been impossible to negotiate, but Nancy particularly enjoyed the chance to consider herself part of society by association. Although he barely referred to his wild uncle in his autobiography, Norman spent plenty of time with him until about the age of thirteen. Sam's new stepson, eleven-year-old Frank Crampton, remembers proudly the pleasure that Norman took in the set of carpenter tools his stepcousin bestowed on him one Christmas. This same new relative inadvertently reveals, in his own memoir, that his mother and stepfather spun a different story for him than the one printed by *The New York Times*—a version that was probably passed down to the Rockwell boys as well: he believed that his Uncle Frank invidiously disinherited Susan Crampton to obtain control of stocks and securities she had

endorsed over to him after her first husband's death. The disinheritance "followed a request of my mother that the securities be returned to her." Only a few years after Uncle Frank's death did Susan recover her fortune, according to her son, and even then it was but "a small fraction of what had been hers."

If Waring and Nancy indulged in the sin of envy around this time, no one could blame them. Nancy's side of the family had decided that it was the Rockwells' turn to care for Eva Milner, Nancy's mentally retarded niece; Amy, who had been staying with Nancy and Waring, would exchange places with the sweet but emotionally demanding girl. Eva Milner Orpen, two mothers dead by the time she was eight years old, would, over time, disappear from the map of the Rockwells' lives, unnoted in family stories and memoirs, a quiet footnote in a few distant cousins' memories. Certainly Nancy and Waring, basically compassionate people, tried to do their Christian duty by her, and at least one cousin claims that the girl lived for five or six years with the Rockwells. Norman Rockwell's sons recall his vague mention of Eva as an additional drain on his mother's meager psychological resources. But the dominant impression in family recollections is of the Rockwells' shame at having such a clearly defective relative. Oddly similar in instinct to Erik Erikson's denial of his own Down's syndrome baby, none of Rockwell's colorful anecdotes even suggests that Eva existed, in spite of the fact that her care further exhausted his mother. Surely by this point, when the young boy was about seven years old, he must have sorely needed a lens with which to focus his often chaotic, drama-ridden city life, especially since his parents believed in providing few explanations to children. How to make sense of the family logic that seemed so irrational to him, even then? His deliverance would come at the hand of a British and, more significant, thoroughly Victorian novelist—Charles Dickens.

4

A Dickensian Sensibility

Given the broad strokes with which Norman Rockwell's melodramatic early life could be painted, his parents' choice of Charles Dickens as their literary hero seems a natural fit. What we know of the Hill and Rockwell familial sensibilities from at least the 1860s suggests that the determinedly middlebrow novelist would have appealed to Norman's great-grandparents on both sides. With their frequent access to Manhattan, it is likely that either John William Rockwell or Thomas Howard Hill caught one of Dickens's lectures on the novelist's second speaking tour of the States, when he exhausted himself reading in sixteen eastern cities between November 9, 1867, and April 22, 1868.

Around 1902, Waring began to augment the after-dinner routine of copying magazine illustrations with what quickly became an even more important ritual: reading aloud a chapter of Dickens. Nancy was pleased; she felt her children were getting the benefit of high (British) culture and monitory lessons about life as well. If George Horace Lorimer's individualist politics spun out an American folklore of good

and bad citizenry, then Charles Dickens might well, in this respect, have been considered his English cousin. As the media historian Benjamin Stohlberg would put it, both men, theatrical creatures that they were, believed that the "meaning of life is not hidden but wrinkled on its surface, its secrets exposed in the truthful light of daily living."

From the first words that he heard intoned, Norman found himself mesmerized by Dickens's stories. Waring would pull out the novel they were working on, and proceed to read aloud in his "even, colorless voice, the book laid flat before him to catch the full light of the lamp, the muffled noises of the city—the rumble of a cart, a shout—becoming the sounds of the London street, our quiet parlor Fagin's hovel or Bill Sikes's room with the body of Nancy bloody on the floor (I squirmed and lifted my feet to the chair rung)." The image of Nancy's bloody body in *Oliver Twist* must have carried particular impact; after all, Nancy Rockwell frequently voiced her sense of victimization, resulting in her extended family tagging her, half ironically, as "poor Nancy." Possibly the inadequate mothers who crowded Dickens's stories provided an escape valve for Norman's own deep resentments toward his mother's insensitivity. Unaware of the pain she was inflicting, Nancy worked against his fledgling attempts at self-respect at every turn, from commenting unfavorably on his appearance to "curing" his bed-wetting by hanging the soiled sheets prominently outside their window in hopes that public humiliation would deliver her dry linen.

The evening readings commenced when Rockwell was around eight years old, an age when children begin to explore, in hopes of comprehending, the logic that governs their complicated universe. Later reminiscences imply that Rockwell believed his own little world off-course from its beginnings, largely because of the confused values that bruised family interactions. Dickens clearly celebrated community, the relatedness that came through filiation of any sort, not only familial. His world, as Rockwell's would be, was one of romance. And it was a world in which a sense of humor had the potential to redeem what would be otherwise intolerable.

Michael Kimmelman, art critic for *The New York Times*, wrote in reference to a very different artist from Rockwell that "art, or at least art that matters, traffics in a space between the world as it might be and the world as it is. Whether we feel better or worse about ourselves in its midst depends on the kinds of artists involved, but either way the best artists make us linger in the spaces they concoct if only because afterwards the real world comes more clearly into focus." A similar Dickensian oxymoron—idealistic realism—gave shape to the young boy's earliest observations of the world around him.

"I would . . . draw pictures of the different characters—Mr. Pickwick, Oliver Twist, Uriah Heep. They were pretty crude pictures, but I was very deeply impressed and moved by Dickens. I remember how I suffered with Little Dorritt in the Marshalsea Prison, had nightmares over Bill Sikes and Fagin, felt ennobled by Sydney Carton: 'It is a far, far better thing that I do. . . .' The variety, sadness, horror, happiness, treachery, the twists and turns of life; the sharp impressions of dirt, food, inns, horses, streets; and people—Micawber, Pickwick, Dombey (and son), Joe Gargery—in Dickens shocked and delighted me." Rockwell learned to draw exaggerated characters whose appearance functioned as an entire network of values. More important than the specific experiences of illustrating the figures on Dickens's stage, however, was the philosophical cast of mind the boy absorbed from the fiction: "So that, I thought, is what the world is really. I began to look around me; I became insatiably curious. . . . And I began to look at things the way I imagined Dickens would have looked at them."

Ordinarily, one must give serious pause to artists' self-prognostications. In most cases, when public figures pronounce on the best ways to "read" them—what cultural ancestors explain or contain their power—the danger exists of our being taken in, of being led to interpret the subject exactly as he or she wishes. Rockwell, in contrast, developed the habit of speaking plainly by his early twenties, but his self-revelatory truths tended to be dismissed by his fans and critics alike, who thought his bald reflections were just another manifestation of his modesty.

Rockwell did not make statements about influence lightly; at age sixty-five, when he was reflecting on Dickens's impact, ten years of therapy had, at the least, delivered to him the self-examined life. Although Rockwell avowed the importance of Charles Dickens upon his imagination in his typically understated fashion, his choice to place Dickens center stage in his autobiography—to have the novelist appear on the first page, as well as several times thereafter—speaks volumes.

Atypical in his candor, Rockwell nonetheless eventually learned to hide behind the truth, accustomed to having his pronouncements about his depression, his artistic insecurity, and his debt to Dickens ignored. His humility became a protection against people taking seriously anything that would jar the popular perception of an artist who painted bromides. To his own detriment, the trails his insights led to yield far greater game than the illustrator himself ever was willing to track, even at his most introspective. Dickens, for instance, provided a grid within which to position the disparate scenes of his urban childhood, and Dickens's theatrical storytelling validated the exaggerated strokes by which Rockwell painted his own tales. Even the moral substance that undergirds Dickens's novels—comic and dramatic—helped shape Rockwell's own ethical imagination. Awkward and ironic as it may be, the reality remains that England's most popular literary novelist largely inspired the Rockwellian narrative vision of America.

If Dickens was such a determining power on Norman Rockwell, then we also must ask: How did Dickens look at things? In *David Copperfield* and *Bleak House,* the very immensity of the novels speaks to their theme of worlds splayed across cities that symbolize the absence of the family kindnesses that should be innate. Their sprawling plots indict communities, including the government, that harm rather than heal the weak individual. Important to these novelistic visions is the mandate that society act as a surrogate parent for the frequently missing father (and mother)—and the tragedy that follows upon its failure to do so. Rockwell chose Dickens's favorite "child" (as the author referred to his novel) as his own: *David Copperfield,* a story of a

fatherless boy tended by the Micawbers, wonderfully humane projections of Dickens's own desires for substitute parents. In this often humorous parental displacement, Dickens, who had actually begun the novel as his autobiography, evades plumbing his psyche in favor of fantasizing an adult fairy tale full of redemptive pathos. In the process, he is able to give birth "to his own father," parenting, in effect, *David Copperfield*. It is a method of repeating and reinventing childhood that Rockwell would absorb and tailor to his own illustrative uses.

By far the most consistent positive image of family life that Rockwell would later brandish, Dickens's nightly presence in the Rockwells' dining room bonded, however superficially, father and sons. The rather limited emotional connection forged between Waring and his boys occurred through typically Dickensian images: narratives centered on desire, on gentle womanhood and loyal fraternity, strident selfishness and the regeneration of human connections, city decay and pastoral restoratives. Dickens gave Rockwell a way to think of masculinity outside of athletic prowess or professional achievement: the writer's male heroes seemed most celebrated for their courage in the face of temptation, their gentility and modesty when they could easily act otherwise, and their expansive spirit and goodwill. Hard work was valued; sloth despised.

To the real extent that the somber Waring exhibited many of these values himself, Norman was now able to appreciate and admire his own otherwise uxorious father. "[My father] had something aristocratic about him, the way he carried himself or the set of his fine dark eyes. His substantial mustache was always neatly trimmed. He wore dark, well-tailored suits and never removed his coat in the presence of ladies. He did not drink but was a gentlemanly smoker. Dignified, holding to the proprieties, gentle and at the same time stern; but distant . . . even when we were children, treating us as sons who have grown up and been away for a long time." Victorian, in other words. Reading Dickens aloud clearly animated Waring's solemn demeanor, and in its afterglow the man's dogged devotion to his wife assumed an

aura of selfless sacrifice: "My father's life revolved around [my mother] to the exclusion of almost everything else. He cared for her constantly and with unflagging devotion." Such loyalty would impress and influence Rockwell's own development as a family man.

Just at the point that Rockwell was beginning to interpret his environment, if in the piecemeal, impressionistic manner of a child, Dickens was there. The often violent and frequently hilarious scenes given voice by Waring's nightly readings surely allowed Norman to project his internalized bogeys onto the outside world instead, dissipating them into Dickens's universe. Such projection, Bruno Bettelheim argues, is the reason that classic fairy tales still retain their near universal appeal. Dickens's ability to mediate through narrative images the intensity of city life seems to have provided Rockwell with tools by which to make sense of, even to tame, the chaos he believed surrounded him. And as Rockwell drew his way out of the stories his father read—as he illustrated the terrors and humor himself—he owned them and created the resolution to his own uncertainties. He was discovering that he could voice his feelings by articulating them in his work. If a too-scary passage hung in the dining room air, Norman could concentrate instead on redoing Micawber, that genial parent substitute for the fatherless David Copperfield: "I'd draw Mr. Micawber's head, smudge it, erase it and start over, my tongue licking over my upper lip as I concentrated. Then I'd ask my father to read the description of Mr. Micawber again." It was up to him, the illustrator, to decide what to emphasize.

Except for *Great Expectations* and *Hard Times,* all of Dickens's novels were initially published with extensive illustrations. *Pickwick Papers,* Dickens's first novel, was in fact conceived as a text in support of a series of prints. The novelist worked with eighteen illustrators, including some of the most prominent artists of his day. His principal collaborators, however, were H. K. Browne, known as "Phiz," and George Cruikshank, both of whose precise, exquisitely controlled pen-and-ink drawings leaned toward the kind of social satire produced by William Hogarth. Browne's and Cruikshank's ability to ren-

der the competing emotions of a dozen characters in one scene made the artwork so important to the interpretation of Dickens's novels that critics tended to pay as much attention to the illustrations as to the text.

Such a collaboration between visual and verbal artists seemed natural to Waring and Nancy's generation, and Rockwell grew up tutored by cultural assumptions that valued illustration as much as its verbal correlative. Rockwell drank in the power of pictures to ameliorate the often ugly realities as well as to illuminate happiness, through the shrewdly calibrated expression of extreme emotion. Phiz and Cruikshank especially rendered fine line drawings that retain their ability to please today, quite apart from the stories they illustrate. But the major relevance of their illustrations for Rockwell's own later work would be the pains these two illustrators took to exaggerate the emotions on each face: however complicated the group scene, its thematic point was made quickly by a shift from otherwise "realistic" drawing to caricaturing facial expressions.

No wonder that his grandparents' generation had awaited so impatiently the next chapter of the new novel; learning how, forty years earlier, Americans had practically laid siege to New York Harbor, anxious to see if Little Nell would live or die, Rockwell was sure he would have been among those fans as well. How sensible it must have seemed to the child, accustomed to the communal pleasure that mass periodicals provided his own little household, that these great books had almost all been published first in serial magazine format, usually monthly, occasionally in weekly installments, easily accessed by millions of readers. The power of the periodical was no surprise to him; on a personal level, a magazine's arrival had heralded joyous hours of escape since he'd been five years old. Norman grew up accepting as natural the coalition of serious literature and illustration, and as normal their joint appearance in commercial, even disposable formats.

"I sometimes think we paint to fulfill ourselves and our lives, to supply the things we want and don't have," Rockwell explained when asked for the motivation behind his work. "Maybe as I grew up and

found the world wasn't the perfectly pleasant place I had thought it to be I unconsciously decided that, even if it wasn't an ideal world, it should be and so painted only the ideal aspects of it"—pictures, he states very specifically, that contain no "self-centered mothers"; stories, he made sure, that show "grandpas" playing baseball with the kids. The illustrator adopted the psychological and formal method that Dickens used to distill complex narrative scenes into dominant emotions painted with one broad brushstroke, filled in with an overspill of graphic details.

· · ·

The popular nightly readings had to be temporarily suspended for a few weeks in 1903, when Phoebe Waring Rockwell died. The stout, dignified woman, like the rest of the Waring family highly respectable and equally well-to-do at the time of her marriage, had, it seems, somehow lost most of the money made several generations before and bequeathed to her at various stages. Rockwell later acted, in front of his children as well as with curious journalists, as if he knew almost nothing about either Phoebe or John Rockwell. In spite of having lived close to each other throughout Norman's youth, the two generations apparently shared the barest of relationships. No rancor is evident, simply a psychological distance so extreme as to render the grandparents mere acquaintances instead of close relations.

And yet, upon Phoebe's death, Waring's newly widowed father convinced his son's family to share his too-empty Manhattan brownstone. The spacious apartment at 152nd Street and St. Nicholas Avenue marked an improvement in the young family's fortunes; the neighborhood was slightly more residential, the grounds were landscaped, if only with a few elms here and there, and now the trolley rumbled romantically several streets away, instead of nerve-rackingly in front of their door. In contrast to his brother's slightly scornful nod at the "mock fireplace with the plastic mantelpiece" that connoted "a move up," Jerry Rockwell, even forty years later, would remember the apartment at 832 St. Nicholas Avenue as a lovely dwelling worthy of

pride, a memory at odds with Norman's ambivalent, cautious praise, as the older brother himself recognized. "The central hall was ninety feet long and all the inner rooms opened on this long hall. . . . Our parlor and sitting room was on St. Nicholas Avenue and our dining room looked out on St. Nicholas Place. Street to street." The new address was part of a high plateau that rose 110 feet above the level of the river, affording a "panoramic sweep of the Harlem plain, the Bronx and Long Island Sound."

But in spite of the certain excitement Rockwell felt at moving to his grandfather's handsome residence, and though his grandfather remained a steady fixture in his life until Norman was nineteen, he would rarely refer to John William Rockwell. The strongest sign of his presence may well be the frequent motif of (often idealized) elderly men in the artist's oeuvre. A picture taken of "Father Rockwell" around 1880 suggests that the odd mixture of cold and heat that characterized Waring took its temperature from the coal executive's family hearth. A loyal man who appreciated his wife's more frivolous nature, John was an authoritarian yet distant parent, just as his son would be. Paradoxically, the remoteness that characterized the Rockwell men seemed to depend on a loving wife's loyal presence for its power. These husbands relied on their spouses needing them, and when the women died or grew unmanageably ill, the men became uncentered, their carefully organized mental states fractured. Partly a matter of generational and old New England ancestral inflections that imigrated with them to New York, their particular brand of intimacy— one based on an impassable psychological space between family members—coincided with marital love.

John William Rockwell's loneliness after Phoebe's death led him not only to house his son's family; it encouraged less tonic measures that threatened to embarrass the beneficiaries of his largess. Nancy's niece Amy Milner was in residence again, but now she was a young woman who had begun to be wooed by equally youthful and attractive suitors. Nancy and Waring hadn't counted on Father Rockwell insinuating himself among them. "Aunt Nancy used to tell us that they

were worried sick that Waring's father would embarrass them by marrying Amy, who was still staying with them," Mary Amy Orpen recalls, still chuckling at the memory. "She was in her early twenties by then, and after he started wining and dining her and taking her to the theatre so he'd have companionship, my aunt was just scared to death about the whole possibility. Luckily Amy found someone else to go out with before long. Father Rockwell was over sixty at the time."

Rockwell must not have found his grandfather's behavior amusing, or he surely would have translated it into the Dickensian frame he used to discuss other family comedies. Perhaps neither Father Rockwell nor Amy provided him grist for his particular narrative sensibility, which typically depended on a kind of childlike innocence for its punch line. Unwilling to embrace the conventional adult wisdom that judged as deviant what to him was merely eccentric behavior, Rockwell sought the gently ironic, the harmlessly funny, the generous, or the exceptional in such people instead. Gil Waughlum, for instance, the brother-in-law of Phoebe Boyce Waring, became an almost Falstaffian figure in the artist's catalogue of stories. Uncle Gil festooned the family's house with Christmas presents on Easter Sunday—and actually decorated the wrong house at that; he held Fourth of July fireworks on Christmas Day and brought chocolate rabbits for Thanksgiving, until finally he was put away in an institution.

To the young boy, Uncle Gil's bighearted embrace of life brought to mind Mr. Dick from *David Copperfield,* an intriguing identification given its window into Rockwell's associative methods. This Dickensian categorization of his uncle Gil "reassured" Rockwell that all was right with his world—and his perceptions. "I guessed," he decided, setting down the principle at age nine that would guide his career, "it was all a matter of how you looked at something."

Similarly, Rockwell cast his eccentric great-great-aunt Paddie, widow of Isaac Paddock (and sister of Phoebe Rockwell's father, Jarvis Waring) as Mrs. Jellyby from *Bleak House,* whose "telescopic philanthropy" caused her own children to go without food while she focused on the natives in Africa. In his autobiography, the illustrator recalled

his aunt's wealth, although "we didn't visit Auntie Paddock because of her money. We genuinely liked her. Still, the thought of the money did cross our minds." Inside his aunt's imposing but narrow gray stone house, maids, summoning bells, and incense greeted the Rockwells as they waited for the "firm footsteps" of the serious but good-natured woman. According to Rockwell, on every visit she insisted that the family troop upstairs to pay homage to the untouched bedroom of her eleven-year-old son, who had died in 1861 during the same tragic week that she lost her husband. The vivid recollection of the boy's room—the "wheels of the overturned toy wagon" and the "dump cart loaded with sand"—insinuates the strong impact that his aunt's altar to her lost child made on her nephew. He was impressed, too, by her lack of macabre or self-pitying airs; she simply wanted to maintain the dead among the living, and inviting her relatives to visit the childhood scene kept him alive for her.

Rockwell remembered well how Aunt Paddie's trips to Sing Sing were her "lifework." "Once a week, rain or shine, winter or summer," the coachman drove her to Ossining, New York, where she distributed and read Bibles to the convicts. It irritated the boy that she didn't do as much for her own family; every Christmas, she gave him nothing "but a hand-embroidered washcloth with my name stitched on it. I wasn't strong for washcloths in those days." When Auntie Paddie died in 1904, she left everything to the convicts at Sing Sing, with the exception of one hundred dollars to Jerry.

As Tom Rockwell, the artist's middle son, has taken pains to emphasize whenever someone cites his father's autobiography as a bible of truth, his father felt free to invoke creative license, especially with already eccentric characters who seemed able to stand on their own. In contrast, Rockwell's most poetic memories of his youth inevitably emphasized people connecting, whether through familial, social, or physical structures. Against urban chaos, he began early to contrast a utopian harmony just outside the city's reach. One of his most romantic recollections involved leaving Manhattan behind during his family's Sunday outings on the trolley, where members of the neigh-

borhood sought the elixir of fresh country air through their joint pilgrimage to the Bronx park at the far end of the streetcar line.

The weekly frolic was infused with a sense of community that knit the scene into a harmonious whole: "I remember that everyone I knew—grownups, kids, maiden aunts—had a trolley pillow which had been made by the ladies of the family especially for these Sunday and evening excursions," Rockwell reminisced years later. He recreated vividly the way the trolley would pick up speed the farther from Manhattan it got, and how the ladies would clutch their hats and their children, with the men affecting nonchalance as the trolley seemed terrifyingly close to swaying off the tracks. At the end of the line, his family would unpack their picnic, and, "spreading our second-best tablecloth on the grass, would enjoy a meal in the country, then catch a later trolley back to the city." The conductor's hands, "always gray from handling the change all day," the crunch of the gravel when the conductor walked around the parked car, the shower of electrical sparks when the trolley was revved up for the trip home—Rockwell's recall depended on details that carried with them strong visceral charges. A melancholy gradually replaced his earlier joy as the evening darkness of the city's outskirts yielded to the overabundance of light the closer he got to home. Such emotion—the desire to rekindle the perfect moment that also hovers over the bittersweet redemption of Oliver Twist as he finds himself perpetually suspended between community and the peculiar solitude of the big city—sustains the grown man's memory over the decades.

5

Urban Tensions, Pastoral Relief

In spite of boyhood pleasures that evoked vivid associations over fifty years later, Rockwell consistently typified city life as evil incarnate. At the age of sixty-five, he distilled the thirteen years he lived in New York City into a couple of potent vignettes: "Unfairly perhaps," he admits, but "two memories of the city overshadow all else." He then frames these personal touchstones within a masterfully eerie style, almost guaranteed to bring to life the fear that overtook the boy. The first story centers on the night that President McKinley was shot: "I remember the streets were dark except for the yellow pools of light beneath the gas lamps. The newsboys were shouting: 'Extra, Extra. McKinley assassinated. Extra. Extra.' And people were gathering under the gas lamps, reading the news and brushing off their faces the moths and flies which swarmed about the light. There was a kind of horror in the streets. Because I did not understand the meaning of the word 'assassinate,' I thought McKinley had been killed in some cruel, torturing way. I was only seven at the time. The next day we went to church, where they played 'Nearer, My God, to Thee,' McKinley's favorite song, and my father and mother cried."

Whereas the first recollection reveals a general sense of foreboding, fractured sentences recall the boy's anxiety in a slightly more ominous second scene: "The other memory is of a vacant lot in the cold yellow light of late afternoon, the wind rustling in the dry grass and a scrap of newspaper rolling slowly across the patches of dirty snow. And a drunken woman in filthy gray rags following a man and beating him over the head with an umbrella. The man stumbling through the coarse littered grass, his arms raised to cover his head, and the woman cursing and screaming, beating him incessantly until he fell, then standing over him, kicking and striking him again and again about the head and belly and legs. And I remember that we kids watched, silent, from the edges of the lot, until a policeman ran up and grabbed the woman. Then the man got slowly up and, seeing the policeman struggling with the woman, attacked him, swaying drunkenly and swearing."

The horror of it all is what mattered: "I forget how it ended. But the memory of that night and of that drunken woman became my image of the city. Against this image of the city—exaggerated and distorted as it is, I have never been able to rid myself of it entirely—I set the country."

Both Dickens and Rockwell, in spite of their own urban sensibilities, powerfully indicted the depravity of large cities, though, typically, Rockwell's harsh judgment was rendered through his general artistic denial of the subject. It comes as no surprise that in spite of spending the majority of his youth in Manhattan, Rockwell so successfully shucked off his native identity that his audiences were constantly surprised by his New York accent. Even though Rockwell lived on the Upper West Side until he was a teenager—a true urban kid—upon his first whiff of fame, he would disclaim all ties to the city. And he would exaggerate the humbleness of his Manhattan childhood, transforming its landscape into a Dickensian cauldron of violence bubbling on every side street.

His outlook was surely influenced by his parents' fears, in addition to his own. As the New York City historian Barry Lewis reminds us, the subway's completion in 1904 allowed unprecedented numbers of African Americans and Eastern European Jews to move into Rock-

well's neighborhood, the part of Harlem eventually called Sugar Hill, later to be absorbed into Morningside Heights. Lewis explains that "[F]rom the point of view of Waspy couples who typically were entrenched in an English world view that depended upon pastoral ideals and urban horrors, such 'infiltration' was extremely scary. All they saw was the 'foreigners' taking over, and they felt threatened physically as well as psychologically." Steven Millhauser's novel *Martin Dressler* describes early-twentieth-century Manhattan's evolving landscape from the viewpoint of a nervous white observer: "The old neighborhood was changing. Poles and Bohemians stood in doorways and leaned out of windows, ragged children sat on the curbs, and everywhere you looked you saw the black-eyed Ostjuden, dark and curly-bearded, gabbling their harsh tongue, crowding the streets, filling the tenements."

It was against this image of the city that Rockwell would establish his myth of the country. The summer vacations that his family took to outlying counties, where the rural boardinghouses—working farms, for the most part—offered up croquet for the adults and daily freedom for the children, would eventually codify his aesthetic: "Those summers, as I look back on them now more than fifty years later, have become a collection of random impressions—sights, sounds, smells—outside of time, not connected with a specific place or event and all together forming an image of sheer blissfulness, one long radiant summer. God knows, a country cur has just as many fleas as any city mongrel. But I didn't see them. . . . that's the way I thought of the country then and still do in spite of myself."

His attempt at fairness over, Rockwell almost immediately defends his preference by explaining that two months after he signed a year's lease on a New York studio, he was walking down Sixth Avenue and saw a man knock a woman down under the El. During World War I, the elevated trains lost their status as stylish, even sublime monuments to Modernism, and became symbols of the underside of industrialization, their thick, black girders casting into shadow all who walked beneath them. To Rockwell, such deterioration seemed inevitable in a city predicated on violence. That same day that he wit-

nessed the man slugging the woman, he observed an old man leaning against his window at Child's Restaurant drop dead directly in front of him. "These things happen in the country," he admits, "but you don't see them. In the city you are constantly confounded by unpleasantness. I find it sordid and unsettling." He had not, of course, been "constantly confounded" by unpleasantness in his boyhood in Morningside Heights, but it was safer to blame the city than his parents for his failure to receive the family warmth and validation he craved.

The country, his psychological salvation, became Rockwell's safety zone, the place where he could center himself mentally and experience the freedom from failing to measure up to the male norm that was increasingly his lot in Manhattan. His country memories vividly re-create everything from the horses' shaggy manes trailing in the drinking hole, to the animals' "hot heavy smell," to the satisfaction he gains when he currycombs them well. The kids wrestle in the warm hay, and after they fall exhausted into its sweet smell, they gaze upward at the late afternoon sunlight reflecting dust motes swirling around them (a dramatic contrast to the "small patch of blue sky" enclosed by the "tenement concrete walls" when Rockwell and his city buddies "dig to China" in the city). In Manhattan, "we kids delighted" in running up to the roof and spitting on passersby in the street below; but "we never did things like that in the country. The clean air, the green fields, the thousand and one things to do . . . got somehow into us and changed our personalities."

From at least one photograph of Rockwell's summer in Florida, New York, around 1904, his joy transformed his face. Catching frogs, which he was allowed to take back to the city (where they promptly, and appropriately, given his beliefs, died), the high-spirited skinny country kid looks as if he has just won first place in a 4-H footrace. To his surprise, he found that he came off well in the country, especially in contrast to Jerry's snarling superciliousness. Norman's slightly retiring nature, coupled with the quick wit and expansive curiosity that often charmed those around him, was appreciated by farm boys and

their families. And he appreciated in return their "open" expressiveness, the quality he sought in others, according to his granddaughter, to compensate for the "negative space" his own emotional distance created. Helping the local farm boys milk the cows, Norman found himself at peace, the harmony of his surroundings reflected in a new self-assurance. He was by nature a hard worker, as long as he was interested in the task, and the farmers must have been impressed with his constancy. The sense of community that resulted at the end of long days spent sharing the farm boys' labor surrounded him with a bonhomie otherwise missing in the tense city life to which he returned.

Jerry Rockwell's memoir cues us to a curious omission in Rockwell's memories of his country summers: "I sometimes wonder whether Norman got his first thirst for art up at Wallkill, New York. One of the other boarders at this time was a Ferdinand Graham, a commercial artist with cowboy tendencies. Norman adored this man and loved to watch him sketch and paint. Graham had a regular cowboy saddle and rode a very small horse. He had overlong legs so they almost touched the ground on either side. I can see him now riding by at a gallop and Norman standing wide-eyed in awe." Jerry's complete disregard for the years of drawing that had already defined Norman's interests suggests its own brand of sibling competition. "I think that I've always wanted to be an artist," Norman believably informs us. "I certainly can't remember ever wanting to be anything else. . . . It was gradual. I drew, then I found I liked to draw, and finally, after I had got to know something about myself and the people and things around me, I found that I didn't want to do anything else but draw."

It is possible, of course, that Jerry's memory was inaccurate, or that Graham's kind of painting was beneath the adult illustrator's notice; but it is just as plausible that, whether consciously or not, the memory was simply too potent to be articulated. "I think the [country summers] had a lot to do with what I painted later on," Rockwell said. Imagine the wonder felt by the child, who felt his own worth to consist entirely of his ability to draw, when he happened on a perfect tem-

plate for his dreams—the artist hero as masculine, western horseman. At some level, as Jerry's account implies, the mesmerized boy must have felt that anything he could ever wish for was right in front of his eyes.

Another pleasure of Norman's summer vacations consisted of escaping Nancy Rockwell's vise. She tended to linger on the porch, where she would drink iced tea and gossip; and when family events such as hay wagon rides brought them together, the group was too large for her to control her sons. On the one hand cloyingly expressive in the love she professed for the child whom she felt most resembled her, she also was notorious among her own siblings and their offspring for her critical nature. "I heard that Aunt Nancy was always like she was when she lived with us, later in life," states even her one defender, Mary Amy Orpen. "I liked her, because she was kind of plucky and interesting, in her own demanding, odd way. But she always went up to kids and told them they ought to be doing the very thing they were not. If they were playing outside, they should come indoors and read. If they were enjoying quiet activities inside, she'd tell them to go out and get some exercise. Always, always, she criticized children as her way of guiding them. She didn't mean it so badly; it just came off that way. It must have been a real trial to grow up with her. Maybe her sons just learned to tune her out."

No wonder Norman developed his desire to avoid the unpleasant. And little surprise either that the summer farms vouchsafed him an emotional center where he felt complete and fulfilled, harmoniously in sync with a world he wanted to be part of.

If we consider the way his psyche was organized—reflected in his later compulsion for a clearly focused, precisely defined professional life, punctuated with flights of spontaneous escape whenever he felt the urge—the hyperstimulation of urban life must have alienated his affections early on. A cacophony of sounds competing for prominence assaulted the ears of New Yorkers: horse hoofs beating against hard pavements or cobblestoned streets played off the sounds of modernity—seemingly ceaseless subway construction, the roar of

the elevated trains, the clatter of the omnibus, and even the infrequent automobile vying for space. Pungent aromas of coal residue mixed with omnipresent horse manure to create acrid early-century air pollution. To Rockwell, the vision of pastoral escapes perfuming the corrosiveness of the cities seemed real, not romantic. The country's simplicity, magically thought by some to reunite the child with his authentic self, was perfectly articulated when Waring read from *Oliver Twist:* "Who can describe the pleasure and delight, the peace of mind and soft tranquility, the sickly boy felt in the balmy air, and among the green hills and rich woods, of an inland village! . . . It was a lovely spot to which they repaired. Oliver, whose days had been spent among squalid crowds, and in the midst of noise and brawling, seemed to enter on a new existence here." As more than one critic has observed, Dickens reconciles in this particularly dark novel (which Rockwell recalled so viscerally) the warring desires for independence and community. Rockwell, whose cool but insistent autonomy coexisted with an equally compelling need to be (a well-liked) part of a group, would have intuitively responded to the major mythic tracks laid down in this novel.

Unfortunately, his parents decided that Norman's socializing would best be expressed through a demanding church schedule that would make the most devoted worshipper flinch. St. Luke's had been organized in 1820, the first church in Greenwich Village, according to New York diocesan records. Known as "St. Luke in the Fields," it was supported financially by Manhattan's prestigious Trinity Church on Wall Street. An uptown parish offshoot—a Romanesque brownstone church on Convent and 141st Street—would dominate Rockwell's "free time" throughout grade school, his country summer idylls the only exception. The boys joined the choir, where the choirmaster bullied them until, according to Rockwell, they "sang . . . like angels." He raged at them, called them insulting names, and hit them, while they passively "perched [on their stools] silent, whitefaced." The boys were held to a punishing weekly routine of three rehearsals a week, a dress rehearsal on Friday, and four services

every Sunday. Their putative reward was to graduate to singing at the Cathedral of St. John the Divine, the nearly completed bishop's seat. In truth, the boys' only pleasure derived from a church battalion motivated by the recent action in the Philippines; this warrior-inspired religious group was given authentic miniature uniforms complete with wooden swords and allowed to participate in parades under St. Luke's banner.

Nancy's own participation at St. Luke's appears to have been impressive as well, at least for someone too weak to perform ordinary household duties. Church records show her to have been a particularly active parishioner. She was appointed as St. Luke's representative to the St. John's Cathedral building drive, and she served as a delegate on the Women's Auxiliary to the Cathedral League. Such activity belies her nephew's observation that she seemed "a typical Victorian woman—Waring did everything, she didn't know how to do anything, even manage her finances, after he died." Nancy's "complete looniness" was somewhat selective, a matter of where she chose to spend her energies. Her mother's pattern of seeking release from the demands of a busy household through church fellowship had imprinted itself on Anne Elizabeth Hill's youngest daughter. From the early days of her marriage, she had found being a housewife tedious and exhausting. In contrast, church life invigorated her. Even Nancy's love of needlework, her favorite way of showing affection, went most often toward beautifying the parish chapel (although one of the few remaining relics of the boys' infancy is the first pair of booties that she knitted Jerry and then passed down to his brother).

From their earliest memories, Jerry and Norman Rockwell associated their mother's giving of herself with her participation in the local church—and rarely with her relationship to their father or themselves, which lacked the easy warmth they observed in other homes. In 1900, New York City's population was 85 percent foreign or had foreign-born parents, creating a mixed neighborhood that reflected family styles much more expressive than the New England and Victorian heritage dictating that of the Rockwells. Looking around them,

the boys perceived that their mother poured into the church the af-
fection that neighborhood women lavished on their households, and
so religion became their competition for her attention.

The dangers that Norman felt he and his brother faced just getting
from 832 St. Nicholas to 141st Street contributed even more reason
to associate things religious with punishment. "A slum lay between
our house and the church. We'd walk hurriedly through the dim,
gaslighted streets. Gangs of ragged children taunted us. Drunken men
lurched against us. We clutched rocks in our fists, expecting every
minute to be set upon," the illustrator later recalled.

Although the boys had been warned too vividly by their parents to
be able to pause and assess the scene for themselves—no one ever did
attack them—the local landscape varied bewilderingly. Up at the
155th Street station, where the Sixth Avenue El stopped, they'd hop
off the clanging steel stairs and emerge into an odd mix of old picnic
grounds and new housing developments. But the area most worri-
some to Rockwell consisted of four-family row houses built next to
overgrown lots with weeds too thick to walk through. He might have
to pass an empty lot where rats scurried even in the daytime, while on
the adjacent land construction for a business office would be under
way. The competing bids for his attention merely added to the overall
aura of violence he associated with the neighborhood. Peter Rockwell
remembers his father's recounting how "he used to climb up on the
apartment roof and watch the Irish and Italian gangs fight each other
with bicycle chains. He felt that this kind of violence kept him from
ever really experiencing the proper innocence of childhood."

To some extent, Norman's lack of confidence in his physical
prowess against such threats of violence was justified. He was not ex-
actly growing up to look or act like the strongest boy in the class.
Called "Mooney" by the other kids, who liked him because he was
funny and quick and willing to play pranks, he wore round rimless
glasses that made him appear owlish and that attracted attention to
his dreaded oversized Adam's apple. Increasingly, as physique and
athletic talent came to matter, Rockwell felt himself losing ground.
The cute pigeon-toed amble everyone commented on when he was

little had worsened, not improved, as his mother had optimistically predicted. Worst of all, his willingness to draw for the guys had lost its magic; now, even Norman's best buddies gravitated to Jerry, a real boys' boy, strong and athletic. If there was competition between brothers under most circumstances, there seemed no reason for the younger boy to even try to win against Jerry: "[He] always came in first; I always came in last, puffing and blowing."

"The New York public schools became athletically minded," as Jerry admitted. "And we boys all became athletic"—all, the implication was, except for Norman. "My specialty was the high jump but I cannot remember Norman participating." Part of the city's self-imposed mandate to develop a unified idea of being an American involved the masculinization of boys—through athletics. Norman decided to develop his body into something closer to his brother's, setting out on a self-improvement program of push-ups, deep-knee bends, and jumping jacks. As he explains in his autobiography, he performed them religiously every day in front of his bedroom mirror, until he decided that his embarrassing protruding Adam's apple, his "narrow shoulders, jelly arms, and thin measly-looking legs," weren't willing to respond.

By the age of twelve, Rockwell had decided that he was in truth a "lump, a long skinny nothing, a bean pole without the beans." Being a "nothing" stung. Like the protagonist of *David Copperfield*, who feels himself to be a "blank space" that "everybody overlooked," the youth pondered ways to gain attention. Paradoxically refusing his victimization, he developed a bizarre trick that, he thought, made sense of the deformed appearance he felt himself to present. Walking along the street, he would stretch his shirt sleeve over his arm so that people passing thought he lacked a hand and would "feel sorry" for him. At other times, he'd practice a "crooked limp," expedited by his severely turned-in feet. The parents so energetically tried to correct the young boy's pigeon-toed stance with orthopedic shoes that the expense and continued effort convinced him he was "some sort of a cripple."

Nancy encouraged her younger son to think of himself as weak and in need of her assistance. In light of her peculiar treatment of him, Norman would understandably have identified with David Cop-

perfield, called "Daisy" by the masculine Steerforth who treats him like a girl, and whose own self-centered mother thoughtlessly engineers her son's destruction through her silly preoccupation with ancestral caste. An outgrowth of his poor self-image during these years, Rockwell's famous modesty, which included asking anyone nearby to critique his work in progress, became one of his most admired traits. Genuine on the one hand, it also bore the weight of insecurity's backlash that whipped even the successful adult artist.

Rockwell's dogged devotion to his art seems too extreme to be indebted solely, or even mostly, to its recompense for his physical shortcomings. Yet the very intensity with which he applied himself to his paintings—he worried even in his seventies that an art director might not like his work and would fire him—shores up the illustrator's own compelling statements: "All I had was the ability to draw, which as far as I could see didn't count for much. But because it was all I had I began to make it my whole life. I drew all the time. Gradually my narrow shoulders, long neck, and pigeon toes became less important to me. My feelings no longer paralyzed me. I drew and drew and drew." Was work his antidote to depression? "I put everything into my work. A lot of artists do that: their work is the only thing they've got that gives them an identity. I feel that I don't have anything else, that I must keep working or I'll go back to being pigeon-toed, narrow-shouldered—a lump."

But by 1905, his family would consider the problem of corrective shoes a luxurious distraction. Another drama began its run in the Rockwell household, one that lacked the comic dimensions of the gawky boy's role. Uncle Samuel had been diagnosed with a degenerative disease that, though Rockwell would refer to it somewhat obliquely in his autobiography as "locomotor ataxia," was syphilis, which in its advanced stage did go by the more exotic nomenclature. "My uncle got his illness from too many ladies," the illustrator would whimsically toss off, ignoring the up-close view he had suffered of his father's brother dying an agonizing and humiliating death. Since the tertiary phase of syphilis occurs anywhere from five to twenty years

after the original sexual transmission of the disease, the date of Samuel's ill-fated dalliance is unknown. At this point, he had been married to Susan Crampton for seven years, three of them "in secret." Someone, probably his shocked wife, procured a home for him in Mamaroneck where he could deteriorate more privately than in New York or among the Yonkers relatives: the lack of muscular coordination, the spastic, uneven walk, and the loss of bladder and bowel functions were among the manifestations that played particularly poorly in public.

On November 21, 1907, Samuel Rockwell, forty-one years old, died. Spinal paralysis and heart failure were cited as the official causes of death for a man whose death certificate reads "no occupation" and "single"—in spite of Susan Crampton's Manhattan directory listing in subsequent years as Samuel Rockwell's widow. For the past two years, Father Rockwell, traveling between Mamaroneck and Manhattan, had helped care for his son, a burden that at least distracted him from his loss of Phoebe. Now Sam might be gone, but Waring's brood would surely flourish in the country. The scant records that were not destroyed in the aftermath of Samuel Rockwell's death suggest that Father Rockwell negotiated some arrangement with his son's widow allowing the elderly man to retain the Mamaroneck house after Sam died.

Although Nancy ensured that the family history recorded a minor bout of malaria that Jerry was said to have caught during a summer spent at an outlying farm in Whitestone as the Rockwells' reason for leaving Manhattan, Samuel D. Rockwell, Jr.'s ignominious demise actually occasioned their good fortune. In truth the itinerant, perpetually discontented Nancy was overripe for another move. Nor did Norman need much persuasion: at last he could experience living year-round among grass, trees, space, and sky. After almost thirteen years of a city boy's life, he would walk away from the old neighborhood without looking back. He was not and never would be a nostalgic person.

6

Mamaroneck: An Interlude

Even Jarvis, far more content in Manhattan than Norman had ever been, agreed that Mamaroneck was a definite step up. "We still had to go a half mile to get to school, but now [we ran] thru fields and flowers," he wrote in his memoir years later, affirming his younger brother's darker urban vision. Today a town of twenty thousand, in 1907 Mamaroneck (located along Long Island Sound, only twenty-four miles from Manhattan) was a pleasant if sleepy commuter village of twenty-five hundred. The water lapped the shore within sight of the Rockwells' home at 121 Prospect Street (eventually renumbered 415), the inland sea's gentle rhythms seducing both boys into learning to sail. Gables jutted out at the top of their three-story house, enabling the Rockwells to see all the way down to the water, a view obscured in the coming decades by a large-scale apartment complex built to accommodate the growing population. With a large redbrick front porch, the residence held its own in a solidly middle-class neighborhood, its cheerful exterior matching the hominess of the pleasant surrounding houses. In 1986, town historians would erect a small

plaque (its dates wrong) outside the door of the private residence: "Home of Norman Rockwell, 1903–1911."

Jarvis—or Jerry, the nickname he now insisted upon—had his own reasons for recalling Mamaroneck so fondly, and, as usual, they involved his athletic prowess. The central school, built in 1889, housed all grades in its monolithic brick structure at 740 West Boston Post Road, later Mamaroneck's town center. Predictably, he remembered the institution primarily for its football team, where he was the school's star player. "Norman cheered for us," he noted, testimony reinforced when Rockwell reenacted the Mamaroneck fight song almost sixty years later to the astonished delight of Dick Cavett's television audience.

Norman failed to share his brother's pleasure in their school: the courses bored him, his grades were again mediocre, and his participation in all-important sports was negligible. Barely pulling a seventy in drawing, in algebra—the class whose teacher he adored—he "of all things" made an A and ranked first in the class. He was happy, however, not only to be out of the city, but to escape the shame he had most recently experienced at P.S. 46. Before leaving, he'd exploited a chance to impress his mother by enlarging a story about the principal praising his exemplary sketch of the San Francisco earthquake. He'd transformed what had been, in truth, a simple show-and-tell in the man's office to a starring role in the school assembly, where he was asked to stand and explain how he had made the drawing. His impulses were right, even if the truth was otherwise: his mother validated him fully, more than he'd bargained for. So impressed that she wanted to thank the principal for recognizing her son's special talent, Nancy Rockwell visited the school the next day and, to the everlasting mortification of her red-faced son, carried on about the achievement in front of his astonished teacher.

The new school proved superior in other ways, mostly through the lack of tedious repetition that the early grades had demanded. Its improvement over its predecessor didn't begin to compare with the happy contrast between the two churches, however. St. Thomas's

Episcopal parish, only a few walking blocks away, employed a far more relaxed, humane approach to religion, especially choir participation, than had St. Luke's. Because their father had taken on heavy responsibilities within the church hierarchy, the Rockwell boys were fairly conspicuous within the church community. On December 3, 1907, Waring joined the vestry, the governing body of laypeople in the parish, specifically involved with church finances and the conditions of the physical plant. Within a week, he was elected vestry clerk.

Norman's own religious life at St. Thomas's proceeded far better than had his tenure at St. Luke's. When the choirboy's voice changed, he was assigned the role of crucifer, an honor probably beholden in part to Waring's position. Every Sunday, Norman bore the cross aloft as he led the procession down the church aisle.

If his choir experiences here were less harsh than those administered by his earlier Teutonic master in Manhattan, the more casual St. Thomas's nonetheless completed Rockwell's disillusionment with organized religion. As crucifer, the adolescent saw up close the conflicts between values and actions that the people of the church sometimes embodied. The sexton, for one, disappointed him with his careless disrespect for the task he honored in public; when alone, the man spit on the crucifix, all the time grumbling as he polished it with a dirty rag. The choirmaster himself often turned up drunk, so that the irritable sexton and bewildered crucifer had to prop him up on his way to the altar.

What did Nancy, who at regular intervals rehearsed her disgust at her alcoholic father, think of this state of affairs? Did Norman tell her about it, and did she believe him or instead assert that he was not to accuse churchmen of such indecorum? At the least, the inconsistency between his mother's condemnation of Howard Hill's drinking and her ability at some level to look the other way when a church matter was involved encouraged Rockwell to abjure institutional religion.

Church did provide one major attraction. The thirteen-year-old's hormones on alert, he especially enjoyed the new interactions with girls that St. Thomas's facilitated. Boyishly aggressive, he interacted with them most easily by making any exchange into an adventure, such as the time that he and a friend climbed into the belfry after

church to call down and tease the girls on the grounds of St. Michael's, built in 1901 as a "wayward home" for troubled young women. In contrast to his more obvious responsible side, Rockwell frequently acted on impulse. One Sunday, he accidentally got locked into the belfry; after several hours of imprisonment, he was released, only to face greater torment at home. "Norman Percevel, you're late," his mother complained. "Dinner is spoiled. And after I worked so hard." Since Norman lamented that illness had motivated his foray into the open air of the church tower, his conscientious father dosed the miserable boy with castor oil. Misadventures aside, much more fun percolated on Sundays in Mamaroneck than in Manhattan. When, for instance, the girls in the communion lines passed by his carefully chosen seat on the edge of the choir pew, Norman would pull at their skirts until they hissed, "Norman Percevel *Rockwell,* you let go of my skirt this minute or I'll tell your mother on you." "Tattle-tale," he'd huff back—letting go. Boys were much easier to deal with: they could be predicted to pull hard to get away from Norman's hold on their belts, until, when he suddenly released his grip, they'd tumble into the person ahead of them. His friends joined him in these games, making the weekly religious ordeal more fun, if less holy.

An easy camaraderie with boys was matched by his touching erotic awareness of girls. At the age of sixty-four, Rockwell recalled a coming-of-age encounter that presaged the wonder and genuine pleasure he would always feel in the presence of women. A sensual response to their alien presence marks his visual, almost tactile memory: "I remember walking into a room in a friend's house during a swimming party one summer afternoon. . . . The sunlight was streaming through the open windows; a warm breeze curled in the curtains. All around the room, lying in disorder on chairs, tables, the window sills, were girls' underthings—white bloomers, white bodices with blue frills, lacy slips. I stopped, utterly thrilled by a sense of femininity. I could hear the shouts of the bathers on the beach below the open windows. The pink ribbons on a bodice stirred in the breeze. I felt I had penetrated into the strange, secret world of girls which had heretofore been closed to me. I could hardly breathe, the sense of it was so strong."

The adolescent absorbed two mind-sets that dominated his adult attitudes toward women: a reverence that stemmed from their sexual difference and inspired in him a sort of adoration, and the assumption that women were capable, strong, and could shore him up at least as well as the other way around. For all her faults, Nancy Rockwell's complex blend of little-girl seductiveness and absolute imperiousness presented her son with the image of a many-sided woman, largely a positive bequest but responsible in part for his occasional ambivalence toward feminine beauty. Rarely persuaded by the conventions of the age that women by nature should look a certain way or inhabit particular social roles, Rockwell nonetheless often appeared nervous about his "right" to draw or to have intimate relationships with the women sanctioned by his culture as the most attractive. Even as a mature adult, the artist sometimes seems akin to the hypnotized monster in the classic 1954 horror film *Creature from the Black Lagoon,* whose libido is awakened and then chastened by the strong, beautiful woman swimming just beyond his grasp. And his own descriptions of early encounters with girls sound like poetic expressions of more primal emotions, similar to those that journalist David Wood recalls produced in him by the infamous *Black Lagoon* movie: "Early into my adolescence, I identified totally with the obvious feelings of the monster," Wood writes. "Like him, I felt that the distance between the beautiful woman beneath him in the lagoon and someone like me was impassable."

Female teachers provided an accessible, reassuring screen on which to project his nascent sexual feelings, and Rockwell paid much closer attention to the women heading his classes than to the subject being taught. As an adult, he recalled with chagrin the teacher, "Miss Genevieve Allen," whom his class—led by him—tortured with their silly questions; and he recounted falling in love with Miss Helena Geer, she of the "trim little feet and ample hips," whose skirts rustled as she walked by, a "cloyingly sweet perfume" wafting forth. Most of all, he felt understood by Miss Julia Smith, who asked him to draw holiday-colored chalk murals on the boards each season. (She also was his long-term math teacher, suggesting that her ready apprecia-

tion of his talents registered in his algebra grades.) After Rockwell's fame was well established, the then-blind schoolteacher wrote him a letter, asking if he remembered her. The sweet correspondence that followed spawned the idea for Rockwell's September 1935 *Post* cover, a tribute to schoolteachers.

Teachers who valued high marks and conventional behavior would have overlooked Norman, but the occasional perceptive soul must really have enjoyed the unusual boy—spirited, good-humored, quick, talented, usually polite, and industrious on those few academic occasions when he chose to be. He figured out that, in spite of his "bean pole" appearance, friendliness went far, and so he made friends quickly. In truth, such efforts came easily: he seemed predisposed by nature to like people, and they tended to respond in kind. Before long, he and his new gang had devised more of the slightly subversive activities that he'd enjoyed in the city. But his mother unfailingly engineered some new indignity sure to reduce him to the absurd figure he feared being. One of her worst missteps was to insist that her hapless son wear Father Rockwell's oversized floppy coat that dwarfed the boy's thin frame. "Norman Percevel, that is a perfectly fine coat," she responded every day as he begged her to reconsider.

"I hated that coat," he later recalled. "[I'd walk to school,] my scrawny neck protruding from the high, upright collar of my grandfather's paddock coat, which had been handed down to me. . . . At first I'd been sort of proud of it. No other kid in school had such a magnificent coat. But it was too big for me—the skirt swept around my ankles, the cuffs lapped against my knuckles—and pretty soon it became the laughingstock of the whole school. But my mother insisted that I wear it." On the first day of spring, he "lugged it out to the back yard, poured turpentine on it, and burned it."

Nancy and Waring cited the need to live frugally on those occasions when their sons protested such economies as wearing hand-me-down coats several sizes too big. And, at least according to their younger son's memories, the boys rarely had the pocket money common to the other kids. Rockwell's frequent references to his family's modest circumstances are confusing, in light of Jarvis's lack of similar

complaints, as well as the reality of Waring's solidly middle-class in-
come. The vagueness with which the artist treats his grandparents
and the actual first real homestead in Mamaroneck suggests that the
source of the family's financial difficulties receives strongest explana-
tion here.

Norman Rockwell's oldest son, Jarvis, recalls hearing stories about
"someone, either Pop's father or grandfather," losing his business but
electing to pay off all his employees rather than take with him the few
remaining assets. Waring Rockwell's position with George Wood was
secure, and the company did not go under; the coal business, how-
ever, suffered great losses in the financial downturns of the 1890s as
well as in the crash of 1909. It seems likely that Waring and Nancy
Rockwell not only took care of Father Rockwell after his wife's death
but supported him financially as well. The most probable scenario ap-
pears to be one that includes Susan Crampton establishing a home in
Mamaroneck for her syphilitic husband, Samuel Rockwell, followed
by John Rockwell living with his dying son and eventually losing his
own apartment in Manhattan, at which time Waring and Nancy
moved to Mamaroneck and combined their households again, Waring
paying all the bills. Earning around $2,500 a year from 1907 to 1909,
roughly the equivalent of $44,500 in 2000, he could take care of fam-
ily expenses, including his wife's penchant for expensive clothes, but
he would have had little left over with which to indulge his sons.

Whatever the reasons for his parents' frugality, Rockwell decided
early on that he wanted more money. At the age of thirteen, the boy
mowed lawns for spending money, but soon he explored more effi-
cient enterprises. His best investment (costing the young teenager the
whopping sum of $25, equivalent to around $430 in 2000) was buy-
ing the mail route out to Orienta Point, the "other" end of the village
where millionaires lived, the site of luxurious mid-nineteenth-century
summer mansions, their old boundaries marked today by what have
become the main streets of the wealthiest part of the town. Norman
rose every morning at five-thirty to deliver mail to the distant (three
and a half miles) residences, since ordinary service stopped short of
the estates. He received twenty-five cents per day per customer.

An observant philanthropist and fellow parishioner whose family had built St. Thomas's Church, Mrs. James Constable took special notice of the industrious boy and treated him (albeit in the kitchen, with the butler) to cakes and ice cream every Monday, when he came to collect his money at the end of Orienta Avenue. He wanted to impress the gracious lady who kindly solicited new customers for him among her rich friends. But when the boy tried to match her sophistication, he embarrassed himself by mispronouncing the occasional word. Her gentle corrections mortified him and convinced him more than ever that money bought knowledge and station in life; that if his father earned more than a measly office worker's salary, he would know how to speak proper English.

Making money was especially important to the adolescent in light of his father's talk about the alarming market setbacks of 1909, one of eight cyclic recessions that hit the emerging American economy during the late nineteenth and early twentieth centuries. Norman was old enough to realize that if one of those economic downturns had ruined his grandfather financially, it might do the same to Waring. But possessing wealth had become somewhat of a goal in itself to the boy, a marker of something less innocent than mere financial security. Slightly uneasy at a trait he didn't approve of but still couldn't shake entirely, the middle-aged artist acknowledged his youthful embarrassment at being less well-heeled than those around him: "I imagined that if you had money you talked correctly. And more—you were self-confident, well-mannered, free from embarrassing accidents, debonair, handsome, et cetera. How money performed these prodigies I never stopped to think."

Rockwell's poor grades in school, in tandem with comments he later made about his restlessness in the classroom, suggest that he needed outlets for his youthful energy anyway; with money his objective, his industriousness knew no limits. By the time he was fourteen, he had begun tutoring two boys—either in algebra or drawing—and he discovered that he was a fairly talented teacher, especially when it came to explaining methodically how to approach a task. At the same time, because he was preparing to be confirmed in April, he spent

more time than usual with the pastor of St. Thomas's, who agreed with Mrs. Constable's assessment of Norman's potential. He arranged for the boy to instruct the already illustrious Ethel Barrymore and her friend in the rudiments of painting. Barrymore, who had helped pay for her brother Lionel to attend the Art Students League and to study art in Paris the year before, encouraged her young teacher to pursue the same paths. "I spent every Saturday afternoon that summer sketching with Ethel Barrymore . . . and her friend," Rockwell later recalled. "I went along more for the companionship than anything else, I think. We would paddle out in a canoe to Hen Island or some deserted beach, where I set up the easels in a sheltered spot and showed the ladies how to hold the brushes or mix the paint to get the dry green of the beach grass. After an hour or so we'd have a little snack from the picnic basket they always brought along, and I'd pack up and we'd return. Ethel Barrymore didn't sketch very much. I remember she was beautiful, absolutely magnificent."

Rockwell's reaction to Barrymore's beauty and charisma, both of which bowled over a young Winston Churchill as well, reverberates with undertones similar to the bedroom scene where the girls' under-things gently lift in the breeze, inspiring the youth to a new level of reverie. This time, though, with the woman actually present, he describes himself as the unworthy observer: "That must have been a sight—me, a long gawky kid bending over the graceful Ethel Barrymore, guiding her shapely hand across the paper, the sea wind ruffling her hair, my great Adam's apple churning up and down my neck. She was very gracious, queenly; I was almost dumb with admiration, awe." Such awe sounds as indebted to her quintessential femininity as to her celebrity.

Ethel Barrymore apparently reported favorably on her tutor. His reputation as an artist grew, and the kindly Mrs. Constable commissioned the tireless young man to design four Christmas cards for her to send to friends. Her munificence was a good thing, too, because Norman had hatched a plan.

7

❧

Manifest Destiny

Norman had decided to study art; he had known for as long as he could remember that he wanted to be a painter, and now he felt ready to begin. To their credit—and as testimony to Rockwell's absolute determination when he wanted something badly—his parents allowed him to study on Saturdays at New York City's Chase School of Art (now Parsons School of Design). He caught the trolley on Palmer Avenue at seven A.M., riding to 188th Street and Bronx Park, where he took a subway to 125th Street and transferred to the west side. The trip took two hours each way, since Norman had to use the cheaper mode—trolley and subway—versus the faster but more expensive train. Observing his unwavering commitment, and swallowing their amazement at his detailed attention to every assignment, his parents convinced his principal to let him skip school on Wednesday afternoons to attend Chase then as well.

William Merritt Chase, who first trained at the National Academy of Design in the early 1870s, had taught at the Art Students League (and would again) until the mid-nineties, when he left to create his

own school. He aimed at nothing less than transforming New York—whose city scenes he depicted long before gritty urban legends became the stuff of modern painting—into the center of the art world. Still, for all his self-styled progressiveness, Chase was categorical in his aesthetic judgments. On the one hand, he had a reputation for being forward-thinking: Kenneth Hayes Miller, the teacher of many of America's most important regionalist painters, sought out Chase after being expelled from studies at the competing school. But later on, Chase's limited vision would handicap his appreciation of the Armory Show, America's formal introduction to Europe's modern art. "Dressed in frock coat, top hat, and boutonniere," the dandified artist strolled around "reviling everything," according to art historian Gail Levin.

When Norman Rockwell began studying at Chase School of Art in 1908, he had not yet decided what kind of artist he would be: commercial or fine. At this time, the divide between the two was not as severe as it would quickly become; artists instead made a stronger distinction between illustration and advertising. He knew he was talented; so many adults, and even his own boyhood friends, had nurtured this conviction from the time he was six years old. And his parents encouraged him wholeheartedly, assuming his abilities to be inherited and based on a natural foundation. "It'd be nice to make my life a sob story," he recalled years later, "but the truth is, my parents supported me from the beginning." At Chase, Rockwell apparently began considering illustration as his most logical career. The timing for such a decision was propitious: "The Golden Age of Illustration," when magazine and book illustrators were the celebrities of their day, was at its peak when Rockwell went to Chase.

At the Chase School, Rockwell received his first training in the history of art, and here he learned to appreciate the controlled but fluid brushstroke of James McNeill Whistler and John Singer Sargent, whom he would later praise as the earliest influences upon his artistic development. Both painters achieved incredible beauty through virtuoso technique in which each brushstroke contributed to

perfection, and both men avoided succumbing to the inherent danger of overworking a scene, a temptation to which Rockwell often yielded. It must have mollified the student that Sargent had painted "his own" Ethel Barrymore in 1904, a portrait that appeared frequently in publicity releases. Equally gratifying, Rockwell absorbed at Chase the sense of a natural coalition between fine art and illustration. He learned that the English Arts and Crafts movement and Aestheticism had influenced the beginnings of the Golden Age of Illustration, around the time that Modernism staked out its earliest claims in Paris. In other words, illustration was legitimized by the same blue blood coursing through the veins of more prestigious genres of art.

However odd it seems in light of virulent twentieth-century arguments over the proper criteria that would "Make It New" (the art world's mantra), the early touchstones of Modernism actually inculcated many of the values celebrated by the burgeoning world of illustration. Modernism's laurel wreath, "flatness," initially included illustration in its early coronations: the very concept of "flatness" was at first associated with the popular, as the art historian Tim Clark notes. "Flatness" took shape as an antidote to the overelegant, and its successful realization was marked, as Clark points out, by as "plain, workmanlike, and emphatic" a painting, photograph, or poster that could be produced. The prosaic was elevated, so that "loaded brushes and artisans' combs" became objects of veneration, paradoxically, because they represented good, hard, honest manual labor. Flatness, at the beginning of its fashion among modern artists, celebrated the mass cultural moment, making it a value congenial to illustration.

At the end of the nineteenth century, there were other reasons to consider illustration among the fine arts: Winslow Homer, Edwin Austin Abbey, John La Farge, and the magnificent Howard Pyle were art-school-trained illustrators who helped elevate the status of illustration from a craft to a fine art. As Michele Bogart observes, in the late 1880s "high standards" and "broad appeal" seemed to present no contradiction, in part because access to illustration, as with fine art, was limited to a small segment of the population. But this generation

was, essentially, the first and the last to sustain a self-image that comfortably wed their work as illustrators and as easel or mural painters.

Howard Pyle's legendary talents, his attention to historical authenticity and detail (including his prodigious costume wardrobe for his models), and his ability to render elegant formal compositional values in highly complicated pictures impressed the young Rockwell tremendously. By the time Rockwell had begun his studies at the Chase School, Pyle's virtuosity was well established: he represented more than anyone illustration's Golden Age, when the market demand for such work far exceeded what he could provide, even working his seemingly nonstop hours. Pyle's sense of form, of detail, of color, his organization of space—all these virtues were augmented by the painter's facility with words as well: he was an accomplished writer of children's tales.

Like Rockwell, Pyle had been a mediocre student, whose greatest early pleasure had consisted of the monthly arrival of the family's magazine subscriptions. He would pore over the illustrations, soon busying himself by copying the best drawings—just as Rockwell and his father had done. Pyle's boyhood years encompassed the Civil War, and he grew up enamored of the battle scenes in *Harper's Weekly, Frank Leslie's Illustrated Newspaper,* and, later on, the illustrations in British publications. He devoured *Punch* and the *Illustrated London News,* and through all these venues he became acquainted with drawings (usually reproduced from woodcuts) by Whistler, John Millais, Ford Maddox Brown, Holman Hunt, and Winslow Homer. Many of these artists considered their illustrations to be the commercial side to their real art, which was fine painting. But, as an adolescent, Pyle made no distinction. This was, by and large, the art he grew up with.

There was much to recommend Howard Pyle to the young Norman Rockwell, including the leap in talent and ability that Pyle had made during the first five years of his professional work after three years of schooling. His initial attempts are less impressive than the work from Rockwell's early years, and even after the most important of the children's magazines, *St. Nicholas,* had accepted a story that he

wrote and illustrated, the editors continued expressing disappointment at the poor way that Pyle's pen drawings held up for reproduction. At *Harper's,* his illustrations were routinely reworked by the experts Edwin Austin Abbey or Arthur Frost, which demoralized the young artist. Finally, in 1877, when he labored for an extra six weeks over an assignment to convince the editors that he needed no assistance, he achieved a turning point in his career—at the age of twenty-four. Howard Pyle's story became the exemplar by which Rockwell would measure his own.

In Mamaroneck, the rhythm of Rockwell's life had increased dramatically, since he now juggled the demands of Chase, high school, and earning money. His energy was up to the challenge; a full schedule, if self-constructed, made the adolescent feel worthwhile. By 1910, at age sixteen, Rockwell believed that Mamaroneck High School drained his energies, distracting him from his real work. Rockwell finally misbehaved badly enough to be kicked out during his sophomore or junior year, according to the first interview he ever gave, seven years later: "I had so much fun at school that I was expelled my second year in high school." From other pranks he described, such as running the principal's long underwear up the flagpole, we can assume the mischief was fairly minor. But as the illustrator gained fame, he began to worry that youngsters would emulate his naughtiness and he'd be blamed for a generation of high school miscreants, bad for the teenagers and for his reputation, so he bowdlerized the story and became a high school dropout instead. His high school records (other than grades from his sophomore year) mysteriously disappeared, according to local school officials, ensuring that the cause of his expulsion would remain a secret.

Whatever precipitated his dropout status, Rockwell's poor grades, even in drawing, and his attempts to win favor by playing the class clown, would probably alert today's teachers to an attention deficit disorder. Such a syndrome is symptomatic of other high achievers who proved incapable of mastering the protocol of school days: Abraham Lincoln, Edgar Allan Poe, Thomas Edison, and Albert Einstein

are just a few who suffered from similar afflictions. The years of low self-regard that their school experiences engendered in such men proved resistant even to their future success, and an "agitated depression" expressed in highly focused work compensated—perhaps over-compensated—for their earlier failures. People who suffer from agitated depression, which some experts believe is essentially the adult version of attention deficit disorder, manifest many of the typical signs of depression, while a simultaneous restlessness directs the depression outward, into activities that absorb the excess energy. Rockwell and his mother both appear to have been afflicted with this syndrome, but at least the illustrator was able intuitively to collate his disease with its proper solution: he knew he wanted to become a famous artist, and getting kicked out of school was the quickest way to start the process.

Art school, full-time, was now on his agenda, but his father told him he'd have to pay for it himself. Chase had been everything he needed to get his professional training under way, but everyone knew that real artists had to take a full-time course of study at the venerable National Academy of Design once they became serious about their careers—it was just the thing to do, mainly because the school had been around since the nineteenth century. Founded by Thomas Cole, Rembrandt Peale, and Samuel F. B. Morse, the academic program was modeled on London's Royal Academy and other great European art academies. Enrolling at the Academy would even make Rockwell eligible to win the yearly contest to study in Rome, the Prix de Rome, the school's homage to the Académie de France's own history-painting contest, dating from 1663.

Already earning a fair amount from his paper route and odd jobs but aware he would need to squirrel away more to see himself through the fall semester in Manhattan, Rockwell accepted a summer position at what appeared to be an exclusive local camp. Instead, the enterprise was a scam, run by a greedy fraud who bilked rich parents out of large sums for wildly inadequate childcare. True to the Dickensian grid through which Rockwell viewed the world around him, his adult

account of the camp borders on the comically absurd, with the boys and girls eating gruel, Rockwell teaching French (having never even heard the word *oui*), and everyone almost drowning. By the end of the fiasco, Rockwell had discovered he would not get paid; his father, no doubt happier with Jerry's summer performances in St. Thomas's theatre group than with Norman's continuing vagaries, told him he'd have to solve the problem himself. No solution presenting itself, the irritated young man left in the fall for the National Academy of Design far less financially secure than he had anticipated.

Rockwell speaks only of "studying briefly" at the staid institution. School records reveal that Rockwell actually registered for two semesters: fall 1910 and fall 1912. Intriguingly, he was kicked out the first time for failing to complete an assigned painting. Because he did not follow through on tasks he really disliked or disagreed with, we can assume he was contemptuous of the project. His description of what he considered to be arid training smacks of the decay surrounding Miss Havisham in *Great Expectations*, with broken Roman busts and dust-covered marble body parts littering the classroom floors.

He was dismayed, too, at the lack of camaraderie between students and teachers; after all, traditional academic structure had failed to suit his personality, and he had not suffered through those years at Mamaroneck High School only to feel oppressed yet again in the art world. Nor could the location of the school—next door to the dreaded St. John the Divine, which had eaten up much of Rockwell's boyhood—have contributed positively to the environment. In particular, the plodding means by which students worked their way up the pecking order dismayed the ambitious student. Among Rockwell's most vivid memories of his brief tenure at the Academy was the rating system that rewarded the week's best drawings by assigning the winning students numbers that determined who got to pick the model's pose and where each artist could set up his easel. As a newcomer to the life drawing class, Rockwell fretted over being stuck in a corner, where he saw little more than the female model's feet and "rather large rear end."

The National Academy of Design was not at its strongest during this period; beginning to look stodgy and dated rather than impressively pedigreed, it had failed to negotiate a place for itself in the newly emerging art world scene. Although William Merritt Chase had bet on Manhattan assuming the art world's lead by now, he was off by a few decades at least. Modernism had stormed Europe, and its sonic waves put American artists on the alert that they needed to catch up. The Armory Show, which would install European Modernism as the beau ideal, was only two years away. The Academy, in spite of the continental avant-garde, still stressed painting based on narrative content. At least the school-trained illustrators and easel painters alike agreed on the fundamentals of painting, insisting that artists be able to execute the academic idea of "the basics," regardless of their professional goals.

If a certain moribund air hung over the Academy in 1910, its Old World methods had been indicted as early as July 1875, when students and faculty broke away to found the Art Students League, a student-run organization housed in a twenty-by-thirty-foot "cockloft" on the fourth floor of a building at 108 Fifth Avenue. The League had grown from a handful of malcontents to a school attracting thousands of students from all over the world. It didn't take long before Rockwell, who had heard about the edgier and more egalitarian League from students at the Academy, found himself at their permanent quarters at 215 West Fifty-seventh Street. Here, in keeping with the League's democratic method of encouraging young artists to plot their own course of study, teachers' names were listed on a central board for students to take their pick of the lot.

By the time he entered the Art Students League, Rockwell was almost certain that he wanted to be an illustrator. The Art Students League, progressive and stridently proud of it, approached illustration with the same seriousness that it did pure painting. By now, Howard Pyle's efforts to deracinate from illustration classes the taint of femininity, of being a more decorative career than real painting, had paid off: illustration was serious and worthy artistic work that, admittedly,

proved a bit too financially lucrative to be in the same category as fine art but still stopped short of the commercial pablum of advertising.

Rockwell later claimed he more or less flipped a coin when he first stood in the corridors of the Art Students League; knowing nothing about any of the professors, he randomly chose to study anatomy with George Bridgman and illustration with Thomas Fogarty. The first was a well-known life studies teacher, the second an accomplished drafts-man who taught a techniques course culled heavily from his own pro-fessional experiences. In later accounts of the role that chance played in his studies, Rockwell meant to sanction implicitly the prodigious range of his innate abilities; he could just as easily have ended up in Kenneth Miller's course, he said, which would have made him a mod-ernist instead of an illustrator. In reality, Rockwell was too directed a student, too savvy not to have asked around before selecting his in-structors. And he fails to mention that he studied with not one but two illustration teachers during this all-important first year—Fogarty and Ernest Blumenschein. The doubling-up implies "an unusual ded-ication to illustration so early; it was highly unconventional to take more than one such course at a time," according to League curator Pam Koob.

Thomas Fogarty's importance to Rockwell's career came as much from the publishing world contacts he generously fostered for his stu-dents, especially the best ones, as it did from his earnest and long-remembered exhortations to get inside the picture frame, to know what each person was feeling, thinking, and doing. Fogarty did enjoy some little renown: in 1907, for instance, the Metropolitan Museum of Art had purchased his sketch *Wee Annie,* an illustration for the popular magazine *Pearson's.* But as Michele Bogart points out, this transaction occurred in conjunction with self-interested magazine companies pressuring the Met to create a separate department of il-lustration, a vision encouraged by Frederic Remington and contested by N. C. Wyeth. Rockwell himself would later comment that Fogarty was not a particularly good artist, but he was a very dedicated and car-ing teacher.

Fogarty taught from two modes, the classical and the pragmatic, and he depended on the old-fashioned method of emulation. First, he would summarize a story and ask the students to decide what elements were most ripe for representation; then he showed them reproductions of those stories' illustrations done by Pyle or Abbey or Remington, explaining why each artist had made his particular choices. At the same time, the teacher solicited the "cheap magazines" for work he could hand out to his classes, and, whenever a student delivered an appropriate illustration, the publication would use it, a method that engendered minor income and the beginnings of a portfolio for the aspiring artist to show around town.

Under Fogarty's impetus, Rockwell learned the importance of self-promotion; he even spent some of his hard-earned cash on having business cards printed: "Artist, Illustrator, Letterer, Cartoonist; sign painting, Christmas cards, calendars, magazine covers, frontispieces, still life, murals, portraits, layouts, design, etc." Fogarty pushed Rockwell to get his work in front of a paying audience and, through his efforts, the young illustrator garnered enough small commissions that winning a League tuition scholarship at the end of his first year proved far less important than it would have the year before. His winning drawing is an illustration (probably assigned in class) of Oliver Goldsmith's poem "The Deserted Village," captioned with the verse "But in his duty prompt at every call, / he watched and wept, he prayed and felt, for all." Within the context of this poem about a once bustling little village that industry kills, the lines refer to a town minister known for his compassion to anyone in need. Rockwell's illustration of the man kneeling at the side of a dying villager is graceful, simple, and beautifully wrought from a technical point of view. From the floor to the framed painting above the headboard of the bed, the shading is subtle, multifarious, and precise. Already, Rockwell's pleasure in rendering light sources appears in the reflection of the single candle illuminating the bed.

Over four decades later, his mind's eye substituted a more personally significant scene for the winning picture. He described the schol-

arship drawing as portraying a bedridden boy gazing longingly at the Fourth of July fireworks cascading outside his window. By the time he was famous enough to command an audience for his autobiography, Rockwell no longer wanted to remember that he had once articulated the darker side of life more than competently. He furthered the illusion that from his beginnings as an artist, he'd illustrated only the wholesome side of life; somber deathbed scenes did not fit into his repertoire. Fireworks, however, functioned mnemonically as childhood excitement that failed to detonate fully, at the right time, in the right place. His father had short-fused Norman's pleasure when he'd insisted that his sons modulate their ignitions into lighting one firework at a time, causing the boys to complicate the whole enterprise into nothing but one giant, hot disappointment. And there was Uncle Gil, too, who good-heartedly set off the works in the right way for his nephews—but during the dead of winter, not when they carried the cultural meaning the boys wanted to be part of. Rockwell's winning scholarship picture, as he fantasized it, positioned a disappointed boy, yearning to be outside partaking in the timely celebration, sick in bed instead. Never fitting into the current scene at the best time—too late for the Golden Age of Illustration, too early to chance the modern age of painting—the grown man always believed he had missed the moment, in spite of his celebrity status.

If Thomas Fogarty encouraged Rockwell to get into the real work world fast, it was George Bridgman who inspired in him a love of perfectly executed drawing. Bridgman's passion for the human body found elegant expression in his exquisite renderings of bones, muscles, and sinews, as well as the way they interacted during different torsions. Insisting that color and "lovely compositions" were secondary to the foundation of a painting, he frequently reminded his students that "you can't paint a house until it's built." Bridgman's fame was specifically, stubbornly confined to the student population, although that crowd included some illustrious acolytes over the years. In 1942, *Time* magazine claimed that his name was "as unfamiliar to the general public as it is familiar to practically every artist in the U.S."

Bridgman taught as many as seventy thousand students through the first half of the twentieth century. He mesmerized his anatomy classes with his eccentric habits, which *Time* related with relish: he was well known for "carrying around a batch of wrist and finger bones in his pocket and earnestly examining them at odd moments on subways and in restaurants. At home he kept a hand pickled in glycerin and carbolic acid and studied it for weeks until putrefaction forced him to bury it in the garden to the horror of his Negro gardener. Once a taxi driver, aware of his interest in cadavers, appeared on his doorstep with a dismembered human leg that an unidentified medical student had left in his taxi."

Rockwell always esteemed technical mastery. And he especially appreciated that such a great draftsman did not stint on his instructional duties. As Rockwell observed Bridgman's talents, he noted approvingly that in spite of his brusque manner, the man clearly enjoyed teaching. Akin to Rockwell, he liked people, disdaining only those pretentious students who "dressed like artists, talked like critics, and loafed like pigs in summer." "Prim and meticulous" as well as sardonic, Bridgman's old-world gruffness seemed totally devoid of old-fashioned meanness, Rockwell later painstakingly explained. The League had encouraged a tradition of pugilistic painters from the beginning of the century, when Frederic Remington's emphasis on ruggedness campaigned to undo the frequent association of the decorative and effeminate with art. George Bellows and then Thomas Hart Benton furthered the cause when they taught at the school during the 1920s. Jackson Pollock and Arshile Gorky would eventually commandeer Bridgman's studio when the accommodating instructor was absent and hold massive bathtub-gin bashes. That Rockwell, eager himself to be a "man's man" but uncomfortable around such artificial manifestations of masculinity, grew so fond of Bridgman speaks volumes about both men.

Bridgman took stock of Rockwell as quickly as the student did his teacher, and he was equally impressed. As an adult, the illustrator would proudly recall how during the master's legendary turns at each

student's easel, where he corrected the drawings with heavy black marks, he praised Norman's painting as just right, while all the others needed more light. At times, however, when Bridgman charcoaled in a "heavy black line down the center" of Rockwell's drawing, demonstrating how to obtain the "main line of the action . . . down *through* the hip," the student groaned inwardly. Revealingly, he had established a ritual of taking the week's painting home to show off to his parents, and now he would spend "all the next day laboriously trying to clean off Mr. Bridgman's black line" before exhibiting the damaged project. But Bridgman took pains to ensure Rockwell understood his own worth; when he gave another student the winning number one for the week's illustration, for instance, he consoled Rockwell that number two was actually better, since first place implied that the student's talent lay in parroting back the lesson rather than expanding it with his own insights.

At Bridgman's behest, Rockwell became class monitor, which meant he auditioned the models who posed nude as well as instructing them during the sessions. He and a few other students soon began a deeply satisfying routine of joining Bridgman at the end of each session: a janitor would provide the teacher with a beer and his acolytes would "flop down on the floor around him" and listen to his stories about Howard Pyle or Edwin Austin Abbey. Reveling in his company, the admiring young artists would look on in amazement as their teacher, between sips of beer, brilliantly sketched a muscle on a scrap of paper.

Almost as important to Rockwell as Bridgman's own techniques and personality was the homage the great instructor paid to Howard Pyle, a former student at the League. Precisely because the decline of the Golden Age was already dimly perceived, if consciously denied, by students hoping to partake of its riches, Pyle, the illustrator who had ushered in the era, had become nearly God-like in their opinions. George Bridgman had trouble conducting class through his tears on November 9, 1911, the day that the fifty-eight-year-old Pyle died. Largely as a result of the vocation that Howard Pyle represented to Rockwell in fall

1911, the younger man felt that illustration offered him the chance to be a prominent contemporary artist as well as part of a great historical tradition. Although Pyle had become a kind of celebrity illustrator by the 1880s, publication of his stunning color illustrations had been forced to wait on the development of the four-color process of the early new century, so that in effect, Pyle had been allotted less than a decade in which to establish his brilliance as a colorist. Clearly, the way was paved for those capable of fulfilling the work the master had begun. But Howard Pyle proved to be only the first of the great illustrators to die during Rockwell's tenure at the League; by the end of those two years alone, Edwin Austin Abbey and Frederic Remington were dead as well. Rockwell would eventually associate the death knell of the brief-lived Golden Age with their burials. For a good twenty years more illustration would hold its own, but the art had peaked a little too early for Rockwell to breathe its rarefied air.

The Golden Age was well enough established by this point that it was reasonable for Rockwell to believe he was entering an artistic field that could deliver, all in one package, artistic fulfillment, critical acclaim, and great wealth. Paradoxically, though, the very technologies that helped modern illustration gain its aesthetic foothold worked against its longevity, assuring its anachronistic status instead. Photography, a newer model of representation hot on its heels, ran only a pace behind radio, television, and talking movies, converting the public to a more highly charged, stimulating aesthetic than illustrators could conjure. Mere illustration, neither as realistic nor as fantastic as the images increasingly mass-produced by advanced technologies, lost its place fast. Even the new availability of cheaply mass-produced magazines and books, suddenly affordable to an undereducated or undexposed public previously inured to art, bore dangers for Rockwell's profession, as well as immediate rewards: the quality of the illustrations decreased as the assignments were meted out to little experienced, low-paid, often less talented illustrators.

In other words, when Rockwell entered the Golden Age, it was already flirting with its own demise.

. . .

The Art Students League proved perfect for Rockwell and he flour-
ished in its midst. Here, the surroundings reassured him that he was
on his way: the League occupied the upper three floors of a five-story
building, a total of more than eleven thousand square feet of floor
space. The students had access to spacious studios, a members' room,
a clubroom, a boardroom, the director's office, an art store, and a "re-
fectory" where they could prepare their own food. Always (even
painfully) sensitive to his physical surroundings, Rockwell now ex-
uded a palpable self-confidence that had been quietly taking root the
past few years. His talent and his tenacity combined to impress his
fellow students that he was bound, out of all of them, to succeed.

In spite of the putative liberality toward aesthetic categories, the il-
lustration students were, nonetheless, at times put on the defensive by
the "pure artists." Even though Rockwell explained his choice to pur-
sue illustration by asserting the familiar conundrum that "there was
not such a clear divide at the time between fine arts and illustration,"
the distinction roiled the waters at times. One day, for instance, when
one of the "lunchroom crowd" (students who "wore beards and soft
wide-brimmed hats and chatted about art all day long over cups of cof-
fee in the lunchroom") cornered him in the school cafeteria to exclaim
in a mixture of "scorn and awe," that "you know, if I worked as hard as
you do, I could be as good as Velázquez," Rockwell's answer was swift:
"Why don't you?" Wounded by the jibes of young colleagues headed
toward "serious" (noncommercial) careers, he welcomed the chance
to recommend his own discipline to those whose sloth he disdained.

Most of all, Rockwell's study of his illustrious mentors convinced
him that his pleasure in being mass-reproduced—his awareness that
in contrast to the static and limited nature of a museum painting, his
own works were being disseminated to as large an audience as any
artist could dream—fed on pride similar to what Howard Pyle felt as
America assumed the mantle of world-class illustration around the
time of Rockwell's birth. Pyle's convictions could have been Rock-

well's own, almost twenty years later. As Pyle's biographer declares about the father of American illustration: "He felt a sense of security in the niche he had climbed to. He was part of America, a land of prodigious appetites . . . The country hungered for pictures and was beginning to devour them at an extraordinary rate. . . . He knew that the illustrator was the artist of the people. He and his fellow illustrators confronted an opportunity no artists of the past had enjoyed."

Rockwell turned his work ethic into an essential part of his identity, claiming that because of his natural addiction to a schedule he never missed a meal. Others might speak of inspiration and vision; to him, art, imagination, and creation flourished when sleep, meals, and pay were dispensed at predictable intervals. When the yearly student ball and drunken revelries came round, he and his friends sanctimoniously locked their doors so they could continue working, rather than join the "pure artists" at their debaucheries—though he did once admit, "I really got into the ball at the end, and the silly parade downtown—I just didn't have time to join in the preparations ahead of time." When he paused long enough to reflect, he did occasionally worry that his regular habits argued against him being an innate, real artist. "Being somebody to my parents and brother and to my friends in Mamaroneck meant a lot to me. I wasn't a rebel," he declared, explaining his choice to become an illustrator; he wanted to make his family proud.

Aside from everything else, a major distinction—perhaps the most important one until World War I—between artists who chose illustration and those who pursued easel painting lay in the social objectives of each group. In the twentieth century, artists were increasingly expected to paint from inside out, to create their paintings, whatever the ostensible subject, from the heart and soul of their solitude. Inner sight and inspiration trumped what seemed the pallid competition of mere recording.

Such interiority was the legacy of Romanticism, so that even the allegiance of the Impressionists a generation before to the external world of nature was deliberately filtered by their subjectivity, by their

awareness that different viewpoints would change the object before them. However alien their world appeared to the Cubists of early Modernism, a similar privileging of inward vision held.

Illustrators, however, saw their task as reflecting faithfully the world they inhabited, if at times through the defamiliarizing lens of art. Imitating life at its most tedious, its idealized best, and its tragic worst, illustrators would find it much harder to claim the God-like mantle of the creator that modern artists could invoke. By personality, illustrators therefore tended to be more gregarious, more extroverted, more social creatures than fine artists, who relied on their feelings and intuitions to produce masterworks. And for people like Rockwell, who avoided exploring his emotions in any depth, the chance to create his art by reflecting narratively on the world was a godsend for the low-level depression that seemed to dog him. The often ungodly schedule that illustrators kept, wedded to their easels, locked into commissions and deadlines that fine artists considered anathema to inspiration, suited his impulse to channel his energies into his work.

Regardless of their academic tracks, many students, Rockwell included, found themselves performing odd jobs in order to pay their living costs and school fees. At first, he drew various stages of fetuses contained in jars at a local hospital; next, he worked the eight-to-midnight shift at Child's Restaurant at Fifty-ninth Street and Columbus Circle, too quiet a location during the evening hours to avoid boredom or make any money, in spite of the location's colorful evolution into a "cafeteria society" for homosexual men in the know. One day, in the middle of complaining about the lifeless job, Rockwell was interrupted by his sympathetic listener, an art school friend, who invited his colleague to try out his own part-time work. Within hours, the illustrator had fallen into a job that energized rather than enervated him—he was hired as an extra at the Metropolitan Opera. Rockwell, his love of the theatrical well established, thrilled to the larger-than-life aspect of grand opera, from the bizarre costumes he wore, to the chance to occupy the "jockey seat" in the elephant's head during *Aïda,* from which position he worked the pachyderm's

trunk, affording him unlimited opportunities to play the boyish pranks he still loved. The young man reported this job proudly to his parents, whose collection of opera recordings had been one of the few cultural signposts that Rockwell felt distinguished them from the far Upper West Side hoi polloi. Waring and Nancy couldn't help being impressed when Enrico Caruso, a talented caricaturist himself, befriended their son, charmed by the exuberance of the two art students backstage and impressed by their drawing skills.

Drawing necessarily occupied most of Norman's time that he didn't spend in school or at the Met. Luckily, Thomas Fogarty, sensitively aware of his students' financial needs as well as their various abilities, helped the ambitious young man procure his first professional assignment. In 1912, when he was eighteen years old, a commission to illustrate twelve *Tell-Me-Why* stories brought Rockwell some financial security and visibility, so that in spite of earlier assignments, he came to consider this his first real publication. The collection by C. H. Claudy was published by McBride Nast and Company as a question-answer sequence, an early parent-child interactive book. Although as a mature artist Rockwell chuckled over these early pieces, several of them hold up well as examples of a broad-brushed romantic technique, large blocks of graduated grays opposing bold use of open space. His dramatic use of simplified form to achieve focus even hinted vaguely at a fashionable orientalism that bordered on the surreal.

Fortified by this proof that his career was truly under way, Rockwell decided that the right working space would be crucial to enabling him to meet deadlines. Recalling his first studio, rented on the strength of the *Tell-Me-Why* stories, Rockwell enjoyed explaining how he and an equally naïve friend had, unknowingly, leased the attic room above a brothel. Only when Waring—apparently in spite of his much-vaunted innocence—showed up and, looking around, immediately informed the boys of their mistake, did Rockwell realize why the pretty, friendly girls from below who visited the artists every so often seemed to have no regular work schedule. As interesting as Rockwell's profession of almost bumpkinlike innocence is, his account of the

worldly roommate (Edmund F. Ward) in cahoots with him, equally unable to distinguish a bordello from an office, seems even more fanciful. "He'd say to me [quoting Harvey Dunn], 'Sure, you want to be an illustrator. But you've gotta be a MAN'—he'd always say this in capital letters—'first.' I'd ask, 'Can't a woman be an illustrator?' which would make him mad and we'd go at it, curse and insult, for an hour. But we were great friends." It seems unlikely that such a guy couldn't recognize a whorehouse.

In light of the number of stories Rockwell would tell over the years about bordellos that he did not recognize or enter, Uncle Samuel's horrific death from familiarity "with too many ladies" made its mark on the nephew who observed the still young man's excruciating demise. "My father was always nervous about sex," Jarvis Rockwell recalls. And no wonder. Rockwell was thirteen years old when Sam died, the very age when his own sexual awareness and urges were taking front and center stage. The timing of the two events—one man dying from overly indulging urges similar to those the younger one was just now experiencing—could hardly have been worse.

Rockwell left the studio-cum-brothel immediately upon his father's disclosure and found a bona fide space in Brooklyn, in the area today known as Brooklyn Heights. The studio stood next to the Brooklyn Bridge, and so the Fulton Street elevated railroad next door rattled the windows throughout the day. Large enough to contain several well-established artists as well as tradesmen and an irritatingly loud dental office, the building housed Rockwell's afternoon illustration class instructor, Ernest Blumenschein, his presence legitimizing the wiser choice of space this time. Blumenschein was respected for his illustrations of Jack London, Willa Cather, and Booth Tarkington novels at a time when drawings for important books invoked Howard Pyle's legacy. The instructor occasionally ambled over to Rockwell's studio to seek models from the League students sharing the large space, thrilling them all with the chance to see how he worked.

At least the Brooklyn studio provided Rockwell with some distance, however abbreviated, from his difficult family. By the end of

1911, Father Rockwell had moved back to Manhattan, probably because Nancy had complained that caring for the elderly man was too difficult for her. She was having more trouble than usual with her "nerves"; vague family records suggest that the Rockwells moved into a boardinghouse on Palmer Street, a few blocks from the home on Prospect. On May 13, a month after the boys graduated from Sunday school, Waring submitted his resignation to the St. Thomas vestry. The family moved into a socially modest Manhattan boardinghouse, primarily—according to the vague explanation the parents gave their sons—because of Nancy's increasingly poor health. She was simply not up to the demands of taking care of a household, Rockwell would later explain, whenever he discussed his parents.

Norman's resentment at being reduced to life at the boardinghouse "among people I didn't like and couldn't respect" "choked" him, and embarrassment motivated him to give no Manhattan address to the League to substitute for either Mamaroneck residence. He would never forget the "utter silence of a rented room in a boardinghouse," and the failure of people to live in proper family units that the place represented to him. The common suspicion that such close quarters bred opportunities for easy morals was well founded, if only because of the compressed opportunities the boardinghouses afforded: "Our objection to the Institution of Boarding may be all summed up in one sentence," worried one earnest reformer. "As our virtues are much more dependent on our surroundings than we are willing to admit, when the check of home is removed (and a boardinghouse is, emphatically, NOT a home) all sorts of evil are likely to rush in." Thomas Fogarty's ferreting out for Rockwell the odd illustration job here and there was partly due to his awareness of the family's reduced conditions, not a distinction the proud young artist, finally making a name for himself through his talent, wanted to maintain.

He was furious at his mother, but he let the anger simmer rather than express it. He blamed her for the family's entrenchment in the down-at-the heels midtown boardinghouse. And he held her responsible for Waring having to resign precipitously from the vestry, citing that

his wife's health dictated his absence "for a time." The other vestry members sent the conscientious Episcopalian a warm letter of praise, celebrating his "unfailing patience" with the minutiae of church business. He had provided "a comfort to the vestry and a service of real value to the history of the parish." Norman, convinced of his mother's incompetence and selfishness, believed that choosing a boardinghouse over a place of their own was damaging self-indulgence on Nancy's part. Yes, it was convenient for her to have nothing to worry about—from cooking, even buying groceries, to cleaning, to doing laundry. The boardinghouse took care of everything, all for one payment each month. But other women provided their families with a normal home; why was she special?

Without his parents, Rockwell had finally enjoyed big city life. He had saved on rent money by living at home, though he frequently kept late hours in Manhattan, sleeping over at his studio or at a friend's apartment. Given his later continued financial support of mother, aunts, uncles, and cousins, it is entirely possible that he had been contributing his income to his family for some time. And if his earnings helped to pay for housing, one can only imagine his entreaties to his parents to reconsider their move, especially in light of the dark visions he later, predictably, once again projected onto this subsequent domestic period of city life.

Tom Rockwell has suggested that an aura of sexuality askew or run amok permeated his father's memories of the women who lounged around the house while their husbands went to work. He was, after all, an eighteen-year-old tall, slender man, whose steady purpose and self-confidence animated the casual charm he had already mastered. Too suggestive of the suffocating attention his own coy mother had sometimes paid him, the pathetic flirtations of the bored women "in their rollers and their housecoats" sealed Rockwell's image of city life as decadence and decay. A tell-all book about the titillations of living in a typical mid-level boardinghouse during this period included the chapters "In the Wrong Bed," "From Bad to Worse," and "Love Finds Its Way." The vision of Norman loading the family belongings in Ma-

maroneck, storing the furniture at a polite but disapproving family member's house in Yonkers, and then unpacking the objects that would fit in the boardinghouse, is unpleasant, to be sure.

But the reason that the family left Mamaroneck so suddenly may well have been the discovery that Nancy Hill had breast cancer. The tiny woman would deal resolutely, even courageously, with the crisis, although she refused to confront the emotional trauma of losing her breast and facing possible death. "What was really interesting about Aunt Nancy, who everybody thought was a hypochondriac, was that when something was actually wrong, as with this case, she did what needed to be done," Mary Amy Orpen remembers. "I have to give her credit. In her own way, she had lots of spunk. From everything I heard later, on the day of the operation to remove the malignancy and the breast as well, she got herself to the surgeon—all alone—and after the office operation, returned home by herself as well."

Shocking as it seems today, breast cancer, which by the late nineteenth century had begun to achieve the proportions of an epidemic it retains a century later, was treated in the doctor's office. At least anesthesia was now routinely administered; until the 1860s, a glass of wine was often the sole support the patient received before the cutting began. By 1912, Nancy was given both ether and an antibiotic. She probably was subjected to the radical mastectomy—removal of the entire breast, the lymph nodes, and the large pectoral muscle with connecting ligaments and tendons—that Dr. William Halsted had developed a few decades earlier. Mary Amy Orpen recalls that her aunt eventually had the second breast removed as well.

Nancy Rockwell's cancer was caught early, and she recovered. But discussion of such disease was still taboo in general company, and even among family members in some Victorian circles. Rockwell apparently never knew that his mother had suffered such a serious threat. In spite of the credit she deserves for her courage, Nancy's repression of emotion during this traumatic period typifies a style of coping that her son mastered as well, though he would deny the bogeys differently by painting redemptive pleasures in their place. With-

out fuller disclosure of the facts, Rockwell naturally assumed that Nancy's hypochondria and mental fragility landed them at the boardinghouse—and he may have been correct, regardless of his mother's physical illness. Her attacks of "nerves" disabled her more than anything concrete, according to her relatives.

Predictably, the boardinghouse served up irresistible raw materials to reconfirm Rockwell's Dickensian template for the city. To move into such a lower-middle-class "home" just as he was earning his wings humiliated him, and, as a result, he interpreted its machinations through the most dramatic magnifying glass at his imagination's disposal. The women come off, in his recollections, as near harridans parading around all day half-dressed, disgusting the fastidious young man with their sloppy housedresses flapping open, their discourteous pink curlers, their constant nagging discontent. When their husbands arrived home nightly from work, they dolled themselves up—not for their spouses' edification, but to be taken out on the town to redeem their boring, listless days. Rockwell's contempt for their laziness oozes out of his descriptions, and the unhealthy air of a house full of unsatisfied sexual urges bombarding the young artist— "too young" to compel the women to button up their gowns in modesty around him—smells overripe in his narratives.

To enable himself to escape the claustrophobia of the boardinghouse, Rockwell rented a studio space next door, so that he could slip out in the middle of the night if he wanted to work up a new idea. But he found the whole setup stifling, and a few months in this atmosphere helped motivate him to grab the chance to spend the summer away from the city, which, though he didn't seem to notice, had functioned admirably as a source of personal fulfillment as long as his parents were living elsewhere. Now he went to Cape Cod, to Charles Hawthorne's artist's school, where he would spend perhaps the most idyllic three months of his life.

To understand the significance of his summer at Provincetown, Rockwell's myth of unwavering loyalty to the art of illustration must be dismantled. Certainly, he had learned enough about individual he-

roes of the Golden Age of Illustration to recognize his natural affinities with them. He knew that he had the personality common to great illustrators—he could see that from the hammy theatrics he shared with Edwin Austin Abbey, or through his Howard Pyle–like obsession with the accuracy of the detail. Once he became an art student, the long working hours that distinguished illustrators as overly conscientious or, to their denigrators, drudgelike, came naturally to him. And he honored the profession of illustration in and of itself, as one that allowed for the mass reproduction of art for the most people in the highest causes.

But though he entered the Art Students League determined to become an illustrator, his rapid success engendered its own burden, deferred for those less precocious: was such a talented man really willing to turn his back on the world of "pure" art in favor of the "merely" commercial? In spite of the official League position that illustration was just as fine an art as fine art—and even accounting for the frequently rehearsed historical arguments that aesthetic hierarchies didn't exist until late in the Renaissance, at best—line-and-ink drawing, as well as painting that was local and tendentious in its aim, had never enjoyed the position of "fine" easel painting, defensive assertions to the contrary.

Still, had Rockwell been inexorably pleased with himself, he could be excused. To have achieved a modest commercial success before he turned twenty exceeded the fantasies even he had entertained for years. But at this point in history, the thirty-year reign of the Golden Age of Illustration was besieged by threats everywhere, and the romantic validation of the pure painter held the day. Rockwell was not, as he would later claim, immune to the siren call of fine art. For one thing, during the past few years he had been exposed in depth to painters—the Dutch School, in particular—with whom he'd been only passingly familiar before. And, appeasing his substantial ego, teachers and students had praised his talent for pure painting; the comment about Velázquez that he repeated from the artist-manqué implied a certain envious awareness of him on others' parts.

It is easy to overlook Rockwell's agonizing crises of doubt about his vocation. Because the rollicking good time he makes of his life as an illustrator depends, in his autobiography, on an accretion of nonstop detail, he cannily disengages the reader's normal sensitivity to subtle but crucial shifts in his tone. Honest on the one hand, the truthtelling takes second place to the narrative energy that distracts the reader. The overload of detail itself, like a nonstop talker, dissuades the listener from probing deeper—and protects the storyteller from painful analysis as well.

Retrospectively, the successful illustrator presents his decision to attend Provincetown as serendipitous, an impulsive gesture to escape the metaphoric stench of the boardinghouse. And he counters that corruption with the exquisitely fresh sea air of Provincetown, where the fisherman community represents the pure and the good. But just as Rockwell had brushed aside any appearance of deliberately choosing his teachers when he entered the League in 1911, so now he was downplaying the seriousness with which he approached studying easel painting with one of the League's own. When Rockwell narrates his memories of the summer that he allowed himself to spend as a carefree, quasi-bohemian artist, indulging in an unconditional happiness he would rarely experience, the loss beneath his yearning temporarily disrupts the narrative flow—if one pauses to listen. The summer Rockwell spent studying with Charles Hawthorne in Provincetown crowned the illustrator's lifelong association of escape from the city with unfettered joy, convincing him, if only for a few months, that he was talented enough to paint anything.

8

❧

Earning His Sea Legs

In 1894, the year that Norman Rockwell was born, Charles Webster Hawthorne arrived in New York City and promptly became a night student at the Art Students League. Two years later, he began studying with William Merritt Chase, and during the summer of 1896 he attended Chase's Long Island artists' school in Shinnecock. Here he studied plein air painting, learning how to interpret outdoor light through a wide-ranging color palette. In 1898, Hawthorne traveled to Holland, where he fell under the spell of Frans Hals, whose Dutch tonal style influenced Hawthorne's oeuvre. After he returned to the United States, Hawthorne opened his own school, choosing the tip of Cape Cod for its rugged, picturesque terrain and its dramatic quality of light.

Hawthorne attracted thousands of painters through the years, and it wasn't long before Provincetown became the summer destination of students determined to join the ranks of professional artists. The friendly fishing community with the stellar northern light provided cheap living ready-made for artists: you could rent a room for fifty

cents a night; for $25, you could get a studio for the entire summer. Writers, journalists, Greenwich Village freethinkers, and activists soon seized opportunities to visit their painter friends. Rockwell's tenure in the summer of 1912 predated by only a few years what became the urban sophisticates' hegira to the far end of the Cape; when he studied at Provincetown, the freedom from commercial constraints, the sense of being part of a special group of interesting, vibrant people among a solid and welcoming community of commoners, the down-to-earth nature of the worldly, self-made, but low-key Hawthorne, who believed passionately in the value of solid teaching of the fundamentals, all combined to give Rockwell a brief taste of life as a pure artist.

Sociable as ever, upon his arrival Rockwell quickly made friends, and the artsy group he inhabited played their roles to the hilt. The students ate, for instance, only when they had money, even if that meant dying for art. One girl whom Rockwell befriended went without food for three days, in spite of her chronic ill health, which turned out, romantically but fatally, to be consumption. They compensated for the paucity of libations with the healthy outdoor air, where they set up their easels for plein air rituals whenever the salt breezes allowed. At the Art Students League, the studious Rockwell had mostly refused to participate in the yearly costume balls; here, he and his friend Bill Bogart won first place at the end of the summer for their dragon outfit. When they weren't painting or eating or dreaming aloud, he and Bill fastidiously plotted the winter trip to Paris that they were determined to take. Memorizing the most efficient paths from one famous location to the other—"You want to go to the Opéra. How do you get there?"—Norman and Bill quizzed each other until they could have drawn the maps themselves.

But if he dreamed about going to Paris to study, Rockwell's deepest loyalties were to painters farther north: the Dutch and Flemish schools that included Frans Hals, Pieter Brueghel, and Johannes Vermeer as well as his hero, Rembrandt. Their attention to the domestic and local, to interiors and mundane scenes as the rightful domain of high art, influenced the illustrator deeply, as did their strong articula-

tions of color, light, and space. Hawthorne's pedagogy echoed many of Rockwell's aesthetic values, ranging from his allegiance to Hals to his substitution of Provincetown's local rough-hewn Portuguese fishing community for the Netherlands' domestic scenes of homey, untutored men and women.

It is true that the nineteenth-century genre painting exemplified by Americans such as George Caleb Bingham and Winslow Homer contributed to Norman Rockwell's artistic pedigree: both luminaries had succeeded as important easel painters as well as reaping commercial rewards for their illustrations. But it was the Dutch School that spoke to him personally—a predilection that Charles Hawthorne's teaching strongly reinforced. Within a few years, a copy of Rembrandt's self-portrait would welcome Rockwell each day to his easel. With no close second, Rembrandt was the painter whose ability to convey his love of humanity in his subjects' faces filled Rockwell with awe; and it was Rembrandt whose broad range of techniques and attention to detail inspired Rockwell's own quest for perfection, even when he was painting magazine illustrations that would be quickly discarded. It was Rembrandt whom the illustrator would commend without hesitation when queried about the strongest influence on his work. And, when asked what art he would take to a desert island, he replied, without hesitation, that he would take a "Rembrandt or two" and "a good Howard Pyle."

At the summer's end, Rockwell returned far more reluctantly to Manhattan than he'd supposed possible. He changed the direction of his League studies for the fall semester, enrolling in only one class—drawing—taught by Frank Vincent DuMond. Like Bridgman a renowned teacher, DuMond possessed additional cachet as a prominent easel painter. But even more dramatic was Rockwell's reenrollment in the National Academy of Design, where he signed up for two fall courses: illustration and life studies.

The summer with Hawthorne had profoundly influenced him, that much is clear. Rockwell's willingness to return to the staid Academy, the site of his earlier expulsion for not completing an assigned picture,

reflected his decision to develop himself as a fine artist. But almost at once, this decision was forced to compete with the carrot of financial prosperity dangled in front of him. To his ambivalent pleasure, he found that he was as much in demand as ever with publications needing illustrations for literature aimed at contemporary youth. No longer forced to work as an extra at the Met to pay his studio fees, he had established enough of a reputation that he was receiving steady assignments from children's magazines. Although they were not the prestigious adult forums he would have preferred, they still paid well and provided all-important public exposure. Even Howard Pyle had started out at *St. Nicholas,* an important endorsement for the path Rockwell was treading.

In late 1912, impressed by the quality of his work and his obvious tenacity, Thomas Fogarty urged his former student to present his portfolio to Edward Cave, previously the editor of *Recreation Magazine* and newly appointed to take the local monthly, *Boys' Life,* national. Cave auditioned him on a tedious-to-draw Boy Scouts camping guide, then assigned him a story set for early 1913 publication—the first of what would prove to be four hundred contributions by Rockwell to *Boys' Life.*

At the beginning of the fall flurry of commissions, Rockwell was exhilarated if soon exhausted by the sheer amount of work he was undertaking, though his earnings were still modest. Word was spreading that he produced fresh, sharply executed illustrations for children's literature, at a time when the field had been tackled primarily by women artists, such as Jessie Willcox Smith and Sarah Stilwell Weber, with most important male illustrators declining such assignments. Work—ever more work—would prove to be his salvation for the rest of his life, and, at this early date, it liberated him from the dry-as-dust studies at the Academy as well. Still, after the flush of earning real money and being treated like a professional wore off, Rockwell found illustrating for children's magazines repetitive and tiresome. Intensely ambitious, he was comparing himself against the best in his tradition—Howard Pyle, most of all. Too soon after returning from Provincetown, the pleasures of finding himself in demand transmogrified into the grind

of a deadening routine: he found himself emotionally harried as he worried over meeting magazine deadlines for drawings he was not particularly interested in doing. And by late fall 1912, *Boys' Life* was making sounds about promoting him to a more permanent, lucrative position, possibly as art director. All of eighteen years old, he found himself growing restless.

After the promise of Provincetown, he now imagined himself consigned, ironically, to a lifetime of illustrating for American boys the "real boy" identity he had not that long ago desperately wanted for himself, while he watched his brother fall into it, effortlessly, instead. As he pondered his way out—how to become a great artist of one sort or another, instead of the scary dead end of children's illustration that he now sometimes feared—his salvation appeared in the unlikely person of John Fleming Wilson, well-known author of *The Land Claimers*. The popular 1911 novel centered on the often greedy and sometimes courageous pioneers who rushed into Oregon's rugged Indian coastal territory once the government opened the Siletz lands to white settlements. The same year, Wilson published a highly successful science-fiction short story in *The Saturday Evening Post*, "The Rejected Planet."

Struggling with alcoholism when Rockwell contacted him for advice about illustrating a story the writer had sold to *Boys' Life,* Wilson had nonetheless promptly responded to the artist's request to help him locate an authentic life raft for the painting. Taking Rockwell under his (usually inebriated) wing, the thirty-four-year-old writer hatched a convincing plan, supported by their joint trips to Scribner's publishing offices, where he'd leave Rockwell outside. Financed by Wilson's publisher, the twosome would travel to the Panama Canal, a topic of great cultural interest at the time. "I'll write . . . you'll illustrate. . . . We'll blast the canal and Davis and Pennell into the bargain," Wilson told the awestruck student. Richard Harding Davis, a war correspondent during the late nineteenth century, wrote manly adventure accounts, including magazine articles on the progress of the canal. More important to Rockwell, from January to March 1912,

Joseph Pennell had quietly created thirty of the most vividly evocative lithographs ever produced, elegantly conveying how the crucial final stages of construction were bringing the Panama Canal to life. Massive locks of a size never before seen, drops, cranes—Pennell's line drawings offered vivid witness. Joseph Pennell—not the publicly recognized name that many important illustrators retain—was well respected by Howard Pyle and is considered by some art historians to have done more than any other single artist of the period to elevate the quality and status of illustration into an art.

To Rockwell, the promise of competing on this level—in this league—represented the ultimate fulfillment of his dreams. The resulting coverage—Wilson's text illustrated by Rockwell—would, the young artist thought, ensure his fame. Rockwell was stunned; he was positioning himself to become nothing less than a Howard Pyle, a success earlier in his career than even the Master had managed. Let Frederic Remington and N. C. Wyeth take the West; he'd be a manly artist forging a more exotic path. Or he'd be the true boy-artist, conquering nothing less than the Panama Canal. "I was intensely ambitious," he would quietly, still painfully, explain of this period later.

Over a period of months, Wilson convinced his eager companion to invest in equipment, preventative medical care, and even to cancel bona fide commissions in order to complete preliminary studies for other Wilson texts. He took Rockwell drinking in the mornings and to bordellos in the afternoons—all of which, the illustrator carefully declared in his later years, he left untouched. To his father's increasingly skeptical inquiries about Wilson's character, Rockwell replied that the man was simply too busy to meet Waring.

The inevitable happened: Wilson skipped town, Scribner's told Rockwell they had never heard of the journey they had supposedly funded, and Rockwell was shamed in front of his family and friends. Most of all, the trajectory he had by now fantasized for his career, all of which depended on staking his claim in Panama, evaporated in hours. He came, he softly informs us, "as near to having a nervous breakdown as I ever have."

Rockwell descended into a clinical depression during the late winter of 1912 that lasted several months, its grayness sapping his interest in eating, socializing, and, for perhaps the only time in his life, his art. Paralyzed into inactivity, he sat in his dark studio and stared at the pigeons on his windowsill. The usually emotionally stiff Waring, true to his good-hearted nature, tried hard to rally his son, and when he failed, he and Nancy sent Norman to spend long afternoons walking the countryside at one of the farms where their child had earlier thrived. There, in true Wordsworthian fashion, Rockwell slowly regained his soul, back in touch with the mythology of innocent childhood that inspired his art.

9

❧

A Cover Celebrity

Rockwell returned to Manhattan in late 1912, determined to make up for lost time. Within a few months, John Fleming Wilson also reappeared and very briefly seduced Rockwell into accepting his excuses for his earlier unexpected departure. He invited Rockwell to a party at his Brooklyn home, but when the artist arrived with Eleanor Bordeux, his Mamaroneck girlfriend, the level of debauchery frightened not only his date; it alarmed her escort as well. Rockwell contrived a flimsy excuse to get away, leaving Wilson embarrassed in front of his guests. The Rockwell family consequently moved out of the Manhattan boardinghouse, largely, Norman said, to prevent Wilson from tracking him down. Just as relevant, surely, was his new involvement with *Boys' Life,* which enabled the illustrator to help pay for improved accommodations.

Rockwell had performed his first few assignments so well that he was working steadily for the magazine in early 1913, operating as art editor as well as illustrating several of each issue's stories. The part-time job left him free to pursue plenty of other commissions, and the

$50 a month that *Boys' Life* paid him allowed him to refuse the occasional unappealing job. By the time he left the magazine in June 1917, he had personally provided over four hundred illustrations. The early drawings for *Boys' Life* are generally romantically rendered, evincing strong line but soft focus, elevating by their technical mastery the often plebeian stories they interpret. Howard Pyle hovers over many of the pieces, and even, at times, Pyle's brilliant student, N. C. Wyeth. Rockwell ordinarily distanced himself from Wyeth, implying that unlike the Chadds Ford acolyte, he remained his own man.

Rockwell's position in 1913 as art editor of *Boys' Life* pegged him as a specialist in illustrating American boyhood, then a lucrative foothold in the commercial world. But if the potential financial security was reason to celebrate, the effect on Rockwell's psyche was more equivocal, and he knew it. To some extent, the *Boys' Life* job seemed to paralyze him into a permanent romance with childhood. The boy he had wanted to be, the guys he admired, the ones who got mistreated, the bullies, the lads clearly nurtured in the most ideal family settings—such themes reappeared over the next six decades, as if playing out a scene that he was determined to get right. His dissatisfaction with his childhood became the substance of his adult success, as he painted from his memories, often transforming the dross into golden scenes from an imaginary past. It is no accident that even in his old age, a word used commonly to describe his charm was *boyish*.

Since he was fourteen years old, Rockwell had believed that financial security would afford him greater self-esteem. Now, as his own professional efforts enabled his family to move into a far more respectable residence, he began to relax into a more secure public image. The shift to tony New Rochelle, New York, massaged Rockwell's bruised ego. Only a few miles from familiar Mamaroneck, New Rochelle's aura of gentility and nature, of wilderness civilized, bestowed a sophistication on the community that its homier companion town lacked. Yet it determinedly clung to the local traditions that made it a place people returned to: between Huguenot and Main streets, for instance, a "most courtly Italian" roasted coffee at his popular shop;

within easy walking distance of that stop stood Kerwin's drugstore, Pete Donnelly's restaurant, Charlie McGurk's saloon, and even Coles Phillips's studio in Sutton Manor. Ware's department store, Hyman Frost's clothing store, the National City Bank, Eddie Cordial's laundry, the YMCA, Ed Carson's jewelry store, and Chappie's barbershop were their neighbors.

Directly bordering Long Island Sound, the lively city of thirty-five thousand had developed nine miles of waterfront into private and public beaches peppered with often luxurious homes. Seven public parks, 132 miles of paved public streets, six banks, a dozen social clubs, and, most of all, its status as having the highest per capita wealth in the state of New York were all statistics trumpeted by the local realtors. Undoubtedly of special interest to Nancy Rockwell, convinced even before her genuine medical crisis of a near daily new threat to her health, New Rochelle enjoyed the lowest mortality rate in the state as well. Balancing its determination to be contemporary with a Yankee attention to tradition, the city was solidified by mon-eyed stability. According to Tom Hochtor, the nonagenerian town his-torian, New Rochelle "hasn't changed all that much since Rockwell lived here. Unlike those places whose populations just exploded after the world wars, New Rochelle got touched gently—more people, but not dramatically so. And the way of life pretty much evolved slowly, so the changes just don't seem so big as they are elsewhere."

For Rockwell, New Rochelle's éclat stemmed from its repository of famous artists. Not only Coles Phillips resided locally; an enclave of celebrity illustrators and cartoonists who wanted to live outside of but conveniently close to Manhattan chose the lush city for their home, among them Clare Briggs, Victor Clyde Forsythe, and best of all, Frank and Joseph (J. C.) Leyendecker. Rockwell met the New Rochelle clique quickly, since his own profile was sharpening monthly. Of them all, J. C. Leyendecker impressed him the most.

Joseph Leyendecker was high on Rockwell's list of heroes; his technical virtuosity, his range of styles, his narrative intelligence, all contributed to make him probably the best living illustrator, at least in

Rockwell's opinion. Several of the *Boys' Life* charcoal sketches show Leyendecker's ghostly traces in the elongated, elegant human figures, precise drawing, and modern thematic treatment of stories. Leyendecker's first *Post* cover, the May 20, 1899, black-and-white drawing based on a Spanish-American War story, had been exactly the type of picture Waring enjoyed sharing with young Norman and Jarvis, so proud of their little military battalion at St. Luke's. By the time Leyendecker's second cover was published in 1903, Rockwell was working alongside Waring, copying illustrations from popular magazines. J. C. Leyendecker would complete 322 covers for *The Saturday Evening Post,* exactly the number that would prove the end-stop for his younger friend in 1963. During that decade, Rockwell would answer a student's letter about Leyendecker's influence on the younger illustrator this way: "Apart from my admiration for his technique, his painting, his character and his diligence, he didn't have that much impact upon my work."

Leyendecker's talent was prodigious, especially his adroitness in shifting from one style to another. Particularly strong in drawing and composition, he created black-and-white sketches whose crisp execution inspired the sharper lines that appeared in Rockwell's illustrations for *Boys' Life* as of 1916. Leyendecker's Arrow Shirt ads, which practically created single-handedly the look of the Roaring Twenties young man, combined elegance of line with a slight narrative superiority indicated in his characters' barely perceptible aloofness, a technique Rockwell admired but did not emulate. Leyendecker's careful but broad brushstroke was employed in the most masterful of color compositions, including ads such as the 1900 Rogers and Company printing service, with the rigorously drawn, glorious reference to Michelangelo's Adam, and the 1917 Kellogg's Corn Flakes ad in which a Dutch Masters–inspired little girl far exceeds the demands of the occasion. Her luminous skin and the glorification of the domestic deliberately refer to an age when lavishing painterly skill on a child at breakfast was considered a legitimate enterprise among the very best artists.

In moving to the same town as the luminary Leyendecker, Rockwell and other illustrators could join forces and reassure each other that they weren't being written out of the history of art. Change, it was clear, radical change, was in the air—too rarefied for Rockwell to breathe easily. Oddly neglected in Rockwell's accounts of this year, just as he was making his bid to enter America's professional art world, the 69th Regiment Armory Show, an exhibition of over sixteen hundred pieces of American and European modern painting and sculpture, was being set up in New York City. February 17, the momentous opening date recorded in the consciousness of all art students of the period, came two weeks after Rockwell's nineteenth birthday, and within five days of John Fleming Wilson's debaucheries in Brooklyn. The first large-scale exhibit of contemporary art, including several notorious pieces by Henri Matisse and Marcel Duchamp, drew record crowds during its one-month New York run, and even larger numbers attended the smaller, edited show mounted afterward at the Chicago Art Institute. Artists and lay audiences alike could no longer avoid the new definitions of art contesting the age-old academic emphasis on representation. The picture plane could never again be taken for granted, and the subjectivity of the artist crowded other aesthetic priorities.

The Armory Show actually highlighted the broad spectrum of Provincetown talent: Oliver Chaffee, Stuart Davis, Marsden Hartley, Edward Hopper, Abraham Walkowitz, and Marguerite and William Zorach represented their own versions of what they thought modern art should be. Rockwell was right to realize that in theory, at least, he could join their ranks—if he would take the risk. At his own school during this period, Rockwell observed the League's "inner circle," the Fakirs, parodying Duchamp's *Nude Descending a Staircase*. This highly social group, self-appointed art students who deflated the stuffy or the self-important, orchestrated their riotous annual year-end ball even more gleefully than usual in light of the changes clearly overtaking the art world. Parades and costume balls abounded, but Rockwell, in spite of his theatrical leanings, refused to budge from his

work schedule. "They knocked on my [studio] door and I wouldn't an-
swer," he later admitted. It was against this fevered panorama of ex-
pectations and excitement (League students were still fervently
debating the Armory Show two months after it closed) that Rockwell
urged his family to relocate to New Rochelle after Father Rockwell
died in March, liberating Waring from any responsibilities for allaying
the old man's loneliness.

In New Rochelle, the family moved into Brown's Lodge, owned by
a lady reduced in circumstances, a "family hotel" that tried to blend
the reassuring values of the past with awareness of contemporary cul-
ture. Its earnest attention to decorum relieved Norman's anxieties.
The boardinghouse organized the floors so that "young people" lived
on a separate level from their parents' apartments, an arrangement
that encouraged unmarried single men and women to continue living
at "home," assuaging the guilt of parents who would rather pay others
to create such an inviting domestic atmosphere than to do so them-
selves. Nancy and Waring promptly joined St. Paul's Episcopal
Church, but this time Norman opted out. By 1913, he'd had enough
religion for a lifetime. He'd acquiesced all the way through last
spring's confirmation. Now, though still deferential to his parents in
most things, the nineteen-year-old began to assert himself as his own
man in matters such as religion, albeit proceeding cautiously as he did
so. He disliked hurting people, even when he disagreed deeply with
their values or behavior.

According to various articles in the New Rochelle newspapers,
Brown's enjoyed an even more substantial reputation than Rockwell
acknowledged, functioning much like today's upscale apartment com-
plex. The boardinghouse even included several dining rooms where
local clubs—Kiwanis, Rotary, and church groups—held monthly
meetings. Rockwell's life at Brown's afforded him the first rewards for
being considered a man of good prospects. Not even twenty years old,
he was earning the early-twenty-first-century equivalent of $860 a
month from *Boys' Life* alone, an annual salary of $10,320. He began to
squire various girls around town and polished his natural friendliness
into a more suave but still accessible version that appealed to women.

But though Rockwell quickly developed cordial, even affectionate relationships, he usually implied more intimacy to those involved than he really felt. He procured studio space, for instance, at 360 North Avenue in the Clovelly building, next door to a brusque, good willed woman who ran the *Tatler,* a gossip rag for the city. The two struck up a friendship, and Rockwell tried to guide her to a less defensive stance that would net her easier social acceptance among New Rochelle's elite. Describing her years later, in spite of the warm friendship they'd shared, Rockwell nonetheless discharged her in short order, explaining that she was snubbed because her father was a butcher, motivating her to turn catty. The digression was necessary for him to get to the important point of their fortuitous (and fortunate) acquaintance, as far as he was concerned: when she went out of business, he was able to rent her office and knock down a wall to enlarge his studio space.

While his brother's reputation grew, Jarvis set out in his own directions. Continuing to act in the amateur theatrics he had begun three years earlier at St. Thomas's, he also discovered new ways to exploit his athleticism. He enjoyed beating his brother in tennis matches, especially since Norman, no mean player himself, at least had a chance against Jarvis in this sport, by virtue of now being three inches taller than the older boy, as well as possessing a much leaner body. Jarvis was still clearly the athlete of the family. During the summer of 1913, he took advantage of New Rochelle's proximity to the water and began racing, somehow even managing to buy his own boat. He entered his dory, the *Rocky,* in the Orienta Yacht Club's regatta in August, but just as he positioned himself in second place, a dangerous squall struck, capsizing every boat but his. The newspaper account comments on the able rescue of the four other boats and their crew; Jarvis Rockwell alone, however, true to his brother's memories of his physical prowess, rode out the squall in safety, "being driven clear across the Sound" and arriving home late that evening.

The younger son was getting his share of attention too. In March 1914, the *Tatler* published the first known interview with Norman Rockwell. Rarely noticed by later critics searching for the illustrator's

motivations or aesthetics, the startling article follows in the wake of Rockwell's summer at Provincetown: his involvement with John Fleming Wilson, the three-month depression and recovery, the brief reconnoiter with Wilson again, followed by the move to New Rochelle. In the period between arriving at Brown's and this interview, Rockwell had spent his time painting or sketching a variety of subjects, and in an impressive span of styles. His answers to his interviewer, however, belie the turbulence and variety of the previous eighteen months, making it sound as though the artist was fixated on a regimen of boys and animals. In fact, he was responding to feeling hemmed in by his *Boys' Life* job, which consisted of too much administration and too many "children only" illustrations. He was beginning to feel trivialized as an artist and was scared of getting his wings clipped before he had left the ground.

To his interviewer's question "Do you like illustration work?" the twenty-year-old "tall, thin figure . . . [with] a big bass drum laugh" responded: "No, I hate it. It's so cramped." He explains by way of complaining that, for instance, in his current assignment, he is yet again forced to draw a baseball diamond, and that in spite of trying it from every possible new angle he can imagine, there is not much new he can think to do with it. And yet, "as long as authors continue to write baseball stories and as long as little boys continue to read them, I suppose I will have to draw them." Asked "why don't you give up illustration?" he responds, "I'm not big enough I suppose, and figuratively speaking the children must have shoes." (The children, presumably, were his parents, whom he had certainly begun helping financially by this point.)

Rockwell continues candidly discussing the ways he might escape from his current field and strike out into new painterly directions: "I intended giving up illustration this winter and going to Norway for several months and studying the Norwegian and the Swedish painters, but my contracts interfered and my work piled up, so that it looks as if I wouldn't get off before spring, if I am able to get away then." Norway? Since this is the only such reference Rockwell will ever make, at least publicly, we can do no more than conjecture what he was thinking.

Most likely, Charles Hawthorne's open admiration for the turn-of-the-century Norwegian genre painting that emphasized fishing and farming suggested the itinerary to the Provincetown devotee.

The line of teachers under whom Rockwell had studied, from Chase to Bridgman to Hawthorne, represented the influences of the Düsseldorf and Munich schools, the first encouraging the Hudson River School's attention to meticulous detail and high finish, the other urging more attention to color and brushstroke, with the painters of choice Rubens, Hals, and Velázquez. The German schools motivated a turn to the homey and domestic, and many of the students under their sway found their way to the north, to Norway and Sweden, where they resided in fishing and farming villages ready-made for such a painterly emphasis. Here the painters of the late nineteenth century, Rockwell's teachers, could explore narrative painting, learning to create theatrical vignettes out of the everyday life of the villagers. Lured by such tales, as well as by more recent trips to lands north by Art Students League members including Rockwell Kent, whose name had already caused others to confuse the two men, the young illustrator was obviously considering what it would mean to follow their paths.

In addition, Edvard Munch hailed from Norway; he was a painter who represented solutions to Rockwell's two major problems: a tendency to tighten up in his painting and its emotional correlative—a lack of spontaneity. The Norwegian painter effected moving, disturbing paintings with a very loose, expressive style that remained realistic as opposed to abstract. Conceptually, Munch painted the everyday men and women of his time, like Rockwell, and did not overly embellish or dramatize; yet his figures are haunting. In general, Norwegian and Swedish painters were associated with a more dramatic, gloomy content than other artists; and Rockwell had become increasingly concerned that he was getting trapped into children's art. Seeking out its opposite was in many respects a logical idea.

But most surprising of all, the pragmatic Rockwell, who rarely theorized about life or art, philosophized about why he might redirect his life so dramatically: "The trouble is you only have one life and you

might just as well take the risk of making a success or failure at the thing you want to do, as to make a partial but sure success of the thing you don't like to do." He hastened to smooth over any hurt feelings his apparent disloyalty might have caused: "Not that there isn't a big field for illustration and not that there aren't great illustrators; for example, I am a great admirer of Howard Pyle's work. Of course, he is dead now, but he had the power to make his illustrations absorb the atmosphere of the story, you know." This may well be the only record of Norman Rockwell suggesting that he wanted something more than being a great illustrator—and that he feared he wasn't good enough to make it as a fine artist.

If Howard Pyle's death in 1911 had occurred auspiciously for an ambitious student who now could fantasize taking the great man's place, in retrospect, Pyle's untimely demise almost immediately had become a symbol of an entire age on the wane. Already Rockwell's nod in the great man's direction conveyed subtle elegiac overtones for the profession whose greatest modern credibility rested on Pyle's reputation.

Had he come to these conclusions courtesy of his father's intervention during the terrible winter two years earlier, as he re-trod the countryside of his youth? It had taken a full-fledged depression to allow Rockwell the luxury of undirected thought, and now it seemed as if the floodgates had opened wide. "I am working like a dog," he continued, explaining that, though he tries to wring every bit of imagination from the texts that he can, too often he is "continually being limited and bounded by the author, because your illustrations must agree with the text, and sometimes the author hasn't the least idea what he is talking about." Good student of George Bridgman to the end, he laments that an author "will have the man raise his left foot and throw the boulder with his right hand, which is an absolutely unnatural position, you know."

Yearning to do "real" art, and admitting that he is growing tired of illustration, the artist nonetheless concludes with the ambivalence that underlies such bravura: "I know a little hamlet on the coast of

Cape Cod where a man can live on three dollars a week, if he likes fish. Now, I don't care anything about society—people taken collectively are a sham—singly they are companions. I think that it does a man good to be poor, especially an artist, he has a greater incentive to work. So this little hamlet would be ideal, if I liked fish. I don't like fish, and there is always that eternal *if* in every man's life."

As Michele Bogart notes, Rockwell signals throughout his life that he enjoyed investigating modernist ideals; his aesthetic standards were, ironically and tragically, in fact similar to those of the very critics who ignored or belittled his work. But, so frozen was he in his own fear of leaving what he knew he could do and be loved for, he became the ultimate symbol of the reaction against Modernism and an escape from its ills.

And it is true that Rockwell was fundamentally at odds with contemporary notions of what an artist should be. Savvy art historians, realizing that the majority of celebrated modern artists from Monet to Jackson Pollock underwrote their bohemian, anticommercial posture with someone else's money, have long smiled at the Romantic myth of the starving artist. In contrast, painters such as Rockwell, whose background had neither inured him to material desires nor allowed him the luxury to disdain them, openly sought financial success. If the day-to-day industriousness of illustrators as a class seemed plebeian to those artists who sought more ethereal rewards, Rockwell himself was wed to his desire for financial security. And such pursuit of economic stability allowed him a self-respecting way out of confronting the fear of failure that often plagues successful public figures interested in swerving from their expected paths.

At the same time that Rockwell gave this soul-searching interview, he was keeping long hours producing illustrations for *St. Nicholas, Youth's Companion,* and *Boys' Life.* Some pieces, like the charcoal sketch for George M. Johnson's "A First Class Argument," provided rewards beyond the monetary: Waring modeled for Rockwell's drawing, information the illustrator wrote into his inscription on the piece fifty years later to the friend who bought it. Periodically throughout

his life Rockwell would flirt with changing professional course, but he never again approached the crossroads that he did during the years from 1912 to 1914, before he had solidified the image that encouraged Americans to think they owned him.

To some extent, the beginning of World War I forestalled the urgency to make clear decisions about his career's direction. All America was keeping watch, even though the majority of the country agreed that isolationism was its proper path. New Rochelle felt the European war's presence particularly keenly, because Fort Slocum, located on Davis Island six hundred yards from the town's shore, processed the most recruits east of the Mississippi. All around him, Rockwell's acquaintances, hearty, strapping young men, enrolled in the armed services. And those who didn't—the illustrators who comprised the New Rochelle Art Association, for instance—joined forces in the "poster" campaign, imitating luminaries such as James Montgomery Flagg, who had created the compelling image "Uncle Sam Needs You."

Jarvis Rockwell was thinking about joining the Navy, but in 1914 he was just getting his job with a cotton goods company, C. E. Riley, under way. He had fallen in love with fellow boarder Carol Cushman, a lively, well-liked fledgling actress, whose few small roles in films had already gained her the beginnings of a reputation. "Actually, my mother was Willard Skinner's girlfriend—he was one of the boarding-house gang of friends—and then on the way back from taking Willard to the train for the Navy, my dad and mom decided they were made for each other," Dick Rockwell says. Actually, to be more precise: according to a personal log Jarvis kept between September 19 and Willard's departure on September 26, he actively pursued Carol, stealing his "first hug" at Willard's going-away party, and his "first kiss" after taking Willard to the station the next evening.

Love letters between the two from 1914 to 1916 fill in the quotidian details of the Rockwells' days, revealing, for instance, that Jarvis and Norman's circle of friends all played golf. They walked a lot, too; in fact, much to his chagrin, the day after a sumptuous Thanksgiving

dinner, Norman and Waring had ambled off, while Jarvis got stuck storing summer clothes for Nancy: "I expect to feel called out for further duty any minute. Ma certainly can find lots of things to do when she starts puttering." Consistent parental patterns finger Norman as Waring's favorite, and Jarvis as Nancy's.

On February 27, 1915, Carol's parents gave a dinner party in honor of her engagement to Jerry, notice of which appeared in *The New York Times*, *The New York Herald*, and *The New York Press* a few days earlier. The following month, Jerry received a congratulatory note from an old friend, reminding the newly engaged man to tell "Norman not to do any stunts right away," since everyone first needed time to get used to Jarvis's engagement. Such advice implies some knowledge of the younger brother's impulsiveness, the possibility that he would rush out and get married himself.

By the summer of 1915, the Rockwells were able to relocate from Brown's to an even more upscale establishment at 39 Edgewood Place. Edgewood's, as the boardinghouse was called, appealed especially to single teachers and other young professionals, so that opportunities for the sons to develop same-age friendships seemed limitless. Waring and Nancy themselves had developed into a more outgoing, social couple after Father Rockwell's death in 1913. According to Jerry's letters to Carol, his parents had taken dancing lessons the previous fall; and now Edgewood's spirited camaraderie encompassed even the parental generation. Letters from Willard Skinner, the Rockwells' good friend who had shipped out to Cambridge University Officers Training Center in England, emphasize his thwarted expectations at receiving so little correspondence from "the bunch" at Edgewood's. Taking pity on the lonely Englishman, Nancy and Jarvis wrote him. Willard responded appreciatively, thanking them for their attention, and especially grateful for the local gossip they shared, but he suggested wistfully that it would be nice to hear from Norman. Indeed, when Norman mentions Willard in his autobiography, he simply notes that he was killed in action—and then he passes quickly on, missing not as much as a beat at the memory.

Norman's failure to continue relationships once the friend was gone reverberated particularly loudly for the injured parties, because the artist so clearly enjoyed socializing in general. References by family, friends, and even newspaper reporters make it clear that he was one of the first to join a party. But he had already developed his striking tendency to concentrate only on the moment at hand; regardless of someone's importance in his life, once the man or woman disappeared physically, the illustrator basically jettisoned the relationship. When Jerry writes to Carol on September 23 that he is meeting one of the Rockwells' boyhood friends for dinner—"he and Norman and I are old friends. We were really brought up together"—it is understood that Norman will be too busy to join them. "He just never looked back," his good friend and fellow illustrator Mead Schaeffer once reflected.

Sometime during the year, Rockwell had met fellow boarder Clyde Forsythe, a successful cartoonist ten or twelve years his senior. Together, the two men arranged to rent Frederic Remington's old studio. A corrugated iron barn previously used for massive sculptures, the structure was uncomfortable year-round. But for Rockwell, the associations from those formative weeks in the country, where his first in-the-flesh artist, Ferdinand Graham, had alternated painting with flamboyantly galloping away on his steed, found perfect expression in this chance to inhabit the literal space of the great artist of the West. At least unconsciously, working in Remington's shadow validated the illustrator, and his willingness to put up with the studio's distracting temperature extremes attests to the psychological trade-off Remington's aura provided.

Clyde (Vic) Forsythe played a pivotal role in Rockwell's early professional growth. Soon after he and Norman teamed up, for instance, they presented a show of their work at the New Rochelle Public Library, whose program stated that Rockwell was available for portrait commissions. More important, the older, successful, and conventionally masculine man believed in the boy's talent, and he convinced him he was ready for the big time. Forsythe drew a daily comic strip whose

characters engaged in some side-splitting absurdity every day of the
year, as Rockwell painfully noted. He appreciated his friend's suc-
cess—and his work ethic—though he disliked the genre he worked
in; he complained that the daily grind of forced humor wore down not
only the cartoonist, but also his studio mate, who was forced to guf-
faw convincingly at every day's punch line. Years later, Rockwell con-
fessed to his son Tom that the most appalling part of Forsythe's work
was the aftermath of the comic strip's termination a few years into its
production. An oversight in Clyde's contract forced the company to
pay him, even when they stopped using the cartoons, as long as he
sent them in as originally specified. Rockwell was repelled by his
friend's willingness to churn out the work for several years under
these conditions, which consigned his art to the trash bin even before
its execution.

But the silly humor of the shared studio space lightened up what
was becoming the otherwise intolerable certainty that he was heading
for a dead end. Rockwell knew that he wanted to ratchet up his suc-
cess, but he didn't know how. Instead of pursuing the obvious path
and staking out the editors of the adult monthlies, he resorted to
painting the exhortation "100%" in gold on the top of his easel. He just
had to work harder, he decided—he must give his very best. Only
after Clyde put his foot down on his studio mate's daily agonizing did
Rockwell dare admit what he really wanted—the big time, particu-
larly the cover of *The Saturday Evening Post*. Because Clyde Forsythe
was a loyal friend to Rockwell over the years, and since the story re-
flects favorably on the cartoonist, it's impossible to gauge the accuracy
of Rockwell's insistence that only Clyde's aggressiveness convinced
the illustrator to approach the *Post*. Obviously, Rockwell considered
his action somewhat presumptuous, and by the time he spun out the
account, he was enmeshed in his own self-construct of modesty.

At first shocked (or pretending that he was) at Clyde's effrontery—
imagine, urging him to submit his work to the *Post*!—Rockwell didn't
take long to be persuaded, though he had to be coaxed into abandon-
ing what Forsythe considered the ineffectual "pretty girl" theme he

had begun to pursue in imitation of *Post* artists Harrison Fisher and
Coles Phillips, formidable practitioners of the subgenre. The dashing
Gatsbyesque Phillips was often mentioned in the same breath as
Rockwell, largely because the two men were in the same age range:
"One might see the handsome, debonair Coles Phillips walking along
a New Rochelle street, or, one street over, the friendly, curly haired
young Norman Rockwell," announced the *New Rochelle Standard-
Star.* As if unwilling to compete, Rockwell appeared to cede to the
slightly older Phillips, determinedly single-minded in his eroticization
of women, the right to "sex up" female characters.

Against Rockwell's worried insistence that "pretty girl" paintings
represented the major trend of the *Post* covers, Clyde encouraged him
to return to the topic he did best—kids. The cartoonist patronizingly
explained that Rockwell lacked the ability to draw beautiful, seduc-
tive women—an observation somewhat at odds with the evidence of
several illustrations over the next decade. But from this point on,
Rockwell relates this supposed innate inadequacy as the rationale for
his choice of subjects.

Forsythe did have reason to suspect his friend's capacities. In
1916, for instance, Rockwell painted the first of what would be, over
the next three years, six covers for *Leslie's,* an illustrated weekly. Pub-
lished as the January 11, 1917, cover, *Fact and Fiction,* or *Old Man
and Young Woman Reading,* the painting suggests the odd difficulty
female beauty sometimes presented him. A vibrant-looking elderly
man, his face sketched in detail that manages to convey age, geniality,
intelligence, and physical attractiveness, sits beside a female com-
panion in her twenties, drawn fastidiously and evocatively, the pile of
her fur coat, the vividness of her white daisy clearly suggesting the
freshness of youth versus the maturity of age—until one examines the
face itself. A lovely blandness is articulated from a fairly flat plane,
suggesting Rockwell's reliance on Leyendecker's women, not the mas-
ter illustrator's greatest strength either.

Rockwell's attitudes toward pretty women were complicated in
often admirable ways that could not be represented adequately in a

painting. Certainly he blossomed in their presence and made a point of pronouncing publicly the pleasure he took in their company. Predictably, their archetype was his mother, whose outstanding characteristic apart from her hypochondria was her vanity. "Aunt Nancy wanted the best of clothes and shoes no matter what the financial situation, even when she was at the very end of her life," recalls Mary Amy Orpen. "She had to have beautiful things to wear, and it was clear that her prettiness was what had attracted Waring to her originally, and what made him such an attentive husband throughout their married lives." Waring's uxoriousness bothered his son, who believed his father's near servitude to his wife harmful to his health and manhood: "People used to say my dad was a saint [for treating Nancy so well], and I'd pretty much have to agree," he dryly informed an interviewer. Tom Rockwell believes that his father developed a tendency to disdain men who appeared passive in the face of their wives' power, in contrast to his general tolerance of others' family life.

Without excessive psychological speculation, it is fair to connect Rockwell's ambivalence toward his mother—the cost to others of her vanity, her desire to be tended, her physical weakness, and her unattractive if enviable ability to get what she wanted—with his longtime championing of the cultural or economic underdog. The child, the lower-middle-class "everyman," the homebody just short of worldly sophistication, these Rockwellian types evolve from what his children have described as his lifelong identity with the outsider, stemming from the mixed messages Nancy gave him as he grew up. The artist was uncertain how pretty women, whom he appreciated on a personal level, fit into a healthy society. Tomboys and older women, by contrast, were allowed—expected—to have wrinkles and other imperfections, and so their larger-than-life figures, such as his wartime *Rosie the Riveter,* gained perfect expression. He found such strong females interesting and, paradoxically, nonthreatening. But the conventional pretty girl frequently eluded him, and his odd unwillingness (that he named an inability) to represent this traditional feminine icon was noticed by his fans.

Related to the complicated ways that Rockwell took pleasure in the company of beautiful women is his lifelong appreciation of handsome, especially rugged-looking men. But part of the price Rockwell paid to purchase the loyal companionship of rougher-hewn men than himself was the implicit right they had to be judged bawdier, more sexual, more conventionally masculine than their beanpole friend. Quickly in the presence of his League teachers, then with friends such as Clyde, and eventually among his naval associates, Rockwell took his place as a purveyor of mostly wholesome, noncompetitive, but clearly heterosexual goods. From our contemporary point of view, his pattern of relying on masculine surrogates to supply the missing alter ego he lacked inevitably raises the possibility of homoeroticism at the very least. And yet, though Rockwell seemed to react with less shock or dismay at the "specter" of homosexuality than did most men of his day, there is no hint of such attachments in his own relationships. He appreciated beauty, objectively, in men and women; and he regretted that he lacked something he so enjoyed observing in others. His much-vaunted charisma was partially the result of learning to compensate for the conventional attractiveness he yearned for.

So when Clyde Forsythe gently ridiculed his earnest attempts to paint seductive women and kindly told his friend to stick to what he did best—children and animals—Rockwell listened. And, as if to blunt further his boldness in approaching the *Post* and to ward off charges of arrogance, Rockwell told the story (after George Horace Lorimer's death) of his first meeting with the formidable editor of the *Post* so that he came off as overly eager, earnest in his everyman way that effectively engendered sympathy, not envy, in his listeners. On one level—and it never changed—Rockwell failed to believe that he had the right to assume the status and stature of the chosen. His compulsion to place himself at the mercy of others (even if he was the aggressive one) not only perpetuated modesty as his primary virtue; it also obscured a grandiosity, a certainty that he was *at least* as good as anybody else. Without such an underside to his formidable insecurity, the artist would not have come into existence.

After Clyde convinced him to show his work to Lorimer, Rockwell spent several weeks working up five idea sketches, two of which he rendered as finished oil paintings in black, white, and red, the only colors that the *Post*'s two-tone process reproduced at the time. Next he designed a special wooden portfolio in which to carry his work to Philadelphia, where the Curtis Company headquarters building, housing the *Post,* was located. Ordinarily he wrapped his paintings in brown paper, but he didn't want to fumble in front of the great George Lorimer, getting his hands or feet caught as he untied the string, a mortification he'd already endured while talking to art editors elsewhere. But his determination to avoid playing the fool backfired, when the carpenter heeded Rockwell's instructions exactly, building an oversized, extremely heavy black box, twelve inches wide and thirty-three by forty-four inches otherwise. Although he bought a well-cut herringbone suit in hopes of looking accustomed to success, Rockwell was dismissively treated every time someone saw the "black coffin," as he began to think of it. He wasn't allowed on the subway with it—the box took up four or five seats, the conductor told him; once he got to Philadelphia, he was summarily dismissed from the fancy foyer and told to use the freight elevator on the other side of the building.

Rockwell had learned from his efforts to break into publication elsewhere how important it was to take the chance of just showing up, unannounced. The *Post* archives support his claim that he had not dared call for an appointment ahead of time, for fear that Lorimer would refuse to see him. Once in the inner sanctum of the *Post,* separated from George Horace Lorimer's office by only a few doors, he was immediately humiliated by two writers he held in deep respect, Samuel G. Blythe and Irvin S. Cobb, who made him the butt of their joke about the body he must have hidden in the amazing black box. Apropos of nothing, the miserable illustrator suddenly recalled the voice of the friendly publisher at the *Tatler* telling him, months earlier, that he had the "eyes of an angel and the neck of a chicken."

Fighting a severe attack of nerves, he explained to the receptionist that he had brought some paintings and sketches for Mr. Lorimer to

see. No doubt impressed at the imposing "portfolio" Rockwell had lugged all the way from New Rochelle, the kindly woman asked Walter Dower, the *Post's* art director, if he would see the illustrator. Dower came out to the waiting room, glanced at Rockwell's work, and then quickly gathered it up, excused himself, and asked the painter to wait while he conferred with Lorimer. The Boss must have liked what he saw, because Dower returned within a few minutes, telling a dumbfounded Rockwell that they would accept the two finished pieces now, and the other three sketches on completion. The Boss could pay the young artist $75 per final painting, the equivalent of $1,145 in 2000.

Rockwell would interact with Lorimer for more than twenty years, in a manner redolent of his relationship to Waring, roughly Lorimer's age. Very few people were known to have ever called Lorimer "George"; those who dealt with him as closely as Rockwell did over as many years inevitably called him "the Boss." Rockwell instead never swerved from calling him "Mr. Lorimer" to the end of their oddly constricted but affectionate relationship. In spite of Rockwell's extraordinary value to and popularity with the *Post,* he and Lorimer did not enjoy the friendship that the Boss developed with several of his writers, maintaining instead cordial interactions along the lines of Waring Rockwell's with *his* boss named George.

In truth, George Lorimer was a near perfect editor to appreciate the young illustrator chafing under the constraints of *Boys' Life* and suffering from the limited audience his work for the scouts' magazine reached. Lorimer believed that as editor in chief, he had to emphasize the positive in American life, and address the negative (when a direct attack was untoward) through tactful if passionate admonishment. Such politics led him to issue occasionally contradictory statements— he once declared the need for fewer "Pollyannas" only a few weeks after appealing for more—as he sought to explain his vision for an American population of seventy-five million people. His *Post* would be "without class, clique, or sectional editing"—this last reference a blast at those magazine publishers who pandered to supposed regional tastes and mores by adjusting their contents according to the subscription area.

By 1916, Lorimer had created a flourishing weekly magazine packed with first-rate fiction and trenchant reflections on business and politics. And he was proud of his achievement: when Rockwell absentmindedly walked into the Boss's office one day with an *Atlantic Monthly* tucked under his arm, Lorimer immediately asked why the artist bothered to read a publication whose stories were all rejects from the *Post*. Because Lorimer's boundaries for what would appeal to his audience were sacredly maintained, regardless of his personal affection or professional appreciation of a particular writer or artist, would-be contributors who were more experimental or simply beyond the concerns of middle-class Americans found it easy to dismiss the popular magazine, especially since Lorimer, in their minds, spoon-fed the populace. That he felt honor-bound to respect the values of the millions who bought his magazine failed to impress them.

Such condemnation was hardly ideologically pure; Lorimer's unheard-of practice of paying his contributors upon acceptance of their work—unlike other journals that paid months, even years after publication—engendered a roster of writers unmatched elsewhere. Still, the onus of writing for an unabashedly middlebrow, if often highly educated, audience proved too much for some contributors to bear. Dorothy Parker, for example, had written a successful humorous piece for the *Post,* but she remained ambivalent about Lorimer's conservative politics. Yielding to his generous invitation to spend a weekend with his family at their country home, she was deeply offended when, as she and the Boss toured the lavish grounds of his estate, Lorimer spouted his fervent beliefs in capitalist enterprise. Back in New York, she bludgeoned the editor with nastily witty stories about his crass commercialism that she spread among her friends. When word reached Philadelphia, she was not asked to work for the *Post* again. The liberal assumptions about the magazine's reactionary politics were a bit presumptuous in their own right: often unnoticed, Lorimer's ventures frequently escaped such sweeping generalizations, such as his 1904 publication of Clarence Darrow's workingman's argument in support of the open shop.

Himself a dropout from Yale—to his parents' disappointment, Lorimer had left school to work for the Armour meat packing business—he believed that the general level of excellence opened up to everyone by the world of commerce, as opposed to the elitism promoted by enterprises dependent on sequestering themselves from "everyman," was the basis of the country's greatness. He worked hard to teach his readers that their duty was to marry the latest innovation or technology that came down the pike with an American way of life—individualism based on tolerance. He was, in other words, a Yankee, born of the New England brand that underwrote American liberalism, whether Dorothy Parker and her ilk admitted it or not. Industry was the key to the future, and Lorimer wanted Americans to train themselves to be its thoughtful, well-informed captains.

While the editor had been busily shaping the country's most popular opinion organ during the previous fifteen years, Rockwell was molding himself into the perfect illustrator for such a national, unified vision. His poetic appreciation of the communal trolley trips of his childhood had hinted at the artist to come. Rockwell would typically seek the thread that laced people together, and he would excise the discordant strands, or turn them into gentle caricature that, implicitly, granted him superiority over the story. The material appearing in Lorimer's *Saturday Evening Post* emphasized passionate commitment to the country's communal welfare at the same time that it gave readers a sense of control over their world. Some sleight-of-hand was involved, since the "specious sense of mastery," as cultural historian Jan Cohn points out, allowed readers to think themselves too sophisticated to get caught up in the ideology they were being presented. Others might fall for simple idealizations, but they wouldn't. Norman Rockwell himself would rarely mistake the ideal for the real, but his audience's confusion of the two sustained his career for more than fifty years.

Although few accounts exist of the editorial reaction to Rockwell's first *Post* cover, Lorimer's publication of six paintings by Rockwell between May 22, 1916, and the end of that year suggests the editor's

great pleasure in his new hire. Since the response of the *Post*'s reader-ship to an artist or a writer largely determined who got the most as-signments, it seems clear that Rockwell's art was popular from the start with the middle-class Americans who waited eagerly each week for the latest *Post*.

Rockwell's first cover depended strongly on his audience's em-brace of childhood stereotypes. Consisting of a sissified boy pushing a baby carriage, the infant's sex ambiguous, the painting is full of self-revelation that would pass unnoticed even in later critical commen-tary. Two delighted, slightly rough-looking "boys' boys" taunt the aggravated baby-sitter. As art historian Eric Segal notes, Rockwell be-gins here to construct a complicated maleness that reflects and repu-diates, or at least complicates, mainstream America's preconceptions. The nipple protruding from the bottle in the boy's breast pocket calls attention to his "female" role as caretaker, and his dandified outfit mocks both his assumption of his father's role and his lack of proper masculinization. But the two boys harassing him hardly recommend boyhood either, even on their terms: the least fully articulated boy is made to look like a goon, while the majordomo leaning on the carriage is oddly feminized to match his target—his hair is elaborately curled, his finger is curved in an imitation of a lady holding her cup of tea, and his face resembles oddly that of the girl-boy.

Stylistically influenced by Leyendecker in their strong, at times ex-aggerated vertical lines, the personalities implied through the pic-ture's broad strokes—the boy who knows and dislikes that he comes off as a sissy, the bullies who make life hell for anyone not like them-selves—drew from Rockwell's earlier Dickensian lessons in creating "types," or representations that with one visual intake proclaimed who and what they stood for. Just as Dickens advanced his plots through such theatrical characters that they strained credulity, so Rockwell developed a narrative strategy of telling even a fairly complicated tale quickly and fully through portraits pushed to the edge of caricature.

Fueled by his own abject memories of being ridiculed in his grand-father's oversized, too-grand hand-me-down coat, Rockwell played

with the boundaries of proper male attire and attitude in this initial *Post* cover. Here, a "Percevel" has been forced to adopt an adult male's role and attire, diminishing his real masculinity as he mimics the grown man. The dominant cultural code of this period enabled Rockwell's audience to grasp the meaning of the picture at once. Popular books on manners routinely emphasized the humiliation a child experienced at being dressed "in an outlandish fashion that renders him conspicuous. . . . A boy should be dressed like a little boy."

Eric Segal points out that within nine months of his first *Post* cover, Rockwell was commissioned to illustrate "Percy" in the story appearing in *St. Nicholas*'s July 1917 issue called "Making Good in Boys' Camp." Here, the "Percy," the fancy newcomer to camp, is the object of scorn to the "real boys." "Percy" is again dandified, a repeat of the 1916 baby-sitter, except that this time he is dressed in knickers, standing at the side of a chauffeur. The caption to the picture reads, "Percy arrived in camp the most dressed-up lad you ever saw in your life." In an ad appearing the following month in the *Post* for Black Cat hosiery, Rockwell is careful to show well-dressed young schoolboys who nonetheless demonstrate the restlessness he means to connote the all-American boy. The message is clear: it's fine for a boy to dress properly if he has to, but at heart he's really home on the farm instead.

Rockwell's romance with American boyhood is more complicated than the mythology surrounding his person has allowed. Lacking any suggestion of what contemporary sleuths first look for—pedophilia—it instead seems to have been an attempt to catch up on what he never had, to represent his ambivalence toward the simple stereotypes available for early-twentieth-century masculinity. Finally, however, it became a commercial trap that he resented deeply.

Sue Erikson Bloland, an analyst who spent her own adolescence among Rockwell's New England community, observes that "often energies spent in the name of re-creating boyish pleasures speak of times not past, but never enacted in the first place." Rockwell quickly became known in New Rochelle for his easy affinity with the young models he hired. Even his innovative method of paying them—four rolls of pennies that he stacked by increments of ten onto the models'

"side" of the table, motivating the restless youths to hold their poses to earn more pennies—speaks of his easy connection. Still very young himself, he delighted the boys especially with his pranks ("girls were far easier to deal with," he recalled; "more polite and disciplined"), though he made the division between work and play clear.

Strategic in his appeals to the parents and townspeople, he perfected careful quotes to hand out to local reporters that cemented his reputation as a safe, even avuncular figure to have around town. Press attention for at least a decade following 1914 emphasizes the real-boy nature of his paintings and of his affectionate but properly distant relationships with the children. To some extent, and perhaps necessarily, in light of the number of models he used, Rockwell commodified the children into marketable figures, on which he expended very little emotion. When he recounts the story of his favorite young model, Billy Paine, falling to his death at the age of fourteen from a windowsill in the boardinghouse where the boy and his family lived, he expresses more shock at Billy's friend's depth of grief than at the boy's untimely end. Rockwell never pretended that he was deeply invested in his models, but, over the years, their stories would assume a remarkable similarity: models of all ages felt their short time with the artist to be a major highlight of their lives. The illustrator came off as commanding, yet authentically "human," warm, and modest—kind of like them in many ways, all of which was true. But Rockwell painted tableaux, filling them with authentic pieces from the period. It was as objets d'art, not living people, that his models proved the most valuable props on which to project his own unfinished boyhood.

Although he admired his father's steadfastness and loyalty, Rockwell based a major element of his personality on Nancy's childishness—she got what she wanted, after all, by acting as if she had never left girlhood behind. Childhood was romanticized; adulthood infantilized. To remain a child was all things good; Waring's adulthood seemed dreary by comparison. It can come as no surprise that in later years Rockwell's most admiring acquaintances would append to their praise of his genuine friendliness, "make no mistake, though; he always got what he wanted. He didn't let *anything* stand in his way."

10

Becoming Somebody

If Norman was focused on making his reputation by the time he took the train to the Curtis headquarters in Philadelphia, Jerry was trying to figure out ways to make something of himself, too. In 1916 he joined the National Guard, where he was stationed in a cavalry unit. As an elderly man, he would enjoy chiming in when war stories were being bandied about: "I was wounded in the battle of Fifth Avenue," he would explain. "The occasion? The Victory March, and I fell off my horse, in front of everyone. I had to walk back to the stable." At this point, according to Rockwell, he himself was considered physically unfit to serve in the war because he was underweight: though he was between five feet nine inches and five feet ten and a half inches tall (his medical records vary), he weighed only 130 pounds. Claiming a fuzzy memory about the exact reasons he had not been inducted into the armed services, he added that his many dependents might have kept him at home, a totally illogical explanation that belies his apparent nonchalance about not enlisting along with the other young men his age.

During these years of Rockwell's early success, Jerry was irritated that his younger brother was getting more attention from the girls than he was; financial and social stature now mattered as much as looks and physical strength. He was chagrined to see Norman pulling ahead of him in earning power, and he decided to try his luck at business. Dick Rockwell, Jerry's son, repeats the family lore about Carol, his mother, preferring Norman to Jerry at the beginning of their acquaintance: "Norman was more sophisticated, and my mother had graduated from Smith a few years earlier, in 1914 or 1915, and she was somewhat worldly herself." But Carol's friends convinced her that an artist's future was extremely uncertain, and so she redirected her attentions to Jerry instead. Practical about matters of the heart, Rockwell quickly began to date another pretty boarder, Irene O'Connor, a schoolteacher three years older than he. But he made a point of punishing Carol for her decision: "When Norman got his first *Post* check, he converted it into one-dollar bills and came home and piled them in front of my mother to show her how much money he made," Dick says. Although Dick Rockwell's parents handed down to their sons some obviously envious accounts of their famous relative's actions, this story, its hint of vindictiveness at odds with Rockwell's personality, does accommodate believably his penchant for practical jokes.

Rockwell's own recollection mentions nothing of actress Carol Cushman but admits that, flushed with his success at the *Post,* he precipitously proposed to Irene O'Connor, calling her from Philadelphia. She rejected him at first because she was in love with an agricultural student at the University of Michigan; unwisely, Norman kept pleading his case until she relented, largely because the *Post* commissions promoted his future prospects. (In his private reflections to his son Tom in 1959, he suggested more duplicity on Irene's part: "I didn't know about the agricultural student at the time," he said. "But we weren't unhappily married—well, she was, I wasn't.")

Interviews published in the next decade, before the marriage had soured and the facts went through revision, make it clear that Rockwell's decision to marry Irene was one of those oddly impulsive ges-

tures he would make throughout his life. Jerry and Carol had been planning to wed for the past two years, waiting only until they felt financially able. Norman preempted them by marrying first. By early 1916, Norman's parents had announced that they were slated to move for at least a short period to New Brunswick, in order for Waring to manage a New Jersey branch office for George Wood. Rockwell abhorred being alone; as much as he needed solitude in order to paint, feeling protected emotionally by a nearby family member was crucial to his mental well-being. Jerry as well as his parents were leaving; Rockwell would have panicked at the thought of being left behind.

Like the last boy to be chosen for the team, isolation created a sense of emptiness and inadequacy he could never expunge except by looking outward, to a spouse or parent. As long as such a loyal intimate was at hand, he did not have to turn inward, confronting a giant hollowness; nor did he have to examine the world outside in ways that caused him further distress. "I have the ability to shut myself off from unpleasant or disturbing experiences. Or, rather to shut off the part of me which paints," he explained.

If it had been up to him, Rockwell would simply have discounted this first spouse from 1916. He later "forgot" to mention his previous marriage to his children from his second wife; the three boys learned of it from a *New Yorker* article in the 1940s. He had to be pressed by his wife in 1959 to discuss the earlier relationship in his autobiography; left to his own devices, he would have written as if Irene O'Connor never existed. Yet they were married for fourteen years! Two of Rockwell's strongest personality traits—his denial or avoidance of pain and the accompanying lack of interest in emotional retrospection—combined to turn Irene O'Connor into nothing but a hard-earned footnote in Rockwell's history.

Irene, born in Watertown, New York, near the St. Lawrence River, was twenty-five years old when she married Rockwell, the same age as Nancy Hill when she wed the younger Waring Rockwell. Irene's Irish-Canadian family, of far greater pretensions than their means, had moved inland to Potsdam, about sixty miles from Watertown, when

she was a child. Henry O'Connor, a self-described "Canadian not Irish" grocer, took great pride in belonging to the local country club, which, as one acquaintance remembers, was a modest enterprise open to anyone who could pay the dues. Irene attended Potsdam's Normal College for teachers, a subsidized course of higher education for those willing to teach a specified number of years in return.

Newspaper accounts vary even on the date of the wedding, which was in fact held on the morning of July 1, 1916, at Blessed Sacrament Catholic Church, though in the pastor's study as opposed to the conventional sanctuary. The ceremony is described in the Potsdam paper as "a quiet one" that took place on June 30, the too-early date reflecting Irene's own uncertainty about how and when the interfaith union would occur. Marie O'Connor, Irene's sister, was her maid of honor; Jerry served as Norman's best man. Both sets of parents attended, as did Rockwell's best friend and his wife, Victor Clyde and Cotta Forsythe. Because mid-decade weddings tended to be modest affairs in deference to the increasing awareness of the war, the low-key occasion attracted less attention than it might have. Still, Irene's traveling suit of blue silk faille, her large white hat, and her white sweet peas hint at a certain lack of festivity. At least she adorned the simple wedding outfit with the gold watch and sapphire ring her husband had given her.

Following the ceremony, the gathering moved to Edgewood Hall for a wedding breakfast, after which the newlyweds "motored" with the Forsythes and Marie O'Connor to Jersey City, where the couple boarded the train to Lake Minnewauskie, New York. About two hours away, this Catskills resort catered to the upper middle class. It was a wisely chosen spot for a honeymoon, in light of the heat wave New York was experiencing in early July.

Even when Rockwell does finally mention Irene in his autobiography, he omits the reality that their marriage was fraught from its beginnings: because Irene was Roman Catholic, he had to agree to raise any offspring of their union in his wife's faith. "They kept trying to convert me, but they didn't succeed," he confided. "It didn't matter

much anyway, because Irene hardly ever went to church herself." What Rockwell fails to add when he mentions their lack of children is the disagreement between the two on this very subject. According to a model whose family was friendly with the artist, Irene did not want to have children, and her husband did.

Nancy Rockwell, who would have been displeased at the specter of her younger son going childless, must have been further agitated that her daughter-in-law was Irish; although Irene's parents hailed from Canada, the ancestry was clear, and to Nancy's high Anglican blood, it was just bad lineage. Even her genial, kindhearted brother Tom had, in correspondence during his sea voyage, evinced signs of prejudice toward the Irish. Even more worrisome to Nancy than her daughter-in-law's heritage, however, were the pretty young woman's social aspirations. Her friendliness to her new husband seemed genuine, but any deeper attachment appeared to be to his financial prospects, and she troubled little to hide her desire to join high society. After only two weeks of life in the newlyweds' stuffy, tiny third-floor apartment near the center of New Rochelle, Irene huffed off to spend the subsequent two months with her parents, moving back into the family's impressive colonial house.

In the meantime, Rockwell lacked a proper studio, a problem more pressing than his bride's disappointment in their humble apartment. He rented the top of George Lischke's garage on Prospect Street behind Brown's Lodge, an area near "Pill Street," where the town's doctors and lawyers lived in one of the oldest and most beautiful parts of town. With the landlord's permission, he knocked out the north wall of the garage in order to install floor-to-ceiling glass that would guarantee the best light. Now he felt ready to compete with his peers.

The saturation of so many illustrators within the boundaries of New Rochelle proved particularly salutary after America entered the war. The Committee on Public Information, the propaganda ministry charged with moving the American public from an isolationist position to a militaristic one, turned to the Society of Illustrators to pro-

mote these goals. As a result, illustrators enjoyed a new self-esteem as they saw their art become, however temporarily, the means of doing social good. But the very effectiveness of using first-rate illustrators to visualize what were, in the end, government ads eventually backfired in terms of positioning illustration among the serious arts. Advertising took up residence under its rubric instead, while illustrators themselves quickly discovered that the real money lay in doing the ads, not in executing limited editions of classics.

Better-known artists from the generation just prior to Rockwell's got the plum assignments anyway, a hierarchy that allowed Rockwell to concentrate his efforts on his own commercial career, seeking venues outside the United States government. Shrewdly, he began to pass along the sketches that Lorimer rejected for *The Saturday Evening Post* to *Leslie's Illustrated Weekly Newspaper,* a popular national magazine that lacked the prestige and the pay of the *Post.* Of the seven covers Rockwell provided for *Leslie's,* the most famous is probably the October 5, 1916, *Schoolitis,* where a boy feigns illness to avoid going to school.

A week after *Schoolitis* appeared, Rockwell's first visual reference to Hollywood took shape on the October 14, 1916, *Saturday Evening Post* cover. In a gesture that typified the dynamics of many of his future covers, Rockwell focuses on a crowd's reaction to an event rather than the event itself. Theatregoers are shown enjoying a silent movie, possibly Charlie Chaplin in *The Little Tramp.* This cover was scheduled to appear roughly a month before his brother's wedding to Carol Cushman. Perhaps it was a present, a tribute to Jarvis's bride, the actress; the lag between the artist's submission of a finished painting and its publication was usually two to three months, so that Rockwell would have been able to estimate the timing of the cover. Even if not meant as a gift, the painting was probably inspired by the upcoming ceremony, since the subjects for Rockwell's covers often emerged from the events occurring around him.

By the time of his brother's nuptials, marriage was proving problematic to the young artist. In light of his trouble adjusting to Irene's

expectations of companionship and of normal work hours, he may well have needed to get away as a kind of temporary escape. In July 1918, when the war's end seemed in sight, Rockwell joined the Navy. Until now, George Lorimer's rabid isolationism had given him pause; he would not have wanted to offend the Boss. But all around him, men of every age had been signing up—in many cases, when they were too young or old or physically unfit to meet the government's standards—going to heroic lengths to get Uncle Sam to let them in. Previously, shame at not serving had eluded the illustrator; suddenly, he felt embarrassed at his lack of patriotism. Decades later, discussing his time in the service, Rockwell lied even to his son, telling him that he'd enlisted a year earlier than he actually did—July 1917, instead of 1918. And, although he claimed to have been refused during an earlier try because of his weight, the twenty-four-year-old was still seventeen pounds under naval standards. He recalled stuffing himself (with the military doctor's approval and encouragement) in order to weigh in, the bananas, doughnuts, and water finally enabling him to meet the minimum weight requirement, but his enlistment folder still records, under "remarks," the notation "underweight."

Reporting to the Brooklyn Navy Yard, Rockwell found himself on a ship bound for Queenstown, Ireland, where as "landsman for quartermaster" he would varnish decks. Ordered to change course within hours because of a submarine ahead, Rockwell's crew diverted to the Charleston Navy Yard, where the artist pulled guard duty and burial squad, both of which frightened him. Soon assigned to create cartoons and layouts for the camp newspaper, *Afloat and Ashore,* Rockwell coasted through the next few months. When he took ten days' leave and attended an illustrators' dinner at the prestigious Salmagundi Club in Manhattan, he misbehaved in the boyish mode he resorted to throughout his life, especially when uncomfortable about the trappings of his environment. On this occasion, famous illustrators and artists had gathered in support of the poster war they were waging, and, according to Rockwell, one of his friends pinched him, causing him to yelp loudly—as if they were back in the church pews

warding off boredom. Reprimanded soundly by a lieutenant commander present among the guests, who, according to Rockwell's recollections, termed him a disgrace to his uniform and to his profession, the illustrator thereafter "resolved to stop trying to be a sailor and just be myself. It was the only safe solution." Such aw-shucks modesty veils the strategy Rockwell had almost perfected: when he felt in danger of becoming, as he put it, the "beanpole without the bean," he acted out in a childish fashion. His antics supposedly illuminated his own inadequacy (thereby ameliorating any pressure to perform as an adult) but also implicitly (since he was such a nice guy) indicted those around him as supercilious or less "authentic" than he.

Within a few months of his enlistment, the Armistice was declared, causing a temporary freeze on discharges. Rockwell chafed at the delay in getting back to his job and maneuvered to have himself judged "inapt" for naval work. Still an honorable discharge, the solution was less than elegant, embarrassing the illustrator enough to flavor his accounts with an unmistakable chagrin and contributing to his disguising his actual service record by an entire year in hopes of averting the appearance of cowardice or of a lack of patriotism.

Within days of his November 12 discharge, Rockwell was back at work in his New Rochelle studio. He picked up his pace, not only producing cover art for the *Post, Leslie's,* and *Judge,* but also beginning to exert almost as much energy painting advertisements as he did working on his magazine illustrations. One way that he could defend himself against the fear of prostituting his art was to ensure the quality of his advertisements, which were often as painterly as his other work. In many cases, such as two illustrations he produced for Del Monte canned vegetables, the ads actually ran in *The Saturday Evening Post,* giving him extra reason to be cautious of how he used his talent.

He had accepted that he would have to depend on advertisements for the bulk of his livelihood, particularly given the lifestyle the young couple had embraced. As soon as Norman secured the income, he and Irene moved into the smaller half of a fancy house on a pretty New Rochelle side street, a residence they both enjoyed for its un-

derstated elegance. Irene was not an inexpensive wife; fairly soon into their marriage, the illustrator recognized the tacit agreement that ruled their marriage: she would be his companion, sexual partner, and hostess, as long as he provided an affluent style of living. Rockwell later acknowledged that he quickly recognized Irene's lack of real love for him, but that he enjoyed their friendship and found it gratifying to have someone managing his social life. The couple gave parties envied by others, and they were invited to many reciprocal social events. Early in their marriage, rumors began circulating around town about Irene's flirtations, but the disapproving accounts Nancy related to relatives about her daughter-in-law's eager extramarital socializing with handsome escorts contrast with the memory of one old-time resident of New Rochelle, who remembered hearing that Irene was "prudish." Given the social mores of the community, which changed dramatically as the 1920s progressed, it seems likely that Irene behaved conventionally in public for at least the first five or six years of the Rockwells' marriage.

Rockwell himself lodged no complaint against moving up the social ladder, in spite of his earlier protestations of hating society. Their community, wealthy even in notoriously well-off Westchester County, was entering the age of consumerism gone mad, and Norman watched his father finally start to make good money as a manager for George Wood. Less satisfying, Jerry was improving his own fortunes at an alarmingly impressive rate in the city, where he was trying his hand at business as he trained to become a trader on Wall Street. Keenly aware that his brother was pulling in $4,500—the equivalent of more than $43,000 in 2000—Rockwell felt motivated to shore up his own social status. When Irene suggested that they make a greater effort to hobnob with "society," her husband offered little resistance.

In spite of his new marriage and his stint in the Navy, between 1916 and 1919 Rockwell executed twenty-five *Post* covers as well as an abundance of story illustrations. In 1916, he produced five black-and-white illustrations for *American Boy;* the following year, he executed eight more, some of which, such as *Dory Mates,* in which a

polar bear attacks a rugged fisherman bearing aloft an ax, or *Jim of the Reef,* where a terrified elderly man confronts a young boy, exhibit a new range of emotion. His greatest effort was nonetheless reserved for the sixteen illustrations he created for *St. Nicholas* during the teens; after all, even Howard Pyle had considered this publication worthy of his work, and it still enjoyed a reputation as the premiere children's magazine. Considered the most distinguished of a post–Civil War group of excellent children's literature, its cultural level has never been equaled.

By 1919, Rockwell was enough of a national phenomenon to be used in a *Life* magazine solicitation of new subscriptions. The illustrator is the youngest artist featured in the full-page ad that printed photographs of the heads of important and popular writers and illustrators, Charles Dana Gibson among them, who contributed to the magazine. The text at the top of the page reads: "These are only a few of the regular weekly contributors," and a caption is placed beneath each photograph. Under Rockwell's picture is the phrase: "Whose *Life* colored covers are known all over the world."

Only twenty-five years old, Rockwell should have been deeply satisfied. The art director for *Boys' Life* for the past six years, he had exhibited his paintings on the cover of the *Post* for the last three. He had achieved the reputation he had sought as a wunderkind, and art directors predicted great things for the unflaggable young man. True, his workload was staggering, though it was fairly typical of successful illustrators. In 1916 alone, he published six covers on the *Post.* In 1917, there were four; four more the next year; and, in 1919, eleven. Twenty-five years old, twenty-five covers, and he was starting to feel worn out, not energized as he had expected. True, he'd won both the job and the girl of his dreams, but they were taking too much out of him to leave enough room for happiness.

11

<center>❧</center>

A Stab at Adulthood

Success would always prove a palliative for Rockwell's vocational fatigue, and by 1920 he had hit his stride. Developed for *The Country Gentleman* back in 1917, his series on Reginald, the overdressed, "sissy" city boy, and the Doolittles, the unruly country brothers, had run its successful course, and now Rockwell's illustrations began to assume a new painterly sophistication. *The Shadow Artist,* for instance, executed for the February 7 cover of *The Country Gentleman,* evinces more richly articulated, less caricatured figures. As the decade proceeded, Rockwell's greater talent for rendering the body and facial contours of elderly characters than those of children would become clear, the distinction perhaps a result of George Bridgman's emphasis in life drawing on more mature bodies. More likely, however, Rockwell's complicated relationship to the reality and ideals of childhood encouraged him (albeit unconsciously) to homogenize his drawings of boys, especially, in accordance with his own repetitive fantasy.

Nonetheless, Rockwell would return to children's themes fre-

quently throughout the twenties, his increased assignments outside of childhood's realm gradually appeasing his fear that he would be known only as someone who drew for kids. Among the most gratifying signs that he was now considered a serious contender was the respect shown him by New Rochelle's coterie of famous illustrators. And when he was invited to sit at the speaker's table at a celebration held by the New Rochelle Art Association, he knew he was a somebody. The Association, committed to raising money for a monument to the soldiers who had fought in the Great War, had arranged for a benefit dinner. According to his autobiography, he was seated between J. C. Leyendecker and Coles Phillips, while his friends such as Clyde Forsythe stared enviously in admiration at the stars in the front of the room. Rockwell felt momentarily gratified. No longer under his mother's thumb, he was now a man of the world, sanctioned by the brightest lights of a prestigious local arts society. What could be a more auspicious sign of the new decade's promise?

Probably because Rockwell was a relative newcomer to the organization, the toastmaster, Charles Dana Gibson, inadvertently passed over him when it was his turn to be introduced. The young man was mortified; Gibson's refusal to rectify his mistake, in spite of a note that the gracious Coles Phillips quickly passed to the speaker, just embarrassed him further. But Rockwell pulled a triumph out of the occasion anyway; he felt almost justified in asking the Leyendecker brothers to dinner, since now, after all, they had already eaten one meal together. As he himself appreciated, if only out of an attempt to mollify a publicly humiliated colleague, the famously courteous men accepted.

Excited but nervous, the Rockwells cooked what was basically a Thanksgiving dinner in July, perhaps in homage to the turkey farm that the Leyendeckers rather whimsically maintained on their grand property. The young couple reasoned that they couldn't go wrong by re-creating the quintessential American meal, and so they decided to risk the unusual choice for a hot summer evening. Unfortunately, when the Leyendeckers first entered the Rockwells' home, stiffness overtook everyone. Neither Norman, usually loquacious in social

gatherings, nor Irene, conversationally adept by now, could budge the
painful silence in their living room. After what seemed an inter-
minable awkwardness, the maid they had hired for the occasion
called them in to the dining room, and as the foursome took their
seats, she started to set the turkey platter on the table.

It never got there. The maid slipped, and once again, in front of his
local hero, Rockwell found himself feeling exceedingly foolish. Under
the table he dove, reaching for the turkey, at just the moment that
Leyendecker himself went for it. Even allowing for Rockwell's typical
embellishment in recounting such episodes, some such event clearly
broke the ice, and the men bonded over the absurdity of it all.

Becoming friends with Joe Leyendecker contributed tremendously
to Rockwell's self-esteem. To be found worthy by a man he admired in
so many ways—professionally, most important, but personally as
well—seemed to Rockwell like an imprimatur of his own worth. What
did it mean, exactly, for Norman Rockwell to spend his early profes-
sional days in the midst of the New Rochelle illustrators and artists?
The degree to which living among one's peers affects one's art is al-
ways a complicated measure. Traditionally, the presence of talented
people engaged in similar types of activities is assumed to exert a lev-
eling influence on art, nudging it toward a recognizable cultural
shape. The Abstract Expressionists, for instance, drank and drew and
slept together over the sprawl of New York City, and a certain identi-
fiable template emerged that registered seismically in the art world.

For Norman Rockwell, living in New Rochelle during the 1920s,
the presence of J. C. Leyendecker and, to a far lesser extent, his brother
Frank, encouraged his intuition that illustration was a supremely wor-
thy use of artistic talent. When Rockwell later told the inquiring stu-
dent that Leyendecker didn't really have much "impact" on his work,
his judgment was rendered in the immediate aftermath of a contingent
statement, "apart from . . . his technique, his painting, his character
and his diligence." Not much is left out of such a "qualification." And,
in truth, Leyendecker's versatility, his superb draftsmanship, his stead-
fast nature, and his dedication to his art confirmed for Rockwell the
values he himself had held since his student days.

Less obviously, Joseph Leyendecker served as a personal role model to his young admirer. He and Frank were modest, courteous, and hardworking, in spite of the fact that they lived in the kind of ostentatious splendor more often at odds with such virtues. Although they tended to keep to themselves, both brothers were, in fact, the city's top celebrities. "People used to come down to the railroad station in New Rochelle in the middle of the morning just to watch J. C. Leyendecker and his brother Frank emerge from their limousine and walk to the platform in their matching outfits—e.g., double-breasted blue blazers, white flannels, black-and-white saddle oxfords and ebony-and-white walking sticks—in transit from their 14-room Franco-Suburb chateau to Studio Leyendecker in New York," remarks Tom Wolfe, in an essay review of contemporary books about illustrators. And, as he notes, those New Rochelle gawkers had included in their ranks Norman Rockwell, determined to get rich and famous "the Leyendecker way."

The Leyendeckers lived on a five-acre estate on Mount Tom Road, their 1914 pseudo-Norman mansion accoutred with five bathrooms, four fireplaces, and two large center reception halls. Two studios were attached to either side of the three-story structure. Barely visible from the road, the property—adorned with a rose garden, hemlocks, massive twin oaks, a fountain, and a fish pool—faced Long Island Sound. The lands were so lavishly landscaped that in 1952 the shrubbery alone was estimated to be worth $25,000. If the townspeople bore any resentment toward the brothers, its roots evidently lay in their wealth, though at least one old-timer remembers that their "obvious" homosexuality heightened the sense of exclusivity around them, signaling to many of New Rochelle's middle class that the artists "were too rich and special to mix with the likes of most of us." And yet the self-effacing but funny young Rockwell bonded immediately with Joe Leyendecker the night the two men met under the table.

Throughout the years, the only complaint about Leyendecker that Rockwell ever voiced publicly was about the older man's refusal to monitor the grasping behavior of his lifelong partner, Charles Beach. Tom Rockwell says that his father understood that the two men were

lovers, but that he felt uncomfortable bringing up what was culturally still a controversial topic in his 1960 autobiography: "Pop knew that the Leyendeckers were gay," Tom Rockwell says. "But in 1960, it seemed better not to get into that. It wasn't necessary in order to make the points Pop wanted to make." Even before homosexuality was treated liberally, however, Rockwell himself was unconcerned about someone's sexual orientation; it was Beach's steel grip on Joe Leyendecker that bothered the illustrator, perhaps playing out Rockwell's fear of his mother's oppressive neediness and ceaseless demands. Insinuating his way into every professional corner of Leyendecker's life, according to Rockwell, the handsome, chisel-faced lover eventually pushed both the gentle Frank Leyendecker and their loving sister Augusta out of Joe's life. Except for his relationship with Beach, Joe turned into a near hermit, losing touch with the contemporary world, a solitude that Rockwell believed, finally, sapped his brilliant art of its vitality.

According to Leyendecker's biographer, Rockwell exaggerated his friend's reclusiveness as well as his relationship to the movie-star-handsome model. It is true that Rockwell's scornful description of Beach's possessiveness and excessive influence rings of personal resentment, perhaps because within a year of that infamous turkey dinner, Beach had begun to refuse to let others, including Rockwell, see Leyendecker without his presence. (In fact, no one at *The Saturday Evening Post* would ever meet Leyendecker, including Lorimer.) Usually polite, Rockwell chafed at being controlled by others, and he doubtless wanted to speak his piece to Beach, an impossibility given the disloyalty and disrespect to Joe such behavior would have implied. Unfettered, Beach barely veiled his contempt for Leyendecker's visitors behind a grating obsequiousness, until he had gained so much power that he even began to treat Frank rudely in the presence of Joe and his guests.

One of the few places, at least in the early twenties, that the Leyendeckers could socialize without Beach intruding was at the Art Association, and Rockwell quickly gained stature among the cognoscenti when his growing friendship with Joe and Frank was no-

ticed. But the slight vestige of high society that clung to the edges of
the Art Association led Rockwell to keep himself at some distance
from the organization most of the time. Even at this early stage in his
career, he had developed a way of portraying people as if he easily
identified with the "human condition," and he molded his public
image the same way. In truth, at a deep level he really was ambivalent
toward upper-class culture—the inflections of education, of money,
of taste, of general intellectual superiority that denizens of high soci-
ety assumed as their natural right. If as a teenager he had lamented
his lack of such things, by the time he finished art school he had ac-
quired a certain honest disdain for the pretense he believed such priv-
ileges often implied.

Nonetheless, the Art Association proved a perfect communal con-
duit for the city's pool of artists. In 1921, the Association decided to
beautify the approaches to the city, thereby furthering New
Rochelle's interests at the same time that they were promoting their
suburb as an enviable bastion of artists. The group divvied up the as-
signments, deciding on twelve wrought-iron-upon-concrete bases
with which to stud the city's boundaries. Two years later, only ten
were complete, Rockwell's among them. As undistinguished as the
rest, his was called "Rich in History," a series of three revolutionaries
watching out for the enemy. Initially, at least, the Art Association's
concept earned the artists, who volunteered their services, points for
community spirit.

Rockwell also created his own goodwill by relying upon local peo-
ple for his models. As early as 1919, a local journalist had written up
the lucky children who posed for "one of the best and most popular of
the top-notch magazine artists of today." The writer quotes the artist:
"Billy Paine is my favorite model. . . . He has posed five years and is a
dandy little actor, he understands moods and expressions no matter
how complicated."

In general, Rockwell dispensed with professional models when-
ever he could, believing their studied body language scotched his cre-
ativity. To use the world, in effect, as his agency, invigorated his work
far beyond what a dial-a-type professional could provide. In the twen-

ties, according to Clyde Forsythe, he would walk around New Rochelle, sparing "neither time nor expense in finding the right model or object needed to fit into the subject he is painting; he never fakes. All the dogs in town know him. Along the street he is greeted by schoolboys and their granddads and grandmothers. They all love him; they are his models first; then his friends." Rockwell's consistency—he was affable, seemingly unflappable, and promiscuously curious, whatever the subject—encouraged the people he encountered to believe their exchanges with the illustrator more meaningful to him than they in fact were. He simply treated everything and everybody the same way.

Looking at people—observing the man on the street up close—seasoned Rockwell's early, usually half-shaped concept for an illustration into its fully realized final form. A policeman's flagrantly protruding ears might motivate one theme, a fireman's beautifully shaped head another; a housewife's consternation at the grocery store yet a third. Sometimes his process of association would pull together all three disparate scenes into one coherent narrative. Rockwell never underestimated the part in his success that such real people played, and his gratitude toward them was genuine. But for those lucky enough to be chosen as his models, the connection inevitably felt deeper: accounts they would offer journalists decades later revealed that they never again would feel valued so highly as when they modeled for Norman Rockwell. Mary Whalen, who was Rockwell's favorite girl model, describes the way that the painter made her feel: "He cared about my twelve-year-old imagination. He felt that if I understood what he was trying to accomplish in a painting, the picture would be good, but if I didn't, there was something wrong with his idea. We were all in it together, somehow. At least he made me feel that way."

Those who have systematically collected the accounts of Rockwell's models have awaited in vain any significant variation on this theme. Men and women, girls and boys, who posed for the illustrator believed themselves touched by a great man. To some extent, Rock-

well did invest his models with the importance they assumed, but while they functioned for him primarily as props in his imagined world, to them he seemed closer to a creator.

Sue Erikson Bloland, whose family became close to Rockwell and his children in the 1950s, believes that much of what she has concluded about her own father, Erik Erikson, was equally applicable to the illustrator—Erikson's patient as well as a good friend. To believe that someone exists who is better than ourselves seems to be a basic human need, at least in Western societies. People seek fodder for the culture's fantasy constructions of heroes. We want others to be bigger than life, to justify our own frequent sense of insignificance. Rockwell, similar to Erikson, filled this role for his public, though in the artist's case, a matter-of-factness, in conjunction with his low-key but friendly affect, heightened his idiosyncratic charisma.

Rockwell's ordinariness, in other words, was the base of his celebrity. As part of his (simultaneously real and contrived) identification with the people who bought the magazines that subsidized his career, Rockwell fostered an image of normalcy from his earliest success. Especially amid the profligacy of the Roaring Twenties, Lorimer's conservative—or, perhaps more accurately, libertarian—leanings devalued the *Post* among intellectuals, artists, and the social elite. A certain lack of fashionableness clung to it, even though the editor hired the best writers money could buy. For Rockwell, this meant that respect for his aesthetic achievement increasingly became concentrated among the striving, solidly middlebrow, middle-class readership, with the members of his own social and artist class admiring him more for his fame and income. What appeared to be his own propensity to depend on hard work instead of inspiration, his concern over tending those on his own doorstep instead of worrying about global issues, furthered the domestication of his image as an artist.

But while his everyman persona created devotion among his middlebrow audience, it devalued him in the institutional art world. And the popular press inadvertently helped bury him in the eyes of serious critics. An interviewer from the *Globe* noted approvingly the "peculiar

appeal in Rockwell's work. His favorite subject is boys, good, whole-some boys not of the Smart Alec type, and he would rather catch some home-going subway rider smiling over the realism of his work than receive plaudits on his technique from a dozen fellow artists." Misleading in its implication that Rockwell preferred "their" judg-ments to those in the art world proper, the comparison does represent accurately the illustrator's early, almost obsessive desire that the pub-lic love his work.

Repeatedly, he would be damned by the praise of journalists eager to celebrate his difference from "real" painters. One admiring inter-viewer observed that "Norman Rockwell is not a Greenwich Village artist who wears McDougal [sic] Alley airs, long hair and immaculate smocks with a silk tie carefully arranged. He hasn't even the regula-tion Van Dyke beard. No, Norman Rockwell is just a plain, ordinary, clean, likeable young fellow." Even Rockwell's mundane brand of pipe tobacco is offered as an example of his normalcy.

The following summer, the *Sun* chimed in: "If you should take a walk or a drive around New Rochelle, or if, by chance, you happen to live there, you probably will find nothing peculiar or anything smack-ing of Washington Square's Washington Mew [sic] or Macdougal Alley. Yet New Rochelle boasts at least as many well-known artists and writers as Greenwich Village. You will notice no dreamy eyed, long haired, unpressed velvet trousered young men wandering about the streets of New Rochelle." Instead, the writer continues, you might see a "laughing, curly-haired young man walking down North Avenue to his studio"—Norman Rockwell; or "on Main street, going home to his wife in Sutton Manor, a good looking, youngish man, without a hat and probably cleanly shaved"—the debonair Coles Phillips. The piece continues smugly to note the lack of patronizing attitudes or affecta-tions among New Rochelle artists, who, except for once a year when the "arts people" gather for their annual Travers Island party and stay out all night, are a "healthy, normal New Greenwich Village."

Throughout the early twenties, popular journalists sought to reha-bilitate the very idea of an artist at Rockwell's expense, though they

meant to do him a service. They were playing out a war of self-esteem, using Rockwell as their redemption. Major Manhattan critics were comfortably well informed about the modern artists in their midst; whether for or against the contemporary art largely inspired by European painters, such commentators on the current scene felt themselves to be in the know. Suburban journalists, however, assumed that the haughtiness or supercilious response aimed at them by urban artists showed them up as country mice to their city cousins; in truth, they often didn't like or understand the new painting sanctioned by the New York art world.

This divide between the cognoscenti and the untutored American masses would only deepen throughout the twentieth century. The Westchester County newspapers' relief at the famous painter Norman Rockwell's affability and accessibility—his personality seeming to mimic his audience-friendly art—anticipated the future, when Rockwell's work would become a symbol for a middle-class, often well-educated audience that felt itself scorned for its aesthetic preferences. That members of the professional ranks comprising the intelligentsia of 1950 would feel compelled to hide their love of Rockwell is no surprise; that suburban journalists in the early 1920s were already defensively detailing his virtues as a normal versus "different" artist sets the tone from the beginning of his career for the ambivalent reception that would span it.

A subtext of confusion over exactly what and how to consider Rockwell—as "just" an illustrator or as an artist—also fueled the early interviews that protectively lauded the painter's ordinariness. Most full-time illustrators, for instance, couldn't take enough time off from work to stay out all night like the Greenwich Village "types" the journalists scourged—and among whom Rockwell would have enjoyed a party or two himself. In 1920, in addition to his eleven covers for the *Post,* Rockwell published six covers for the second most popular American magazine, *Life.* Two of them show Rockwell developing the same idea, but in such radically different visual terms that the viewer can only laud the stylistic difference. *Life*'s July 1 cover, *Carrying On,*

depends upon a triangular arrangement of a young father, mother, and baby backed by an inverted triangular figure of a soldier running forward, bayonet and gun at the ready. The smiling father, gazed at expectantly by his wife, represents the future of postwar America, a seal lettered with the words "American Legion" behind the mise-en-scène. *Life*'s August 12 cover, *Fortune Teller with Young Couple,* again employs the triangular format, with the gypsy fortune-teller in the background reading an incredulous-looking young man's palm, his sweetheart wriggling happily off to the side. The lush brushstrokes of the latter scene emphasize the Romantic treatment of an already sentimental subject, while the emphasis on angular lines in the earlier cover recalls the leanness of the war times just past. Of the twenty-eight covers that Rockwell provided for *Life* between 1917 and 1924, sixteen would relate specifically to the Great War. In nearly every case, as in these two postwar paintings, the narrative content emerged from a contrast between the past and the hopes for a future immediately over the horizon.

In 1920, Rockwell also began a series of twenty full-color oils for Edison Mazda Lampworks, the commissions continuing through 1927. (He completed eight in 1920 alone.) In the beginning, the company paid him $800 per painting, raising his fee to $1,500 at the end of his tenure. Reproduced mainly in the Curtis publications, the *Post* and the *Ladies' Home Journal,* the paintings were some of his most masterful renderings of light and illumination, compelling enough that many of them stand on their own, quite outside the advertising series. Throughout his career, Rockwell took great pleasure in representing light sources, but he never concentrated more attention on the challenge than in this impressive series of intimate social scenes, staged with characters of all ages.

Quite apart from the intrinsic aesthetic merits of the assignments, or the monetary rewards, Rockwell also lavished exceptional detail on the ads because, in 1918, Maxfield Parrish, a former student of Howard Pyle's at the Drexel Institute in Philadelphia and an illustrator whom Rockwell deeply respected, had begun to publish his own series of lushly colored full-page ads for the electric company, a com-

mission he would complete only in 1934. In later years, when asked to reflect on Parrish, Rockwell first lamented that the long-term ad campaigns that Parrish conducted for Edison Mazda as well as his other extensive commitments to advertising art seduced him away from the best use of his talent, "toward greater income" instead. But after Rockwell revisited Parrish's original paintings at a special exhibition, where he was able to see the work the artist completed for purposes other than commercial commissions, he found himself "completely reconverted" from his earlier agreement with those illustrators who blamed Parrish "for the loss of the ideals of American illustration." Because he had seen Parrish's oeuvre in the context of the painter's entire life, he could again celebrate the artist as "a great technician, a true lover of beauty, a magic colorist and an original humorist."

The Edison Mazda advertisements forced Rockwell to think about the ways that electricity had enabled the march into modernity, since that was the major thrust of the company's campaign. Efficiently, the illustrator made the logical transition from these ads to painting other pictures symbolizing the contraries of past and future. When, for instance, Rockwell painted his *Memories* cover for *Literary Digest* (June 25, 1921), the Roaring Twenties had already imprinted its fashion sense on women, but the illustrator instead presents us with a young woman, sitting in an attic among old family relics, lost in thought spawned by examination of pasts not even her own. Painting with obvious reference to the styles of Rembrandt and Vermeer, he lights the scene from a single source, so that the delicate girl, her illumination seeming both natural and otherworldly at the same time, is set apart from the clutter in her midst. The domestic umbers, ochres, and siennas of the attic's collection of wood, brass, and fabric objects contrast with the breezy blues and whites of the girl's clothes, so that her figure glows against the worn surfaces.

What is peculiarly missing from this worldview is the present, a place where the woman is grounded in the particularities of the actual moment. And in that lack, the viewer intuitively enters and completes the painting. The art historian Kathleen Grant aptly glosses this arena:

"[It is as] if her thoughts have truly elevated her from the world of dusty realities to a world of glistening dreams. . . . Rockwell paints the girl at the very moment that the dream takes shape behind her quiet eyes—but before it can be reflected in her face. In doing so, he does not suggest the nature of the girl's fantasy but instead invites us to speculate according to what *we* see—or wish to see—in the painting."

Reluctantly denying himself the painterly challenges that held his attention in the Edison Mazda campaign, Rockwell acquiesced to the enticements of the Orange Crush corporation, though the quid pro quo was strictly money—lots of it—for work. Impressed by his paintings for Edison Mazda, the soda company convinced Rockwell to sign on for a twelve-painting series of ads, largely through the help of the illustrator's wife, who egged him on in spite of his reservations. After four full-color paintings, he got out of the deal, vowing in the process never to get trapped in an inviolable contract again. Short agreements he could handle; lengthy commitments hedged him in on every level, from the artistic to the logistical to the geographic. He liked his freedom too much to feel owned, he often asserted, and the amount of advertising he undertook was already prodigious. To be at the mercy of an agency's art director was intolerable.

Rockwell's aversion to long-term contracts was encouraged by Leyendecker, whose four decades with the *Post* never included a written agreement. But a cautionary tale anchored Leyendecker's freedom to a more mundane reality: without such contracts, the illustrator was never sure of the next month's income. The "fine artist" assumed that penury might be the price of refusing to sell out by going commercial; the social honor attached to such possible poverty seemed some recompense. But the burden of financial success was ever-present to illustrators, who recognized the trade-off their artistic choices were supposed to purchase: economic stability in lieu of romantic individuality. When offers failed to arrive in time, the illustrators were therefore badly compromised, both practically and emotionally. Leyendecker had dealt with these issues by deciding to live always just beyond his means, declaring that such practices

would dictate his continued work and discourage any laziness. Instead, as Rockwell noted in his autobiography, the illustrator was forced to accept too many advertising commissions when other work slowed, and eventually his creative output suffered, further stalling the high-paying cover assignments he had come to expect.

Not that Rockwell was immune from investing in glamour. Partly because of Irene's predilection for the good life, but also as personal recompense for his "deaconish" behavior back in his Art Students League days, when Rockwell worked while others took time off, he allowed himself to play at the decadence that accompanied the twenties as they roared into wealthy Westchester County, taking few prisoners among the upwardly mobile. At the same time, he was keenly aware of his position at the *Post,* which reached the peak of its success in this decade, when, according to cultural historians, it became "a dominant force in middle-class culture." Although intellectuals tended to scorn the magazine early on for its ostensible appeal to middlebrow readers, the quality of many of its fiction writers of the period speaks well for the purportedly undereducated classes: F. Scott Fitzgerald, Frank Norris, Stephen Vincent Benét, Willa Cather, Joseph Conrad, William Faulkner, Theodore Dreiser, Ring Lardner, Sinclair Lewis, Rebecca West, Edith Wharton, as well as early works by Carl Sandburg and Edna St. Vincent Millay. To such evidence of its omnibus appeal, critics replied that illustrious writers had only their second-rate work published by the *Post,* circular reasoning at best.

Among the social events that Rockwell recalled somewhat ruefully in later years, when he recounted the Jazz Age in New Rochelle, was the summer party he and Irene attended in Westport, Connecticut, "a raucous affair . . . where all the guests were dressed in pink jackets and riding habits." Although his autobiography places it much later in the decade, the early morning site of poolside debaucheries and drunken displays of sodden wit must have occurred in 1920, since Fitzgerald played in Westport then, not in the late twenties when he stayed in Europe. In his middle age, the circumspect illustrator noted wryly that "everyone was drunk and a woman fell into the swimming

pool and I thought it was all very grand because I met F. Scott Fitzgerald, the famous writer, and heard him sing a rowdy song."

At least at the beginning of the decade, Rockwell still felt extremely uncomfortable among high society, even though he could comport himself expertly when required. Far more enjoyable were the trips he and Irene took across the state to her childhood haunts near the St. Lawrence River. Her parents had a wooden "love shack" as they called it, basically a run-down three-room cabin in a small resort area called Louisville Landing, directly across the river from Aultsville, Ontario, a Canadian point of entry from the United States. Today under water as a result of the construction of the St. Lawrence Seaway in the 1950s, at the time the "camp" provided a summer respite for Rockwell, who rented a studio in Massena, six or seven miles away. Often he used local settings for the paintings he worked on during these periods, such as the amalgam of the nearby stone church and the Gibsons' clapboard house on the Christmas 1925 cover of the *Post,* which also included a local resident as the main character.

Rockwell's immediate use of the "real people" in the neighborhood engendered tremendous goodwill, and his gratitude for the need they filled was usually misinterpreted as a stronger affection for the person than really existed. He loved hanging around the camp with the customs officer, Eugene Gibson; the two became "great friends," and sat on Eugene's porch "for hours smoking their pipes and swapping stories," according to Eugene's family. Rockwell did a lot of fishing on the St. Lawrence in spite of his later protestations of being no sportsman, and one of Eugene's relatives frequently served as his guide on the fishing trips. According to his great-granddaughter, Connie Lewis Reitz, Eugene was the only person at Louisville Landing with a phone, which allowed him and his family an embarrassing glimpse into the dynamics of his marriage. When Irene was in residence and her husband was in New Rochelle, "Norman would call and ask Aunt Jess to go down the lane and get Irene to come to the phone. Aunt Jess said she always felt so sorry for Norman. He was so nice and

Irene was so mean to him. Jess would tell Irene that Norman wanted to speak to her on the phone. Irene would refuse to come to the phone. Jess would go back and tell Norman that she couldn't locate Irene."

The marriage politely limped along, and Rockwell enjoyed Irene's companionship in the evenings, as well as the pleasure of working hard all day at a job he enjoyed and coming home to a meal cooked by his pretty wife. As long as he was allowed to paint undisturbed, he was content and easy to be around; but when family or friends intruded too often on his studio time, he grew irritable. Such a territorial response to his workaday schedule was necessary or he would never finish all of his commissions; inevitably, he overextended himself by accepting too many offers.

In 1921, he discovered what would become the antidote to vocational exhaustion: travel. The art director of the Edison Mazda ads, who felt that he and Rockwell were kindred spirits, invited the artist to accompany him on a company trip to Venezuela, the art director's barely disguised excuse for a vacation. The trip was Rockwell's first foreign travel, and he realized almost from the first day of his adventure that even the act of relocating to a place outside of work reinvigorated him. And the more exotic the locale, the better. From this point on, whenever he felt overwhelmed by stress, Rockwell dropped his work, in spite of pending deadlines, and took a trip.

In his autobiography, Rockwell described the adventures the two men shared in terms that suggest the trip was truly dangerous at times. Including everything from a fearsome ocean crossing aboard a ship with a drunken crew, to bullfights and local boundary skirmishes conducted by terrorists, the journey to South America appealed to the curiosity that existed alongside of Rockwell's loyalty to his own community. Paradoxical though it may be, Rockwell's cosmopolitan spirit, the citizen-of-the-world mentality that revivified his aesthetic energies, fueled the creation of six decades of what would be variously praised and condemned as "universal," "timeless" pieces of "Americana." Without the foreign travel Rockwell undertook throughout his

life, the "American" dream of tolerance and liberality and general goodwill would have withered before he was forty.

Certainly as soon as he reached his own city limits, he was inevitably embroiled in some family drama, either with his parents or with Irene's family. In 1921, Nancy and Waring, who had moved at least three times since their sons' weddings in 1916, moved yet again, leaving Brown's, where they had relocated in 1920. Now they rented an apartment at 145 Center Avenue in New Rochelle, owned by George Peck, a social acquaintance of Norman and Irene's, who probably helped his friends quietly subsidize the older couple's home. Certainly, by now Rockwell's parents could afford to live in a style typical of the solid middle class; Waring's income hovered around $7,700, and the following year, he even purchased his first car, a Chevrolet sedan, according to the luxury tax he had to pay. Yet signs point to their conscientious son ensuring that they didn't have to watch their budget.

If Norman was accustomed to being put upon by his parents, Irene herself felt overburdened by her husband's expectations. Assuming that because she was married to a well-known illustrator and no longer had to support herself, she could devote her time to cultivating society, she had been surprised to find that Norman assumed she would handle his business correspondence and fan mail, and that she would read to him at night as well. Explaining to her college magazine editor why she was late with her dues, she wrote a note that was published in 1921 in their annual volume: "I am always busy with writing, etc., as I do most of Mr. Rockwell's work. He is on a trip to South America now, so I am doubly busy attending to everything while he is away." By this point, Rockwell had established the routine of having someone—usually Irene—answer each piece of fan mail he received, the number of which spanned from ten to two hundred letters per cover. Unflattering responses were almost nonexistent.

Two paintings that Rockwell produced for the *Post* in the autumn after he returned from his trip abroad reflect his new awareness of the release that travel provided: the cover published on January 14, 1922, shows a pigeon-toed boy agog over the pictures inside his exotically la-

beled three-dimensional viewer; and, a month later, on February 18, an office worker is seen reading, open-mouthed in amazement, a letter or card that transports him from the present moment of workplace tedium.

The theme of escape continues to permeate Rockwell's paintings during the twenties and early thirties, though suspension of time, not place, is most often their foundation. The April 29, 1922, *Post* cover, *Boy Lifting Weights,* summarizes neatly Rockwell's consistent ideology that impels him to omit indications of the present moment. The painting's beanpole boy with the round-lensed glasses is, we know, part of Rockwell's past: the Francis X. Bushman–type masculine pinup on the wall in front of him, the slogan "it's easy" (to be a man) written next to his bulging biceps—an image of what could, in theory, have become the transformed adult of the future. A representation of Rockwell in the here and now, however, is absent.

Franklin Lischke, whose father owned Rockwell's studio and who, as a boy, modeled for the illustrator, remembers that Rockwell called himself "Francis X. Bushwah" during this period, a self-mockery that referred to the he-man of the times, the silent-movie actor Francis X. Bushman. (Typical of Rockwell's rich accretive method of association, the "Francis X." also happened to be the name of Joe Leyendecker's brother, the "other" Leyendecker.) Bushman was the first screen matinee idol, whose tanned, muscular body made women swoon. The movie star's celebrity was short, lasting from 1911 to 1915, the period when Rockwell was leaving adolescence behind, along with any hopes he'd had of late blooming. This April 29 *Post* cover of the skinny, pigeon-toed adolescent pumping iron in front of a mirror, with a muscleman's picture pasted to the wall for inspiration, was motivated by the illustrator's own fledgling attempts in his teens to reconfigure his gangly body and regain some standing among his athletically inclined friends.

Oddly, such an emphasis on what could become, or what is going to happen, or on something that already occurred for which people now yearn ineffably and ineffectually, sustains a narrative desire that transforms the ordinary into the universal, even at the same time that

it seems to emphasize the individual. Desire as the underlying motif sanctifies viewers' belief that what they are responding to is applicable to any person anywhere—even as the audience assume the experience to be very specifically rooted to their own moment in time.

Critics sensitive to the dangers of false universalizing, of claiming attention to the individual when in fact most of the complexities of culture are obliterated in the name of that particular "universal" creature, consider such narrative strategy an act of bad faith. And certainly the role that Rockwell's humanism plays in maintaining a culture's preferred view of itself should be held to close and constant scrutiny; art must be accountable, at least if one believes in its relationship with and importance to a society. But there is another side to the same coin: for one thing, it has proven impossible to travel to parts of the world where one might expect Rockwell not to translate hospitably, and fail to be surprised at the Chinese, Pakistani, or Sudanese response to the "human moment" common to Rockwell's American fans. Too, the act of holding up a mirror to some of a culture's best impulses—to present an idealized portrait as if its positive values are within reach of every citizen—may possess merit more complicated than a typically disapproving historical analysis will allow. Would the nation have been better served had Rockwell painted the social realities that loomed at least as large as the space of desire he created instead? Perhaps. But it is naïve to insist that anyone knows the answer.

12

Building a Home on a
Weak Foundation

In the spring of 1922, Rockwell decided that he wanted to study abroad for a few months. Despite his pleading with Irene to join him on what would be the first trip to Europe for either of them, she elected to stay home. Rockwell remained in Paris for eighteen days, attending art school in the morning in an effort to expand his vistas. He lived in a small students' hotel in the Latin Quarter, spending afternoons at the galleries and museums and sketching everywhere he went (unaccountably, leaving most of the results in Paris). At the end of this period, he spent another two weeks traveling in southern France and along the Italian Riviera, then into Switzerland.

Speculation abounds that Irene chose to spend Rockwell's weeks of absence in local dalliances of her own. One longtime explorer of Rockwell's trail, Robert Berridge, interviewed two of Irene's closest friends thirty years ago and, as a result, hints that she stayed behind because of the "seven-year itch." No hard evidence proves extramarital involvements by either party in the early twenties, but the likelihood is high, given the marital openness she and Norman would

pledge within several years. And Irene's careless lack of interest in her husband, other than as a companion to exciting social events and as an excellent wage earner, was always embarrassingly obvious to suburbanites in New Rochelle.

Margaret McBurney, a highly credible source whose family knew the O'Connors and whose good friend was close to Irene as well, insists that at one point during this period Rockwell's wife "ran off with the chauffeur." In light of the illustrator's method of bowdlerizing the events in his autobiography, it seems probable that his slightly incongruous story about a profiteer's chauffeur working as a go-between to bilk Rockwell of his savings is in fact a subtle reference to the affair. Rockwell explains that once when he was "away"—this time, supposedly in the hospital—the chauffeur led his wife to the shady investor, who convinced her to turn over $10,000 the couple had saved from Rockwell's work. Even more pathetic than it would have been anyway, the story manages to victimize the innocent painter for his ineffectiveness; instead of spending any time recovering from a nose operation, he had to go to work immediately to remake their fortune. To make matters worse, Irene was recklessly indiscreet, and Nancy Rockwell began to get fed up with the public gossip trailing her son's marriage around town.

Rockwell ignored his mother's warnings about family propriety and focused on the professional definition he had struggled with abroad. The School of Paris was flourishing, a disparate, loosely knit conglomerate of international artists that encouraged various forms of representational art, especially since analytic Cubism, Picasso's major contribution, had waned in influence. At the least, the aesthetic atmosphere was more congenial now to a figural painter than it had been before the Great War. Nonetheless, during the classes, he explained in his autobiography, students had approached him and accused him of being behind the times; his attention to drawing marked him immediately, they told him, as passé.

Visiting American artists insulted him more ambivalently than the European students had: Rockwell recounted that several friends from

his student days approached him and lamented that he had gone over to the enemy—"You have sold your art! You had good possibilities but you have sacrificed your talent by descending to a level that satisfies the multitude. You are lost!" Before he left for the States, however, these same "advocates of the new art" cornered him to ask if they too could find some advertising jobs back home.

Rockwell was well aware of the trend of American artists taking up residence in Paris, and he ensured that he'd never be mistaken for an expatriate in the making: upon his return, a local newspaper reporter noted happily that "Mr. Rockwell went to Paris this spring, but he didn't remain long. If the boys were fond of him before he left, their affections were increased many times when he said on his return, 'America is the place for me, boys!' "

As if determined to anoint the young man the patron saint of local boys, the journalist practically emasculated the artist whom mothers in New Rochelle preferred over Sunday school for their sons: "Mothers are wont to remark that they would as soon have their sons in Norman Rockwell's care as in church—so great, so good, so uplifting, is his influence on little boys." Asked to account for his success with the youngsters, Rockwell responded politically: "Perhaps it was that satisfaction I received from having my work accepted together with an intimate love I've always had for children that directed me toward the work that has now become a hobby with me—that is, painting little boys, and having them for my models, thereby enjoying their youthful and inspiring dispositions."

Within a year, Rockwell had massaged his foray into foreign venues into a refinement of his mythical Americanness, establishing an image that would ward off the thing he feared most: being forgotten. Writing admiringly of the homespun artist, his interviewer explained: "Before leaving home, he had thought to remain abroad perhaps a year and carry on his work, but he wished to continue with American subjects and there he found not enough characters typically American from which to work. . . . The simple, genuine qualities of American life present unlimited subjects, to his mind, for the

painter who will but see and understand and properly value his own people."

By this point, Rockwell's aspirations to reach beyond his earlier achievements in style and content had been doused with a splash of cold reality, at the hands of George Horace Lorimer. When the illustrator returned from his spring 1922 journey abroad, he excitedly carried to the Philadelphia office at least one painting done in the "modern style," which Rockwell later recanted as a very poor imitation of Matisse. Lorimer thought it over for a while, then turned and gave one of his top two cover artists a little speech about sticking to the simple stuff he did best. Rockwell was plagued already with fears that during his travels his public (including the Boss) would defect, and Lorimer's dislike of the new material frightened him. Exploring new territory, risking leaving a proven success, is scary under the most supportive circumstances; the combined pressures of Irene's emphasis on income and Lorimer's on continuity conspired to keep Rockwell firmly in his place.

Within a few years of this first trip to Paris, his friend Clyde Forsythe would explain that whenever Rockwell's schedule overwhelmed him, he just peremptorily jumped up and left—took an unplanned trip to a "far-off land"—"astonished to find upon his return that his clients still remember him." His surprise at his continued success moved Forsythe to remark, with some satisfaction, upon Rockwell's "inferiority complex," proof of which is Rockwell's consistent dissatisfaction with every painting he completed, believing that "the fine thing is always yet to be done."

Although decades later in his autobiography Rockwell professed his awe of George Horace Lorimer, the truth was more complicated. (His canny modesty deceived at least one otherwise astute Lorimer scholar, however, who explains that other artists were not quite as "dominated" as Rockwell was by the crusty editor.) In 1922, Lorimer was busy interpreting America to itself, frequently in thoughtful, complicated ways. He supported the repeal of Prohibition, even as he insisted that Americans obey the oppressive law until they changed it. Farm prices, taxes, the current state of the theatre, crime statistics,

town and highway construction, the Ku Klux Klan—it seemed that little escaped the *Post's* scrutiny. On one of the most controversial subjects, war debts, Lorimer was adamant: he believed that the European nations that had incurred war debts should pay them, instead of depending on the open purses of underappreciated Americans whom the Old World dared still treat condescendingly. It was the right, even the responsibility, of individuals to make their own way, he argued, limited only by their willingness to work hard.

Lorimer's earlier wartime isolationism, his diatribes against immigration, and his contempt for the popular idea of a melting-pot stew were a few of the positions that did not sit easily with Rockwell. Maintaining a formal but cordial relationship over the years helped the artist to retain a sense of philosophical detachment from the *Post's* editorial content. After all, his covers were remote from the content within, their major objective the creation of a visual story whose narrative could be read at a glance. He respected the editor, but he did not agree with his politics, solving the uncomfortable schism by retreating behind a claim of being apolitical.

Such an assertion was meant to ward off demands that he pick sides on any issues that would, in the end, only encroach on his work schedule. But his "apolitical" and charitable demeanor encouraged people to ask too much of him at times; and his preoccupation with his painting frequently was mistaken for passivity, allowing his goodwill to be abused. When Irene's father, Henry O'Connor, died of liver disease on August 10, 1922, the Potsdam grocer had made no arrangements for the financial future of his bewildered wife or three unmarried children. In short order, Rockwell found himself supporting them all under his own roof. For the next two years, though the arrangements would alter slightly, the four O'Connors occupied more of Irene's attention than did Rockwell, who found himself alternately amused by Hoddy O'Connor, Irene's brother, and repulsed by his profligate appetites.

Although Rockwell had coexisted with several generations under one roof most of his life, he did not refer to the actual experiences in his paintings. Instead, he idealized the contrast of ages in his art. Two cov-

ers alone in the year following the onslaught of in-laws, *A Meeting of Minds* on February 3, 1923, and *The Virtuoso* on April 28, develop the contrast between a youngster interacting with an aged man. The February cover shows a little girl listening admiringly to the older cellist, who is facing the audience. The second picture reverses the order, foregrounding dramatically a handsome prodigy playing his violin before an awestruck older musician at his feet, eclipsed by the full-size representation of the young man who clearly is destined to take his place. In each painting, a theme of connecting through what is unvoiced, through an imaged arena of longing, conveys the scene's power—the girl and the old man, separated by too many years to bridge with words, are united in the unspoken realm of beautiful sound; the virtuoso, by contrast, reminds the elderly admirer, holding his own instrument, of what he has lost, if only the potential versus its realization.

Consistent with his reluctance to focus on the time at hand, Rockwell addressed the prospect of change by developing a theme that valued retrospectively and appropriately something from the past, while optimistically implying the equally satisfying substitution of a future. This perspective purchased a complete denial or avoidance of a present that would otherwise demand introspection. The "timelessness" that fans and despoilers alike ascribe to Rockwell's art resides largely in this implication of a charitable timeline, with life's vagaries made bearable through the promise of history's ultimately benevolent march.

By avoiding the present during these years, except through the most reassuring references, Rockwell spoke to the anxiety underlying the nation's buoyancy. The audience Rockwell played to was, in many ways, as culturally uneasy with the moment at hand as he was with its psychological weight. As at the turn of the century, technology was transforming the culture at a breakneck speed, from mass productions in print to the proliferation of movies, radio, and the ultimate instrument of change, the automobile. Even the emotional energies required to make the transition to the new information age fomented stress; many of Rockwell's largely middle-class audience had been born into an antebellum or Victorian sensibility. To reflect on the past

and to project a positive future had the effect, paradoxically, of slowing things down long enough to make sense out of what threatened otherwise to disintegrate into cultural disarray.

This dynamic was not, in the end, nostalgia, though Rockwell's narratives were often appropriated to such an end. His distaste for pausing from his assignments long enough to register fully the life of the moment apparently reflected the agitated depression driving his obsession with work. His father's storytelling through the heart and narrative voice of Charles Dickens had provided the first meaningful escape from the incoherence of his family life; the early popularity he gained through his ability to draw took over later on. Rockwell realized when quite young how to be well liked, and though he developed fully his most rewarding personality traits—his humor, his spontaneity, his warmth, his easy tolerance of others, his native intelligence—he sought most of all to be loved through his skill as an artist. His career was motivated by such a need; audience response validated his art. On those rare occasions when he failed to elicit the communal chord he had expected, Rockwell took the disappointment as a spur to aim higher on the next project. The popular perception was correct: the painter cared greatly what his untutored viewers thought. The reasons for such reciprocity between artist and audience were less than salutary, more complicated than the image created by the media. Rockwell admitted that his entire identification as a worthwhile human being resulted from sustaining his art as the conduit to love. If he stopped painting, or if people stopped liking his work, he would resume his identity as the eternally pigeon-toed youth who saw repeated reincarnations throughout the decades of canvases. His painting bought him love; and with his extreme intelligence, the man never doubted the connection between people wanting his art and wanting him. On Rockwell's side, his role soon enough became a responsibility, a duty that he felt he owed his audience. From his father he had learned the honor of being dutiful, but he could never quite shirk the sense of duty's confinement as well.

As a result of the lifelong, inextricable link between what he did and who he was, Rockwell would find himself in a quandary every few

years, sometimes more often. He desired the freedom to paint as one of those very Greenwich Village artists the local journalists smugly set in contrast to their man—in other words, answerable to no one but himself. His work as an illustrator—and his greater psychological needs as a man—argued otherwise. Inevitably, infrangibly, the need to be loved prevailed.

Within three or four years of Westchester County's determined mythmaking, Rockwell had decided how to fine-tune the romance of his origins. His tweaking of his past now substituted a sense of having his destiny prescribed by Nancy and Waring for his earlier accounts of an almost preternaturally adroit use of pen and paper. By the end of May 1923, he was explaining to interviewers that "at the age of eleven [he had] had his career all mapped out for him by his mother." His personal coming-to-art took place under the loving counsel of wise parents: "unlike the usual beginnings of genius," as one approving interviewer noted, "his talent was not stifled at home but encouraged." This new emphasis shored up the growing consensus that Rockwell was an artist of the people, ensuring that the illustrator had emerged full-blown from a "normal" home. What did he gain from this shift of emphasis?

Rockwell took solace in assuming his parents' preordained knowledge of his career. His desire to be connected to them, precisely because the real relationship was so superficial, would somehow, of course, surface in his work. Just as important, if he needed his art to win him popular love, he realized that the public he served appreciated the kind of family-man painter who had humbly reacted to his first acceptance by the *Post* with complete restraint; according to the admiring writer at the *Standard-Star,* "his feet [are] squarely planted on the highway to recognition and success." Once again, the journalist domesticated the artist into a nonthreatening species of the man next door, a guise well served by Rockwell's own natural diffidence and good humor. If acquiescence to the model foisted on him repeatedly by suburban writers would serve his future as a successful illustrator, why resist?

Cannily, the illustrator began to build on the public's expectations. *International Studio* magazine printed an interview in September 1923 in which Rockwell embellished his early humility: "Even the suggestion [that he solicit *The Saturday Evening Post*] raised Rockwell to such a rarified atmosphere that it at first made him dizzy. . . . Armed with two finished drawings and sketches of two other ideas, he journeyed to Philadelphia. Almost tremblingly he handed his drawings to an assistant in the office who carried them into a mysterious sanctum. Minutes of breathless suspense passed—the longest of the young artist's life. Then the assistant returned with the pictures and Rockwell reached mechanically for the portfolio, feeling guilty at having even presumed" to approach the magazine, the awestruck journalist reported.

Smitten with the affable artist's innocence and humility, the journalist also observed how Rockwell's humble nature extended to his art: the illustrator "especially likes to paint children, for their faces are not masked by self-consciousness, and old persons whose true characters have become impressed upon their faces by the hand of time." Importantly, the writer continued, "success has not in the least removed the simplicity or the earnestness of his character. Today he is twenty-nine years old, and he dreads reaching the advanced mark of thirty in a few months." Immaturity, or at least a lack of worldliness, the interview implies, maintains the integrity of Rockwell's art. And, for all the self-conscious irony contained in Rockwell's exaggeration about his advanced years, the truth prevails in this self-observation as well. He was afraid of losing touch with his youth, the realm that had gestated his art in place of the boyhood he had wanted.

By this point, Rockwell's reputation as a normal guy was encouraging businesses to use him to promote the trustworthiness of their products. Although most of his early endorsements were for companies unrelated to art, a 1923 issue of *International Studio* devoted a full page to showing him in his studio, using Devoe and Raynolds artists' paints. This same publication had, after all, avowed that "the name of Norman Rockwell [is] quickly becoming more familiar to millions of Americans than that of Raphael."

One can only flinch for Rockwell when thinking of the sneering rebuttals such fatuous praise must have elicited from other artists of the time. Ill-informed accolades were exactly what Rockwell did not need. And the backhanded compliments that well-wishers offered skewed the truth about the illustrator's own beliefs and aesthetic values. In spite of Rockwell's lifelong admiration of much modernist painting, interviewers who wanted him to feel otherwise almost without exception worked the discussion until they got a quote that validated their own dislike of modern art. Typical of such overstatement was one journalist's conviction that "modernist art strikes Rockwell as fanatical. He can not see why a picture that is indefinite as to subject, motive and the ability of its painter, is any higher art than one which is comprehensible to all humanity."

Rockwell's genuine allegiance to the Old Masters did, undoubtedly, reassure his audience, though it was Rembrandt, not Rubens, whom he venerated. Rockwell read voraciously about Rembrandt, his life and person as well as his art. He admired his painting so deeply that he sought other ways to interact, mentally, with the great artist's world. Even on a trivial level, Rockwell considered his inclusion of a dog in many of his illustrations sanctioned by the Master's own ubiquitous mutt, often present in Rembrandt's most high-blown paintings.

Exactly when the artist developed his passion for Rembrandt—it appears to have been nothing less—is unclear. By December 24, 1921, the *Literary Digest* cover of *Grandpa and Children* is unambiguously modeled on Rembrandt's deeply sculptured adult faces, with the flatter planes and rounded profiles of the children's faces referring to typical Netherlandish portrayals of youth. A similar treatment of faces and light would be rehearsed in the June 24, 1922, cover for the same magazine.

Such cozy domestic scenes induced a false sense of inclusion among many of the aspiring middle-class audience, reading into such narratives their own dreams: "Anyone seeing his work must . . . realize that one of the ingredients mixed with Rockwell's paints is his genuine love for all his race." What exactly "race" meant to this re-

viewer is unclear, but it certainly did not include people of color; until the 1960s, Rockwell did not make a black subject the center of even one painting. How grievous an omission was this?

Over the next ten years, whenever Rockwell wanted to paint a black man on a *Post* cover—pretending that there was nothing political to such a request—Lorimer told him that the country wasn't yet ready for such a move: colored people could only be presented in subservient roles, unless they were being illustrated in the context of a story within the magazine. Another illustrator, Alan Pyle, angered the Boss when he submitted a Thanksgiving cover with a black man holding the turkey; the painting was rejected and Pyle rebuffed for trying to create trouble. Lorimer placed his faith in a classless society unburdened by a loathsome leisured set, but he meant such a structure to develop through the rigorous work ethic that rewarded people on earned merit alone. He did not yet see evidence that America was ready for "colored" people to play a prominent role in representing the country's immediate interests, and he had no desire to confound his readers with such a potentially revolutionary implication. Bothered by such narrowness, Rockwell, as usual, buried his unhappiness and faced the immediate reality of his audiences instead—after all, they were the source of his income and much of his self-esteem. He began to court more aggressively the image he'd already begun to shape as an apolitical person, so that he could avoid responsibility for trying to influence magazine policies. No religion, no politics, no ethnic origins: only the overspill of quotidian details that were meant, paradoxically, to evoke a sense of the universal.

Of course, Rockwell was political, but he hoped that operating under the banner of tolerance, generosity, and goodwill to all would anchor him to neutral, unarguable values. And his commitments to such virtues were real; affable he might be, but he knew who he was in terms of character. For that reason, his fifty years of Boy Scout calendar covers proved a constant irritating reminder of the conflict between art and commercialism. After Rockwell painted the 1924 cover, the Boy Scouts, thrilled that the nation's response to the illustration

had been wildly enthusiastic, entreated him to do one the following year as well. Rockwell's acquiescence initiated a lifetime routine toward which he felt ambivalent at best. Donating his time for the first few years, he then discovered that Brown and Bigelow, the calendar's publisher, was a for-profit company. Relieved that he needn't feel responsible for a charity's financial well-being after all, he tried to beg off doing future Boy Scout calendars by explaining that his schedule no longer allowed him the indulgence. In response, Brown and Bigelow agreed to pay him more handsomely than he'd imagined possible, and Rockwell began to depend on the yearly commission for a major part of his family's income.

But if he thrilled at the prices he commanded with the St. Paul, Minnesota, company—as a young illustrator, he received the impressive sum of $500, and every few years, when he almost begged to quit, the company raised the salary by thousands, sometimes doubling the commission—he chafed at the artistic constraints that the Boy Scouts imposed. Subject matter, attention to detail that went even beyond the illustrator's predilection, and style were all tightly controlled by the organization. In contrast to Lorimer's approval, the Boy Scouts administration seemed determined, in Rockwell's view, to send the painting back every year for some trivial change. He got to the point that he deliberately rendered something slightly off-base, so that he knew in advance what correction he would be asked to make.

Rockwell's calendar sold two million copies every year, the sale yielding tremendous coverage as well as good money. But precisely because he did value at least the appearance of disinterest in partisan politics, he grew to dislike the determinedly conservative social aura that clung to every Boy Scout calendar cover. By 1960, he finally began to speak up about such reservations. In 1924, however, he had more immediate claims on his attention than the luxury of ideological disputes.

The drain of having Irene's noisy family foisted upon him had eroded the evening reading routine he treasured to keep himself mentally sharp and focused for the studio. By spring, Rockwell was feeling

the need to get away. The family ad campaign waged by New Rochelle Chamber of Commerce brochures extolled the virtues of the suburbs with pictures showing a beautifully dressed wife holding a happy baby, two decorous children, and one equally well-designed dog waiting for the returning patriarch at the (flower-bedecked) door of their happy home. Rockwell's memory of his childhood home existed in counterpoint to such a family portrait, with his father commuting across Manhattan at the end of his workday for forty-five minutes in rush hour to run inside and tend to his needy wife. Now the artist was confronting yet another variation of this scene—no wife waiting at the door when he returned home from his studio, but a passel of demanding relatives instead, seeking his money and Irene's attention.

His restlessness was aggravated by the illness and death that seemed to be multiplying monthly in New Rochelle. Lucius Hitchcock, president of the New Rochelle Art Association, had seasoned his annual report with the gratifying news that New Rochelle contained more artists per capita than almost any other city in the United States. Before the year was over, however, he would bear more tenebrous news as well: Frank Leyendecker, fifty-one years old, was dead, and Coles Phillips, gravely ill with a kidney disease for which he was seeking treatment in Europe, clearly suffered with a terminal condition. Within the next ten years, not only Phillips but Clare Briggs, Edward Penfield, C. J. Munro, and Kenneth Clark would all be dead.

Rockwell watched Frank Leyendecker's demise up close. A family argument, with Charles Beach at the center, according to Rockwell's embittered account, had ousted both Frank and his sister Augusta from the Leyendecker mansion. Rockwell helped Frank move into an empty garage under his own studio, though the depressed man never even unfurled the rug he stacked against the unfinished wooden planks. A victim of alcohol and drugs, Frank Leyendecker apparently died of an overdose, most probably of cocaine or heroin, both in plentiful supply at the time. Rockwell considered all three Leyendeckers innocent pawns in the pocket of Joe's wily lover, Charles Beach, and

his disgust at Beach's manipulation of the family is unmistakable in his autobiography, where he likens the man to a "huge, white, cold insect clinging to Joe's back. And stupid. I don't think I ever heard him say anything even vaguely intelligent."

Given Rockwell's typically understated avowals of affection throughout his life, his obvious fondness for the hardworking, gentle, and genteel Leyendecker brothers proved among the strongest emotions he felt for anyone outside his family. Impressed initially that the Leyendeckers, celebrities that they were, accepted him as a friend, Rockwell ended up surprised at the love he came to feel for the brothers, the warmth of friendship that grew up between them.

Other deaths, not as emotionally significant to Rockwell, occurred within this time span. Rockwell's great-aunt Anne Waring Paddock died, leaving her nephew Waring the executor of her will. The family had reason to assume they'd benefit at least somewhat from their friendly relative's wealth, especially since her closer family members had died years earlier. Instead, she left only nominal gifts to Waring and Jarvis, both named after her father. Any hopes Rockwell had entertained of his parents' financial liberation dissipated when the will was read. Rockwell sympathized with his father's inevitable if politely masked disappointment; he, too, was feeling the sting of reality in his life as stress at home increased, the demands of too many people creating intolerable interference with his work.

As usual, his mental state was enacted in several *Post* covers, the first published on June 7, 1924. *The Daydreamer* shows a bored office clerk, sitting at his desk but escaping his environment by dreamily recalling things past, the fantasy image of an old ship positioned over the *Post* logo as if to suggest the magazine itself as a means of escape for the bored middle classes. He would reprise the theme of the enervated worker on his May 16, 1925, cover, *Man Playing Flute,* in which an elderly clerk indemnifies the tedium of his dull desk job by stealing a few minutes to play the flute in his office. That workers would find their jobs so stultifying as to require compensatory fantasies or music breaks to get through the day proved an inevitable

component of Lorimer's American dream, the consolidation of a heterogeneous nation into one economically and culturally secure entity, unified against any outside threat. Rockwell valued the recompense over the job, implying that if man—specifically—is forced to confront the present moment without access to the imagination, it will prove unbearable.

The year was taking its toll on Rockwell. His enthusiasm toward his work waned, especially the overload of advertising he had accepted, and toward his personal life as well. By the end of 1924, Rockwell decided he had enough of sharing his home and wife with her mother, sister, and two brothers. Hoddy alone was too much for Norman's peace of mind: a decorated war hero, the large man suffered from nightmares that would cause him to fall out of bed at least once a night, hitting the floor with a loud thud that reverberated through all three floors. The larger-than-life brother-in-law felt himself entitled to whatever Rockwell could provide. "Pop also told me he had to finance two abortions for Hoddy," Tom Rockwell recalls, his tone suggesting that his father thought the situation morally shaky.

Perhaps a sense of being overwhelmed by so many family claims on his resources contributed to his decision in 1924 to separate from Irene when she refused to live alone with her husband after he requested that they find a place to live by themselves. "And leave my family?" she asked her husband in surprise. On affirming that he was asking her to choose, she didn't hesitate to name everyone except her husband as her priority, as surely her husband knew would happen. The reality was that he needed an escape, and he put the responsibility on Irene; he realized that she would never kick out her family, and that she would have no desire to accompany him to Manhattan.

Rockwell moved out of his own home, happy to have an excuse to return to the art world where he had established his identity ten years before. He installed himself in the Salmagundi Club, a house founded in the late nineteenth century by National Academy of Design students as a temporary home for artists, by this point located at 47 Fifth

Avenue. The membership, dating from 1880, included Howard Pyle and, more recently, Charles Hawthorne, currently in residence at the League. Still an all-male institution in 1924, the club allowed Rockwell a few weeks, at least, to revel in the solidarity of his own kind— men who were doing art, and who gathered in the evenings to talk about it over their pipes and cigars.

True to his belief that one's craft was well served at any stage by study and practice, he registered at the Art Students League for the upcoming 1925 winter term, choosing an etching class taught by master Eugene Fitsch. George Bridgman, Joseph Pennell, and Charles Hawthorne were all teaching during this school year, but only Fitsch taught in the evening hours, from seven until ten, when Rockwell had finished his own work. Too, Rockwell had to calibrate carefully the distinction between presenting himself as a well-established professional and one of his teachers' success stories. It would not do to appear too much the neophyte again. Etching was a return to a technique redolent of Dickens, not of Rockwell's own art school days.

Within weeks, Rockwell supposedly came down with a severe case of tonsillitis that landed him in the hospital; because Rockwell had his tonsils removed when he was a little boy, his use of the pseudo-illness probably substituted for a less seemly ailment. Either he or Irene seized the opportunity for a reunion, and as soon as Rockwell agreed to his wife's demands for an expensive new house, she immediately convinced her family to return to Potsdam as her part of their deal. Rockwell thought the O'Connors had belonged in their spacious colonial homestead all along, instead of confusedly camping out with him and Irene to stave off loneliness and to escape what they considered too rural a location. After they left, Norman and Irene climbed into their shiny new roadster and drove to their "camp," their little love shack on the St. Lawrence River, where the illustrator rested for a few weeks to regain his strength. He would come to rue the devil's bargain he had struck with Irene: he regained his wife, but at the proverbial cost of his soul. However hard he had tried to escape becoming immersed in the moment, he was now

firmly committed to being a creature of his day, which happened to be the Roaring Twenties.

In *The Great Gatsby,* Scott Fitzgerald's iconic novel about the very rich among whose types Rockwell now traveled, Nick Carraway describes memorably the new context for the illustrator's narrative imagination: "The last swimmers have come in from the beach now and are dressing upstairs; the cars from New York are parked five deep in the drive, and already the halls and salons and verandas are gaudy with primary colors and hair shorn in strange new ways and shawls beyond the dreams of Castile. The bar is in full swing, and floating rounds of cocktails permeate the garden outside, until the air is alive with chatter and laughter and casual innuendo and introductions forgotten on the spot and enthusiastic meetings between women who never knew each other's names.

"The lights grow brighter as the earth lurches away from the sun, and now the orchestra is playing yellow cocktail music, and the opera of voices pitches a key higher. Laughter is easier, minute by minute."

Rockwell gave it his best shot.

13

Cutting a Fine Figure

The next five years were Norman Rockwell's experiment with decadence. Irene wanted a prestigious address, so he arranged to build a cheap but chic residence on the most expensive property he could afford, Premium Point. In the middle of the decade, he capitulated to Irene's wish to be a part of high society. He knew how to shine. After all, as one typical newspaper column noted, his "wise cracks and burlesque" kept any party "in an uproar." Careful not to forget his beanpole image that was always at risk of being exposed, the illustrator became adroit at the preemptive first strike: "His funniest moments are when he is making fun of himself." Rockwell became a master at self-effacement.

Much has been made of Norman Rockwell's theatrics, his hammy acting out of the characters he wished his models to convey. He liked thinking through his body, working from the outside in. Such histrionics are often intuitive for visual storytellers; Rockwell's historical mentor Charles Dickens himself was an amateur actor whose celebrity followed in part from his theatrical personality, which re-

warded him financially as well as psychologically through his exhausting series of often sold-out public readings.

Such a theatrical bent is predictable for those whose natures lead them to narrate life to the masses, a category that includes illustrators. As one scholar of the great Howard Pyle explains, "A strong histrionic strain was the motive force that breathed life into his pictures, but it was scarcely a rare possession for an illustrator of ability. The gifted illustrator usually finds it working for him involuntarily—an instinct of his genes so native that he accepts it as a matter of course. At times the artist may become conscious that he is grimacing as he works, his face is contorting with all the passing emotions he is trying to depict, or that his muscles are twitching into the shapes he is trying to form on the canvas. . . . The performance might well seem odd and dubious to an uninitiated spectator, but the artist knows he is tapping a source of power that will help to sweep him through and over many obstacles. If he can feel and act out in his own muscles the movement that concerns him, he is likely to be able to animate his drawing, impart a swing or rhythm to it and lift it above mere mechanical competence."

Becoming a social player was just more acting, a role repeated enough that it became natural. Norman and Irene became charter members of the Bonnie Briar Country Club, housed in a monolithic mock Tudor structure to the north of New Rochelle. Built just a few years earlier, the club was noted for attracting more of the "younger people" than such clubs usually did. (The year before, on the exceptionally hot late morning of July 18, 1924, the two-and-a-half-story wooden structure that housed the New Rochelle Yacht Club had gone up in flames. At least temporarily, the Bonnie Briar was the biggest game in town.)

Rockwell had already learned to play tennis, and now he became good at it, his eye-hand coordination honed by the years spent at his easel, and his long lanky frame conditioned by his spartan diet and a brisk daily walk of at least three miles. His son remembered years later that his father beat most players, even those better than he, by

virtue of his absolute resolve. He played with a ferocity that hinted at the revenge he exacted on those childhood boys whose athleticism excluded him. At least one good friend recollected that Rockwell also played a good game of bridge but a bad set of checkers—this latter "weakness" probably feigned to maintain his self-effacing image, in light of the actual prowess his family recalls.

Every year Rockwell's personal and professional profile had climbed in tandem, both sides of his life feeding off each other. In late 1925, he was honored with the significant assignment to produce the *Post*'s first four-color illustration, for the February 6, 1926, issue. He played the image of the magazine's founder, Benjamin Franklin, hovering over the magazine against the idea of change, with a colonial figure painting out one tavern sign and installing another. The magazine's unprecedented subscription and circulation success had actually stymied the *Post*'s attempts to move from two-color to four-color printing until they could obtain presses with high enough speed; by 1926, when the magazine made the switch, Curtis's *Ladies' Home Journal* had already been using the more advanced technology for several years. The *Post,* at four million circulation by now, simply took longer because of the daunting logistics. The verisimilitude that Lorimer had valued since his renovation of the *Post* at the turn of the century now became visually much easier to accomplish. Possibly as much a psychological as a practical boost to production, the innovation helped the *Post* and George Horace Lorimer regain their momentum as leaders in the field.

In later years, when Lorimer's individualist politics would seem particularly dated, one reflective critique insightfully teamed Benjamin Franklin and the editor of the *Post* as "arch-Americans in their profound belief that the meaning of life is not hidden but wrinkled on its surface; that its secrets come out in the astute living of it; and that its supposedly ineffable values merely make for confusion and failure in this responsible world. This defense of the surface they do not hold naively, but as an archly integral social philosophy. . . . Franklin was our first pragmatist and behaviorist, the forerunner of Dewey and

Watson and our Big Business leaders, who would recondition all reflexes into the best means of living and call it a life. Mr. Lorimer helped to manipulate this philosophy into an American folklore."

Rockwell's manipulation of his own image had produced somewhat of a bifurcation, creating tension between him and his parents. Nancy and Waring were not pleased with the rumors about their son's Jazz Age marriage, and, for reasons never clarified, they became estranged from him for several years—as many as seven, according to one account—in spite of living within a few miles of each other. Rockwell was busily juggling several identities: the social circle he inhabited with Irene delighted in his ribald behavior among the hedonists; his slightly off-color jokes and his impersonation of a bon vivant at the country club parties reassured the parents of the children who modeled for the artist that he was no better at heart than they were.

Rockwell later lamented "tricking" his public, especially the children, by hiding behind a patina of respectability that was false. Particularly onerous to him were the extramarital freedom his social group espoused and the heavy drinking that eventually eroded his previous sacrosanct schedule. In the references to the period that he made many years later, his regret is greatest for the hypocrisy of presenting himself daily to his child models as a trustworthy man whose actions matched his words, as opposed to someone who might be sleeping with the child's mother. Rockwell's preference for acting in ways he considered honorable was dramatically reinforced as a result of the Roaring Twenties, especially because he felt that the cost of maintaining a divided identity had vitiated the integrity and energy of his art.

Not only Norman's parents backed off from him at this time; Jerry and Carol, still living in New Rochelle, were also busy with their two sons, Dick and John, born within the first five years of their marriage. His responsibilities motivated Jerry to put in even more time at work than Norman. While the famous illustrator first hobnobbed with high society and with the "artsy" set, the other Rockwells were scraping along the best they could. Jerry worked on Wall Street as a bonds

salesman, with his earnings averaging $100 a week. As his income gradually rose, he had earned a total of almost $10,000 in 1924, the increase enabling him and Carol to buy a car, and rent a pleasant if "unpretentious" apartment in Pelham, near New Rochelle, where they spent weekends, and a modest Manhattan efficiency where they lived during the week. Before long, the salesman's long hours began to pay off handsomely, and the couple joined a beach club in New Rochelle and hired a part-time maid and nurse for the boys.

Because Norman's brother and his wife were spending most of their time in Manhattan, they could legitimately claim few opportunities to visit. And on the weekends when Jerry and Carol returned to Westchester County, they spent their family time with Waring and Nancy, with whom Jerry was determined to stay close. According to Dick Rockwell, his father and mother began mixing with a social crowd as stylish as the illustrator's, though it didn't intersect much with Norman and Irene's.

Norman compensated for the lack of his own family by taking advantage of Irene's mother's standing offer to use the family camp at Louisville Landing whenever he wanted a break from his routine. On August 13, 1926, he traveled to the O'Connor cabin, where he combined a few hours of fishing with days of painting at the studio he rented nearby. He planned to stay for two months as a change of pace from New Rochelle, where the constant social engagements messily fragmented his work schedule. He had the skylight enlarged before he began working, and once it was installed, he insisted that "the studio [be] absolutely barred to visitors until 5:00 pm." At the end of August, he returned prematurely to New Rochelle, suggesting that his dictum had gone unobserved by the townspeople. Back home in their expensive, prominent residence, Rockwell felt more secure about the increased public awareness of him after he and Irene bought a German shepherd, Raleigh. The dog quickly became his faithful companion, walking with him to and from the studio every day.

A few months later, Clyde Forsythe wrote an article on his friend that was published in the December 18, 1926, *Post*. Because of

Forsythe's up-close knowledge of his studio mate and good social companion, his comments are more revealing than most. Forsythe praises the illustrator's art as "kindly, whimsical humor and . . . quiet, loving interpretations of life, painted in [a] naive and wholesome manner"—all of which quickly attracted "advertisers galore" as well as editors. "How brilliant!" you might think, Forsythe continues; but no, "Not at all! A plugging, plodding student in his studio. There has never been a period of brilliance in the course of Norman Rockwell's advance. The answer is Work! After work, more work. After work in the studio, work at home, reading worthwhile literature on art and life, thinking out ideas—studying—work. Rockwell's hobbies are work and work. The only aggravating thing about him is work." This extraordinary praise-that-damns seems manipulated to please Lorimer, with his unfaltering belief in the superiority of business and personal application to intellectualism and aestheticism.

But even if Forsythe was preening for the Boss, the article returns to the theme too doggedly for the cartoonist's combined awe and irritation at his friend's work ethic to ring false. Without a doubt, he admires him: "He studies the work of Howard Pyle and goes back to Rembrandt looking for counsel; then to Abbey and Millet or Cellini. . . . His art library is large and growing; there are no books of twaddle. His knowledge of the lives of past masters is great and his respect for them profound." He ends the piece by claiming yet again that in spite of the other pieces of the man—his sense of fun, his charm, his modesty—most characteristic is that "after all—work, work, work."

But all was not work, at least not compared to what Rockwell was accustomed to in the early part of the decade. A lack of energy, a stasis, informs many of his illustrations during the last few years of the twenties, reflecting the lack of mental nutritives in his life, as well as the vast reserves of time and effort required by his social life. Peter Rockwell, the artist's youngest son, recalls his father's bawdy account of a seduction attempt he made during this period. "My father had probably had a bit too much wine one evening, and so he told me the

story of a young woman he'd had his eye on during the 'wild' period of his first marriage, after Irene and he had decided to have an open arrangement. He spent several weeks working to impress the woman, and finally she agreed to a private liaison in his studio one night. But when she undressed, she turned out to be entirely flat-chested, her bosomy image entirely the result of 'construction.' My father, never worried about being able to perform, was so shocked that he couldn't exactly 'rise to the occasion,' and in total humiliation he got in the car and started to drive her home. He was so preoccupied with his embarrassment that he drove in reverse and hit some flower beds when he meant to go forward, and he kept driving like this all the way to her house. The whole seduction attempt ended in one of those nightmare messes."

Other women came into Rockwell's purview, including, at least tangentially, the widow of his colleague. In 1927, the debonair Coles Phillips succumbed to the degenerative kidney disease he'd been fighting for several years and died at his home in New Rochelle's Sutton Manor. "As an artist his line was accurate and firm, his sense of color sumptuous, his taste fine, and his standards constantly higher," claimed one eulogist. He was "a splendid technician and a prolific though conscientious producer." Much praise was aimed at the seriousness with which he openly took advertising as a career, and at his "acute business sense [that] gave him an advantage over many of his fellows, and [that caused] business men . . . to treat him with marked consideration."

Phillips was only forty-seven years old, and he left behind a beautiful, intelligent wife, the writer Teresa Hyde Phillips, and four children. Phillips's final job had been illustrating stories that his wife had contributed to the *Post* and to *Collier's Weekly*. Peter Rockwell remembers that at a talk he gave in the late 1980s, "a woman came up to me and said that everyone had expected my father to marry Coles Phillips's widow. Maybe she's the one he had the affair with." Teresa Phillips was the sort of woman Rockwell admired: talented in her own right, she had arisen at six each morning in order to put in three hours

writing for major publications until her sick husband arose at nine, when she tended him. She expertly managed the lives of their children and their business ventures, such as Coles's pigeon farm, while maneuvering herself professionally so that upon her husband's death she would be offered a high-paying job as Ray Graham's assistant at the Graham-Page Motor Car corporation. Soon the tragic death of Graham, the president, left her on her own once again, and, refusing to play the role of victim, she procured an agent and provided for her family through her writing.

Teresa Hyde Phillips was also considered exceptionally beautiful—slender, with black wavy hair, blue eyes, fair skinned. She had served Coles Phillips as his primary model for most of their marriage. But her very vitality and maturity demanded a meeting of minds and lives that would have intruded too much on Rockwell's need for solitude; he wanted loved ones physically nearby, ready to have an evening cocktail when evening came, but he did not have the emotional framework to incorporate the kind of intimacy that marriage with Teresa Phillips would have demanded.

Rockwell's energies were being drained by more prosaic activities as well. The shabby construction of his nouveau riche house on Premium Point bought the couple more trouble than the prestige Irene had bet on. Neighbors complained about the inappropriately modest addition to the neighborhood, installing fences to protest the eyesore. And in spite of ten years of working as an artist, Rockwell still lacked his own studio, one built to the illustrator's specifications. After the front yard more or less sank into the septic tank, he arranged a trade with an acquaintance who wanted trustworthy neighbors for his mother on the north side of New Rochelle, a wooded area of upper-middle-class homes.

The house at 24 Lord Kitchener Road was perfect for Rockwell. Isolated in comparison to the other neighborhoods he'd been inhabiting, yet bearing enough cachet to placate Irene, the colonial house with white shingles and green shutters—Rockwell's dream home as a boy—was sited on a lot that could easily accommodate a studio. An

article in *Good Housekeeping* emphasizes the Rockwells' choice location in an "outlying section of New Rochelle, New York, on a large plot with considerable space around it, [which] thus satisfied [the artist's] desire to live in the country and yet be conveniently near his friends and to have a quiet place in which to work."

To complete their new home, the couple bought extremely expensive eighteenth-century American furniture from the Manhattan antiques dealer Ginsberg and Levy. Quickly, Rockwell engaged his friend the architect Dean Parmelee to design the perfect studio space, approximately twenty-three by twenty-five feet, built onto the garage and separate from the house. The studio's interior was Early American, the current craze, and Rockwell and Parmelee traveled all over New England to gather authentic furnishings. The men found the perfect colonial model at the Wayside Inn in Massachusetts, which led to covering the studio's outer walls with rough fieldstone. To take advantage of the best light, Rockwell installed in the north wall a window that began about three feet off the ground and extended upward for eleven feet. Opposite one window was a recessed fireplace with built-in bookcases on either side. Above the fireplace area was a railed balcony on which he draped things that he wanted to paint; behind it he could climb up to a storage area. A large ship's wheel chandelier hung in the center of the room, where he set his easel and palette table.

The studio cost him $23,000, the equivalent of $216,667 in 2000. Although nothing suggests that his budget was overstrained by the extravagance at the time, the costly enterprise set a precedent that made such expenses seem reasonable to him later on, when his income was spread much thinner.

The Parmelees became family friends of the Rockwells, their association lasting through both men's lifetimes. Although Parmelee's office was in New Rochelle, he actually lived in Mamaroneck, close to Rockwell's old home at 95 Prospect Avenue, where he had relocated a few years earlier from Tennessee. Just before her death, Dean Parmelee's youngest daughter, Betty, recalled the friendship in some

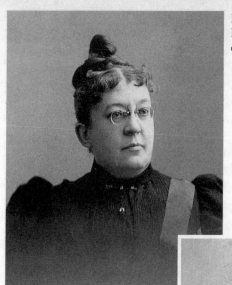

Phoebe Waring Rockwell,
NR's paternal grandmother,
c. 1890.

John William Rockwell,
NR's paternal grandfather,
c. 1890.

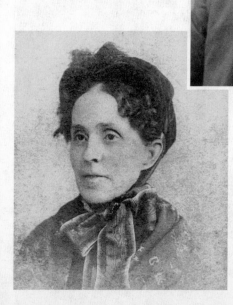

Anne Elizabeth Patmore Hill,
NR's maternal grandmother,
c. 1882.

ABOVE: Jarvis Waring Rockwell ("Waring"), NR's father, December 24, 1887. RIGHT: Anne Mary (Nancy) Hill Rockwell, NR's mother, c. 1882.

NR (left) and his brother, Jarvis ("Jerry"), 1895.

Jerry (left) and Norman catching frogs at Lippincott's farm, c. summer of 1904.

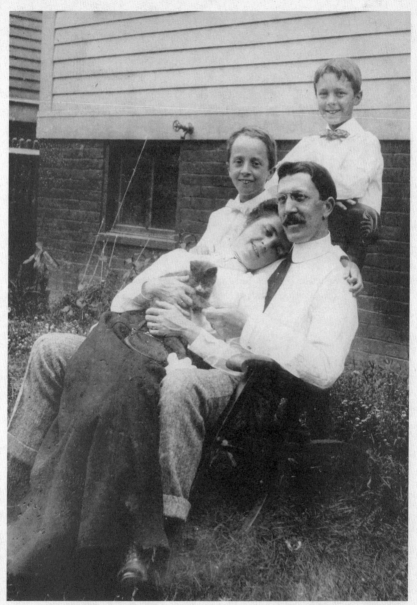

Clockwise from upper left: Norman, Jerry, Waring, and Nancy Rockwell, c. 1905.

Summer boardinghouse, c. 1899. Jerry and Nancy are second and third from the left in the back row; Waring stands at the far right; Norman sits in front, at the far right.

Family portrait, December 1911: Waring, Norman, Jerry (left to right), and Nancy.

Norman and his first wife, Irene O'Connor (right), on a picnic, c. 1916.

ABOVE: Jerry Rockwell's wedding to Carol Cushman, 1916. In the back row, Waring stands at the far left, Norman at the far right; in the middle row, Nancy stands at the far right, with Irene beside her; Jerry is seated, to the left.

Norman (left) and his buddies during his three-month stint in the Navy, Charleston, South Carolina, 1918.

NR at work outside his New Rochelle studio at 40 Prospect Street, 1921. The boy is Franklin Lischke.

NR inside his studio, 1922, at work on *The Runaway*. He would later discard the easel in favor of a "painting table." A reproduction of Rembrandt's *Syndics of the Drapers' Guild* hangs prominently at the left.

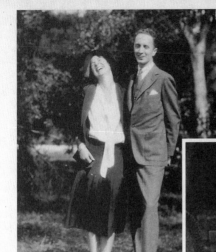

Mary Barstow and Norman Rockwell, courting in Alhambra, California, early spring 1930.

Mary and Norman, Alhambra, days before their wedding, April 1930.

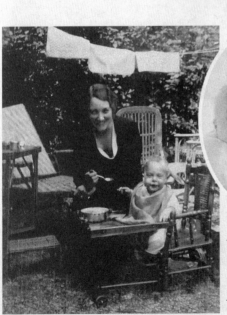

ABOVE: Jarvis Waring Rockwell, NR's firstborn child, and Mary Barstow Rockwell, 1931.
LEFT: Mary Rockwell with baby Jarvis at the Rockwells' rue de Cambon rental, Paris, 1932.

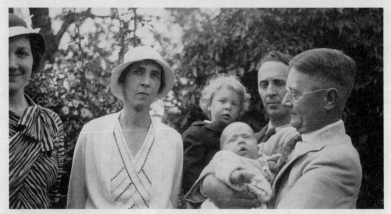

Showing off the Rockwell sons in Alhambra: Mary Rockwell, Bernice Barstow (Mary's mother), Jarvis, baby Thomas, a tense-looking Norman Rockwell, and Alfred Barstow (Mary's father), 1933.

ABOVE: Jarvis, Tommy, and their father on a rare family vacation, c. 1934. RIGHT: Tommy, Mary, and Norman, sailing to England for Mary's abortion, spring 1938.

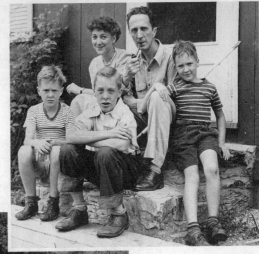

On the stoop of Rockwell's studio, c. 1943: Tommy and Jarvis, Mary, Norman, and Peter.

Relaxing with the next-door neighbors, the Edgertons. In front: an Edgerton daughter, Jarvis, and Tommy. Behind: an unidentified woman (probably Amy Edgerton), Clara Edgerton, NR, an unidentified man (probably Amy's husband), and Jim Edgerton.

The Rockwells' first house, in Arlington, Vermont, NR's studio in foreground, early 1940s.

Rockwell painting his World War II poster *Let's Give Him Enough and On Time,* Arlington studio, 1942.

Jack Atherton critiquing NR, Arlington studio, c. 1948.

Rockwell (Jarvis alongside him) posing as a model for his own painting, 1945.

Main Street, Stockbridge, Massachusetts, 1954. Above the shops, Rockwell can be seen looking out of his studio window, which he installed as soon as he moved into the building.

Tom Rockwell's wedding to Gail Sudler, at the Little Church Around the Corner in Manhattan, June 1955. From the left: an unidentified woman, Gail's mother, Mary and NR, Gail, an unidentified woman, Gail's father, and Tom. Mary, battling depression, had recently been institutionalized and undergone electroshock therapy; Norman picked her up from McLean Institution for the celebration and drove her back afterward.

Mary Barstow Rockwell, probably 1960, painted from a late 1940s photograph.

A haggard Rockwell at work, months after Mary's death, 1960. Note the portrait of Mary, from 1952, hanging above his paint rack.

Norman and Mary ("Molly") Punderson at their wedding, Stockbridge, October 25, 1961.

Rockwell hamming it up with his faux Jackson Pollock canvas, 1961—assuming the Abstract Expressionist's famous stance, substituting his pipe for Pollock's signature cigarette.

Norman, Molly, and Cynthia ("Cinny") Rockwell, Peter's wife, visiting the Acropolis, 1967.

Norman and Molly, joined by friend Doug McGregor, embarking on one of their daily bike rides in Stockbridge, c. 1970.

ABOVE: The front jacket of *The Thief*, 1977.
TOP RIGHT: Jarvis Rockwell's etching of a
Korean woman, 8" x 6", early 1950s.
RIGHT: A rose window designed and carved
by Peter Rockwell, from sandstone quar-
ried by the artist in 1982, Tuscany chapel,
Italy, mid-1990s.

NR having tea on the
"Escapebo," the private
extension he and Molly
built onto their house to
escape gawking tourists,
early autumn 1978.
Though weak and con-
fused in the last months
of his life, Rockwell still
had a sense of humor:
note the tea cozy he'd
placed on his head. To
his right: his nurse,
Mary Quinn, and Molly,
holding Sid.

detail: "I think my father was more the social type than my mother; he played tennis or golf while my mother gardened. And New Rochelle was so social in those days. My dad went to the Beach club all the time. He liked to play, and so he provided good distractions for Rockwell, who worked too hard." Rockwell's recreation was often publicly tracked; a local publication even noted when the illustrator ordered a new set of sails for his small sailboat, called *Little Dipper,* which he enjoyed taking out on the Sound with Dean.

By now, though Rockwell could travel elsewhere undisturbed, in Westchester County people often recognized him on sight, so Dean quickly figured out respites from the burden of local celebrity. "My father loved to go camping in Vermont too," Betty remembered, "and he'd take Norman along. They'd put on old clothes and go hiking for several days. On the other hand, my father drove an open-top roadster, Cadillac roadster, and then a Pierce Arrow roadster. He frequented the Museum of Natural History and the Metropolitan Museum of Art in Manhattan. He and Norman enjoyed doing so many things together."

The Parmelees also socialized frequently as a couple with the Rockwells. "Both my parents went to the Glen Island Casino, also along the Sound, in the Pelham area; there was a famous dance band and sometimes swing bands, and even young people would go there to socialize. My mom and dad and Norman and Irene often drove up to the supper clubs in Manhattan for dancing and dinner," their daughter recalled. "I heard that Norman loved to dance. I can still see them all in my mind's eye, going out together, the women wearing their long skirts then and strings of pearls down below their waists, everybody laughing—whenever Norman was around, there was always fun. But my mother didn't have a lot in common with Irene—Mother liked making clothes for all four of her girls, and simple things like canning preserves and jams in the basement."

Betty Parmelee always believed that Norman enjoyed hearing about her father's unconventional path to his status as one of New York's highest-paid architects, as if Dean's lack of prestigious degrees

reflected well on Rockwell's own earlier choices. And, just as the illustrator had learned to draw through Waring's nightly example, Dean's father, an architect in Knoxville, Tennessee, had also inspired his son, who eschewed the formal route of architecture school and learned the trade in the older man's office. After high school Dean went to Detroit, Philadelphia, and Chicago, apprenticing briefly with each of the great architectural firms and studying with the great resident architects, such as Frank Sullivan. Akin to Norman even in his religious patterns, he refused to go to church as an adult—overzealous Baptist regimentation during his Tennessee childhood, he suspected.

Norman also got a kick out of listening to Dean's accounts of the great palatial homes he built on Orienta Point—where Mrs. Constable had befriended the illustrator years earlier—especially the stories about D. W. Griffith's end of the development, where Griffith maintained a movie studio throughout the 1920s. Betty Parmelee's recollections about the opulence of the area are reminiscent of the impression it had made on the boy determined to earn his art school tuition by delivering mail to its privileged inhabitants nearly twenty years before: "Orienta Point was so beautiful; the kids who lived there even got to come to school in a limousine, driven by a chauffeur."

As the two men swapped stories, Dean became a substitute brother for the illustrator, albeit only for a few years. By 1927, Jerry's income was escalating dramatically as a result of having started his own bond trading company; increasingly, he and Norman found they had no time for each other. For the next two years, he and Carol lived more extravagantly than Norman and Irene, and the two brothers continued to drift apart, mostly out of lack of interest in each other, according to Jerry's son Dick. More dramatically, Carol's newly discovered passion for couture clothes, glamorous parties, and rendezvous with other men seduced her away from Jerry as well. She was finding her children and her husband inconveniently "boring." In 1930, she would scandalize her relatives when, chastised by the stock market crash, she wrote a revealing article for *Cosmopolitan* magazine

in which she discussed the moral failures that her wealth had engendered—although Nancy, oddly feisty herself when the occasion moved her, was impressed as well as mortified by her daughter-in-law's gutsiness.

If Carol was not the ideal mother, her grandson, Nick Rockwell, remembers her husband as pretty unappealing himself. "I thought it kind of odd that my dad and his brother grew up calling their parents by their first names, Jerry and Carol, from the time they could talk," Dick's son recounts. "But it's easy to see that my grandfather rejected intimacy, preferring to maintain the distance between his children and himself, though he pretended that the supposed closeness in age was the reason for preferring first names over the conventions. Frankly, at least when I knew him, Jerry Rockwell was racist, anti-Semitic, and told nasty jokes that enraged my father [Dick Rockwell] and got them into fights. He was cold and didn't seem like a happy man; and I don't think he and my grandmother Carol were too fond of children. All their lives, by the way, they maintained separate bedrooms."

But in 1927, the couple was riding high. "I remember how proud they were of an article that appeared in *The Wall Street Journal* referring to Jerry as one of the 'Young Lions of Wall Street,'" Dick Rockwell recalls. His parents rented two expensive apartments in exclusive Blind Brook Lodge in Rye, and restructured them into one large home. They spent most of their time, however, in the Manhattan hotel suite they leased in place of their earlier efficiency, and they began enjoying the theatre on a regular basis—when they weren't attending the fancy parties to which they were now routinely invited. A hired couple took care of running the household, and a part-time maid, according to Carol's own account, took "John and Dick entirely off" their mother's hands. Jerry bought his wife a Cadillac Eight, gave her a generous clothing allowance, and provided membership at three new clubs, including the American Yacht Club. The couple began attending separate parties, and Carol initiated a series of intrigues. On the rare occasions when the two found themselves alone together,

they were "bored and restless," and Carol joined Jerry on a trip to Paris only in hopes of meeting interesting people. She did, including a handsome man who asked her to marry him, and whom she refused, it appears, only because he wasn't rich enough.

Yet for all of Carol Rockwell's bad behavior, Irene's actions were far more flagrant. Family gossip included snippets of information about her party conduct. Dick Rockwell remembers that as a little boy, whenever he walked into a room and heard the name "Irene" among the buzz of conversation, all talk mysteriously ceased as soon as the adults noticed him. "Baba [the children's name for Nancy] would tell me stories about the parties Irene attended—without Norman—and that she misbehaved, that she was 'quite a party girl.'" Dick remembers Irene as "pretty, brunette. But she would do such truly outrageous things. She registered at a hotel in Pennsylvania or New York with a guy once under the names of Mr. and Mrs. Norman Rockwell. It was a pretty stupid thing to do, as you might imagine, because Norman knew where he was that night, and it wasn't there!"

Odds are that Norman was in his studio, working. *The Little Acorn,* a local paper, reported in November 1927 that Rockwell "has closed a long time contract with *The Saturday Evening Post.*" The following January, the paper claimed that "the bidding for the product of [Rockwell's] brush [had run] high with 'Liberty' pushing the 'Post' to the limit." Over thirty years later, Rockwell recounted the events differently. Setting the event back several years earlier, he explained that the new, lavishly underwritten magazine *Liberty* had indeed courted him, just as it had many other writers and illustrators associated with the *Post.* Irene and Clyde Forsythe, in the illustrator's version, both urged him to defect to the new publication, where he would be earning twice what he made at the *Post.* After all, they reminded him, Lorimer had given him only measly raises along the way. Why worry about the repercussions for the *Post*?

Rockwell, who had recently executed a plum assignment—a cover of Charles Lindbergh to accompany the pilot's *Post* tell-all about his flight—couldn't decide what to do, and, in the middle of a sleepless

night, he jumped up, boarded a train to Philadelphia, and when the Curtis Publishing company opened its doors, he sped in to present his dilemma to the Boss. Lorimer looked down, unwilling to beg or bargain for his premier illustrator's loyalty, and only when Rockwell announced that he was staying, immediately doubled his salary.

The account in *The Little Acorn,* circulated either by Rockwell, Irene, or one of the magazines involved, is surely the more accurate one, given the public and timely nature of its revelations. Whether Rockwell incorrectly remembered his response to the challenge, changing his reaction to loyalty that overcame the seduction of money, or deliberately reconstructed the scene to make such a point to his audience of 1960, the contrast between the strict commercialism of the actual event and the emotional overtones of the "memory" reflect ways that the illustrator's values or his desire to be valued changed over the decades.

By 1960, American readers would not have responded with the same wonder that such a close call commanded in 1927. At the time of Rockwell's autobiography, the *Post* was gasping for air, and leaving it for a rival magazine that paid more money sounded eminently sensible. But the 1920s were a different story: Will Durant, Henry Ford, Vachel Lindsay, Groucho Marx, Rube Goldberg, Carl Sandburg, Edna St. Vincent Millay, Al Smith—they all contributed to the *Post* during this decade. As one analyst commented: "I often think a thing is not really published in the United States until it appears in *The Saturday Evening Post.*" True, urban sophisticates prided themselves on reading *The New Yorker,* whose debut in 1925 as an omnibus humor, literary, and nonfiction magazine featured cover illustrations more fashionably decorative than the *Post's.* But enough of a crossover audience existed at this point that the *Post,* resolutely middle-class as it was, remained an acceptable magazine in the homes of the literati.

The Little Acorn's assertion about Rockwell's contract with the *Post* was, in any event, misleading. It is highly unlikely that he signed any kind of conventional, legally binding deal with the publishers; instead, Lorimer and he agreed that he would not work for other magazines

without the *Post*'s approval, and that his first priority, even before ac-
cepting advertising commissions, was to produce their covers. This
was no small constriction: in the 1920s, between them Leyendecker
and Rockwell produced one third of all covers for the *Post*. Only the
two men were allowed to submit mere sketches to Lorimer for cover
approval; other artists had to produce a finished painting for the edi-
tor's vote. And Leyendecker's pay was a model for the younger man.
During his most productive years, during World War I, Leyendecker
got from $1,500 to $2,000 per cover. Now, as the 1920s came to an
end, Rockwell already commanded from $250 to $500 per cover, de-
pending on the painting's complexity. And, since he followed
Lorimer's injunction to ask for twice his *Post* salary before accepting
an advertising commission, his income rapidly began shooting up-
ward.

Such productivity cut into Rockwell's newly found enthusiasm for
the whirling social life that Irene plotted for him. His popularity de-
manded that he work extended—if, nowadays, too often uninspired—
hours. He explained to a journalist the erroneous ideas people have
about the "leisurely lot" of artists, his opening reference striking what
was, for him, an oddly social tone: "I don't even have time to play golf.
Every morning from 7:00 to 8:30 I take a brisk walk with a friend out
in the country and this, with a little tennis, is all the exercise I get. For
ten years I have promised myself to take Sundays off, but it is still a
matter of conversation and not of realization. I am in the studio daily
until after five and two nights a week. Joseph Leyendecker works
every day from 10 in the morning to 10 at night and probably will the
rest of his life. I do on an average of two pictures a month." He con-
tinues with a rush of words to explain, apropos of no apparent provo-
cation, that if he weren't an artist, he'd like to be a surgeon or,
particularly, a movie director.

When not going out socially or working in his studio at night, the
illustrator explained, Irene read aloud to him, so that Rockwell was
happily gaining an education through volumes of Russian, French,
Swedish, and American literature—just as "Howard Pyle said that

that was how he received his education." Especially since an artist's eyes are so tired by the end of the day, the system served him perfectly, he explained. Rockwell loved hearing the classics, especially the sweeping historical epics charged with heightened emotion; Tolstoy, Dostoyevsky, and, of course, Dickens particularly restocked his imagination every evening, making the studio encounter inevitably more fruitful the following morning.

But he also hid behind the emotional catharsis that densely textured great novels provide, substituting the imaginative release of fiction for the drama of daily life. Only when caught unawares did he let spontaneous emotion escape him. In 1928, Rockwell started to offer to a local journalist a controlled, dry narration of child model Billy Paine's death. Eddie Carson, Billy's best friend, had accompanied Rockwell to the interview, and Rockwell, joking good-naturedly with the boy about the trouble he and his friends too often stirred up, momentarily forgot where the topic would lead him. He began merrily to discuss Billy's tendency to play tricks in the studio, finding himself stammering within seconds: "Billy Paine was the worst of all and—." The interviewer explains that "both smiles faded. For some time neither [Rockwell nor Eddie] seemed able to speak." Then the artist recovered enough to continue talking: "Billy was the worst of all. Full of mischief every minute. A few months ago he started to play one of his good-natured tricks on another boy. He climbed out of one window at his home and started to climb into another. He fell three stories. When they picked him up they found his skull was fractured." "There was silence again for a time," the writer notes solemnly.

When Rockwell took Eddie out to the car after the interview was over, the writer peeked out the window and observed that "they were clambering into the car like two kids—talking, laughing, taking a swat at each other as occasion offered." Such mimicry of boyish playfulness remained a constant of Rockwell's mature life. Engaging in childishness helped the artist avoid connecting on a deeper level, enabling him to forestall potential emotional intimacy. This pattern functioned at a particularly overdetermined psychological level, since Rockwell

was imitating the idea of boyhood, rather than the real life he himself had been granted as a child.

The type of admiration that Rockwell's worshipful journalist exudes is exactly the kind of thing that created a backlash of resentment in the New York art world. Terming the illustrator a young man "in the very front rank of American artists" did not engender affection among the New York cognoscenti, who assumed such populist laurels to indict those they crowned. Similarly, during this same period, when *Judge* magazine gave Rockwell its "High Hat" award, citing him "for having become, while still a young man, a tradition in art," the epithet damaged him far more than benign neglect would have. Usually implied in the encomiums was a nod toward Rockwell's distinguishing mark of sincerity, an old-fashioned virtue in the magazine world. The freestanding covers of the early *New Yorker* also depended on humor and even, according to at least one of its art directors, timelessness as their milieu, but irony, not earnestness, was the juggernaut of the new.

14

❧

Losing His Way

For someone who, "while still a young man, [was] a tradition in art," Norman Rockwell at the age of thirty-four was feeling very much otherwise. He certainly was succeeding in his juggling act, appearing to be the stolid, highly respectable artisan-workman during the day and the enviable dandy by night. Still, the dichotomy seemed to wear down his imagination. A listless spring left him determined to find a solution to a growing sense of professional staleness, but he packed up as usual for a summer break at Louisville Landing, where the locals took him out fishing on the river and sat around with him afterward on their porches, smoking tobacco and sharing tall tales. Although Irene was not very popular around town—she was considered a "socialite," someone who carelessly answered the door in mud packs that implied that she did not like being disturbed—her husband was accepted as a real guy by the small group of regulars. The pace relaxed Rockwell, and he usually found that he painted better after such a respite.

During the summer of 1928, the camp break among Irene's family and friends didn't work the expected antidotal magic. From their cir-

cumstances by the end of the season, it appears that the Rockwells agreed at some point in July to take separate vacations during the following two months. Rockwell joined the Larchmont Country Club as a special summer member, living there while Irene was away. At that time, the club was very much a male bastion, inhabited by rich Manhattanites who spent summers in Larchmont to escape the city's heat.

Irene stayed in Potsdam, only fifteen miles from the Landing, at least for part of the late summer. On August 29, she gave a luncheon at the Potsdam Country Club for her mother, sister, and two local friends, ensuring that a notice was printed in the local papers, citing her as "Mrs. Norman Rockwell, wife of the famous magazine illustrator."

During this summer of apparent discontent, Rockwell decided that Dean Parmelee's hilarious vision of a stag trip to Europe, joined by Rockwell's wealthy Manhattanite friend, the politically leftist and highly vocal Bill Backer, was just what he needed. At the end of the summer, the three men sailed on the same ocean liner that Rockwell had taken to Paris in 1922. Before the irrepressible threesome ever got to the Continent, they found themselves engaged in minor adventures with interesting fellow travelers. Once abroad, the three ran the gamut from visiting "every known cathedral," according to Betty Parmelee, to stumbling—once again, accidentally—into a brothel, where—once again, innocently—the men befriended the naked women, convincing two of them to get dressed and go out for a night on the town. A few weeks later, when back in Paris, the men revisited the brothel to see how their new friends were faring, and they were hailed as conquering heroes, so unusual had their "no strings attached" generosity seemed.

To the question of the autobiography's accuracy regarding their father's sexually pure encounter with the prostitutes, Tom and Peter Rockwell returned two opposing answers. "I just don't think, given the state of his marriage and the marital agreement about open sexual relationships, that Pop simply took the women shopping," the youngest son responded. In contrast, Tom Rockwell believes that "my father

bore a particular innocence about him in such matters—willful inno-
cence, that is certainly possible, given that he was a deeply intelligent
and sophisticated man. But I find it totally in keeping with his char-
acter to imagine that scenario of the brothel exactly as he told it."
Rockwell was no prude, and he had been living the life of a Jazz Age
swell, but his deep sense of self-possession, affability, and respect for
women and for himself combined to make it out of character for him
to trade sex for money. And his early experience with the fruits of
prostitution—watching his Uncle Sam in the agony of final-stage
syphilis, and hearing the cause of death declared "being with too
many women"—made such encounters especially unappealing.

The men traveled from Paris to another site where masculinity was
a subtext, a duel in Heidelberg. After watching the episode end with
one man bloodied enough to earn a reprieve if not respect, they took
the train to Austria, recovering through extended hikes in the Alpine
clouds the American self-reliance they'd lost sight of below. Alternat-
ing museum study with athletic feats, they toured the Prado in Spain,
where, during a careless moment, they lost Rockwell's thick, fully
stuffed sketchbook that he'd busily worked in during their entire trip.
Instead of the tantalizingly complete book of European drawings the
illustrator had expected to bring home, the cartoon postcards he sent
to friends, including one buddy at Louisville Landing, comprised the
bulk of his oeuvre. The postcard shows three traveling companions
walking single-file down the road, a dachshund trailing alongside.
Dressed as a hiker, Norman is carrying a stein of foam-laden beer.

By this point, Irene no longer even tried to maintain the appear-
ance of interest in her husband's life; Rockwell mentions briefly in his
autobiography that he failed deliberately to tell her when he planned
to return. In lieu of typical spousal affection, Rockwell's dog became
the centerpiece of stories about keeping the home fires burning. Ac-
cording to an absurdly sentimentalized account that Irene's brother,
Howard O'Connor, provided after the illustrator's death, "Raleigh
Rockwell" refused to eat while his master was in Europe. Almost dead
by Norman's return, Raleigh was brought back to life by the "caring

person" that Norman was, and the illustrator refused to ever leave him again till the dog died of old age. "Norman was kind. He was probably the kindest man in the world. He never changed. He wouldn't even let his dog down," Hoddy explained to reporters almost fifty years later.

One possible twist on Rockwell's desultory remark that the men had decided against telling anyone when they would dock is suggested by a September 22, 1928, column in *The New York Times*. Among the illustrious passengers disembarking from the Lloyd Sabaudo liner *Conte Biancamano,* which departed from Genoa and Naples, are Norman Rockwell, followed in the report by Mrs. Dorothy Caruso, the very attractive young widow of Rockwell's old friend Enrico, returning to Manhattan after five months in Italy. It is irresistible to speculate about the possible friendship between the two acquaintances—both, in their different ways, unattached to a mate. Although he provided meticulously detailed notes on other aspects of his travel, Rockwell failed to include mention of taking an Italian ocean liner home, or of encountering the widow Caruso on board. Ordinarily one to revel in happy social coincidences, the illustrator's silence about this chapter of his journey is unusual.

While their son was living a life that looked to them like a step away from morbid decadence, Waring and Nancy Rockwell were capitulating in their own way to the jazzed-up culture of the Roaring Twenties. In 1928, Waring's income from George Wood and Sons had reached $8,700, allowing the couple to move to 62 Milton Road, in Rye, New York, not far from Jerry and Carol's expensive apartment. A year earlier, in 1927, a luxurious new country club had opened at Milton Point, an exclusive area of Rye. Known as the Peningo Club, in honor of the Native Americans who had settled the region, the fancy, exclusive beach, sports, and social organization had as one of its first presidents none other than Waring Rockwell. The following fall, on November 4, 1928, the Westchester Sunday newspaper published a picture of the club's president and his wife dressed up in flapper outfits for the Halloween party held in the clubhouse. Nancy and Waring look about fourteen years old, their youthfulness a spillover from the odd innocence of their faces as well as their frivolous costumes.

Jerry and Carol Rockwell sometimes socialized with the older couple, while Norman and Irene remained at a conspicuous distance, outlawed from communication most likely because of Irene's inability to make peace with her difficult mother-in-law. With Jerry reaping superb returns from his holdings in a French bank, he made enough money to provide for any extras his parents wanted. He had even bought a thirty-foot yawl, which he proudly named the *Nancy R.* He raced the sloop four times in the next year, winning twice. Nancy and Waring's grandson Dick was nine years old at the time, and he remembers that his athletic father used to sail the boat into the harbor and show off by lassoing the buoy with a hook in order to slow his speed as he went by.

The family theatricality that seemed to run through the Rockwells' veins enhanced the illustrator's value as a public performer, as Rockwell made good money using his name for other than artistic purposes. Years earlier, he had participated in judging a Miss America contest; now, in early 1929, he was asked to join a prominent group of illustrators taking turns discussing their concept of "beautiful women." John Held, Charles Dana Gibson, Penrhyn Stanlaws, McClelland Barclay, and James Montgomery Flagg had delineated their individual aesthetics of feminine beauty, the artistic reflections prominently underwritten by Hind's Honey of Almond cream. Rockwell cannily used the January 10 broadcast to forward his belief that beauty could not be adjudicated.

First, he recalled briefly the beauty contest he had judged a few years before with the cartoonists Clare Briggs and Nell Brinkley. People rarely agree on what constitutes beauty, he emphasized, and he himself had never painted a conventional "pretty girl" in his life, surely a grand overstatement. This oft-repeated lamentation masquerading as self-criticism is a polite way to indict the cultural norm of beauty as hackneyed and artificially limited. Rockwell, like most artists, enjoyed heightened visual awareness of the world around him: without a trace of self-consciousness, he would comment on a man's beautiful facial structure, a woman's compact musculature, the various skin tones and colors among Americans.

In his radio talk on feminine beauty, Rockwell explained that he disliked the day's prevailing formula—arched eyebrows, enlarged eyes, no shadows on the face, no nostrils, Cupid's-bow mouth arranged in a sort of suppressed yawn, no gums showing. In contrast, Rockwell explains, he delights to see a woman laugh: "The best artist's models are not the classic beauties; they are girls with good looks and enough personality to put life into their faces. . . . Let me say too— that there is nothing more satisfying to this particular artist than the sort of beauty that is made by care, and by character. It takes an awful lot of character for some girls to make the most of the features they are endowed with. That character may find its source in their work, or it may spring from their particular talent, or it may simply be a fierce, self-respecting pride that is determined to make the most of their endowment of beauty. Their classic charms may be their eyes—only— or a well-turned chin, or a smooth skin, or a combination of such matters—but the woman whose beauty I like to paint is the woman whose character has given her a quality which simply makes the classic pretty-girl look forlorn and helpless by comparison." Characteristically, Rockwell ended the talk by modestly undercutting the very authority he had just confidently asserted, since of course he himself lacked both beauty and brains, and so on.

Over the next six months, Rockwell accepted fewer professional requests for his attention and instead upped the pace of his socializing, trying to match the urbane disregard for propriety of the circles he now frequented. He found it harder to come up with fresh ideas for his cover illustrations, which demanded a relaxed mental space where he could create whole narratives from scratch. Instead, he did some of his finest story illustrations during this period, including one of a writer's circus memories, *Playing Checkers,* published in the July 1929 issue of *Ladies' Home Journal.* To this day Rockwell's oldest son's favorite, the oil, thirty-five by thirty-nine inches, holds its own as a first-rate painting. The careful and complex spatial composition, the unsettling use of vivid scarlets and scalding yellow, the brilliantly painted surfaces—all these are, finally, unspoiled by Rockwell's typi-

cal compulsion to wrench at least one character's expression into car-
icature, in the name of quick access to a story line. This painting
shows the force with which he could paint, the energy he could con-
vey through even a static scene, that would become a mainstay in the
painting he would do in the late 1940s and into the 1950s.

After he finished *Playing Checkers,* he took off for what he as-
sumed would be another inundation in the European Masters such as
he had previously undergone during his museum stops abroad. This
time, however, he would learn to go for cocktails at the London Em-
bassy and pass up the Louvre as outré, barely able to keep up with the
affectations of his traveling companions, who believed that once you'd
visited a museum, there was no reason to return. *Westchester Home
Life* led off its spring column by noting that "a sextette made up of so-
cially prominent people in New Rochelle are embarking on a Euro-
pean cruise. This party will include Mr. and Mrs. Norman Rockwell,
who are making their annual visit to the continent, accompanied by
Mr. and Mrs. William Monroe Young and Mr. and Mrs. Peter Rath-
bov." The party was to depart on May 24 on the S.S. *France,* and in
Paris they would rendezvous with Mr. and Mrs. Fred Peck of Wilmot
Road. This last arrangement seemed made-to-order for the Rock-
wells; they had socialized for years with the Pecks, who lived nearby.
But the Westchester newspaper got at least one detail wrong: the
Rockwells were truly modern. The artist would once again travel solo,
while his wife stayed behind. Perhaps Rockwell consoled himself that
the Pecks would relieve his loneliness, since they were all especially
good chums.

When Rockwell returned from the last trip he would take to Eu-
rope during the roiling 1920s, he realized that his wife had never once
traveled abroad with him during the entire last decade of his marriage.
And now, back in New Rochelle, he found himself alone even at 24
Lord Kitchener.

Irene had gone up to Fisher's Landing, a fancier area than the fam-
ily retreat at Louisville Landing, but still close by. Recently, the Rock-
wells had built their own little cabin a few miles from the O'Connors'

more modest site. Her presence sans Rockwell provided a few mo-
ments of confused excitement in September, when the left-wing artist
Rockwell Kent was shipwrecked off the coast of Greenland. The local
newspapers, mistaking the two artists for each other, claimed that
Mrs. Rockwell had rushed off from camp to meet her stranded hus-
band. The press would have found reality more intriguing than their
fantasy rescue: if the stranded Rockwell had been Irene's husband,
"she would never have bothered to go to him," according to what
Robert Berridge heard when talking to Irene's friends and neighbors.

Norman came home to an empty house, because his wife had
fallen in love with Mrs. Fred Peck's brother, and the only thing Irene
wanted from him now was a quick divorce.

. . .

Norman had to feel that his wife's new object of affection was every-
thing that he was not. Machismo, not drawing skills, was the key to
Irene's heart. One year younger than the artist, strapping Francis
Hartley, Jr., of Boston, Massachusetts, graduated from Phillips An-
dover Academy, followed by Yale University in 1917. After college, he
immediately enrolled in the Navy and was sent to MIT for ground
school, and then to Pensacola, Florida, for pilot training. During the
war, he participated in night bombing raids, his fearlessness gaining
him a certain renown. Although he was never shot down, about a
month before the war ended he had to ditch his aircraft in the English
Channel when the rudder of his plane broke. His wireless antenna
was swept away in the crash, forcing him to seek aid by messages sent
by the carrier pigeons he had with him. Seven hours later, he was res-
cued by a submarine.

Such masculine prowess sounds like material for a Rockwell cari-
cature, not real life. And to add to Rockwell's humiliation at having
his wife leave him for such a genuine he-man, she had rendezvoused
with Hartley through his sister, the same Mrs. Frederick Peck with
whom Norman had toured Europe during the previous spring. Mrs.
Peck had earlier introduced Irene to her brother when Mrs. Rockwell

accompanied her to visit her family in Boston, where Francis worked in the family business as a chemist. Irene and Francis deepened their relationship while Norman and the Pecks were enjoying themselves in Europe.

By the time Irene leveled her husband with the news that she had fallen in love, Rockwell was a solid product of the emotional template laid down throughout his childhood, especially by his mother. Now, at this juncture of an adult crisis, his boyhood lessons guided his response. After all, observing his parents' marriage had lubricated Rockwell's acceptance of Irene's self-centeredness. If a wife chose not to accompany her husband on his first—or on any—trip abroad, in spite of his entreaties otherwise, that just seemed part of the natural progression set in place by Nancy Rockwell, who was encouraged to think of herself before anyone else in the family. Rockwell grew up expecting no one but himself to satisfy his deepest emotional needs, which he finessed through his work.

In spite of Irene and Norman's agreement to base their extramarital affairs on sex only, avoiding messy emotional entanglements, Norman knew that the frenetic pace they were keeping these days invited a dramatic climax. As a result, his wife's announcement that she wanted a divorce did not totally surprise him. Initially, he responded out of his belief in the sustaining loyalty of marriage: duty was everything.

He tried to reason Irene out of leaving him, dangling their high standard of living as the bar she wouldn't want to lower by marriage to a poorer man. He got nowhere. On October 10, borrowing Hoddy O'Connor's Cadillac to pursue his wife to Louisville Landing, where she had fled to be with her mother, Rockwell sat down and negotiated the details of their marriage's dissolution, which apparently included Irene's proud announcement that she wanted neither alimony nor financial recompense for the life they'd shared since 1916. Family members have suggested that Rockwell might have invoked the quid pro quo of "forgiving" adultery in exchange for release of financial claims.

Two weeks later, on October 24, "Black Thursday," when the bottom began to drop out of the stock market, Irene O'Connor arrived in Reno, Nevada, declaring her intention to file suit for divorce. The item was of course newsworthy, and the announcement, though small, appeared in the New York papers as well as being wired around the country via Associated Press reports. At this point, the cause was announced as "incompatibility." Five days later, on "Black Tuesday," October 29, the stock market collapse was complete.

Suddenly, other worries commanded Rockwell's attention, and, far more dramatically, that of his brother and, by extension, his parents. Carol Rockwell remembered that "Jerry came home about five, looking drawn and much older. He sat down in the living room and stared at the rugs in unnatural silence. I was awaiting the delivery of two Paris gowns before dashing to a cocktail party at Greenwich. My wardrobe was already overstocked with expensive things, but a man who intrigued me for the moment had suggested that a cerise evening dress would look stunning on me." When the gowns arrived, Jerry told her that they lacked the funds to cover the purchase. It was his way of announcing that they had been ruined.

Carol decided that she couldn't make it without money, that she would not go back to the "hand-to-mouth" existence of the couple's early years together. Whether she planned to kill herself or merely to desert her family is unclear; only Jerry's sad rejoinder that he didn't think he could count on her, that she had become too "soft and pampered" to start all over again jolted her out of her massive self-pity. Together they joined emotional forces, renovated their fractured marriage, sold their belongings, and worked toward making Jerry's talent for woodworking into a viable source of income. She assured her worried, wealthy friends from the old social set that "making beds and sweeping" did not ruin her figure or break her nails: "[they] are no worse a strain on the body than sports, and not nearly so hard on the looks as three or four hours of dancing on a crowded night-club floor."

In later years, Jerry glossed over his losses as reflective of his more sensitive character, one that was not truly cut out for Wall Street:

"When the 1929 panic ruined so many people, I decided it would not ruin me. Two of my business friends killed themselves, and I felt that I should finish life in a less dangerous occupation. It was exciting to work on corporate structures, but they can be destroyed overnight by strangers. I wanted to create useful things that were durable." Thus, he explained, it was logical to enter the educational-toy field, where lasting materials are valued.

What he omitted from this account, which explained that his heart had always been attuned to the tender needs of children, was the fruitless year after the Crash when he and Carol tried to set up a brokerage firm in Rye. Only after that failure did he move his family to Kane, Pennsylvania, where he converted his boyhood passion for carving wooden ships into a career of designing toys for Holgate and then Playskool, eventually becoming one of their principal designers. Especially in light of the cold personality that his relatives recall, including his distant, at best, treatment of his own children, Jerry's attraction to the things of childhood strikes a chord redolent of his brother's idealization of youth.

. . .

After his humiliation at the hands of his wife, Rockwell packed his bags and fled to the city, where he could lick his wounds in private, even as he was comfortingly close to that which never failed to sustain him: the Art Students League. The moniker itself was a reminder that he was first and foremost a student and practitioner of art. He rented out the Lord Kitchener house, taking a luxurious apartment at the Hotel des Artistes instead. Untouched by the Crash, and more determined than ever to prove himself a man of the world, he promptly spent enormous sums of money on the internal reconstruction of rooms and walls, enabling him to throw a lavish party that assured all his society friends back in the suburbs that he was not vanquished. Temporarily, he enjoyed the company of artist Emil Fuchs, but when Fuchs's daily lunches cut too deeply into Rockwell's working hours, he curtailed such socializing. Later, he came to realize that Fuchs was

somewhat of a failure, someone who lived on the laurels of his past. When Fuchs shot himself, supposedly because he had terminal cancer, Rockwell seemed to infer that his has-been status played an equal part in the man's suicide. But the suicide also must have reminded him of the inability of his own talents to ward off desertion and win loyalty—from boyhood friends years ago and from his wife even now.

In his autobiographical account of the painful months from October 1929 to January 1930, Rockwell narrates some of the funniest episodes in the anecdote-packed book. He recounts the travails of his horseback riding lessons in Central Park, where the combination of his English gentleman's riding habit and his complete ineptitude on the horses turns every encounter into a comic production. But he fails to explore why, of all activities to distract him from his grief, he chose horseback riding. Along with golf and tennis, both of which Rockwell had mastered to the satisfaction of his New Rochelle friends, horseback riding would have been the mark of a gentleman. Perhaps he hoped to hide behind the identity of a "Percevel" at last.

Rockwell remembers, even three decades later, that his overriding awareness during this period was of how foolish he looked to others. Instead of associating such feelings with the very public humiliation Irene had handed him, he generalizes it into an inner state of turmoil he can't quite understand. In contrast to the hilariously vivid accounts of runaway horses and amused spectators—who patronize the rider as a clown of a man—Rockwell ascribes his sadness to walking outside his building and stumbling into the "bums and drunkards" littering the park benches. Twenty-five years later, Rockwell would ruminate aloud about how much he presently enjoyed rambling around the Bowery whenever he visited Manhattan, in order to absorb the vivid atmosphere of the colorful bums in the neighborhood. But in 1929, the sight of such people upset him so much that he holed up in his apartment for the next few days. He fails to mention that their presence reproaches him with the possibility of a similar future—or, at the very least, for living so grandly while others suffered so greatly. As an interviewer had noted in the *Globe* six years earlier, "[Rockwell] be-

lieves that too close contact with the things he pictures would cause him to lose his perspective." The same writer approvingly observed: "The strangest thing about [his] realism is the fact that Rockwell has never done himself what he pictured his boys as doing. And he attributes whatever success may be his to this fact."

Such park bench scenarios gone awry surely felt like frightening rebukes to the artist who had previously used similar material in light-hearted ways. As the historian William Graebner notes, the Depression may well have triggered Rockwell's anxieties about being able to continue earning enough. But at this point, the time of the Crash itself, the economic crisis unmanned him in a highly paradoxical fashion, cruel in its caprice: in spite of Rockwell's impressive prospects of sailing through an economic depression unscathed, his wife—the woman to whom money and social standing were supposedly everything—had left him for another man, less affluent but the very embodiment of masculinity.

At the tail end of the twenties, Rockwell had many reasons to be depressed. In addition to the humiliation of Irene's departure and his genuine sadness at being bereft of his best friend, as he once put it, and quite aside from the fear that the Crash had instilled about his financial future, he had moved to Manhattan just as the Museum of Modern Art mounted its second exhibition, from December 13, 1929, to January 12, 1930, in honor of nineteen living American artists said to be representative of the principal tendencies in contemporary painting. Rockwell Kent, whose narrow escape the summer before when his boat capsized in Greenland had misled New Yorkers into thinking that it was Norman Rockwell who had adventured so far from home, was represented by five pieces. Although Rockwell and Kent, both of whom had studied with William Chase, were frequently confused by the public, the men usually pretended to find it amusing. Given Rockwell's present state of mind, the show at MoMA emphasized his second-rate status as an illustrator; he couldn't even make the cut among nineteen living American artists. According to what he told friends three decades later, he was hurt that he was not included.

His desire to provide the standard of living Irene thought appropriate had motivated his acceptance of too many advertising jobs during the twenties, commercial work that cut into time he might have used to paint "for himself." From *Encyclopaedia Britannica* to Fisk tires, from Sun-Maid raisins to Jell-O, from Black Cat hosiery to trousers, needles, and chambers of commerce, he had done it all, rarely skimping on quality, while he was also consolidating his position as the coequal of Joe Leyendecker as *The Saturday Evening Post*'s number-one cover artist.

But becoming the country's best-known illustrator was not quite as meaningful to him as he had expected it to be. Paradoxically, the popularity of the *Post* (its circulation at the end of the twenties was nearly three million), its status as the signpost for American middle-class prosperity, awareness, and modernity drained its artists of any claim to serious consideration among the critical elite who defined aesthetic hierarchies. As twentieth-century art became more and more dependent on the middleman role of the critic to teach and interpret nonnarrative, nonanecdotal art to America's bewildered middle class, the very kind of representational painting used to illustrate even the finest books and stories lost any claim to its status as art. And even as this schism became apparent at the upper echelons of the institutional art world, middle America was blurring the boundaries between art and illustration, framing *Post* covers to decorate the walls of their homes.

Rockwell had no clear vision of where he was going, or even where he wanted to go, at this point. Most of all, he needed to reclaim some self-respect. He continued to give parties, determined to avoid the emptiness of his too-large new home as much as possible. At one all-night revel, after everyone had been drinking for a while, he found himself agreeing to a proposal he had rejected already in the past: art editors from *Good Housekeeping,* who had been harassing him for months to illustrate the Bible, convinced him this time to say yes. The next day, when someone from the magazine called, he reneged, but they warned him they would hold him to his legal oral commitment. Lorimer suggested Rockwell get out of town for a while until things cooled down.

As usual, there was probably more to the story than what Rockwell would admit. He mentioned several times throughout his life that he deeply admired the series his friend Dean Cornwell had done for *Man of Galilee,* published by the Cosmopolitan Book Corporation in 1928. The colors came from a browned palette of reds, golds, and beiges, and the figures were beautifully drawn as well as magnificently hued. Later reproduced in *Good Housekeeping,* the series motivated Rockwell to try something similar, even as it discouraged him from spending the time to compete with Cornwell's enviable achievement. His complications with the magazine probably had to do with more of a promise than his "drunken" assent implies, and, as usual, his belated realization that he just didn't have the time to produce something worthy of the assignment. *Good Housekeeping,* more than likely, wouldn't let him out of the commitment, unlike the pliant clients whom he convinced in such cases with his abject mea culpa.

At the time of the noteworthy party, Clyde Forsythe, who with his wife, Cotta, had moved back to his native California, was on one of his annual visits to the East. The couple invited their old friend to return with them, an invitation Norman eagerly accepted. On the train trip out West, they told him of a young woman they wanted him to take out, and Rockwell, in spite of his supposed affirmation of bachelorhood as an easy way to avoid work disturbances, found himself eager to meet her.

But he had more pressing reasons to get out of New York than the fearful pursuit of *Good Housekeeping*'s art editors: as if he hadn't already suffered enough publicly over the demise of his marriage, Irene was, insensitively as ever, bringing the debacle home to him again. The Rockwell marriage officially over, she headed back to Manhattan to begin a new one, meaning more publicity with his name attached.

Legal papers filed in the second judicial district court of the state of Nevada, county of Washoe, state that the divorce case was heard, without a jury, on mid-morning January 13, 1930. Irene, as plaintiff, appeared with her attorneys, the Reno lawyers Cantwell and Springmeyer. The defendant was not present but answered the complaint through his lawyers, Harwood and Diskin. Irene entered her testi-

mony and other evidence on her behalf; the defendant none. The allegations were found to be true, and all settlement arrangements, conducted outside of court, were declared to be fair and just. In spite of the fact that at this point in history the reasons for a marriage's dissolution had to be proffered, Irene's presumably (according to Rockwell's account) drummed-up charges bear the ring of truth. She claimed mental cruelty, declaring that her husband was always absorbed in his work and had persisted in telling her that they were not suited for each other and should get divorced. In light of Rockwell's tendency to deny the unpleasant as long as it was possible, it seems unlikely that he had actually suggested the divorce; instead, he may well have agreed in his out-of-court settlement that these were terms she could present without his contesting.

Five days after the divorce was granted, just enough time to allow the newly single woman to pack, get to New York, and unpack, on January 23, 1930, the Associated Press announced the marriage of Mrs. Irene O'Connor Rockwell, former wife of Norman Rockwell, the illustrator, to Francis Hartley, Jr., of Boston, Massachusetts. The wedding took place in Manhattan at Marble Collegiate Baptist Church. Inevitably, newspaper accounts of the wedding began or ended by referring briefly to Irene's recent divorce from the illustrator Norman Rockwell.

Rockwell could expect no sympathy or support from his parents, who, it appears, were still not speaking to him. Mary Amy Orpen remembers that "when Aunt Nancy spoke of the divorce, she'd say, 'It's just what you'd expect of that woman. I doubt that she helped Norman out much in the aftermath.' "

Because he showed so little emotion, it is hard to know exactly how deeply Irene's leaving affected Rockwell. Based on his actions not only immediately following, but for several years thereafter, it seems likely that Rockwell's inability to please his wife, to make her like him enough to stay with him, activated deep reservoirs of pain for him. He had earned his mother's respect through his success as an illustrator, showing her that he was superior to her father as well as her

husband, both in his amateur drawing and in his ability to make a good living. Now, as he confronted the specter of his socialite wife not finding "all this," as he said to her in wonder—nor his fame besides—enough to keep her from running off with another man, he started doubting his talent and his work in a more profound way than he'd ever allowed himself.

And yet, when Rockwell later told the story of his first marriage, he spoke dismissively, as if the relationship hardly mattered, although, in fact, he had been married a total of fourteen years. Mary Quinn, Rockwell's well-respected private nurse near the end of his life, will never forget her astonishment when she reached into the eighty-five-year-old man's bedside drawer to retrieve medicine and pulled out two old love letters from Irene. "I thought I was seeing things, and so I looked at the dates, which were in the 1920s. When I went into the drawer two weeks later, the letters were gone."

Whatever reason he had for keeping those letters for fifty years is a matter of conjecture. But in 1930, things were clear: Norman Rockwell was floundering, frantically looking for stopgap measures to help him avoid looking within.

15

❧

A New Beginning

The blind date in California went well. On March 27, 1930, approximately two months after Irene O'Connor Rockwell married Francis Hartley, Jr., newspapers announced the engagement of Norman Rockwell to Mary Rhodes Barstow of Alhambra, a suburb of Los Angeles. The papers duly noted the whirlwind courtship of two weeks' standing, as well as the social status of Rockwell's twenty-two-year-old fiancée. A graduate of Stanford University and member of Kappa Kappa Gamma sorority, she was related to the famous Gary family of steel millions. Her mother's cousin was Bertha Gary Campbell, daughter of Albert H. Gary, a lawyer for J. Pierpont Morgan and director of U.S. Steel.

Mary Barstow was fourteen years younger than her future husband. The sweet, smart, pretty, and innocent young woman had been teaching fifth-, sixth-, and seventh-grade mathematics in nearby San Gabriel, although what she really wanted to do was become a writer. She had enjoyed a few flirtations, but by and large she preferred books to boys. "Mary Sunshine," as she was known around the community,

had even dated Alan Hoover, Herbert's son, once or twice. "Everybody knew who she was," her younger sister Nancy recalls. "Partly because she always got top grades, that 'S' for superior they gave back then."

The Barstows lived at 125 Champion Place at the east end of town, in a spacious brown wooden house with beautiful gardens and an avocado tree "half the size of the house." Alfred Barstow, Mary's father, was a lawyer. "He always reminded me of Humpty-Dumpty," Jarvis Rockwell, the illustrator's oldest son, remarks. "He was a sweet, nice man, but fairly ineffectual lawyer. His wife, my grandmother, seemed much more in command. And her family had been so successful that I think she was a little bit scornful of her husband, who retired early."

According to Nancy Barstow, Norman was lucky that it was the school term when he arrived in California, since Mary ordinarily spent summers in Newport Beach and on the Balboa peninsula. Nancy remembers that Mary loved going out on the speedboat that a friend of hers owned, which she would drive around the bay. But now, in January, she was teaching school. A romantic by nature, she was ready to be swept off her feet around the time that Rockwell met her, and the idea of an older man and a dramatic courtship suited her just fine.

The illustrator recounted his relieved surprise upon first meeting the woman whom the Forsythes had been so sure of; she was every bit as impressive as they'd promoted. But he was discouraged when he called her afterward for a date and she begged off, saying she was busy. Until Clyde reassured his friend that Mary Barstow had indeed attended a P.T.A. meeting the night Rockwell had hoped to take her out, the illustrator was sure she couldn't be interested in "an old codger," a divorced man such as himself.

She was, and he pulled out all the stops to impress her. Since with Clyde's help he had arranged several interesting commissions in Hollywood, Rockwell's task was even easier. He had decided to do a *Post* cover about a "rawboned, glamorous cowboy . . . an actor dressed in chaps, boots, and spurs having his lips painted by a hard-bitten little

makeup man." The publicity director at Paramount proposed Gary Cooper, who was between pictures. The next morning, Rockwell remembers, "the door of the studio was quite literally darkened and Gary Cooper strode in. What a man! When I looked at him I actually *felt* my narrow shoulders and puny arms. He was a wonderful model and a very nice, easy guy. He was always playing some cute trick on Clyde and me—exploding matches, ash trays which jumped when you touched them."

Norman made sure to regale Mary with stories of his glamorous new acquaintances, years later teasing her that he had planted stars in her eyes. The illustrator put his imposing social skills to work in Los Angeles, before long meeting Fay Wray, best known for her role in the movie *King Kong*. Another Hollywood celebrity, gossip columnist Hedda Hopper, became Rockwell's friend and ally as well. In spite of his predilection for "just folks," the illustrator was savvy in the ways of self-promotion; by now, he had already developed his habit of whipping out his pipe as an identity prop whenever a photographer was in the area. And Rockwell respected, in a slightly obstinate fashion, the open artificiality of the Hollywood crowd; people here didn't pretend to be something they weren't, since their jobs were all about role-playing.

Although the *Los Angeles Times* had noted that Rockwell "was divorced recently at Reno," the local reporters nonetheless played gently with the Yankee illustrator from back East, who appears in the photographs of this period to be caught up in a movie that is wrapping too fast. In newspaper pictures of the beaming couple applying for their marriage license, Rockwell looks shell-shocked: slightly wary, a little disdainful, a bit calculatedly debonair. The *Los Angeles Times* reported that Rockwell gave his age as thirty-three on his marriage application; either they made a mistake in their reporting, or Rockwell was displaying a bit of uncharacteristic vanity.

Mary, in contrast, embodies a joyful, young upper-middle-class woman who is absolutely certain that she is doing the right thing. Within a few weeks, pictures of the couple at the time of their en-

gagement suggest that they are perfectly matched—the bride's exuberance shedding more light into the illustrator's guarded eyes with each passing photograph. By the time of their wedding on April 17, 1930, both seem to be romantically comfortable in a way new to Rockwell, at least. They touch naturally and easily, whether sitting out in the garden, at parties, or at city hall.

Their ceremony, held in the Barstows' luxurious garden, was performed by a Presbyterian minister. The wedding was well attended by family and friends, 140 party guests spilling over the semitropical grounds. Once again, Clyde Forsythe served his old studio mate as the best man. By the beginning of May the couple had returned to Manhattan, which Mary had never seen, and taken up married life at the Hotel des Artistes, where they remained for three months. Whether to return in triumph to the site of his previous humiliation, or to please his new wife with a suburban spread akin to her homestead in Alhambra, Norman decided that the Rockwells would take up residence at 24 Lord Kitchener as soon as the tenants renting the house agreed to move.

Without a doubt, Rockwell was smitten with the outgoing, enthusiastic, and intelligent young schoolteacher he so quickly asked to become his wife. But he was also transparently relieved to meet someone to replace Irene, the first schoolteacher-spouse meant to substitute for his mother and father. It takes no navel-gazing to glean the complicated dynamics set into motion by Nancy's critical, self-centered—yet, at some level, loving—mothering, and Waring's distant, authoritarian, but well-intended fathering. Rockwell's pithy self-pronouncements reveal much about his motivations. When, for instance, he said, as he did frequently, that one reason he became an illustrator instead of risking a life in "fine arts" was to please his parents, he told the truth. What he did not assess until much later, under the auspices of psychoanalyst Erik Erikson, were the ways he kept trying to compensate for the childhood he lacked, by positioning his wives to play out the roles for which his parents had only auditioned. He wanted someone to take care of him and his household in the very

ways Nancy had failed to do in his childhood home; and he deeply valued the chance to support such an orderly household through hard work that paid well, in contrast to Waring's life at George Wood's.

Little information exists about the couple's early adjustment to their marriage or to the trials of living among the very New Rochelle society that Rockwell associated with wastrels and moral frauds. Rockwell had returned to the same house given national coverage in *Good Housekeeping* three years earlier as his spousal home with Irene, bringing to it a new bride only six months after his first wife had humiliated him publicly. He encountered many associates from the old circles, the very atmosphere he felt had caused him to lose his way. Even when he had fled to Manhattan immediately after Irene's departure for Reno, he had felt himself played as the fool, no matter what he did. And yet, other than a letter Mary Rockwell wrote to the Barstows two years after the Rockwells' wedding, his only even oblique reference to the shame to which the divorce exposed him appears in his autobiographical account of feeling foolish in the eyes of others during his life in Manhattan immediately following the separation.

The return to Lord Kitchener Road also marked a sort of moral stubbornness as well as his characteristic denial of the unpleasant. Mary Rockwell racheted that denial up a notch, by virtue of her determined cheerfulness; and her emotional neediness found expression by making herself indispensable to her spouse, including living wherever he wanted. But the challenge of living in a community where he had been made to look extremely silly to many of the very people he continued to see professionally and personally fed Rockwell's incipient depression. "You see," Mary explained to her parents in the letter she wrote them in 1932, "for two years before we were married, while he was going with that crowd [Irene's social group], he was drawing on all his past reserve. After the divorce and our marriage, he was a different person entirely, but his work went on being the same." He tried very hard to "reconcile" the two—presumably the newly emerged man with the old art—but the attempt failed. Deciding that the memories and visual context Rockwell inhabited suffo-

cated him—"the pressure of people and things in New Rochelle was too much, though we saw them seldom"—the couple became desperate to escape the oppression.

After a few months of such worries, other priorities claimed their attention anyway. In late October, just six months after their wedding, Norman's father found out that he had stomach cancer. For unknown reasons, he and Nancy then moved a few miles away from their last rental, to Mount Vernon, New York, located within a half hour of Yonkers and New Rochelle, and an hour from New York City.

"It was the oddest thing," Nancy Rockwell would tell her relatives more than once. "The doctor came to see me one day, and he took Waring out of the room to examine him instead, and found out he was sick and I was not. Who would have guessed?" That Christmas, Jerry and Carol drove from Kane with their sons, Dick and John, to meet Norman's new wife and to say what they knew would be good-bye to Waring. They were struck by "how sweet Mary was, how truly gentle and sweet," according to Dick Rockwell. From Dick's admittedly vague recollection, it appears that the holiday was used to heal the rift between Rockwell's parents and the illustrator. All the family had gathered in one place, and everyone knew Waring was very ill; he was now on a pension from George Wood, unable to work for the first time in his adult life.

At least Waring had lived long enough to enjoy his younger son's extraordinary success. Six weeks after Christmas, the day after Rockwell's thirty-seventh birthday, the *Standard-Star* published a lengthy interview that led off by positioning Rockwell as an anomaly in the history of art: "There probably never has been in the world's history before an artist with a regular audience of at least 6,000,000 people, so may we please introduce you to Mr. Norman Rockwell, whose covers on *The Saturday Evening Post* are known, we venture to say, to every inhabitant of the United States." Rockwell's determination to be casual, relaxed, and "himself" early in his career paid off in the inevitable pleasure interviewers took in his company. But the authority and command behind the modesty failed to dampen his admirers' de-

termined infantilization of him; to the *Standard-Star* writer, for instance, he seems "like one of the whimsical, shamefaced urchins he paints so ridiculously true to life."

What appearance does New Rochelle's most famous "magazine artist" cut to the outside world? He is "tall, lean, and has bushy hair. He looks like an ad's ideal of the clean-cut young business man, only his eyes are more alert than even the ad could make them and he permits himself to be more frank and natural than other young gentlemen would dare to be." The description couldn't have conformed better to Lorimer's image of the perfect illustrator for his magazine if the Boss had written it himself.

A week after this interview, on February 10, Rockwell wrote Bessie Riddell, Lorimer's longtime assistant and de facto art editor whose upcoming marriage would retire her from the *Post* offices, that he was "delighted that you are going to be married. Life is incomplete any other way, and I know you are going to be very happy. The other feeling is sincere regret that you are not going to be my art editor any more. We certainly did get along swell together, didn't we? I hate to see you go. Believe it, it's going to be a real empty spot for me." He continues a bit later, "And I just want to say that the man you marry will get one of the finest women I ever knew. . . . Mary joins me in all the good wishes in the world." Rockwell's real fondness for the irrepressible Bessie Riddell, his own pleasure at being happily married, and his continuing friendship with "Joe Leyendecker" (implied in the postscript he appended)—this new abundance in his life receives testimony through the handwritten note. Only a year after he found himself adrift, it looked as if everything was on solid ground again. And he had recently been told the most exciting news of all: he was going to become a father.

But the price Rockwell paid for repressing and denying so much anxiety and turmoil would have to be paid, and almost as if the very security of his current surroundings allowed him to relax his vigilance, the depression he'd been holding at bay now surfaced.

During the summer of 1931, happy to play the part of a knowing, famous relative and relieved to feel pride again in the company of his

wife and her family, Rockwell generously wrote Mary's sister, Nancy, about her fledgling attempts to become an artist:

> Draw all day, cast in the morning and life in the afternoon, or vice versa. . . .
>
> The reason I keep harping on the drawing is that good draftsmanship is in more demand and better rewarded than any other department of art.
>
> Learn how to draw people sitting down, standing up or on their heads or any old way and your work will always be liked and wanted. . . . Many times in art school you'll hear the phrase "anyone can learn how to draw." This is one of the most ridiculous fallacies in the world, as only about ⅛ of the people who go to art school ever learn how to draw after years of hard work. . . . you'll hear plenty of fine talking from those who can't draw—all about abstractions of design and color and symmetry and all that sort of stuff.

Rockwell's irrefragable belief in the importance of drawing well fit squarely within the tradition of the greatest illustrators. Recently, N. C. Wyeth, like his teacher Howard Pyle before him, had become disgusted at the tendency of students to avoid "that vital necessity of knowing how to draw." Concerned that the current slew of art students was slighting the task, Rockwell emphasized the point to his sister-in-law: "There's one thing that all great artists have in common—when I say great, I mean really great—some have color, but poor composition. Some have great feeling but no arrangement. Some have lofty ideas but no color. But believe me they all can draw, because you can't express yourself decently without it. So Nance, old kid, let 'em laugh at draftsmanship, but he that laughs last lays the golden egg."

Mary especially appreciated her husband's taking the time to write her family back in California because she herself was feeling the burden of advanced pregnancy. The first humid air of the summer felt portentous to everyone, as family and friends watched Waring degenerate painfully, his naturally slight body wasting into signs of impending death. During the spring, Jerry and Carol and their two young sons

had visited the stoical man several more times. Nancy and Waring had decided to travel to Florida to see relatives, and no one expected Waring to return alive. On August 6, a month after Rockwell expansively wrote his sister-in-law, Waring Rockwell died in DeLand, Florida. And, on September 3, Norman's first child, Jarvis Waring Rockwell, assumed his patrimony. The illustrator became the New York patriarch. He joyfully took on the role of father and, far more uncomfortably, moved to ensure his mother's well-being, financially underwriting her move to Kane, Pennsylvania, to live with Jerry and Carol. Rockwell was relieved that his brother welcomed her. Nancy herself was deeply comforted by the new baby's birth; she wrote to the son of her dead brother Thomas that "I am so sad without Waring. . . . But the baby, named Jarvis Waring Rockwell after my dear husband . . . is great solace to me."

Before "Baba" could go live with her son and daughter-in-law, Norman had to loan Jerry the money to buy a house. During their first year in Kane, Jerry had rented a house on the south side of town, but the one they bought now was much nicer, with its large front porch, grand piano, and four bedrooms upstairs, the "huge" one for Baba. The combination of feeling responsible for both his mother and a new child added to the stresses that he was registering from other sources. Not at ease about his own finances, Rockwell realized that his investments were showing the effect of the Depression. The same portfolio of stocks valued at $38,000 the year before had now declined by 30 to 40 percent.

Yet for all his worry, Rockwell was better positioned both personally and professionally than he'd ever been. In accordance with the times, as well as in keeping with his own strict adherence to the domain of the studio, he did virtually no childcare. "He bragged about not knowing how to change a diaper even after I was born," his grandchild Daisy Rockwell remembers. Mary delighted in caring for little Jerry, however, though her first concern remained her husband's welfare, which meant, essentially, his career satisfaction. Luckily, in light of the Depression, it was a good time to be associated with *The Sat-*

urday Evening Post. As if the *Post,* along with the rest of the country, had recovered from the long party of the 1920s, in 1931 a leaner, more aggressive magazine suggested a new direction for the next decade. F. Scott Fitzgerald's exquisite melancholic story "Babylon Revisited" was published, and Sinclair Lewis returned to the *Post*'s pages as a Nobel laureate. Most startling, Lorimer had chosen to serialize Leon Trotsky's *The Russian Revolution,* granting a cachet of unpredictability at the very least. Perhaps the *Post* would prove capacious enough to give Rockwell room to grow.

Still, the artist found himself unable to kick his depression, the conviction that he was at a dead end, unsure where to take his talent, unconvinced he had staying power. From letters Mary wrote to her parents the following year, as well as from comments Rockwell himself made in the decades ahead, during the early thirties his ideas weren't coming like they used to; he felt his work for the *Post* to be stagnant, and yet even such disappointing results took him longer than ever.

Tom Rockwell, the artist's middle son, believes that the illustrator had never paused to calculate the costs of dealing with his failed first marriage, adjusting to a new one, confronting his father's death, and welcoming the birth of his first child. Instead, he exerted prodigious efforts to detour anxiety via his art—essentially the insight the illustrator himself maintained openly throughout his life. He focused his emotions in his paintings. Sometimes, in a circular movement, the work diminished as a result, making him feel even worse.

Rockwell's books on the life of the long-suffering Rembrandt were well-thumbed from the illustrator's earliest years. In his self-definition as a perpetual underdog and outsider, as Tom Rockwell puts it, Rockwell enjoyed identifying with others of similar psychological cast. Rembrandt had experienced deep periods of depression when his first and second wives died, ceasing his painting entirely for years. At other times, just like Rockwell, he scurried to take on as many heinous commissions as he could find, in order to make the payments on the lavish house he had built in Amsterdam to prove to others, including

his parents-in-law, that he was more than "just a painter." As one critic notes, "after years of trying to break out of portraiture and into history painting, he had condemned himself . . . to portraiture, to an endless scrambling for money, to a perpetual sensation of being behind, to an interminable scurrying for commissions to paint people he didn't like and a ceaseless avoiding of people to whom he owed money." Rockwell did not, so far, have to evade bill collectors, but he worried that such a fate might be his if he let up on his work.

Mary Barstow Rockwell, whom at least one of her sons would always think of as a kind of Pollyanna, had progressed overnight from the protected status of a sheltered young woman living with her parents to being the wife of a world-famous illustrator. To her everlasting credit, she proved herself up to the demands of marrying a depressed artist carrying a great deal of emotional baggage. In February 1932, when the exhausted illustrator decided that a dramatic shift of location would jump-start his imagination, his loyal wife promptly agreed, with only two weeks' notice, to move to Paris. On February 1, 1932, two days before Rockwell's thirty-eighth birthday, the artist had written his sister-in-law about the recent exhibit of Diego Rivera that he and Mary had seen in Manhattan, stressing Rivera's solid groundedness before the Mexican painter had dared risk studying in Paris. The illustrator also wanted to paint "his own art," informed by the best lessons of his elders and contemporaries as well. As his thoughts jelled, he had decided to follow the course so many young men had two decades earlier—he would chuck it all to live in Paris. Of course, he was not a young man, and it was 1932. The relocation was unlikely to result in radical artistic reorientation, and in his heart he must have realized that.

Fully aware of the challenges of moving to a foreign country, and armed with nothing but good intentions, adequate income, and a baby and family dog, Mary nonetheless encouraged her husband to seek his professional rejuvenation. Yes, she told him, we'll go to Paris, and there you will find inspiration.

What must Rockwell have felt, now that he had a helpmate who put his needs above her own? Mary's behavior contrasted starkly with

that exhibited by both his mother and Irene, and the grateful illustrator, always generous with his laurels, would have shared his pleasure with her. His gratitude, deeply and sincerely felt, would have egged her on, rewarding her for her complete focus on Norman's needs, on Norman's feelings, on Norman's life. Mary not only organized his home life so that he could work whenever he wanted, but she was available to him emotionally and socially the minute he called. The result? The couple grew to trust Mary's intuitive response to any crisis or more mundane aesthetic expression that Rockwell encountered.

They packed for at least six months abroad and sailed with five-month-old Jerry and Raleigh, the loyal German shepherd, to Paris aboard the R.M.S. *Mauretania* on February 28. Even though Mary Barstow had grown up comfortably, the social level of this shipboard experience dazzled her. From the "fried smelts rémoulade" to the "roast Pheasant à l'Anglaise," everything seemed exotic. In her letters to her family, the twenty-four-year-old woman wrote of the people they met and of her attempts to keep her husband company on deck while also tending to the often upset baby below. Mary especially worried about the artist's back, which caused him constant discomfort from an injury he received when he had tried to lift their Ping-Pong table on his birthday. Throughout the fall, he would require the services of an osteopath, and his daily work at the easel would literally pain him.

But for now, on board the ship, Rockwell felt new enthusiasm for his profession, armed with the certainty that something good would befall him abroad. And in truth, this trip, with his firstborn son and, finally, the adoring wife he had sought at his side, must have promised a kind of rebirth.

The results of his own self-consciously pursued renaissance, predictably, fell short of his hopes. Even in 1922, over a decade after Picasso had inaugurated a revolution in art, Paris had provided a near surfeit of pictorial riches, it is true; the variety of representational and figurative art expressed by those loosely grouped under the name School of Paris would seem a dispensation for the kind of work most congenial to Rockwell's imagination. But by 1932, the climate toward

such painting was shifting, and critics were restless for something new. Rockwell again had waited to make his bid to join the "real" art world just long enough that he was out of sync.

They docked at Cherbourg, arriving in Paris by train in the early evening. Before the couple even considered sight-seeing, the first order of business was finding Rockwell a studio. By the end of the first week in March, as Mary shares in her letters to California, the couple had found the "perfect" place, an old building being renovated, on the avenue de Saxe. "It has a direct north light, grey walls, and a coal stove and—piece de resistance—a couch and shelves in a corner all covered with deep wine colored velvet. It's really nice and the woman had an easel Norm could use. He bought a table, a stool, put out his sketches and a clothes tree with costumes until it looks very homelike and exactly the place to work." The couple had been staying at the Hotel Wagram on the rue de Rivoli until this point, and since they had now located Rockwell's workplace, they had a better sense of where to look for housing. Even without a home of their own, however, Mary found the radical change from New Rochelle wonderful: "I am beginning really to enjoy Paris. There is NOTHING like it. There isn't the rush and hecticness there is in America."

After a month and a half of looking for an apartment, on April 11 Mary and Norman found a "little villa with a garden," at the end of a "funny little street that ends against a pair of gates, where the only sounds you hear are convent bells and roosters." Complete with bowers of spring flowers, a fig tree in bloom, and wicker garden furniture, the furnished apartment within easy walking distance from the studio seemed perfect to the young, eager housewife. Although they signed a six-month lease for the furnished house at 12 Villa de Saxe, paying 3,500 francs a month, she imagined they would stay even longer, "as it is the absolutely ideal place for Norm's work."

It also seemed the ideal place for Mary, who wrote her parents that "I love Paris more and more and feel I could be perfectly happy here pretty nearly always. It is about seventy times as nice as New Rochelle and I think I feel more at home already. We never want to go back

there again, I am sure." The young woman merges her identity with her husband's consistently, a habit she would refer to ironically many years later, but one that, for the moment, granted her security. Her emotional dependency is understandable: not only had she married a man she barely knew; according to her sister, she had been warned by well-meaning relatives and friends that the famous artist had just gotten divorced, that it was dangerous to risk being salve for his wound—being a transitional relationship, a trophy for a man on the rebound. And, Nancy Barstow has explained, Mary grew up winning love from her stern, imposing mother by being the good oldest child, tending the others, making good grades, earning affection. Described as sweet and giving by almost everyone who knew her, Mary's goodness tends to obscure the reality that while her husband was often absentmindedly blind to her suffering, he did not ask, even implicitly, for the level of self-sacrifice she rejoiced in giving. Nor did he reject it. Whatever made her happy and did not get in the way of his work was okay by him.

A few days after Mary described Paris as paradise to her parents, the dutiful daughter—who would apologize to her parents if she went two days without writing them—nearly gushed in her excitement that her husband seemed to be breaking through the depression that had plagued him throughout their two-year-long marriage: "And now the best thing of all that I have to tell you is about Norman's work. The preliminary struggle—nearly two years long, has ended at last and he knows what he wants to do. He sent a final cable to Snyder and Black, refusing to do the Coca Cola, but letting them use his name. (He couldn't do less as he had seesawed between yes and no so long.) He has indefinitely postponed his *Post* covers. I personally rather doubt if he'll do any more. (Private, all this—I know you wouldn't tell it anyway.)"

Such news is astonishing indeed; the *Post* covers have always been considered Norman Rockwell's bid for as much creative license as his vocation warranted. That he not only now found them cumbersome, appropriating too much of his talent and time, but that he discussed

his new resolve with Mary persuades us of his seriousness, in going to Paris, to chance a dramatic new direction. The mess he got himself into with Coca-Cola typified what became a lifelong quandary when he refused to say no to a persistent client, then found himself unable to complete the project on time. Apparently, Coca-Cola worked out an arrangement with the artist by which several ads from this period were published under Rockwell's name but were largely executed by an anonymous second party. In the future, when Rockwell felt the need to renege on a professional commitment, he would simply bow out of a project completely or convince the company to postpone or abbreviate the assignment. His fame and good intentions compensated for the chance that hopeful corporations knowingly took (his reputation for delays and cancellations became legendary, the price for consorting with someone so popular) when they commissioned him anyway. But Rockwell never stopped agonizing over deadlines, and his tendency not to meet them.

He had actually made his radical decision to leave the *Post* before the couple sailed for Europe. Mary explained to her parents that he got scared of the idea of "so complete a change," and worked "furiously" to get four cover ideas completed as his security before they departed. She happily notes that she didn't think he'd actually paint the ideas once they settled in Paris, but she wisely kept this opinion to herself; proudly, she opines that her work to know her husband has paid off, since she can "prophesy" what he will end up doing "way ahead of time." Rockwell did find himself relying on her loving knowledge of him and his work before making professional decisions. To the extent that he could license such emotional luxury, Norman Rockwell was intimate with Mary. And until now, intimacy had been a stranger to him.

A week before Mary's excited revelation to her parents, Norman had made six separate beginnings on a *Post* cover, finally too discouraged to continue. Thoroughly bored with trotting out the "same old thing" for the *Post,* he believed the only way he'd be allowed to do something different was if he painted in an entirely new style. The ar-

tificiality of his attempts was all too apparent; he wasn't painting out of a conviction that the style under way felt right, but that it might be more contemporary. As Mary confides, "He kept worrying because he didn't really like most modern things and so wasn't going with the trend." He took the day off, hired a new model for the morrow, and spent several hours wandering around the Louvre as well as a modern gallery. Energized, he rushed back home to insist that Mary return with him to several exhibits, and they took the model as well, so that she could see the source of inspiration for the project she would be working on.

Unfortunately, neither the art he was scrutinizing nor the painting he then executed is ever named. Mary, unlike the New Rochelle so-phisticates who a few years earlier had considered a second trip to the museum redundant, found the Louvre, always Rockwell's favorite museum, "the most thrilling place I think I've ever been." After two more hours studying the paintings, they left, and Rockwell told his wife that on the following morning, he was going to begin the first of three days sketching around Paris. Taking his time and allowing his imagination to roam freely felt like a luxury to the man bound for over a decade to deadlines and correspondingly rigid work habits. "For the first time in his life he is going to be a free man and do every thing he really wants to do. Oh it's glorious!" his thrilled wife exclaimed.

At times, Mary Rockwell's relentless enthusiasm becomes tedious. Too aware of her good intentions, Rockwell would have hesitated to suggest she shape her life according to her own wishes as well as to his. Emotionally independent, used to fulfilling many of his needs without spousal help, he would have assumed she, too, had needs best addressed outside their marriage. Yes, he hoped for participation in his career, but he showed no signs of demanding the complete im-mersion that she gave. Eventually, inevitably, habit bred expectation. On the one hand, Mary's complete immersion in her husband's career connected them from the start at the level most important to him; at the same time, however, it set up a pattern, whereby her husband un-consciously assumed their intimacy to occur on the very level where

his person and his work were indistinguishable. Since Mary was determined to be a good wife, many years passed before she could acknowledge that her enthusiasm for the terms of their intimacy had waned.

One wonders about her parents' reactions to the ceaseless and circular theme of her husband's mental well-being: did they try to warn her that she was losing herself in the "we" she had started to invoke when speaking of Rockwell's work? On April 26, she wrote the Barstows a particularly convoluted, telling letter, explaining that Norman "has found the courage to do what he wants . . . which is experiment with all sorts of things for the next six months to become an artistic artist instead of a commercial one." She tells them not to fear that he will "go modern," since "[T]hat is his last thought. Never." For a time, she admits, that possibility worried him, until he made peace with his preference for the Old Masters. Now, "he's decided to be the thing that is in him to be—to do what he did, only in a much finer way."

To his credit, Rockwell tried hard to reinvent himself as someone free of the compulsion that drove his work—the desire for crowd adulation, for assurance that his work was seen by the masses and appreciated by many. Validation through his art was what kept him from regressing to the pigeon-toed beanpole of a nonman. But he also feared that the Golden Age of Illustration was dead, and that the divide between a "real" and a "commercial" artist was now absolute. His concerns were not that he lacked the talent to do the real art; instead, the ghost of apprehension flitting over Mary's letters is fear of the cost. He had achieved great fame, respect, and income; now, to risk being unappreciated or ignored must have terrified him as much as the thought of decades of more *Post* covers. And when, in an aside, Mary tells her parents that the magazines reassuringly keep contacting her husband, even in Paris, we know by now that she speaks for them both in these letters, not even primarily herself: "I must say it is gratifying to get cables from the *Post* and the *Journal* even though you [we, Rockwell] aren't doing any work."

The turmoil created by Rockwell's roller-coaster moods about his work surfaces in the near frantic shifts in Mary's correspondence, sometimes wildly contradicting the previous day's confident information. A week after the explosive news of her husband's change of direction, which must have shocked her parents, she wrote them that ". . . the important thing is about Norman's work. I last told you about how he decided to experiment. That didn't satisfy him for long so he and I thought and talked a great deal more, went to the Louvre and he decided that the only thing he really wanted to do was the same sort of thing he'd always done so we felt much better." He had restarted one of the canvases discarded a few weeks earlier, applying to it new ideas, and he was mollified (although her parents surely know by now, even if their daughter doesn't, that this, too, will change). And, Mary adds, they decided to move out of New Rochelle "the minute" they can find a colonial house in Connecticut situated on large grounds. "We couldn't stand going back to New Rochelle! But I honestly look forward to getting back and finding our place." Who really knows if Mary wanted to move to Connecticut, when she herself probably didn't?

The Barstows can't be blamed if they came to dread the mail; just noticing the manic swings in their child's married life would have justified any fears they had of their daughter marrying an older artist set in his ways. Perhaps they started worrying, too, about the reference to Rockwell's obsession with work that had been published as the grounds for Irene's divorce petition; it did sound as if all the man valued was work. No return letters to Mary exist, and very few comments in hers about them, to apprise us of their response. All that Mary's younger sister recalls are her parents' concerns that their child was a quick solution to the older man's wounded pride, and that she would not prove up to being in the limelight anyway.

But Mary had adapted well, to the extent that she ends up maternally reassuring them, a few weeks later, to calm their fears: "Please do not be worried about Norman, because there is really nothing to worry about. I meant to make it clear that he is just going through a

period of transition which is necessary to an honest artist when he is changing the purpose or direction of his work. Before he had few thoughts beyond *Post* covers. Now he wants to do much finer things, but of the same human sort, and probably he will do some covers again when he gets straightened out. . . . Neither of us is worried at all down at the bottom. We both know that he has to go through this to get out in the clear again. And because he has the courage to do it, he's bound to come out."

Week after week, as if enmeshed in ongoing negotiations of the most delicate, crucial sort, Mary reported on Norman's state of mind and progress. It is easy to imagine the readers on the other end making a game of opening her letters at some point, just to leaven the unending seriousness of the saga. Soon even biological and aesthetic procreation become coequals in the Rockwell household: "I have one big tremendous announcement to make—no, not another child—but its equivalent—a picture finished. . . . He worked terribly hard on it, but it doesn't look worked at all. [N]ow he feels he has something he can develop and go on and on with instead of working right up against a flat wall all the time as he has since we have been married. So it has all been worth while, all the agony and struggle he has been through."

Incredible as it seems, the family had resisted mentioning the obvious, though others had apparently urged upon the couple a recognition of Rockwell's state of mind: "By the way I give you people a tremendous long mark of credit, not one word have you said about depression and no one else has missed mentioning it. But then you're not a depressed kind of family, praise Heaven." In such praise lies the root of Mary's own denial of negative emotions, a habit that meshed neatly if dangerously with her husband's own.

Other than managing Norman's crisis, which was her priority, Mary concentrated on doing right by the baby—and, after her duties to both family members were done, enjoying her new life in a foreign country. She explained to her parents that Jerry was the best baby imaginable, but that because of Norman's needs, she found it impossible to give him her undivided time. On July 15, she detailed for the

Barstows the precise schedule by which she tended her child. In the middle of this letter, she reaffirmed their newest arrangement to return to New Rochelle in October rather than to stay on in Paris (an earlier plan), partly because Norman felt that he should see his mother. Also, she commented incidentally, "my longing for familiar things and sudden eschewal of drink and cigarettes would point to the fact that another member of the family is on the way, which I am very glad about as I am very fit—and much thinner—and feel even better than last time, and especially because Norm is SO tickled." After thus casually announcing her pregnancy, she immediately added: "I have other even better news. The day I have been waiting for two years arrived yesterday and Norman came home with the definite knowledge and feelings that his problem is completely solved and that whole new worlds are opened to him." Her husband had found a new method of executing the *Post* covers: "It will take him perhaps five days at most to do a *Post* cover now whereas before it took two weeks time, out of all proportion to their value." She exults: "And do you realize how entirely remarkable what he has done is? What perseverance and patience and every other good quality it has taken?"

It is amazing that at this juncture—the twenty-four-year-old woman pregnant with her second child—Mary considered it "even better news" that the anxiety over Norman's career was resolved. More astonishing still, she seemed to believe this resolution in spite of all evidence pointing to the continuance of the drama. Predictably, by the end of July, she was writing that they were now considering going to Manhattan to live: "We are thinking—only thinking so far— of taking an apartment in New York this winter which would be loads of fun. I've always wanted to live in New York in the winter."

By early August, her hopes were high: "Norm has just sent off two *Post* covers, and, now, having found a different technique in which he feels there are possibilities, he feels free to experiment to his heart's content, which means he is really going to be an artist." The real issue—and we can only imagine how it hung over the little household—was what Lorimer would say about the new technique. "Of

course, privately speaking, it is going to be perfect if the *Post* approves of his new covers and I've not the slightest doubt that they will; it will be so much velvet because it takes him about one third of the time it did to do them, so he can depend on one a month for income and spend the rest of the time painting from which there will also be income of course. So the struggle is really won." Not yet, of course.

At least while the Rockwells awaited Lorimer's judgment, Mary had a few weeks of hoping for "normalcy," whatever that must have come to look like to her. She confessed that she felt that she and "Norm" were starting out on a "normal sort of life" for the first time since they'd gotten married, because now, at last, Norman was straightened out. In an unusually self-conscious moment, she notes how "amusing" they must appear for changing their minds constantly; they'd decided to find a nice little New England town in place of Manhattan for the winter.

While Mary seems to have taken at least this brief moment to ponder her personal journey, by mid-August the Barstows were once more receiving letters centered on their son-in-law, although the writing reeks with anxiety that threatens to break through their daughter's optimism: "Everything he does now shows new advancement and new possibilities until I feel that he is really going to do great things. I know it and he must have every possible chance. Of course our present decision rests on what we hear from the *Post* concerning the two covers he just sent over. I have no doubt what we'll hear. Of course he has." She proceeds at a near manic pace to explain again the difference it will make if Norm can spend just five days a month producing income (doing a *Post* cover) and devote the rest of his time to painting whatever he wants. Believing himself liberated from the past as a result of his tenure in Paris, he has suggested that they stay there at least for the winter. If they were to return to New York, Mary clearly parrots her husband, it would mean being in New Rochelle for at least a month before moving to Manhattan, and seeing all their friends again would drag down the work.

But of course, within a few days, the Rockwells are again undecided. "The difficulty is that we are still awaiting word from the *Post*

about the two covers, which makes Norman just as upset as possible, though he is bearing up nobly and working on the Boy Scout calendar."

According to American friends who stopped in to visit, the artist was working nonstop, nobly or otherwise. Leah Parmelee and her four girls were on their way back to New York after a year of living abroad, and they arranged to visit with the Rockwells on their return to New Rochelle. Daughter Betty Parmelee recalls how happy Mary seemed, taking care of her baby; she also remembers that they didn't get to visit with Norman at all: "He was always off working, like usual; we never saw him." Mary eagerly prepared a lunch for them all, noting that her grapefruit cocktail, cold chicken and tomato, string bean, pea and cucumber salad (made, she told her mother lovingly, just like you make it), homemade biscuits and ice cream and cake all do her proud. Sounding incapable of being anything but giddy with happiness, the woman remembered by her children as rarely going near a stove if she didn't have to concluded her letter: "I really do adore cooking."

Social distractions such as the Parmelees' visit sprinkled Mary's days with some relief from her husband's relentless worry about Lorimer's reaction to his new paintings. Unfortunately, this wasn't a good time to appeal to the Boss's more liberal instincts. At the *Post,* workers were noticing the dark cloud Lorimer carried with him. He worried that Franklin Roosevelt's New Deal would be disastrous for the country in the long run; though he often explained that he agreed with some of the objectives, the president's methods for obtaining them were at the heart of the problem. More worrisome still, the muscular shape the *Post* exhibited at the opening of the decade had already gone flabby, as Lorimer published too many ghostwritten memoirs from stage, screen, radio, and government celebrities designed to stanch his audience's interest in glossier publications. Rockwell represented a failproof winning commodity, and the Boss was in no mood to indulge his major illustrator's wish to experiment.

As long as he worked for Lorimer, not only was Rockwell hampered in his desire to try new formal directions in his art; his subject matter was circumscribed as well. In particular, nothing controversial was to be part of the cover illustration. Such intransigence over the il-

lustration topics fueled Rockwell's need to find other ways to avoid repeating himself.

Apparently, though there is no record of the actual transaction, Lorimer rejected both of Rockwell's new works, nor do we even know what the pictures looked like. Whether the illustrator was devastated or relieved—most likely, at some level he experienced both emotions—he decided that he had to follow the path others thought of as his, and his little family returned to New Rochelle in October after all, taking the S.S. *Berengaria* back home.

Within a few months of their return, Rockwell learned that he was being included in the 1932–33 edition of *Who's Who*. Any hope Mary entertained that the honor would boost her husband's aesthetic energies quickly proved another chimera. At 24 Lord Kitchener Road, everything returned, way too soon, back to normal.

16

No Solution in Sight

Mary Rockwell spent the first part of 1933 getting a room ready for the child due in early spring; her husband plowed on in his studio, the weight of increasing financial responsibilities beginning to unnerve him. He had been earning around $40,000 annually for the past couple of years, which should have allayed his anxieties. He knew no one was immune from the Depression's reach, however, and he had learned how easy it was to burn through money. And his expenses were high; his itemized expenses actually amounted to about one hundred dollars more than his total income. His household costs totaled over $12,000; his insurance and taxes and dependents (including his mother) another $12,000; his studio expense almost $9,000; and household additions and painting over $6,000. And although he and Mary did not live acquisitively, they enjoyed being able to tend to their growing family's needs without having to cut corners. If they decided to take a trip, for instance, they wanted the money easily available, even on a whim. And when Mary saw the perfect transitional bed for little Jerry, she enjoyed buying it without worrying about the price.

On March 13, 1933, an unseasonably cold day, Mary gave birth to the Rockwells' second son, Thomas Rhodes Rockwell. Tommy's father had turned thirty-nine the month before, enabling him to joke that his energy for a baby did not equal that of a young man's. The drain on his physical resources came not from fatherhood, however, but from work, which in turn left him less to give as a father and husband than everyone in his family, including himself, would have preferred. But the painter knew no other way; his art came first, babies or not.

Mary's hope that her husband would become happy with his work after their return from Paris went unfulfilled, in spite of the ripe cultural moment that Rockwell, arguably, could have seized. During the thirties, a loosely termed movement that celebrated close ties to one's roots developed, a quasi-Romantic American regionalism. Among the painters who influenced such artistic currents at various phases were John Stuart Curry, Grant Wood, and Thomas Hart Benton. In their own way, the gritty American Ash Can painters of the twenties, whose stylized naturalism hovered over some of the *Post* covers a few decades later, served as precursors to these new realists.

If Rockwell had wanted to enter the world of "real art" according to his own lights, and leave illustration behind, it seems logical that he might have found a way to do so exactly here, among the Regionalists. In wealthy Westchester County alone, the aesthetic efforts of the government's intervention—the 1933 Public Works Administration and its offshoot, the Works Project Administration, two years later—left their imprint on everything from murals in post offices to the newly redesigned parks and graveyards. The kind of art that thrived under such patronage tended to be regional in nature, dedicated to representing somberly the reality of the ordinary person.

Mary Rockwell's letter of 1932 had reassured her parents that "Norm" would stick with representation—his trips to the Louvre had convinced him to be true to himself—but it would be a new art-full representation. As the *Washington Post* critic Paul Richard noted in 1978, Rockwell could be said to stand halfway between the bookends of American realism, Thomas Eakins and Richard Estes. Why did the

artist ignore the obvious possibilities suddenly open to him in the 1930s?

In light of the identity Rockwell later assumed as an avatar of the New England homestead, an integral part of the mythological landscape of rural America, it is startling to confront the lack of rootedness that lay at the heart of his art. He had not developed a strong sense of grounding in any one place either by temperament or through childhood experience. In spite of having spent almost all of his childhood in New York City, he limned that experience as a lack rather than the fullness that urban identities provided to other artists. And rootedness was integral to Regionalism. Historian William Graebner has argued convincingly that the artist was not comfortable with the local, relative quality of the individual embedded in a particular society. Previously a master of mass culture in the 1920s, when the absence of strong ties to family, friends, and a particular community, accompanied by pleasure in social mobility, defined the period's common values, Rockwell lost his way during the following decade, when his dependence on the individual-as-universal lost its meaning in the context of the Depression.

"What was missing [in Rockwell's paintings of the thirties] were the grounded, placed, and ultimately political voices of the Great Depression: the cotton farmer in Alabama, the steelworker in Gary, the retired couple in Long Beach, the housewife in Des Moines," Graebner comments. But what else would we expect, the historian shrewdly points out, from an artist whose autobiography uses a Dickensian lens to focus on the importance of the grounding he himself lacks, and therefore idealizes: "My address," said Mr. Micawber, "is Windsor Terrace. . . . I live there." In choosing this line as his autobiography's first quotation from Dickens, Rockwell implicitly reminds us of his own childhood traversed by too many moves and too much uncertainty to root the artist to his landscape.

Taking the measure of things through the surface fits well the tasks of an illustrator, and Rockwell's distant father, difficult mother, and first marriage whose emotional heft barely registered over fourteen

years set him up neatly for his job. He would explain in 1959 that "the surface of things is very important in illustrations—the kind of clothes people are wearing, the houses they're living in, what they're talking about." To enter the world of "fine art" proper, even through the apparent friendliness of Regionalism, would have required a psychology the painter lacked.

Although not a superficial person in the ways the epithet is most commonly invoked, Rockwell continued throughout his life to live on the surface of things. Now, in 1933, he conscientiously tended to his mother's needs, for instance, by assigning her personal care to his wife, while he made sure to pay her bills—and tactfully at that. In early November, the month that Mary turned twenty-six years old, she and Norman installed Nancy in a boardinghouse in New Rochelle. After a year of the sixty-eight-year-old woman living in Kane, her oldest son and his wife had had enough of her—or at least Carol had. Nancy's habits and relentless whining, interspersed with praise of whatever family members lived anywhere but here, proved far too much for Carol Rockwell's own demanding personality. "She paced up and down, relentlessly, making a very hard to describe sound with her throat all day long. My mother just couldn't stand her. Plus she demanded such attention and care all the time," Dick Rockwell recalls.

Without complaint, after her expulsion from Kane, Norman had immediately set his mother up in Providence, Rhode Island, with her cousins. But "Ma" had quickly tired of that arrangement, and she wanted to be near one of her sons. Mary, determined to make her happy, ensured that the querulous woman spent much of her time at their house. For her daughter-in-law's birthday, Nancy gave her a new copy of *Anthony Adverse,* a Victorian novel that the grateful young woman immediately began reading aloud to her husband. She wrote her own parents that her little New York family was happier than ever, especially, she adds, "as I really feel Norman's work is going to go well." Clearly the major theme that determined the tone of the household remained Rockwell's attitude toward his work.

Mary had helped Nancy Rockwell organize her belongings in Providence for the move to New Rochelle, and she unpacked for her once

they were back in New York. Although she admitted that "everyone in Providence [the cousins] said that she was difficult etc.," Mary believed, after three weeks of being around Nancy Rockwell, that all the older woman needed was a little "thoughtfulness," and she committed herself to making her mother-in-law happy. "I can do anything to keep Ma happy—and she is so darling and grateful for anything I do—and adores the children so that it is a pleasure to do it." Although Mary Rockwell's determined good cheer commands respect, her sons' uneasy sense that it came at a cost—that she, in a different way from their father, flinched from reality—seems consistent with the positive spin that pervades her letters regardless of the subject. Still, the natural goodness that the admiring Rockwell always believed to characterize his wife seems a valid appraisal from the evidence of her correspondence as well as acquaintances' memories of the way she treated those around her.

Mary's determination to emphasize the positive in her mother-in-law didn't rub off on her husband, who found Nancy's presence a real hindrance to his work. When she wandered out back to his studio and forced him to paint to the tune of her throat noises, he asked her to sit outside instead, if she really wanted to be near. She perched on his studio steps, a presence just beyond his door. More than once, she volunteered her son to speak at local women's associations in which she participated. Mary's enthusiasm, endless as it seemed, dissipated under the pressure of her mother-in-law's relentless requirement for "thoughtfulness," so that within the next year or so, Nancy Rockwell was shuffled back to Providence.

By early 1934, Rockwell needed even more mental room than usual to focus on his work anyway, now that he was allowing himself the occasional license to take photographs from which to paint, instead of depending exclusively on live models. After Franklin Roosevelt became president, the federal funding of various arts, especially as they documented government activities, furthered an emphasis on documentary-type realism, which in turn helped elevate photography into the art that Alfred Stieglitz had pioneered years before. As the younger illustrators incorporated the use of the camera into their de-

signs, creating more sophisticated work than was possible from real life, Rockwell was torn; eager, on the one hand, to experiment with the new angles and perspectives that his colleagues were achieving, he couldn't shake his feeling, on the other, that the camera was a kind of cheater's tool. This line of thinking was undergirded by Joe Leyendecker's distaste for the very idea of using photographs; Rockwell shared his friend's concern that art students just starting out would start neglecting their drawing skills.

Regardless of the justice of this latter fear, the noise about cameras inauthenticating the illustrators' work was illegitimate from the start. Too many examples of brilliant artists' dependence on some variant of photographic reproduction—from Vermeer to Ingres and Matisse—are well known to imply otherwise. Rockwell developed his own ways of distancing himself from the helpmate, conjoining the best of two traditions. As a result of his lifelong ambivalence toward using photographs in lieu of live models, he not only paid others to take all the pictures—unlike most illustrators, he took none of his own—he nearly always hired unskilled workers unrelated to the art world, and then taught them how to take pictures for him, as if to emphasize that anyone could do this part of the job. He legitimized his use of the camera by deemphasizing its importance to the enterprise.

During this period of agonizing over how to move his painting forward, including incorporating photography into his process, Rockwell decided that he would enjoy returning to book illustrations, especially since that was the venue for the greatest illustrations of ages past. Although his published series of figures from American literature, including most notably paintings of Louisa May Alcott, author of *Little Women,* dates from the late 1930s, his friend's daughter Betty Parmelee dated at least some of the work from this year: "I recall that I posed for Norman a few times during 1934 for a series of characters in American literature. Mary would sit and read to him while he worked; she was so sweet and dear, always." Because the Parmelees had shared the sad news with their friends that they were moving to Florida—the Depression had dried up Dean's sources of income in

New Rochelle—Betty believed the artist wanted to use her before he lost the chance. Such a contingency of painting from live models—their availability—was another factor urging Rockwell to succumb to the camera.

Two years after Mary's buoyant letters to her parents about the Paris visit meant to relaunch her husband, he was still searching for his way. For their first family vacation, he asked Mary to spend several weeks in Provincetown, where there would be other painters to inspire him. Site of the painter's Cape Cod summer idyll almost twenty years earlier, it was a perfect place for swimming and sailing, both of which Mary loved. In a letter to her parents anticipating the trip, Mary earnestly explained that "[Provincetown] is an artists' colony into the bargain which means it and the people will be quite unlike an ordinary summer place and thoroughly interesting."

No notes on the summer remain, but a later neighbor and friend of the Rockwells, Leah Schaeffer Goodfellow, recalls that both Fred Hildebrandt, Rockwell's favorite male model, and Leah's father, illustrator Mead Schaeffer, met with Rockwell during the vacation. They all were at Provincetown together, which may have been the result of deliberate planning or simply a case of like people choosing the same vacation. Schaeffer and Rockwell both used Fred frequently enough that the illustrators ended up consulting with each other before working the model into their schedules. Rockwell may have ensured that Fred was in residence; combining work and supposed summer pleasure was a pattern that had been firmly in place during the decade of vacations at Louisville Landing.

The summer proved full of distractions for the artist; Mary's family visited from California, Ma Rockwell continued to find new ways to place demands on Norman and Mary, and the Provincetown vacation itself, accompanied by a toddler and a baby and a palette, was far from total relaxation. Norman's focus was under constant siege. One indication that the summer left too much stress behind is the trip he made with Fred Hildebrandt into the Canadian wilds soon after. Uncharacteristically, during the weeklong journey he kept a diary, which

yields unexpectedly sweet, personal insights into the private man. The little journal is especially significant, because no mention of the trip exists otherwise; nor did Rockwell share the diary publicly. More of a sportsman than he ever admitted to being, and prone to missing his family and worrying over children not his own, the artist seems markedly less theatrical when writing for his eyes only. The account also captures Rockwell's impressive intelligence, his quick and shrewd assessment of situations and people, and his limitless curiosity and detailed observation of the world around him.

He and Fred arrived in Montreal on September 3, hoping to start their trip off with a baseball game, but finding instead that they had to board a train for an eleven-hour ride immediately. For the next seven days, the two men and their guides canoed through gales "blowing right in our faces," confronting "rain squalls and continuous wind." Sometimes the going was especially rough, or the environs awesome: "Hard paddling against it [the weather]. Kept thinking of Jerry's remark 'Hard work, Daddy.' One guide saw moose, we saw a mink and a muskrat. All this country has never been timbered. Virgin forest and innumerable lakes and connecting rivers."

The small group broke camp every day or so, paddling furiously to arrive at the next location where they hoped to bag a moose, and where Fred anticipated unparalleled trout fishing. Rockwell was far more interested in the former than the latter, although the guide's ability to stalk partridges and bring them down with a rock—"by the way, we have no firearms"—commanded his greatest respect. At one point, he wrote that "before lunch, I was terribly low, wished I was home, lonesome of [sic] Mary, Jerry and Tommy. Tried to figure out how I could get home without losing face altogether." Then, with the whimsical wryness characteristic of his humor, he notes, "but after the weather cleared and I caught the fish, I loved my family no less but I was more content."

The subject of family was not far from the artist's thoughts throughout the trip. When an owner of the camp company brought his children to bunk with the men one evening, Rockwell noted with

concern the children's apparent poor health; they were too thin and coughed too much. He observed worriedly that "[the parents] seem very fond of the children but take no care of them. . . . One by one the kids practically collapse of fatigue and sleepiness and they are stowed in the rough camp beds. . . . They are all girls but one and all but two are very sickly looking." His own charges back in New Rochelle had been much on his mind just before picking up the five children at the landing; while fishing that afternoon, the group had heard someone calling out to them, and Rockwell was "afraid it was a telegram from home."

At the end of the weeklong, seven-mile canoe camping trip "all upstream," Rockwell concluded his diary with the type of jocular adieu he habitually adopted when he felt happy: "Here we sit writing the final words of this testament and how are you?"—akin to Robert Browning's cheerful "God's in his Garden and all's right with the world." Twenty-five years later, he would end tapes he recorded after a day of studio work similarly—if he was pleased with the work.

Back home, working in the midst of a supportive spouse and two small sons who adored him, Rockwell soon had even more cause to appreciate his good fortune, even as he mourned someone else's sad fate. On November 4, 1934, his ex-wife Irene O'Connor drowned in her bathtub, a probable suicide. For the previous two years, the poor woman had been a patient at McLean Sanitarium, whose manicured lawns and Adirondack chairs, with upper-class clientele to fill them, failed to suggest the degree of suffering behind the expensive walls.

She and her aviator husband had barely been married for two years when she entered the institution, located within an hour's drive from their home, a widely regarded sanitarium and Harvard University teaching hospital associated with Massachusetts General. Although it had undergone some rough financial times in the twenties and would face harrowing financial constraints in the decades ahead, the thirties were an especially strong period for McLean, whose policies were by and large among the most liberal and humane of early and mid-century hospitals for the mentally ill. At this point, very little existed

between the two extremes of treatment facilities—expensive private institutions such as McLean, and state-subsidized asylums. At the upper end, treatments were still based largely on whatever method seemed to placate the patient best, whether it be playing tennis, hydrotherapy treatment (jet streams of water aimed at their bodies), or basket weaving, contributing to such institutions being sneered at for their country club airs. Very little medication was available, and trained psychoanalysts were just beginning to inhabit the scene.

Within the subsequent decade, insulin shock treatment and electroshock therapy would be employed, and the first significant line of pharmacological intervention developed around the same time. But none of these methods was available in the early 1930s. Serious, rigorous, and humane medical intervention was, however, consistently attempted at McLean. The year of Irene's death, the annual report announced that "three patients had been treated by [the new method of] 'orthodox' psychoanalysis." At the time of Irene's admission in 1932, she and her family would have been informed of the talking cure. But those treating the mentally ill with every resource they could muster often expressed despair at their low rate of success, and with the still primitive state of their knowledge of mental disease.

Given the confidentiality of such medical records as well as the lack of surviving family, no way exists to confirm Irene's diagnosis but, at the time, the majority of McLean's 250 patients were determined to be suffering with manic depression, then classified as a psychosis. Years later, this diagnosis would be refined to reflect the various faces of depression, of bipolar disease, and of mild schizophrenia, in the process downgrading all but the last to neuroses. Still, being hospitalized at McLean for two years suggests that Irene was seriously ill, whatever her condition was called. She must have despaired of her future, since the modalities of treatment would have implied its probable bleakness: as the hospital history explains, and the yearly bulletin made clear even then, "Recently admitted patients with acute illnesses [are] more likely to receive substantial psychotherapeutic attention than the presumed chronic or demented for whom there [is] scant hope of improvement."

Although newspaper accounts—inevitably noting her connection with Rockwell—claimed that she had drowned in her bathtub at McLean, her death certificate makes it clear that she died in her tub at home in Brookline, Massachusetts, near Boston, where she lived with her husband. The death certificate also rules the death from water in the lungs an accidental drowning, but those who have researched the circumstances all believe that Irene committed suicide. Only four months earlier, the forty-one-year-old patient, heavily dependent on her mother all her life, had faced the death of the older woman. Possibly Irene had finally left the hospital in order to attend the funeral, declining to return. In any event, she died at home.

It seems likely that Irene had suffered with some symptoms of her disease during her fourteen years with Rockwell. Pictures of her in her early twenties as well as associates' accounts of her behavior suggest a personality that alternated between extreme melancholy and wild bursts of energy and activity. Her erratic behavior toward money—on the one hand, holding it up as her god, on the other, investing her husband's $10,000 in a boardinghouse acquaintance's scheme—matched her refusal in late 1929, on Rockwell's frantic entreaties, to consider her probable new financial situation if she left Rockwell for a chemist. Nor could the new life she traded for the one in New Rochelle have come close to granting her the prestige she had previously enjoyed as Rockwell's spouse. For more than a decade, Irene could claim the center of attention easily, as the wealthy, attractive young wife of a famous man who would have happily remained faithful to her and their marriage had she been interested. It is unlikely that the hard-hitting risk taker Francis Hartley, bound for the 1938 Olympic Games, shared the same virtues as Irene's gentler first husband.

Even if Rockwell somehow avoided the plentiful newspaper accounts and the gossipy friends eager to fill him in, he undoubtedly would have been informed of Irene's death by her brother, Howard. Hoddy, unlike the rest of his family, had remained in New Rochelle, and he bragged of his closely sustained connection to the artist, decades after it had in fact been rent asunder. "His assertions weren't exactly true," attests Tom Rockwell. "I got the feeling my dad thought

Hoddy was a character, and he always enjoyed such larger-than-life people. But that was all. I myself went to meet Hoddy when I was trying to piece together Pop's life. He was just as Pop had described him, including his huge hamlike arms, which he showed off to me as proof of his strength; and he told me one of the most vulgar jokes I've ever heard in my life." Hoddy, alone of those who knew Irene, insisted that his sister could not have killed herself.

Thirty years later, the perfectly lucid illustrator would feign forgetting that he had ever been married to "that pretty girl who lived in my boardinghouse," to the astonishment of those present. Whatever the fourteen-year marriage had meant to Rockwell, his illogical, complete denial of Irene's existence in itself hints at the significance that her leaving him held. Her bizarre death, given Rockwell's propensity for avoiding exactly this kind of ugliness and in the context of their divorce having occurred only four years earlier, must have been "unsettling," to use his favorite word for circumstances he tried to avoid.

Major life changes seemed consistently in Rockwell's purview during this period, including the professional leadership he took for granted. For the first time unsure of the country's pulse, George Horace Lorimer found himself responding defensively to his critics, who incorrectly reduced his politics to knee-jerk conservatism.

Although worried whenever word went out that the *Post* was experiencing turmoil, Norman was far more engaged in the public's response to his art than in their reaction to Lorimer's leadership. Every bit as entwined with the readership as was the Boss, Rockwell took the measure of his success through his fan mail. At the end of 1934, concluding the year on the same note that it had begun, Mary Rockwell wrote her family happily about the latest signs that her husband's now four-year-long depression had run its course: "At the moment I am awfully excited. I've just opened the mail. Altogether in the last three days Norman has gotten at least twenty letters on his last *Post* cover—the most appreciative letters—which is only another indication that he's all straightened out at last—life is interesting not to say exciting." It would never be anything less.

17

⚜

Reconfiguring

Mary's optimism aside, her husband still saw no way to escape what he considered his dead-end path—churning out, with enormous expenditure of energy, cover after cover for *The Saturday Evening Post,* receiving the praise of readers grateful that "their" artist wasn't like those "real" modern artists. Years later, after this line of praise became constant, he told his youngest son ruefully, "Just once, I'd like for someone to tell me that they think Picasso is good, and that I am too." Instead, he received praise such as that lavished by the Heritage Club's monthly publication to its mainly well-educated middle-class members: "Although some may say that Picasso is a better artist than Norman Rockwell, although some will say that Thomas Hart Benton is a better artist than Norman Rockwell, it cannot be denied that Norman Rockwell is the best known artist in this country: his name is known in household, cabaret or farm. And this is because he paints like an imp."

Infrequently, an artist whom the illustrator respected would dare to assert a contrarian opinion of Rockwell's value. George Grosz, the

German Expressionist, insisted, "He has excellent technique, great strength, and a clearness of touch that the old masters had." Grosz, whose earlier roots in Berlin Dadaism and whose harsh caricature of the German bourgeoisie would not have made him an immediately obvious choice to defend Rockwell, believed that "his things are so universal that he would be appreciated anywhere."

In 1935, Rockwell was offered a prestigious commission that reminded him of the historical antecedents that had motivated his love of illustration. The chance to place his name next to those heroes who had illustrated the classics helped to reinvigorate his stride. The occasion was the centennial year of Samuel L. Clemens's birth, and one of Rockwell's greatest admirers, George Macy (of department store fame), decided that his Heritage Press should publish new editions of *Tom Sawyer* and *Huckleberry Finn*. Although a few well-known illustrators had taken their turn at the books, a stellar performance akin to that achieved by H. K. Browne or Edward Kemble for Dickens had eluded them. Even Howard Pyle and N. C. Wyeth had illustrated a few of Twain's texts, but nobody had gotten his two most famous works quite right yet, at least as far as George Macy was concerned.

Rockwell could even claim that Clemens, or Mark Twain, as he was known to his public, already flowed, albeit weakly, through the bloodlines of the illustrator's family: Twain had been a weekend houseguest of Uncle Sam Rockwell's wife around the time that Waring and Nancy were getting married. A more specific kinship surfaced when Rockwell discovered that Twain seemed at least a blood brother to himself, another artist who created out of the same compensatory needs that Rockwell did. The match of raconteurs, author to illustrator, seemed ideal. Almost in wonder, Rockwell related to a contemporary writer the story of an old judge who had known the author as a young boy: "He told me that Sam Clemens was really a sickly, sensitive boy, so what he put into his stories were the things that he would have done had he been stronger—things that he no doubt dreamed of doing. If he had actually done these things, possibly he would have been such an extrovert that he could not have written about them."

Part of the project's appeal to Rockwell was the mandate (from the ghost of Pyle as well as the very alive George Macy) to make such classic illustrations historically accurate. Rockwell set out to explore Hannibal, Missouri, making much of the fact that no previous artist had bothered to authenticate his illustrations for Twain. As if this assignment fueled his confidence in his future, Rockwell finally justified to himself using the camera to prepare properly for the final oil paintings. Now, when he was following in the footsteps of Howard Pyle, and joining a very select club of those chosen to illustrate the classics, he could appeal to his own instincts, and his own desire to move forward and transform his talent into the next stages.

He developed a routine, wherein he drew from live models back home and relied primarily on photographs on site. Quickly, he learned the merits of the camera over live modeling in almost any context. Previously, a painting had required an average of three days with each model; when the models were animals or young children, the process stretched out even further. Relying on live posing also limited the contortions he could demand; a child, especially, could only hold a difficult position for a short period of time. He was correct that his reputation would suffer when word got out that he had caved in; Edward Hopper was to say that he had "nothing but contempt for Norman Rockwell," whose paintings were all done from photographs "and they look it, too." But, as usual, the artist simply decided to do what would serve his art best and turned a deaf ear to the critics.

Rockwell read the Twain texts carefully, sketching in the margins his concepts for the scenes he considered most vivid. From the often tiny gestures he scribbled, his accretive method of working shows clearly. A moment here, another one a few paragraphs later, and within a few pages, a full-concept sketch emerges. Certain constraints were clear from the start: he needed to spread the color plates fairly evenly throughout the books, and Macy had limited the number of illustrations to eight color plates per book. Other than these requirements, he was free to collaborate with the muse of Mark Twain.

The illustrations are generally considered a great success, and Rockwell himself was very happy with the results. The *Tom Sawyer* collection, published the following year, employs the caricature of Rockwell's 1920s paintings of children and their adventures, while the *Huck Finn* series, published in 1940, leans far more in the direction the illustrator would travel in the late thirties, toward a grittier, detailed realism expressed in a more painterly fashion. Rockwell's contrasting treatment of the two stories clearly aims at implying the duality of Twain's texts; those who do not admire the results usually find the cartoony *Tom Sawyer* figures unworthy of the subterranean pressures of childhood implied in Twain's work. Nonetheless, Rockwell's illustration of, in this case, the perhaps too aptly named whitewashing scene in *Tom Sawyer* remains one of his most widely circulated illustrations: in 1972 the U.S. Postal Service issued the picture as a stamp.

The town of Hannibal, Missouri, expressed no reservations either, and George Macy was truly delighted with the illustrations, especially for *Tom Sawyer*, which were delivered in a more or less timely fashion. Hannibal's Chamber of Commerce begged Rockwell more than once to loan the original oils to its local Mark Twain museum. In January 1939, when the town museum was forced to send the paintings to a temporary exhibit in New York, local civic leaders wrote Rockwell detailing what a loss it represented to their institution: "Last year we had more than thirty-four thousand visitors who took the time and trouble to register at the museum," they explained. Groups planned their vacation around Hannibal, the letter informed Rockwell, because they'd heard that the oils were on display. Please, the Chamber of Commerce entreated the artist, return the oils to their temporary home as soon as possible.

At the end of a year crowned by this jewel of an assignment, Norman Rockwell felt that he might be back on track again. Mary, naturally, was thrilled that her husband was in such good spirits and that his friendly nature was coming to the fore as a result. She had always enjoyed being around other people, and the years of her husband's de-

pression had too often been emotionally lonely ones for her. Rockwell, aware of the sacrifice his work exacted from her, set about making more of an effort to socialize. On December 31, 1935, the Rockwells were guests at a wild New Year's Eve party at the Waldorf Astoria, where they enjoyed themselves enough that they mentioned the event in future years to their children, including their youngest, who was conceived, they believed, on that very night.

That magical evening did indeed mark a turn for the better. In 1936, the Nassau Inn in Princeton, New Jersey, commissioned Rockwell to do what would be his only mural, a detailed historical vignette of Yankee Doodle, 60 by 152 inches. Closer in spirit to Hogarth than anything else the illustrator did, the painting proceeded by starts and spurts, while Rockwell continued to work on the Mark Twain paintings alongside the *Yankee Doodle Dandy*. During the nine months that he worked sporadically at the Princeton project, finally mounted in 1937 onto the wall where it remains, he also began work on a series of literary figures, including a mannered, eerily compelling Ichabod Crane that would have unnerved Washington Irving himself. Regrettably, the paintings were never published, but Rockwell's new confidence shone forth in their execution. Keeping company with authors he considered worthy of the best art could offer had proven to be the jolt to his system he'd been looking for.

His newly elevated spirits allowed his lighter side to take over for a while, and events that would have stung him earlier actually amused him for a while. He and the artist Rockwell Kent had, for some years, been regularly confused for each other. Especially since the openly left-wing Kent was viewed suspiciously by many of the conservative Americans who embraced Rockwell, the confusion had continued to amuse both sophisticates, far more than their publics. Both men wrote an amusing and good-natured vignette for the spring 1936 volume of a quarterly for "bookmen," *Colophon,* contrasting the perils and pleasures of being mistaken repeatedly for each other.

Such a forum proved particularly gratifying in light of the (admittedly short-lived) feature inaugurated that year by the *Post,* a book-

review section defiantly called "The Literary Lowbrow." A kind of re-
verse snobbism, Lorimer's anti-intellectualism seemed to be going out
of its way to offend the literati. And yet there could be no doubt of the
cultural clout the *Post* still carried. For instance, although every noted
illustrator in New York had practically begged Hollywood to take a
look at a model in consistent demand for magazine cover poses,
Mardee Hoff, only after Norman Rockwell used Hoff on the *Post* in
March 1936, posing her as a movie star on tour, did the studios take
notice. The day the *Post* hit the stands, three movie companies wired
Lorimer to get the model's name, and Twentieth Century–Fox had
placed her under contract by the end of the following week. When
asked by one of the Fox executives why he hadn't been told of her ear-
lier, Hoff replied, "You have. I'm the girl Mr. Rockwell and Mr.
[Joseph Medill] Patterson have been telling you about for two years."

Regardless of the cachet the *Post* conferred in certain circles,
Rockwell understood by now that critical respect and his own per-
sonal satisfaction would largely lie elsewhere. He spent the summer
working on the mural in Princeton and on sketches for various Amer-
ican classics that he hoped could be produced as a series. Usually a
time when he tried, however unsuccessfully, to slow his pace, sum-
mer this year was a time to focus even more than usual on his work,
as the Rockwells' third child was due in early fall, and he wanted the
security of finished work by the baby's arrival. His extra efforts and
Mary's saintlike patience with them seemed worth it when, on Sep-
tember 16, 1936, Peter Barstow Rockwell was born.

Over the next few months, Rockwell heard rumors that some big
changes were about to occur at the *Post*. He couldn't allow himself to
worry about what the gossip portended, because he had too many
commissions he needed to focus on. Having another baby in the
household didn't affect him very much, since he allowed nothing to
throw off his daily work routine. But thinking about the future of the
Post could really trip him up, so he put such thoughts aside.

Toward the end of the year, however, a few days after the nearly
three-month-old Peter had been baptized at the neighborhood Epis-

copal church, Lorimer tearfully explained to Rockwell that the board
wanted a younger man to take over the leadership of the magazine.
The Saturday Evening Post had lost touch with the nation's mood, and
its publishers believed that new blood was needed to realign the mag-
azine with its age. During the twenties and thirties, Lorimer had stri-
dently promoted his vision of a nativist America just emerged from its
Old World cocoon. Determined to convince the nation to embrace
isolationism and to bandage the wounds of the Great Depression
locally rather than through federal intervention, he had ended up
sounding more melodramatic than romantic in recent months. And
yet, when the December 26 edition of the *Post* informed its readers,
through the first signed editorial in its history, that the Boss was retir-
ing, it was easy to understand the ambivalence even of those who had
sought the change. Lorimer's politics had always been far more com-
plicated than categorical, as this crazy mosaic of liberal and reac-
tionary measures reflects:

> For many years we have advocated the protection of investors; proper
> regulation of child labor, particularly in the mills, the factories and in
> some farming operations; slum clearance; the conservation of natural
> resources, and other reforms.
>
> As we have often said, the curse of America has been our haste
> to develop and to overdevelop everything in sight for the sake of a
> quick private profit and a continuing public loss; to graze and to
> overgraze our ranges; to bring in hordes of aliens, regardless of their
> fitness or unfitness for Americanization, to meet the demand for
> cheap labor. . . .
>
> . . . in spite of this America has always forged ahead on the
> courage and initiative of its private citizens. . . . Could a paternalistic
> government have done better? I venture to doubt it. . . . character
> cannot be imposed from without.

The tributes to Lorimer at this time, and even more the next sum-
mer, when he died of throat cancer, suggest the reasons Rockwell ad-

mired the Boss. His former competitors around the country wrote of him, "He was a man whose fairness and honesty established new and higher standards in the professions." And, "He was the demonstrated success of our ideals. [He possessed] an integrity of purpose, an intellectual force, and a human quality." "The Henry Ford of American literature" praised *The New York Times,* and the paper continued that the *Post* had "probably had more influence upon the cultural life of America than any other [publication]." *The Herald Tribune* declared that Lorimer "was the most notable magazine editor of our times," shaping middle-class consciousness into a more thoughtful, mindful morality.

One of the last editorial decisions of this complicated man whom critics sought from the beginning to pigeonhole was his acquisition of a series of articles by Gertrude Stein. Her topic was money, a subject usually far too sacred to assign to anyone except the economists or hard-core reporters. When his staff, opposed to his frivolity, asked him why he had made the move, he answered just as he would have more than thirty-five years before: because it amused him. This conviction that his own tastes would resonate with his millions of readers guided the decisions Lorimer made throughout his tenure, and it steeled even his final days. The integrity and good intentions that seemed always to have guided the editor convinced even his intellectual and financial enemies that the country should rightly mourn the passing of a great man. His death saddened Rockwell, who was already finding himself unsettled by Lorimer's successor.

18

Plotting Escapes

During the early part of 1938, Rockwell took his family out to Alhambra, where Mary and the boys could visit with the Barstows, while he worked his connections in Hollywood. Once again the artist painted Gary Cooper, this time for a promotional poster for his new movie, Samuel Goldwyn's *The Adventures of Marco Polo.* At least every few years since 1930, Norman and Mary had managed to return to California, but now, with three little boys in tow, the trip was more stressful than previously. And the artist wanted a reprieve from extended family anyway; he'd spent money and time the previous year on his mother's hospitalization in New Rochelle, for nothing of any consequence as far as he was concerned, and now he needed to locate some calm.

Back in New Rochelle, the daily onslaught of ugliness that began in late February was the furthest thing imaginable from the peacefulness Rockwell sought. On February 24, 1938, a twelve-year-old boy, Peter Levine, started home from Albert Leonard Junior High School, taking his usual route. He stopped off at the candy store on the cor-

ner of Fifth and North avenues, then wandered over to the electric shop to get some wire to repair his skates. About the same time, his mother opened the door to her house and found a note on the step, telling her that by now, her son had been kidnapped and that those responsible expected $60,000 in ransom in exchange for the boy.

Peter's father, Richard Levine, was a financially comfortable Manhattan lawyer who lacked the affluence to make his family a compelling target for extortion. Stunned, Levine offered a $25,000 reward for the recovery of his son alive, and $5,000 if he were found dead. For three months, reports surfaced daily about someone seeing Peter somewhere around the United States. And as word got out that the Levines were left-wing sympathizers who had recently hosted a meeting for citizens interested in exploring communism, people began to wonder—even to hope, in self-protection for their own families—that the kidnapping was politically motivated.

Twelve-year-old Peter Levine—sweet, handsome, slightly bow-legged, and a "typical boy"—had his picture broadcast all over the nation, but in New Rochelle, the drama consumed the city. Cars, houses, and sewers were searched, and Boy Scouts were bused into town to help re-tread paths already traveled at least once. Parents and children alike would open the *Standard-Star* every day to another picture of the doe-eyed boy seeming to stare pleadingly at them over the breakfast table. Circulars with Peter's picture appeared everywhere; newsreels played at the local Loew's.

For any parent, it was a nightmare. For the high-profile, wealthy, extremely visible Rockwells, it must have been unbearable. Everything that Rockwell wanted to avoid, all the potential violence he felt urban living contained, had taken root in his midst, enacted on the downtown streets where his first local studio was located. His Boy Scouts, now put to use to hunt down a kidnapped child—this wasn't what he had in mind for calendar fodder.

In the spring of 1938, before the case was resolved, the Rockwells precipitously went to England on vacation, yanking Jerry out of first grade. Their sudden departure left their accountant, Morton Kutner,

flustered about how to handle their financial affairs, as well as other errands they expected him to tend to. He wrote them in London about the trunk they had left behind in their hurry, assuring them that he would forward it as well as their correspondence.

The Rockwells' sudden departure was less frivolously motivated than their friends assumed: Mary Rockwell was going to England to get an abortion.

Although Peter was too young at the time to remember, later, anything of the extended vacation, both Jarvis and Tom, then seven and five years old, recall odd moments from the months abroad. "I recall random things," Jarvis says. "That we saw a tank stored in a garage once; and that we went over on a German cruise ship, as though that became a big deal at some point when we all talked about that summer." One of Tom's most vivid memories centers around the bed-and-breakfast they all stayed at for a few weeks; he and Jarvis both think they were separated to vacation at various homes while their mother was "sick," as they were told. "Never were we made to worry about any of it," they claim.

They only came to know of the real reason for the trip years later, when their parents were called on to advise one of their grown sons on the subject of abortion. Pictures of Mary would seem to bear out the lack of stress that the boys remember: rarely during the 1930s does she look as radiant, even lyrically happy, as now. Her husband looks, in contrast, tenser than usual, and one picture taken before they departed seems comically, if accidentally, to symbolize their dilemma: standing side by side, the couple evince different attitudes—in her hat, with a corsage on her coat, Mary appears slightly bemused; her husband, however, looks tense, his long arms crossed in front of his waist, his hands awkwardly dangling, crossed in front of his crotch, as if to hide the scene of the crime.

During the summer, Rockwell finally indulged his desire to visit luminaries he had studied in school, including Arthur Rackham, who, among other things, had done the exquisite pen-and-ink drawings for *Peter Pan* back when Rockwell was first thinking about pursuing illus-

tration as a career. When recalling the London vacation for his autobiography, he spoke only of these encounters, especially his wonder that he was asked to paint in the eyes on a self-portrait that George Belcher, a famous elderly illustrator, was completing. Jarvis remembers his father's excitement at meeting his childhood heroes: "He was just bubbling over with it, he was beside himself."

From their friends—mercifully absent themselves during the kidnapping's denouement—the Rockwells got the news that, on May 30, on a beautiful Sunday evening around six-thirty, the yacht captain for the wealthy heiress Mrs. Lewis Iselin sighted a small torso being carried by a strong east wind onto the rocks off Mrs. Iselin's Davenport Neck estate. He called the police, who waded out to the rocks to find the headless, limbless body clad in the same maroon windbreaker and blue sweater the papers had imprinted on everyone's mind for the past three months. Peter Levine's head had been sawed off, his arms and legs eaten by fish. Two teenage boys—the black hoods, chains, locks, and firearms found in their home corresponding to other evidence in the case—ended up receiving three- to seven-year sentences for attempting to extort $25,000 from the Levines, but although the F.B.I. thought them guilty of kidnapping and murder, they were never convicted and the crime remained unsolved. Now the papers published pictures of men in rowboats, "grappling in search of [the] slain boy's head."

What part the kidnapping had played in the Rockwells' decision to get the abortion, or their subsequent decision to leave New Rochelle forever, is a matter of conjecture. But from what we know of Mary and Norman's attitude toward this type of public tragedy, a violence so extreme as to be undeniable, it seems impossible that they weren't deeply marked by it. And it would have been impossible not to become keenly alert to their own family's vulnerability to kidnapping and ransom efforts. The almost nonstop stress their marriage had sustained since its inception—the painter's depression, the young wife's near immediate assumption of motherhood—three sons in six years—and now this horrible event, surely helped motivate their decision that

they could not handle the complications of another pregnancy and additional family member.

A month before the Rockwells returned from England, a hurricane hit Westchester County full force, deluging New Rochelle with five days of rain. Dozens of boats on the Sound and the Hudson River were smashed, old, valuable trees uprooted, and beaches washed out. Somehow the storm seemed a metaphor to Norman and Mary, who realized anew when they arrived in time to observe the storm's damage that they wanted to get out of New Rochelle permanently, not just for a few months. Later, Rockwell would claim that his sudden inspiration that he could buy a farm in a small town for what one trip abroad cost them guided them to start shopping in the country. Like most major choices, the Rockwells' supposedly impulsive decision to move was actually backed by years of reflection, dating to those days in Paris six years before, when they'd discovered how much happier they were with a slower pace of life.

Now, with the Levine case staring them in the face—in New Rochelle, it had received more coverage than had the Lindbergh kidnapping—and the sordid kidnapping and murder somehow symbolizing all those things Rockwell disliked about the city, they decided to take the next, obvious step. After all, they had made the radical decision to abort a family pregnancy; clearly, they were trying to invest emotionally and logistically now in a path that would improve their family's well-being. And they—or Norman—had used up New Rochelle anyway.

Fred Hildebrandt, the model and friend who had accompanied Norman on the camping expedition to Canada, talked often about the Vermont hills around the Batten Kill river, which he believed to be the site of the best trout fishing in America. Not much for fishing, Norman paid little attention until he heard others chatting about the Green Mountains as well. When it turned out that the illustrator Mead Schaeffer had become a convert to the beauties of life across the border, Rockwell decided it was time to explore.

Mary and Norman spent a leisurely weekend around Bennington,

where they found the landscape far too social, too reminiscent of what they wanted to escape. On the verge of giving up, they were shown a large colonial house on four hundred acres of land, set back from the road in the remote town of Arlington, Vermont—a village only ten minutes from the New York State border. Rockwell liked the way the townspeople conducted themselves when he visited the general store or asked questions of people walking by; they were friendly but not forward, reserved but unaffectedly courteous, interesting and intelligent without pretense, and hardworking above all else—an ethic the illustrator recognized as the common coin of the realm, in spite of the divide between farming, which most of them did, and painting covers for *The Saturday Evening Post*.

The Rockwells felt that their sons would receive the bucolic, innocent childhood Rockwell himself idolized as every boy's ideal; and the personalities of the Vermonters lent themselves, the artist believed, to opening a whole new panoply of models to him. Probably in response to the Regionalists, as well as to the gratifying experience of being rooted in a happy family life, his painting was taking him toward such visuals anyway: he sought faces and figures nowadays that spoke of their connectedness to their land, their homes, their families. The New Rochelle population, he had come to feel, were too adept at masking their emotions, at homogenizing their characters into a kind of suburban anonymity or insipidness. If he began anew, his studio scented daily with the aroma of fresh pungent cow manure wafting its way through the rooms, he would have arrived back at the source underwriting his childhood myth of liberation, the country his permanent soil at last.

Cautiously, the Rockwells purchased the house in 1938 at first as a vacation home, aware that the place was not yet ready to live in over the winter. Between then and the summer of 1939, they would enjoy driving back and forth, gradually getting acquainted with the townsfolk, and carefully setting themselves up as good neighbors, even though they were 'Yorkers, in the lingo of the town. Through his regular reading of *The New Yorker* and *The Atlantic Monthly*, Rockwell had kept abreast of the Southern Agrarians, a group of poets and critics

who aggressively promoted a return to the agrarian way of life that would forestall the rise of monopoly capitalism and collectivism, and who had romanticized the return to the rural. Certainly the idea, following the free-for-all of the 1920s, that a simpler way of living carried its own rewards, was very much in the air during this subsequent decade. Rockwell was smitten: the idea of moving to the country seemed to solve much of his current unrest.

Rockwell began painting some *Post* covers in Arlington, including one that he had begun just after returning from England. It would appear as the October 8, 1938, cover, incurring more than the usual number of comments for its unusual twist. On the command of Lorimer's successor, Wesley Stout, the background circle on the *Post* cover had disappeared, allowing the subject to take its own most natural shape. This autumnal painting by Rockwell exploited the new pictorial options, albeit gently, in what appeared to be an aesthetic tease: a blank canvas holding an ominous "due date" notice faced the artist, whose back was to the audience—the first, but not the last time Rockwell would employ such a metaphor.

A text about art making a comment about making art, ad infinitum, such self-conscious reflexivity was a familiar conceit of modernist literature and painting. But the charm of this cover is still striking, even while its meaning is deeply personal. The horseshoe on top of the easel for good luck and the pipe tucked into the pocket consolidate the myth of the modest, hardworking artist, the everyman doing a nine-to-five job like the rest of his readers. Consistent, dependable, he may face problems being creative—but he'll get the job done, one way or the other, we can count on that, regardless of the stark evidence to the contrary staring us in the face.

At the same time, the past spring's events lend special explanatory power to the "due date" sign at the top of the blank canvas. Here, in place of Rockwell's unfailing creative progeny appearing when it is supposed to, sits an all-encompassing yawn of white, the due date productive of nothing this time, the painter turned not to his audience, but in private, mute dialogue with the missing picture.

Rockwell connected with others most vividly and viscerally

through the *Post* covers—and with himself, most intimately of all. Years later, his friend Erik Erikson would tell him that he painted his happiness rather than lived it. The statement was one that resonated deeply with Rockwell; he described it often, as an acute moment of self-realization. For his family, a sense that their life to some extent imitated art—that they spent their energies trying to live the covers their father painted—frustrated their desire to be close to their parents. Jarvis maintains that his family can best be understood "as a group of well-meaning people all turned away from the center of the circle, with a cipher at its heart." "I felt that our home was unreal, and I felt it early on," he continues. Almost preternaturally observant, the oldest son very early on displayed his father's great intelligence and restless ambition. "Somehow, at age seven, I recognized the truth. And I felt things were given to me and then taken away, suddenly not there anymore. Like I'd feel secure as if I understood how things were, how they were supposed to be, then it was all gone somehow."

Sue Erikson Bloland, daughter of Erik Erikson, believes her relationship to her father similar to Jarvis's with his: "Dad's fame—particularly his idealized image as a father figure—engendered fantasies in both of us: he SHOULD be the perfect father, and I SHOULD be the ideal daughter that one would expect a perfect father to have. We were both drawn to the illusion of specialness that his public image seemed to offer us. As a result, the experience of disconnection left us both feeling more deeply flawed and ashamed." Yes, responds Rockwell's oldest son, that sounds just right.

A preoccupation with the missing father, or with the need for the child to father himself through his art, must have reverberated in unconscious tracks each time that Dickens's novels brought Rockwell's own remote father back to life. And Mary read Dickens aloud to her husband throughout their marriage. When Rockwell's own father had died, a month later the illustrator's firstborn son had replaced him, neatly, almost without missing a beat, engendering a new Jarvis Waring Rockwell. Of course—even inevitably—the artist would replicate the same well-meaning but distant relationship with this son, who in-

conveniently refused denial and protested, almost from birth, instead. "I wanted to connect so badly, and I kept trying, and all I can remember from my earliest days is my father trying too, but pulling back, every single time I got close," Jarvis still laments. But at least within this generation of Rockwell men, the father encouraged his son's voice, enabling Jarvis to aim his protests in the right direction, in contrast to the illustrator's own internalization of his discontents with his Victorian father.

His father's absence unfortunately heightened Rockwell's gentle but unmistakable contempt toward his mother. According to his sons, he thought her a hypochondriac, a silly and annoying, ineffectual complainer. Never once did he fail to take care of her logistically, but his lack of filial affection was fairly clear to everyone, including her niece, Mary Amy Orpen, who salutes Rockwell's unceasing generosity to his mother in spite of his feelings. Having tired of Providence—or the exhausted relatives in Rhode Island having exceeded their patience with Nancy—Mrs. Rockwell was back in New Rochelle that year, looking forward to spending Christmas of 1938 among her three young grandsons, "even though," as her niece remembers well, "she preferred girls instead." Her artist son disliked having her around because she distracted him from his painting. Besides, he often felt anxious during the December holidays, wishing they would pass quickly so he could resume his work schedule without feeling the brunt of family expectations.

His confidence regained as a result of having successfully illustrated *Tom Sawyer,* Rockwell once again resumed accepting far more commissions than would prove feasible to complete. Word was getting around that with his acceptance came the unspoken—he might renege on the agreement, or at the least, end up months if not years late completing the assignment. From now to the end of his life, Rockwell felt oppressed by his inability to say yes to more requests, and by his compulsion to accept so many commissions that his only hope of ever making deadlines was to work seven days a week.

On February 24, 1939, George Macy wrote him a playful but wor-

ried letter from London, asking if the silence from his side by any chance meant he had not yet begun the *Huckleberry Finn* illustrations. Macy's suspicions were of course on target, and Rockwell wired him finally on March 10 that he didn't see how he could possibly meet the deadlines. On April 6, Macy wrote a beseeching letter: "I beg you to try to arrange your affairs in order that you may do these pictures for us." He offered to rearrange the already announced publication schedule so that Rockwell would receive an extra five months' grace period. Although it still placed tremendous pressure on him, Rockwell agreed. The sleepless nights from worry, the embarrassment at dealing with disappointed clients (he usually had Mary deliver the bad news), the concern over finances—the artist's difficulty with arranging a practical work schedule was real and caused him great distress. But at some level, it served more than one purpose. It delivered the rewards that made the pain worthwhile.

Part of the pressure slowing Rockwell down with the Heritage commission was his uncertainty about his new boss at the *Post,* Wesley Stout, a man who enjoyed wielding his power by sending Rockwell's paintings back for changes. Stout ensured that Rockwell saw negative comments that came his way; though he admired Rockwell's work, he disliked the unchallenged position that the illustrator seemed to hold at the magazine.

Stout's touchiness agitated Rockwell; he was used to the way Lorimer operated, and he knew how to make him happy. Worst of all, under Stout, the *Post* decided that J. C. Leyendecker represented the past, and it wanted the magazine to seem more future-oriented. Unceremoniously, the famous illustrator was dropped from the ranks, and Rockwell alone remained of the truly old guard. But at least now, the motivation for Rockwell to keep up with the times emanated from outside as well as his own inner drive, and such a challenge was exactly what he needed to feel new.

Rockwell was aware that Stout seemed resentful as much as grateful for his continued presence. Under such conditions, with the tensions threatening to distract him from his work, a move to the

country sounded a wise prescription. And, according to the Rockwells' oldest son, who had just become old enough to notice family nuances, Mary Rockwell had started getting nervous at times about the flirtatious attentions the New Rochelle socialites paid her husband. She was struggling with tending her husband's voracious emotional needs for her support—as well as serving as his business manager and secretary—while raising the boys basically by herself. The vestiges of Rockwell's much looser "society" days hung all around them, including the daily reminder of the very house that Norman and Irene had lived in together.

By the summer, the Rockwells had decided to make the Vermont home permanent, their hot weather experiences having yielded everything a life in the country could offer at its best. On July 10, 1939, Mary wrote her sister: "You should see the swimmin' hole! It is about three times bigger than we expected it would be! We have an ancient row boat and the children row over it most of the day; they learned the first day. We had a great adventure yesterday: took the old row boat with Jerry, Tommy, Norman, Fred and me in it and went about two miles down the river, over rapids and so on, landed and ate our supper which we had had the foresight to put in a tin pail as the boat leaks. The boys decided they had had enough of rapids, and I don't blame them, so they and I were put ashore and went up through the fields, successfully evaded a large skunk which I nearly stepped on, got through a sturdy barbed wire fence, me on my back, and walked up the road past an assemblage of people in front of the house, me in shorts, and you can imagine how that would look and the seats of all our pants wet."

In mid-August, Nancy's cousins from Providence visited the Rockwells in Arlington for a family weekend. Mary arranged for a perfect country atmosphere: a steak dinner on the porch, swimming in the brook, mountain climbing, lots of peach ice cream. Cousin Mary Amy Orpen, long interested in pursuing a career in art, created a series of pen-and-ink sketches to record the visit. Rockwell admired their combination of cartoonish spontaneity and adroit design sense; over

the next few years, she would share her visual diary with him, until he borrowed her visual concept for a famous *Post* cover of his own—her influence not acknowledged.

By the end of October, the Rockwells were ready to concede defeat; the house simply had to be set up for winter before the five of them could live there. "We are not staying up all winter after all," Mary wrote her sister. "There were too many obstacles in the way, such as three quarters of a mile of road that would probably be impassable part of the winter and no heat, except our two chunk stoves and a fireplace, which would not be adequate in zero weather. . . .

"I can't tell you how much I love it up here though. It is such a neighborly, friendly atmosphere, and everybody is so nice. I think the secret of the whole thing is, that Norman has always wanted to be able to get a change each year, and in this way we can. But you know me, my enthusiasm always runs away with me, and I want to go the whole hog and stay right here all year! But knowing I have to go back, I think I certainly ought to be able to find some advantages in doing so, don't you?"

Even sixty years later, Jarvis Rockwell finds his mother's lack of reality confounding. "She thought nothing of yanking us in and out of school," he recalls. "I hated leaving New Rochelle, where my friends were, and where city life was all I knew. In Arlington, one kid came to school with no shoes—he couldn't afford any. And my parents really didn't prepare me for this at all. I just was kind of thrown in there." And confounding the children was the abrupt about-face that seemed to accompany every so-called decision. The children were never sure where they'd be in a month's time.

Around this same time, Norman, too, writes Nancy Barstow, but, predictably, his letter centers more on his work than on his family. He shares with the eighteen-year-old aspiring artist his contradictory attitude toward using a camera to expedite his illustrations: "Now I'm painting every other picture with the help of photograph[s]. But even in the ones with photos I make a color sketch from off the model. The younger generation of illustrators (damn 'em) are all drawing from

photograph[s] but I can't get over the feeling it is cheating. . . . Last summer Joe Leyendecker (the old maestro) dropped into the studio and I had the floor plastered with photograph[s]. Neither one of us appeared to notice them but it was just as though a fresh corpse I had just murdered lay there. The awful and unmoral thing about it is that the pictures that people seem to like best are the ones that I leaned on photographs with."

The documentary realism that photographs allowed soon became more urgent to the work of anyone interested in the fate of his society. On September 1, 1939, Germany invaded Poland. In the midst of great anxiety about the future, Rockwell's work began to emit a stronger sense of the present moment, less idealized, rooted more in time and place than during the previous two decades. Paintings from the late 1930s have convinced those interested in the illustrator's evolution that by 1939, he had successfully negotiated the transition to a new level of skill. From this point on, his paintings evince the qualities that elicit from critic Dave Hickey the appellation "democratic history painting."

During this period, Rockwell appropriated and updated the traditional (primarily Dutch) genre painting, which emphasized low subjects and everyday activities primarily as symbols of the ephemeral, into an American version that invested the everyday with a sense of historical consequence. In Vermont, Rockwell could finally bear to ground his art in the particular; the satisfactions of place and family would allow him to become rooted in the present at last.

Rockwell's move to New England also represented a completion of a circle: his earliest American ancestors had settled in Connecticut, and now, almost a half century old, the artist embraced the countryside as symbol of the liberality he believed, rightly, to have triumphed in the United States, whatever the politics of the moment.

More important than the reverberations of the past, the move gave him the sense of newness he periodically needed to find in his physical environment or risk drying up in his art. The relocation allowed

him to construct more fully the myth out of which he could create: the return to the idealized countryside of his youth would "win us back to the delusions of childhood days," as Dickens poignantly celebrated the power of representation to remember utopias that never were.

Part II

NEW ENGLAND

19

New Roots
in Old Vermont

The Rockwells returned to New Rochelle before the winter became unbearable in their summer home. Six-year-old Jerry especially had been a victim of their failure to plan ahead. Shocked at the differences that school in a rural community entailed, on his first day of second grade, he decided the experience was beyond him and, at recess, he simply walked home. His mother, according to her letter to Nancy Barstow, may have thought the experience healthy, but Jerry—not called Jarvis until he was an adult—grew up feeling constantly displaced instead. The whimsical manner in which his parents had begun his grammar school in a sophisticated suburban area, then precipitously announced that he must forgo the many friends he had made there in favor of starting second grade in a one-room school-house, and, finally, removing him from that environment with just as little notice—this pattern of unintentional ill treatment stored a reservoir of resentment in the youngster, who felt he couldn't make himself heard.

Back in New Rochelle, while her husband worked frantically on

covers and advertisements during January and February, Mary's days ranged from tactfully answering voluminous and sometimes presumptuous fan mail that included special autograph requests—inscribed on proofs or prints to be provided by Rockwell, rather than on a piece of paper—to paying bills for veterinarian runs last summer and fall to Dr. Treat, whose records show near comical disasters surely influenced by the city slickers' inexperience at rural life: one day a cat was brought in with a fishhook in her tongue, a month later a dog stuck with porcupine quills. But Mary's least favorite work came from having to parry with annoyed patrons who were the victims of Rockwell's overextended schedule. The letter she wrote her sister on January 25, 1940, contrasts dramatically with the excited, eager tone she had adopted eight years earlier when discussing her responsibilities to her husband regarding his career. Now she acknowledged being behind on everything, and having been forced to put aside her letter writing in favor of tending the three boys, running errands, and performing "little jobs" for Norman. In addition to helping him in the studio, she was in charge of entertaining work-related guests, such as an editor from Brown and Bigelow, the calendar company that paid Rockwell so handsomely for the yearly Boy Scout cover. Even as she sneaked in these fifteen minutes to write her sister, she should have been on her way to Manhattan to "inform about six people that after all he can't do their jobs."

Mary sighed over the morally shaky practice of accepting commissions and then failing to do them, saying that "the only ethical thing about the whole matter" is that nowadays she knew how to alert the victims right away, instead of "putting it off" as had been the case in years past. With some asperity, she complained that the only code artists follow is to protect their work; "minor things" such as someone else's plan or even a commitment to help them "just don't enter into the picture." "From nine years' experience I would say that you can't tie artists down to any kind of ethics except what is best for their work, which is after all a pretty high kind of ethics itself, which an awful lot of them don't follow."

Mary knew her husband's disingenuous method of taking on more than he could deliver must have seemed oddly out of character for him, and she explained that he had "unfortunately [pursued] the policy of accepting almost all of the jobs that were offered to him so that he'd feel very safe and secure, I guess." Mary had begun to sense from his nervousness that he'd once again gotten himself into a bind, so she forced him to review his schedule with her, resulting in his request that she go deliver the bad news to the six unlucky firms in New York.

Particularly because of the tension this pattern caused, she felt keenly the release of the four days they had spent the previous week with the Schaeffers in Arlington. Mead and Elizabeth had already made the permanent leap from New Rochelle to the country, and Mary was struck by how much fun everyone had together and how reassuringly "simple" life felt. Whether walking in Robert Frost's snowy woods—the poet had been an earlier denizen of Arlington—or attending the high school boys' and girls' basketball games, "there was more to do than we had time for." The boys loved the increased opportunities for physical activity in the countryside, though Mary includes mention of Rockwell's superstition (really, his unremitting anxiety) that they "knock on wood" when speaking of the children's well-being, to ward off injuries. Almost incidentally, she remarks that she is about to begin reading Verlaine to her husband, but that "Mrs. R" had been taking up too much of their time for them to be able to read much at all. She had been taking her mother-in-law to the doctor at least once a week, who found nothing wrong with her except "just nerves," and, Mary added in an aside at odds with her sweet sentiments a few years earlier: "If he only knew it, an extreme case of self-centeredness."

At times, Mary Rockwell's life sounds unmanageable. From repeated comments by friends and professional associates, Rockwell did far less around the house than the other hardworking husbands of that era: "I don't see how he got away with it," the well-respected and busy illustrator Jack Atherton once said. "He never even took out the garbage." And yet, because he indulged himself so little except in his

work, Mary felt protective of his exhaustion more than her own. She carried out the filial duties toward Nancy Rockwell, and strove to be an involved mother. The shortcuts she tried to incorporate often fell short: "For three months, we had a housekeeper who packed Tommy's and my lunches for school," Jarvis remembers, only half-laughing. "Every day, for all three months, we'd open up those lunches to nothing but a sandwich with lettuce and mayonnaise."

Most of all, Mary had become her husband's most trusted critic; he enjoyed talking over his ideas with her, and elicited her critique of the finished product. Although he solicited opinions from anyone who walked into the studio, Mary's counted the most. Yet her consistent plea that he recognize when he had finished a painting, instead of holding on to it, repainting a tiny detail until the last moment possible, went unheeded. So did her suggestions for loosening his style, in spite of his lifelong lament that he too often tightened up and overworked a painting.

Mary also handled the couple's finances, including their checkbooks (which went unbalanced, as the checks rarely were entered) and their taxes, which were complicated. That she rarely felt the satisfaction of doing a job well is understandable; just covering all her bases required an enormous expenditure of energy. There was no time to complete an assignment thoroughly, and to know the joy accompanying such activity. She didn't even have the opportunity to stop and appreciate the team she and her husband played on together. And she worked at remaining physically and mentally attractive as well: her husband looked forward to having a good time as his reward for working seven days a week, from eight to five—and then some. When he felt himself able to take a break and go out to dinner or to that week's square dance, he wanted Mary to join him, and the nicer she looked and the happier she seemed, the better off their evening. Nor was his wife unaware of the opportunities her husband, as a celebrity, had for extramarital dalliances, especially since many of his frequent business trips did not include her company. She took pains to ensure that his appreciation of pretty women remained focused on her.

As Rockwell worked frantically on several major ads he had accepted, including a series for Niblets corn, where his picture of two children eating—one of them his son Peter—was offered by the company for sale as a "full color reprint, suitable for framing," other patrons fumed. (Peter himself recalls the experience ruefully, because his father paid his sons only one dollar to model, versus the five dollars that other kids now received.) By this point, George Macy had written increasingly frantic letters to the illustrator regarding his Mark Twain edition, at first sending Rockwell pleasant, apologetic queries, asking him to reassure the Heritage Press that the *Huckleberry Finn* illustrations were on track. But the formerly starstruck owner became apoplectic when Rockwell finally got up the courage to tell him he was far from meeting the deadline. Macy sent out delay notices to all the subscribers to the series, a list of twelve illustrated books that were to culminate in 1940 with Rockwell's *Huckleberry Finn,* and the response overwhelmed him with worry. On April 1, he wrote Rockwell, "I have tried to be pleasant. . . . I like you and Mrs. Rockwell too much, to want to do anything nasty; besides, legal action would not bring beautiful pictures from you, and I do want to get beautiful pictures from you. . . . But do you not think that I have the right to conclude that you are taking advantage of my good nature? I do not believe that you would so blithely break a similar contract with the Curtis Publishing Company. . . . This is not fair treatment of me or of my company. . . . What are you going to do about it? Are you going to do work for others in that portion of your time which should be devoted to my work? When will you now promise to deliver the color paintings?"

The indignant Macy attached a list of representative responses from the club's subscribers to the announcement that Rockwell's *Huckleberry Finn* would not be part of the series they had paid for after all. The illustrator must have winced painfully at the letters, if he allowed himself to read them at all. "Your changing of your contract is improper. Please cancel my membership"; "Is the Heritage Club in healthy shape if it cannot produce its books?"; and "It happens that

Huckleberry Finn is the book I most desired. I shall be unable to continue my membership" represent the panoply of angry responses.

Rockwell wrote one of his agonized apologies for the mess, and promised to get the pictures done as soon as possible; Macy received them in time to publish the book before the year was out.

Why did he consistently bring such dilemmas on himself? The fear of running out of money was real; enough illustrators who had committed suicide when their work was no longer fashionable stood as examples to Rockwell of the ephemeral nature of his fame, and he didn't want to feel compelled to pinch pennies, particularly given his childhood experiences. He'd given up pursuing fine art, he could argue, for financial security; if he threw that away, all his choices would be for nil.

On an emotional level, his need to accept more commissions than he could possibly execute served to stave off the feelings of inadequacy that he never was able to shake. If he believed that without his work he defaulted to his childhood identity of a skinny beanpole, one way to ensure a more attractive self-image was to keep the coffers of work overflowing. Many years later, in relationship to less important issues, child psychiatrist Robert Coles would suggest that Rockwell was occasionally passive-aggressive with him, though they were both extremely fond of each other. The term may be too much of a catchall to elucidate the dynamics of Rockwell's overextensions of his schedule, but certainly it is possible that he "got back" at the very public that lauded him for his ordinariness by exerting power over them as a reminder of how special he was.

Perhaps the Macy tension was the final motivation to undertake a simpler life, but by spring, the decision was firm: they would move to Vermont and see if making it their permanent home felt right. Mary corresponded with contractors, landscapers, and other experts at winterizing Vermont homesteads. Wallpaper for Peter's room was chosen, lilacs and wisteria planted, and train schedules to Philadelphia for the delivery of Rockwell's *Post* covers scrutinized. Already an expensive enterprise—Rockwell, unlike other cover artists, matted and framed

his *Post* covers extravagantly, connoting their position as serious oil paintings—the transition of the illustration from Rockwell's studio to Curtis Publishing's office building would become even more costly, as connections from Arlington were more complicated than from the suburbs of New York City.

Although they wanted to hold on to their New Rochelle house until they were sure Vermont would be a permanent home, the Rockwells needed to rent it out, which they did for $150 a month. They were buying the isolated farmhouse and four hundred acres for half what such a setup would cost in New York, but their finances were precarious in spite of Rockwell's handsome income. A few years earlier, they had found themselves unable to pay back a $1,500 bank note when it was due and, though the bank allowed them to roll the note over for another three months, until Rockwell's expected checks came in, such incidents embarrassed them, and fueled the illustrator's tendency to overload his schedule. They did not examine ways to trim the fat from their spending, however; the pace at which both Mary and Norman worked seemed to demand the conveniences that ended up eating into their budget. And, though the Fords they drove did not have to be new, they both felt they deserved to order household items such as wallpaper and prime cuts of beef with impunity. Rockwell bought only the best, top-grade materials for his painting, and Mary, especially, was unlikely to think the personal side of their lives should absorb the costs.

Just before the Rockwells packed their belongings for their summer—and, this time, permanent—transition to the Green Mountains of Vermont, *American Artist* published an interview conducted in the New Rochelle studio. Opening with a reference to Rockwell's inclusion in a group including "Cruikshank, Abbey, Frost, and Pyle," the laudatory article hints at the laurels the artist wore throughout this next decade, consolidating his position as America's most popular artist at the same time that the divide between the real painters and the commercial ones becomes the permanent sneer of class division. Different from previous interviews, however, the *American Artist*

piece details Rockwell's use of the camera in his work, emphasizing that photographs served the illustrator only as "supplementary aids to his drawings," and that Rockwell deliberately made at least one out of every four illustrations without them.

Moving to Arlington resituated Rockwell among brethren who practiced as he did, using the camera in the process of making their art: not only did Mead Schaeffer live within a few miles of the Rockwells, but Jack Atherton would permanently relocate to the area within a year. J. C. Leyendecker remained an important voice in the back of Rockwell's mind as the illustrator started his professional life anew in the Green Mountains, but he was liberated, too, by working among his contemporaries, instead of the generation before his. By 1940, the reputation of domestic realism among serious critics and artists was at its nadir, following a decline that dated at least to World War I. Realistic twentieth-century art had labored to prove it wasn't part of the academic tradition exploded by the Impressionists, and the type of painting Rockwell did, which hearkened back to the genre scenes that had occupied the lowest hierarchical rung even in the nineteenth century, had by now transmogrified into the popular form of the people, the equivalent of vaudeville theatre in place of Samuel Beckett or, at least, Sean O'Casey.

Having sophisticated artist friends such as Mead Schaeffer nearby steeled Rockwell's resolve that his kind of art was worthwhile, and proved of immense practical value when he needed a professional opinion that he trusted. Elizabeth ("Toby") Schaeffer and Mary got along well, though the former participated more directly in her husband's career than did Mary, having studied photography to take pictures for her husband. She and Mary became friends, often sharing the burden of shopping for props for their spouses' latest paintings. Quickly the two families, not much more than friendly acquaintances in New Rochelle, became inseparable in the adventure they had undertaken. During an interview he gave at the end of his life, Mead recalled fondly their trips to the Brandywine territory, where they visited the N. C. Wyeth and Delaware Art Museum, the men in front talking

art, the "girls in back happy to be able to talk about something else." They frequently drove together to nearby Bennington to lecture to art students, often collecting useful assistants in the process. Mead was a good illustrator whose work was featured in prominent places, including the *Post*, but they both knew that Rockwell was better, and that no doubt oiled their relationship. "Schaef," as he was called, worked more as the method actor to Rockwell's careful attention to technique, Marlon Brando to Laurence Olivier. And, as usual, Rockwell was fond of Mead, but Schaeffer adored his friend.

It must have seemed a further sign that this move was the right thing when Rockwell, soon after unpacking his studio materials, went looking for a handyman. Tapping a gardener on the shoulder, he started with recognition when the man turned around: it was Gene Pelham, a young fledgling illustrator from New Rochelle who had modeled for Rockwell years before. The two men chatted, each equally excited to see the other, and within minutes Pelham had become not only Rockwell's general assistant but his photographer as well. The illustrator showed Pelham how to take the slew of shots he needed, as well as how to develop them in the darkroom he set up at the back of his studio. The two men came to depend on each other's company, although, once again, Gene ended up feeling more connected, assuming a deeper friendship than Rockwell did.

By the end of 1940, the Rockwells felt themselves settling into a Vermont way of life. They were proving that they could withstand winters where temperatures could drop to twenty below; and they showed the townspeople that they yearned to join their community. Mary and Norman had attended square dances during the fall, the ordinarily gangly man excelling at the moves, gracefully and joyfully dancing his way through the complicated calls. And they were earnestly learning about the town's governance methods, including the sacrosanct town meeting.

As the new year began, the couple was feeling well grounded, in spite of Jarvis's continued unhappiness at having left his best friends behind in New Rochelle. Even he no longer seemed shocked at the

differences between suburban and rural culture, and Tommy and Peter were both happy. Convinced that they should solidify their commitment to their new town, the Rockwells decided to sell their New Rochelle house. They were so satisfied with their new life, in fact, that one evening at the Society of Illustrators meeting in Manhattan, Rockwell urged John (Jack) Atherton, complaining about the local prejudices of Ridgefield, Connecticut, where he lived, to bring his wife, Maxine, for a visit. Rockwell's enthusiasm was persuasive; not only did the couple accept the offer of hospitality, they decided to move to Arlington themselves.

20

Another War to Paint

John Atherton's presence in Arlington proved especially reassuring to Rockwell. Atherton was one of the few artists who seemed to be equally successful as an easel painter and a commercial artist. A talented jazz musician and sometime socialite, he did covers for *Fortune* and, after 1944 and his friendship with Rockwell, *The Saturday Evening Post* as well, but he also exhibited, in contests, his singular surreal pictures of what he called the inner workings of his mind. His work is now owned by major museums, including the Metropolitan Museum, the Whitney, and the Museum of Modern Art in New York City, the Chicago Art Institute, and the Wadsworth Atheneum in Hartford, Connecticut, among others. Opposite in work habits from Rockwell, who depended on three times the preparatory sketches that Atherton did, he agreed with his friend that, whether professional or private, one's routines should be conducted in a pleasant environment. He did not want any part of the suffering ethos of the fine artist; instead, he painted to be able to spend his leisure time, of which he had much more than Rockwell, trout fishing.

Atherton respected Rockwell's talent and work ethic enormously, and the admiration was mutual. When Atherton urged Rockwell to do more painting for his own purposes, unyoked to commerce, the illustrator knew his friend was complimenting him, not implicitly criticizing his work. Atherton exploded at Rockwell about his compulsion to continue illustrating the "propaganda, sentimental trash" known as the "Boy Scout Calendars"; Rockwell basically agreed with his assessment, but insisted on looking at the practical side: tremendous money for little work. Even their arguments were fun: nothing about Atherton was restrained. When he wooed serious critical interest in Rockwell by inviting Robert Coates, an art writer for *The New Yorker,* to his friend's studio, he expressed his dismay at the critic's indifferent response to the work so passionately that Rockwell's own disappointment was exorcised. Atherton and Rockwell frequently disagreed in their aesthetic opinions, but they provided invaluable services to each other.

Added to the presence of Mead Schaeffer, whose extroverted personality meshed perfectly with Rockwell's blend of interiority and theatricality, the scene in Arlington (population twenty-five hundred) became Rockwell's own little Golden Stage of Illustration. The men allowed one another the chance to let down their guard, to be off display in the midst of like souls. Often the Rockwells, Schaeffers, and, less frequently, the Athertons, followed in a few years by illustrator George Hughes and his wife, convened for cocktails after the day's end, calling it the "children's hour." They talked shop: heated, engaged, lively common discourse. And they entertained art editors from out of town, proud at inspiring awe toward their intimate artists' community. Schaef remembers his good friend as "A Will Rogers, if you know what I mean. . . . He was so boyish. . . . He had a curiosity and enthusiasm about everything."

Around this period, the publicity that Rockwell received in national magazines and newspapers reflected the solidifying of his myth. Early in 1941, it was still possible for *Family Circle* magazine to assume its readers didn't know what he looked like, "although you've

been acquainted with him for years through his work." A spread of Ar-
lington photos stages the three boys on their bikes, in the midst of the
participating father, "whose only vice, according to Mrs. R, is over-
working," but who takes "time out to cycle with his wife and sons."
Those sons laughed as adults at the frequency with which such
spreads were arranged, believing that they spent more time playing
with their father for publicity than they did in their daily lives with
him.

The *Family Circle* article, "He Paints the Town," sets out the asso-
ciations that the name Norman Rockwell now invoked. He is called "a
country boy at heart," who retrieved his Vermont wife from her tempo-
rary California home. The couple, the article continues, are lauded
throughout the town for their attendance at the monthly town meet-
ings, the weekly square dances, and their participation in Community
Fund projects; somehow, Mary had managed to chair the previous
year's street fair. And if overwork is Rockwell's vice, he is seen to rem-
edy the impression of overseriousness that it gives by invoking the
childish play he and his boys engage in, including "water-throwing at
my breakfast table," according to his "lovely" wife, who "listens to her
famous husband with the tender, whimsical smile of a wife who un-
derstands and loves [his boyish bad behavior]." Years later, Peter Rock-
well would recall those bouts of play: "My father would suddenly act
like a kid with us, picking up a bowl of Jell-O and smashing it in our
face, allowing us to chase him down with whipped cream, exploding
water balloons into each other's bedrooms, including his and my
mother's. All she ever said was, 'Don't forget you have to clean it up!' "

But most of all, in contrast to other famous artists, Norman Rock-
well is presented as everyman, no better, by implication, than all of us,
in spite of his fame and fortune and talent. "Rockwell's paintings rep-
resent his people as they look to him," the article concludes, "and,
glory be, he sees them even as you and I see them, and that's why we
appreciate his work."

Occasionally, Rockwell strayed from the reinforcing images of
"homely" Americans that such interviewers preferred. During the

spring of 1931, one such foray for *The American Magazine* produced the fascinating illustration for the story "The Sharpshooter." The commission to illustrate a story with a boxing match at its center gave Rockwell the chance to make a visit to the city, so he spent an evening at a boxing club at Columbus Circle in Manhattan, where he studied the appearance of a smoke-filled room and the types of people who inhabited it. In discussing the composition with Arthur Guptill (the writer of the first book on Rockwell), the illustrator explained that the chance to do a horizontal layout thrilled him, as most magazine covers were done vertically. He used strong parallel lines in the floor and the ring's ropes to accentuate the horizontal expanse, and he invoked indistinct gray tones for the smoke-filled room, something he wouldn't ordinarily do, he explained.

The opportunity to challenge himself artistically clearly invigorated Rockwell, and the result shows in the painting. A cross between the Ash Can realism of George Bellows and an anachronistic scene from a film noir, *The Sharpshooter* comes close to being museum worthy. The atmosphere and sense of great space in this painting were created by placing the strongest tonal contrasts in the foreground and reducing them as the subjects recede into background. Under the guise of providing immediate comprehension, however, Rockwell pushes the boxer's face one step beyond expression and into caricature, and he manipulates the posture of the female spectator, a sinewy hard blonde, into body language that seems just one remove from reality, ensuring that we don't think he is taking himself too seriously as a painter. The impact of such exaggeration in a potentially masterful painting becomes clear by comparing it to the restraint evident— though barely—in *Playing Checkers* four years earlier.

While the illustrator intended to use the move to Vermont to challenge his painting, Mary Rockwell also was eager to develop her talents more fully than she'd been able to the past ten years. Most of all, she hoped to become involved in literary projects, bringing her closer to her longtime desire of becoming a writer. Soon after the family had settled in, she met Dorothy Canfield Fisher, a well-known second-tier fiction writer and local philanthropist who had been one of the found-

ing members of the Book-of-the-Month Club. Deeply loved and ad-
mired by many, Fisher seemed to cast an immediate spell on Mary
Rockwell, who wrote to her sister Nancy about "Mrs. Fisher's" latest
kindness or advice, this first spring pertaining mostly to what she
should plant in her garden. Rockwell wasn't as persuaded by Mrs.
Fisher as his wife was; when, after a party, he expressed his lack of en-
thusiasm for the writer, Mary told him that he just didn't like someone
else commanding the center of attention.

Dorothy Canfield Fisher was herself accustomed to being the
leading cultural light in Arlington, in spite of earlier, brief forays into
the region by Robert Frost and Rockwell Kent, both of whom Fisher
had befriended and urged into the community. Rockwell's de facto es-
tablishment of an illustrators' colony may well have brought out her
own sense of competition. In spite of her kindnesses, she tended to
dispense her compassion as the noblesse oblige of royalty. Her culti-
vation of the common touch apparently smacked of patronization to
Rockwell, who nonetheless paid her great respect in public and
among his friends.

And, more important that any reservations Rockwell held about
Fisher, he welcomed the chance for Mary to pursue her own interests,
even if that meant Fisher mentoring her. His own life seemed in mag-
nificent order, and his new sense of being properly centered encour-
aged Rockwell to accept more story illustrations from magazines
outside of the Post, albeit within the Curtis Publishing group. Al-
though he never employed an agent, he did rely on a central clearing-
house, American Artists, which acted as a liaison between well-known
illustrators and top magazines. During a summer negotiation with
McCall's, the company clarified with "Norm" that, from past experi-
ence, they had identified his top two priorities: delivery time and type
of story. Contemporary love scenes especially bored him, they in-
formed editors, though if the magazine set back the illustration a hun-
dred years, say, the challenge might woo him.

By mid-1941, the national mass-culture magazines, especially
those aimed at women, were doing anything short of commissioning a
story with his pick of subject, just to obtain Rockwell's services. As a

result, he gained more opportunities to illustrate challenging projects, including a story for *McCall's* about Abraham Lincoln, one of Rockwell's all-time personal heroes. His ever-increasing popularity brought its own negative side, however, as distant family members, such as Harold Hill, Nancy's nephew (who, as an infant, had tragically lost his young artist father Thomas to consumption), began to make yearly requests for family portraits from their celebrity relative. And general fan mail, not only people with legitimate claims on his acquaintance, became ever more burdensome, even as it remained intensely gratifying. Now people sent Rockwell pictures of their legs—perfect, they were told, for one of his covers of young women; or letters of entreaty—how their father or mother would love to pose for the artist; or ideas for Rockwell's next cover, another burden, rather than an inspiration, to the artist.

Even though Vermont created some of the distance he needed to elude his enthusiastic audience, Rockwell still needed periodic escapes from the place he associated with the pressure of deadlines. Although he rented a studio and worked just as hard when he went out to Alhambra and stayed with Mary's parents, the change of pace allowed him to get away from art editors and publishers who knew too easily where to find him in Arlington, and gave him a respite from the cold—and his boisterous family as well. Every few years, Rockwell would take off for a few months, and when the Christmas break began, Mary would follow with the boys in tow. In 1941, feeling as usual the pressure of too many deadlines and not enough time, Rockwell fled to the Barstows', where he holed up, having fed several patrons back East the line that he was sick and in a California hospital.

A measure of his fame came when the Hollywood and New York gossip chief Walter Winchell broadcast the sober news that Norman Rockwell, hospitalized, was gravely ill. Compassionate letters from companies that Rockwell owed artwork to—commissions whose work was overdue—arrived, begging him not to worry about anything but getting well. One letter from American Artists makes it clear that the excuse had worked to forestall the *McCall's* assignment due January 1:

after reading the "contents of your telegram," the editor agreed to an extension of February 1. It was a ploy Rockwell used with some regularity, though ethically it was less bleak than at first glance. The artist drove himself regularly to the brink of what used to be called a nervous breakdown, and he had no vocabulary convincing enough to call off those (justifiably) hounding him.

Rockwell was already in Alhambra by November, and in early December, Mary took the boys out of school early so they could have a longer break from the Vermont winter. Just after they arrived at the Barstows', the Japanese attacked Pearl Harbor, and the boys got more excitement than they had imagined possible. "My grandfather was convinced that the Japanese were going to invade California any day," Jarvis remembers. "My brothers and I began pulling metal wagons around the neighborhood, asking for tin cans for the war effort. The whole thing seemed like a lovely dream to us; I was the oldest, and I was only ten. Those beautiful streets, where the eucalyptus and orange trees made the place smell like a bower, because the area used to be a huge nursery—it just didn't seem possible, as my grandfather kept insisting, that the Japanese were going to come attack us in the middle of the road."

In spite of sitting through too many of their ineffectual grandfather's tirades against Franklin Roosevelt, the boys loved the change of pace when they visited California. But they failed to develop a close relationship to their grandparents, even though the Barstows were "perfectly nice" to all three young grandsons. A certain distance among the family members kept the emotional temperature in the household too cool for the rowdy Rockwell boys to feel connected to their California relatives.

They were quite fond of their grandfather, believing his wife to be much sterner than he. "It was clear that my grandmother ruled the roost," Peter Rockwell believes. Their grandfather, by contrast, was a "Humpty-Dumpty figure, with his wonderful oval face and slightly silly, immature air. We all got the feeling that my grandmother, and then my father too, didn't totally respect him, because he'd not been

very successful at his law practice." But what made the most impres-
sion on the children, according to Jarvis Rockwell, was the way that
their mother's parents expected everyone to ignore what to them were
weird things—such as "Crazy Aunt Grace," whom even their mother
had been taught to regard as perfectly normal. "And with her mime-
colored, white-powdered face and bright blue eye shadow, she wasn't,
as even we children knew," Jarvis laughed. "This background of denial
is how my mother grew up, so no wonder she had problems herself."

After December 7 that year, the Rockwells spent the rest of the
month talking about the war—what they thought would happen, and
what they would be able to contribute, especially back in Vermont.
The artist had begun his efforts the year before, when the first recruit
call went out. Rockwell was eager to assume the position that J. C.
Leyendecker had held in World War I, when the older illustrator had
been among the most prominent of the wartime propaganda artists.
This time, Rockwell would take on the challenge of showing the
American people the ideals and ideas behind the gruesome realities
they heard about in the newspapers, letters from soldiers abroad, and
war correspondents writing in the mass magazines. What made the
carnage of another European war worth more American lives?
Through paintings that some critics would condemn for whitewash-
ing the dirtiness of battle, Rockwell conveyed the small pleasures that
made up the bulk of life back home, however much they contrasted
with the size of suffering he felt unwilling to tackle.

If Rockwell's practical sense of his own duty for World War II was to
create images that would ensure the men and women fighting overseas
got the logistical and emotional support that sentimental images would
ensure, some of the soldiers in the front lines might have preferred that
the ugliness of their daily lives be paraded instead. As Private David
Webster of the 101st Airborne wrote, after he watched a friend die in
combat in February 1945: "He wasn't twenty years old. He hadn't
begun to live. Shrieking and moaning, he gave up his life on a stretcher.
Back in America the standard of living continued to rise. Back in Amer-
ica the race tracks were booming, the night clubs were making record

profits, Miami Beach was so crowded you couldn't get a room any-
where. Few people seemed to care. Hell, this was a boom, this was
prosperity, this was the way to fight a war. We wondered if the people
would ever know what it cost the soldiers in terror, bloodshed, and
hideous, agonizing deaths to win the war."

Rockwell's philosophy of wartime propaganda was based, however,
on the effect such ugliness had on him; he turned from violence
whenever he could, and his strong mechanism of denial sought less
direct paths of working for the good of those who suffered, including
the G.I.s. To ensure, as the government put it, that the soldiers got
"what they needed, and on time," he felt his talent lay in convincing
the Americans at home that they were investing in their vision of what
the country stood for in its very Yankee entrails: freedom. This time
around, he would do better than his fledgling attempts during the
Great War.

One of the first images Rockwell created for the war effort was
Willie Gillis. In contrast to Leyendecker's tall, handsome, masculine
icon from World War I, Willie took shape as an unimposing, slightly
goofy young man with a shock of reddish hair, a somewhat bewildered
smile, and a still developing, gangly body. Rockwell had dreamed him
up in a conversation with his wife, who suggested the name Willie
Gillis because she'd just finished reading the children a book "about a
Scotch boy, Wee Gillis" (not Wee Willie Winkie, as has often been
printed). Over the next five years, Rockwell painted eleven *Post* covers
with Willie as the central character, ranging from the first cover,
where he was shown at the head of a group of hungry but happy young
soldiers following him because he carried the food package from
home, to the last, in 1946, where the teenage recruit has grown into a
serious young man, attending college on the G.I. Bill. Readers loved
the reassuring image of their everyman son, brother, lover, neighbor,
or friend, who reminded them of the same guy they worried about
daily. Gritty cover images supplied by Rockwell's friend Mead Schaef-
fer brought home the size of their men's challenges overseas; the so-
lidity and predictability of Willie Gillis implied that the war was an

aberration and that life would eventually resume its reassuringly triv- ial, domestic pleasures even though they had been disrupted by the second global conflict in thirty years.

In early 1942, once the family was settled back into their snowed- in farmhouse, Rockwell painted the third Willie Gillis cover, his most somber. Although Willie is at church, the scene takes on a slightly melancholic aura from the isolation of the boy. In the three pews shown, only Willie's torso and face are visible; the shoulder of a man in front, and the arm of a man behind, their respective officer stripes and upper enlisted hash marks prominent, are the only other people represented. Willie's eyes are sad, bright with unshed tears, though the pictorial ambiguity on this point is unusual for Rockwell. He could be sitting through an ordinary Sunday service; or he could be at a funeral. Whatever the occasion, he is no longer carefree.

As if confronting such realities wore Rockwell out, he decided by February to go back to California. His home life was peaceful and or- ganized, and there was plenty of room after the renovations—four bedrooms upstairs, for instance—but the cold kept everyone indoors, and the artist often found it hard to concentrate. He enjoyed the reg- ularity of their home life—the family rose at six-forty-five, breakfasted together, and, after the boys went off to school in a neighbor's car, he and Mary biked or, in the snow, hiked the mountains behind their house. He went to the studio from nine to twelve, ate lunch with Mary at noon, then went back to work until five. By the time he cleaned up the studio one more time (to clear his mind as well as any actual clutter, Rockwell swept it three or four times during his work hours as well), it was time to have dinner. The Rockwells had their evening meal at six o'clock, putting Peter, now six years old, to bed shortly after, and leaving time for the couple to go appraise Rockwell's work for the day, to read aloud, or for Mary to help the boys with their homework while the artist implemented a small change he'd just thought of.

The pleasures of such a life sustained him emotionally. He even encouraged his sons to wander out to the studio after school and sit

on one of his cushioned benches or chairs, doing their schoolwork or painting or chatting, if Rockwell was not undergoing one of his frequent struggles with a particular picture. But because he was so plugged in to a seven-days-a-week work schedule in a location where everyone knew where to find him, he also found himself becoming exhausted far more easily at home than in Alhambra.

Rockwell indulged himself in California, if only a little, by playing the part of the celebrity illustrator, obtaining for his models the starlets and other actors from his movie contacts that ordinarily he'd eschew. He used such professionals for story illustrations, mostly, as well as for the myriad publicity materials the studios actually commissioned him to produce. As long as he was allowed to play with Hollywood on his own terms—briefly and as the famous but friendly illustrator from the East—he enjoyed the encounters, so distant from the daily substance of his life. Instead of admitting that these retreats to Alhambra were just that, Rockwell continued putting out the news of illness forcing him West, in order to slide on deadlines. Eventually, patrons considered Alhambra his second address, as did Henry Dreyfus, writing to the artist about *McCall's* enormous pleasure in the Abraham Lincoln illustration that Rockwell had finally delivered. Whatever irritation Rockwell's missed deadlines caused, when the companies received the paintings at last, their ill will faded in the face of their awe. He could have rushed to meet the deadlines and scrimped on quality, but he seemed constitutionally unable to give less than his best, except on advertisements that he ranked low in both importance and remuneration.

Rockwell stayed in Alhambra until early spring, tracked down even there by Broadway producers interested in putting Willie Gillis on the stage. Such unlikely prospects flattered the artist, but more significant by far to his self-esteem was the replacement of the critical, picky Wesley Stout with the affable, admiring Ben Hibbs, the man who would be Rockwell's editor as long as he remained at the *Post*. Soft-spoken, kindly, but with iron in his soul, as Rockwell would say, the forty-two-year-old editor immediately intensified the written cov-

erage of the war. In this first year that Hibbs took the helm, the immediate symbol of a new reign—the updated *Post* logo, streamlined into a rectangular bar with *POST* squared in the left half, the rest of the title printed in modest letters above—announced the change of guard. Unlike Stout's philosophy, which had been to accept as many different illustrators as possible for variety, Hibbs standardized the covers with five or six major contributors. Rockwell was, bar none, anointed the preeminent.

Ben Hibbs's encouragement ensured that Rockwell felt appreciated and liked again, the circumstances under which he did his best work. Under such leadership, Rockwell's imagination relaxed enough to allow him some free creative thought, which he directed toward realizing a great painting for the war effort. During the spring of 1942, he pondered what project would be best, but, as usual, coming up with a good idea proved the hardest part.

21

❧

"The Big Ideas"

What he finally devised relied on a speech President Roosevelt had made to Congress over a year earlier, on January 6, 1941. Roosevelt opened his talk with a somber reference to the danger the country faced: "At no previous time has American security been threatened from without as it is today." After enumerating the liberal aims of a democracy, Roosevelt catalogued the more abstract principles that, he claimed, needed to be part of all societies. He ended each of these Four Freedoms, as they would be called, with the words "everywhere in the world" or "anywhere in the world." Seven months later, on August 9, he met with Winston Churchill for the first time, the two sequestered aboard a warship in Placentia Bay, Newfoundland. There they discussed ways the still-neutral United States could support Britain's mission, and the means of assistance the British could offer to keep Japan from involving the United States. The outcome of the informal meetings was their joint statement, the Atlantic Charter, whose basic principles of nonaggression, the right to self-defense, and freedom of the seas echoed in principle the Four Freedoms.

Unwittingly swallowing whole the myth that the artist savvily created for them in the early stages of his career, commentators on Rockwell's art have often avowed that the illustrator was apolitical. And by the forties, Rockwell had indeed grown comfortable sustaining the posture that Lorimer's political fervor had encouraged him to adopt in order to maintain some distance from the imposing Boss. Frequently observing—truthfully—that he in fact did not enjoy partisan politics and that he wanted to appeal to all the people, Rockwell made few public gestures that clarified where he stood on the political spectrum. Yet he honestly believed that the Yankee virtues—tolerance for differences, courtesy, kindness, and the freedoms that FDR articulated—were the substance of a political creed that his paintings openly embraced. While the country's remaining isolationists were angry at Roosevelt's signing the Charter, for instance, Rockwell was pleased. Later, when the principles behind the Charter guided the founding of the United Nations, the artist would throw his support behind that organization. Of the beliefs he held most dear, tolerance—and the freedom necessary to ensure its flourishing—were most important to him. His habit of tacking favorite aphorisms on his studio wall prominently included one that read "The Real Test of a Liberal Is the Willingness to Listen Fairly to a Person with Opposite Opinions."

That Americans would fight for freedom, whether for themselves or for others, sat well with his deepest beliefs. For reasons unclear—except that his explanation added drama—Rockwell would later say that he heard the Four Freedoms speech and pondered it briefly, then awoke with a three A.M. epiphany, the inspiration to paint the abstractions into clear narrative stories. In fact, over a year elapsed between Roosevelt's Four Freedoms speech and Rockwell's decision, but the year was crucial to the artist's goal: during this period when Ben Hibbs had come in to replace Stout, the illustrator felt freer to suggest topics, surer of his status. Rockwell nonetheless crafted the story of the Four Freedom posters that he began painting during the summer of 1942 into one of rejection by the government and salvation by Hibbs.

The accounts vary depending on when he told the story, but basically Rockwell claimed to have hopped on a train to Washington with Mead Schaeffer, who wanted to sell the government on his own ideas. From office to office, the two men were bounced around, treated unceremoniously, Rockwell's sketches rejected. Discouraged, the men rode back home, but suddenly realized, as they neared Philadelphia, that the *Post* might be interested. Indeed, it was, and Rockwell began work on the four articulations of abstract freedoms worth fighting for, all of which would be published consecutively in the *Post,* with writers' essays reflecting other points of view as well.

As usual, the facts were somewhat otherwise. Maureen Hart-Hennessey, the assistant director of the Norman Rockwell Museum, explains that when Rockwell and Thomas Mabry, the assistant chief of the Graphics Division of the Office of War Information (OWI), met during the spring of 1942, it is unclear which man had initiated the meeting. But a letter from Mabry makes it clear that the OWI man had written Rockwell during this period, explaining that posters of the Four Freedoms were one of the government's most "urgent needs." Rockwell had traveled alone to Washington to meet with him that spring, and only after that did he have his "epiphany," which was the realization of how he could present the subject effectively. He finished the sketches, then, with Mead Schaeffer and Orion Wynford from the Brown and Bigelow calendar company, returned to Washington, where the confusion at that time from three separate agencies combining into the one, monolithic OWI probably contributed to the shuffling around that the men encountered.

Whether Rockwell stopped impulsively in Philadelphia is not known; what is clear is that Ben Hibbs enthusiastically accepted the sketches, and Rockwell began work on the paintings by mid-summer, with a promise to deliver them in the late fall or early winter for publication. Late June letters from Hibbs about Rockwell's plans for his war series contain a message to convey to Mead Schaeffer about the terrific sketches he brought down as well, noting additionally that the *Post* was excited about Schaeffer's series. Thus, at the time of this note, June 24, the plans were in place to publish the work in the *Post.*

But sometime during the fall, OWI reentered the picture, inter-
ested in using Rockwell's Four Freedoms for the Victory Loan Drive,
in the process rejecting Ben Shahn's version. Shahn, a fine and com-
mercial artist (who continued to be one of Rockwell's greatest admir-
ers) whose work was far grittier and less accessible to the untutored
eye than Rockwell's, had socialist leanings, which may have made him
suspect to the OWI. Still, even after Rockwell was tapped by the
OWI, its chief of the Graphics Division, Francis Brennan, was furious
at the choice of Rockwell over Shahn, especially as Brennan had ear-
lier dismissed Rockwell's ideas. The agitation over the OWI's choice
of Rockwell culminated in the Writers' Division resigning en masse,
and Brennan and Shahn creating a poster of Liberty holding a Coke (a
former Coca-Cola executive, with company ties to Rockwell's illustra-
tions from the early 1930s, had been the arbiter who chose Rockwell);
the caption read, "The War that Refreshes—the Four Delicious Free-
doms!"

Rockwell himself saw the chance to illustrate the Four Freedoms
as his opportunity to produce the "Big Picture" that every artist
dreams of. He hoped to clear the summer of other commitments,
concentrating only on bringing home the abstractions to the American
people. Under Lorimer's avowals of isolationism, he had felt restricted
from indulging his own passions. Although Rockwell's low number of
covers during World War I was due to his position behind the ranks of
the older, accomplished illustrators James Montgomery Flagg and
J. C. Leyendecker, he had also been too uncomfortable to go up
against Lorimer's beliefs. Not only was there a new editor now, but
Lorimer was dead by the time Rockwell undertook his World War II
covers. No paternal ghost threatened the sense of liberation that al-
lowed Rockwell to create the lighthearted Willie Gillis series as well
as the somber and more abstract Four Freedoms.

Hibbs gave Rockwell the license to exercise his fervent belief that
freedom was due everyone in the world, even if Americans had to con-
tribute to its global realization. But Rockwell also believed that most
people reasoned through concrete images far more often and effec-

tively than through abstract principles. His talent, narrating an entire story with one picture, was his tool, and the Four Freedoms, from his point of view, the ultimate challenge to which he would put it.

In spite of his determination to devote his time exclusively to the Four Freedoms, it proved impossible, predictably, to clear his schedule of everything else. At one point during the summer, he had to stop painting and go to Manhattan to see his doctor, Charles Gordon Heyd, who, according to old city records, had restricted his practice to gastroenterology during this period. Rockwell tried to keep medical problems confidential except when he found himself conveniently sick at deadline time, which may account for his not finding a specialist closer to home. A note the artist made to himself laments that the doctor had told him he needed an operation, but, Rockwell wrote next, he informed the doctor that he could not go into the hospital until September, when he would finish the Four Freedoms. What the operation was, or if it ever occurred, remains a mystery. Between illness, finishing commissions for other magazines, and fending off business complications from selling second reproduction rights to earlier artwork, the summer bumped along. Rockwell's loyalty to the Four Freedoms project was absolute, whatever the reality of his life; the memo he made to himself after his doctor's appointment included the poignant "Those 4F's have grown larger and larger in my unfortunate time. I feel that they are worth everything that I can give them and more. I have just got to do that first, it means everything to me" (underlining his).

By now, Ben Hibbs must have known his man well enough not to be surprised when Rockwell told the *Post*'s art director that he couldn't meet the fall deadline.

In early autumn 1942, the *Post*'s art director, Jim Yates, worriedly inquired about Rockwell's progress, reminding him that they needed the paintings soon in order to publish them as they had planned. Rockwell's recent admission to them that he had junked the complete first painting because he had overworked it, and now was redoing it, made them extremely nervous. Rockwell wrote back a pleading letter,

explaining that while he realized they had a right to be concerned—that the writers (Booth Tarkington, Will Durant, Carlos Bulosan, and Stephen Vincent Benét) had all sent in their texts and he was very late on even the first painting—he wanted them to rest assured that he would get them all done soon. He worked exclusively on the first one, *Freedom of Speech,* for a month and a half, believing it to be the most challenging because it contained so many characters. He assured them that he now had it under complete control, that it would go quickly, and that he had cleared his calendar completely for the other three paintings, *Post* covers, and the "unavoidable Boy Scout Calendar," which would only take a few days. Fervently, he concluded the letter by saying, "I just cannot express to you how much this series means to me. Aside from their wonderful patriotic motive, there are no subjects which could rival them in opportunity for human interest painting. Believe me, they deserve everything I can give them."

In mid-November, the *Post* was even more worried than the OWI. Ben Hibbs himself wrote Rockwell to beg him not to redo the third picture, *Freedom from Want,* as Jim Yates had relayed to him was the artist's plan. He wooed Rockwell into accepting his praise of the painting as it stood by explaining that the artist's concern that his painting didn't match the text of the Filipino laborer that would accompany it was irrelevant—the two were not supposed to reflect the same perspective, merely deal with the same subject. Cleverly, and truthfully, Hibbs appealed to Rockwell's painterly side: the government was going to impose a restriction on four-color use inside the magazine, where the pictures would be published. If Rockwell didn't get them the remaining pictures in the next two or three weeks, they might be stuck reproducing them in halftones at best. Politely, but urgently, Hibbs ended the letter with, "Time really is of the essence now, and I can't help being deeply worried."

At that point, probably in relief after the paintings had all been delivered, Jim Yates composed a parody of Edgar Allan Poe's "The Raven," with two stanzas immortalizing Rockwell's frightening habit with deadlines:

Just then did he remember, he had promised last September,
　　Paintings of the Freedoms, said he would complete all four,
　　Through weeks and months he pondered, he planned and thought
　　and wondered,
　　How to paint one on Religion, all the while he gently swore
He never had such trouble with any job before,
　　Not with any job before.
Spoke Yates, I am in trouble, so I came up here to huddle,
　　To beg, to plead, to coax, yes, to implore
Please don't think I am nagging, as the time seems to be dragging,
　　But our presses wait and wait, on almost every floor,
Waiting for the Freedoms, we expected long before
　　Only that and nothing more.

Rockwell finished all four paintings by the year's end, and the *Post* began publishing them on February 20, 1943. That same week, the OWI publicly announced its plan to issue several million poster reproductions of the series. The first picture, *Freedom of Speech*, conveys its abstract principle by showing a handsome, modern-but-rugged man standing in the midst of a group, having his say. Presumably based on Rockwell's oft-quoted inspiration for the piece, this was a town meeting where his neighbor was politely listened to in spite of dissenting opinions, and the seated citizens looking up at the speaker have various opinions themselves. The American ideal that the painting is meant to encapsulate shines forth brilliantly for those who have canonized this work as among Rockwell's great pictures. For those who find the piece less successful, however, Rockwell's desire to give concrete form to an ideal produces a strained result. To such critics, the people looking up at the speaker have stars in their eyes, their posture conveying celebrity worship, not a room full of respectful dissent. The man sitting behind the speaker, as well as the speaker himself, could be staring toward the heavens instead of focusing on people in the room. Rockwell started the painting over four times, uncomfortable with the formal grouping until the last version. In the upper left corner

of the painting, he included a partial view of his own face, his eye positioned at the highest point of view in the room full of ten citizens.

Commonly considered little more than a stock-in-trade signature,
similar to Alfred Hitchcock's movie cameos, Rockwell's appearances
on many of his covers attest, according to Peter Rockwell—a sculptor
and art historian—to the deep interest his father took in theoretical
questions about truth in realistic art. Rockwell's speculations about
art and reality are manifested in several ways throughout his career: in
the early thirties, for instance, he had created a cover with the billboard artist facing his project, the audience privy only to his back; but
one oversized, boldly flirtatious eye stares challengingly at us from the
billboard. Other times, philosophical challenges are implied through
his paintings-about-paintings, covers that allow the picture itself to
react to the viewers who are claiming their right to judge; occasionally,
he combined his famous April Fools' Day cover (replete with forty to
sixty logical incongruities) with the painting that speaks from its
frame, such as the April 3, 1943, *Post* cover. Even Rockwell's particular use of the age-old conceit of the self-portrait emphasizes the slippery nature of truth in art, slyly reminding others that his paintings are
not the imitations of life they often believe them to be.

Rockwell's intellectual sophistication jousted with his need to
please his audience, and the only way he played out such academic
questions about reality versus representation was indirectly, toying
with the viewers in a highly private way, asserting his own authority as
artist outside of the solidarity with the mythic "Average American" in
which his popularity was grounded. Rockwell had, by this point,
firmly established an unsettling way of appearing to side with the
crowd, while in effect holding himself aloof, above them. Critic
Arthur Danto, who admires Rockwell's "intelligence," feels that "there
is something I have not been able to put into words about his depiction of people. He seemed at once sympathetic to them and superior
to them. He does not take them seriously, and the joke is almost always at their expense, as he causes the viewer to feel superior." Paradoxically, Rockwell inserts himself into the paintings to allow himself

to stand back from the implied viewers, to feel superior to them as well.

Every artist has a psychological strategy underlying his imagination, however accessibly or not it appears. Rockwell's layers-of-seeing becomes an overt subject in many of his paintings, such as *Fireman* (1945), *The Art Critic* (1954), and *Triple Self-Portrait* (1961). But it's already present in a less thematic way earlier, in scenes meant to be viewed sympathetically—fixed objects of the audience's knowing gaze. Behind the sentimental exchange lurks a sense of the puppeteer, never out of control. "He robs the subject of a certain dignity in order to make the viewer feel better about himself," the otherwise admiring Danto complains. It was similar to the way that his mother had used her weak younger son to sustain her own fragile self-importance.

The three paintings that followed the first one were also *Post* favorites. *Freedom to Worship* appeared on February 27, 1942, *Freedom from Want* on March 6, and *Freedom from Fear* on March 13. The last two paintings disappointed Rockwell, at least in retrospect, because he felt they came off as smug, especially to Europeans lacking the comfort of distance from the battlegrounds that Americans at home enjoyed. *Freedom from Want,* a Thanksgiving table set with minimal food in comparison with the typical American feast day, nonetheless flaunts in the face of the less fortunate, Rockwell came to believe, the overabundance of turkey, celery, fruit, and Jell-O. *Freedom from Fear* errs by allowing American viewers to sigh in relief that they can tuck their children into bed safely each night, in sharp contrast to the victims of the bombings alluded to in the newspaper the father holds.

But the second painting, *Freedom to Worship,* which took Rockwell two months to complete, pleased him immensely. He fully worked up his preliminary idea in a detailed oil painting on canvas, forty-one by thirty-three inches. Because to Rockwell tolerance was the basis for a democracy's religious diversity, he decided to show a Jewish man being shaved by a New England Protestant barber, while a black man and a Roman Catholic priest waited their turns. He found himself unable to characterize the men not in clerical garb without resorting to offensive

stereotypes—exaggerating the Jewish man's Semitic features, squaring the white customer into a preppy golfer, and rendering the black man as an agrarian. The composition is clean, impressively sparse, in counterpoise to a dense narrative content. Beautifully painted even at the preliminary oil sketch stage, the picture would have failed to convey clearly the government's theme, even if it had exemplified Rockwell's own spirituality.

When he devised his new scheme, he still found ways to suggest the diversity of the population, but more subtly, through visual clues among a unified mass of heads. One man holds the Koran, one woman a rosary, while the man in the middle of the painting exhibits a Roman nose, in clear but understated contrast to the rest of the worshippers. Two very-dark-skinned black congregants frame the painting diagonally, a woman at the top left, a man at the bottom right. The *Post* had not yet made a practice of moving blacks into prominent visual positions, and Rockwell later explained that he bucked the Curtis system by "furtively" painting the face of the black woman at the top; the man at the bottom, with his fez, was too obviously foreign to offend. Across the top of the canvas the aphorism "Each according to the dictates of his own conscience" is lettered in gold, a platitude that suggests the plurality of Rockwell's own thoughts on religion: its likely source was a phrase included in the "Thirteen Articles of Faith" by Joseph Smith, the founder of the Church of Jesus Christ of Latter-Day Saints (commonly known as the Mormons). Rockwell spent almost two full months on the *Freedom to Worship* theme, worried that religion "is an extremely delicate subject. It is so easy to hurt so many people's feelings."

Unfortunately, the tight amalgam of faces—individually exquisitely rendered but en masse saturated with piety—and even the crepey skin on the elderly hands, which have become the objects of worship, push the theme over the edge from idealistic tolerance into gooey sentiment, where human difference seems caught up in a magical moment of dispensation from the Light. The restraint demanded by art that deals with heightened emotion is lacking.

To their detractors, the Four Freedoms try to carry too much weight on their shoulders. The idea of illustrating grandiose concepts with humble correlatives is a sound one; but the executions of Rockwell's scenes announce their own ambition too loudly to work on that premise. Rockwell was forthright about wanting these paintings to be his masterpieces, his "Big Idea" pictures, as he put it. Inevitably, he was unsatisfied, though he believed himself to have articulated in *Freedom of Speech* the nobility of certain abstract principles that he valued deeply. Paradoxically, had Rockwell not struggled so hard to be worthy, if he had stripped down his portrayals to the kind of quiet small scenes he would do in the fifties, the series might have been the big pictures he desperately wanted to produce.

Still, most viewers felt in 1942 like the twenty-first-century *New York Times* critic who admires Rockwell's mastery: "I'm not interested in the intentions of artists. . . . I'm interested in consequences." And, while some people thought that Rockwell's paintings conveyed a slightly patronizing take on his subjects, the majority of his audience saw it otherwise; as *The New Yorker* would remark two years after the publication of the Four Freedoms: "They were received by the public with more enthusiasm, perhaps, than any other paintings in the history of American art."

Viewed in the best light, the paintings prove an example of the sum exceeding its parts, the total effect of four domestic paintings about such lofty ideals inspirational in their combined heft alone. The Four Freedoms did, in fact, forward the aims that Roosevelt had set forth and accomplished the work that the best illustrated fairy tales attempt, turning abstractions into forms that exorcise demons. In any event, the United States Treasury quickly surmised their profitability, harnessing the original oils to a tour, cosponsored with *The Saturday Evening Post,* of sixteen cities, seen by 1,222,000 people, and raising $133 million in war bonds for the Treasury. The *Freedom of Speech* painting illustrated the commemorative covers for war bonds and stamps sold during the show. The exhibition's significance even motivated board members at Rockefeller Center to make extensive alter-

ations to the International Building in order to properly house the exhibition.

Rockwell was pleased at the public's reception to the paintings, and at least as happy that his art had filled the coffers of a cause he supported. He did not, however, become heavily involved with the exhibition, instead mostly limiting his appearances on its behalf to those locations where he needed to travel in order to undertake new assignments. As usual, he barely paused to take in the present; he was already thinking ahead to what he could do in the wake of his latest success.

22

❧

Square Dancing on the
Village Green

During the fall of 1942, when Rockwell was bearing down on the Four Freedoms, Mary was worriedly calculating whether to accept an offer on their New Rochelle house or to renew the renters' lease instead. A prospective buyer had shown up, and it would be good to get out of paying on two mortgages; but she had little chance to consult with her husband on their financial matters, though the letters from the realtors became more pressing when she failed to respond in a timely fashion. Worse still, the Internal Revenue office had written of an impending audit. Correspondence from the Rockwells' accountant reveals Mary frantically trying to find old records and checkbooks that she'd not kept track of in their move—the period the government was going to audit. In spite of her husband's intermittent suggestions that they hire someone to take over at least the business finances, Mary had insisted that she could handle the monetary interests of both family and career. Now, tactfully, the accountant wrote the Internal Revenue of Mrs. Rockwell's less-than-thorough bookkeeping, advising the office that the Rockwells would nonetheless do everything possible to comply.

Photographs of Mary Rockwell from this period show her beginning to exhibit signs of stress. Circles under her eyes have become a permanent fixture, and, though ever mindful of her figure, she has begun to put on weight. An interview in *Good Housekeeping* describes her as wearing glasses regularly, which she explains she used to avoid when she could for the sake of appearances; now she thinks such vanity silly. Possibly a positive sign of independence, it seems just as likely that Mary's flouting of old standards for her appearance stemmed from her inability to spend time on what now seems frivolous. Her sons are eleven, nine, and six years old, and her aging mother-in-law is still living nearby; her husband depends on her daily feedback and discussion, and expects her to answer his voluminous fan mail, collect props, and deliver his paintings, and she often has to take the train to New York or Philadelphia—all in addition to handling the finances. At least the Rockwells hired a couple to work part-time for them: Mrs. Wheaton as the cook, Mr. Wheaton as a handyman.

Rockwell's income was certainly high compared to that of most Americans, but he and Mary lived somewhat carelessly, making travel and household decisions impulsively in ways that caused them to pay premium prices where more cautious and timely buying would have cut their costs dramatically. Now they decided that it was foolish not to spend some of Rockwell's earnings on hiring more outside help, since Mary was overburdened and Rockwell always behind. Again this year, at Christmastime, the couple found themselves unable to pay off a bank note for $1,500, electing instead to ask the bank to roll it into a larger loan for $2,500, tiding them over until the payments they expected at the beginning of 1943 arrived. Reprieved until January 10, when the entire note would come due, the Rockwells paused to notice that their year's income had dropped to around $37,400, largely because of less income from ads, as Rockwell had cut back on these in favor of the Four Freedoms. Neither the Sunday dinners, with the uncompromisingly fine roast and vegetables, nor the yearly trip to the Ringling Brothers circus at Madison Square Garden, Rockwell's treat to his sons, was threatened by the slight decline in their finances. Still,

as 1943 opened, Mary Rockwell was stretched thin from solving one problem after another, with very little intervention from her husband. Even positive events required energy she felt short of: the household was turned upside down when the painter was honored in Washington by Under Secretary of the Treasury Daniel Bell, who presented Rockwell with the Distinguished Service Award for lending his talents so bountifully to the war cause. At least by late spring, Mary felt relief from the improvement of the family's finances, when the *Post* check for $10,000 arrived, payment in full for the Four Freedoms.

By mid-May, the harried woman had more than the usual reasons to feel pulled from all sides: the boys were home from school with the measles. At least they were going through it at the same time, and she only had to come up with one set of diversions for her bored sons. About a week into their quarantine, the Rockwells' middle son, Tommy, sleeping restlessly either from the illness or because he'd napped so much throughout the day, groggily wandered into the bathroom around one A.M., when a desultory glance outside the window confused him; he thought he saw orange flames leaping out of his father's studio next door. He woke his parents, and Rockwell, finding the phone out of order, drove to the next house, a half mile away, to call for help. By the time the fire department arrived, the entire studio had burned to the ground. Rockwell's career-long collection of authentic period costumes, his extensive reference library, thirty original oils, all his materials, were gone. Neighbors gathered throughout the ordinarily dark early morning hours, sitting on the hillside with doughnuts and coffee Mary provided, comforting the artist and watching the smoldering ashes. Rockwell took the public and private attitude—which, as Mary later noted, had worried her—that the calamity was not so hard to manage after all.

Fortunately, the last of the Four Freedoms had been shipped off only a few months earlier, and from comments Rockwell made, it is possible that the paintings, all published by now, had been stored in the studio until a few days earlier. Perhaps the near catastrophe of losing them made it easier for him to conduct himself stoically now, be-

havior that won respect from the Vermonters. He announced to his family the next day that since they were all tired of being so isolated anyway, they would find another house in town, rather than rebuild the studio.

News of Rockwell's studio fire was published nationally; Rockwell himself publicized the event by, naturally, working it out in his art. Copying closely the model his cousin Mary Amy Orpen had developed of sketching tiny cartoons on one page to illustrate a series of events, he created a page of whimsy, making it sound as if the barn burning was but another great adventure in the life of a country artist. The real cost to him went unexpressed, though Mary Rockwell, even at the time, believed her husband's lack of dealing with his loss would come back to haunt him. As soon as the nation's illustrators learned of the catastrophe, they banded together to replace much of what he had lost. Fans began sending him costume pieces, which he stored in the garage until even that overflowed.

In the meantime, he and Mary had located a large, clapboard farmhouse three miles down the valley in West Arlington. Situated across from the village green where they square-danced on Friday nights, the 1754 residence sat fifty feet from its twin building, occupied by a well-respected local dairy farmer and his family, the Edgertons. Rockwell signed the mortgage within days, and began arranging for an old red barn out back to be converted into his new studio. Until it was completed, he worked in Schaef's space, much smaller than what he was used to. And within a few years, he had a small cottage built in the woods about a mile from the house, so that he or Mary could escape the increasingly oppressive sense of being a tourist site, especially in the summers.

The Rockwells would come to feel that the biggest blessing derived from the fire was the friends they gained next door. Jim and Clara Edgerton barely managed to support their four children through nonstop work on their small dairy farm, but their sense of fun, their dignity, and their tolerance of others resulted in the two families, as different as they were, becoming fast friends. In later years, when

Rockwell was interviewed about the Edgertons, he explained: "Farming is a hard life in Vermont," due to the short growing season, lack of flat land, and the rocky fields. He liked Jim and Clara, because "hard life and misfortune haven't soured [them]. . . . I don't think they know how to be mean-spirited or nasty."

Rockwell liked people in general, enjoying their idiosyncrasies, indulging their weaknesses, as long as they weren't self-important or patronizing. A man like Jim Edgerton would have earned his deepest loyalty. The enviably handsome man was known for his gentle disposition and generosity. Always one to cosign for others' loans even though he barely had enough money for his own family, he was too proud, his son Buddy believes, to borrow money from anyone in his life except for Rockwell, and Buddy believes it a measure of the artist's character that his father felt able to do so. Somehow, a relationship developed between Jim and Norman that allowed the farmer to freely borrow money until the milk checks arrived, when he'd promptly repay the loan. Buddy believes that Rockwell's enormous tactfulness eased such matters. "One time, I know Norman wanted to paint their farmhouse. But my dad didn't have enough money yet to do ours, and Norman didn't want to make him look bad. So he just waited till we could both paint the twin farmhouses at the same time."

Clara Edgerton ran errands for Rockwell, becoming, after Mary, the person he entrusted most often with delivering his ad work to New York and his covers to Philadelphia, when there was no time to mail them. Joy Edgerton helped Mary with kitchen work and assisted her when she entertained out-of-town guests for dinners; the other two children baby-sat for Peter. Most of all, Buddy Edgerton hunted and fished and played ball with Tommy, even buying fishhooks with the money he earned from modeling for Rockwell.

"I believe that Tommy kind of relied on my household for the normal things a boy often does with his father," Buddy says. "His own father was always working and didn't have the time to teach him to drive, like my father did, or go fishing. Sometimes it seemed as if Tommy lived at our house, and I loved it. He and I were close friends,

even though I was a few years older." What the Vermont neighbors thought of the frequent columns lauding Rockwell's parental involvement, such as *The Boston Globe*'s May 30 spread that year, showing the artist "giving his son a baseball lesson: the artist will let a painting wait almost any time," while he shows his son how to hold a bat, was never recorded. Certainly such public mythologizing confused at least the Rockwells' oldest son, whom the Arlington community always thought of as "different," Buddy recalls—"Jerry was more of a loner or outsider." Jerry—Jarvis—Rockwell recalls his acute discomfort at feeling his family actually lived on the covers of *Saturday Evening Post*s, rather than in reality.

And, while Rockwell's sons agree that the Edgertons played a special role in their lives, Jarvis also believes that the relationship was necessarily compromised by the huge divide between the wildly successful New York illustrator and his life, on the one hand, and the native Vermont farmers, on the other. "That difference between us, that we all, especially my father, tried to pretend wasn't there, created a subliminal tension," Rockwell's oldest son asserts. "People enjoy talking about how close everyone was to each other, how we fit in, and that's not exactly true. I was well aware that the townspeople realized that my father was making a lot of money off capitalizing on their way of life, on semi-becoming one of them. There was no bad faith on anyone's side, it was just the reality. What could you do about it? But it was like the elephant in the living room that everyone pretends isn't there and steps around."

Hints of such tension surface in Buddy's still envy-tinged reminiscence of the flagrant ill-treatment of expensive toys he witnessed next door. "The boys would own these incredible new bikes that I'd never even seen before, and they just left them outside. Once Tommy was given a very expensive .22 for Christmas, one I would have given anything for. And he left it outside and let it rust. I told him I couldn't believe it." Group snapshots of the Edgertons with Rockwell convey a sense of the painter's slight awkwardness, especially in contrast to pictures of him socializing with his illustrator friends and their families.

Rockwell's professional success was never as wonderfully entwined with his personal life as during the mid-1940s. His tight community of illustrator friends fed his energies—intellectual, technical, social. During this year, Jack Atherton won fourth place in the "Artists for Victory" show, his painting *The Black Horse* receiving the $3,000 prize out of more than fourteen thousand entries. The Metropolitan Museum took the painting into its permanent collection; if the event stung a little, Rockwell also clearly received validation from working with and being friends with Atherton. When Rockwell could take the time off from his own work, Mead Schaeffer, the third of the regular trio, took his neighbor and colleague along with him for company on many of the tours of military facilities he conducted to paint his fourteen covers of combat forces. Bumping along on a dusty road in a jeep and examining the tanks appealed enormously to Rockwell. Such jaunts combined his desire to socialize with people who spoke his language with the practical need to soak up wartime atmosphere.

Accompanying Schaef to the Army bases helped produce two of Rockwell's best World War II pieces, the poster *Give Him Enough and On Time* and the *Post* cover *Rosie the Riveter,* published on May 29, 1943. The massive migration of women during the war into jobs previously held by men was nationally touted as patriotism at work. A year earlier, a popular song of this name made the rounds, as the sight of women in overalls and carrying industrial tools became routine. Rockwell's particular contribution to the image was to combine so many significant iconic references into one portrait of a woman. Oversized, strong, and well-muscled, her powerful riveting gun lying provocatively across her heavy blue jeans, Rosie seems to be the Statue of Liberty come alive. Modeled obviously from Michelangelo's Prophet Isaiah, the painting's reference was immediately caught by *Post* readers, a few of whom questioned the propriety of appropriating Michelangelo. Rosie acquires additional moral weight through the placement of her foot on top of Hitler's *Mein Kampf,* while the ham sandwich she holds domesticates her out of self-righteous monumentalism. Her red curly hair and upturned nose feminize her, even as her ruddy complexion

keeps the portrait from becoming a patronizing twist on gender. This woman manages to be prepossessing, powerful, extraordinarily competent—and womanly, too. As another noted *Post* illustrator of the time, Pete Helck, wrote Rockwell in admiration, he had meant to write a condolence letter about the fire, but having just seen Rosie, "I could no longer procrastinate. I think it's a beauty, and full of dignity in spite of its grand humor. And, Rosie's right arm is a piece of painting that positively thrills me. Rosie's swell bulk and design make her a contemporary Sibylle."

Norman Rockwell is not usually thought of in the company of gender-bending artists. Yet his quiet belief in women's strength and their right to live active lives informs many of his paintings. Whatever lessons he learned from his mother's manipulative weakness he may have saved for himself; as his youngest son insists, the artist was a master at getting women to take care of him, even to defend him, in spite of the fact that he was perfectly capable himself. He appreciated and turned to strong women who were players, who assumed their own competency. In his art, such attitudes took various forms, including the cliché, such as his well-known cover of the tomboy, the picture of the schoolgirl with pigtails who sits happily outside the agitated principal's office, smiling broadly in spite of her badly blackened eye. More suggestively, the August 24, 1940, *Post* cover of the camper returning home from the summer had "raised a small tempest of dissension," according to *Post* editors, because of the ambiguous gender of the child.

Although the subject was painted as a girl—the long hair barely visible, at the least, gives the identity away—the accoutrements of frogs, tadpoles, plants, and the child's general disarray, as well as the boyish suit and hat, confused the audience. A Girl Scout claimed that, in addition to the suspicious snake and field mouse, other markers of masculinity come from the "big feet, legs, hands, and ears." But a Boy Scout insists that "no boy" would ever so "clumsily" apply a knee bandage, and that the youngster's coat "is buttoned girl-fashion." It is easy to impugn Rockwell's cultural naïveté in pretending he could

universalize the particular, but in cases such as this one, the joke seems to be on us: the artist is far too adept at delineating boys from girls to have accidentally failed to denote the gender. In this painting, the lack of Rockwell's typical specificity gently indicts the audience that too often sentimentally homogenizes his art against the intention of the artist.

As comically incongruous as it seems, during the period when Rockwell's Four Freedoms were blanketing the country with what some artists complained was an anemic and whitewashed vision of war, the F.B.I. decided to hunt bear in the Vermont woods. Whether the result of some specific concern—perhaps the public unhappiness Rockwell had expressed about the government not leaping at his initial offer to do the Four Freedoms for them, that matter commonly alluded to in the magazines of the period—or merely a routine secret inspection of someone speaking as an American diplomat of sorts, J. Edgar Hoover had decided to do a little investigating of the nation's most popular artist. A Freedom of Information request reveals an F.B.I. folder on Rockwell that was initiated between the time of the studio fire and the publication of *Rosie*. An internal memo (with the writer's identity blacked out) reads: "Pursuant to the Director's instructions I spent a short while with Mrs. Norman Rockwell showing her the Exhibit Room this morning while Mr. Rockwell was taking the photograph of the Director." The memo continues by detailing the interest Rockwell had shown in doing a picture sketch of the Bureau as well as executing the commission for Hoover's portrait. If his fans and detractors both considered Rockwell domestically patriotic or prosaically apolitical at worst, the F.B.I. needed to assure itself that there was no Communist infiltration being perpetrated by a potentially Pied Piper artist capable of piping the nation into the sea. Within a few years, they would find more fodder for their files.

By the summer after his studio burned to the ground, Rockwell's new one, modeled—with only minor variations—on the old, was well under way, in spite of wartime restrictions on materials. Permits from 1943 reveal the exemptions the illustrator obtained because of the na-

ture of his work, much of it related to wartime illustration, though he still had to use nonpriority materials. In late July, he explained to a journalist from *The Boston Globe* that his neighbors were building him a new studio behind the recently purchased farmhouse, making it sound in the process as if the old site was too haunted by sad memories of his losses for the family to rebuild there. Instead, the less romantic truth was that he had been thinking about relocating to a less isolated residence anyway, and this move was enabled financially by the insurance policy he had held on the studio that was destroyed. Rockwell's focus throughout the interview resolutely remains on the virtues of the townspeople, his models. He testifies "earnestly" to the interviewer that "lots of states have mountains, but only this has Vermonters." He continues by extolling the character that the "folks" around the Batten Kill river share and that city people by and large lack.

Rockwell's admiration and loyalty are sincere, and no doubt he believes what he is saying. But he also was adeptly continuing the public relations campaign he waged throughout his life, battling the public's eventual fatigue with his success by representing himself as an average and even ingenuous talented man in awe of the (implicitly) better people around him. He had set himself up with an enormous challenge: presenting himself as accessible to his fellow citizens, and seducing them into helping him whenever he needed assistance to meet his deadlines, while maintaining the energy, time, and empty space in which to create. Finessing the impression he gave others that he thought they were special, or at least highly worthy of his attention, with their sometimes subsequent misunderstanding of their claim to his friendship, required careful thought and masterful manipulation.

By October, the Rockwells had finished renovating their eighteenth-century farmhouse, largely to Mary's specifications, and the studio had been in use for a couple of months. Life felt more manageable in this location; the covered bridge led from the main road over the river and onto the village green, where the Grange Hall, a popular community church, and the little one-room schoolhouse dot-

ted the expanse of well-tended grass. The Rockwells and the Edgertons lived in the houses on the hill, overlooking a near perfect bucolic landscape two hundred feet in front of them. In the middle of the month, Nancy Rockwell came for a two-week visit; her great-niece Mary Amy Orpen, eager to see the new house, accompanied her on the bus from Providence. Rockwell was sending his mother around $350 a month now, as well as paying the cousins for her expenses, but she felt that she never had enough money to do the things she wanted. His own income had skyrocketed this year to $49,000, largely because of the Four Freedoms, but his professional costs alone totaled more than $14,000. If it would have been cheaper for his mother to live with the family in their new large farmhouse on the Batten Kill, Rockwell didn't care: "The general attitude toward Baba that I felt in the household was of pity and a slight contempt," Jarvis remembers.

Mary Amy Orpen remembers that, as usual, Norman was busy working the whole time they were visiting. He also was dealing with an exciting request by the composer Robert Russell Bennett, who wanted to turn the Four Freedoms into a symphony, as well as the general commotion surrounding a popular national tour of well-respected artists' paintings on the theme of freedom, with Rockwell's four representations occupying the starring role in the exhibition. Requests for interviews and for commissions of all sorts multiplied, and by December 1943 the artist had every reason to feel particularly independent and secure about his future. The Society of Illustrators sponsored a wildly successful evening at the end of the year with Rockwell and Jack Atherton discussing the dangers of the power art directors were wielding at magazines. Rockwell had even recently completed another movie promotion project, which he always enjoyed, this time for *The Song of Bernadette*. Although he sent the painting in on time, Twentieth Century–Fox had to hound him to find out when he and his wife would arrive for the movie's premiere, occurring on January 25, 1944.

But in spite of his status as America's most popular artist, cited re-

peatedly in press coverage from all over the country, Rockwell had begun to suffer another bad emotional spell. Mary later wrote her sister that she had expected something like this as a delayed reaction to the fire; throughout 1943, he had "sailed easily" through his work, only beginning to stumble as the new year began.

The first sign that the artist was emotionally out of sorts occurred when he decided against attending the Hollywood premiere in favor of spending more time in January 1944 hiking the land behind their house, renovating tired spirits in their own backyard. The couple spent the mornings navigating the gentle mountains that surrounded them, walking a mile and a half up the road, then climbing upward until Mary found herself out of breath, her fit, 135-pound husband not missing a beat. But they both felt the span of "white birches and meadows and fences and walls below" with the "red barns against the snow" to be a peaceful respite from the "sound and the fury" going on in the rest of the world.

It was hard for Rockwell not to think often about the war, given his prominent place on the roll of artists available to help with government propaganda. The OWI, by February, had dampened its earlier enthusiasm for emphasizing the skills of "fine" artists over illustrators, unlike their strategy for World War I; the illustrators proved more effective with the people. The talent pool of artists' names that the OWI sent to the poster division in New York included many of Rockwell's friends, including the stylish painter Constantin Alajalov, Harry Anderson, Andrew Wyeth, Pruett Carter in Hollywood, and all of Walt Disney's cadre of artists. Rockwell's characteristic choice to domesticate World War II for those left behind stressed not the ugliness and violence of battle but the human need for connection and gratitude that didn't pause even under such extreme conditions. From Rockwell's point of view, the war was eminently worth fighting, and so the only question for those not in the service was how best to contribute. Willie Gillis sought to validate the duty that Americans had to accept as they fed their young men to death in exotic places. Supporting the soldiers by a show of solidarity was the gift they could offer up, and

Rockwell's wartime painting emphasizes that conviction. Ensuring that Americans understood the more abstract philosophy behind such sacrifices, however, demanded a more overtly political statement, and it was in the Four Freedoms that the painter rendered the democratic ideals he believed in deeply.

But Rockwell's obvious idealization of things American, regardless of the care he took not to portray other citizens of the world as evil (except for Hitler), reverberated worrisomely with some of his audience, including the teenager Neil Harris, later an art curator and historian involved in mounting a major Rockwell exhibition. After all, the larger-than-life posterization of the noble citizenry, and Rockwell's typical celebration of a pastoral society, felt distressingly akin to the pictorial propaganda favored by both the Nazi and Soviet regimes. True, Rockwell had never pretended to paint the strictly real, but he had established as an audience a near cult following that apparently wanted his vision of America to be real. Native New Yorkers such as Harris felt their own experiences denied; and, indeed, when only a handful of Rockwell's hundreds of covers for a magazine published in urban Philadelphia even acknowledged America's great cities, their citizens tended to feel marginalized in Rockwell's vision of America. The occasional city scenes that do appear position their protagonists in resistance to the obvious disorder generated around them. Only by reducing the scenes to vignettes of enclosed community—so that the city is reduced to a small town—does Rockwell seem willing to plot his stories around an urban center. As Harris observes, "Rockwell defined the city more emphatically by contrast or withdrawal from it."

The heightened collegiality imposed by the common cause shared by the nation's finest illustrators would probably have honed the insecurity always lying in wait for Rockwell. He could see up close the changes being effected by the next generation of talented young illustrators who had grown up educated by the possibilities of the camera. By 1944, the *Post* cover graphics as altered by Ben Hibbs's leadership had been in place for two years. In contrast to the pattern of the covers Rockwell executed under Lorimer, the backgrounds had become

as important as the central image, largely because photography had enabled easy access to all types of location scenes; now, an empty music hall, a backyard in Troy, accidents of light, daringly unusual angles, could all easily comprise the drop against which a central subject might be painted.

As Susan Meyer points out, Rockwell had taught himself a lot about photography, and he was able to "pull off any number of tricks in the darkroom if needed," yet he wasn't even interested in looking through the lens at a photo session, let alone in taking the picture himself. He knew he didn't want professional effects, which he would have been tempted to go for if wielding the camera; he preferred working from gray middle tones in the black-and-white photos, so that he wouldn't be seduced into photographic effects he didn't want. He usually had three prints made for each subject—one normal, one very dark for highlight details, and one very light for details in dark areas.

Gene Pelham, who took most of the photographs for him, used a four-by-five-inch camera generally set at f8, and he typically developed the film and prints in Rockwell's darkroom at the back of the studio immediately after the shoot, so that the next morning the illustrator could choose the best ones and get to work. Pelham loved working for Rockwell, who encouraged the man's own work, helping him get two paintings published in *The Saturday Evening Post*. In a phrase eerily repeated by the photographers who worked extensively with Rockwell, Pelham felt that Rockwell was "almost like a brother to me." Such intimacy came at a cost; Rockwell expected Pelham to be available whenever he needed him, even though the man had a wife and children. He would remember the way that Rockwell made him feel so necessary to the artist's success and even his emotional well-being that he dared not refuse him: "I'd get a call most any time of the day or evening and the minute I recognized Norman's voice, I knew what would come right after the hello. It would be 'Gene, I need you.' Norman could never rest or put anything off when he had a new project started."

But one time, at least, he was able to resist Rockwell's blandish-

ments. "It was Christmas Day, and I was home opening my gifts with my family. The day before, [Rockwell] had begged me to come help him for a few hours. I told him he was crazy, that he needed to take the day off too. But he kept pleading, desperate. Well, this morning, Christmas Day, I heard a knock. I couldn't believe my eyes—it was Mary Rockwell, and he'd sent her to beg me. I could tell she was unhappy doing it, too, but I still said no."

Rockwell compensated for yielding to the camera's efficiency by constructing a veritable piece of theatre, himself producer and director. Days were spent collecting costumes, props, the best lights, and the finest available models before the shoot began. When it was time to take the pictures, Rockwell had the photographer take shots of individuals, of groups, close-ups of the set, of pieces of the props, of someone's hands. He varied his requirements, sometimes asking for a hundred photos of a staged scene, sometimes three or four of independently choreographed moments. Usually he would act out the expressions he wanted assumed by the "actors," as he thought of his models.

His use of the townspeople created tremendous rapport between them and the artist. An illustrator who later studied with Rockwell, Don Spaulding, observed that "he treated [his models] like 'honored guests.' " Rockwell made them know how much he valued their work and that the success of his paintings depended on *them*. Never patronizing or condescending to his models, he advised other artists: "If your models feel that you are their friend instead of their boss, and if you make them feel that they are very important to the success of your pictures, they invariably will cooperate. You cannot get people to do things for you that are difficult, no matter how much you pay them or order them about, unless they like and trust you."

He paid his models more than the other local artists did, to the grumbling of these friends. And when the townspeople volunteered to model for free, as they inevitably tried, he insisted on paying them his standard fees: five dollars for children, ten dollars for adults, and for special assignments, such as the woman who posed for *Freedom to*

Worship, fifteen dollars, knowing that she had eight kids in her house to feed. After thanking his models profusely, he'd send out for Cokes for the kids and give everyone their check in a sealed envelope, a gracious detail they appreciated.

Such workdays were long, and the rural respites he'd imagined enjoying, the waterhole and the extended bike rides, occurred more infrequently for him than even for Mary, who at least had the excuse of taking the kids for recreation. As soon as the spring thaws seemed imminent, much to everyone's dismay, Nancy Rockwell decided to return to Vermont. This time, the Rockwells situated her in an upscale boardinghouse in nearby Bennington. In late spring, the twenty-year-old Mary Amy Orpen visited her relatives, and Rockwell used her to model for his projected August *Post* cover of a young woman lying indisposed in her bed. What she remembers most about the trip, however, is her surprise at her aunt Nancy's "liberated" reaction to a sketch that Mary Amy drew of herself skinny-dipping under the bridge next to the village green, the first swim of the season. "Aunt Nancy wasn't disturbed at all by my nakedness or my friends either," explained the budding artist. "She was just irritated that I had risked catching a cold when the weather was still so unpredictable."

Rockwell continued to paint more war-related themes, however obliquely they related to actual fighting. Soldier lovers, ration boards, mail from home, European refugees—all took shape in his quest to domesticate, for ordinary people, the reasons Americans were fighting. When government officials sent him wires asking if they could reproduce images they saw published in various magazines, he answered swiftly and with pride that of course they could, free of charge, but that he would ask only to reserve the ownership of the painting and image after their use was finished.

The apparently nonstop growth in his popularity wore out his wife, and even his children found themselves more annoyed by the steady stream of tourists gawking at their house. By November 1944, Mary Rockwell was tired out from answering fan mail from *Post* readers, even though only one cover had appeared over the past four months.

In the past, she writes her sister, she never knew if a particular cover would elicit much response, but for whatever reason (one suspects the new popularity from the Four Freedoms), the letters seemed to come nonstop these days—and it was her job to answer them all. She enjoyed the chance to retreat to her sunny little office for such a chore, but she dreaded trying to keep up with the correspondence in a timely fashion. On the positive side, she successfully hosted the Rockwells' little social group for Thanksgiving, pulling off cooking the entire turkey dinner herself for the Schaeffers and the Athertons.

Most promising, she was relieved that her husband seemed to have conquered the depression he'd been fighting all year, though it had been particularly difficult in the past three months. She believed the emotional aftershock from losing his past in the studio fire had played itself out, and now he could rev up the pace at which he'd been finishing paintings, instead of doing them over three or four times before he was satisfied.

23

As High as He Could Fly

At the beginning of 1945, Rockwell's national fame was confirmed when *The New Yorker* contacted him for an extensive interview they planned to conduct in the early spring for one of their famous in-depth profiles. By the time the piece ran on March 17 and March 24, the Rockwells had traveled to California, where Rockwell took occasional time off to contribute to good causes, such as the Easter Seals for Crippled Children of Los Angeles County poster contest. The rest of the time, he worked on projects, including the complicated *Homecoming,* which would be published on May 26 and become Ben Hibbs's favorite Rockwell cover. This painting, showing the joyous reactions of lower-middle-class apartment dwellers to a soldier's return, includes two boys who have climbed up the tree outside the building, the one on the top a black child, as well dressed as his white friend.

It is tempting to speculate on the reaction to the article of those around him in California. All the sons remember is their shock at learning, especially through such a public forum, of their father's previous marriage. The interviews said little new about his art, but in

reading the news that Rockwell had been married for fourteen years
before his union with Mary Barstow, the country got its first glimpse
of a more complicated artist than the national image had conveyed.
The writer, Rufus Jarman, mentions Rockwell's "melancholy brown
eyes" and his "boyish" stringy pleasant looks, and the good-natured air.
Jarman is respectful but distant, fair but never fully engaged, almost
as if he is picking up on a similar lack of connection from Rockwell's
side. He explains that Rockwell has turned out an average of one
cover every six weeks for the *Post,* earning the country's gratitude, and
the "professional art critics'" contempt, though as a class, the writer
explains, they tend to dismiss illustration. Such critics term Rock-
well's work "dull, flat, and uninteresting," and, Jarman notes, Rock-
well is represented in the Metropolitan Museum only by accident,
with a historical waistcoat he sent for evaluation and ended up donat-
ing instead. "Gosh" and "Gee" are two of Rockwell's favorite locutions,
the journalist notes a bit dubiously, as if unsure if he is being duped
by a subject cannier than himself. (He was.)

Already, in 1945, Rockwell was willing, however, to let seep some
of his boredom with the Boy Scout calendars. He explains to Jarman
that he'd been having trouble coming up with a new subject each
year, and that the Boy Scouts "are simply going to have to devise some
new good deeds or Brown and Bigelow will be in a hell of a fix." Rock-
well tells the story of how he and leftist sympathizer Rockwell Kent
have to send mail to each other frequently, since their names confuse
their audiences. As at other times, when an anecdote about the two
"Rockwells" unfolds from either man, a sweet warm generosity seems
to suffuse the moment, though the two men never met. Rockwell ex-
plains about the studio fire—how he suspects he left a pipe burning
near the curtains, and hot ashes ignited the cloth. Jarman, suspicious
of the artist's upbeat attitude toward the event, asked Mead Schaeffer
his opinion, which ended with Schaef's joke that Rockwell almost
convinced him to burn down his own studio.

As the *New Yorker* profile was appearing, the new art editor at the
Post, Ken Stuart, introduced himself to Rockwell and discussed his

understanding of the contractual agreement in spirit, if not in print, between Rockwell and the *Post*. The two men would always maintain an uneasy relationship, though in later years Rockwell thought it best to feign otherwise. Throughout the last half of the decade, Stuart and Rockwell jockeyed for position in the *Post's* hierarchy: would Rockwell continue to have unlimited access to Ben Hibbs as his first line of defense, or would Stuart's opinions reign, in terms of the selections of the magazine's art? Alternating between a slippery imperiousness and an obsequious display, Stuart worried Rockwell from the start, not least because the artist already believed that in the wake of World War I, the art world had suffered from such professionals dictating to the artists what they should paint. On April 17, Stuart sent Rockwell a copy of Ben Hibbs's letter of agreement to continue their old terms, though Stuart reminded Rockwell, who must have requested the document, that he had already told the illustrator that the contract is "self-renewing" anyway.

Although Rockwell and the *Post* perpetuated the idea that Rockwell never was under contract to the magazine, presumably implying his superiority to the norm as well as his uncoerced faithfulness to the *Post,* a transitional period following Ken Stuart's employment as art director included letters between Rockwell and the *Post* that clarify, indisputably, that however briefly, Rockwell did work under what he considered the onus of a contract. When he referred to this period a few years later in a letter to Ben Hibbs, he reminded the editor that when he was under the contract—presumably during Ken Stuart's first few years—it had forbidden him from accepting any assignments from other magazines. As a result, his *Post* covers suffered, he explained, because he was suffocated by sameness. He needed the occasional outlet to stay fresh for the *Post*—exactly the reason he and Hibbs had returned to a no-contract agreement.

The *New Yorker* profile provided Rockwell with even more clout than he'd previously held, and by the time the Rockwells returned to Arlington from their California respite, the artist was feeling eager to tackle the challenge of creating the next good idea. Mary, relieved at

the positive tone of the article and her husband's (albeit temporary) optimism, decided to tackle projects outside the domain of his work. First, she took up the subject of selling—finally—their first Vermont house, which they were still paying for while holding a mortgage on the West Arlington farmhouse as well. She had decided to invest, with John Fisher, the husband of her increasingly good friend, writer Dorothy Canfield Fisher, in the local joint movie theatre enterprise, which was in danger of going under—the Modern and Colonial Theatres in nearby Manchester Depot. It is hard to imagine Rockwell's enthusiasm for the risky venture (which eventually lost money for the Rockwells), especially because much of its allure for Mary would have issued from its association with the well-off, older Fishers, who enjoyed performing public good deeds. But Rockwell's earnings were particularly strong this year; by the end of December 1945, he had earned over $52,000. Their increasing financial strength—including a small family inheritance on the Barstow side—allowed Mary some leeway to direct their investments, and so her husband concurred with her plan. While she delved into the earnings and losses statements of the theatre with John Fisher, her husband began gathering photographs for the reference division of the Metropolitan Museum, which had finally requested Rockwell's work—photographs of it, for their files on illustration.

The boys, as usual, were thrilled to be out of school for the summer, and they spent most of their time on the village green, Tommy playing ball, Peter swimming in the nearby river, Jerry kind of wandering around, figuring out what was most interesting that day. One afternoon in early July, as the fourteen-year-old walked around the field where several boys were throwing a baseball, someone threw particularly poorly and hit a tree, the ball then ricocheting off and smacking Jerry's head. He stumbled home, where several minutes of vomiting and the urge to sleep convinced his parents to call the doctor. Within the hour, he was in an ambulance on the way to the hospital, his mother and doctor at his side. "My mother said that the doctor forced her to listen to him gossiping all the way to the hospital

about someone they mutually disliked, just to take her mind off of my injury," her son remembers.

Jerry's skull was fractured, and he stayed in the hospital for several days until it was determined that the concussion he suffered was healing. His father must have been terrified, remembering the death of his favorite child model, Billy Paine, from the same type of injury. But Jarvis remembers that his parents emitted the calm and controlled aura the sons had come to associate with them in almost all circumstances, except when they were roughhousing or all playing loud "boy" games. Still, the family was frightened, and they were ambivalent about the private drama being publicized in national newspapers. Almost immediately, letters from professional associates of his father's started pouring in, expressing their regret at the news. Many of them combined their best wishes for the son's recovery with a request for an update on their commission's progress, which Mary Rockwell dutifully provided. When the artist painted his October *Post* cover that summer, he made a point of including Jerry as one of the models in the scene of a returning Marine who sits among his neighbors sharing war stories.

Apparently, Rockwell was convinced of Jerry's full recovery by August, at least according to F.B.I. reports. Scouting among artists for clues as to participation in the July 21 Manhattan convention for the New York State Communist party, the agency kept an eye on Rockwell. Entered into his file, alongside a report of the July convention, is a notice that an informant who has "furnished reliable information in the past" advised them that in August, Rockwell was mentioned as one of the 150 leading artists who had contributed to a collection of paintings and sculptures presented to the Soviet Union by the Art Committee of the National Council of American-Soviet Friendship.

An entirely legal enterprise, the Council aimed at preventing the very Cold War that in fact ensued after World War II. The F.B.I. file makes it clear that the agency, under J. Edgar Hoover's direction, would keep tabs on Rockwell from now on.

Mary spent much of August getting Jerry, his recovery complete, ready for boarding school. At Dorothy Canfield Fisher's suggestion, he

was entering Oakwood, the Quaker school in Poughkeepsie, where, everyone agreed, the boy who seemed always to keep his own counsel might thrive, though at $450 per semester, tuition was a bit steep. Certainly he had never felt authentic in the local Arlington school, where he was supposed to fit in with a rural population that had little in common with his own household, in spite of what he felt appearances were meant to suggest. "We didn't even read the *Post* in our home," he laughs. "My dad subscribed to *The Atlantic Monthly* and *The New Yorker,* more the kind of writing he enjoyed." Tommy, luckily, managed to do well at just about anything. Popular with girls for his good looks, and with boys for the skills he learned with the kids next door, he also made high grades and followed his mother's love of reading and writing. In the summer of 1945, the older boys, however temporarily, seemed well situated; Peter, by contrast, was having problems his mother didn't know how to solve.

"Between fourth and ninth grades," he remembers, "I just kind of dropped out mentally. Everything seemed boring to me; I was bright, quick, and I felt wrongly harangued by teachers who lacked imagination from what I could see. I made the worst grades possible, barely passing each year, even though the teachers knew I could have had the best grades in their classes. So I wasn't exactly popular with them either, as well as the bullies outside the classroom who really enjoyed picking on me."

The various stresses of the year were exacerbated by having Nancy Rockwell nearby in Bennington, even though Rockwell's mother acted as though they lived hundreds of miles apart. She complained at how little they visited with each other, and sought ways to move to a more luxurious accommodation, in spite of the expensive residence she inhabited already. In February 1946, she wrote a lengthy letter to Mary, exclaiming that she at least read about Norman in the Bennington papers, and that she couldn't listen to the radio shows her daughter-in-law suggested, because she was so deaf that the necessarily loud volume she used annoyed the other residents. She hoped to go to a movie with the good cousins visiting her from Providence, though she feared she could not if her check from Norman didn't ar-

rive that day. She was enjoying reading *Young Bess,* by Margaret Irwin, a fictional account of the romance between Thomas Seymour and the future Queen Elizabeth I, which reminded her happily of her own illustrious family heritage. She ended by ensuring that Mary knew how much the friends that Nancy made earlier in Arlington hoped that Rockwell's mother will return in the spring to live among them, a prospect that surely aggravated the cold Mary was fighting at the time.

While Mary kept Nancy away from her son, he completed the painting the *Post* would use on its April 6 cover, *The Charwomen in the Theatre.* If Rockwell's kindly presentation of many of the lower-class workers in his *Post* covers feels uncomfortably close to condescension, the cleaning women collapsed in exhaustion, but vivified by reading the *Playbill* after the show is over, evade such charges. Here, at least, the women look properly tired, not merely glossed over. And the intense interest with which they read the program inspires respect in the viewer for their refusal to be victims. Ken Stuart, in Rockwell's view the still-new art director, urged the *Post*'s prominent artist to pursue his talent for tapping into the heartland of America. Over the next few months, Rockwell worked out special cover ideas with Stuart, including his participation in a grassroots journalism series that Stuart dreamed up. However proscriptive the art director's newly enlarged role felt to the artist, it also relieved him of having to think up every idea himself. In May he traveled to Paris, Missouri, to judge poultry shows as part of the plan to describe America's weekly newspapers, and then rushed home to receive several art students visiting his studio sporadically throughout the month.

Word had gotten out not only to art students that Arlington was a great place to look at illustration up close. Through his friendship with Jack Atherton, George Hughes, a stylish illustrator a generation younger than Rockwell, had decided to join the choice community of artists. He and his wife, Casey, loved to ski, and they were ready to exchange the more social circles they'd inhabited the last few years for the rural atmosphere Jack had found transformative for his own work. Known primarily for fashion drawings and illustrations of romantic

stories, Hughes wanted to develop as a consistent *Post* artist; the magazine had already solicited his work. Underestimating the challenges of running a farm, the couple bought their own and promptly threw a party to meet the town's artists. Norman convinced them to make it a costume party, and he came in an elaborate eighteenth-century military uniform—"He loved costume parties," remembered Hughes, decades later. On another occasion, Rockwell asked Hughes to accompany him to a party with a theme of the World War I armistice. The men rented French-Algerian soldier costumes from a theatrical costume supplier in Manhattan that Rockwell had used often, and Hughes remembers that they had a riotously good time.

By this time, the Rockwells had become more than casual, if less than close, friends with John and Dorothy Canfield Fisher. Mary joined in the library board's reading of new books, in the process screening literature for the Book-of-the-Month Club, which Dorothy advised, and helped appropriate the tiny library's funds for future purchases. Dorothy had found herself reaching out to the community during the past year even more than usual, as solace for her son's death in the Philippines the previous summer. From her own children's comments, it appears that Mary Rockwell almost idolized the powerful woman, as did many others. Her academic background—a Ph.D. in French literature from Columbia University—and her publications record—she had published everything from a book on Montessori teaching methods to novels to children's literature, these last in the genre of parent-child question-and-answer stories that Rockwell had illustrated when he was starting his career—combined to make her a daunting figure. But her devotion to communal welfare meant that she involved herself deeply with the Arlington community, and she especially enjoyed encouraging people like Mary, who was trying to combine dedicated mothering with developing her own nascent literary talents.

The Fishers also quietly worked to support liberal causes, and, during this summer, they and the Rockwells signed a letter to the president of the University of Vermont commending the sorority that

had recently bucked the system in order to accept a "young colored woman." The letter asked that President Millis pass on to the students the four signatees' "great pleasure in learning from their action, that there is still vitality in Vermont's old, humane tradition of fair play to all, and that each individual shall be valued—or not—only on his personal worth." In the response she sent to the group, the dean of women contrasted the Fishers' and Rockwells' generous, unsolicited shows of support to the criticism of the Alpha Xi Delta girls that she continued to receive daily.

Rockwell corresponded during this same period with the Bronx Interracial Conference regarding race relations. And, except for the occasional porter, blacks continued to be conspicuous for their absence on his *Post* covers. George Horace Lorimer had left the *Post* in 1937, and certainly by the time of Ben Hibbs's ascension to editor in chief, in 1942, Rockwell could have dared to push the issue. Still, unless he was asked to compromise his painting or to paint a scene that flouted his deeply held beliefs, he was unlikely to protest such cultural omissions; his validation at the hands of the *Post*'s staff, and his glorification through its public, were more important. He would express his social liberality elsewhere.

In spite of the liberal politics that Rockwell shared with Dorothy Canfield Fisher, he could never shake his ambivalence toward her. Certainly he was less categorical in his thinking or response than she was—and less vocal, as well. Although he voted for the Socialist candidate for president in 1948, Norman Thomas, he allowed fellow Vermonters to assume he supported the Republican candidate instead. Thomas appealed to many of Rockwell's core beliefs, even if at first glance, the pacifist would not seem a natural choice for the man who illustrated the Four Freedoms. But both men held to positions that would later become mainstream liberal tenets: for a minimum wage, against child labor; against communism as embodied in Stalinist Russia, but for a communal, compassionate government involved in its citizens' lives. During Rockwell's early career, Thomas had been a Presbyterian preacher, ministering to the poor in Harlem. After he left

the pastorate to become a politician, he carved out a kind of patriotism extremely congenial to Rockwell. One of his professions of faith that would have resonated easily with the illustrator held that "If you want a symbolic gesture, don't burn the flag; wash it."

But Rockwell kept his own close counsel about things political, and Dorothy Canfield Fisher thought that a mistake. The artist thought that the best way for him to reach the largest audience—with stories he believed in painting—was to let people hope he voted their way, as long as that way was consonant with democracy. Fisher was more vocal, and to Rockwell, at least according to Mary's comments about his dislike, she was cleverly self-congratulatory in her promotion of such writers as Richard Wright and Isak Dinesen. Mary insisted that her husband was simply irritated that Fisher sparkled at social gatherings and took the attention off him. Probably there was envy involved, but even the celebratory preface Fisher had written in the spring for a fall publication about Rockwell, Arthur Guptill's *Norman Rockwell: Illustrator,* sounded some notes that would have seemed patronizing to the shrewd artist. In defending Rockwell's neglect of the negative side of life, she claims that his omission of tragedy can't be aimed only at pleasing the public or he'd paint nature, which has a huge audience, and he fails to take that path. "He purposefully makes his own choice from an inner necessity. Every artist learns early, or he is no artist, that he must drink out of his own cup, must cultivate his own half-acre, because he never can have any other."

Dorothy Canfield Fisher did make the important point that until now had been mentioned only casually: Rockwell's debt to seventeenth-century Dutch genre painters. Although the illustrator admired Vermeer's mastery greatly (on a trip to Delft he even proudly figured out the exact window Vermeer looked out to capture a certain quality of light), it was the painters considered more strictly within the genre tradition that Rockwell emulated, including Ter Borch, Jan Steen, and, especially, Pieter de Hooch. Years later, Peter Rockwell, himself an art historian, would second this selection, insisting that de Hooch, not Vermeer, most strongly informed his father's treatment of

light; and even local publications such as *Vermont Life* within a year of Guptill's book declared that Rockwell should be ranked with "great genre painters," though the writer suggested that we link him with American artists such as George Caleb Bingham. Still, as the Manhattan dealer Michel Witmer insists, "the brilliant way that Vermeer pulled off a fluffy beauty in the face of the everydayness of things is surely ancestor to Rockwell, just as Velázquez's clever rendering of even great people as humble and real explains Rockwell's admiration of the Spanish painter."

Not least for the serious emphasis it gave to the painterly qualities in Rockwell, Arthur Guptill's book marked an important moment in Rockwell's career. The text provided a brief glance at Rockwell's charming rural life in Vermont, assessed the full force of his charm and wit, then devoted most of its pages to explaining how Rockwell painted his pictures. The explanations were technical and fulfilling, taking the reader through the photography sessions to the preliminary sketches to the painting itself. Even the brands of products are listed, from the eraser Rockwell used to degloss his sketching paper, to the fixative he used to keep his charcoal from smudging, to the brand of paints and undercoating. Guptill draws a picture of the way Rockwell sets up his palette, naming every color, from the alizaron crimson to cadmium orange to cobalt blue.

The book struck a respectful and affectionate tone, and it remains a classic for anyone wanting to understand Rockwell's technique. That Guptill undertook the project, for which he accompanied Rockwell around the country on various photography shoots, as well as sitting with him in the studio, speaks to the artist's national prominence in 1946.

Rockwell took a few days during the fall to promote the book, which generally received positive reviews, though just as frequent were remarks that its subject was outré among current painters. One tack commonly used among interviewers was that of *The Cleveland News*, where Rockwell's superficial country airs were contrasted in surprise with his sophisticated conversation. Writing of the "people's

illustrator," the editor exclaims "what a country boy Rockwell, the New York City born-and-educated man, looks! . . . lean, emaciated, homely, relaxed, with a humorous drawl and gentle good manners." At a lunch in honor of Rockwell that the editor attended, before the amazed newspaperman knows it, the artist is discoursing with art directors about "Rivera and Orozco" or "telling art school students about the house-paint preparations which will save their canvases."

The artist did not devote as much time to promoting Guptill's book as the author had hoped for, since Rockwell could not afford the time off work. The family traveled to California for the holidays, where the local film industry lavished press attention on Rockwell for the extensive advertising he had created for Twentieth Century–Fox's *The Razor's Edge,* especially a full-color painting of actor Tyrone Power. Yielding more pleasure to both Mary and Norman, however, was their year-end realization that the earnings had reached $52,600 in 1946, news that relieved their worry over escalating costs such as Jarvis's private school bills and Nancy Rockwell's mostly imaginary health problems.

Mary was irritated over nonfamily members as well who, she felt, tried to claim too many of her husband's resources. Most of all, she was growing jealous of Gene Pelham, whose indispensability Rockwell often and loudly proclaimed. Rockwell's sincere and obvious appreciation of the photographer's devotion to the artist's needs, taking as many pictures as his boss needed, and staying as late as necessary to develop them, encouraged Pelham's loyalty. Rockwell's instinctive ability to make others protective of him engendered a sense of intimacy on the part of the caretaker that wasn't necessarily felt by Rockwell himself. As an elderly man, Gene Pelham made some slightly contemptuous references to Mary's flightiness that suggested he and Mary were competing to feel most important to the illustrator.

Two new acquaintances whom both Norman and Mary believed to represent real improvements to their social and professional lives were Mary and Chris Schafer, who moved from Chicago to Arlington this year because they wanted a rural place to raise their kids. They

bought illustrator George Hughes's farm, but they likewise decided that tending fifty cows was more work than they had bargained for, and they sold it but stayed in Arlington anyway. The bastion of illustrators nestled within the mountain community gave rise to a lively social life. "Any event was an excuse for a party," Mary Schafer remembers. "Bastille day, a birthday, whatever. Conversation [was] amazing, its range—Rockwell familiar with subjects from baseball to literature, Jack so much about music. Norman [possessed such a] keen sense of humor." The overabundance of wit led to many long nights of party games, including Charades, Twenty Questions, and something called "the Game," where players wrote on a sheet of paper what they most liked and disliked. The papers were distributed and people guessed who had written what. Rockwell's were always particularly telling, she recalls: what did he most like? Checks in the mail. And he liked least the extra edges of perforated white paper surrounding a sheet of new postage stamps.

It's pleasant to think, at least, that the new vitality the family-oriented Schafers brought to the community inspired the Rockwells to seek more time to enjoy their own brood. In 1947, Norman and Mary decided that they deserved a real vacation again, one with no other relatives around. They hadn't really taken one, except to go to California, since Peter's birth. And, as the theme of children appeared in all six of his *Post* covers this year, Rockwell seemed to be especially aware of his sons, possibly, as Jarvis suggests, because the oldest one had been at boarding school. Since everyone in the family liked water sports, Provincetown conveniently suited them all, and they rented a house on the beach for at least a month, after Rockwell had secured use of a studio nearby. The family arrived to discover that, totally coincidentally, Mary Amy Orpen and her college roommate had rented the cottage next door. The Rockwells and the two young women went sailing together, where Mary Amy noticed how relaxed the water made Mary Rockwell. The girls left soon after the Rockwells arrived, which is when disaster, as the sons recall, struck. "My parents were riding bikes, and the front wheel of the bike my dad had rented col-

lapsed suddenly, with no warning, throwing him over the handlebars," Peter remembers vividly. Rockwell broke his upper jaw badly, a complicated fracture that involved a delicate repair to the maxillae as well as replacing the teeth he had knocked out. Because it was the Fourth of July, no dentist could be found, and Rockwell rode around in a taxi, ending up a few hours away in Hyannis before someone was found to wire the artist's jaw shut. Luckily, a dental surgeon who had worked on veterans with war wounds was in the area, and the specialist operated on the artist. Although Rockwell pretended to be sick when he needed deadline extensions, he was especially reticent about real medical problems, and he strove successfully to keep this latest injury under wraps. Pictures of his face before and after the accident, however, show the slightly realigned bone structure.

Although Jarvis believes his father enjoyed, in one sense, the scars and war stories that served as the aftermath of the accident—"it was the boy thing, the way it was all so typical of being male, that's what he liked about it"—Rockwell spent long hours over the next year in the dentist's chair. The accident cost him income—that year, his earnings dropped to $37,000—and money out-of-pocket as well, for the expensive medical repairs. Typically, he made a joke of the experience, claiming that he was one of the only people he knew who went to the dentist so often that he fell asleep in the chair.

The rest of the family enjoyed their vacation immensely. As Tommy's end-of-summer note to Baba made clear, they spent their time swimming as much as possible. Mary's childhood summers at California beaches paid off, according to Peter Rockwell. She was such a good swimmer that she'd swim "way out beyond the surf and keep going, occasionally taking me with her." When Rockwell healed enough to go out of the house, the family awoke at three A.M. to catch a ride on the commercial fishing boats, so they could see what real fishermen did for a living. And, in the late afternoons, the boys would sit on a bench with the local old men and learn to whittle pieces of wood into rowboats. But Rockwell himself spent a frustrating summer, his jaw wired for months. Back home, even more than usual

Mary found herself picking up the professional slack that her husband's injury created.

In spite of moving Nancy Rockwell back to Providence, Rhode Island, Mary's household duties seemed to expand in the fall as well. She found herself frequently driving her mother-in-law back and forth between Arlington and the cousins' home, since the older woman's health actually did seem to be deteriorating and the bus and train were difficult for her to manage. Mary often hosted the Providence relatives en masse, partly because she was too busy at home to provide transportation for her mother-in-law or to facilitate the older woman's visits to the Rockwells' house. She also coordinated the schedule for students touring Rockwell's studio, whether for the occasional visitor from a professional school, or the group of sixth-grade students from Burlington who happily selected Rockwell's studio as their yearly field trip. Soon afterward, when one of the girls from the class died of leukemia, Mary would ensure that Rockwell's memorial gift to the school arrived safely, his painting for the November 8 *Post* cover, *The Babysitter*. And she engaged throughout the second half of that year in discussions with Rockwell's lawyers over the feasibility of continuing to hold the mortgage on the Modern and Colonial Theatres, whose owner was typically unable to make his monthly payments.

Infrequently, Mary got away from her home duties by traveling on location with her husband. As part of the illustration series of Middle America and small-town occupations that Rockwell, at Ken Stuart's behest, was still doing for the *Post*, he went to Portland, Indiana, in early November. From what her sons remember, she didn't like Ken Stuart, and she wasn't partial to her husband's work being yoked to Stuart's ideas. When the Athertons and Mead Schaeffer's family got together with the Rockwells for the Thanksgiving holidays, Jack and Norman were able to practice what they would preach about too-powerful art directors at their joint talk, the coming week, at the Society of Illustrators. Strategically, Rockwell had shared a place on the same stage that spring with Ken Stuart himself, discussing other challenges that illustrators faced. As her husband would tell Mary repeat-

edly, it was important to create alliances, and to choose your battles carefully.

As if afraid that his growing reputation would create animosity toward him, Rockwell determined that it was more important than ever to get along with everyone. He had decided to initiate a new line of calendars, to be published by Brown and Bigelow, the same company that issued the Boy Scout calendars so successfully. Rockwell approached the Minnesota manufacturer about illustrating a yearly product based on the four seasons; he would provide four quarterly scenes for each year's calendar. The first copy would come out the following year, and from 1948 to 1964, the series would compete only with the Boy Scouts calendar for first place in sales. But the commission meant yet more demands on Rockwell's time, and other overcommitments he had made had to be backed out of as gracefully as possible by his wife, acting on his behalf.

Also looming was his potential involvement in a correspondence school for illustrators that his friend Al Dorne was trying to set up. By the end of December, Rockwell's lawyers had decided the enterprise was legitimate and worth their client's participation. During the school's early planning stages, Rockwell was supposed to survey the market for such a program among the artists manqué of Hollywood when he made his next trip to California, and his interest was keen enough to start putting out feelers.

Fortunate at least since the early thirties in eventually devising interesting new venues—or, perhaps, industrious in his efforts to prepare for such good fortune—Rockwell rarely had the need to conjure up excitement. Mary Rockwell, in contrast, read books primarily to satisfy her desire for adventure, and the less demanding her household responsibilities became as the boys grew older, the more time she had to lose her sense of self. Nobody remembers when she first started drinking too much. Certainly, by the beginning of 1948, she was showing signs of mental fatigue. She was only forty years old, and her two oldest sons were spending most of their time away from home, Tommy having recently joined Jarvis at Oakwood. And her

youngest was only six years away from entering college himself. It was time for her to reestablish herself outside the roles of mother and wife, and she began participating in local writing classes. At this stage, Mary's sons sometimes wondered why their mother worried so much; but, looking back, Jarvis recalls seeing her hunched next to a visiting teacher on their living room couch several years before, earnestly talking to the other woman about her own unfulfilled ambitions and fears of inadequacy.

It is easy, so much so that the ease urges caution on us, to posit Mary Rockwell's problems, the subsequent years of alcohol abuse and mental illness, as integrally connected to her husband's career and his consequent emotional distance. Like Zelda and Scott Fitzgerald, we could surmise: the talented woman, forced to play second fiddle to her famous husband, languished in the wake of his fame. And Mary Rockwell did dedicate herself to ensuring that her husband's work could always proceed unimpeded, from cooking the food he preferred to keeping the hours he worked best by to spending her days taking care of his professional and domestic needs.

But it is also true that Norman Rockwell was not averse to hiring people to do the chores Mary performed instead. He had admired her brains and competence and social extroversion from their first meeting; and nothing suggests that he enjoyed her sacrificing any of them on his behalf. He just didn't want her needs to stand in the way of his career, and she knew no other way to meet such a requirement than through making herself indispensable to him. What is saddest about such a tale is the evidence suggesting that he found indispensable what was in fact easiest for her to give—emotional support, belief in his talent, and honesty in her criticism. The rest—the running of errands, the housekeeping, the answering of fan mail, the tending of his mother—all this he found easy to replace with professional help, when Mary finally had no more ability to provide it.

After George and Casey Hughes were released from the responsibility of the farm that they'd sold to Chris and Mary Schafer, they moved closer to West Arlington and found themselves free to social-

ize more frequently. Jarvis Rockwell recalls the suave, dashing, man-about-town figure that George Hughes cut; he remembers, too, his sense that his mother had developed "a crush" on the urbane illustrator. "I can't recall all the clues," he says. "But even a picture I've seen brings those memories to mind—my mother, looking really pretty and kind of dolled-up, when ordinarily at this time she didn't make much of an effort. And it was to be with the Hugheses."

During an interview in 1986, George Hughes spoke not of Mary Rockwell but of Mary's husband's disconcertingly obvious habit of discounting the younger man's artistic judgment. Rockwell solicited his advice in order to determine what not to do on a painting in progress. He'd ask him something, turn to Mary and say, "See, George likes that," or "George doesn't" and then immediately do the opposite. Whether a real response to what he saw as Hughes's limitations, or a spouse's jealous rejoinder to his wife, Rockwell's jovial nastiness was out of character.

Yet he could also be kind to Hughes, who considered him a particularly thoughtful man. When Hughes's daughter was getting married and her tense father was preparing to go to New York City for the wedding, Rockwell unexpectedly called, saying the situation might be stressful for him, since he would be seeing so many old friends from his first marriage as well as giving away his little girl. Rockwell declared that he and Chris Schafer, now their mutual friend, wanted to go with Hughes to keep him company. "Their presences made it easier for me but I never would have asked. It was like Norman to offer without being asked," Hughes recalled.

Rockwell spent a good deal of time in New York City that year, for occasions far afield from girding up shaky friends at family weddings. According to F.B.I. informants, on February 28, 1948, Rockwell was listed on a sponsoring committee for a mass meeting to be held at Madison Square Garden, its aim to raise funds to aid the ten Hollywood writers and directors fired after being cited for contempt by the House Un-American Activities Committee (HUAC). Publicity about the event appeared in the *People's Voice*, which the California Un-

American Activities Committee had cited as "communist initiated and controlled or so strongly influenced as to be in the Stalin Solar System." Rockwell was among those who had invited John Gates, editor of the *Daily Worker,* to join a meeting to be held in the Gold Room of the Savoy-Plaza Hotel in Manhattan. The rationale of the meeting was to combat censorship.

Throughout the spring and summer of 1948, Rockwell worked on several ads, including a first-rate oil painting for The Watchmakers of Switzerland. An old watch repairman is meticulously rendered, from his wrinkled, crepey hands, to his overgrown eyebrows. The rest of the canvas is more loosely painted, with the oil thinly applied as though for a sketch. The crowded pictorial space of the work points to what will be a hallmark of Rockwell's remarkable achievements in the next decade for the *Post.* In this ad, the total effect dramatically exceeds what corporations were accustomed to getting from the commercial artists they paid.

Although meetings among illustrators had begun, by now, to include worried murmurs about the postwar shifts in taste, including far greater dependence on photography for magazine art, Rockwell's popularity remained undiminished. Among the rash of summer publicity, however, including *Boston Globe* pictures of him and Mary at the local square dance, and Newark, New Jersey, newspaper articles about his life as a "teener" (teenager), there was the ambivalent note struck about his right to status among the educated. *Time* magazine, for instance, ran a picture of him helping Grandma Moses, a Vermonter herself, celebrate her eighty-eighth birthday. After commending the shrewd, practical woman for professionally striking "a pose that even her most critical dealer would accept as an authentic American primitive," *Time* notes the helping hand lent her at the party by "Norman Rockwell, who also paints, after his fashion." Playing the smug, categorical journalists far more adroitly than they realized, Rockwell touted Moses as the "most exciting figure in 20th century art." These days, he continued, you had to stand in line to buy her work, a product of "using housepaints." A *Los Angeles Times* journalist hardly knew what to make of Rockwell's genial patter.

In the late summer, before Jerry and Tommy returned to Pough-keepsie for Oakwood's fall semester, Rockwell painted his *Christmas Homecoming*, the *Post* cover to be published on Christmas Day. The painter's firstborn is the centerpiece, a near prodigal son whose community welcomes him en masse. All the Rockwells, and Grandma Moses too, appear in the painting: Mary joyously hugs her son, and Peter and Tommy stand at the side, while Rockwell looks the part of the proud father, pipe in mouth, sage smile on face. Mary seems slightly frazzled, however, and it turns out that Rockwell was not taking artistic license.

24

◆

Signs of Stress

By the fall of 1948, crying scenes had started occurring within Peter's hearing. Before, the boys had occasionally heard their parents arguing behind closed bedroom doors, but nothing was ever said that scared them. In fact, their parents usually got along so well that they had been shocked a few years earlier when their father good-naturedly laughed at Mary's disastrous attempts at a new pancake recipe, causing her to flee upstairs in tears. "We'd never seen Pop make Mother cry, and it was shocking," Jarvis has stated.

One evening, his brothers both away at boarding school, Peter sat on the top of the stairs and listened to his parents down below. "My mother was sobbing, and my father, obviously bewildered and upset, said 'Why don't you just stop drinking?' and Mother answered, 'Because I can't.'" Records from a doctor in nearby Bennington suggest that, for the last year at least, Mary had been seeing a psychologist. And the neighbors certainly were well aware that there were problems. "I remember going in to visit with Mary one day," Joy Edgerton recollects. "I liked to talk with her; she always read so much, I think

often an entire book every day. So she had interesting things to share. This one day, she was all excited about some psychology book she had been reading; I got the feeling her doctor had recommended it. Maybe it was Erich Fromm, the *Art of Loving*? And she urged me to read it. I did, but when I returned it and tried to discuss it with her, she became distant, even defensive, and that was that." Nearly a decade later, doctors would detail the severe mood swings that Mary suffered, and her confusing reaction to Joy seems a manifestation of the problem that only worsened with time.

The same neighbor remembers that at the dinner parties the Rockwells hosted during the late 1940s, Mary, who had promised her husband to swear off alcohol, would sneak next door to get a drink from the Edgertons' liquor cabinet to "settle her nerves." And by this time, Nancy Rockwell had started telling tales in Providence of Mary's reaching down to the side, when she was driving her mother-in-law back to Rhode Island, and swigging quickly from a flask.

Mary's car trips soon incorporated a new ritual, driving from Arlington to Stockbridge, Massachusetts, to receive psychiatric treatment from Dr. Robert Knight, the director of the well-regarded private mental institution Austen Riggs. Founded in 1919 by Dr. Austen Fox Riggs as the Stockbridge Institute for the Study and Treatment of Psychoneuroses, the humane, forward-looking, and extremely expensive residential center was only an hour and a half from Arlington. Mary could leave in the morning and be home before Peter got back from school. A few times, he remembers, she would set up a Friday and Monday appointment and take him out of school to accompany her, enabling the two of them to stop off in Stockbridge for Mary's first appointment, then drive to Poughkeepsie, two and a half hours through the Taconic mountains, to see Tommy and Jerry at Oakwood. They simply reversed the order on the way home. On other occasions, when Mary felt too nervous to drive, Clara Edgerton from next door would take her to Stockbridge.

Seriously undercutting Mary's attempts to strengthen herself emotionally just now was the notice from the I.R.S. that they planned to

conduct yet another audit of the Rockwells' taxes, this time for 1945. The family lawyers pleasantly explained to Mary that she'd need to locate a long list of records in order for them to work effectively with the I.R.S. agent. She found them, but, according to family and friends, the auditor announced that he had never seen financial records kept so poorly, a cruel indictment of the woman who had proudly insisted that she could handle the finances all by herself. Her sons remember the tremendous stress the situation put on everyone; photographer Gene Pelham, frequently impatient with Rockwell's wife anyway, took matters into his own hands after the audit was finished and arranged for the Rockwells' friend Chris Schafer—formerly an accountant in Chicago—to take over the family's financial records. Schafer was incredulous when he discovered, during his first week on the job, that the Rockwells had accidentally paid their federal income tax twice that year.

Mary surely sensed Gene Pelham's contempt for what he considered her incompetence. "She was always flitting around," the man recalled decades later, infirm and by his own admission unable to remember the past clearly anymore. "She would disappear for days, never any idea where she'd go. Just a socialite, I think." That Pelham, who worked so closely with Rockwell, held such erroneous ideas about the woman whom sympathetic neighbors remember desperately grinding the car gears as she tried to drive off quickly in pursuit of the latest prop needed by her husband speaks volumes about what went unspoken between the artist and his "intimates," as well as Pelham's own territorial feelings toward his boss. "She wasn't that deep a part of Norman, not a big part of him at all," Pelham sniffed as he recalled the late forties.

From her sons' accounts, the I.R.S. audit accelerated Mary's problems. By late autumn, when Rockwell was ready to head out to Los Angeles for one of his near regular winter retreats, he'd had enough. He told Mary that she could follow with Peter only when she had the drinking under control. To Peter, and perhaps to his mother, it felt a little like desertion. "I was twelve years old, and he left me alone with a

mother who was falling apart. It doesn't seem to me to have been a very responsible thing to do." Mary drove her husband to the train station, and on the way home she asked Peter if he'd like her to take him and a friend to the movies. "It was a bit of a distance," her youngest son still remembers, "and we rarely got to go. I was bewildered, but happy, at this turn of events." The child's uneasy feeling that something was "off" received confirmation once they were back home, when Mary suggested that Peter sleep with her in his father's stead. Not only would being together ward off their mutual loneliness, but she was scared of noises outside. "It wasn't exactly the wisest thing to do, for a mother to put her pubescent son in bed with her," Peter says. "I have no memories of anything untoward, but still, it makes me cringe. She was just so lonely, and I guess it made her feel less abandoned."

Although it felt a bit like that, Rockwell had not abandoned them, of course, and before Thanksgiving, mother and son made their way out west, leaving the older boys to spend the school holiday with the Edgertons. "On the train trip to California," Peter remembers, "my mother just broke down. I had been walking around the corridors, finding them fascinating. When I got back to our compartment, I found porters and attendants swarming around my mother. To this day, I'm not sure what happened, except that she may have gotten drunk for the first time in a month or so, and perhaps she collapsed from that." Peter was fighting his own demons by this point. They had stopped in Chicago long enough for mother and son to catch yet another movie, and the subject, a wicked woman who fakes being good, scared him into begging his mother to reassure him that she wasn't like that, too. Jarvis Rockwell believes that he and his brothers felt that their mother had no personality; "she was insubstantial, but like a sweet lady who wanted to do all these things for us. She was like an actress in a play, and try as we all might, we couldn't 'see' her, and I don't think my father could at all. It was as if Pop and us were her only means of expression."

When the two bedraggled Rockwells arrived, neither told the artist about Mary's collapse on the train. The artist had arranged to work in

Hollywood for some months, and it was easy for Mary and Peter, who was excited at the thought of attending school there, to concentrate their attention on the stylish Roosevelt Hotel, where they would stay for the next four months. Located across the street from Grauman's Chinese Theatre on Hollywood Boulevard, the hotel attracted Hollywood's most important figures, including movie stars whose glamour proved a useful distraction to the Rockwells just now. Peter needed no inducement to settle in; he was excited at the new surroundings. Mary tried to be.

Within a week of their arrival, she wrote the older boys one of her feverishly positive letters, this time smacking of her desperation to smooth everything over. She described how relaxed "her husband" (an odd locution to use with their sons) was, and then launched into a description of the uproarious antics of a Laurel and Hardy taping they had all just attended. She wanted to laugh so hard she choked, but she held back, because everyone had been instructed to be quiet. The letter, meant to reassure her children that all was back to normal, was instead frightening in its near hysterical good cheer. The older boys rejoined the family at the beginning of their Christmas break, at which time, as they recall, the problems that had recently broken through the surface were just brushed under the table again, although in retrospect they realize that their mother had begun seeing a psychiatrist in Los Angeles. "I know that later doctors claimed that the California psychiatrist ruined Mary," Nancy Barstow Wynkoop said in 1999, the ninety-five-year-old woman speaking passionately about her adored older sister. "I think the Los Angeles doctor told Mary she should blame Norman for her problems, and everyone else wanted her to blame my mother." But Mary actually kept many of her troubles from her sister. Asked about the unhappy woman's struggle with alcoholism, the sister to whom so many cheerful letters were written drew a blank. "I never heard about that," she replied honestly. "Mary had a drinking problem?"

From what Nancy could reconstruct, the California psychiatrist Mary frequented from 1948 to 1949 told his patient that she needed the space to become "self-actualized," to reject being a mere exten-

NR's 1912 scholarship drawing, Art Students' League, unpublished illustration of Oliver Wendell Holmes's "The Deserted Village."

The Quarry Troop Life Guards, for a story in *Boys' Life*, September 1915.

ABOVE LEFT: *The End of the Road*, for a story in *St. Nicholas*, November 1915. ABOVE RIGHT: *Vinegar Bill*, for a story in *Boys' Life*, January 1916. LEFT: *The Lucky Seventh*, a 1914 illustration for the book by Ralph Henry Barbour, published in 1915 by D. Appleton and Company.

Checkers, oil on canvas, 35" x 39", 1928, for a story in *Ladies' Home Journal*, July 1929.

ABOVE: *Love Ouanga*, oil on canvas, 30" x 62", for a story in *American Magazine*, June 1936. RIGHT: *Peach Crop*, oil on canvas, 16" x 36", for a story in *American Magazine*, April 1935.

Strictly a Sharpshooter, oil on canvas, 30" x 71", for a story in *American Magazine*, June 1941.

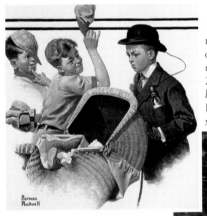

LEFT: *Boy with Baby Carriage*, oil on canvas, 20.75" x 18.625", *Saturday Evening Post* cover, May 20, 1916. BELOW: *And the Symbol of Welcome Is Light*, ad for Edison Mazda, oil on canvas, 40" x 28", 1920.

ABOVE: *Bridge Game, Saturday Evening Post* cover, May 15, 1948. RIGHT: *Ichabod Crane*, oil on canvas, 38" x 24", intended for a series on fictional characters from American literature, c. 1937. BELOW: *The First 4th*, for a story in *American Magazine*, October 1939.

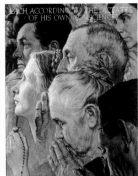

THE FOUR FREEDOMS

TOP LEFT: *Freedom of Speech*, oil on canvas, 45.75" x 35.5", *The Saturday Evening Post*, February 20, 1943.

TOP RIGHT: *Freedom to Worship*, oil on canvas, 46" x 35.5", *The Saturday Evening Post*, February 27, 1943.

LOWER LEFT: *Freedom from Want*, oil on canvas, 45.75" x 35.5", *The Saturday Evening Post*, March 6, 1943.

LOWER RIGHT: *Freedom from Fear*, oil on canvas, 45.75" x 35.5", *The Saturday Evening Post*, March 13, 1943.

BELOW: *Willie Gillis in Church*, *Saturday Evening Post* cover, July 25, 1942.

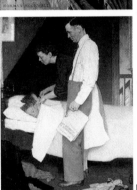

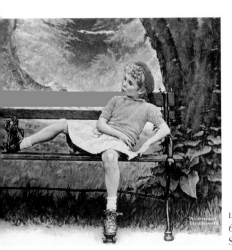

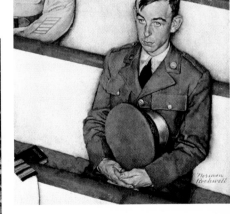

LEFT: *The Meeting*, oil on canvas, 29" x 63", for a story in *Good Housekeeping*, September 1942.

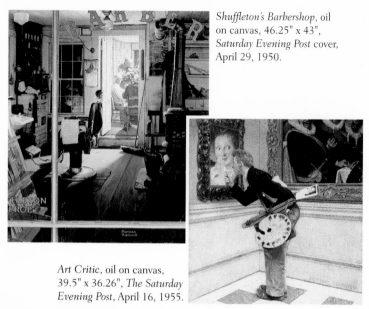

Shuffleton's Barbershop, oil on canvas, 46.25" x 43", *Saturday Evening Post* cover, April 29, 1950.

Art Critic, oil on canvas, 39.5" x 36.26", *The Saturday Evening Post*, April 16, 1955.

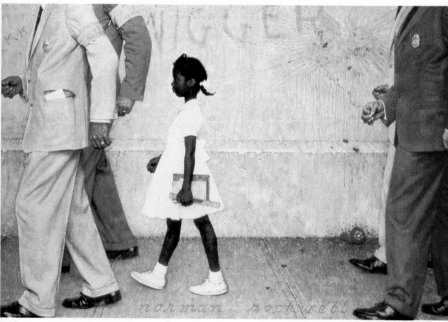

The Problem We All Live With, oil on canvas, 36" x 58", for an article in *Look* magazine, January 14, 1964.

Saying Grace, oil on canvas, 42" x 40", *Saturday Evening Post* cover, November 24, 1951.

Breaking Home Ties, oil on canvas, *Saturday Evening Post* cover, September 25, 1954.

Murder in Mississippi (also known as *Southern Justice*), oil on canvas, 53" x 42", sketch for an article in *Look* magazine, June 29, 1965.

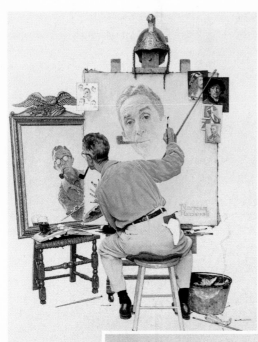

Triple Self-Portrait, oil on canvas, 44.5" x 34", *Saturday Evening Post* cover, February 13, 1960.

The Connoisseur, oil on canvas, mounted on board, 37.75" x 31.5", *Saturday Evening Post* cover, January 13, 1962.

sion of her husband. And Nancy was correct in remembering that other mental healthcare professionals would maintain that the California doctor had severely harmed Mary by giving her what they considered to be a false and easy way out of examining mental problems that instead stemmed from her childhood: her severe mother had demanded constant proof of her daughter's love and competence. From his comments to his children and to friends, as well as the evidence of extant correspondence, Rockwell himself, true to his practical nature, was interested most of all in what could be done to help his wife, not in why she was troubled. And while he never flinched from agreeing if lamenting that his absorption in his work was complete, even to his family's detriment, he also continued to believe that Mary could get well if she figured out what would make her happy.

In a letter that Mary sent from Los Angeles to a friend in Arlington, she mentioned how much more relaxing it was to be in Hollywood than enmeshed in the old routine of Alhambra and later Pasadena, visiting with her parents. Apparently, her husband agreed: according to newspaper articles, he negotiated a prolonged ten-month visit when, in late fall, he approached his friend the dean of the Los Angeles Art Institute (later renamed the Otis Institute of Art) about finding a good studio space in the city. After thinking it over, the dean decided to create the space Rockwell needed by offering him a position as the school's first painter-in-residence. Because the institute, attracting mostly illustration and design students, had recently decided to place more emphasis on the fine arts, Rockwell's presence was originally low-key. Nonetheless, news spread of his amazing work techniques as well as word about his charm, and, before long, he had agreed to teach a Saturday class. Throughout the past two decades he had become accustomed to giving after-dinner speeches as well as formal talks on art; besides, he had taught an occasional class at the Phoenix Art Institute in Manhattan, and he knew he came off well, whether in front of a classroom or on an auditorium stage.

Rockwell thrived under the praise of ambitious, young, talented students, and from the chance to mingle with new colleagues from the generation or two after his own, Joe Mugnaini especially. Movie-

star handsome, Mugnaini was a bit of a peacock, used to getting all the local attention for his impressive oil paintings as well as his intimidating good looks. The painter was commissioned to do the artwork for many critically and commercially successful books, and in later years he would become known as the best illustrator of Ray Bradbury's science fiction. The two colleagues became friends, and just as the interactions with the Vermont illustrators nourished Rockwell's work, the artistic mutuality in Los Angeles helped him produce several exceptional *Post* covers during his year's tenure in California.

After their first four months at the Roosevelt, the Rockwells rented a handsome house for three hundred dollars a month from old friends, Gordon and Clara Griffith, which they kept until their scheduled return to Vermont in September. Tommy and Jerry had their own great adventure: on their way back to their Poughkeepsie boarding school after their winter break, the boys got stuck in a blizzard in Green River, Wyoming. For three days, they camped out in their train as if pioneers in the wilderness, radio accounts terrifying their mother but thrilling the boys and consuming young Peter with envy.

Determined to create a space for himself within the always busy family that seemed rarely to listen to the youngest child, Peter Rockwell asked to attend a nearby Catholic junior high, a first in his secular family's experience. His concerned mother wrote to Dorothy Canfield Fisher, who disdained the authoritarianism of the Catholic Church and had shared with Mary a column on a book burning in Ireland, the sort of incident to which adherence to Catholicism led. Fisher wrote back a reassuring letter about Peter, however, explaining that the Church's high ritual and exoticism typically attracted children, as it had even herself during her youth.

Peter, the family bookworm they all kidded about being a "junior encyclopedia," was admitted to the school, which turned out to be mediocre, but he enjoyed deeply the after-school programs geared toward the children of an affluent community, including a ride in the Goodyear blimp. His father took him to movie sets at least three times, where he got to meet Vic Damone and John Wayne, among

other stars; and the Barstows brought him to Pasadena many weekends to play canasta with them. "I remember my grandfather as being especially kind to me," he says. "Other adults never asked what I wanted to do, but he did, and he even arranged for me to attend a Rose Bowl game that everyone else assumed I was too young to want to see."

Back East, the two older boys were feeling somewhat estranged from their family, by both distance and anxiety. Jerry, a senior, began to make such poor grades that it soon became clear that he would not graduate that year. When he called his father to discuss his unhappiness, Rockwell suggested that he drop out of school and come spend the semester with them. Joe Mugnaini had already arranged to combine some business in New England with driving Rockwell's car back to California, so Jerry could just catch a ride with him and his wife.

"I'm not sure it's the best advice to have given me," Jarvis laughs now. "I mean, shouldn't a father encourage his son, especially a high school senior, to stay in school?" But Jerry jumped at the chance to leave Oakwood. Once he was ensconced in Los Angeles, he enrolled at Hollywood High, where he enjoyed for the first time being merely one among a large group of celebrities' children. Still, he failed to earn the credits he needed for graduation.

"I took some painting lessons during this period, and my dad thought I was talented. We decided that when we returned home, I'd enroll in art school." Was Rockwell fearful of his eldest pursuing such a competitive, uncertain field, especially in his own wake? "My father was actually very happy that his son would be an artist. He loved art, and he liked that I was continuing in that tradition."

Throughout the winter, Rockwell kept busy working on several elaborate *Post* covers, including *Roadblock* and *New Television Antenna*, both of which, in their starkly different ways, rehearse the illustrator's interest in the passage of time. A dizzying grid of carefully worked out angles guides Rockwell's construction of these complex, busy covers; they register a new authority in Rockwell's painting. The pieces also presage the massing of detail and filling in of space that

becomes the hallmark of Rockwell's greatest work in the 1950s. *Road-block* reveals a large moving truck marked "Pepies," almost wedged in between two apartment walls, thwarted not by the challenge of bricks and mortar, but by a small bulldog parked obstinately in its path. Neighbors appear from everywhere to gawk in amazement, including two immaculately dressed black children in the front of the pictorial space. In *New Television Antenna,* the notion of progress is repre-sented by the man struggling to put up the television antenna on his roof, with a church steeple's faint cross behind the house echoing the antenna's wire angles. According to his sons, Rockwell didn't actually watch television in 1949 but was still a holdout for the radio. Neither, of course, did he go to church.

For both paintings, he used students and professors as his models, giving them a chance to see how elaborately staged his photography sessions were, as well as to observe his considerable prowess as a di-rector. Throughout the months at the Art Institute, he also cordially invited interested parties to his studio to watch his methodical, if sometimes agonized, approach to painting. Although he varied the steps depending on the project, Rockwell typically projected onto a canvas the photographs he wanted to use, and then roughed them in by tracing them with a pencil or charcoal. At this stage, the tracings looked more like squiggles than drawings, and if he was sure ahead of time what part of a photograph he would employ (the tilt of a man's head, the shape of an apple), he felt comfortable having his assistant—in California, a Hollywood photographer named Pete Todd—trace the image, since he mostly used it just to arrange his composition. Al-though advances were made in projectors over the next few decades, Rockwell stuck by his Bausch and Lomb model, the Balopticon that he had used from the early stages of his career, when he used to pro-ject his sketches instead of photographs. He touted it to his students as an evil necessity, essential for enabling the illustrator to meet dead-lines, but deadly if the artist stopped practicing his free drawing out of laziness enabled by the machine.

After he'd used as many of the photographs as he felt efficient, Rockwell would next make a detailed, finely tuned charcoal sketch.

Then, he would project that sketch onto the linen canvas, usually thirty-three by forty-four inches, larger than the *Post* cover reproduction. He approached the covers as if they were art for himself, not a commercial patron, and treated them as if painting stories for people to look at directly, not something for commercial reproduction. Any concessions he made to mass reproduction dealt with clarity of storyline; because, according to marketers, the audience needed to grasp the meaning within two seconds, he exaggerated facial expressions to convey the emotion immediately. Such belief in the integrity of his painting stood behind his unusual practice of framing his painting before delivering it to Philadelphia.

Also uncommon was Rockwell's practice of painting a complete color oil "sketch" before starting the final picture, so that he could work out the color scheme to his satisfaction. These sketches were often highly finished, and some critics preferred them to his finished covers, because the painting was usually looser. It had only been in the previous few years that the illustrator realized that his various sketches and charcoal renderings were valuable to collectors, as well as the final oils. When he found out that people in the Los Angeles art community owned some of his early work from the twenties, he traded the sketches of his current projects for the older pieces, since the studio fire of 1943 had left him bereft of his work prior to that year.

Throughout the spring, Rockwell lectured at special classes, judged local beauty contests, and entertained journalists such as Hedda Hopper, who coyly reported in her gossip column that Samuel Goldwyn had roped the artist into doing a portrait of one of the mogul's favorite actresses. In his autobiography, Rockwell went further, claiming that the producer hired him to paint the ads for a movie until the illustrator decried the inauthentic costumes, offending Goldwyn. Jarvis Rockwell's memory of the Hollywood connection is twofold: the family's fear of what his mother might awkwardly announce when Hedda Hopper was around, and the standing invitation, infrequently accepted, for the kids to use Walt Disney's swimming pool whenever they wished. According to Diane Disney Miller, Dis-

ney's daughter, Clyde Forsythe was a good friend of her father's, and it seems likely that Disney and Rockwell first met through Clyde's introduction on one of the earlier California vacations.

Rockwell was also busy during this period helping Al Dorne establish what he excitedly believed would be an innovative way to reach America's talented heartland. Dorne's earlier suggestion that Rockwell think how he might participate in such a project was serious: a prominent group of American illustrators, Rockwell among them, discussed the best way to organize the proposed correspondence school in New York, to be called the Institute of Commercial Art. Al Dorne thought the school could work in conjunction with the prestigious, nonprofit Society of Illustrators, of which he was currently the president. The Society had to back out of the arrangement, partly because of New York education laws and conflicts regarding nonprofit organizations, and Dorne relocated the project to Westport, Connecticut, where rents were cheaper and where many of the teachers already lived. According to an interview Rockwell gave in the late 1960s, in its early stages, the school negotiated an exchange with Yale University, although those connected with Yale's art department as well as with the Famous Artists' School remain flummoxed at Rockwell's revelation.

Rockwell's initial enthusiasm for the project, however, seems well founded. According to Walt Reed—the author of important texts on the history of illustration, and the owner of New York's Illustration House, a prominent gallery of the nation's premier illustrations from the last 150 years—the course was the best ever devised for the study of illustration. Founded on the principle of postgraduate education for talented illustrators, the school asked twelve top artists to devise a course of study based on their own methods of producing their work. The proposed format would allow the enrolled students to receive instructions and critiques of their work, through the mail, from the painter with whom they had signed up. The teachers also would gather a couple of times a year at the school to compare general notes and to offer a few special classes.

During its first months of operation in 1949, students were allowed to pick the teacher they wanted to study with, but after 90 percent of them chose Rockwell, the consortium of instructors revamped the curriculum, so that every student would receive one lesson from each of the twelve teachers. Even this concept was predicated on more advanced students than those who actually enrolled, however, and, finally, the course of study devolved into a covey of well-respected but less famous instructors hired to teach from a four-volume compilation based on the original twelve instructors' lessons and to critique the students' work themselves. The original twelve faculty members offered workshops twice a year for these teachers and, during those times, they demonstrated how they would choose to respond to various students' submissions.

Al Dorne was the perfect person to spearhead such an institution. Championing the profession of illustration, he was frequently outspoken: "I understand there is a fine line drawn here between what are considered two kinds of art—fine art and commercial art. In fact, there are two kinds of art: good art and bad art. That is the only difference." Dorne's school was on the cutting edge of education, providing big-city advantages to small-town customers, a democratizing of higher education that appealed greatly to Rockwell. His own scrupulous account of his working methods shows how seriously he continued to take the role of teacher, and the lessons became the basis for his book *Rockwell on Rockwell,* which, along with Arthur Guptill's text, remains the most thorough explanation of his techniques in existence.

While her husband was growing stronger on the West Coast, from both a change of atmosphere and the excitement of burning new tracks, Mary Rockwell was merely surviving. Newspaper interviews with her, in which she rather listlessly claims that the job of a famous painter's wife is to encourage him to maintain his integrity, are accompanied by photographs that show a woman with sad, tired eyes. "I've wanted always to feel that [my husband] was confiding his purposes in his art to me," she said, "and that I would never stand in his

way of accomplishing it for any selfish reasons of my own." A little later, she adds, "A creative artist never stands still. He goes either backward or forward. And it's somehow the wife's job to help her husband grow."

It is hard to see how Mary Rockwell could have felt very important during this period. Rockwell got more attention than ever, between the camaraderie and interest of new colleagues, and the numbers of awed students following him around the campus of the Los Angeles Art Institute growing weekly. When the projected course to be team-taught by Mugnaini and Rockwell was announced for the summer, it filled immediately.

The illustrator's newfound celebrity included an increase in the numbers of visitors invited to his studio to respond to his current work-in-progress. Mary was used to the communal criticism that Rockwell compulsively solicited. Although his closest friends joked that he ended up doing what he thought best anyway, his recruitment of advice was, in fact, as genuine and interested as the flattered spectators believed. "He'd invite people into his studio to critique, and watch their faces to see if they instantly got the picture or not," Mary Schafer recalls. "We all felt we were contributing to an important thing. He'd take in all the opinions—and the next day he'd discard them all." Only Mary Rockwell's opinion carried true critical weight. Although this dynamic remained in place in Hollywood, she was nonetheless encountering increased numbers of outsiders who clearly believed their judgments significant to Rockwell's work just when she was feeling more fragile emotionally than she had ever been.

As the family prepared to return to Vermont at the end of the summer in 1949, Jerry announced that his interest in pursuing a professional career had crystallized; he felt sure it was the right thing to do. Rockwell immediately devised a plan that he thought might help everyone, including Mary, who would be comforted by having her sons nearby: they would insist that Tommy, who was very happy at Oakwood, return to Arlington High School, and Rockwell would build a studio for Jerry adjacent to his. Jerry could attend the Art Students

League in Manhattan for a few months, then come home to his own
professional setup next to his father's.

In fact, the beautiful studio was almost an exact (smaller) replica
of Rockwell's own. And while his eldest son was pleased, he was also
somewhat intimidated to be working under the literal shadow of his
overly disciplined father. Nonetheless, he did go to the New York
school where Rockwell had begun his career, and during those
months, he even spent some time studying at the National Academy
of Design as well.

Back home, it turned out to be especially fortunate that Tommy, in
many ways the easiest child, with his good looks, high grades, and
easy affability, had stayed home with Peter to help keep his mother
company. Rockwell became engrossed in yet another career crisis,
this time emanating from the *Post*'s art director. For years, as the illus-
trators had seen their independence eroding, they had been tense
about the increasing power invested in such positions. So far, Rock-
well had held his ambivalence in check and had experienced no rea-
son to doubt his autonomy. But the previous year, Ken Stuart had
pushed the artist too hard, both in requesting that he paint Stuart's
ideas rather than his own, and in suggesting minor changes in the fin-
ished products. This fall, Stuart overplayed his hand.

He wrote to Rockwell to inform him that they'd made a few
changes in his recently submitted oil, *Before the Date,* because *Post*
audiences weren't as sophisticated as professionally trained artists and
would be confused by the formal perspective Rockwell had employed.
The staff had agreed that the two young people preening for their date,
a girl and a young cowboy, would appear to be dressing in the same
bedroom. Reluctantly, Rockwell accepted the critique and the art di-
rector's adjustments. But when the picture was published, the artist
saw that Stuart had actually painted out the figure of a horse Rockwell
had placed within the window view of the cowboy. His shock rever-
berates in the letter he shot back to the *Post.*

Distraught, he told both Ken Stuart and Ben Hibbs that things had
gone too far. For an artist to find his work altered without his permis-

sion, to have someone else "paint it" and use his name, was unethical, even stretching as far as he could. If this was now the policy of the *Post*, Rockwell could work for them no longer.

He was serious, that much is clear. And over the next six months, Hibbs treated him delicately, wooing him back to happiness. Ken Stuart had provoked a showdown that he lost. Once Rockwell realized that he took priority over Stuart with Hibbs, he began extending himself to befriend the conquered art editor. As he later told Mary, he had won, and from now on, they should all just be friendly. The best work would get done that way.

Clearly, however, both personal and professional pressures were affecting Rockwell's work. During the late fall, he began his sketches for *The Facts of Life*, a relatively straightforward painting of a middle-aged father sitting down to explain the birds and the bees to his adolescent son, the painting deliberately suggesting that the two parties are equally terrified. He would spend a year and a half on the minor painting, completing one oil rendering only to decide the room was wrong. After finishing the next version, set in the living room instead of the bedroom, he realized he'd used the wrong father figure. On and on the changes went, making the painting his most fraught, at least for his youngest son, Peter, who posed for the child in one of the cover's incarnations. Now convinced that his father's own discomfort with sexual frankness and his concern about adequately fathering his own sons were the grist of the supposedly artistic difficulties, Peter remembers the bizarre determination to get it right in this painting that plagued his father for eighteen months.

In light of the typical father-son connections of the period, and given Rockwell's own coming-of-age as he watched his uncle die of syphilis from "being with too many women," the tension seems understandable. But Rockwell's obsessiveness over this particular subject literally cost him greatly, because he spent so much time on the one picture that he had to take out loans to cover his lack of income.

And in the meantime, Rockwell's family scene was breaking down around him. By 1950, Mary was beginning to reach out to friends in

the community to regain her mental stability. Clara Edgerton, her next-door neighbor, was, by now, taking commissions to New York and even transporting *Post* covers to Philadelphia when Mary was feeling bad. Soon, the kindly woman started accompanying Mary daily on long walks, allowing her to sound off about her depression. At night, when Mary couldn't get to sleep, she began calling Toby Schaeffer to talk, keeping Mead's wife up till two or three A.M. with her long discussions of what she could do to reinvent herself and to flesh out her own talents. "My mother had always been a partner with my father," Leah Schaeffer recalls. "She was his photographer, and they had this teamship that I didn't feel Mary and Norman did. Maybe that's because my father didn't work nearly the hours Norman did either, or take his work so seriously. Sometimes Schaef would say, for God's sake, Norman, the painting is finished. Just stop! And Norman would say he just had to do one more thing to it. He said he wanted to please his audience, and my dad said why? And when he said he wanted to be a household name, my father and Jack Atherton would yell at him, and they'd all really get into it. So Mary had to live with that kind of ambition and perfectionism, and she liked talking to my mother about it."

Mary had found no release in the world outside herself; instead, her Arlington friends such as Joy Edgerton remember her searching for "something" in nearby Episcopal and Catholic churches. She joined a writers' group, and though the stories and poems she proudly shared with her sister show signs of literary intelligence, their clumsiness and cliché in no way bode well for her aspirations to send them eventually to *The New Yorker* or *The Atlantic Monthly*. Her life kept unraveling, instead of improving: during this next year, according to her sons, she had two car accidents, apparently related to her drinking. She would later have her driver's license revoked by the Massachusetts police; since she still lived in Vermont, her driving to Riggs must have been the occasion of their action.

During the first few months of 1950, among some of the most trying personal times Rockwell had faced since the humiliation dealt him by his first schoolteacher wife, he painted what many consider

his masterpiece, *Shuffleton's Barbershop,* appearing as the *Post* cover on April 29, 1950. His art historian son explains that his father loved finding new challenges, and now he had taken on the problem of painting a small group of men playing musical instruments in an illuminated inner cubicle at the back of a large darkened room, all seen through a plate-glass window. Finally, he had created a powerful painting, whose impact lies in the details that overwhelm in exactly the right way, in their potency. The final moment in which Rockwell compulsively adds the overkill to most of his paintings, pushing the portrait into caricature partly to avoid being judged as a serious artist, never occurred in this painting. It's as if Mary actually spirited the piece away from him, as she threatened to do so many times when he was overworking a painting.

John Updike once observed that *Shuffleton's Barbershop* "yields nothing in skill and reflective interplay to a Richard Estes. It differs from an Estes in the coziness of the details Rockwell has chosen to illuminate . . . [but] this is amazing painting." The painterly achievement in such prosaic moments as the stepboard on the barber's chair, its metal grillwork articulated but in shadow, capture the viewer's attention as much as the scene-within-a-scene. And the small black cat that sits quietly near the front of the outer room, observing the elderly men in the distance as they practice their instruments after closing time, controls the viewer's experience perfectly, refusing any tendency for the onlooker to feel superior as the outsider who sees without being seen. The cat, lacking the careful articulation of the rest of the painting, also contrasts in its plebeian status to the potentially arty treatment through the left side of the plate glass, where the background is rendered *en grisaille,* a method of working up a scene in shades of gray and tan often used to imply distance.

Shuffleton's owes a particular debt to the qualities Rockwell explained many years later most impressed him in Vermeer: his "eye for meticulously rendered, palpable surface detail," which appealed to him as a like painter of "practical temperament." Even Vermeer's faults—his temptation (though usually controlled) to overload his

canvas with details—could be Rockwell's own. And Vermeer also employed photography as an aid, as the supplement that Rockwell always claimed it to be. Although historians waffle on Vermeer's use of a camera obscura, convincing evidence suggests that he used the device to perfect his perspective and to help him capture light more precisely. Like Rockwell, he was an inveterate reviser, a perfectionist. Unlike Rockwell, however, he worked at a leisurely pace, producing two or three paintings a year to other Dutch artists' norm of forty or fifty.

Genre painting in general seemed to sharp-eyed and knowledgeable viewers in the mid-fifties to underlie the illustrator's own work: a prominent New York collector explained that he had begun collecting Rockwells because the painter was "20th century genre painting. I don't know anyone else who's specialized in American genre. Maybe photography killed it off, but, in my estimation, when posterity looks back on the art of the 20th century, Norman Rockwell will occupy a singular place."

That any collector retained the independence in 1950 to value Rockwell or genre painting in general is impressive, in light of the large-scale conversion of American art to the principles that had been decreed in 1939 by the modernist art critic Clement Greenberg. "Avant-Garde and Kitsch," Greenberg's watershed essay, laid down the laws of good art for decades to come, and such art definitely excluded picture painting. Greenberg's thesis depended on the subordination of illusion and storytelling to an emphasis on the process as the end product. Painting that called attention to itself became the coin of the realm, the graphic arts counterpart to a tenet of literary modernism by now decades old. This philosophy, transferred to the visual arts, took hold with painters quickly, but the educated and upper-class audiences and buyers of fine art required more time before letting go of the familiar. By 1950, however, as Tom Wolfe has remarked, even those who fashionably held to the lack of distinction between fine art and illustration preached that the purpose of art was "to present, not to represent," a dictum that usually elevated geometric shapes and abstract modes.

If we believe the later pronouncements of his psychoanalyst, the redoubtable Erik Erikson, Rockwell's brilliance with *Shuffleton's Barbershop,* and the flowering of his realistic work of the fifties, flowed freely out of his unhappiness, not from any respite in the drama of his home life. According to Erikson, Rockwell painted his happiness, as he put it, rather than living it. In early 1950, he was deeply worried, yet he had the advantage of Mary's physical proximity, intermittently and, he assumed, permanently. And Jarvis, reassuringly, was next door in his twin studio. Rockwell was anxious yet secure, worried but motivated.

Larger cultural changes threatened his landscape as well: the challenge to illustration that had hummed under the surface since the war's end, from the rise of television to the prominence of color photography, was gaining momentum. Rockwell couldn't know yet that the 1940s had been the last major decade for the illustrator, but his ear was too keenly tuned to his society's beat not to register the signs all around him. Most ominously, the *Post* Christmas covers had gone to George Hughes and to Constantin Alajalov, an illustrator of the stylish cartoon more typical of *The New Yorker* than the *Post*. An age of consumerism had begun in the prosperity following the war, and a new cover ethos that reflected suburban emphasis on the modern good life was aging Rockwell's storytelling quickly. If he could give up the onus of reinventing the Golden Age of Illustration, he could just let himself paint.

By the end of the 1940s, an emergent aesthetic in illustration showed that Modernism had finally had a serious impact on this mostly commercial art form. Instead of the strict adherence to narrative realism, new schools of talented illustrators, as Steven Heller points out, included artists who had assimilated the lessons of abstraction, such as Robert Osborn, Robert Weaver, Robert Andrew Parker, Tom Allen, and Phil Hayes, all of whom were more influenced by the paintings of Mark Rothko, Franz Kline, and Willem de Kooning than the traditional forces behind Rockwell's work. But Rockwell painted his happiness by relying on the lessons of mastery he had

spent decades perfecting, and now, when he was experiencing severe personal anguish, he had no desire to change course. Just as Robert Frost derived "a certain strength and stability from reliance on form," writing to *The Amherst Student* that "anyone who has achieved the least form to be sure of it, is lost to the larger excruciations. I think it must stroke faith the right way," so did Rockwell lean on his similar aesthetic sensibility. Even if Rockwell had the ability to switch gears at this stage in his career—which he might have—he pursued the opposite tack: perfection of his form. From *Shuffleton's Barbershop* and *Solitaire,* both painted in 1950, onward, the decade would see him produce painting after painting, each of which staked a claim for inclusion in histories of American realism.

Tellingly, however, the write-ups that the *Post* provided on their artists continued to explicate Rockwell's painting as cloyingly old-fashioned, even empty-headed stories of an Arcadia populated by a few real people whom the artist personally knew. "In this delightful setting [a local barbershop], Norman Rockwell is relieved periodically of surplus hair. Beyond the charming still life, in the room where life is less still, sits barber—and cello player—Rob Shuffleton, making music with friends." The vignette identifies the models and speaks of "bygone days" and how little has changed in this part of Vermont. The artistic virtuosity, and the bittersweet aura of time and humility that hangs over the painting, not only go unremarked, they are trampled to death in the onrush of saccharine praise.

25

⚜

Putting One Foot in Front
of the Other

Throughout their parents' troubles, and even in the face of Rockwell's absolute commitment to his art above all else, the Rockwell sons never doubted their father's loyalty to their mother. Nor did they question the genuine difficulty Mary Rockwell confronted as she tried to get well. Most of all, the boys felt confused, because so little was explained. Tom Rockwell's best friend, Buddy Edgerton, saw him "swallowing Maalox all the time." Rockwell became adamant about the older boys staying close to home while their mother was so sad, and Dick Rockwell, their cousin, remembers his own impression from visiting at the time that Mary was deeply upset at the idea that her boys were growing up and going to move away. "I felt so bad for her," he recalls, tearing up as he speaks. "She was always incredibly good to me, one of the only people in my life to send me letters and packages overseas when I was in the service. Now, when I saw her, one of her eyes seemed to roll around oddly, and I thought she was really going downhill." Mostly as further inducement for Jerry to stay at home, Rockwell decided to create a summer artists' colony that year, and he requested that the Art Students League send him their best students for an internship in Vermont.

When the League director approached twenty-four-year-old Don Spaulding, he jumped at the chance. Spending four months in Arlington studying with an illustrator he considered a master was an experience that fundamentally altered his approach to illustration, enabling him to become the successful cartoonist of *Lone Ranger* and *Buck Jones*. Four other Leaguers came with him: Don Winslow, Robert Hogue, Jim Gaboda, and Harold Stevenson. William McBride, an extremely talented young artist who had talked to Rockwell after a lecture the illustrator gave at the University of Vermont, also joined the group; when *Photography* magazine did a feature on McBride as "Germany's leading American photo-illustrator," the photographer granted the majority of his accolades to Rockwell.

The six art students lived and worked in the one-room schoolhouse on the West Arlington village green that Rockwell himself had used as a temporary room in which to paint after the fire in 1943, until construction on his new studio up on the hill next to the family's new house was finished. At the back of the room, kitchen and dormitory-style living quarters were built on to a platform that had once served as the stage for the schoolhouse. Rockwell, who never exhibited his own work in the house or his studio, hung several of his paintings and two by Mead Schaeffer on the walls.

In the months that Spaulding observed Rockwell up close, he saw little to unsettle his hero worship. The only criticism he would level at the illustrator was the complete lack of household responsibility that accompanied Rockwell's exhaustive work schedule: "He never had to do a thing. I fixed a door once; I doubt he even knew how. Whenever something went wrong in the household, he said that was Mary's responsibility." Rockwell's attitude toward the need for absolute focus on work extended to his sometimes annoying praise for Will McBride, "fixated on his work," who, somewhat to the other students' disgust, got away without doing the dishes, because Rockwell "thought he was a genius, not like the rest of us, whom I sneakingly thought disappointed him," Spaulding recalls.

Just as Charles Hawthorne had done in Provincetown years before, Rockwell adopted a low-key, casual method of instruction. He

issued informal assignments and arranged for models to pose for the students. He might saunter in during the day to comment on their work, or he would invite the students into his studio later to respond to his painting in progress. Rockwell encouraged Mead Schaeffer, Jack Atherton, and George Hughes to talk with them. According to Spaulding, Rockwell enjoyed sitting around and "talking about bringing back the Golden Age of Illustration—all the time, he talked about bringing it back, and how Howard Pyle was his hero."

Most inspiring to the students, Don Spaulding remembers, was watching Rockwell at work. He shared aloud with them all of the stages he went through—planning, photography, sketching, and painting—and his methodical techniques unraveled before their eyes. "Watching him paint was like being reborn," Spaulding said quietly, still awestruck at the memory more than twenty-five years later. "It looked so easy. . . . I couldn't wait to get back to the easel, but the next time I'd work, I couldn't accomplish what he did, no matter how much I applied myself. He simply came onto this earth a genius." Rockwell emphasized to the students the importance of discipline and hard work; at times, he explained, he'd deliberately simplify his technique, choosing a one-point perspective, perhaps; but on other occasions, he would resolve a problem by figuring out a more complex treatment, such as the challenge of reflecting light through three different barriers. But always Rockwell was excited about the new painting, hoping that this one would be the masterpiece.

The students' presence clearly inspired Rockwell to perform well. Not only did their praise gratify him, but, just as in Los Angeles the previous year, he deeply enjoyed becoming part of the tradition of great illustrators who taught. His hero Howard Pyle was as famous for the students he molded in his Wilmington and Chadds Ford school and studios—the "Brandywine group"—as for his own work. And George Bridgman had carried on the tradition of taking seriously the passing on of his master's gifts, a kind of painterly laying-on of hands. Now Rockwell could position himself within such a tradition, by creating an Arlington school.

The piece he did during the students' early tenure, *Solitaire,* published on the August 19, 1950, *Post* cover, remains one of his most undervalued works. The picture shows a traveling salesman tucked into his motel room bed, a suitcase stacked on his lap to hold his cards. Loneliness and ingenuity both come to life in the formally exact picture, the potential air of Willie Loman–like tragedy marred only by the omnipresent domesticating details—the extra photograph on the wall, the towels neatly hung in clear view.

Although most of the students left at the end of the summer, Don Spaulding stayed into the late fall, while Don Winslow continued to live in the schoolhouse for several more years. Winslow acted as Rockwell's apprentice for a while, tracing the drawings onto the canvas and painting in an occasional background that required tedious application. Since Rockwell was as warm and funny as Spaulding had been led to believe, he was startled to find the illustrator bonding with the oddball in their group, the manic-depressive Winslow. "They'd often share jokes together, kind of like they understood each other on a different level from the rest of us. And when Don would get low, which he often would, Rockwell would give him pep talks, telling him to pick himself up, get moving. And he'd show him how to correct the problem—it was always about work—and later we'd hear them laughing together over another private joke."

Rockwell eventually found an agent for Don Winslow, and he tried hard to help him deal with his mood swings, which sadly, before the decade was over, would lead to suicide. Over the next few years, though, Winslow eased Rockwell's studio demands, but, according to Jarvis Rockwell, Mary tried to get him to leave. She disliked the way the young man's kinetic presence cut into the spousal intimacy she gained from being indispensable to her husband's work. If she didn't occupy that role, she wasn't sure what she was supposed to do with her life.

Throughout Rockwell's enacting the decisions he had made long ago to sustain a workload that would succor his various psychological needs, he tried hard to function honorably as a family man. And he

made sure that his family would continue to want him, in spite of his unavailability to them. Yes, he worked seven days a week, all year long; and true, he seemed slightly distant even in the *Post*-like routine pleasantness he bestowed on his wife and children. He had fed them just enough of himself, of his charm, his humor, his warmth, his caring, to make them want the real thing, the intimacy of a husband and father who saved his private best for them. But he withheld this part of himself so gracefully that it had taken his wife almost twenty years to dare accuse him of failing her. Mary had begun to lose hope of ever possessing her husband, and in that loss of faith and the waning of her belief in ever becoming the true object of desire for Norman Rockwell, her energy to fight her psychic demons faltered.

Probably in 1950—the letter is undated, but evidence suggests the year—Norman Rockwell wrote what was surely the most important and perhaps the only love letter of his life: "Dear Mary," it began,

> I love you devotedly and completely, Jerry and Tommy and Peter love you. They believe in you. They are fine boys due to your love and care.
>
> I love and need you always. I know I am extremely difficult at times due to my absorbtion [*sic*] in my work. Sometimes it takes everything I have and all my time.
>
> No one else but you could have helped and sustained me as you have for *twenty* years.
>
> We have come a long way and I know we can, as a team go further and higher.
>
> You are the finest person I have ever known. You are thoroughly and deeply *good*.
>
> You are surrounded by people who love you. Jerry, Tommy and Peter. The Edgertons, Miss Briggs, Mrs. Fisher, Jack and Max and every one in our valley and in Arlington. They all wish you well.
>
> But most of all I love you completely and want you always.
>
> If you decide you want to be free, I consent.
>
> But I earnestly believe we can have our best lives together.
>
> Norman

Obviously Mary, residing at Austen Riggs, had suggested a divorce, and Rockwell had taken her seriously. Tom Rockwell recalls with pain what a difficult time this period was for the entire family; Mary decided, for reasons still unclear to the sons, that she would only allow Peter to visit her, and turned away her husband and two older children. Peter remembers that he knew, somehow, that he was not to mention the family at all until he was instructed to do so. How did Rockwell explain Mary's problem to their sons? All three claim that the matter was, just as before, never discussed; everybody just dealt with it, though they weren't sure what "it" was. "All we knew was that my mother had some problems. She'd come back and forth over the years from treatments, and things would feel weird around the house," Jarvis says today. "The mood, or the atmosphere, or something, wasn't right. But that's all, nothing more specific. In a way, that was the worst of all, not understanding, and nobody saying a word to help us figure things out."

Still trying years later to figure things out, Tom Rockwell recalls, perplexed, that his father always encouraged his mother to do what she wanted, and that he urged her to hire people to help with his work and the household, instead of her taking on so much herself. "Pop just wasn't the sort of man to boss someone around, especially his wife," he says. "But my mother insisted on being in charge of things."

Nancy Barstow Wynkoop believes that in light of her sister's position as the eldest of three children, and the impression that Mary gave off that she received her sense of importance within the Barstow family by nurturing them all, it is no surprise that she would transpose that psychology onto her marriage. The obvious conduit to her husband was through his work, since that was what was most important to him. She couldn't give up the household duties, since she measured herself against a feminine ideal, but she wanted to curry Rockwell's dependence on her management of his professional life as well.

Studies of the differences between men and women alcoholics cite the surprising causal nature of women's unfulfilled romantic or primary emotional relationships in their turning to drink to assuage their emptiness. The connection between depression and alcoholic

abuse becomes circular in many cases, one breeding the other. And, as the psychiatrist son of Rockwell's old friend and architect, Dean Parmelee, states, the biological factors for depression may well out-weigh any cultural or social contributions anyway.

In the early fifties, Austen Riggs profiled its typical patient as twenty-seven years old, and collectively highly intelligent young peo-ple who have not "found themselves in terms of identity, personal re-lationships, capacity to work and to learn through study, or in self-direction." The minority, the older patients, tended to be people who had "accomplished a great deal" but couldn't solve their marital or vocational problems. Austen Riggs took as the goal of its therapy to provide immediate help that enabled its patients to get back on track in the outside world, while thereafter continuing treatment to eradi-cate their crippling neuroses. Individual psychotherapy and limited psychoanalysis, medication, and group interaction formed the core of their treatment options. As the decade progressed, innovative pro-grams in drama, art, and dancing were also developed under highly trained professionals. Patients constructed a greenhouse on the prop-erty and began a daycare/nursery school as well.

In other words, Austen Riggs was one of the most humane, ad-vanced institutions of its time. Since Irene O'Connor's hospitaliza-tion at McLean in 1934, professional interest in mental health and strongly motivated attempts at new treatments had progressed, but governmental and citizen support were just beginning. In 1950, Riggs, McLean, and Chestnut Lodge outside of Baltimore, Mary-land, were the only high-level treatment centers for the mentally ill. If you had little money, you went to state institutions, usually poorly staffed, underfunded, and behind the times in treatments. And in spite of Riggs's impressively optimistic atmosphere and superb staff, at the time that Mary Rockwell needed it, its strength was in treating the young. Possibly because such a clinical profile was easier to treat—at the very least, for younger patients hospitalization tended to impinge less upon heavy professional and family obligations—the institution was gaining a reputation for suiting best the under-thirty

crowd. Celebrities walked the hallways; two decades later, James Taylor would immortalize his treatment there in the phrase "from Stockbridge to Boston." But whether the center served Mary Rockwell particularly well is hard to know; there was no better alternative.

The mode of treatment at Riggs depended on an open institution: admission was voluntary only, and patients were free to leave the grounds when they wanted, mingling with townspeople and doing local shopping. Riggs's treatment was aimed at the range of mental illness spanning severe psychoneuroses to character disorders, including mild schizophrenia. Mixing the sick with the well, it was hoped, would provide the former with useful reminders of good health, as well as reducing the stigma still attached to mental illness. Medication, a newly available treatment, was invoked when it was considered useful; especially in the 1950s and early 1960s, before more sophisticated therapies and drugs were developed, the medicines—thorazine, lithium, and tranquilizers such as Miltown and then Valium—were poorly understood and sometimes too freely administered. Mary Rockwell was put on Respermine, an early tranquilizer. Throughout the decade, it was often hard to tell whether her slurring of words was due to the drug, to alcohol, or to mixing the two; the dramatic dangers of the latter were not fully recognized at the time, and Mary felt it a triumph to confine her drinking to the evening hours.

In 1951, Erik Erikson left Berkeley, where he had tangled with the administration over the loyalty oaths the university was demanding during the McCarthy era. His position at Riggs would prove an extended sabbatical of sorts before he would begin teaching at Harvard near the end of the decade. Riggs allowed him to take a small patient caseload (never more than four people at a time) and to concentrate on his research and writing. The year before, Erikson's *Childhood and Society* had been published to great acclaim. The book explored the various identity stages human beings confront as they age, as well as the idiosyncratic inflections that different societies imprint on their children, nearly always restricting their emotional development as a result of every culture's inevitable shortsightedness.

Exactly when Mary Rockwell's husband decided that he, too, would enter therapy at Riggs is unclear. Bills exist from 1953, and a letter the following year from Erikson speaks of him as Rockwell's therapist. Erik Erikson would have been a good fit for Rockwell for several reasons: he had been a talented novice portrait artist in Austria before giving up art for psychology, after traveling to Rome to see Michelangelo's work and concluding morosely that he couldn't compete with such artistic brilliance. He possessed an expansive curiosity, which found a perfect forum in studying cultural variations between societies: *Childhood and Society* ranged from studies of Sioux and Yurok Indian children to American Negroes; it ruminated on the stages of development each person traverses during a lifetime; and it analyzed the childhoods of Adolf Hitler and Maxim Gorky. Rockwell and Erikson shared similar personalities, according to Erikson's daughter, Sue Bloland, who observed both men up close. And, although neither man had a professional degree, both had achieved celebrity status in their fields.

Erikson's research in *Childhood and Society* about the hard and rejecting American mother—a description that, according to Jarvis Rockwell, was appropriate to Bernice Barstow, Mary's mother—might have helped Rockwell understand his wife better. Erikson explores what he considers the American identity problem—eternal adolescence—in light of the mother's unwillingness to assume the proper adult role herself. And he relied heavily on his own strong wife, Joan Erikson, to enable his professional activities. Although the cost of Joan's tending to her husband's vocation may have been a certain neglect felt by her children, according to Sue Bloland, Erikson would have been sympathetic to Rockwell's feeling of being deserted by Mary, who had become entirely unreliable in representing her husband in public. No one could be sure if she would have her drinking under control, or if she would talk coherently or even talk at all.

But what may be most remarkable about this period in Rockwell's life is his willingness, admittedly in a partial sense, to put his wife first, even ahead of his career. The general population, especially the

one that Rockwell played to, was not sympathetic to the idea of mental illness or alcoholism. The artist would not have been the first important figure to try to cover up family information that might damage his career. And Rockwell, whose celebrity depended on the image he projected as the live embodiment of the covers he painted, had more to lose than most. Yet from the beginning of her problems he urged Mary to seek whatever treatment might help her, and he actively supported her attempts however he could. Rockwell's sons remember their father as deeply concerned that he had somehow harmed his wife, and he was always particularly melancholic whenever Mary seemed down, affected sympathetically by her moods.

Around the time that Mary apparently explored the idea of leaving her husband, he was working more heavily than usual on things he didn't enjoy doing. He was spending enormous amounts of time on advertising campaigns, largely because of the prohibitive costs of the boys' schools and Mary's private therapy: Riggs alone charged about $1,800 per patient per month. The *Post* was not the highest-paying magazine, even for Rockwell, who was being paid between $2,500 and $5,000 a cover these days. Advertising was where the easiest money was, but such work failed to yield any aesthetic nourishment. He had recently worked on a poster for the American Red Cross, for instance, that paid $1,000 for a job easily and quickly executed, but the project provided absolutely nothing in the way of flexing his artistic muscles.

When he subsequently reached out to find other magazine outlets worthy of what he considered his real painting, Ben Hibbs yelped too loudly to be ignored. A year earlier, Hibbs had protested Rockwell's participation in the Hallmark Christmas card campaign, beginning with the artist's inclusion in the 1948 series of the company's "Gallery Artists" of celebrity figures. In late 1950, he had waylaid Rockwell's assumption that he was allowed to paint for such magazines as *Cosmopolitan,* whose editor, Herbert Mayes, was eager for Rockwell to take on some first-rate stories. In rough drafts of pleading letters that Rockwell wrote Hibbs, trying to explain the urgency of having venues

besides the *Post* covers that would allow him to do satisfying work, he
scrawled across the bottom of the page in huge black letters,
"PLEASE, PLEASE, PLEASE."

The *Post* was too important to antagonize, and Rockwell backed
down when Hibbs continued to demur, but the stress of sparring with
the editor, whom he liked and admired, following on the fracas with
Ken Stuart, whom he didn't, was wearing. And the outcome of this
flurry of genteel altercations involved a large change in Rockwell's life,
though neither the *Post* nor the artist publicly acknowledged the shift:
beginning in 1951, when Rockwell painted only three covers for the
magazine, his yearly appearances were severely reduced. Apparently,
the trade-off that allowed Rockwell to do so much advertising work
during the fifties involved agreeing to a limited appearance with the
Post.

Steve Pettinga, a staff member at the Curtis Company archives,
believes that the polls the *Post* conducted, where people were stopped
on the street and asked to rate that week's contents and cover on a
scale of one to five, may have influenced Hibbs's willingness to let
Rockwell's number of covers decline. A newer, slicker, more urban
look had surpassed the folksiness of Rockwell, in spite of the artist's
continued popularity. Of late, the audience for the *Post* was showing
more diversified tastes, and Hibbs needed to cultivate a younger gen-
eration of subscribers.

By spring 1951, Rockwell had at least received some news that
cheered him up. The Metropolitan Museum of Art was doing a cele-
bratory show for the Art Students League, and of the seventy-five fa-
mous artists who had studied there throughout the decades, Rockwell
was represented by *The Soldier's Return*. More gratifying yet was the
letter from the Met's curator of American paintings, Robert Beverly
Hale, who lamented having no Rockwell in the museum's permanent
collection, saying that he planned to change that. Buoyed by such en-
couraging news, Rockwell accepted Joe Mugnaini's offer to mount a
joint show of their oils and drawings in Compton, California, in early
June.

Such confidence in the artist as these events suggested, especially following on the heels of the *Post* contretemps, shows up in the painting he completed that summer, published as the *Post* cover of November 24, 1951. *Saying Grace* celebrates the tolerance at the base of any democracy, Rockwell's absolute conviction that self-righteousness is not only unattractive but undermining to a free society. Set in a diner outside a railroad yard, the scene centers on two slightly menacing young male types almost bent over a table as they observe the bowed heads of an elderly woman and her charge, a little boy. Cleverly, Rockwell reverses the conventions by which such liberal values typically were illustrated, positioning prayer, an activity most *Post* readers considered the correct cultural norm in 1951, as the anomaly in danger of being treated disrespectfully. The painting narrates the right of deviants to be respected for practices that don't injure others. If Rockwell had refused to include the half-figure seeming to stand respectfully in the upper left of the picture, *Saying Grace* would be a masterly painting, devoid of the sentimentality with which the hat-in-hand spectator infuses it. From a technical point of view, the parallel rhyme of the *grisaille* alone is striking: the trainyard and beyond are seen through the plate-glass window in muted grays, echoed by the left foreground corner, where a sliver of a man is articulated in gray, his newspaper and coffee cup close to the center of the foreground. Rockwell's virtuoso achievements in varying depth of field command our view; the theatrical effect of a proscenium stage is offset by the partial figure in the lower left of the painting, the half-glimpsed man helping to establish the distance between the table and the rest of the dining room. At the same time, the figure invites us into the room to take his place, to complete his presence.

The implied threat of the young men, the sense that they are potential hoods or testosterone-laden twenty-year-olds looking for a fight, is undercut by their sense of curiosity and engagement, though they don't appear to be converted into potential piety by the sight of the elderly woman praying. The championing of the young that the critic Dave Hickey points to as one of the greatest anomalies about

Rockwell's art—his message in the 1950s, when others were painting America's youth as rebels without a cause, that the kids were all right—takes shape here. It will be Norman Rockwell who, in the late 1960s and the 1970s, when other commentators are lamenting the radical element among the nation's youth, repeatedly stakes out the position that the "hippies and yippies are alright. They're doing great, you just give them a chance."

Hardly pausing to savor his achievement in the *Saying Grace* painting, Rockwell turned immediately to the advertising commissions once more piling up. Greeting the illustrator at the beginning of 1952 was an anxious letter from the agency that had arranged for Rockwell to do a four-painting campaign for Kellogg's Corn Flakes that would pay $15,000. Since Kellogg was expecting final delivery in March, the agency needed an update from Rockwell. At least the bad news that Rockwell must report this time did not include his backing out of a promise; he had explained when the original contract was written that he could only "hope" to complete the paintings by March.

Instead, as he now informed the agency, he could not possibly get to the paintings before September, meaning that they might prefer to find someone else. He was just so far behind on his yearly commitments to the *Post*, Hallmark cards, and Brown and Bigelow that all other ads had to wait. What he failed to include was any mention of the other ad campaigns he was still painting, such as an extensive one for Smith, Kline, and French pharmaceuticals. In this same period, he was forced to turn down offers from George Macy to undertake work he would have deeply enjoyed, illustrating more classics, including *Little Men* and *Little Women*. His family expenses were climbing faster than he could keep track of. Yet he refused, now and in the future, to price his work at what corporations were willing to pay. He believed that some correlation between worth and amount of time spent on a project held true, regardless of the commission, and so nearly every respondent from the commissioning companies remarks on his "more than reasonable" rate.

From letters between Robert Knight, the director at Austen Riggs,

and Rockwell, it appears that Mary was in residence at the center during the summer of 1952, when the illustrator was worrying about getting Tom securely into Bard College for the fall, and getting Peter off to Putney, an exclusive, strongly liberal boarding school in Vermont that would give him the education Arlington couldn't, and where he would not encounter the local bullies who had troubled him in his small town. Jerry, in Korea with the Air Force, was not in need of financial support just now, but his father knew he would soon be returning and would want to continue his (expensive) career as an artist. During August 1952, Rockwell wrote to Dr. Knight, Mary's doctor, about beginning therapy himself; Tom was already seeing Dr. Knight, and the director was uneasy about treating yet another family member. But so many staff members were on vacation that Knight was in a bind. He suggested that he and Rockwell meet during August, and that he turn the artist over to someone else after Labor Day. So it is that Rockwell's treatment at the hands of Erik Erikson probably dates from the fall of 1952.

At least he was able to enter therapy on a positive note: Robert Beverly Hale had gotten permission to accept Rockwell's *Freedom of Speech* for the Metropolitan Museum's permanent American art collection, with Rockwell being paid a nominal fee of $100 for the painting. Rockwell was really excited over this news, and he ensured the *Post* knew about it immediately. In later years, journalists' contempt for his art would be expressed by sneering at the Met's purchase price for an original Norman Rockwell, but the point was otherwise for those in the professional art world: except for the Old Masters or the traditionally valued modern art that the Met paid real money for, artists effectively lobbied to have the museum accept a painting as a donation. No one imagined that Rockwell belonged in the first category, and the acceptance of his offer, in light of the thousands of offers that were politely declined, was a testimony to his stature among certain experts in American art.

By October 1952, Mary was back home in Arlington, where she was busily engaged in a writing workshop. She wrote Tom a lengthy

letter at Bard that rambles inconsequentially about her latest poem, assuring him that therapy aids the writing of poetry. She mentions that she drove to Stockbridge the day before on the mere assumption that Tom had an appointment at Riggs and she would see him; he did not, and so she attended Eisenhower's campaign stop in nearby Pittsfield instead. She makes much of her solo political trip, perhaps because her husband had recently painted Ike, and the resultant *Post* cover had just appeared. The five-page typed letter describes without self-consciousness the reading and rereading aloud of her latest long poem to her husband, who had listened with interest, and who routinely critiqued her writing thoughtfully. After she made some changes, she reread the poem to Norman, some parts several times over when he failed to understand a point; and since Maxine Atherton was staying with them temporarily, she recited it to Maxine for feedback as well.

A month earlier, Maxine Atherton had suddenly become a widow. Jack Atherton, a hearty man in his sixties, dropped dead of a heart attack while salmon fishing in Canada. The Athertons had moved from Arlington to New York only recently, but on her husband's death, "Max" had driven back to Arlington to stay with friends until she became emotionally centered again. Jarvis Rockwell recalls that his mother had always exhibited signs of jealousy over Maxine, who was exuberant, energetic, and funny, and whom the Rockwells felt sympathy toward even before Jack's death; her husband's gruff nature had often made Max's home life difficult. Imagining Rockwell's now extremely needy wife reading and rereading the tortured verses to her living room audience of two is somewhat uncomfortable, in spite of what was clearly Rockwell's strong encouragement and appreciation. Mary informs Tom innocently that Maxine perceptively pointed out to her various segments of the poem that sound as if they're in the wrong order; surely her son, a talented writer, cringed mentally.

For the first part of 1953, Rockwell worked hard on the Kellogg's ads, getting them in shape for winter delivery. And although he no longer had to provide the detailed, exhaustive, and generous feedback

that he'd earlier provided to the students of the Famous Artists' School—the new name adopted two years earlier by the Institute of Commercial Art—he did fulfill his obligations to visit Westport, Connecticut, in order to tutor the panoply of young instructors the school had hired, offering them a window into his way of thinking about others' illustrations. Rockwell enjoyed mingling with people of all ages, but he particularly liked being around "young people," as he called those in their teens and twenties, and so this opportunity to interact with the latest generations to teach at the Westport school gratified him.

He particularly enjoyed visiting with his sons' friends. This year, during the extended spring school break, when Peter brought home a few boys and girls from Putney, Rockwell put them into service to pose for his *Post* cover *The Soda Jerk*. Peter was the star of the painting, and his school companion Cinny Ide at least got her derriere included, as the family later jokingly remembered; Rockwell rubbed the rest of her body out and painted in that of another model.

At the moment, even *Post* covers seemed somewhat of a luxury to the artist. The bills coming at him from all quarters forced Rockwell to continue accepting more advertising work than "real painting." In November 1953, he took on a long-term contract with Massachusetts Mutual Life Insurance, and the next month, he worked hard at getting the long-promised Kellogg's Corn Flakes campaign under way at last. Publicity photographs from such ventures show him looking increasingly hounded.

Part of his tension ensued from the ongoing drama of his home life. Throughout the year, Mary had been going back and forth to Riggs at least once a week, and frequently she would live there as a resident patient for a few months at a time. Peter Rockwell remembers that his father was frequently lonely; Jarvis Rockwell recalls watching his father standing by himself up on a hill near their house, when the Vermont weather was gray and the wind was blowing hard, and the "stick figure" that was Pop looked like someone sad because "it was all falling apart." Once, he told one of his sons that if it weren't

for them, he'd kill himself. Perhaps he was being melodramatic, but Erik Erikson would believe him to be suicidal.

Rockwell's family had always felt the burden of sustaining an image in Arlington, and now the almost grown sons realized the oddity of pretending things were fine, even though half the intellectual community knew otherwise. Often the boys felt they had to avoid dealing with the truth even with their father. Asked if they felt they could "relate" to Rockwell as they grew older, Jarvis answers, "as always, if it was on his terms. If you could stay on his psychological level, where he could deal with things. But not if you tried to swerve things in your own direction." One of Jarvis's strongest memories is his father's strong reaction during this year to Shirley Jackson's short story "The Lottery." "I got back from Korea in 1953, and my father just wanted to keep talking about how powerful that story was, how the village just chose somebody and stoned the person. He found the story really moving and potent." Jackson's vivid short story had been published in 1948 in *The New Yorker*, provoking such outrage that hundreds of readers canceled their subscriptions. Why Rockwell became fixated on "The Lottery" now, five years after its appearance, is perplexing, unless he had recently learned of the biographical underpinnings of the story and applied them to his own life.

The title, "The Lottery," refers to a small New England town's yearly ritual of drawing lots to see who will be the sacrificial victim stoned to death by the villagers. Until the story's climax, daily life seems to hum along much as it does in small towns everywhere. But when the citizens are shown passively accepting the evil annual sacrifice of an innocent townsperson, readers are forced to reevaluate what lies beneath the tranquil surfaces of their communities.

The author of the story was married to one of the group eventually known as the New York intellectuals, literary critic Stanley Edgar Hyman, who taught at Bennington College in Vermont, about an hour from Rockwell's home in Arlington and the site of several guest lectures that the illustrator gave. Smacking of the kind of superciliousness that Rockwell detested, Bennington's social world treated

outsiders such as Jackson and her Jewish husband with disdain bordering on contempt. Yet Bennington proudly flaunted its status as a good New England community in the fairy-tale state of Vermont, and the townspeople felt themselves immune from criticism, saving that for the New York city slickers instead.

By the end of 1953, the Rockwells would decide to leave their own Vermont idyll and move to Stockbridge. Although they had planned to make Arlington their lifetime home, and had even bought local gravesites, Rockwell assured his wife that, after employing two hundred residents from their town over the past decade, he had used up the model pool anyway. He also felt eager for more socializing than the mountain community could provide, especially now that the Athertons and, even more of a loss, Mead and Elizabeth Schaeffer had moved away. (Leah Schaeffer admits that Mary's late-night depressed appropriations of her mother wore on Mead so badly that they moved to get out of her reach.) It seemed silly for Mary to be driving back and forth, as well as Rockwell, who was willing to expand his own treatments with Erikson, when they could live right there, within a lovely setting.

Major decisions, such as leaving the community you've lived in for ten years, are usually influenced by more than one factor. The Rockwells' move to Stockbridge during a period when the illustrator seemed, to his son, obsessed by Jackson's story may have reflected their recognition that Arlington was no Eden. Perhaps Rockwell's *Post* cover of people gossiping madly, based on the rumormongering of local townspeople, spoke volumes about a rural nastiness that was capable of matching urban malaise any day.

26

❧

On the Road Again

Partly to avoid awkward questions and answers, Rockwell had shared with no one outside the family the decision he and Mary made to move to Stockbridge. Gene Pelham recalls that he was in the studio, working with the illustrator, when the moving trucks pulled up. Only then did Rockwell explain the plans, and Gene started to cry. "That man was like no other," he would say. "I don't care what you say, no other artist will ever touch him. He did everything an artist could do." Rockwell knew that Gene had come to depend on him for the major part of his family's livelihood, and he gave him "several" good paintings, one of which Pelham sold only in the late 1990s to fund his pay-in-perpetuity at an elegant assisted-living home.

The Edgertons were shocked, too. "We just found out one day, and that was that," Buddy remembers. "The Rockwells left lots of things behind—including a picnic table I remember my parents walking back to our yard. Tommy gave me his .22. We were all sad, but we knew why."

Most people didn't know, however, that the Rockwells wanted to

be near Riggs. The Edgertons did, but they would not share their knowledge until 1999, when Peter Rockwell started speaking publicly about his parents' problems. Their long-held discretion, and that of other Rockwell acquaintances from Arlington as well, attest not only to the hold that loyalty had over previous generations, but to the deep affection that the Rockwell family had engendered in others.

The Rockwells moved to Stockbridge just before the December holidays in 1953, and they spent a miserable, sad, and dislocated Christmas at the boardinghouse near Riggs where they were lodging until they found a more suitable residence. What Rockwell must have felt at revisiting the kind of "home" he had hated as a boy can only be imagined. But, as always, his first order of the day was to find an appropriate studio. He rented the space above the meat market on Main Street (a few blocks from Riggs), which he promptly renovated by replacing the wall with plate glass.

One high moment during the move occurred when Rockwell asked a local man, Louis Lamone, to help him move his belongings up the stairs into his new studio. The rough-spoken, energetic worker from the nearby General Electric plant had never heard of Norman Rockwell; he later would say he just wanted to make a dollar. As he helped Rockwell lift heavy boxes, he figured the skinny, plainspoken man in his khakis and blue work shirt couldn't be an artist, because he lacked the flamboyant or self-centered temperament associated with them, and, besides that, he didn't seem to have a lot of money, like the famous painters he'd read about. Later, after Rockwell had asked the man to become his assistant, taking over the role Gene Pelham had played in Arlington, Lamone came to feel the same ferocious loyalty and protectiveness toward Rockwell that Pelham had. He especially appreciated the respectful way that Rockwell treated him, never talking down to him, and picking up the slack for mistakes Lamone might have made. At the same time, Lamone was amazed at how hard the painter was on himself, always worried that his current painting wasn't good enough. And, as Lamone recalled years later, his employer was willing to call him on his self-admitted tendency to get full

of himself at times: Rockwell would tell his temporarily unbearable assistant that it was time for him to go shovel some doodoo (not the word that the earthy Rockwell would have used, for sure) that the dogs had left in the yard, and Lamone would shape up fast.

Stockbridge itself was a much more sophisticated community than Arlington. Only ten minutes east of the New York State border, just as the Rockwells' last home had been, the determinedly small New England town had its beginning in 1737 when, as Sheffield village, the area became part of a land grant used to establish a missionary settlement for the Housatonic Indians. The Native Americans commingled peacefully with English settlers until 1785, when they resettled in western New York State. The community's record of tolerance was a proud touchstone for its approximately two thousand residents, generally highly educated and supportive of liberal politics and upper-class cultural activities.

With no industry and served by only a smattering of local stores, the town had flourished economically, largely because of the tourist trade. Visitors spent money in the restaurants and inns; not infrequently, after spending a few seasons in the Western Berkshires, they bought summer homes in or around Stockbridge. A few miles away was Tanglewood Conservatory, summer home of the Boston Symphony Orchestra; and the nineteenth-century Bellefontaine mansion was almost as close. At seven hundred feet above sea level, the cozy village nestled in the Berkshires seemed to many travelers to share the topography of England's Lake District. During the time that the Rockwells lived in Stockbridge, its citizens included Reinhold Niebuhr, the famous liberal theologian; Thornton Wilder and William Gibson, both illustrious playwrights; and Erik and Joan Erikson. Just beneath such national prominences was a roster of professionals, all well known in their field.

By the time that the Rockwells moved to Stockbridge, Rockwell had already done some hard work on lifelong, persistent struggles with depression with Erikson, who had become his friend as well as his analyst. In social situations, both men made similar impacts on people around them, though in truth they often gave little of them-

selves. Sue Erikson Bloland has summarized her father's effect in terms that apply equally to Rockwell's: "He became the luminous center of attention at most social and professional gatherings, where people milled around him, obviously excited, doing their best to make conversation with one another while awaiting their turn to engage with *him*. . . . Friends and admirers all seemed intent on idealizing my father, seeing in him someone much more important and powerful than themselves." In a description exactly like that of Rockwell's sons, she recalls how "people would ask me, 'what is he really like?' and I knew they wanted their fantasies confirmed, not an honest answer about a real human being."

In January 1954, in spite of a workload aimed at compensating for not yet having sold the Arlington house, the painter took time to fête a longtime, aging executive at the *Post,* Jack Lyme, who was being honored by a Boston organization. Rockwell felt himself and the public well served by Lyme's devotion and decency, and, in such situations, he was willing to put himself out. In contrast, a few years earlier, he had felt free to bow out of attending his cousin's wedding in Providence, and Mary had protested attending yet another social function solo. Instead, the Rockwells hosted Mary Amy Orpen and her new husband at the little honeymoon cabin they owned down the road from their house. With floor-to-ceiling windows on three sides, and a deck adorned by an Alexander Calder mobile (Calder's daughter attended Putney with Peter), the site proved the ideal spot for the newlyweds' postwedding celebration. Mary stocked its refrigerator with lobster and wine, and she apologized again for not making it to the ceremony in Providence. Her husband was willing to sacrifice his family's and friends' claims on him socially when his commissions were behind; shortly before their move, he had left a dinner party in Arlington early in order to go home and work, in spite of its being given in his honor.

In February 1954, when the Rockwells were still house hunting, Mary Rockwell wrote to her brother that she and Norman "are having a wonderful time together and besides that like Stockbridge so very

much." But at least one son, Jarvis—who, on finding that he did not fit particularly well into the Air Force, hurried home as soon as he could—remembers how uncomfortable his parents looked together. "They really loved each other, I know that," he says. "But it's as if there was a kind of hollowness in my mother herself, and when they were together, I noticed my father especially seemed slightly uneasy, though he was trying to hide it. And I remember my father frequently at this time talking about that recurrent dream he had, that one about the empty lot, with rubbish all around, but a vast vacancy. He claimed it was New York City when he was young; I don't know."

By March the Rockwells had found a perfect yellow clapboard house to buy, priced at the exact price they were asking for their Vermont house. Next to the cemetery, a few blocks from downtown, the house was ready for them to move into by early spring, and Mary Rockwell began to feel more settled. She wrote to her sister that she was already planning the enlargements she'd like to make, and she explained the particular virtues of the new residence, including the way the "monster," as Norman called the television set, was tucked away into an anteroom. She shared a studio space with Jerry downtown, above the pharmacy and not far from Norman's, and found it rewarding to have a place to hang her work. She and Norman attended a weekly art group currently held on Wednesday mornings at Peggy Best's studio on Pine Street. Her husband continued to enjoy his studio overlooking Main Street, where he could look out of the huge plate-glass front and see "people instead of mountains." Only a week later, however, she wrote to Nancy that "we" (quotation marks hers) had been struggling with a *Post* cover.

From at least as early as their move out of the boardinghouse into their own home, the Rockwells felt sure that they had done the right thing by moving to Stockbridge. Here, unlike Arlington, the best of two worlds seemed at hand: small-town living in conjunction with a particularly vivid intellectual and artistic community. The social center of this scene was Peggy Best, an extremely talented artist whose close friendships with Wallace Stegner and John Cheever had intro-

duced her to Marshall Best, one of the founders of Viking Press. A divorced mother of two, she had moved to Stockbridge to teach painting at Riggs in 1950. Peggy Best held salons and slide shows at her own little gallery on Pine Street, within walking distance of Riggs and all the Main Street shops; and she began holding a weekly sketch class that allowed the artists in town to pay for a communal chance to work from a life model and maintain their skills.

Norman and Jarvis were not the only painters in the family now; Mary had begun to produce abstract canvases from art classes at Riggs. She and her husband joined Peggy's classes, and all three became good friends. Setting aside the times at Peggy's studio as opportunities to experiment, free of all professional demands, Rockwell practiced looser brushstrokes as he once again worked from live models, while Mary was able to try a new form of expression. Rockwell encouraged her to keep painting, including her bent toward the abstract, and his praise seems remarkably free of the condescension one might be tempted to excuse in such a situation. Mary began seeking Peggy out as a friend, someone to talk to when what her son Jonathan Best recalls as her "severe bouts of depression" settled in. "I remember my mother telling me [Mary] would walk for hours around Stockbridge at times trying to shake the depression and suicidal urges. I think my mother performed a lot of handholding," he says.

As usual, Rockwell himself was unavailable for much handholding. A few months after they had finished unpacking boxes and settling into the house on Church Street, he had to fly to Southern California for the Third National Jamboree of the Boy Scouts. He worried about leaving Mary before the family had had enough time to adjust to their new residence, but he also reminded himself that one of the motivations for their relocation was for times just like this: he could travel with the assurance of a nearby support community for his wife. Once he got out West, where he visited New Mexico as well, he became excited about the insights he was gaining for the increasingly burdensome calendars. On this trip, he noticed the unsung heroes of the organization, the leaders who gave up so much of their free time

to direct the troops. His pleasure at this new observation allowed him to rekindle some enthusiasm for continuing the yearly calendar cover.

Around this time, a nonprofit advertisement was published, using a photograph of Rockwell, pipe in hand, bow tie at neck, accompanied by the caption, "An All-week, All-year, All-life thing." The ad, promoting church attendance, must have provided a good laugh in the family who now lived, after all, next to a cemetery, a daily memento mori. A short text, supposedly written by Rockwell, explained that his family went to church together on a regular, not special basis. Since the Rockwells had rarely attended church at all except for the baptism of the boys as three-month-olds at St. John's–Wilmot in New Rochelle, the ad constitutes one of Rockwell's few arguably hypocritical representations. Although someone else wrote the copy, he had to approve it. In one sense, however, in light of the work that the attendance crusade was performing on behalf of "all creeds, races and classes of people," Rockwell's pro bono work for them is consistent with his fervid belief in the principle of tolerance.

He could not afford to do too many paintings or ads without reimbursement, however. During late spring 1954, as Rockwell worried about how he would pay for the new house, Tommy's tuition at Bard, and Peter's first year at Haverford, which would begin in the fall, he explored the possibility of Jerry attending City College in Manhattan, where tuition would be free after his eldest son established residency. Instead, Jerry decided to return to the Boston School of Fine Arts, and Rockwell had to figure in those costs as well. Throughout his life, he was sure to provide his sons with financial help, though he tried to balance cushioning their own load with encouraging their independence. When Peter and Tommy now decided to open a summer bookstore in nearby Lenox, for instance, Rockwell helped underwrite it, as well as paint the wooden sign for the door. The boys' venture proved financially successful—they tripled their investment—and they were able to move the bookstore to Stockbridge the following summer.

Occasionally, his attempts to help his relatives backfired financially. He had learned not to expect loans to be repaid in full; already,

he had written off not only part of a loan Jim Edgerton had been unable to pay back, but the entire amount that Nancy Wynkoop, Mary's sister, had incurred when her husband's business had problems. Nonetheless, late in her life, when discussing her brother-in-law's personality, Nancy bristled at what she considered his brush-off when a fire destroyed her family's house and Rockwell helped them financially, but gave her the feeling, she said, "that he didn't like poor relatives." More likely, given the accounts in the artist's ledgers and the discretion with which he did people favors, he was feeling particularly overextended when approached again by the Wynkoops, and he felt unable to say no to them, though Nancy's husband had defaulted on loan notes that Rockwell then assumed. When his own brother's son wrote him for help, he sent John Rockwell the requested funds, but he wrote Jerry, still living in Kane, Pennsylvania, asking him to assume a loan note on John's behalf.

Jerry Rockwell had not mellowed with age, and his treatment of his children merely echoed his lifelong petty nastiness toward his brother. Family tales of the toy designer's behavior to his sons as they grew up, when he punished their infractions, for instance, by confining the offender to his room for the entire summer and leaving his food on a tray outside the bedroom door, meshed with Rockwell's own rueful stories about being bullied by his older brother—including, according to Jarvis Rockwell, an especially memorable occasion when Jerry threw Norman out of a second-story window.

Now, on reading of Norman's assistance as well as his hope that Jerry would assume the loan note, the aggrieved man dashed off an angry letter, accusing his brother of undermining him. He knew Norman had helped his son Dick earlier, he wrote, and he wanted to stress that it was no favor to the boys to show up their own father like this. Surely his sons could work out their own problems, as he and Carol had after the 1929 crash. In any event, he could not and would not assume the note, but, he added confusingly at the end, he hoped Rockwell could do whatever he could to help his nephew, Jarvis's son.

Jarvis's reference in the aggressive letter to Rockwell as the "rich

uncle" must have hit a particularly sore spot, given the tight financial situation Rockwell constantly found himself in, as he supported a multitude of relatives in addition to his own household expenses. As always, however, unless he felt there was a moral conflict, he swallowed the bile and took care of John Rockwell. But he did then write to one of his cousins in Rhode Island who had tended Nancy Rockwell and asked if the man's father, Jack Orpen, could get along without the weekly money Rockwell had been sending him, partly because his business was in trouble. Rockwell gently explained that he was having financial worries of his own, and that if there was any way Jack could do without his help, it would be good to know. "I think you know how happy it has made me to be able to send the amount I have each week to Jack," he kindly says. "But in all honesty it is becoming more and more questionable whether I can continue to indefinitely do so." Because of his rising household expenses, he explains, he is "working harder than I ever did before, and still I have a time working everything out. So I am trying to retrench wherever I can, and quite naturally I think, the thought arises that perhaps your folks could get through alright without my help." Monthly ledgers several years later reflect that Rockwell continued sending the assistance through the end of the decade, at least.

The artist's slightly defensive diction—"and quite naturally I think"—betrays the discomfort he feels at having to ask for permission to withdraw his charity. In spite of his generous support of whatever relatives seemed to ask, he assumed some primal sense of responsibility for them, even when he himself was in difficulty. It is difficult to figure out exactly why he accepted, apparently without conflict, the responsibility to provide for distant relatives and for nephews he rarely saw. Seeing his actions as recompense for guilt at making so much money is one way to view the largesse. But people who knew Rockwell up close think that this private generosity was a deeply ingrained part of his personality and part of his general affection for people. He simply believed in people helping others whenever they could. Jack's daughter, Mary Amy Orpen, never realized the ex-

tent of Rockwell's assistance to his extended family; she was aware of cousin Norman putting her through Pratt, including buying her all the best art supplies she could find, but she didn't realize that he was supporting her parents as well as his mother at the same time.

And unspoken in Rockwell's letter to Jack Orpen, as if such bluntness would be rude, is the reality that most of the money the artist had sent the Orpens was meant to compensate for their tending to Nancy Rockwell, whom her son supported with monthly checks as well. During the late summer of the previous year, Nancy Rockwell, age eighty-four, had died. The last few months of her life, she was a victim of a mild dementia that hardly seemed to affect her personality but that had necessitated her move to a nursing home in Providence. The cousins arranged for her funeral to be conducted by Robert Orpen, a relative of Samuel Orpen, Nancy's brother-in-law, the Episcopal priest who had married her and Waring more than sixty years earlier. Rockwell himself arranged for a special funeral car on a train headed for New York, which he paid to stop in Yonkers for his mother's coffin to be transported to St. John's cemetery, where she would be buried in the family plot beside Waring. *The New York Times* gave the complicated woman an impressively long obituary, given her anonymity—except as the mother of Norman Rockwell.

Inevitably, in light of how his art helped him to process his emotions, once his mother's death had time to sink in, Rockwell would create covers whose theme dealt with loosening intimate bonds. During the following year, the subject had reverberated deeply enough that he had plenty of psychological material out of which to create powerful paintings. Throughout the summer of 1954, he worked on two significant *Post* covers, *Breaking Home Ties* and *The Art Critic*. The first, published on September 25, 1954, showed a dressed up, college-bound young man waiting eagerly for the train, his tired farmer father hunched over beside him. A collie rests its head on the boy's knee. Even though the facial expressions of both characters are broadly rendered, the painting is one of a small group of fifties realist pieces that exceed almost all the rest of Rockwell's oeuvre. The boy

looks unable to contain his excitement over leaving, however much he would prefer to be tactful; the older man appears unable to say anything meaningful, in spite of the emotions conveyed even in the drag of his cigarette.

Rockwell readily admitted in later years that the dispersal of his own family at this point inspired this painting, and in the same breath, he explained that he painted the dog to symbolize what the father was unable to say. *Breaking Home Ties* appears indebted to Dean Cornwell's series of biblical paintings that Rockwell had long praised, both in color tones and composition. The gold, amber, brown, and scarlet colors of Cornwell's 1928 *Christ and the Woman at the Well* are reproduced here, and the seated father, hunched slightly forward as he confronts his son's departure, appears directly modeled on Cornwell's Christ, seated at the bench. Even the formal weight of the otherwise centered composition shifts slightly to the right because of the dog's presence, just as the passersby in Cornwell's painting shift his pictorial plane to the same side.

Such reference to a religious series whose romantic execution Rockwell had admired suggests, whether consciously or not, that the illustrator struggled with the exits his sons were making, and the scary challenge of starting life anew, in Stockbridge, with only Mary. His willingness to move for her treatment was a sign of his own developing awareness that he played no small part in her troubles, and he did not flinch, whatever image the American people maintained of him as patriarch of the perfect and happy family they all desired, from aggressively seeking help for her and for himself. But his life was unfolding in ways that were far afield from any of the ideal pictures he had created for himself of what happiness looked like.

At the end of the summer, before Jerry went off to Boston, Rockwell painted a cover that was just as close to home, and even less accessible to superficial interpretation. *The Art Critic,* not finished until months later and published only in April the following year, embarrassed his son, and possibly, from Jerry's recollection, distressed the artist's wife, but Rockwell never discussed with his family the per-

sonal context for the painting. Rockwell's artist son posed for the smug young critic caught staring at the décolletage on prominent display in the portrait he was supposed to be studying. When he saw the finished painting, Mary Rockwell's son was not impressed: "I was disgusted by the painting, because I was looking at a bosom, which my mother had posed for, and my father knew that I knew."

The woman whom the student subjects to his magnifying glass combines Rockwell's photographs of his wife with two other sources: Frans Hals's *Portrait of a Woman,* from 1634, and Peter Paul Rubens's sketch of his first wife, Isabella Brant, around 1610. As his own painting evolved, Rockwell had struggled to define the appropriate female personification: the gamut ran from the classically pretty to the charmlessly mundane. As the picture develops, the woman is first caricatured as comically overreacting to the young man's rude stare. Although she becomes more conventionally attractive, her disapproving reaction to the student's scrutiny, instead of her beauty, dominates the picture. In her final incarnation, however, she appears knowing and flirtatious instead, amused at being visually stalked by the prematurely jaded "art critic."

The Art Critic even extended beyond the immediate family struggles it invoked, from the eldest son's following in his father's footsteps and sometimes seeming to know it all, to the confused sense of where Mary Rockwell's deepest loyalties lay—to her husband or her son?—to the institutional stature of Rockwell's own long career. Although to Jarvis, the most fraught interplay occurs between the young man and the object of his gaze—the portrait of a flirtatious woman—Rockwell was plumbing his own complicated family background even more deeply. A stockpile of sketches makes it clear that he spent enormous energy deciding which Old Master painting to hang on the wall to the right of the student critic, and he kept alternating between a Dutch landscape and a group portrait. By this time, enough press references had linked Rockwell to the Dutch School that he was in danger of revealing too much to his public and to himself about the motivations behind his supposedly "universal," nonsolipsistic painting, as his

works were always assumed to be. Now he shrewdly avoided the need to confront the personal history embedded (if only unconsciously) in *The Art Critic* by eschewing Dutch genre painting, the field most closely tied with his own professional development through the years.

To complicate the reference to ancestry, artistic or otherwise, Rockwell wedded two highly influential Dutch paintings in his final group portrait occupying the position of sentinels over the scene. To the right of the student, three appalled Dutch elders almost jump out of the frame in their astonishment at the upstart's impudence. The painting is a parody of Frans Hals's 1616 group portrait *The Company of Saint George's Militia* and Rembrandt's even more famous 1662 *The Syndics of the Clothmakers' Guild.* Art students—one of the subjects of the painting—would have immediately recognized the predecessors inspiring Rockwell's fake masterpiece, since the famous Dutch group portraits were prominently studied in art school. And the history of both portraits was taught as well, including the cultural symbolism of hierarchy and judgment that the paintings carried. Hals's work reflected an officer banquet where rank is observed through seating, while Rembrandt's painting narrated the pronouncements of the cloth guild on the dry goods brought to them for acceptance or rejection. *The Syndics of the Clothmakers' Guild,* with its ready-made reference to Rockwell's own father and the proud paternal profession of George Wood and Sons, was frequently lauded for its near perfect formal composition and arrangement of space. George Horace Lorimer had hung an oversized copy of the painting on the wall to the right of his desk; the Syndics stared in judgment at Rockwell every time he visited the Boss to audition his ideas. Rockwell, who also prominently displayed a reproduction of *The Syndics* in his New Rochelle studio during the 1920s, makes it his own in *The Art Critic* by appropriating Rembrandt's lesser-known preliminary sketch of only three judges instead of the six shown in the finished portrait.

At the time that Rockwell was working on *The Art Critic,* Erik Erikson sent a handwritten note on his behalf to Mary Rockwell's therapist, Dr. Knight. He told Knight that, speaking for his client, he

felt it imperative that Rockwell take a vacation to Europe that fall, a trip proposed by his son's fiancée's parents, which neither Rockwell nor the other couple wanted upended by Mary's presence. Rockwell was very depressed, and at the point of suicidal ideas, behind which lay the realization that Mary would probably never be well enough to live with as a reasonable person, nor sick enough to reside in an institution. Instead, Rockwell would spend the rest of his life trying to help her and to compensate for her illness.

Erikson explains that Mary has insisted to her husband, in spite of all evidence to the contrary, that she can make the trip sufficiently; in fact, she has suggested that she could semi-officially represent Riggs by checking into Kessell Hospital in England when they reach that country. With the boys all leaving the house at the end of the summer, the timing for her to be left home alone is poor, she has pointed out. Erikson notes that while this is true, Rockwell is struggling with the same adjustment to missing his children. The analyst ends by imploring Knight to see what he can do to ensure that Erikson's client gets this vacation that he desperately needs.

While this negotiation on Rockwell's behalf was going on, Rockwell signed papers to sell the Arlington house, for which he had spent over $20,000 on the studio alone, for $29,500. He began working on ads for products ranging from lifestock to gravestones to optical equipment. And Kellogg's was getting such positive feedback from the set of ads Rockwell had finally delivered that they suggested another series, this time paying him $17,500 for four, though Rockwell had accepted an earlier offer of $16,000. The only assignment he accepted for other than commercial gain was the request from the National Conference of Christians and Jews to do a poster for Brotherhood Week.

Whether Rockwell reneged on the trip to Europe because of the workload or because Mary Rockwell insisted on going along is unclear. But from a letter Mary wrote to Nancy in early September, it seems that she had become reconciled to her husband's vacation without her. She told Nancy that he was going off to Europe for a

month on October 13, and she invited her sister to come stay with her during that time to keep her company. In a good mood, Mary explained that the summer was wonderful, and that she was particularly happy that Tom (the diminutive nickname was dropped around this time) was engaged to a lovely girl whom he met at Bard—Gail Sudler—and that she and her daughter-in-law-to-be were "truly" good friends. Most important, she and Norman "are doing nicely, toots, I should say all crises were things of the past. Stockbridge is certainly a much better place for us than Arlington, more life and movement, if you see what I mean."

The only sign of instability arose when Mary mentioned that they almost bought another house that weekend, in the same fashion as they had impulsively bought the last one in Arlington. The yellow clapboard home purchased just six months earlier had already proven too small, she felt.

Perhaps the financial pressures combined with his worry over Mary's illness—or maybe in the end Rockwell was ambivalent about leaving her for a month. Perhaps Gail's parents had to cancel the trip; Tom and Gail Rockwell remember only vague references to the plans. But the depressed artist ended up spending early October at St. Luke's Hospital in New York, where, as his friend and accountant Chris Schafer wrote several correspondents, he was admitted for a rest.

Throughout the next few months, Rockwell was dealing with matters as disparate as his nomination to New York City's prestigious Century Club for high achievers in the arts (he never got around to completing his application), and his representation in a *New Yorker* ad for Chase Bank, in which he appeared as "the world's worst businessman," in need of such superior services as those of Chase. Perhaps at some level Rockwell courted looking naïve in financial matters, because he found it incompatible to yoke artists with wealth; appearing oblivious to such concerns in *The New Yorker* would prove a perfect forum to establish his purer mind-set, free from the moneygrubbing that accumulated wealth might suggest.

For whatever reasons, his depression began to subside by the end of

the year. Possibly the October hospitalization had done the trick. On January 13, 1955, a jubilant Rockwell sent a note to Robert Knight at Riggs: "Dear Dr. Knight,—I have complete confidence in you. Last night I slept twelve hours. Sincerely, Norman Rockwell." Either he had seen Knight instead of Erikson because the latter was away, a frequent occurrence, or Rockwell had requested a chance to talk with Mary's doctor about her progress, and she had granted permission. Whether the note refers to medicine or an optimistic evaluation—or even assurance that Rockwell wasn't the cause of his wife's problems—is unclear.

Whatever respite from minor dramas had been granted was soon replaced by a trauma that shocked the whole family. Peter Rockwell, fencing for Haverford against Princeton, was pierced through the lungs and heart in a freak accident that "couldn't happen": the opponent's épée, a rigid sword, lost its protective button and the blade pierced Peter's right armpit, just above the edge of the chest guard. At first, no one, including the injured fencer, knew the injury had occurred, but when Peter tried to stand up and instead fainted, first aid attendants realized that something was wrong. They waited to see if he felt better, but when he kept falling as he struggled to get to his feet, they decided to call an ambulance, and he was taken to the hospital at Bryn Mawr. In the emergency room, the shocked doctors found the wound.

Peter was in critical condition for several days, and the combination of his father's fame and the freakishness of the accident made the event a subject of press coverage all over the country. His parents stayed calm, showing no signs of panic, he remembers, remaining at his side until he was totally out of danger. Mary took a hotel room in Bryn Mawr until he was ready to return home several weeks later. Family life was further complicated when the hospital visits left Tom with a staph infection, and he was admitted to Pittsfield Hospital near Stockbridge. Peter spent a month recuperating at home, motivating his old girlfriend from Putney to visit him often to help keep up his spirits. From that time on, Cynthia Ide and Peter were a team. And just as Mary thought that Gail Sudler, Tommy's fiancée, was a won-

derful young woman, so she found herself similarly enamored of Cinny.

Peter remembers that for many years, the effect of what is now called post-traumatic shock would strike him unexpectedly, making him feel suddenly out of control and vulnerable to his environment. Mary's fear and concern took a delayed course, as well; she managed to stay together emotionally during the period her son was still in danger, and then she began to fall apart. By the late spring, she was out of control. Even if Rockwell had wanted to mine his emotions concerning the near tragedy, such mental processing would have been self-indulgent; there was no room left in his family for him to show weakness or hesitation. He put one foot in front of the other, as he always did, and he wrote to someone he knew in New Zealand who got Sir Edmund Hillary's autograph for Peter, who was quite taken at the time with the conquest of Mount Everest. By late March, Peter was back at Haverford, and Rockwell thought he could focus his attention exclusively on Mary.

But first he had to attend to business. In the aftermath of all the publicity surrounding Peter's injury, the Corcoran Art Gallery in Washington, D.C., announced that it was mounting a one-man show of Rockwell's paintings that would open in the summer and run through September. At the same time that the news was circulating about the Corcoran's planned exhibition, the *Post* published a twelve-color supplement of some of their most famous illustrator's best-received covers. And through all this, Rockwell hardly missed a beat in terms of keeping to a strict schedule that ensured the bills got paid and the family's other needs tended as best he could.

Helping him stay centered was the great pleasure he gained from attending a "stag" dinner that President Eisenhower gave for a small group of men at the White House. Rockwell had appreciated Ike's casual, natural charm and disarming friendliness when he painted him as a presidential candidate. But the invitation to one of the former general's small, no-press-allowed dinners for people he found relaxing or entertaining made the illustrator so nervous and excited that he got

a prescription for a barbiturate, probably Miltown, to calm him down during the evening. Although he lost the pill, the evening was a personal success anyway for the always insecure artist, who seemed unable to believe the president could enjoy him as interesting company.

In June, Rockwell was asked to attend the Corcoran opening, and he flew back to Washington, if with some trepidation, unsure if he would be ridiculed in the newspapers or ignored by the population. Instead, he was relieved on both fronts. As Selwa Roosevelt wrote in the *Evening Star,* hundreds of people stood in line to see the exhibition. Asked about his family's interest in art, Rockwell began discussing his pride in Jarvis's work, then surprised the interviewer by saying, "If I were starting now to be a painter, I'd be a modern artist too, I think. After all, it's the new and the challenging." To the startled looks that proclamation garnered, he quickly added that he would probably not include the abstract in such a career change. The featured painting for this show was *The Art Critic,* only recently published as a *Post* cover.

Rockwell's late spring and early summer activities made him unavailable, after all, to provide the daily reassurance that his wife wanted. But both Peter and Tommy were back in Stockbridge, running their summer bookshop, with Sue Erikson and Cinny Ide helping out. Tommy's wedding was scheduled for July, and Mary looked forward to the event. Only two weeks before the ceremony, however, in spite of her obvious attempts to hold out, she fell into a dangerous depression.

27

In for the Long Haul

Mary's decline occurred during a period when mental illness was finally receiving national attention at the highest levels. It was not until 1955 that the Eighty-fourth Congress passed Joint Resolution 256, commonly known as the Mental Health Study Act, which in turn, finally, created the Joint Commission on Mental Illness and Health. At last mental illness was a real disease, worthy of medical attention; given the statistics with which it was provided, Congress called the scale of mental illness, both its damage and its scope, "staggering." On the one hand, national sanction greatly eased the public stigma of diseases such as depression; but, on the other, the hard truths it acknowledged could discourage the strongest of heart. Little of a curative nature had been found; managing symptoms was about the best anyone could expect to do. Nor was the cause and effect clear with mental illness: the Joint Commission miserably admitted that professionals themselves differed on "what people 'are' when they are emotionally disturbed or mentally ill, on how they get that way, on what is wrong with them, on who should be placed in that category, on why they stay that way, and on what should be done about it. . . ."

In a serious gesture that implied Mary may have tried to kill herself, Riggs acknowledged that she was too ill for them to treat at this stage, and they recommended that she be admitted to the Institute for Living, in Hartford, Connecticut, a gray stone monolith that some Harvard psychologists, fairly or not, joked darkly should be called the "Institute for the Dead." Mary needed electroconvulsive therapy, otherwise known as shock treatments, or ECT. On June 30, she was admitted to the nonprofit but very expensive center.

Although various media dramatizations have presented electric shock as inhumane medicine, the truth is more often otherwise. Severe in its effects, potentially lethal if administered poorly, it is a last, not first, line of defense against intractable depression. Explored in the 1930s by the Italian neuropathologist Ugo Cerletti as an effective challenge to certain resistant brainwave patterns assumed to induce or control depression, the treatment, which consists of deliberately inducing a major or tonic-clonic seizure in the patient, could be cruel if applied in state asylums—where, as one recent history of ECT puts it, "psychiatry's job seemed to be no more than brutal custodianship."

But fears of the bone-breaking jolts also evaporating memory had dissipated under expert administration of the shocks, which, similar to a natural epileptic seizure, seem to alter synaptic patterns within the brain. Even under the best of circumstances, however—including the anesthesia eventually used to put patients to sleep during the procedure—short-term memory loss is predictable, just as it is for those with epilepsy. Most often, however, in the case of ECT, the memory is retrieved. And even when it is not, the vast majority of patients prefer the release from their devastating depression to an intact memory.

By the time Mary Rockwell was scheduled for ECT, the method had been used in the United States to treat severe depression for well over a decade. Similar to induced insulin comas and other innovative treatments, ECT had originally been used to treat schizophrenia, with only equivocal results. For severe depression, however, it seemed to offer unheralded relief, and patients who received the shock treatments in competently staffed, updated, humane hospitals expressed

gratitude for the first hope of a cure, or at least respite. And to its credit, the Institute for Living excelled in ECT, administering the treatments in as unthreatening and encouraging a way as possible.

Within ten days of her admittance, Mary had undergone at least one shock treatment. In handwriting that had begun over the past year to sprawl uncharacteristically broadly and downward across the page, she once again, part fatuously, part with true courage, explains to her sister that she finds herself in a situation where she must make the best of things. Her distress is keenest because of the timing, "giving out" during such an important time in her son's life. The Institute is fine; there is plenty to do, and she will try to get involved in activities. "But oh how I miss my husband, home and children," she lets escape. She gratefully explains that she will attend Tommy's wedding with Norman and then return to the hospital. And, she adds, almost incidentally, "I had my first treatment and it was not at all difficult—though odd when you wake up at first." There are those who think that Mary Rockwell was "on the side of the angels," her daughters-in-law included. Such a letter at a maximally stressful time grants a certain weight to their testimony.

Mary also wrote to "my darling Tom," trying hard to express how profound was her regret at missing all the prewedding festivities. "I held out as long as I could," she tells him. She also explains how much she wants to write him and Gail a "proper magnificent letter" but that she lacks the resources at the moment; instead, she will simply say "I love you both dearly and wish you very very happy all your long lives."

Mary made it to the wedding; her husband picked her up, took her, and returned her to the Institute. Photographs show the divide between Gail's attractive, happy parents, and the Rockwell parents, Norman trying to keep up his end, Mary looking ill at ease, as if just being there required every bit of willpower she could muster. From the vague accounts that loyal family members are willing to recall, she was unable to hide her mental state: her walk and her speech were unsteady. Professional associates from the *Post*, for instance, including Ken Stuart, whom she disliked, found it hard to hide their shock. While the

wedding preparations were going on around him, Rockwell had to ful-
fill his requirement to show up in mid-summer at the Famous Artists'
School to help judge entries in a Hallmark card contest. The school
director mentioned admiringly the prodigious number of paintings
(meaning advertisements) that Rockwell was producing for a variety of
publications these days, one reason that it was hard for the school to
nail him down to keeping his commitment to teach there twice a year.

During the early fall, while Mary was still undergoing treatments,
Rockwell received a reward for the travails of the past year: he finally
took his trip to Europe, a far more luxurious vacation than he'd
planned for the previous autumn. Pan American Airways sponsored a
round-the-world trip, with Rockwell doing illustrations for future
publicity as well as promotional television shots on location. He drew
an endorsement of the airline that pictured him riding on top of the
Clipper, as if on a magic carpet. He loved it, since he was taken to fa-
vorite old places and to ones he'd never visited before, a total of six-
teen cities, among them London, Paris, Barcelona, Nice, Rome,
Istanbul, Beirut, Calcutta, Tokyo, and Honolulu. Reflecting on his fa-
ther's indiscriminate curiosity about the world, Peter Rockwell holds
as one of his strongest images of his father hearing him lament on his
return that he had not dared accept an offer to visit an opium den;
Jarvis, by contrast, vaguely recalls his father suggesting satisfaction to
the contrary.

But before he could begin the trip, Rockwell needed to ensure that
Mary would be safe while he was gone. The doctors at Riggs had
agreed that Mary would be best off staying at Hartford, where she
would be closely supervised until her husband got back, and she
agreed. In early September, Rockwell stayed in Hartford for a week to
spend time with her. One day, when he was downtown sketching dur-
ing lunchtime, a reporter asked him his name, and he quietly told
him. The news became a hot publicity item, with *The Hartford
Courant* falling for Rockwell's answers to their excited query, "Why
Hartford?" He was there to limber up his arm for his foreign assign-
ment, he explained: "Hartford, you know, has a foreign atmosphere.

The State Capitol could be another Taj Mahal if it were located in India or Siam and the people walking by were dressed in tunics and turbans instead of shirts and ties." The artist continued to point out the parallels between the city's architecture and the various cities he'll be visiting abroad. At the end of the article, called "Rockwell Limbers Up by Sketching City Scenes," the writer concluded that "the illustrator's visit to Hartford is a story *The Courant* almost missed."

Mary's brother Al wrote Rockwell that he was concerned at the artist's leaving Mary at the Institute for the month he'd be gone. Should Al send someone out from California to give a second opinion of the treatment she was getting? In alarm, Rockwell wrote him immediately on returning from his "limbering" session in Hartford that Mary was coming along fine, but that her doctors had informed him that her periods of elation and depression were incurable. (Tom Rockwell also recalls being told somberly by someone at Riggs that his mother was not likely to get well.) The shock treatments had seemed to relieve her depression the most, and they suggested that whenever she felt herself slipping, she return for a treatment as soon after the onset of the depression as possible.

Rockwell reassured his brother-in-law of his complete confidence in the institution, and that he felt Mary would react poorly to bringing someone else into her case. He asked one of her doctors to write to Al. And, he reminded Mary's concerned brother, he loved her deeply and sincerely and would make sure everything that could possibly be done for her would be.

While Rockwell was preparing for his trip around the world, the Berkshire County Museum, in Pittsfield, Massachusetts, with his permission, mounted a show that included works by both Mr. and Mrs. Norman Rockwell; Mary's contribution to the exhibit was an abstract oil. Most people who viewed her work regarded her as an unexpectedly competent but uninspired painter. Rockwell's generosity in encouraging her to show with him is unusual in the annals of dual artists' marriages. The illustrator was trying everything he could devise to help his wife, short of what might have made the most difference:

turning away from his work and devoting himself to her. At this late stage, and perhaps all along, any more moderate compromise would still have failed to succor Mary. Erik Erikson noticed how hard his friend was trying to help his wife; the therapist wrote him during the monthlong Pan Am trip that they all missed him, and he reassured the artist that Mary was doing well. He also mentioned that he had heard about Rockwell calling Mary "regularly" from overseas, and that she appreciated it "ever so much."

Although he returned from overseas in late October, Mary stayed at the Institute until the end of November, when her doctors agreed she was strong enough to return home. Basic room and board was two hundred dollars a week, with all treatments and incidentals added to that base figure. She had been hospitalized this time for six months.

The already dramatic year ended on a horrifying note. During early December, a well-respected magazine illustrator who had worked with Rockwell in California, Pruett Carter, shot and killed his wife and son, then turned the gun on himself. He had been struggling with mental problems for some time, and apparently very shortly before this climax, he had called illustrator Andrew Loomis about his despair. Loomis begged him to hold off his horrible plans, and to talk to Norman Rockwell, whom Carter practically idolized. Loomis got hold of Rockwell, who called Carter immediately to talk him out of the murder-suicide. One account claims that Rockwell was actually on the phone in between the events, begging Carter to put down the gun after he had already killed his family. In any event, there was no stopping him. Rockwell did not discuss this incident, but several of his associates, including Fred Taraba and Stuart Ng, were told the details by people close to the situation.

How Rockwell felt after this tragedy is hard to imagine. His friend artist Dean Cornwell sent him the news clippings from California, saying simply that he had received a card from Clyde (Forsythe) asking him to mail the articles to Rockwell. Especially in light of the emotional troubles plaguing Mary, the whole situation must have been even worse for Rockwell than it would have been for others. And

Mary's own illness was already shadowed by the end that his first wife, Irene, had met.

In February, Rockwell enjoyed a few moments of lightness, and some pleasure at reversing the roles and being on the modeling end of a professional's commission. The famous portrait photographer Yousuf Karsh was putting together a photo book of famous people, and he included Rockwell sitting at his easel in front of two of the Four Freedoms. (Kodak would also use one of Karsh's photographs of Rockwell for an ad in 1959, the same year that Karsh's book was published.) Although by now local Stockbridge photographer Bill Scovill, a talented amateur photographer of mood and nuance, had shot some impressive pictures of Rockwell, Karsh was one of the first national figures to represent the artist among the company of other equally famous and impressive figures.

During the following months, Rockwell painted two *Post* covers, finished by the beginning of the summer. Both are minor works: *Happy Birthday Miss Jones,* an elementary school room's homage to its teacher, and *The Optician,* a pouting preadolescent being fitted with glasses—and looking startlingly like Peter Rockwell had, eight or nine years earlier. Tellingly, both pieces centered on young children, as if memories had been stirred up by his almost grown brood's mishaps and near disasters.

By the late summer, Rockwell shifted to the kind of coverage the *Post* would increasingly request of him. After the two major political parties had confirmed their choice of presidential candidate, Rockwell arranged to paint the portraits of Adlai Stevenson and Dwight Eisenhower. Pleading, whenever a reporter asked, that he himself was an independent voter (which he was), he nonetheless admitted that Ike's sheer charm and personality overwhelmed him. And later, when reviewing favorably a book by Herblock, he demurred at the cartoonist's negative rendering of Eisenhower, though he admitted that his distaste for the exaggeration might stem from being an Eisenhower Republican. By contrast, he explained, because he so disliked Joseph McCarthy, he applauded Herblock's vivisection of that figure, leading

him to conclude that judgments of aesthetics are often mired in partisan politics.

Voters' reactions to the portraits of the Democratic and Republican candidates neatly illustrated Rockwell's putative impartiality in art, at least; both party's supporters were pleased, with the Democratic National Committee even requesting that the *Post* present the portrait to Stevenson, which it did.

Too busy tending to other more urgent problems, Rockwell had managed to postpone addressing a medical condition common to aging men. Now, almost exactly the same time of year that he was hospitalized in 1954 for a rest, the illustrator ended up in the hospital in 1956 for prostate and bladder problems. Ben Hibbs wrote him an encouraging letter about their mutual acquaintances who had come through such operations quickly, though he himself had found something similar extremely messy for himself. Ken Stuart had passed on to Hibbs the rumor he heard that Rockwell would be able to avoid surgery for now; and Hibbs asked if such news was true. It was, and Pittsfield Hospital discharged Rockwell in mid-October. He was back to business by the end of the month, traveling to and from New York for still more advertising work.

High on his agenda, once he got out of the hospital, was to make time to paint his final Christmas cover for the *Post*. As Rockwell Museum curator Linda Pero points out, it is hardly coincidental that he chose the primal scene of a boy discovering Santa Claus is just a trick, as the youngster stumbles across the Santa costume in his parents' drawer, Rockwell capturing the very moment that the belief is demythologized for the child forever. This final Christmas cover, always a prestigious placement of an illustrator's painting, appeared when his once-secure tenure at the *Post* had obviously evolved into an abbreviated yearly commitment, representing the old guard of illustrators, and his family life had crumbled into the very opposite of the tableau of security he had desired.

Around the time that the December cover was published, the Rockwells received their invitation to President Eisenhower's second

inauguration in January 1957. Although he was still fond of the man, Rockwell was now less impressed with Ike's presidency, and the couple decided not to travel to Washington for the event. Rockwell had too many ads to work on anyway, and he was looking at movie publicity commissions as well, including initial ideas for Walt Disney's planned *Old Yeller.* Jerry was out in San Francisco at Erik Erikson's suggestion. "I was trying to define myself, and my father wasn't sure I should go on with art at this point, and Erikson encouraged me to, and told me to move to someplace interesting and far away from my family, like San Francisco. It was great advice."

Once Erikson promoted the idea, Rockwell was convinced, and he supported Jerry financially during the long periods he found himself unemployed. Still floundering, and feeling particularly unsettled about what was going on at home—"I didn't want to know and no one talked about it anyway"—Rockwell's eldest son had begun intensive psychiatric therapy himself. As well as paying the bills without complaint, Rockwell corresponded with Jerry's doctor, seeking advice as to ways he might help his son. His letters show that he was very concerned that his parenting had led to Jerry's problems, and in one touching response from Dr. Wheeler, the artist is assured that he was a good father. Rockwell even asked Erik Erikson, who was in Mexico for a few months, to go check on Jerry and his doctor in San Francisco. On sabbatical to write a new book, Erikson didn't make it to California, so Jerry's doctor came to him.

Not surprisingly, given the recent announcement by Peter that he was going to marry his childhood sweetheart from Putney, Cynthia Ide, the presence of young love inspired the two *Post* covers that Rockwell painted in the spring of 1956. One dealt with a proud couple showing off their prom clothes at the local drugstore, the other with a picture of two wise cleaning women smiling at the hotel room detritus of a honeymoon. *After the Prom,* as Dave Hickey has thoroughly analyzed, is an impressive painting in the tradition of the European masters, particularly in its precise articulation of angles and the delineation of action achieved by careful use of color. Pure Rock-

well, however, as Hickey points out, is the implication once again that the kids are just fine, instead of being threats to a postwar society that wanted, defensively, to close ranks.

Just Married, lacking the technical achievement of the former piece, nonetheless shows the mastery of realistic painting that Rockwell displayed from the late forties to the early seventies. But it also encapsulates more clearly than most paintings the way that Rockwell yields to the temptation to make the audience seem superior to the content of his painting. The cleaning women look too sweet and content to worry us, but because they are also clearly amused and pleased by so little, we smile patronizingly at them. The final step in this dynamic is that the narrator of the entire visual act, which includes us as spectators, drawn into judging the scene, is in fact judging us. The uneasy sense that at times Rockwell feels contempt for his audience plays out in just such an economy. It is present, too, in *After the Prom,* where the picture's potential achievement is effaced by the aura of narrative condescension that hovers over the story.

Mary's painting had also been invigorated lately by her family's romantic pastimes; she seemed to embody the old saw about gaining a daughter-in-law, in the face of losing a son. She loved both Gail and Cinny, and they considered her a good friend. By late spring, Mary was feeling particularly cheerful about all aspects of her life. She sent her sister money to buy good supplies for her own work, and told her to let her know when she needed more materials. Every Tuesday, Mary went for a lesson with Peggy Best, and she claimed it was one of the few rules she made herself keep. She philosophized in a new way to her sister: "A woman's life is quite different from a man's—to be a real woman she needs to do all sorts of things, so that even something she may love as much as painting cannot be pursued as a profession the way a man does. Personally I like the variety of my life. I'd hate to feel I had to go to the studio every day."

During this year, Mary Rockwell finally got her wish to move to a bigger house, one that didn't look out onto a cemetery, which had become too morbid a landscape for her to tolerate. One sign that her dis-

like of their location must have suddenly overflowed into a passionate hatred is implied in the bills for $34,000 that the Rockwells spent on renovations, only to end up moving that same year. Even for them, this was financial folly of the first order.

At the end of the summer, the painter finished his work on Disney's *Old Yeller,* and began more advertising for Upjohn Pharmaceuticals. And once again, he faced the "God damned calendar," the yearly Boy Scout calendar cover. He had been complaining loudly about the calendar for years, but on getting up his courage to call the organization to resign the commission, he'd been told that they would double their pay for the one picture a year. He had planned to replace the loss of income with the pay and stock dividends from the Famous Artists' School, which were averaging around five hundred dollars a month by the end of the fifties. But whenever he remembered that their pay was for one picture only, after all, it proved impossible to walk away from Brown and Bigelow's monetary enticements. For the last ten years that he painted them, Rockwell was getting $10,000 for each year's cover.

As 1957 drew to an end, in place of a Rockwell Christmas cover, the illustrator was treated to the offering of a National Book Award–winning novelist who was himself a well-respected photographer. Wright Morris wrote an important essay in *The Atlantic Monthly,* a magazine read religiously by Rockwell every month, unlike the *Post,* which he rarely saw except for the issues that featured his own covers. The article, called "Norman Rockwell's America," reads as a thoughtful (unlike the usual knee-jerk) indictment of the insubstantial vision that continues to inform Rockwell's painting, through which Middle America has learned to appreciate its idea of art. Tom Rockwell recalls that this was one of the few negative pieces that bothered his father: "For a few days, Pop was depressed over it, but then he realized it was just what he'd been getting all his life, and he got over it."

To make matters worse, Dorothy Canfield Fisher's brother, Cass Canfield, was the editor of *The Atlantic,* and to have such sober criticism appearing under Canfield's aegis rubbed old competitive wounds even rawer.

Luckily, Peter Rockwell's upcoming nuptials took his father's mind off the embarrassment. On February 8, 1958, Peter and Cinny were married in New London, Connecticut. Erik Erikson attended, and even Clara Edgerton came all the way from Arlington, though the weather would have thwarted less stalwart souls. Rockwell, afraid that the "kids" hadn't arranged to have enough champagne to serve everyone, supplied an entire extra case at the last minute. Mary was in far better shape than at Tom's wedding two and a half years earlier. Not only had she driven to New York City to buy the china the newlyweds wanted; she began a ritual of sending the couple a check every month to buy fresh limes and rum for the daiquiris she knew they loved, an odd if loving gesture for a recovering alcoholic.

The wedding proved to be prelude to a particularly fulfilling summer. Peter held a show of his most recent drawings in Peggy Best's studio; finally, his father had capitulated to his youngest's decision that he, too, wanted to pursue a career in art. Peggy Best was invaluable to anyone in Stockbridge interested in art. Throughout the summer, family members were keeping weekly appointments at Riggs; Mary was trying valiantly to stave off the gloom she felt start to descend, its cause unclear.

Rockwell found himself challenged by two not unrelated questions during the fall: should Mary return to Hartford, and should he accept a major endorsement campaign that would pay him handsomely for lending his name to a home decorating project? It became apparent that Mary needed more shock treatments, and so he began driving her weekly for her sessions, a pattern, according to hospital bills, that continued unabated for the next year. His costs once again escalating, and Jerry still dependent on Rockwell's financial support, the illustrator accepted the offer from Colorizer, in which he was presented in magazine ads as endorsing the company's method of coordinating wall color and art. Such projects were anathema to serious artists, who routinely made jokes about those people who bought paintings to match their walls.

At least Rockwell was able to turn to his work for the *Post* during the fall. Of his next three covers, one would become among his most popular: *The Runaway*. Its photographic realism gratifying, it suffers from the same compulsive sentimentality that compromised the potential brilliance of *After the Prom*. Beautifully composed, the triangular figure of vagrant little boy, kindly policeman, and kindly fountain worker overcompensates for *After the Prom*'s invitation to assume superiority to the participants; the patronizing goodness of the two older men in this scene is cloying enough without tempting Rockwell to further burden it with audience voyeurism.

At various times throughout the autumn of 1958, Rockwell told interviewers that he was planning a sabbatical the following year, in order to see what he would paint if he just worked for his own pleasure. Several times, journalists wished him well; occasionally, someone suggested that any gesture toward real painting was presumptuous on his part.

When the new year opened, few signs pointed to the sabbatical supposedly under way for 1959. Rockwell accepted a promotional assignment for Ford's new Lincoln Premier Landau that, while not requiring his painting, forced him to let strangers into his studio to photograph him. Worse, he and Mary agreed to do a special with Edward Murrow for CBS. In February, not only their house but also the entire town was upended in order to produce the half-hour special. Worried sick over what Mary would say or do during the taping—by now, her behavior was too erratic to predict day by day—Rockwell and the boys basically just hoped for the best. The session went well, though it is hard to believe that viewers didn't sense something wrong with the monotoned wife who, sitting in her armchair and infrequently addressed, looked dazed or sleepy.

More interesting than the television show, however, was the publisher Doubleday's idea that Rockwell should write his autobiography for them. Although little hard evidence dates the concept to an earlier period, a few notes suggest that Rockwell might have planned this book the year before, in which case it motivated his "sabbatical." Dou-

bleday sent an interviewer to ghostwrite the book, but Rockwell found the writer impatient and controlling. A better system was developed: Tom, now a writer himself and already employed by Doubleday, would be the scribe to whom Rockwell told his story.

The plan proceeded well, though at first Rockwell found the claims on his time every evening cumbersome. But by the summer he was dictating into a recorder, making him freer than he could be even in front of his son, and allowing him a way to unwind at the end of the day by, in effect, talking to himself. Rockwell enjoyed doing new things, and talking to his audience in this fashion was definitely different from the usual visual relationship he depended on.

Tom Rockwell remembers as one of the most interesting aspects of the experience his father's lack of interest in exploring motivation or cause; instead, he would narrate extraordinary anecdotes, one following the other, including dark periods such as his divorce—without any attempt at interpretation. Tom and Mary had to convince the illustrator to even mention his first marriage; on the tapes, Mary walked into the studio as he was recording this section, and repeatedly she nudged him, "You have to say something about it."

Rockwell clearly meant to create broad strokes of a genial, folksy autobiography that might make him sound like something out of a Dickens novel. And Tom Rockwell captured his father's intention and language impressively, a feat noticed by the admiring reviewers. But the extent to which the charm of Rockwell's autobiography is a kind of fictional gloss on his "real" life is unclear. Inevitably, the audiotapes convey the minutiae of his current daily life—the telling day-to-day details—that speak more eloquently than his stories do. The sixty-five-year-old artist's determination not to become passive, complaining, or boring as he ages surfaces repeatedly, for instance, whether in his contemplation of a trip into the Peruvian jungles or his frequent exclamation that "I don't want to just sit on my tail and get old." Creatively, he searches for solutions to the indignities that age is dealing his body, such as his problem with his vision: no longer easily able to shift his focus between the easel and the stand to its left that held his

sketch, Rockwell helped devise a pair of vertical bifocals that he had made in neighboring Pittsfield, unusual enough that they are entered into the Ripley's Believe It or Not! compendium of anomalies.

Without a doubt, the autobiography does contain many "deep moments," as critic Arthur Danto remarked. But the long, seemingly exhaustive story so replete with details that one loses track of the years also conceals at least as much as it unveils, in its physical abundance. Michele Bogart comments: "[The] myth of comforting superficiality was sustained by Rockwell in his autobiography, an informal, dictated narrative that purported to reveal more of the 'true' man than it actually did. Throwaway comments about Rockwell's depressions, for example, were followed not by introspection about their causes or significances, but by evasive statements about not knowing why they occurred."

At the least, the unending repertoire of stories that the painter unfurls suggests more of a raconteur than a man struggling to retrieve long-buried memories from his childhood. Widely praised by friends and colleagues for his easy, graceful, casual speeches, Rockwell records the theatrical anecdotes in his book with the same causal charm, implying that he merely embellished the truths with rhetorical flourishes and narrative exaggerations. Listening to the audiotapes, however, one hears the tones that inflect his syntax. When he discusses his progress on a painting, for instance, the punishing worry, anxiety, and seriousness with which he undertook each new project comes through without relief. Can he do it again? he questions himself without fail, every time he works on a painting.

Although the content of the tapes and the text of the autobiography do not differ substantially, Rockwell's spontaneous vocal reflections at the end of each workday reveal much about his dramatic mood swings. Always, his happiness is determined solely by the progress in his work. When he laments that he has spent another sleepless night, he invariably explains the problem of his current painting that was troubling his sleep. Sometimes worry overrides his ability to keep painting, and he has to take a Miltown to calm his anx-

iety in the middle of the afternoon. The biggest bonus of the tapes, however, is the omnipresence of the enchanting, engaging, untutored goodwill that his associates always struggled to explain about the artist. Rockwell's strong sense of irony, the device that saves him from despair and delivers him through humor, emerges more strongly on the audiotapes than in any other forum, belying his critics' belief that he didn't recognize the discrepancy between the way things were and the way he painted them. The famous vulnerability that made people want to protect him exists side by side with a quiet, adamantine strength of character.

Throughout the spring and summer of 1959, he struggled with *The Family Tree,* even while preparations proceeded for two other projects—*The Connoisseur* and a mural he was doing for Berkshire Life. To house the oversized mural, he actually converted the old ice-house in the back into an artist's shed where he and his helpers could work on the insurance company's project.

His daily agonizing aloud on the tapes over his progress on *The Family Tree* affords a glimpse of what his family suffered through at countless dinners and other family times. His absorption in the project is so complete that it sounds as if this is the first important painting he has ever done, not a late, and relatively minor, commission. He refers to art sources, he consults knowledgeable friends, he drills Erikson, who pops in every now and then during languid summer afternoons, all to see if each of the heads that he is painting to represent a generation of Americans interbreeding makes sense. The pirate at the base of the tree rankles him most; after all, this was Howard Pyle's specialty, and the anxiety of influence is so strong it threatens to topple his historical progeny. His family urges him to use a black figure early in the branches of the tree, possibly at the beginning, but he worries that it would be too radical a statement, at least from the *Post*'s point of view.

In early June, happy that "this Knox gelatin thing [is] practically done," Rockwell determines to let no more advertising work retard his progress on the family tree picture. Two weeks later, his tired voice

carries the weight of his now monotonous obsession with getting the painting right. Although he has just returned from a day and night in Manhattan, he gives that trip five words' explanation before launching into his latest thinking on the vexing *Post* project: "I've been down to New York—decided to change the founder of the family from the killer type again to a robust rogue. I'm feeling agony over all this— each day I wake up with wild enthusiasm for a new way to do it. Now, I have a great idea for a ribald, seafaring dog—strong, beard, smile on his face, voluptuous gal beside him." He then refers to Erikson's re- cent suggestions, based on his therapist friend's critique of the can- vas: "Dear friend Erikson thinks if I show ribald people I show myself to be healthier. So this is partly due to him. OK, on Tuesday at lunch I went to the Marching and Chowder Club and talked about the Russian exhibit [a show of social realist art Rockwell had seen in New York], but no one was interested. . . . Then Thursday, I woke up and said, I'll put in both women! Robust, healthy moll AND a Spanish woman! In the meantime, the Indian maiden doesn't work."

The Marching and Chowder Club was one of the infrequent but essential recreations Rockwell allowed himself even when he was stumped on an assignment. A group of ten to fifteen men met every Tuesday for lunch at a restaurant in nearby Lenox, where they dis- cussed informally what they were doing that the others might enjoy hearing about. Far less august company than the more formal once-a- month Monday Evening Club, where professional distinction was a requisite to be invited, this group enjoyed finding reasons to laugh loud and to linger long over their food. The change of pace from Rock- well's ordinary days served his work well, and he knew it. But social encounters alone, however pleasurable, never produced the palpable relief that occasionally flitted to the surface of his dictations at the end of a day of fruitful work. At such times, Rockwell would sign off on his tapes with diction reminiscent of his journal locutions from his Canadian camping trip of 1932: "Good night, ladies, and a fare-thee- well to you!" or "OK, folks, it's cocktail hour, let's call it a day." One night, when he is fairly dancing with joy at the progress he has made

on his painting (an emotion at complete odds with his reaction the next morning, on looking anew at the work), he concludes with "Good night, children. God bless you all, you cute little devils." On the morning that was reserved for special recording, he picks up the Dictaphone and, hamming it up, pretends to lament, "I'm late today, girls. Tommy and Gail came last night—very glad they came—very charming people." His voice bubbles with happiness.

Throughout the summer, the artist's preoccupation with the *Family Tree* cover governed his thought, extending even to his sleep, which was consistently interrupted by his worry over the piece, and by his growing dependence on Miltown to curb his insomnia. Toward the end of the summer, his spirits lifted, although, given the radical ups and downs he exhibited each morning—his daily decision often at odds with his conviction of the night before—such a mood swing is hard to credit for long. But throughout the first two weeks of August, he vows that he has caught on, he can feel it. And, energized by such confidence, he became more available emotionally to his family. Jerry, as he still called his oldest son, living in San Francisco and beginning to sell his paintings with some regularity, had recently visited his parents, and, in spite of the awkward emotional distance between father and son, Rockwell felt good that they got along "pretty well." He'd even taken an afternoon off to mountain climb, in an effort to "bond," as he half laughingly, somewhat ironically recorded into the machine one night. And Peter and Cinny were in town, with his daughter-in-law not only helping him on the Berkshire Life mural, but also gently taking over much of the household, making things easier on Mary.

One of his final recorded journal entries, on August 23, worries aloud over things not directly related to the painting, a sign the piece was progressing. He wonders aloud if he handled the newspaper boy's dilemma well: Glenn Pilley had been saving quite a while to buy himself a bike, and Rockwell had decided to loan him the money and work out a contract with "the kid," whom the painter liked and admired for his tenacity. "He was getting discouraged and gonna quit the paper because it would take too long to earn the bike money," Rock-

well explains. The bicycle cost $37.75, and so Rockwell would with-hold fifty cents a week out of his $1.50 bill until the debt was paid off. He wants, he says, to ensure that he has come up with the right solution, one that will motivate as well as help the boy, while not putting himself in the position of "Santa Claus" that the community tries occasionally to foist on him.

On August 25, the family started the day as usual. Mary and Norman had begun a ritual this past year of having their coffee together upstairs each morning, a time they used to talk about the upcoming day before going downstairs for breakfast. Jarvis was impressed when he saw the changes during his visit: "They seemed to be enjoying being together, more bonded than before. I guess things were improving, though since no one addressed anything out loud, I had to just surmise these things."

After everyone had finished with the newspaper, they all went their separate ways, Norman to the studio, Cinny to the icehouse to work on the mural, Peter to a nearby rented workspace, and Mary to straighten up the house. When they regathered for lunch, Mary was moving slowly, but as her daughter-in-law says, "she had been sluggish off and on for so long we thought nothing of it." They ate their roast beef sandwiches, made from leftovers from the night before, and Mary said she wanted to go upstairs to take a nap. Later in the afternoon, when Rockwell went into the house to ask his wife something, he had to go upstairs to wake her.

But she wouldn't respond. He ran out to the icehouse, frantically yelling at Cinny that something was wrong with Mary, to hurry, hurry. Back in the couple's bedroom, Cinny knew as soon as she saw Mary that her mother-in-law was dead. "I could just tell; she was unnaturally still." Rockwell walked around in silent shock, while Cinny fetched Peter and called the doctor. The family vacillated between horrified surprise and a confirmed sense of the inevitable.

The official cause of death was listed on Mary Barstow Rockwell's death certificate as heart failure. Some would say that it fit, no matter what; her burdened heart couldn't hold out any longer. Apparently, the

family's first assumption was that she had killed herself; Rockwell called his nephew Dick that afternoon with such news: "He told me, 'Mary committed suicide.' And when I got all upset, he said, 'She was so unhappy. Try to think of it as release for her.'" To this day, many townspeople believe Mary took an overdose of pills. Jonathan Best, Peggy's son, insists that "everyone knew it was suicide." But Cinny Rockwell, one of the first on the scene, says she thought it over carefully, and there was simply no evidence to support this seemingly logical conclusion. No suicide note—although writing was one of Mary's major outlets when under stress; nothing different about that morning or lunchtime from hundreds of others; no missing medicines.

Why would a fifty-one-year-old woman's heart give out? Even doctors ill-disposed to ECT dismiss the idea that weeks of shock treatments would have caused the death. Instead, it seems likely that the long-term abuse of alcohol and potent psychopharmaceutical drugs, in conjunction with the electric shock, simply triggered heart failure.

St. Paul's Episcopal Church was overflowing at Mary's funeral. Nancy Wynkoop remembers everything going well until the end, when the family got stuck waiting in the aisle for over twenty minutes. The cemetery that Mary had hated seeing out of her backyard windows became the site of her grave. Back at the house, neighbors had supplied food that would outlast the afternoon's crowd and provide meals for weeks to come.

Those who interacted with the widower usually mention that Norman Rockwell walked around for the next year like a marked man. His face ashen, his voice still, he seemed unable to accept what had happened, or, perhaps, unsure what to do about it. Jarvis Rockwell took a roll of pictures of him at this time, and he remembers that the results were so emotionally dark, even when his father was laughing, that it scared him. The prominent photographer Clemens Kalischer, who began to assist Rockwell more frequently in the early sixties than he had when Mary was alive, remembers seeing him ambling around town like a sleepwalker, disturbed and unfocused. Of all the generous efforts of friends and family to help him, one of the most impressive

was the letter from a doctor at Riggs, Margaret Brenman, wife of playwright William Gibson and part of the Rockwells' social circle as well as one of the professionals whom Mary particularly sought out for her sensitive listening to the depressed woman's worries:

> I could not write to you before now for reasons too complex to detail. I want only to tell you that I wept when I heard of Mary's death and thought then for several days of her valiance. I thought too of the pleasant phone conversation she and I had had the week before when she told me a little of the development in her painting.
>
> I know that you know letters like this are very hard to write when they cannot be written perfunctorily—and this one cannot. I want only to add, for whatever it is worth, that I know for certain that with all her ambivalences, Mary knew you had given her much to live on in your life together and felt you to be a pillar in her often troubled life. I wish you well, Norman.

28

Picking Up the Pieces

The sons, in spite of their own grief, rallied around their father, and when Peter and Cinny had to return to Haverford, Tom and Gail basically moved in with Rockwell until he became emotionally stronger. To Peggy Best's condolence letter, the artist answered fervently: "We all loved Mary so much it hits us all at times. . . . My family are truly wonderful. Where would I be without them?"

The artist continued with his weekly therapy at Riggs, and Tom Rockwell recalls that Erikson at one point became worried enough about the possibility of suicide that he took away a gun Rockwell had in the studio. The artist never asked for it back. He began to ask friends such as Clem Kalischer to accompany him to social events, because he so disliked going alone. And now town camaraderie became extremely important to keeping Rockwell from giving in to his depression. Even events such as the Monday Evening Club, where one of the select supper-club members gave a talk after the group dined together at a restaurant, assumed new significance now that he was without Mary.

At least, as always, Rockwell had his work to make him happy. Mary Rockwell would have turned fifty-two on March 31, 1960. The *Post* cover published on April 16, *Stained Glass Window,* has seemed to many close to Rockwell a quiet tribute to his wife. A glorious stained glass is spread across the picture plane, with an artisan dressed in the clothes Rockwell wore to work in, bearing a strong body and face resemblance to the painter, who in fact had posed as his own model. He works on repairing the angels, which decorate the glass.

The *Post* planned to run excerpts of his autobiography in serial form, starting February 13. Doubleday would release the book in April. Rockwell needed to provide a strong cover painting, and he performed what was possibly the most revealing/concealing sleight-of-hand public offerings he would ever present. *Triple Self-Portrait* chronicled the beginning of an amazing burst of innovative work, nurtured by Mary's absence—potent motivation for the sixty-six-year-old artist to paint his happiness.

In contrast to the first self-portrait Rockwell had created in 1939, *Triple Self-Portrait* takes itself very seriously. Now, the issue is not meeting an imposed deadline, nor coming up with a good idea; instead, far more fundamentally, Rockwell asks the crucial question of self-portraiture: who am I? Once again with his back to us, his face averted, this time the painter has almost completed the canvas on his easel, a painting of an impossibly raffish-looking younger Norman Rockwell. Pinned to the upper right side of the canvas are reproductions of famous self-portraits, including Rembrandt's, van Gogh's, Dürer's, and Picasso's *Woman in a Red Armchair,* considered by art historians a self-representation as well. Iconographic mementos of the current painter, his self-branding, appear in the form of his pipe, the eagle emblem over the mirror to the left of the easel, a smoldering trash bucket at his feet (reminiscent of his studio fire in 1943), the fireman's helmet he kept at the top of his easel, and a Coca-Cola, which he sipped throughout the day when he was painting. In place of the support for a sketch that Rockwell would ordinarily be painting from, he looks to the left into a mirror, where he sees the real self, in

contrast to the idealized portrait on the canvas. But his glasses cause the light to be reflected into his eyes so that the lenses appear whited out, rendered completely opaque. What the man in the mirror is, his eyes missing and his back turned to us, we'll never know—except through his art.

The work that stems from this period has been labeled "ironic self-consciousness" by John Updike, who notes that the early sixties was the time when Pop artists made a different kind of full-fledged irony the basis of their art. Rockwell, instead, makes "seeing" his secret subject, similar to that of signature works such as Vermeer's self-portrait from behind—and Van Eyck, whose couple is reflected in a convex mirror. Velázquez, whom Rockwell frequently lauded as one of his favorite painters, used the conceit of a mirror to create his own self-portrait. Throughout his career, Rockwell had worked this theme, even as obviously as in his April Fools' Day covers, where he invited the audience to see that a story that looks on first glance to be transparent can prove extremely complicated, even tricky, on reflection.

Critical attention to Rockwell's *Triple Self-Portrait* would have to wait a few decades, but reaction to the autobiography was swift, and generally positive, though often compliments condescended as they praised. The photograph of Rockwell that appeared on the *Post*'s first installment showed a man shockingly aged in the last six months. The once comfortingly craggy, reassuring face now looked drawn, tentative, and reluctant. Even the bow tie is placed too low to hide the overly large Adam's apple that he had managed to conceal until now.

In contrast to the laudatory tone of most of the book reviews, the one written by a very young Benjamin DeMott for *The Nation* was scathing. Rockwell, "even less winning in print than in paint . . . [with his] timidity and Gee-Gosh-Shucksism," stands for DeMott as a "prophet of mindlessness," in terms of both his career of painting "absolutely mindless versions of the country" and his autobiography, which emphasizes the illustrator's "flaccidity of mind, moral limpness and silliness." That the nation would welcome Rockwell's nostalgia for a culture of leanness, as a substitute for facing squarely the current

"bloated age," raises a key national question about society's lack of intellectual acumen, according to the impassioned critic.

As if in response to such treatment, Rockwell's answers to an interview several months later conducted by *Design* magazine are more terse, slightly preemptive, and lacking in any gee-whiz obeisance to higher powers. He tells the interviewer that "you have to be extremely human to be an artist. You have to take all the ills that flesh is heir to, the sadness and the joys, if you're going to be a human-interest painter. I've had a lot of this." When asked what makes him paint a particular subject, he answers that "I'm interested in why people behave as they do." He expresses some of his highest praise for Picasso, returning later in the interview to Picasso's exceptional drawing ability, as he urges students to pay attention to draftsmanship in school. And he cites Rembrandt as most influential to his own development, with Brueghel, Vermeer, and Ingres as draftsmen he admires. Joe Leyendecker and Howard Pyle are listed as having the strongest impact on his student days. Finally, after defining illustration as "making pictures from somebody's writing," Rockwell explains, "I'm not an illustrator any more. I do genre. That's spelled g-e-n-r-e."

Rockwell took on more projects than he could possibly complete, this time to stave off loneliness. He did finish the illustrations for *Cinderfella*, a Jerry Lewis production, and the comedian's zaniness proved some reprieve to Rockwell's gloom. He painted a precise *Post* cover for the August 27, 1960, issue, a flirtation between a sailor and a young woman outside the University Club in Manhattan, and he placed himself in the left corner of the picture, pipe obvious, so that no one could miss him. Perhaps he was reminding himself, if only subliminally, of the possibility of reentering the dating scene. Or maybe he just wanted to reassure his public that he was alive and well.

The Famous Artists' School was an obvious place to direct his scattered energies, and if the staff in Westport realized that his suddenly revivified interest was a product of his solitude, they didn't let on. Instead, they wrote gracious letters praising their most famous instructor's autobiography, and commenting on the obviously real pleasure they received when he showed up at the school.

But Rockwell wanted someone at home when he got back. Stories abound in Stockbridge about the women aged forty to sixty who all took after the most eligible bachelor in town. And it wasn't long before Rockwell responded, dating in earnest Peggy Best, the divorced mother of two who had befriended both Mary and Norman almost ten years earlier. Letters between the two concerning a benefit exhibit Peggy was coordinating make light note of the oddness of writing to each other; Peggy's studio is within a half mile of Rockwell's home. But, by June, one note seems interestingly personal; all it says is "Dear Peggy, forgive us our debts as we forgive our debtors. Yours, Norman."

Peggy Best's son, Jonathan, remembers that his mother really wanted the relationship to work out. "She hoped to marry him, that was clear," he recalls. "I remember one painful Sunday, when Norman took us out to the fanciest restaurant in Lenox for a lobster dinner, and I found it excruciating. Everyone looked at us, because they recognized the famous painter; and my mother was doing one of those scenes like, 'this might be your new father, I want you to get along.' I liked Norman, but no teenager wants to go through that kind of ordeal."

Peggy Best was a particularly exuberant, extroverted, flamboyant urban artist, whether she was living in Stockbridge or Manhattan. Rockwell liked her, but he must have suspected they could not live together very successfully. Over the next few months, several interested friends, including Erik Erikson, suggested that Rockwell should meet another teacher they thought he might really like.

Mary Leete Punderson, known as "Molly," was sixty-three years old. From a family of strict New England ancestry, Molly had been born in Stockbridge. Her father, whom she adored, ran the redoubtable Red Lion Inn and also participated vociferously in town politics and served as a longtime senior vestryman at St. Paul's. His wife was a semi-invalid along the same lines as Rockwell's mother, and the Pundersons' only daughter thought little of her mother as a result. Extremely bright, the young woman had won a scholarship to Radcliffe; after graduating, she studied at Oxford for a year. She then taught English literature for thirty-eight years at Milton Academy, a high-toned

boarding school near Boston. Recently retired when Rockwell met her, Molly was in the process of figuring out how to spend the rest of her life.

"Miss Pundy's" students had adored her. "Some of the other teachers intimidated us," Shelley Getchell, her student in the late 1940s, remembers. "But never Miss Pundy. She was smarter than everyone, but she was kind and sweet. And she always had something interesting going on, including learning about Esperanto, a language that everyone in the world could learn to speak, and it would break down barriers." Shelley Getchell also recalls that Miss Pundy was the teacher to dress in feminine blouses and skirts, and that every year when Armistice Day was celebrated around the flagpole, two senior girls were selected by Miss Pundy to hold on to her arms, since she fainted at the yearly anniversary of the day her fiancé had died in World War I.

But such weakness was very likely somewhat a theatrical product of its age; Molly Punderson was a strong woman. And she used her strength to further the education of individuals or the cultural life of communities. Susan Merrill, Jarvis Rockwell's ex-wife, remembers hearing from her own usually "cold and hard" father that when they (fortuitously) commuted on the same train every Monday, he found himself talking nonstop about his own education, blossoming under the care of the earnest schoolteacher. Lyn Austin, who founded the Music-Theatre Group in 1970, largely through Molly's crusade on her behalf, could never forget the ferocity with which her teacher fought to revoke the suspension the principal at Milton once imposed on the "eccentric" student. And David Wood, who became one of Molly's best friends in her later life, still smiles at the thought of Molly's reaction to forces she thought to be influencing society for the worst: "After she had retired, every Monday morning Molly went to the bank in Stockbridge and got one hundred dollars in certain bills, to be handed out in a careful fashion during the week to pay various debts. One day, as she stood counting her money on the sidewalk, a member of the religious group that was proselytizing in Stockbridge then ap-

proached her and asked if they could pray together. 'Certainly not!' she replied, thoroughly affronted. 'You are not supposed to be stopping people to pray in the middle of the town!' "

Molly Punderson had never married, and discreet but often self-interested accounts about her private life still float around Stockbridge after all these years. A few months before her death in November 2000, Lyn Austin insisted that Molly had had significant female lovers, one extended relationship in particular. Other friends, Brad and Kay Hertzog, tell the story that Molly's close friend Sally Sedgwick shared with them about Sally's stumbling across Molly entertaining her male lover in the cottage Sally had lent her friend for the week. And Peter Rockwell was informed by his father that Molly had sustained a long-term, once-a-year sexual relationship with a married male lover. David Wood, by contrast, attests to Molly's doctor discussing having to rupture the elderly virgin's hymen before she got married.

With some ingenuity of the sort that Molly herself would appreciate, the various accounts can be reconciled. But, most important, in the fall of 1960, she was an attractive, unmarried teacher who came highly recommended to Norman Rockwell by several of his most trusted friends. The man who enjoyed pretending, in front of his writer-son Tom, that he preferred the verse of Edgar Guest to far greater writers, signed up for an adult poetry course that Molly Punderson was teaching during the evenings in the nearby Lenox Public Library.

He was, apparently, a "naughty boy" at these sessions, not hiding his amusement at their, for him, overly serious discussions of William Butler Yeats and T. S. Eliot. Once, when they were agonizing, as he saw it, over the meaning of a poem by Robert Frost, he pulled rank in order to show off for the teacher. "Why are we all sitting around, talking about what this poem means, when I can just call up Bob myself and ask him—I'll go do it right now, if you want."

Depending on what ending they preferred when telling the story, Molly and Norman might resolve it by allowing the artist to contact

Robert Frost, whom he did know slightly, and hear Frost agree with Molly that the poem was deliberately ambiguous. Other times, they'd admit that Molly insisted Norman do no such thing. Eventually, the story assumed such apocryphal force, probably at the delicious thought of the two similar types of American artists—on the face of it—sharing a moment of domestic intimacy, that various intimates are sure they know the truth, although their versions are at odds with each other. But everybody's account, including Norman and Molly's, is consistent in calling that evening their first date.

On October 18, 1960, upon the occasion of her remarriage, Rockwell wrote to Ida Hill, Thomas Jenkins Hill's daughter-in-law (married to the late Harold Hill who had been left fatherless at the turn of the century when young Thomas died of consumption): "I know it isn't correct to congratulate the bride, but it was wonderful to know you are married to Mr. Cahn. This being a widow or widower isn't any fun, and I wish you people a long and happy married life."

He was too busy, however, to ponder for long the burden of being alone: he had barely finished the portraits of the two latest presidential candidates, Kennedy and Nixon, and he still had to complete a *Post* cover and finish another tedious Four Seasons calendar by the end of January. His family and friends remember him trying to outrun grief with ever more work—but all he seemed to them was gray.

29

Another Schoolteacher

A few months after Mary's death, the nation's favorite father figure had become a grandfather. Cinny and Peter's son, Geoffrey, born in Philadelphia, would grow up in Rome, where the couple moved when Peter decided to pursue a career in stone carving. In 1961, Norman painted a tiny picture of Mary Rockwell holding the grandson she would never see into the top right-hand corner of his *Golden Rule* cover for the *Post*. While he was working on the picture, Peggy Best ended up in the hospital, mostly in need of a thorough rest. She was highly strung and emotionally somewhat fragile, the kind of woman Rockwell could not have thought good for his own mental health. At first, he wrote her a concerned note: "You work too hard [no irony apparently intended]. It's wonderful to have ambition and nervous energy but you've gotta rest once in a while."

She responded with too much zeal to his solicitous tone; alarmed, he quickly set her straight:

I got your letter. You and I have a good and valued friendship, that I greatly cherish. I wish I could be of more help but I am the kind of

person who is of no use with other people's problems. They upset me too much.

As you once said, I was a "Rock of Gibraltor" [*sic*] to Mary. I really wasn't much of a rock as I had to have a lot of help from dear old Riggs.

I do think hope and prayer [sic] that our friendship, that I value so much, will continue forever but don't think of me as a rock. I'm really jello.

A few days later, Peggy wrote him again, this time more strategically. Happy to be off the hook, he answered: "Got your bright letter. We all have problems but when I'm tired, sick or depressed they become fantastic mountains they ain't. Get a good rest and come back to your friends." He signed off with a flirtatious and relieved, "Your eternal, everlasting, unquenchable friend, Norman."

Throughout this period, Molly Punderson was busy writing her friends at Milton Academy, telling them all about dating Norman Rockwell. She informed them that the artist had enrolled for a second session of her modern poetry class. From Peggy Best's subsequent choices, it appears that one of the contenders for the town's most eligible bachelor became aware of her rival within a month or so of returning from the hospital. She decided to go live in France for several months, perhaps partly to remind Rockwell what the town was like without her around. Townspeople still recall how shamelessly women were pursuing the newly single illustrator, and Peggy was savvy enough to put some distance between Rockwell and herself for a while.

If her intentions were to rekindle his interest, the ploy worked. In late August, Rockwell wrote her that

You're greatly missed here in good ole Stockbridge. It just ain't the same. It's been a wild, busy summer. In fact I think I'll spend next summer somewhere else. Maybe La Rochelle [Peggy's village]. . . .

[T]he opening parties at the gallery just aren't the same as when

you preside. . . . I see the old gang but you're the spark plug. (I
mean this as complimentary.) So come home and cheer us all up.
We sure miss you. Love, Norman.

Within a month of the (for him) markedly romantic letter, Peggy was
back in Stockbridge, and Rockwell wrote to her again, though he
could have walked to her studio or called her more easily. This time,
his handwriting was a little shaky.

"Since we are such good friends, I just don't want the news to
reach you second hand. Molly Punderson and I are engaged to be
married. I guess everyone in town will probably know this before long.
I know you'll be pleased for Molly and me." His closing has modified:
"Affectionately," not "Love," is the new nomenclature.

Jonathan and Mary Alcantara Best both believe that their mother
was devastated—that she had really hoped she and Norman would
get married. She had been deeply impressed by Norman's unusually
thoughtful nature, including his ability to enjoy himself at parties
more than anyone, though drinking very little, even in a social crowd
where getting drunk was considered a routine part of the evening's
festivities. In a community of intellectuals and artists, he stood out
above the rest.

People who watched with some amusement the brief bachelor-
hood of Norman Rockwell in Stockbridge recall Molly's shrewd strat-
egy of outlasting her competition. She let Rockwell woo her, all the
while winning him. It probably didn't hurt that Erik Erikson chimed
in with his opinion that Molly would be a more appropriate match for
Rockwell than the fun-loving but vulnerable Peggy, who had already
admitted that she needed at times to be able to lean on the illustrator
for strength.

On October 25, 1961, sixty-two-year-old Mary Leete Punderson
and sixty-seven-year-old Norman Percevel Rockwell were married in
St. Paul's, where Molly had a strong record of weekly attendance, in
contrast with her new husband's habit of confining his attendance
there to weddings and funerals. Before the ceremony, Norman had

sent Molly to pick out a ring and a trousseau; he wanted to pay for them both. She and her good friend Sally Sedgwick went to an expensive department store in Boston, and the schoolteacher shocked even the wealthy socialite with the eighteen sets of bras and panties and the dozen nightgowns she bought. "I didn't see how she'd ever use them all!" Sally told a mutual friend. When Molly saw the ring she wanted, a large sapphire, she called Norman to ask his opinion, since it was twice the price they'd discussed. He told her to get whatever she wanted, and so she bought it.

Wedding pictures show a lovely, compact, trim older woman about five feet three inches tall, with clear, direct, infamously piercing blue eyes. She wore a navy blue suit and hat for the ceremony, and only when she heard Cinny and Peter's toddler call out, "There's Molly!," as she walked up the aisle, did she relax her stiff carriage into her normally erect, confident posture. The newlyweds went to Rockwell's beloved Plaza in Manhattan for the first three days of their honeymoon, then to California, where, strangely, they re-created favorite visits he had made before with Mary, including staying at the Hollywood Roosevelt and visiting Stovepipe Wells in Death Valley, one of Mary's favorite vacation spots. When they returned to Stockbridge, Molly did not try to reinvent the house as her own—except for hanging a Punderson ancestral portrait—any more than Mary Rockwell had redecorated what had been Irene and Norman's. But she did devise a clever plan by which she would not feel she was giving up her own life; for the next two years, she and Norman spent their days at the house on South Street, and their nights at Topside, the cottage her father had built her behind the Pundersons' family house on Main Street, a few blocks from the Rockwells' home.

The marriage would be extremely successful, as if the third time proved the lucky charm for the painter. Both Peter Rockwell and Molly's good friend David Wood were told by Norman and Molly respectively that the couple's sex life was especially gratifying. Certainly this marriage was one of equals more than the previous matches had been, whether from age or temperament or independence. Molly was

not needy, as Mary had been; nor was she materialistic, her premarital buying spree to the contrary, or flighty, as Irene had proven. And she knew how to help her husband; just as important, with no children to raise and her own career conducted, she had the time to do so.

Some of the townspeople thought that Norman was really the lucky one to snag Molly as his bride; only a month before her death, Lyn Austin recalled darkly that "those of us who knew Molly well thought she was stepping down to marry Norman—he was beneath her. Her life of the mind was so intense and lively. He was no intellectual like she was; she lived for her poetry." Insistent that a teacher from Milton Academy, "reminiscent of Gertrude Stein," had been Molly's longtime lover, Austin believed that the always curious teacher simply viewed marriage to a famous illustrator as another great adventure. "Her old school friends, including me, used to go over in the afternoons and have tea with her, so she could talk literature. Otherwise, she would have been bored just being with him." It is extremely rare to find Norman Rockwell the man described by anyone who knew him as boring. More plausibly, Rockwell's seemingly homespun aesthetics and apparent Boy Scout allegiances offended the less conventional theatre director; her disdain for Molly's choice sounds at times as if she had a crush on her teacher and was angry at being betrayed by her liberal hero's choice of a symbol of the Middle America Austin had rejected.

Without a doubt, it is true that Molly Punderson enriched Norman Rockwell's later life. Their frequent trips to Tanglewood were taken at her behest; he, too, enjoyed classical music, but he freely admitted to being as interested in watching the musicians as in listening to them. And the staunch, openly political schoolteacher with a quixotic sense of humor that almost matched Rockwell's own pushed her willing husband to go public with his beliefs, to stop hiding behind a banal banner of neutrality. Finally, the release that Rockwell had experienced through travel was matched by his spouse's own passion for exploring new places. Rather than slowing down as he approached his seventieth birthday, Norman Rockwell, who never had a

high school education, found himself energized by his marriage to his third schoolteacher, one whose joie de vivre matched his own.

Within weeks of their marriage, Molly had ordered Rockwell's schedule into a far more manageable scheme; after her initial shock at how little he had saved, she arranged the family finances so that their investments climbed quickly; she found ways for them to take several major trips a year, usually three that were to foreign countries; and she learned to work as his photographer, hoping to reduce his dependence on his "man Friday," the loyal Louis Lamone, who in fact would become even more important to Rockwell's work after photographer Bill Scovill left in 1963. Molly took scores of photographs on their trips, eventually numbering five thousand prints, but Rockwell only occasionally painted from them. They converted the old icehouse/mural room into a permanent studio for her photography and her writing, so that she could continue working on the grammar textbook she had begun just before meeting Norman.

Molly remained a little jealous of Louis, in spite of his "demotion," in much the same way that Mary had been of Gene Pelham; not only was Norman deeply dependent on him, but the photographer-assistant was territorial, protective of his boss in just the way Gene had been back in Arlington. Louis loved him deeply because he was so kind. "If something went wrong," Louis said, "he always blamed himself, not the other guy. Once I made a terrible mistake about something and all Norman said was, 'I guess you're human after all,' not angry with me for having fouled up his business."

"Norman was incapable of complaining about anything. I never saw him angry," Buddy Edgerton said. He was thoughtful, too; he always brought back gifts for his friends and neighbors from his trips. And if Louis arrived early in the studio, before Rockwell's breakfast, often the painter would think to take him coffee before he'd even had his.

Molly's reasons for hoping to reduce her husband's dependence on Louis Lamone were various. An unattractive underside to her motivation, according to two women who adored Molly and thought highly

of her character, was the class issue: "There was a tiny bit of Molly that disliked Louie's lack of learning—not the lack of a degree, but no appreciation, it seemed to her, of ideas and books. His roughness offended her, and probably she preferred that Norman not be influenced by him," says Virginia Loveless, to which Mary Quinn assents. But, until his death, the artist wrote checks to Louis for performing various tasks, and he paid some of his medical bills as well. Most important, Louis took the majority of Rockwell's photographs for the last fifteen years of the illustrator's life.

Rockwell's affection for Louis Lamone aside, it was nevertheless Molly who helped him to finish his commissions in a more timely fashion than before, mostly through being in charge of a schedule she ruled firmly. Louis's careless disregard of the day's schedule exasperated her; and soon older friends and extended family members from afar began at times to grumble at being held at arm's length, rather than being granted the same access to the painter that they'd always had. Molly even asked Jarvis to call before dropping in, so that the couple's days could assume more order. And she insisted that the time for her husband's nap and his afternoon bike ride, which she now shared with him, were sacrosanct.

Just as in his previous marriages, Rockwell's wife took the blame for managing his affairs as he, in fact, wanted; if someone managed to break through Molly's corridor of influence and get to Rockwell, he acted as if he was delighted to be interrupted, though privately he flailed, as he always had, at too many pressures keeping him from work. "Everyone else was supposed to keep people and stresses away from my father," Peter remembers. "We all did the dirty work to protect him, and my father never had to take the blame for being inaccessible." His granddaughter Daisy recalls that the protection took the form, in the early seventies when she was old enough to notice, of a lack of responsibility for holding up his end of the socializing at a family dinner: "Everyone else would be louder than normal, almost desperate, in an attempt to make up for the 'negative space' my grandfather took up," she says. "He didn't feel the need to join in, and he'd

just get lost in thought about his work if he wanted to, which was often."

To be fair, there was a lot to think about. Rockwell's professional as well as private life changed dramatically in 1961, when Ken Stuart resigned as art director from the *Post*. For the first year in its history, Curtis Publishing operated at a loss, and soon Ben Hibbs left the magazine as well. A totally revamped publication was announced, and Rockwell provided its inaugural cover showing the new art director at work redesigning the magazine. Eight covers followed at his hands, and they illustrate the dubious course the magazine had decided on. To achieve greater immediacy, the *Post* asked Rockwell to do portraits of international celebrities. His narrative abilities, his forte, fell into disuse.

But in 1961, the illustrator had reason to be flying high: Lane Faison, then the chairman of Williams College's art department and respected in the art world, noted in *The Norman Rockwell Album* (basically Doubleday's picture book accompaniment to the autobiography) that Rockwell was part of the tradition of humorous genre painters dating at least from seventeeth-century Holland, perhaps earlier, if some of the art appearing in the marginalia of illuminated manuscripts was included. Before 1961, others had frequently noted Rockwell's shared lineage with Vermeer, but the ancestry began to solidify by this point. Almost forty years later, the critic Dave Hickey would use Vermeer and Dutch genre painting as a starting point from which to launch a reconsideration of Rockwell as a master of "democratic genre painting."

Rockwell's first painting of the new year surprised everyone, except the family members who had helped him create it. *The Connoisseur*, published as a *Post* cover on January 13, 1962, became the subject of compelling analysis in the late twentieth century, none of it certain of the painting's meaning. The picture consists of a large drip painting—associated with Jackson Pollock's style from the late forties and early fifties—which is studied thoughtfully by a middle-aged, prosperous-looking gentleman. The connoisseur's expression is entirely hidden

from us, as he faces the abstract painting, his back turned to us. The man and the painting form a kind of sandwich, with the space in between them—the judgment wrought by their meeting—left hanging in the air. The Pollock imitation is considered by most critics to be competently executed; certainly the intent is to represent the art respectfully, not to mock it. The expensively dressed spectator is accorded dignity as well. His stance is modest, his hands neatly clasped behind his back, in contrast to his rather dandified accoutrements of gloves and swell hat and suit. Clearly this scene between two culturally distinct quarters implies a confrontation—respectful and alert, quiet and contained. But instead of the all-too-obvious interpretive clue Rockwell usually provided, here the artist is mute.

Missed by recent commentators on the provocative painting, however, is Rockwell's visual reference to an earlier *Post* cover from June 27, 1914, by Robert Robinson. Part of a narrative that Robinson had started in 1910, this painting uses variations on an "old codger," as the cultural historian Jan Cohn states, to show the interaction of the modern and the old. The June 27 issue displayed the "geezer" facing off with a Cubist painting (then a new genre), the subject of which seems to be eyeballing him with even greater censure. Dressed in a hat, gray coat, and white gloves, the dated viewer holds a book on modern art in his left hand, using it as a study aid to the painting. In Rockwell's version, the encounter is more of a tie; no one knows who won the standoff. Hat, gray coat, white gloves, older man, and reference book reappear—but this time, the man appears clearly educated, though presumably, given his attire, he may be no more receptive to the abstraction than the "geezer" was to Cubism.

The major difference between the two renditions lies in the ambiguity of Rockwell's painting versus Robinson's clearer narrative line. The baleful eye of the Cubist woman stares out reproachfully at the rube who can't understand her, while the drip painting that Rockwell substitutes uses only the initials "JP" for any traditional narrative reference. And even here, at the moment most insistently Jackson Pollock's, Rockwell's presence intrudes; the usually affable man was

known among illustrators and art editors for denouncing those art directors who omitted an artist's signature.

But why the unusual (for Rockwell) narrative distance? As the cultural historian Wanda Korn explains, a strong influx of cartoons that mock viewers' attempts to interpret abstract art, as well as the vagueness of the art itself, had by now become a staple of mainstream culture. Only a year earlier, for instance, a Peter Arno cartoon in *The New Yorker* had exemplified such a theme: two city gentlemen of the same type as Rockwell's beholder study a Pollock painting and render a heavy-handed, silly, connoisseurial judgment. One says to the other, "His spatter is masterful, but his dribbles lack conviction." And even in the late eighteenth century, cartoons that poked fun at those who bought art for reasons of prestige rather than from admiration proliferated.

Against this tradition, however, Korn sets out the equally potent one that honors the man (often an artist himself) who stares contemplatively at a piece of art. Daumier, for instance (significantly, best known as an illustrator himself), painted a man whose profile allows the spectator to see him admiring a reproduction of the Venus de Milo. He called the painting *Le Connoisseur.*

The *Saturday Evening Post* readers were confused by Rockwell's cover: what was their man trying to tell them? One of the three printed letters to the editor expressed indignation at this foray into enemy territory, one amusement that implied Rockwell was mocking the abstract painters, and one a sense of surprise that the illustrator had it in him to produce a reasonable imitation of real art.

It is impossible to appreciate the significance of Rockwell's story on this January cover, however, without taking seriously the rueful statements he made to others about his place in the art world. "Often Pop would tell me that someone had come up to him and said, ' "I don't know anything about art, but I sure like your stuff." I wish it were the opposite—that they'd tell me, "I know lots about art and I really love your work," ' " recalls Peter Rockwell. The illustrator had swallowed his unhappiness at being taken out of the category of

"artist" long ago, but he was still capable of kicking up his heels in protest.

And he was too intelligent a painter and too capacious and inclusive a thinker to scorn things abstract or modern. He liked and admired modern art, but *Post* patriarch George Horace Lorimer's disapproval had largely caused the painter to "realize" in 1932 that he was meant to continue along the path he had already taken. Not only is Rockwell the narrator recommending tolerance for aesthetic cross-currents in *The Connoisseur,* he is championing the right of abstract painting to take its canonical place in the museums. Gently, Rockwell positions the ersatz Pollock as a wake-up call to those who have admired the illustrator's work largely because they felt comforted by its anti-art implications. In this generous process, he is also implying his own contribution to the history of art, balancing the gently agonized, red dripping letters—JP—on the upper right portion of the canvas, against the traditional block signature, Norman Rockwell, positioned directly below.

The picture is not without flickers of condescension: the dramatic red initials of Pollock's name mock the Action Painter's self-importance. But the painter-narrator patronizes the other side as well, anointing the precise-looking gentleman with a swirl of abstract paint atop his bald pate, and arranging the sparse hair itself around his head to echo the shapes of the painting's drips.

By entering the drip picture alone in a local art contest at the Berkshire Museum, where he won second place, and by sending it to a Cooperstown art show under an assumed name, Rockwell further seemed to mock abstract painting. And he did succumb to various offhand comments implying a subtext of contempt for the vagaries of drip painting versus the craft of traditional easel work. When Jackson Pollock had been crowned the probable "best painter in the world" by *Life* during 1949, the magazine had published a picture of Pollock in his infamous "crouch" position; now, as he worked on *The Connoisseur,* Rockwell had Louis Lamone photograph him in the same pose.

Of course, by 1962, the fuss in the art world wasn't about Abstract

Expressionism anymore anyway; those battles had been won, and Pop Art's ascendancy reflected a renewed emphasis on representation and the figure. Rockwell was too close to the traditions of academic narrative painting to benefit from the turnaround, however, and his painting implies his awareness of this irony as well. In the January 1962 issue of *Esquire,* he explained, "I call myself an illustrator but I am not an illustrator. Instead I paint storytelling pictures which are quite popular but unfashionable."

Molly discouraged Norman's spending what she considered a disproportionate amount of energy on such issues anyway. She believed in the lessons inherent in her strong New England background, which emphasized activity and movement, not contemplation. To escape the end of the Massachusetts winter and greet spring sooner than Stockbridge would allow, the couple went to Hollywood, where Rockwell did research for two books scheduled for publication at the end of the year, *Poor Richard's Almanac* and *Folk Heroes of the Old West.* He relayed his progress to the *Famous Artists Magazine* for their spring report, which also printed recent news from Ben Shahn and Will Barnet, two somewhat hip instructors who had helped update the institute's reputation. And to Helen Macy, who had assumed control of the Heritage Press, he wrote that Molly and he had spent innumerable hours in Philadelphia ensuring the authenticity of his illustrations for the *Almanac.*

Late in 1963 and into the following year, the Rockwells undertook some serious travel, flying to Russia on behalf of the State Department's international art initiatives and to Egypt in order for Rockwell to paint President Gamal Nasser's portrait. In the U.S.S.R., Rockwell traveled as a "specialist" under the aegis of the United States Information Agency. He attended the nation's equivalent of the World's Fair, the Exhibit of Economic Achievements of the Soviet Republics, where he shared a raised platform with three other American artists, all of whom were supposed to work in front of the crowds of visitors, showing them their particular techniques. Rockwell, who was temporarily suspended from the show when an unusual-looking intellec-

tual whom he painted realistically complained that the portrait was a caricature aimed at mocking him, pulled the most interesting-looking people out of line and did rapid oil sketches, exhibiting his ability to paint loosely when he wanted. The sketches, each of which had to be completed within an hour, are evocative and intelligent, but the lack of finish, perhaps because of what we've come to expect from Rockwell, diminishes their power. More successful are the photodocumentary-type paintings he did of a Russian classroom.

The portrait of Egypt's Nasser would be the artist's last cover for the *Post*. Rockwell did not enjoy portrait painting, according to at least one interview he gave, and his knowledge that the *Post* would allow him little else nowadays stemmed any nostalgia he might have felt when he realized the magazine was dying. Both *Look* and *McCall's* began negotiations to secure his services, and though he was flattered at the almost desperate entreaties of the latter, he realized that *Look*, known for its aesthetic quality, would afford him the greatest chance to branch out into the humanitarian pictures he wanted to paint.

Look magazine was in the midst of its short-lived "golden years" when Rockwell agreed to work for it. Dan Mich had returned as editor after a long hiatus, and *Collier's* and the *Post*, the magazine's longtime rivals, were breathing their last, leaving the field open. It expanded its foreign coverage, it published a series on religion by Leo Rosten, and it chronicled the rise of racial tension in the South. This last emphasis most engaged Rockwell's interest, and he would produce what are arguably some of his most effective, moving paintings for the inside, not the covers, of *Look* magazine, before it began its decline in 1966. And the relationship with art director Allen Hurlburt that began in the fall of 1963 would prove enriching, not constricting, and allow him, at the age of sixty-nine, yet another significant chapter in his long career.

Rockwell's turn to an entirely different theme, centered on the most radical kind of disharmony experienced in the United States, creates a dramatic counterstatement to his decades of illuminating cultural harmony. In this conversion, he leaves the more domestic,

feminine world of the beautiful—the small and ornamental and local—for what Michael Fried calls, in speaking of the American re- alist Thomas Eakins, the "figural sublime." Literary writers on the sublime, including Thomas Weisel and Harold Bloom, have most often cast this aesthetic as a powerful struggle against one's artistic forebears in an effort to clear space. For Rockwell, the new sublime is a pronouncement that he is willing to pit himself against painterly representations of big ideas. He had been eager to go in such a direc- tion since at least 1943, when he called the Four Freedoms "the big idea pictures," but at that time he was yoked to positive representa- tions only.

This same year, incongruously enough, he painted the portrait of Barry Goldwater, "a remarkable cranium to draw, tho I'm not sure what's inside it," he quipped; then he traveled three weeks later to the White House, to paint the curmudgeonly Lyndon Johnson. "He was very brusque when I went into his office," Rockwell recalled, "and when I asked for an hour to make sketches he almost hit the ceiling. He told me the best he could afford was twenty minutes and told me to get cracking. I decided to do the best I could, but he was just sit- ting there glowering at me. I finally said, 'Mr. President, I have just done Barry Goldwater's portrait and he gave me a wonderful grin. I wish you'd do the same'—and for the rest of the session he sat there with a fixed smile like he was competing for the Miss America title."

As he did with all the portraits, most infamously with the number he did, reluctantly, of Richard Nixon, Rockwell emphasized the best physical features of Johnson and modified the unattractive ones. Johnson, predictably, was thrilled with a portrait that he could right- fully believe looked like him, even though the wattles under his chin and the prominence of his ears were invisible. When the artist Peter Hurd was commissioned three years later to create the official portrait of Johnson, a brouhaha erupted when Johnson insisted Hurd's more somber and less cosmetic painting was "the ugliest thing I ever saw," and whipped out the Rockwell to press on Hurd as an example of good painting. Hurd was pursued by reporters until he revealed his

hurt feelings as well as his pique that Rockwell, who spent only twenty minutes with the president and then painted from the sketch he made and photographs he had taken, was vaunted over Hurd, who had painted from life.

The contretemps was in all the major newspapers, and Peter Hurd, a gentle and generous man by nature, wrote a letter to Rockwell apologizing for the comment he had made in haste and anger, and emphasizing his respect for Rockwell's work. Rockwell would respond with a similarly gracious note, but the public implications of his inferior status that continued to be part of the culture must have stung. Perhaps his ego was gratified, though the occasion was too grim for true pleasure, when the *Post* reused his earlier portrait of John Kennedy on its commemorative issue after the president's assassination.

Two weeks into 1964, and two weeks before his seventieth birthday, Rockwell gave dramatic notice of his new willingness to stake his political and philosophical territory more openly than he had in the past. *The Problem We All Live With* appeared in the January 14 issue of *Look* magazine. Inspired by reading about Ruby Bridges's first day at William Frantz Public School in New Orleans and the violence accompanying school desegregation attempts all over the South, Rockwell had painted a stunning narrative of four seemingly huge United States marshals, their bodies cut off at the shoulders by the top of the canvas, escorting a young, very dark black girl to school. Their massive impersonality, benign but anonymous, contrasts with her smallness. The child walks with a combined stiffness and unnatural strut that belies her fright, and the preternatural whiteness of her dress against the deep glow of her skin not only announces the theme of the painting—it takes on a spiritual symbolism, as if challenging Americans to act any way other than morally righteous. On the wall behind the little parade is the ugly scrawling, "nigger," with red splashes of color that read at first glance as blood rather than the tomatoes splattered against the wall that they are. The letters "KKK" are carved on the wall in the left part of the picture, and, as if to counterbalance the ugliness of those initials, Rockwell has painted

NR + MP in a tiny heart at the bottom, a love note to the wife who has emboldened him. As Susan Meyer has pointed out, the gaping space between the girl and the men behind her represents about two fifths of the entire canvas, "deadly" were it not for Rockwell's skillful treatment of the tomato-stained concrete wall.

Although *Look* magazine received a small amount of hate mail over the painting, the response was largely positive. Black and white readers wrote to say that the painting said more than they could explain to their children or to themselves with words. And some of them wanted to go on record that this would prove a painting for the ages.

During this same year, Rockwell got up the nerve to tell an old friend at Brown and Bigelow, Clare Fry, that he needed to stop doing the Four Seasons calendar. Feebly, he blamed the decision on his doctor for telling him he needed to take it easy. Molly had ensured that his financial affairs were healthy, and he wanted time and space to continue painting scenes of the contemporary world around him. Now he began to earn good money not for escaping to the past, but for documenting the present.

In late winter of 1964, Rockwell traveled to Cape Kennedy to paint a series commissioned by *Look* on Project Gemini, the series of two-man orbital flights that would include actual space walks for the first time. Rockwell found the creativity that went into producing space suits staggering, and he painted the astronauts suiting up at Cape Kennedy as a kind of modern-day romance, the equivalent of "Sir Galahad girding for battle," as he worded his inspiration for *Look* readers.

The most exotic record he painted of contemporary life was not, however, of the United States, but of daily existence deep within the Blue Nile region, a native area previously explored by only a few white men. Chris and Mary Schafer's son John had joined the Peace Corps, and the Rockwells took him up on his invitation to visit. Rockwell turned the trip into visual material for *Look,* using John himself for what would become the June 14, 1966, cover story on the Peace Corps. John Shafer recalls his amazement at the Rockwells' derring-

do: "They flew in on a tiny twin-engine plane, landing on the grass plot near us. I was just shocked; these seventy-year-olds acting like young adventurers."

All was not fun and games, however. Notes that Rockwell scribbled during sleepless early-morning hours in 1965 attest to his continual struggle over what impulse to trust, and which loyalties to honor:

If only I can hold onto it. To hell with the magazines, my responsibilities. You [Molly] will help, be with me . . . If only I have the steadfastness and get out of the rust [he probably meant to write *ruts*] of fear not a masterpiece and publicity and popularity (cheap) Maybe even no photos Isn't a Peace corps picture the answer. Youthful dedication. Something bigger than yourself. Maybe not art but my only answer, not some magazine or art editor or publicity but of my own free will Have I the steadfastness???? *with you* It isn't just a glorious hollow gesture. Is it? It's late I must do it soon Isn't the Peace Corps the answer. Maybe don't go to them do it on our own. *You and me.* But I mustn't be silly. obligations to commitments family Can I keep it up? . . . doubts, weakness, fear . . . Not the Peace Corps one that allen [Hurlburt, the art editor of *Look*] like but the one I like and believe in. . . . Am I dogging life? *No* . . . anyone I respect would respect *this.*

Ironically, in a twist that Rockwell would have appreciated had its implications not been so evil, his name became publicly confused at this time with a hatemonger of the first order, American Nazi party leader George Lincoln Rockwell. In the old days, when he and left-wing Rockwell Kent had been mistaken for each other, he was largely amused; Kent was talented and intelligent. Now he was upset; this Nazi Rockwell staged appearances around the country, particularly in New York City, as a storm trooper sent to help white Americans wipe out Jews and blacks, both of which he referred to by vile epithets. Eventually, the illustrator began writing to newspapers that printed

the misidentification, threatening legal action if they didn't rectify their mistake. Although all of them, from *The Huntsville Times* to *The New York Times*—which, on February 24, 1965, would have to clarify that Malcolm X's earlier reported remark about his opposition to the Ku Klux Klan and the Rockwells did not, after all, refer to Norman Rockwell, but to "the American Nazi leader," George Lincoln Rockwell—printed retractions, Rockwell never felt such a response to be good enough, though he didn't know what else to do about it.

By the beginning of 1965, he was struggling more than usual with his work, mostly advertising, and sounding in his calendar notes as if the subjects were too banal to motivate him. January 11 was "a very very rough day" in the studio, dictating that he take a Miltown after lunch in order to calm down for his afternoon painting. On January 19, his spirits received a lift when Twentieth Century–Fox called him to ask if he would do the posters they needed for the movie they planned to film that summer, *Stagecoach*. His calendar records the ambivalent, "Thrilled but ———." By the end of the month, although he is still "very low," he becomes "all excited" during the family cocktail hour on January 29, when he and Molly discuss "national problems." His calendar records a string of words: "pictures, Peace corps, Vista, Race Conflict, etc. to hell with mag. work." On the other side of the page, he pens, "Heard from Stagecoach."

But if Hollywood is fun, contemporary issues are meaningful, at least that's what Rockwell's notes over the next two months seem to imply. On February 4, he writes "Big Day!!! Wonderful mail! Heard from A. Hurlburt at last—astronauts to be published April 20 or May 4. Peace Corps for fall. Hurrah! All so [sic] Vista ok. They are happy with my sketch." And on February 26, he is pleased with the final oil for the Vista publication, noting in his calendar that "JERRY HELPED a lot." From March 5, when he mailed the oil sketch of *Southern Justice* (called *Murder in Mississippi* by Rockwell), until March 16, when Allen Hurlburt called with his "ok on 'massacre,'" there are no calendar entries. Clearly Rockwell had been anxiously awaiting Hurlburt's reaction, and the entry on the 16th begins, "Big Big Day!"

Although Hurlburt admired the preliminary oil sketch so much that he suggested publishing it, Rockwell insisted that the art director let him produce a finished painting as well. By the end of April, after Hurlburt spent a few weeks deciding between the two renditions, he phoned Rockwell with the news that everyone at *Look* preferred the sketch, "quite a change," the illustrator notes in his calendar. For the first time in his career, both he and an art director agreed that the earlier oil sketch, with its loose brushwork, delivered more impact than the finished oil, and so for the only time in Rockwell's career, the preliminary study was published while its completed counterpart was not.

Southern Justice, a dramatic tableau of the Mississippi civil rights workers who were shot during the voting registration drive, appeared in *Look* on June 29, 1965. As he had with *The Problem We All Live With,* Rockwell used the dramatic contrast of light and dark to further the theme of racial strife and potential harmony. The white shirt of the white man holding a dying black man contrasts not only with the slain worker's skin but with the bright blood splashed on the ground and covering the third participant. Painted in colors reminiscent of the old two-tone process—white, red, and brown—the painting powerfully conveys the beauty of the ideals behind the ugly cost of their achievement. Rockwell "tried making [the] Civil Rights men heroic, influenced by Michel Angelo," as he had written in his calendar several months earlier.

Reaction among Rockwell's admirers has been mixed on the painting from its publication. Some believe the painting to be strained because, after all, this wasn't Rockwell's kind of thing; others find it masterful, a case of Rockwell finally applying his much-vaunted technique to a historically weighty subject. Even the working photos emphasize the new graphic realism: for most settings, Rockwell preferred to use the natural light from his studio's large north window. But in both *Southern Justice* and the later *New Kids in the Neighborhood,* another racially themed painting, he now added floodlights to accentuate the contrast of light and dark, the artificial light heightening the sense of drama.

During this year of tackling solemn topics, some levity emerged when the art director of the edgy, intellectual *Ramparts* seriously wrote the seventy-one-year-old illustrator that the magazine would like him to take LSD (not yet outlawed) in order to report his findings while under its influence and help dispute all the incorrectly negative press the hallucinogen had been receiving. Always interested in new experiences, Rockwell might have been at least somewhat tempted, had the art director not made the mistake that Dorothy Canfield Fisher had years earlier: explaining that Rockwell should do no advance planning in terms of "subject matter, composition and the like" before taking the drug, so that the creative effects it has on someone whose work "is a kind of institution in your area" would be discernible, the writer trivializes the very artist he is petitioning. Rockwell answered with a courteous, amused, but taciturn note: "As you expressed the hope that I would be intrigued, I was intrigued, but this is not for me." Then, in a new paragraph, he concludes with one sentence: "My schedule makes it absolutely impossible."

The proposal from *Ramparts* may have been inspired by *Esquire* magazine's early August publication of the "100 Best People in the World." Although the editors poked fun at their own pretensions in constructing such a list, the choices are revealing about mid-1960s culture. Writers picked include Nabokov, Tolkien, Salinger, and Gregory Corso; film directors John Huston and Stanley Kubrick; politicians Hubert Humphrey and Norman Thomas; and category anomalies such as Martin Luther King, Jr., and Alfred Knopf. Five artists were chosen: Saul Steinberg, Alexander Calder, David Levine, Josef Albers, and Norman Rockwell. In response to the question, "What do you mean by best?," the editors answered: "We mean best by virtue of what they have done or are or both."

But this was the same era when *Mad* magazine parodied Rockwell by showing his work as a paint-by-number kit, so chances are that he made no more of this honor than he did these days of the ignominy of other media coverage. Most of all, he stayed too busy to care about such things. His break from heavy social issues came from Holly-

wood, where director Marty Rackin had finally convinced Rockwell to take on the elaborate publicity campaign for *Stagecoach*. He and Molly flew to Denver, where the movie was being shot, to paint a roster of movie stars ranging from Ann-Margret and Stephanie Powers and Bing Crosby, all of whom of whom he liked, to Bob Cummings, whom he deplored for his on-set prima donna behavior. The painter's obvious enthusiasm for the field of cinema convinced Rackin to give him a tiny part as a cardplayer in the actual movie. Rockwell's financial records show that almost ten years later, when he no longer had anything to do with the movies, he continued to pay annual fees to sustain his membership in the Screen Actors' Guild. His cameo seemed to yield almost as much pleasure as did the $35,000 he received for the portraits, a poster of the stagecoach being chased by Indians, and other promotional material. Exhausted at the pace the commission demanded, he and Molly took a late autumn trip to Mexico, traveling to Mexico City, Tepotzlan, Taxco, and Cuernavaca, where they visited with Peggy Best, now their mutual good friend, in her new home.

By the time they returned to Stockbridge, Rockwell felt rejuvenated, ready to put the thinking he'd done on this last trip to good use. He had come up with what he thought a fascinating reprise of *The Connoisseur.* At the end of 1965, Rockwell was once more interested in going abstract, as he again explored the breach between modern and traditional fine art, this time replacing Jackson Pollock with Picasso.

30

A Rockwell Revival

Look published Rockwell's latest take on cultural warfare on January 11, 1966. The painting once again emphasized Rockwell's alliance with the new kids of his age, on the one hand, while proudly acknowledging his permanent place among the middlebrow, on the other. On the left side of the painting of a museum exhibition room, a housewife-next-door, appropriately if conservatively dressed except for the incongruous presence of curlers in her hair, stares, almost gawks at, a society portrait by John Singer Sargent. A small child clasps her hand, matching curlers in the little girl's hair. To their right, facing a Picasso, stands a fashionable young woman dressed in jeans, her body language suggesting thoughtful study of the Cubist piece before her.

In the late twentieth century, Sargent would receive a long overdue reevaluation, partly in the wake of a new appreciation among the art world for portraiture and other figural painting. In 1966, however, he was considered not only old-fashioned; his society portraits, such as the one Rockwell has nicely reproduced here, were thought to be sell-

outs of the worst sort, prostitution of his talent to the commercial order. By showing the middlebrow viewers preferring the painter with such a reputation among the institutional powers, Rockwell acknowledged a similar truth about himself. After all, a Rockwell could hang in the same spot as the Sargent and the same "class" of viewers would pick his painting over a Picasso. Nonetheless, reputation be damned: Sargent was a painter's painter, whom Rockwell had mentioned in the twenties as a powerful early influence on him.

But Rockwell stigmatizes "his" group as being unaware of proper museum protocol—no one was supposed to go to exhibitions in curlers—and paints the young, hip woman as typically attired for a member of her demographic. In 1966, however, wearing jeans to view fine art was just as striking a choice as the curlers. And in that moment of acceptance when Rockwell implies—again—that the kids are okay, he also gently prods the viewers into questioning their distaste for the less sophisticated underclass, the little child suggesting that such class divisions will continue to replicate, and that various sorts of art will be necessary to span the divide.

A "*Post* delegation" of three men, the new art director included, trekked to Stockbridge from Philadelphia on August 24, 1966, in order to persuade Rockwell to rejoin the magazine. His calendar notes record only elliptical remarks: "Give me contract or not anything. I want to do etc. etc. etc. NO." A week later, Rockwell notes that he has written to the *Post* declining their offer. A letter from Allen Hurlburt written to Rockwell a full year earlier about the illustrator's rejection of some "other people" expressed the art director's pleasure that "things didn't go so well" at that time; presumably, he was ensuring that Rockwell knew how much he was valued at *Look*.

Until more correspondence is located, we can only conjecture as to the disagreements at the August meeting. Rockwell must have changed his position on contracts as a result of the increasingly dissatisfying *Post* covers he had been subject to over the last decade of his work; with no written agreement, the *Post* would be free to humiliate him again. And part of the deal would surely have had to include

the freedom to continue working for other magazines, *Look* included, especially in light of the loyalty Rockwell now felt to Allen Hurlburt. In recent months, the artist had written Hurlburt of his deep gratitude for his "creative art direction." Hurlburt, after all, "has given me the opportunity over and over again to paint pictures of contemporary subjects that I am fascinated with. I just have to express my thanks and, believe me, I am bending every effort to make my work worthy of the opportunities you are giving me." The delegates from the *Post,* in contrast, must have failed to properly assess Rockwell's commitment to an expanded professional arena.

Rockwell's latest career negotiations ensued even as his sons were becoming accomplished artists in their own rights. Jarvis had been successful enough selling his work on the West Coast that he took an extended trip to Spain and Italy, riding a shiny new Vespa along the Mediterranean coast for several months during mid-1966. While visiting with Peter and Cinny in Rome, he began dating Susan Merrill, an American who was attending art school in Italy. He and Susan had met briefly some years before, but this time, something clicked, on Susan's side "spurred on, no doubt, by his impressive months'-long tan and white blond hair; at the time, he seemed very Steve McQueenish," she recalls.

They returned to the States together, and on September 10, 1966, they were married outside of Susan's mother's farm near Baltimore, Maryland, in a "homemade wedding performed under a ginko tree, complete with bagpipes and hippie wedding dress," the bride relates. Rockwell records in his calendar notes the laconic "Jerry and Susan, married, nice day," and is enthusiastically back in his studio the next day.

It was a period rich with creative opportunities for the illustrator, and he found renewed energies in being afforded such a variety of venues. He had recently sent *McCall's* a script he penned for "Willie Was Different," a story about an eccentric thrush who needed to do things his own way and to have his own solitary space in order to sing the extraordinary music that made him legendary. The only person who understood Willie and made such a life possible in the end was a

spinster named "Miss Purdy," a one-letter change from Molly's school days as "Miss Pundy." *McCall's* asked for more text, and Rockwell's wife expanded the bare plot into a fleshed-out story, with her husband rendering lavish drawings. The book was published as *Willie Was Different* in 1967. Although it is a lovely fairy tale of a story, both text and art, some people have wondered why Rockwell would call the bird by the same name as his famous World War II hero, Willie Gillis. Perhaps this was some kind of odd parallelism: Mary had named that protagonist, and now there would be another of the same name reserved for Molly.

Such concerns as Willie deflected from more serious moral issues, including Rockwell's conflict, during the height of the Vietnam War, over whether to paint a series of six posters for the government. One would show an American soldier offering aid to a Vietnamese child. John Glenn, the first American to orbit the earth, was to be the subject of the main picture, titled *A Leader of Men, an Officer of Marines*. Rockwell's friend the Milton, Massachusetts, professional photographer Brad Hertzog—introduced to Rockwell by Molly several years before—accompanied the illustrator to Quantico, the Marine training base in Virginia. The men were given the royal treatment, and by the time they left, they thought they could justify accepting the commission.

Setting aside their niggling doubts, the two men enjoyed the flight home. Rockwell entertained the flight attendants by administering the Famous Artists' School "talent test" that he now claimed "anyone can pass." But once the men parted, each kept worrying over his acquiescence to a cause he did not fully support. They talked with their wives and called each other, agreeing to decline the offer. Rockwell wrote the Marines simply that "I just can't paint a picture unless I have my heart in it." He explained that he and his wife were of two minds about the project and alluded to the controversy over the war. In letters written in April and May of 1967, Rockwell indicated that his work for *Look* had kept him from completing Glenn's portrait and promised to do it after the election of 1968, for which he was busy doing portraits of the candidates. But Rockwell never finished Glenn's

portrait or any of the other images in the series. In later media inter-
views, Rockwell would reiterate his wife Molly's opinion that it
wouldn't be helping the Vietnamese to depict Marines doing such
things as kneeling over to help a wounded villager, the subject of the
second poster in the series. How much his wife's politics, versus his
own convictions, fueled his decision, is hard to determine, given his
strong disinclination to hurt anyone or to give offense needlessly.

Finally, during 1967, Rockwell had the chance to collaborate with
one of his children on a commission. The illustrator was to do the
sketches for building panels at the Cathedral of the Pines in New
Hampshire to honor the women war-dead of World War II, while his
youngest son would execute the sculptures. Any professional father-
son enterprise might be expected to be fraught with tension, and with
artists, as Peter Rockwell has noted, any natural tension tends to be
magnified. Invoking the loving but complicated relationship between
Henri Matisse and his youngest son, the dealer Pierre, Peter Rockwell
remains exasperated at his father's insensitive reaction to his stone-
carver son, almost losing the commission at one point, when the pa-
trons decided to change artistic direction. "I had to really shake my
father up, because he just said, oh, well, that's that. He failed to see
how important this was to me, both professionally and financially. As
soon as I told him that I myself would call and complain, he got in-
volved, and everything went off as planned."

Rockwell's exotic travels inured him to the more quotidian con-
cerns of his sons, especially since he was willing to ensure their finan-
cial well-being, but when they confronted him, he rallied. Motivating
him in part was his recognition that his life had changed dramatically
in the past five years; his children often joked that they didn't know
where to find him. He and Molly traveled to Russia again during 1967,
for instance, in between trips to England, Greece, and the Balkans.
He was eager to study Socialist realist art, and she was interested in
further exploring the school system that had intrigued them a few
years earlier. On their return home, the illustrator took out the
sketches he'd made of the earlier trip at the end of 1964, and created

photo-realist finished oils of the children and their classroom that he then published in *Look*.

In November, back in the states for the winter holidays, Rockwell painted another portrait of Richard Nixon, whose coldness he found a particular impediment. He confessed to Allen Hurlburt on the twenty-sixth that "It is no Rembrandt." Rockwell had set up a temporary studio in Manhattan's Plaza Hotel, where he got President-elect Nixon to pose for forty-five minutes. Of all the political figures from both ends of the spectrum that Rockwell painted, circumspectly refusing comment on their platforms, only Nixon earned truly negative comment from the painter. Rockwell was deeply disgusted at what he believed to be the then-candidate's insincerity when he stopped two cleaning women in a hotel hallway and promised them that when he was in the White House, they could bring him their problems and be assured he would tend to them himself.

Before the year was over, the Corner House Museum opened on Stockbridge's Main Street. A historical building formerly scheduled for demolition, the Corner House enjoyed great affection among local citizens, Molly Rockwell among them. Four townswomen waged a campaign to purchase the building, which they then turned into a historical society. Rockwell lent many of his oils, and before long, the museum became de facto the Norman Rockwell Museum. By the time of the artist's death, the small exhibition space was attracting five thousand visitors yearly; during the following decade, the increase to over one hundred thousand would dictate that a real museum be built. Renowned architect Robert A. M. Stern would design the building, open to the public in 1993; Steven Spielberg and Time-Warner would endow it; and President Ronald Reagan would serve as honorary chairman of a five-million-dollar fund-raising drive. But for now, the nearly five thousand visitors a year to the little building amazed the townspeople.

Molly convinced her husband to spend much of his time the following year on getting his estate in some kind of order, enabling a real collection of his paintings to take shape. From its inception, the mu-

seum was Molly's passion far more than Rockwell's. Nonetheless, though he painted for a disposable consumerism, the artist had saved what would prove to be forty-five linear feet of fan mail and an equal volume of business correspondence. And he had drawers full of art reference plates and reproductions that he called on for his paintings. Soon it became clear that an all-out effort was warranted; the makings of some first-rate archives were at hand.

His sorting through decades worth of paintings and sketches was further motivated by a query from an important Manhattan dealer about the availability of some of Rockwell's oeuvre for a late fall show. Excited, even incredulous judging from the letters at this time, the illustrator expended great effort deciding which work to include and arranging for loans of favorite pieces he had sold years earlier. From October to November 1968, the Bernard Danenberg Gallery mounted a fifteen-canvas exhibition of Rockwell's work, the artist's first New York City solo exhibition. Several times during the month, Rockwell stopped in to see how business was going. It wasn't. Harry Abrams later enjoyed telling the story of Rockwell's embarrassment as he sat forlorn, the night Abrams stopped in, while a long line of eager spectators waited outside the Whitney Museum to see the Andrew Wyeth exhibition. After all, five years earlier *Time* magazine had practically anointed Andrew Wyeth (son of illustrator N. C. Wyeth, favorite student of Howard Pyle) the real painter of the people in the long cover feature it published. "I want to show Americans what America is like," Wyeth explained.

To put some distance between his disappointment over his poor showing and the upcoming demands on his spring schedule, Rockwell and Molly embarked on a flurry of travel during the first part of 1969. Visiting Portugal, England, Italy, Spain, and the Bahamas helped to ease Rockwell back into a near nonstop work schedule for the remainder of the year. And he was also besieged throughout 1969 by an unusually large number of people who asked him to lend either his name or his art to promote their enterprise. One such group wanted to print Rockwell's earlier illustration for the Department of the Interior, *Glen*

Canyon, to plaster on kiosks in shopping malls. The western land reclamation project had stirred Rockwell, because of the plight of the Native Americans and Mexicans he had grown to respect who lived on the government property. The government had not been as happy about the outcome of Rockwell's exposure to the land, since they meant for his illustration to further the cause of the Glen Canyon dam, not elicit sympathy for those being dispossessed of their sacred lands. The finished oil, with a sad, dignified Indian-Mexican family occupying the foreground of the otherwise impersonal industrial vista, appears almost subversively at odds with the commission Rockwell had been given.

He sharply informed the entrepreneurs who wanted to expropriate the Glen Canyon painting that he had no interest whatsoever in participating in such an enterprise. And to the hundreds of other random entreaties, like the one that came complete with a free skillet, he answered gently that he appreciated the gift and, in the case of the skillet, would certainly fry his morning eggs in it, but he believed participating as a celebrity breakfast eater on behalf of the Poultry and Egg National Board too gimmicky, especially since he didn't know where he stood on the cholesterol controversy. A few months later, he equally emphatically answered Philadelphia mayor Frank Rizzo: while he was greatly honored by the invitation to be fêted in the mayor's city, he was behind in his work and unable to attend the planned reception. Rizzo's strong support of the Vietnam War, at the least, would have shored up Rockwell's resolve to say no.

By the end of 1969, after a particularly hardworking year, Rockwell was ready for another extended vacation. He and Molly traveled to Israel, where he painted the troubled Christmastime mix of soldiers and worshippers in Jerusalem. The travel plans to get there were made impulsively, Christopher Niebuhr remembers from a story his mother told him. Reinhold and Ursula Niebuhr had first met the Rockwells in the early sixties, when the theologian spent summers in Stockbridge to undergo therapy at Austen Riggs for poststroke impairments. Within a few years, they established a year-round residence. In 1969,

Ursula joined Mayor Lindsay's ten-day trip to Israel, where she was appointed to an international task force on the future of Jerusalem. Later in the year, when a professor from Hebrew University visited Stockbridge the day after Thanksgiving, Ursula sponsored a luncheon for him and invited Molly.

Before he left, the man handed out business cards to everyone, telling them to call him if they ever visited Israel. Almost before he had a chance to arrive home, Molly asked Ursula if she thought it would be acceptable to phone the kind professor and ask for help locating a hotel in Jerusalem so that she and Norman could spend Christmas there.

While on their impulsive winter holiday, Rockwell sketched a scene of soldiers and citizens in Bethlehem keeping watch over the Holy Wall on Christmas Eve. He finished the painting at home, framing it before he sent it to *Look,* just as he had done to all his magazine illustrations throughout the years. "A picture without a frame is like a man without a collar. Besides, it helps the picture and makes me feel it is really finished," he rationalized when a journalist during this period asked him about the unusual practice. During the exchange, the interviewer informed him that he had been compared with Rembrandt, to which Rockwell responded, "Rembrandt must turn over in his grave." Yet he had cannily invited such overblown compliments with his earlier remarks to journalists that Michelangelo was an illustrator, after all, when he painted the Sistine Chapel.

The prices that the original oils for the *Saturday Evening Post* covers continued to bring as the seventies began astounded their painter, who expressed amused pleasure and surprise when the topic was discussed in public, and wry dismay at home about the way he used to dispose of the originals without a thought as to their value. (Molly was even more distressed at the casualness with which the painter had dispersed his life's earnings.) During the summer of 1970, one of his paintings brought $27,000. Another measure of his marketable status in 1971 was demonstrated when Endorsements International, Ltd., polled seven thousand advertisers to compile a

list of the one hundred "most wanted" celebrity endorsers of the past twenty-five years. Although Rockwell had never had an agent, he had succeeded remarkably well in promoting his name and image, effectively assuring himself a Rolodex card on the desks of ad agents and art directors. Now, his lifetime efforts paid off. Show business personalities dominated the list with fifty-one names. The runner-up category was sports, with eighteen winners. The art world was represented by just six celebrities—three cartoonists: Milton Caniff, Al Capp, and Charles Schulz; and three artists: Salvador Dalí, Grandma Moses, and Norman Rockwell.

In the fall, the event Rockwell had so eagerly anticipated at last occurred—Harry Abrams's publication of the first major monograph on the artist. Thomas Buechner's text intelligently made the case for the role of illustrator as artist, nimbly sidestepping the now-aged clichés on the question of categories, and plunging into an examination of Rockwell as a modern-day American genre painter, inheritor of the Dutch seventeenth-century tradition. (A few years later, the journalist Sam Walton wrote similarly of Rockwell's strong narrative references to Dutch Masters, including Cornelis de Man, as well as the Dickensian Pre-Raphaelites from England.) Neither hagiographic nor breezily condescending, Buechner, the director of the Brooklyn Museum, spoke more insightfully than any critic had thus far. And he spoke from the authority of a major American museum—although Brooklyn's very city affiliation implied, to many Americans (the art world no exception), the populism that made Rockwell appeal to the unwashed masses.

The reviews of Buechner's book made much of the nostalgia wave sweeping the country. A similar phenomenon would usher in another period of retrospective chic for the artist at the beginning of the twenty-first century, when Rockwell would again become a fashionable commodity to the art world and the educated public both. (To the middlebrow citizenry, he had never been anything less, which, to the rest of the population, epitomized the problem.) The early seventies were seen as a period when it was suddenly acceptable to turn to

the past, before Vietnam and before the supposed divisiveness of the sixties, and to laud an art that dared to represent people, not the sacrosanct inner visions of the artist's mind. Such retrospective scrutiny lived on the edge of cheap chic, however, and critics such as John Canaday of *The New York Times* didn't hesitate to sneer at the lack of knowledge of the real world that they considered Rockwell's work to convey. And they sneered, at least implicitly, at the people who could consider such painting "art."

The period between World War II and 1970 had fused the lessons of European Modernism to the fiery nativism of American icono-clasts, resulting in an abstract art that commanded center stage on the world art scene. Although Jackson Pollock's Abstract Expression-ism had conquered the art world by 1950, the intimidation and bore-dom of ordinary Americans by the art world, and their confusion at what they were being asked to look at in museums—Conceptualism, Pop Art, Minimalism—wasn't complete until twenty years later. Even in 1970, few middle-class American citizens possessed the self-confidence or training, by education or on their own, to feel comfort-able asserting their preference for figurative painting. Yet a full decade earlier, representation had begun to stake its claim again, and now, as the seventies began, a new interest in Rockwell's work re-flected such a shift in critical tastes, trickling down to the supposed unknowing masses.

And Rockwell's savvy response to the turmoil of the 1960s had en-couraged the cognoscenti as well to give the elderly statesman of American illustration a second look. It was Rockwell, after all—he of the courage to paint radical new images when others would have been resting on their laurels—who believed in the future that the hippies wanted to construct. "We should have great confidence in the present generation of young people who are, I think, the very best we have produced—long hair and all. Who is to say that one of these hippies won't be a genius of the future?" Just as he had in the 1950s, so now he reassured the nation that its kids were more than okay—they were swell, and they would lead us into the future assuredly. Such public

affirmation was generous, when this was the same generation, after all, that had lampooned him in *Mad* magazine a few years earlier, and that by and large thought him irrelevant. More impressive still, Rockwell was willing to alienate the public who depended on him to counter the very seemingly wanton culture he had just endorsed. From the beginning of his career until its twilight, the nation's children packed the strongest psychological punch with the illustrator.

Buechner's book was a tome, weighing in at thirteen and a half pounds, and costing sixty dollars—after an early promotional printing of sixty thousand copies priced at forty-five dollars sold out within one week. The sales were undoubtedly furthered by the publicity tour Rockwell himself made through Washington, Philadelphia, Dayton, and Los Angeles. In November and December, he embarked on a fast-paced promotional circuit, appearing on Joey Bishop's, Dick Cavett's, and Dinah Shore's shows. Ambling onto the stage in his trademark pigeon-toed, side-to-side fashion, the painter combined his real affection for the American people with an impressive self-possession that showed the strength behind the country-boy charm. Cooperating pleasantly with requests to recite the Mamaroneck fight song, he time and again evinced his near magical ability to seduce the listener with his supreme self-confidence, even as, at the same time, he managed to make the same admirers eager to protect him from what seemed his odd vulnerability.

But now, the sadness that acute commentators had always noticed flitting through what they called his melancholy eyes seemed more often on display. He explained that he "no longer" believed that he would bring back the Golden Age of Illustration, though he still began each painting with the hope that this would be his best yet. And he managed, as always, to speak an important self-truth while clothing it in self-effacing charm: "I'm no artist, I'm an illustrator," he told interviewers. "When anyone challenges me on that, I always want them to win the argument." Still, he admitted that he worked "from exhaustion to exhaustion," or from fatigue to fatigue, as he told others. He continued to paint seven days a week, making it to the studio by eight

forty-five most mornings, his day over at five. His work was disrupted only by the lunch break he'd share with Molly, followed by a 4.7-mile bike ride up some fairly steep hills, which had helped get his weight down to his current 115 pounds. "The townspeople worried a bit about Norman and Molly out there on the roads. They were up there in age, and they seemed totally unaware of their infirmities. So we all watched out for them, and we'd drive particularly slowly around curves when we thought it was their time to be riding," Mary Quinn, a townsperson and, later, Rockwell's nurse, explains. Rockwell's calendar entries around this period show him deeply aware of the fragility of age and its discontents. Professional associates are now cited by the dates of their funerals, with Rockwell inevitably marking the day only as "sad" or "depressing."

The early seventies also represented the last stage of the great experiment—the innovation—that the Famous Artists' School had embodied. For twenty years, the institution had provided services that, until the last few years, the instructors could pride themselves on. But when its founder, Al Dorne, died, the institution was bought by a noneducational company whose main business was plumbing materials. Rockwell was urged to sell his stocks while he could still make money; listed on the New York Stock Exchange, the stocks he held were worth a couple of million dollars. Molly begged him to at least unload some of his holdings; the bleak financial future of the school was becoming clearer by the day. According to family stories, however, he was also told that to do so would hurt any chance of the organization surviving, and so he held off. In the end, Rockwell lost his entire Famous Artists' School fortune, as the new owners ran the school into the ground and it went into Chapter 11 bankruptcy, leaving a gutted institution for its next intrepid and this time honorable buyer, Cortina, who tried to revive the once-proud enterprise.

31

The Light Recedes

As much as the attention to his decades-long career pleased Rockwell, it also scared him, because it suggested that his tenure as an artist was a thing of the past. Certainly his fan mail continued unabated; one particularly lengthy letter, in contrast to those asking for autographs or extra paintings he might have hanging around the house, requested that the artist help spring the writer from jail at the State Correctional Institution at Huntington, Pennsylvania. Rockwell wrote back a firm but polite rejection, claiming to be in no position financially or otherwise to help, and ending with "I am very sorry, but I think I should tell you these facts." More conventional signs of his continued popularity abounded as well: requests poured in for his $5,000 portraits, ranging from Ross Perot to Tennessee Ernie Ford.

When Rockwell agreed to a commission, he invariably warned of his overly full schedule and the probability of delays. He continued to accept advertising jobs, believing the pay to compensate for the unchallenging assignments, and he allowed reputable companies, such as Parker Brothers games, to license the use of his name. College stu-

dents wrote him about the seminar papers they were delivering on "The Genre of Norman Rockwell," and civil defense lawyers in Mississippi sent him fan mail about how his paintings on civil rights had moved them more than anything they'd ever seen. Predictably, he fell behind and sought creative ways out of his obligations. C.O.R.E., the Congress of Racial Equality, a leftist civil rights organization established for the "liberation of Black People," asked him to design a Christmas card for them; instead, he sent them his potent, surprising painting of two slain civil rights leaders, *Blood Brothers,* a black and a white worker, lying on the ground, smothered in blood. They loved the gift, but they (and Rockwell) thought it too grisly to use as a Christmas card.

Blood Brothers had actually been completed several years earlier for *Look*'s series of articles on the nation's racial struggles, but the editorial board could never quite agree to use it. First painted as the slaying of two friends, one black, one white, in a city ghetto, Rockwell changed it at the magazine's request to two Marines in uniform, killed in a Vietnam village. His idea for the painting was the visual mixing of the blood flowing from both men, reminding the audience that skin color didn't affect the deepest levels of human connection. When feedback from *Look* included the comments from a black editor and ex-soldier who felt the painting was "patronizing," and that Rockwell had failed to show the important point—that in Vietnam, there was no racial prejudice—the artist, deeply frustrated at what he assumed was his untutored awareness of such matters, wrote to the Harvard psychiatrist and author Robert Coles for advice.

Coles, a student of Erik Erikson, had enlisted Rockwell's help for a book he published in 1968, *Dead End School,* a study of poor urban black children and their families, and the effects of their attending overcrowded schools. The book was written to further the aims of school desegregation. Rockwell accompanied Coles throughout the Southeast, and while the psychiatrist interviewed families, Rockwell drew scenes from the children's lives. Well received, the book bonded the two men. Coles especially would later express his pleasure at their friendship, noting the curiosity the artist displayed for everything

around him, and his extreme awareness of the feelings of the often downtrodden people they were dealing with. "I was just truly impressed at his intelligence and sensitivity to people," Coles recollects.

Rockwell had written Coles a worried inquiry about how to handle the disagreement at *Look* over his *Blood Brothers*. His deep concern about causing offense or pain to others occupies the foreground of his inquiry: "The reason I am writing to you is because I know you really have a deep understanding of the negro's feeling about the civil rights issue. Could I impose on you to look at the two photographs and perhaps you have some suggestion as to what the negro editor felt was condescending." Coles, who believes that Rockwell was deeply, vitally committed to racial equality, failed to offer sage enough advice for the painter to salvage the commission, though he placated him sufficiently that in later years Rockwell said simply, to anyone who asked, that "*Look* lost its nerve."

By the fall of 1971, Rockwell was exhausted from all the attention and from his never-failing hard work. He had not paused even during the hot summer, including the August afternoon when he did Frank Sinatra's portrait, one of the first paintings to show the dramatic decline of his abilities. He continued executing various portrait commissions he'd accepted, including one of actor Walter Brennan, for the National Hall of Fame and Western Heritage. The loosely painted result seems more the product of a shaky hand than a deliberate stylistic choice. The artist agreed to be the star of a documentary half-hour television special shot in Stockbridge, and sponsored by the Arrow shirt company, known decades before as much for J. C. Leyendecker's art as for the clothes they manufactured. Such events tired him quickly these days, and at the end of November, replying to the editor of *Ladies' Home Journal* about yet another request for an illustration, he explained that his doctor had told him that he must take a vacation, and that he and Molly were going to Little Dix in the Virgin Islands for about a month.

Pictures of the couple in Little Dix show them cavorting like youngsters. This resort area, located on Virgin Gorda in the British Virgin Islands, was their favorite vacation spot. But by the beginning

of 1972, he was back to the grueling pace that even Molly had been unable to reduce. Rockwell began the year by getting his biannual duty to the Famous Artists' School out of the way; but upon his return on January 18 from Westport, he recorded his belief that the school was "fading fast." So was he, if his new tack of hiring someone to drive him so he could sleep in the back of the car from Stockbridge to Westport was any measure of wear and tear.

During the early part of this same year that, at Rockwell's insistence, the Famous Artists' School would create its last ad using the illustrator's name, a large-scale show, sponsored by the Danenberg Gallery and meant to complement Buechner's monumental book, opened at the Fort Lauderdale Museum of the Arts. It would tour nationally through the end of April 1973, covering nine cities over a period of a year and a half. "Norman Rockwell: A Sixty-Year Retrospective" was, eerily, positioned culturally and among the institutional art world almost exactly as the mammoth retrospective of 1999 would be over twenty-five years later. Even some of the critics would be the same: Peter Schjeldahl wrote a perceptive and generous appraisal of the Danenberg show for *The New York Times*; over a quarter of a century later, he would reprise his criticism for *The New Yorker*. Schjeldahl cites the "phenomenal 'Rockwell revival'" and the opportunity that a Manhattan audience now has to "reappraise the achievement of this prolific, all-American master illustrator." Audiences would crowd the show; the critics would be wildly mixed in their reactions. In their almost exclusive regard of his subject matter and neglect of his painterly skill or technique, both audiences and critics showed how well they had absorbed the lessons of the abstract art world of the forties and fifties. Paradoxically, the very absence of overt subject matter in postwar art had trained the eye to assume that innovative abstraction was its own reward. Pronouncing on Rockwell, spectators no longer had the vocabularies to discuss narrative painting.

On March 22, 1972, the retrospective opened at the Brooklyn Museum, its first major venue, where it would run through May 14. John Canaday, the art critic for *The New York Times*, whose judgment

Rockwell deeply respected, threaded his review from the beginning with contempt for what he saw as cotton-candy narrative art and scorn for those ill-guided audiences who enjoyed it. Rockwell was cited in the review as America's "best-loved" artist, and the hoi polloi who lined the exhibition ramps were, sarcastically, the "best-loving" crowds. The critic nodded not only at the older generation who grew up on *The Saturday Evening Post,* but at the young people now interested in Rockwell because of the current "nostalgia boom." Canaday's review may well represent the epitome of the contempt felt by critics or connoisseurs who either saw no value in a narrative tradition of genre art or misinterpreted, as an arrogant graduate student might patronize Sherwood Anderson or Robert Browning, the stories Rockwell's paintings told. Repeatedly, Canaday offered misreadings of the most egregious sort, reducing to pure sweetness and light the implications of time and loss in some of Rockwell's most important paintings. In contrast to what he believed the patently false world of Norman Rockwell, Canaday ended his review, "It was a pleasure to shoulder my way back to the office through the crowd of pimps, prostitutes and perverts [in Times Square]. They were so real."

It was the very "realness" of Rockwell's paintings that in late spring made the exhibition so popular when it reached the Corcoran Museum in Washington, D.C. (the same venue that in 2000 would house a similar retrospective encapsulating the nostalgia wave of the fin de siècle). Fifteen years earlier, in 1957, the Corcoran had welcomed Rockwell's art at the same time that the Museum of Modern Art in New York was exhibiting Edward Steichen's *The Family of Man,* and knowing, respectful critics used the two shows to ponder the place of photography, illustration, and easel painting among the arts.

As if to avoid reading such stinging criticism as that leveled by John Canaday, Rockwell had decided to leave the country during the month that the exhibition arrived at the Brooklyn Museum. He and Molly went to Rome for three weeks in March, where they whisked Cinny away for a weeklong side trip without her children and husband, a kindness the mother of four felt keenly. The trip to Italy

proved so rejuvenating that the Rockwells immediately began plan-
ning a vacation to the Netherlands. They increasingly depended on
such journeys for more than diversion and rest; the only way that they
seemed able to enjoy privacy these days was, paradoxically, to travel.
At home, they were dealing with everything from letters claiming that
Rockwell had fathered a child in Germany, to a fifteen-year-old boy
who slept outside the couple's front door in hopes of being allowed to
live with them. "I remember someone calling them up at three A.M.
from a Miami bar one time," Susan Merrill says. "The man said, 'I just
wanted to tell you how much I admire your work.'"

Rockwell would have given up advertising work at this time if the
pay weren't so exceptional. Modestly dressed in his typical khakis and
blue work shirt, he told interviewers of his shock in realizing that in
1971 he had made $1.4 million, largely as a result of such commercial
work. One of his most lucrative outlets, he admitted, was the covers
of companies' annual reports, including McDonald's, which paid him
$10,000 for rendering a hamburger, as far as he could tell. Much of
the leap in his income was due to the nearly universally deplored en-
gravings he did for the Franklin Mint during this year, a major com-
mission he notably failed to mention. As the interview proceeded, and
Rockwell was congratulated for landing his portrait of Nixon in Wash-
ington's National Gallery, he protested that the new hoopla about him
being an artist rather than an illustrator was interfering with his work.
Ambivalent about the cost of fame, which seemed tied to proving him
a "fine arts man," he complained, "I'm not painting when I'm out
doing some public stunt."

But at least he was feeling expansive, relaxed, and in no danger of
being suffocated by the past. Grumbling to his wife a little, but turn-
ing a gracious side to his old local government, Rockwell accepted the
New Rochelle Chamber of Commerce's invitation to attend its cele-
bration of the city's history. The city proclaimed June 24, 1972, "Nor-
man Rockwell Day," and proceeded to rename one block of Memorial
Highway "Norman Rockwell Boulevard." Armed with a list of people
he hoped to see, the artist visited the city he'd not returned to since

he and Mary had moved to Vermont; sadly, he confessed with some embarrassment, they were all dead. Increasingly he felt the world around him to reflect the death of his generation, and he stepped up his efforts to make an impact on what he considered a less fortunate, less happy society than the one he'd inhabited.

Around the same time that the illustrator was writing his acceptance to the New Rochelle Chamber of Commerce, he was also sending out a letter to Congressman Thomas E. Morgan in Washington, urging the speedy withdrawal of all U.S. forces from Indochina. He explained that he wanted his letter identified with Common Cause, which supported cutting off all funds and combat activities by the U.S. forces in Indochina, as well as withdrawing unconditionally, the only contingency the release of American prisoners and an accounting for those missing in action. A week earlier, after Richard Nixon had committed to escalating the Vietnam War, Tom Rockwell had written to his father and Molly, suggesting that the two of them participate in the antiwar lobbying campaign under way that was headed by Abe Ribicoff. The artist needed little urging; he felt as strongly about the indecency of the war as did his son.

In the middle of Rockwell's forward-looking efforts on behalf of Common Cause, his popularity continued to be revitalized by the nostalgia wave sweeping a country sick of the present. During the summer, in a nod toward the resurgence of the artist's reputation, the *Saturday Review* published a significant article on illustration's place in American culture. The latest interest in the country's recent past was encouraging the reissue of Old Broadway musicals, of vintage fashions, and of forgotten comic strips, and it included a bid in Norman Rockwell's direction. But without the validation of mass culture that Andy Warhol's ethic had helped promulgate, little room would have been available for such retrospective evaluation. What was kitsch according to *The Nation*'s art critic Clement Greenberg, and later camp under Warhol, was evolving into "popular culture" in the wake of the Vietnam generation. Each transmutation granted the subsequent genre new credibility, until, upon its maturity, it would be institution-

alized as a university discipline. The Brooklyn Museum's retrospective of Rockwell's career reflected such institutional imprimaturs.

In 1973, Ted Kennedy visited with the Rockwells at their home early in the new year, touring the Corner House as well, no doubt Molly's idea in hopes of securing the Massachusetts senator's patronage for expanding the collection. Kennedy enjoyed their hospitality as much as the paintings, and he assured them that he would bring his children back to delight in the exhibition just as he had. A few days later, the Rockwells attended an annual celebration at the Waldorf Astoria sponsored by the printing industries of New York, where the illustrator received a prestigious award given in honor of Benjamin Franklin. In the myriad photographs of the event, he appears to be as proud of having Molly at his side, her bright eyes focused on the speakers as if they were intoning Shakespeare, as he was to win the citation.

Around this time, Erik Erikson asked "Norm" to do him a favor and accept a commission from a sponsor of the Montessori Women Teachers' Association in Vienna, a group to which Erikson had early ties. The anonymous member had already approached Rockwell about doing a medallion, and the illustrator's lukewarm reaction had induced him to seek out Erikson, who, amazingly, urged his busy friend to take on the work. If he did so, no one connected with the archives has seen a copy of the medal, implying that Rockwell might have learned to say no, even to Erik Erikson. He and Molly decided around this time to escape the Massachusetts cold by spending a few weeks in Rome with Peter and Cinny, and travel always provided the illustrator with a graceful way to turn down hopeful supplicants.

On May 9, Rockwell's brother died, "a man commonly known as a misanthrope," a mutual acquaintance told one of the illustrator's sons. Rockwell noted the event in his calendar with the terse remark, "Jarvis died in Florida. Dick called and told me." A few weeks later, the Rockwells traveled to Minneapolis for a Boy Scout ceremony honoring the artist's lifelong contributions, and, while there, he felt forced to meet with representatives from the Green Giant company, for whom he had painted major ads decades earlier. Representatives from

the corporation pleaded with him to grant them an interview for an upcoming issue of the company magazine. Although Rockwell was clearly reluctant to accept yet more demands on his time while dealing with the Boy Scouts, he agreed, requesting that the company limit their talk to the briefest possible time frame.

As he grew older, Rockwell was finding himself a victim of the years spent establishing his accessibility. By the time he got home from the various business activities this time, there were signs that he would soon be forced to start limiting his appearances. Within a few days of his return from Minneapolis, his calendar includes an entry that hints at the changes taking place in his brain. "Felt lousy can't remember what else I did," he noted on May 31; the next day, Dr. Frank Paddock gave him a complete checkup and recommended a major rest. On June 3, he and Molly set off for Little Dix. The Rockwells stayed at the Bay Hotel, a luxury beachfront resort. A note that Molly wrote to Margaret and John Batty, codirectors of the Old Corner House until David Wood took the helm in 1974, makes it clear that even on vacation, Rockwell showed impatience when he was forced to do nothing. All ready to go for a swim, he and Molly were stranded in their room while it rained and thundered, but the lack of lightning irritated her husband, since now there was no good reason why they were prevented from going into the water.

By the end of August 1973, Rockwell was feeling increasingly "off," and he was distressed enough to begin recording his bouts of mental confusion on his calendar pages: "all 'mixed up,' quit at 5 p.m." he writes on August 20. One month later, he "went to bed then hospital in bed until the 27th." The day after he was discharged, he "came out to studio twice but did not work. Took walk to where Erickson used to live. Trying hard to get normal." A week later, on October 5, he still records "feel lousy." Trying hard to normalize his declining health, the artist notes on October 11, when he didn't feel well again, that "after all I am in my 80th year."

He and Molly departed for Little Dix again in November, and on their return, in hopes of turning their domestic life into their own

again, Molly designed what she called an "escapebo" for the south side of his studio and had it built in short order. The outdoor patio was part escape from the gawking tourists out front, and part gazebo. The closeness of their house to the street not only encouraged too many unannounced visitors, but the constant noise from the traffic irritated the Rockwells increasingly as they aged. The escapebo proved a lifeline to privacy, and Molly and Norman began spending as much time in it as they could, sitting there in the evenings after he had finished work and was ready for a hot toddy, and Molly for her own gin and tonic.

Rockwell had little opportunity to miss the significance of his eightieth birthday, since newspapers and magazines all over the country anticipated the February date before 1973 was over. Even Peter Rockwell's latest efforts were, he had announced, studies of his father in honor of his upcoming eightieth birthday. Proud and gratified at the young sculptor's major exhibition at the Shore Galleries in Boston, Rockwell nonetheless felt too frail and overwhelmed by work to risk the crowds.

In early 1974, a birthday interview emphasized the amazing routine the elderly painter maintained, devoting most of his seven-day workweek to portraiture. As if shocked at the prices he commands, and as in awe of them as the population will be, he proudly announced that the Franklin Mint will pay him $30,000 for their bicentennial medal, and that the portraits now go for $8,500. Asked why he doesn't take it easy nowadays, he answered that "I want to be working on a picture and just fall over dead. That's my ideal." Generalities about the "hell" of growing old pepper his responses to journalists this next year; and the handwriting of his calendar notes becomes noticeably smaller and tighter. On January 10, he writes "very confused"; the next day, simply, "I am confused." He and Molly escape to Little Dix at the end of the month, determined to avoid any large birthday celebrations in early February.

His health had clearly deteriorated by this point, at least judging by the number of midnight trips his quiet, loyal neighbors, Helen and

Ernie Hall, made to the hospital with him when he had accumulated water in his lungs. Throughout the years, Rockwell had suffered from bouts of pneumonia, and his lung X rays indicated the presence of emphysema for several decades. He exercised regularly, rarely exhibited shortness of breath, and mouthed his pipe, using it for ritualistic distractions while he worked, far more often than he ever really smoked it. It seems likely that Rockwell's debt to his Grandfather Hill, the artist whose fascination with detail made the illustrator wonder if such obsessions can be hereditary, extended to his health. After tubercle bacilli first enter the body, they usually remain lodged in the host until death, capable of causing clinical disease at any time. The germs can be activated by stress as well as by other contributors to a weakened immune system. Nancy Rockwell, survivor that she was, nonetheless almost certainly harbored the germ, and in the aftermath of Susie and Samuel Orpen's deaths, when their children lived with the Rockwells, Norman and Jarvis Rockwell probably filed away the unwanted calling card in their young bodies as well.

Until his eightieth year, Rockwell's attempts to outrun his increasing fragility by traveling more and more, finding himself at least temporarily rejuvenated by his trips, had worked fairly well. But this time, during his late January 1974 retreat to Little Dix to escape Stockbridge's attempts at a birthday celebration, he fell off his bike in an unexplained accident that bore all the marks of a minor stroke. He and Molly had ridden out for their usual afternoon trip, with Molly leading. Only after she arrived back at the hotel and turned, anxiously awaiting what she assumed was her unusually winded husband, did she realize something was wrong. Summoning help from the office, she retraced their path with a staff member in tow, until they came across Rockwell sitting on the side of the road, dazedly surveying the vista. By the time they were back at the hotel, his confusion had passed, and the couple nervously decided he had just taken a tumble and hit his head. But neither one of them really believed that.

Back at home, Molly arranged for Virginia Loveless, the ex-wife of the Riggs art director, Dave Loveless, to help out at the house. Every-

one in the Stockbridge intellectual community knew about Virginia's cooking, and Norman had begun to lose his appetite. Molly hoped to improve it by arranging for Virginia to cook for the couple on a daily basis, and before long, the warmhearted, discreet woman felt like family to the Rockwells. "Even that year, I knew Norman wasn't really okay," Virginia says. "He just wasn't always on cue, sometimes perfectly fine, other times somehow 'off.'"

Molly and Norman both refused to acknowledge that there was a problem, however, and in a desperate attempt to get things back to normal, the orderly schoolteacher began to rely more heavily than ever on sticking to the routines she'd set up for them both, aimed at regularizing Norman and securing his good health. Her own lifelong insomnia worsened, and she began to inch toward sharing Norman's reliance on Miltown, Seconal, and alcohol to keep sleeping through the night.

When David Wood, a member of St. Paul's and a well-educated English teacher, took on the position of museum director that year, he quickly became such good friends with the Rockwells that they suggested he move into the little apartment that Mary Rockwell had created upstairs in the South Street house. He agreed, and he paid the Rockwells $150 rent each month. His presence was reassuring to both Norman and Molly, since he tactfully combined the role of family watchman with that of friend and tenant.

During 1975, Rockwell was approached, predictably, by dozens of prominent organizations that hoped he could be induced to represent the upcoming bicentennial for them. But by now, the artist's color sense had altered dramatically enough that he could no longer keep up the pretense. Until this point, he had insisted all was well: "I remember once when I showed him an original oil we had bought back for the Corner House," curator David Wood says. "He remarked how dirty it was, and that he was going to take it inside and wash it and then retouch it. I was horrified: his judgment was so off, with the eye problems he was having, that I knew the picture would be ruined. I had to mumble some excuse and get it out of there."

Frank Paddock claims that Rockwell had a special eye condition that affected his sense of color only, but from the reports of Rockwell's vision, it seems that he basically was affected by cataracts or the macular degeneration common by his age. "His distinctions between the range of oranges and yellows became particularly enfeebled," recalled Peter Rockwell. "Color had always been a source of pride to him too, his command of its clarity and values." Worse than the color confusion was the ever-worsening dementia that plagued the artist. Frank Paddock had become Rockwell's doctor largely by default; when he and Mary had first arrived in Stockbridge, Frank's father, located in nearby Pittsfield, had long led the medical group of choice for high-profile figures. Many in Stockbridge came to believe that Frank Junior was more interested in conducting explorations of exotic places, such as the edge of the Peruvian rain forest, in search of the ruins of Gran Pajaten, than in practicing medicine.

Controversy erupted between Paddock, not known as the expert diagnostician that his famous father had been, and researchers on Alzheimer's disease, who came to Stockbridge in crude hopes of making Rockwell their poster child. Virginia Loveless even took a special course on the disease, in hopes of understanding her adored friend's confused mind better. In retrospect, the artist's mental degeneration exhibited many of the classic symptoms of the disease, then still in its early stages of public awareness and medical exploration.

Rockwell knew something was terribly wrong. On June 2, 1975, he recorded only three words in his calendar notes: "I'm all confused." On August 19, he lost his balance and fell, injuring his back. He paused on October 25 to note that "today is Molly and my 14th anniversary." But one week later, on November 1, he is again baffled: "no Louie [Lamone, his assistant], he said I said he was not to come today? Quitting 4 pm going for ride Mary." The Rockwells had not yet employed the nurse Mary Quinn, and the artist never called Molly by the name of his dead wife. On November 5, he records the word "puzzled," and on the tenth, he writes "bewildered." Christmas Day, he ends his calendar notes for 1975 with the simple notation, "I'm mixed up."

Over the next few years, as Rockwell's lucidity became more precarious, Peter visited from Rome, and the two sons within easy driving distance frequented the family home. Tom and his wife Gail made overnight visits from their home in Poughkeepsie, and Jarvis, divorced in 1972, brought his young daughter Daisy most afternoons or evenings to sit in the library, where one of his own abstract paintings hung over the fireplace, with David Wood, Molly, and his father sharing tea or predinner drinks, the old illustrator often downing two of his favorite whiskey sours. Daisy Rockwell, now a professor of Hindi, recalls that Molly and David did most of the talking, while she, her father, and her grandfather sat listening to their erudite discourses on whatever literature was the topic of the day. David, who felt somewhat uneasy at the sense of exclusion of others, remembers that Norman may have gently paid him back by signing his holiday cards to him as "to David, our neighbor, tenant, and friend," carefully keeping David in his place.

David's total commitment to ensuring Rockwell's artistic legacy could not be denied by the artist, however, and he appreciated the efforts both Wood and Molly made to endow the Old Corner House. In the pursuit of such efforts, Molly had convinced him to allow various manufactures of porcelain plates to reproduce his images; in spite of the now common prices of $40,000 and above for his original oils, the Rockwells saw little of such money, since the artist had given away most of his works long before. By their natures, the couple lived modestly: Mary Quinn had to insist that Molly "splurge" on buying lobsters one day when Norman mentioned how much he loved them; she found such a purchase ordinarily too "dear" to encourage. By contrast, friends observed how unworldly the Rockwells seemed to be about most luxury items, such as the time Norman, abetted by Molly, began to empty a bottle of vodka into an expensive bottle of brandy someone had given them, until someone shouted "no!"

The disciplined woman worked hard to improve their family and estate finances, their frequent traveling the couple's only real indulgence. But Rockwell could not effectively retain control over his com-

mercial reproductions nowadays, and by mid-year, unauthorized companies had created such an overflow of plates that the Franklin Mint asked him to sign a public ad deploring the imitations. On November 11, 1975, a full-page disclaimer appeared in *The Wall Street Journal,* among other newspapers, sealing the impression that Norman Rockwell, artist, was not much more than a corporation. Whatever income he and Molly were ensuring through their commercial enterprises, they were mangling Rockwell's artistic reputation.

. . .

In 1976, two years after Rockwell had fled to Little Dix to avoid his eightieth-birthday celebration, Stockbridge insisted on fêting the artist, and though he grumbled irritatedly at home, he had little recourse but to show public gratitude. The reality was that such celebrations called on resources he would rather have marshaled for other purposes. He had created the public's monstrous appetite for him, however, and he knew that. He tried to live up to what his efforts to be liked had wrought.

Stockbridge organizations created floats, and he and Molly sat up on the grandstand, reviewing the parade in his honor. In many ways a repeat of the New Rochelle occasion four years earlier, this time it was more fun, because it was based on the present, and more exhausting because he had deteriorated so much in those few years. But he and Molly were used to their debt to the public, and neither felt it fair to have taken a lifetime of adulation and bow out when the nation's praise became inconvenient. Rockwell lamented in print about the times he might forget to lock his studio, only to return to find a group of tourists happily inside, awaiting him. The most recent such occasion, he "had a hell of a time getting them out—politely." Virginia Loveless remembers with near awe the studied courtesy that both Rockwells exhibited toward those who stepped over the boundaries of propriety: "They would be pleasant to people who just walked into the kitchen, not even ringing the doorbell," she says. "And once, a couple parked in the driveway and took out a cooler and prepared their pic-

nic! When Molly went out to walk her beloved smart, overaged Corgi, Sid (for the classical Sidereus), she simply nodded pleasantly and went her way. It was amazing."

Other than the Boy Scouts calendar, which would be his last, he had taken on only one special commission for the bicentenary. His favorite art magazine, *American Artist,* had requested that he do their cover, a commission he accepted, though according to the magazine's art director, it was clear that the effort took every bit of energy he could muster. "I felt so sad for him," Susan E. Meyer says. "He and Molly both were lovely to work with, but he was clearly failing. He would ask me the same question repeatedly, and I'd call him and he'd not remember what we had talked about. In the end, he wasn't happy with the cover, but I was just pleased we had it, not sure till the end that we would." In spite of the diminished abilities in broad view, the occasion was apt for Rockwell's last public painting. A broken but stalwart Liberty Bell, a ribbon imprinted with "Happy Birthday" being wrapped around it by the frail but determined artist of American iconography, staked their mutual claims to the status of historical relics.

To coincide with the country's bicentennial, Thomas Buechner wrote the text for another well-produced Rockwell art book that was published in 1976. Less costly than its predecessor six years earlier, the thirty-five-dollar text sold as well as the first one. Other less honorable enterprises traded on previous success stories, such as the New England Telephone company, which distributed their 1976 phone books with an obvious (unpaid) takeoff of Rockwell's famous *Gossip Post* cover from the late 1940s. David Wood publicly commented on the unseemliness of such a commercialization, but the sadder reality was Rockwell's inability to fend for himself in such matters now, and the willingness of Lorimer's business community, long thought to be Rockwell's friend, to exploit unfairly the artist's fame.

32

&

Rage Against Impotence

The bird would cease and be
as other birds
But that he knows in singing
not to sing.
The question that he frames in
all but words
Is what to make of a diminished
thing.

—Robert Frost, "The Oven Bird"

And yet Rockwell himself was able only at times to appreciate the success that he continued to accumulate. By the beginning of the next year, when President Ford was scheduled to present him with the Presidential Medal of Freedom, the nation's highest peacetime award, Jarvis had to be sent in his place to the Washington ceremony. Basically, the artist was reduced to being taken out to his studio in his wheelchair, where he complained that it was hard to paint properly with the chair in between him and the easel. A painting of a missionary and an Indian remained in the studio from two years earlier, and

there was an increasing air of disuse settling on the rooms, which was hard to escape. His legs refused to function predictably at all, the weakness he had cited as a boy never corrected fully by his dreaded orthopedic shoes of childhood. Previously embarrassed at what he considered his oafish-looking oversize feet, now he wanted only to reclaim the freedom they had afforded him to work. In public, he depended on a walker and cane, although they both were rapidly becoming inadequate. When tourists ran up to him to snap a photograph, whoever was helping the infirm artist would state politely that Mr. Rockwell would prefer his picture not be taken now, and almost always, they would deferentially turn away.

When it became clear that Molly needed full-time assistance to manage her husband's failing health, she reluctantly turned to a friend, asking for a referral to a trustworthy nurse. After she met with Mary Quinn, whose husband was a well-respected podiatrist in town, she waffled, lamenting that Norman was adamantly against outside intervention. "The whole experience of being hired by Molly was fascinating, sad, and revealing," Mary Quinn says now. "I hadn't been interviewed in twenty-five years for a job—I was rather well known. But Molly insisted upon a formal interview. She told me she didn't want to go against her husband's wishes, yet she felt incapable of taking care of everything now. It broke her heart to do this to him, and the whole thing was really painful for everyone to watch." Two weeks later, Molly gave in to the obvious and called Mary. After a few days, the elderly schoolteacher confessed that she felt she was losing control, that she had little to say about their lives anymore. "I tried to reassure her the best I could, that everyone felt that way in such circumstances," Mary remembers. "But even in the midst of all this chaos, Molly was determined to present her best side to her husband. It always impressed me so much. Her belief in 'doing yourself up' for your spouse extended to me, when I was leaving on vacation and Molly reminded me to take a cosmetics supply. Every day, she made herself up for her husband, and she dressed as lovingly as if they were going out to dinner."

In the house, Molly and David had had an automatic Hoya chair lift installed, which allowed the artist to get up and down the stairs without being carried by someone. "He hated that device," David Wood recalls. "I don't know why—I guess it made him feel inadequate, childlike. And perhaps he felt he would fall out; on the way down, it could be a bit frightening. For whatever reasons, he railed against it." Although he tended to stay upstairs, in one of two bedrooms the couple used for themselves (Norman's with twin beds, Molly's a single), the artist managed to get downstairs every day for the three o'clock ride his wife took him on, in their oversized, decade-old Oldsmobile. "We all got so worried about this routine," Virginia Loveless recalls. "Molly was a terrible driver, though her father had told her she was great, and she believed him. She was a tiny woman, and she could hardly see above the steering wheel of that car. And the two of them went out every day, even in the winter when the roads were bad." Only when Norman started dozing off and falling against Molly as she drove did they give up their afternoon drives.

Many nights he was still able to sign the stacks of prints that the New York gallery handling this new project would send him. Molly had been convinced that one way to endow a permanent museum for her husband's art was to allow a first-rate lithographer in Paris to issue a limited set of prints from several of her husband's paintings. The grammar of prints is large, and the room to maneuver within the genre and still remain both legal and ethical is almost as alarmingly broad as well. Rockwell knew this, and he was extremely uncomfortable about such a method of fund-raising.

For Molly, though, he would do just about anything—and for his sons, too. Molly explained to him that he was ensuring the financial security of his family, as well as endowing the museum that would house his real paintings. Still, he hated the whole affair, and he disliked the brusque redheaded woman who strode through his house, leaving the prints on the table, and not bothering to speak to the household assistants whom she clearly regarded as "the help." He showed his contempt by flipping through the stacks quickly, signing

his name to imitations that he felt reflected little honor on his name or his art. One of his real worries about the enterprise was that tourists who bought the prints were misled into believing them to be artist's proofs. As usual, Rockwell's implicit contract with his audience about the integrity of his paintings was paramount in his hierarchy of ethics.

His discontent was only worsened by the irony of prostituting his talent at this late stage; he had always taken a perverse pride in underpricing his work. A few years earlier, he had told an interviewer that he'd just refused a commission for $25,000 to illustrate plates, offering to do the work, which would only take him one day, for $7,500. Otherwise, "it made no sense. I shouldn't make $25,000 for a day's work." But Molly's good-natured response to the journalist that she simply thought her husband's attitude to be crazy belied her concern that there were so few financial resources to fund an endowment. Nonetheless, when she went away for a few days and returned to find the latest stack of prints untouched, and Mary Quinn explained that seeing how much the process upset Norman, she had refused to make him sign them, Molly terminated the agreement with the Manhattan dealer and her husband was left at peace.

The public relations image provided for Norman Rockwell's death has it that he lived his last few years in serenity, admittedly in poor health, and that he died "peacefully at home," the mantra repeated in essays and articles for decades. In truth, there was little peace in his death at all, nor in the long time that it took him to die. By the end of 1977, as Molly explained graciously and painfully to friends who wrote—including her onetime rival, Peggy Best—Norman was barely recognizable as his old self. Most painful for his wife were his rages, where the usually genial man screamed and shouted at the very people trying their best to help him. According to those caring for him, he would throw tantrums because no one seemed to understand his wish that they pack for him to go to Paris, and no one was willing to help him get to his studio. He couldn't understand their lack of cooperation. Once he managed, in his fury, to lock Mary Quinn in the bath-

room. "It made us cry, the tension and unhappiness upstairs when Norman lost control," Virginia Loveless recalls. "Molly would look so stricken, so hurt that he was flailing out at us, and embarrassed for Norman's sake. She'd try to settle him down, but it was hopeless."

Jarvis remembers that when he would go upstairs to talk to his father, often the conversation would be pure nonsense, about the trip they were taking to the moon, and what the artist wanted his son to bring along. Once, Norman asked his son to accompany him to Paris. "He was completely gone," the eldest son remembers. "I felt that Pop was using trips and travel as an escape metaphor from his intolerable life, the big journey in the sky, the ultimate one." One day, Jarvis asked Mary Quinn if his father was going to die, and when she said yes, he sat down and sketched him in his bed. "I always liked watching Jarvis with his father," the nurse recalls. "I sensed that he really respected him, and that Norman felt that too."

For at least the last two years before Rockwell's death, Molly curtailed her schedule except for her Sunday church activities, and spent most of the days upstairs with her husband, massaging his head for hours at a time. "They were so close," Virginia Loveless remembers. Even though both Rockwells by now had their own bedroom, side by side, Molly often stayed overnight with Norman. "They were physically affectionate, and they looked out for each other." Mary Quinn adds, "But I always thought that Molly put Norman first far more consistently than the other way around. I would have felt a bit put out if my husband didn't treat me a little more special than Norman did Molly."

At times, in spite of the dementia, Rockwell's old raucous sense of humor would break through, and those around him would burst into laughter at his sly jokes. A year earlier, he had explained to an interviewer his belief that though it was better nowadays how they all got problems out in the open, unlike the old days when difficulties and "prejudices" were "pushed . . . under the rug," it was sad that the tradeoff seemed to have been fun: "We laughed a lot more in the old days than we do now. Yes, I understand why we don't any more, but I

regret it just the same." When the illustrator got into a particularly lighthearted mood, Virginia Loveless would find herself howling in laughter, partly because of the ham actor's adroit delivery. "He used to repeat one rhyme particularly often," she says, and two months before he died, Molly wrote it down so they could memorize it: "Little Willie Lager fell into an Anheuser Busch / Tore Schlitz in his pants / Came out a sadder Budweiser boy / Pabst yes, Pabst no." At other moments, he'd repeat obsessively rhymes about lining up his shoes neatly, or about the military-style tactics needed to conquer the bathroom.

Sometimes, Mary Quinn remembers, when he was not lucid he would suddenly call out repeatedly for "Mary, Mary," and she knew "it wasn't me he was calling for." The past resurfaced in other surprising ways, such as the time that the nurse found two old letters from Irene O'Connor in his bedside table, the one that had faithfully displayed a picture of his mother throughout his life. During short periods of sudden clarity, Norman would enjoy talking about his past. He'd reminisce about his ancestors and Molly's, egged on by the portraits of their relatives that hung on the walls. The dining room especially, the walls and rug dark, dramatically red, the warm rich burn of the deep wood furniture casting a glow in the late afternoon sun, seemed to inspire his most complicated and romantic reveries.

One day when things weren't going too well in the household, Norman's yelling reached a crescendo that mobilized his loyal little entourage to carry him downstairs, tuck him into his wheelchair, and roll him into his studio. But now that the big day had come, and the artist was finally inside, he sat there for almost an hour, saying nothing, just staring at the picture on the easel. Finally, he spoke: "This is not my studio," he said firmly. No one knew what to say.

He never asked to return, although his raging against his infirmities continued for a few more months. On the night of November 8, David Wood went up to bed before the Rockwells did. Settled in for the evening, a few hours later he glanced up from his reading to see Molly—still, slight, urgent, and commanding, standing in the door-

frame. She had never before come to his room at night. "He is gone," she said quietly.

He strode quickly down the hall toward the couple's suite of rooms and, entering Norman's bedroom, he immediately realized that Molly was right. Lying on his back, his hand on the coverlet turned gently so that his palm seemed to beseech heaven, the exhausted artist wore a look of repose on his face that reassured David even as it momentarily seized him with grief. He was happy that Norman Rockwell was dead; he hadn't looked this peaceful in years.

. . .

Time magazine would mourn the artist's passing, ranking him with Margaret Mead, Hubert Humphrey, Golda Meir, and Edgar Bergen as among the most noteworthy people to have died in 1978. And the art critic Robert Hughes, in the same publication, would sensitively eulogize the man whom one of his profession had less generously nicknamed "the Rembrandt of Punkin Crick." Norman Rockwell's funeral was held at two P.M. on November 11, at St. Paul's Episcopal Church, where Mary's funeral had taken place nineteen years before, and where he had married Molly two years later. Two hundred passes were printed and distributed by David Wood to parishioners and out-of-town friends. As the "neighbor, friend, tenant" explained to the newspapers, the family had realized that if they didn't take some steps to control the crowds wanting to pay their respects, local people would have no chance to pay theirs.

The service was thirty-five minutes long, led with a reading of Rockwell's favorite poem, "Abou Ben Adhem," also printed in the program. Its author, Leigh Hunt, was a "middling" poet among the giant Romantics whose time he shared. The British writer was a generous, courageous, liberal, well-read man who, quite appropriately, reminds at least one major scholar of the period of—who else?—Mr. Micawber in Rockwell's beloved *David Copperfield*. "Abou Ben Adhem" narrates the enfolding of one man's love for his fellows into love of God; at first denied inclusion among the names of those who "love the

Lord," Ben Adhem's "name led all the rest" "whom love of God had blessed," after the angel has relayed the man's love of his neighbors to the Lord.

During his short and powerful eulogy, David commented that "the world pays tribute to [Rockwell] for his creation of beauty and that is important, but more important was the man behind those images: the sensitive mind, the discerning eye, the loving heart, the generous spirit. We will let the world and time take care of his art, the pictures and the images and what they may say to us. What we say farewell to today is the man, our friend and neighbor."

The sons sat up front with Molly, who, true to the word she had given David, stiffly remained dry-eyed, resolute in her desire not to cry private tears in a public forum. She knew how to do right by her husband; she could rise to the occasion, as the New England school-teacher had always prompted her husband to do when he thought himself too tired or too sick to behave properly. Peter Rockwell led her out of the church, where honor guards of Cub and Boy Scouts lining the paths stood at attention. The coffin was taken to the cemetery a few blocks away, next door to the first house that Mary and Norman had inhabited back in 1954, when they moved to Stockbridge to begin the final leg of their journey together.

Rockwell was buried in a modest plot overlooking an expanse of brilliant green pasture off Church Street. His simple marble tomb-stone gives his name and the dates of life and death, nothing more. On one side of him, slightly to the upper left, is Mary Rockwell's grave. Six years later, and by virtue of the artist's forethought, Molly Rockwell's would be exactly the same size, with the same imprinting, and in the same position, but to the right of Rockwell's marker. Both women would have smiled at their husband's typical tactfulness, and at the way that the artist once again seemed to have it all.

Selected Bibliography

❧

Addison, James Thayer. *The Episcopal Church in the United States, 1789–1931*. New York: Charles Scribner's Sons, 1951.

Allen, Frederick Lewis. *The Big Change, America Transforms Itself 1900–1915*. New York: Harper and Brothers, 1952.

Allison, Rev. Charles Elmer. *The History of Yonkers*. Harrison, New York, 1896, 1984.

Alpers, Svetlana. *The Art of Describing: Dutch Art in the Seventeenth Century*. Chicago: University of Chicago Press, 1983.

———. *Rembrandt's Enterprise: The Studio and the Market*. Chicago: University of Chicago Press, 1988.

Ambrose, Stephen E. *Band of Brothers: E Company, 506th Regiment, 101st Airborne, from Normandy to Hitler's Eagle's Nest*. New York: Simon & Schuster, 1990.

American Painting Before 1865: An Exhibition. Hagerstown, Md.: Washington County Museum of Fine Arts, 1937.

Ashton, Dore. *The New York School: A Cultural Reckoning*. New York: Penguin, 1972.

Baigell, Matthew. *The American Scene: American Painting of the 1930s*. New York: Praeger, 1974.

Barr, Alfred H., Jr. *Cubism and Abstract Art*. New York: Museum of Modern Art, 1936.

Beem, Edgar Allen. "A Rockwell Renaissance?" *ARTnews* 98 (Sept. 1999).

Benjamin, Walter. "The Work of Art in the Age of Mechanical Reproduction," in *Illuminations*, edited and with an introduction by Hannah Arendt, translated by Harry Zohn. London: Fontana/Collins, 1973.

Birmingham, Stephen. *The Right People*. Boston: Little, Brown, 1958.

Blaugrund, Annette. *The Tenth Street Studio Building: Artist-Entrepreneurs from the Hudson River School to the American Impressionists*. Southampton, N.Y.: Parrish Art Museum, 1997.

Bloland, Sue Erikson. "Fame: The Power and Cost of a Fantasy," *Atlantic Monthly*, November 1999.

Blumin, Stuart M. "The Hypothesis of Middle-Class Formation in Nineteenth-Century America: A Critique and Some Proposals." *American Historical Review* 90 (1985).

Bogart, Michele. *Artists, Advertising, and the Borders of Art*. Chicago: University of Chicago Press, 1995.

———. "Artistic Ideals and Commercial Practices: The Problem of Status for American Illustrators," *Prospects* 15 (New York: Cambridge University Press, 1990).

Bragg, Terry A., and Joseph H. Davis. "Scientific Laboratories at McLean Hospital: An Avenue for the Advancement of Psychiatry (1888–1943)," *McLean Hospital Journal* 15 (Belmont, Mass.: McLean Hospital, 1990).

Branch, Taylor. *Parting the Waters: America in the King Years, 1954–1963*. New York: Simon & Schuster, 1988.

Brooks, David. *Bobos in Paradise: The New Upper Class and How They Got There*. New York: Simon & Schuster, 2000.

Brown, Milton W. *American Painting: From the Armory Show to the Depression*. Princeton, N.J.: Princeton University Press, 1955.

Brumberg, Stephan F. *Going to America, Going to School*. New York: Praeger, 1986.

Buchloh, Benjamin H. D., S. Guilbaut, and David Solkin, eds. *Modernism and Modernity: The Vancouver Conference Papers*. Halifax: The Press of the Nova Scotia College of Art and Design, 1983.

Buechner, Thomas S. *Norman Rockwell, Artist and Illustrator*. New York: Harry N. Abrams, 1970.

———. *Norman Rockwell: A Sixty-Year Retrospective*. New York: Harry N. Abrams, 1972.

Burrows, Edwin G., and Mike Wallace. *Gotham: A History of New York City to 1898*. New York: Oxford University Press, 1999.

Bushman, Richard L. *The Refinement of America: Persons, Houses, Cities*. New York: Vintage, 1992.

Carbone, Teresa A. *At Home with Art: Paintings in American Interiors, 1780–1920*. Katonah, N.Y.: Katonah Museum of Art, 1995.

Carr, Stella (pseudonym for Elizabeth Bang). *Stella's Roomers*. New York: Brandie's, 1911.

Chauncey, George, Jr. "Christian Brotherhood or Sexual Perversion? Homosexual Identities and the Construction of Sexual Boundaries in the World War I Era," *Journal of Social History* XIX, no. 1, (1985).

Clark, T. J. *Farewell to an Idea: Episodes from a History of Modernism*. New Haven: Yale University Press, 1999.

———. *The Painting of Modern Life: Paris in the Art of Manet and His Followers*. New York: Knopf, 1985.

Cohn, Jan. *Covers of the Saturday Evening Post: Seventy Years of Outstanding Illustration from America's Favorite Magazine*. New York: Viking Studio Books, 1995.

———. *Creating America: George Horace Lorimer and the Saturday Evening Post*. Pittsburgh: University of Pittsburgh, 1989.

Coles, Robert. *The Call of Service: A Witness to Idealism*. Boston: Houghton Mifflin, 1993.

———. *The Call of Stories: Teaching and the Moral Imagination.* Boston: Houghton Mifflin, 1989.

Crampton, Frank A. *Deep Enough.* University of Oklahoma, 1956, 1982.

Crane, Diane. *The Transformation of the Avant-Garde: The New York Art World, 1940–1985.* Chicago: Chicago University Press, 1987.

Curran, James, ed. *Mass Communication and Society.* London: E. Arnold, 1977.

De Young, Greg. "Norman Rockwell and American Attitudes Toward Technology," *Journal of American Culture,* no. 13 (March 1990).

Derrida, Jacques. *The Truth in Painting.* Translated by Geoff Bennington and Ian McLeod. Chicago: University of Chicago Press, 1987.

Dickens, Charles. *The Pickwick Papers.* New York: Signet reprint, 1964.

Dorman, Robert L. *Revolt of the Provinces: The Regionalist Movement in America.* Chapel Hill: University of North Carolina Press, 1993.

Eagleton, Terry. *The Ideology of the Aesthetic.* London: Routledge, 1989.

Erikson, Erik. *Childhood and Society.* New York: Norton, 1950.

Ernst, Robert. *Immigrant Life in New York City: 1825–1863.* Port Washington, N.Y.: Ira J. Friedman, 1965.

Felski, Rita. *The Gender of Modernity.* Cambridge, Mass.: Harvard University Press, 1995.

Finch, Christopher. *Norman Rockwell: 322 Magazine Covers.* New York: Harry N. Abrams, 1995.

Fineberg, Jonathan. *Art Since 1940: Strategies of Being.* New York: Prentice Hall, 1995.

Fischer, David Hackett. *Albion's Seed: Four British Folkways in America.* New York: Oxford University Press, 1989.

Fleming, Bruce. "Technique in Painting," *Centennial Review* (Winter 1996).

Foster, Edward Halsey. "The Stevens Family and the Arts, 1820–1860," *New Jersey History* 94 (1976).

Fried, Michael. *Absorption and Theatricality: Painting and Beholder in the Age of Diderot.* Berkeley: University of California Press, 1980.

———. *Art and Objecthood: Essays and Reviews.* Chicago: University of Chicago Press, 1998.

———. *Realism, Writing, Disfiguration: On Thomas Eakins and Stephen Crane.* Chicago: University of Chicago Press, 1987.

Friedman, Lawrence J. *Identity's Architect: A Biography of Erik H. Erikson.* New York: Scribner, 1999.

Geldzahler, Henry. *American Painting in the Twentieth Century.* Greenwich, Conn.: New York Graphic Society, 1965.

Golding, John. *Visions of the Modern.* Berkeley: University of California Press, 1994.

Goldman, Eric. *The Crucial Decade: America 1945–1955.* New York: Knopf, 1956.

Goldscheider, Ludwig. *Five Hundred Self-Portraits: From Antique Times to the Present Day in Sculpture, Painting, Drawing, and Engraving.* Vienna: Phaidon, 1937.

Goodwin, Richard N. *Remembering America: A Voice from the Sixties.* Boston: Little, Brown, 1988.

Goulden, Joseph. *The Best Years: 1945–1950.* New York: Atheneum, 1976.

Graebner, William. "Norman Rockwell and American Mass Culture: The Crisis of Representation in the Great Depression," *Property: An Annual of American Cultural Studies*, no. 22, 1997.

Greenberg, Clement. "Avant-Garde and Kitsch," *Partisan Review* (Fall 1939), 34–49.

Guilbaut, Serge. *How New York Stole the Idea of Modern Art: Abstract Expressionism, Freedom, and the Cold War.* Translated by Arthur Goldhammer. Chicago: University of Chicago Press, 1983.

Gunn, Thomas. *The Physiology of New York Boardinghouses.* New York: n.p., 1857.

Guptill, Arthur. *Norman Rockwell: Illustrator.* New York: Watson-Guptill Publications, 1946.

Halberstam, David. *The Fifties.* New York: Villard, 1993.

Hantover, Jeffrey P. "The Boy Scouts and the Validation of Masculinity," *Journal of Social Issues* XXXIV, no. 1 (1978).

Harris, Neil. *The Artist in American Society: The Formative Years, 1790–1860.* New York: George Braziller, 1966.

———. *Cultural Excursions: Marketing Appetites and Cultural Tastes in Modern America.* Chicago: University of Chicago Press, 1990.

Hart-Hennessey, Maureen, and Anne Knutson, eds. *Norman Rockwell: Pictures for the American People.* New York: Harry N. Abrams, 1999.

Hatch, Alden. *Meet Norman Rockwell.* New York: Watson-Guptill, 1979.

Hearn, Charles R. *The American Dream in the Great Depression.* Westport, Ct.: Greenwood, 1977.

Heller, Steven. "Rebelling Against Rockwell," in Maureen Hart-Hennessey and Anne Knutson, eds., *Norman Rockwell: Pictures for the American People.* New York: Harry N. Abrams, 1999.

Hickey, Dave. *Air Guitar: Essays on Art & Democracy.* Los Angeles: Art Issues Press, 1997.

———. "America's Vermeer," *Vanity Fair,* Nov. 1999.

Hofmann, Werner. *Turning Points in Twentieth-Century Art: 1890–1917.* Translated by Charles Kessler. New York: George Braziller, 1969.

Holme, Bryan, ed. *Master Drawings.* New York: American Studio Books, 1943.

Huntington, Samuel P. *The Clash of Civilizations and the Remaking of World Order.* New York: Simon & Schuster, 1996.

Jamison, Kay Redfield. *Touched with Fire: Manic-Depressive Illness and the Artistic Temperament.* New York: Free Press, 1993.

Johnson, Paul. *A History of the American People.* New York: HarperCollins, 1999.

Kasson, John F. *Rudeness and Civility: Manners in Nineteenth-Century Urban America.* New York: Hill and Wang, 1990.

Kimmelman, Michael. *Portraits: Talking with Artists at the Met, the Modern, the Louvre, and Elsewhere.* New York: Random House, 1998.

Kouwenhoven, John A. *The Arts in Modern American Civilization.* 1948; rept. New York: Norton Library, 1967.

Krauss, Rosalind E. *The Originality of the Avant-Garde and Other Modernist Myths.* Cambridge, Mass.: MIT Press, 1985.

Kubie, Lawrence S. *The Riggs Story: The Development of the Austen Riggs Center for the Study and Treatment of the Neuroses.* New York: Hoeber/Harper & Brothers, 1960.

Lacey, Candida Ann. "Striking Fictions: Women Writers and the Making of a Proletarian Realism," *Women's Studies International Forum* 9 (1986).

Levin, Gail. *Edward Hopper: An Intimate Biography.* New York: Knopf, 1995.

Marling, Karal Ann. *Norman Rockwell.* New York: Harry N. Abrams, 1997.

Mee, Charles L., Jr. *Rembrandt's Portrait.* New York: Simon & Schuster, 1988.

Meyer, Susan E. *America's Great Illustrators.* New York: Harry N. Abrams, 1978.

_____. *Norman Rockwell's People.* New York: Harry N. Abrams, 1981.

_____. *Norman Rockwell's World War II: Impressions from the Homefront.* San Antonio: USAA Foundation, 1991.

Michaelis, David. *N. C. Wyeth: A Biography.* New York: Knopf, 1998.

Miller, Alice. *The Drama of the Gifted Child.* New York: Basic Books, 1981.

Millhauser, Steven. *Martin Dressler: The Tale of an American Dreamer.* New York: Vintage, 1997.

Milroy, Elizabeth. *Painters of a New Century: The Eight and American Art.* Milwaukee: Milwaukee Art Museum, 1991.

Mitnick, Barbara. "The History of History Painting," in William Ayers, ed., *Picturing History: American Painting, 1770–1930.* New York: Rizzoli, 1993.

_____, and William H. Gerdts. "Natural Aristocrats in a Democracy: 1810–1870," in *American Portraiture in the Grand Manner: 1720–1920.* Ed. Michael Quick, et al. Los Angeles: Los Angeles County Museum of Art, 1981.

Moffatt, Laurie Norton. *Norman Rockwell, A Definitive Catalogue,* 2 vols. Stockbridge, Mass.: Norman Rockwell Museum at Stockbridge and the University of New England Presses, 1986.

Morris, Wright. "Norman Rockwell's America," *Atlantic Monthly,* December 1957.

Murray, Stuart. *Norman Rockwell at Home in Vermont: The Arlington Years, 1939–1953.* Bennington, Vt.: Images from the Past, Inc., 1997.

_____, and James McCabe. *Norman Rockwell's Four Freedoms: Images that Inspire a Nation.* Stockbridge, Mass.: Berkshire House, 1993.

Musser, Charles. "Work, Ideology and Chaplin's Tramp," *Radical History Review* 41 (Spring 1988).

Myers, Kenneth John. *The Catskills: Painters, Writers, and Tourists in the Mountains, 1820–1895.* Yonkers, N.Y.: Hudson River Museum of Westchester, 1987.

Nemerov, Alexander. "Wyeth's Theatre of Illustration," *American Art* 6, no. 2 (Spring 1992).

Norman Rockwell: A Centennial Celebration: The Norman Rockwell Museum at Stockbridge. New York: BDD Illustrated Books, 1993.

"Norman Rockwell: Illustrator of America's Heritage," *American History Illustrated,* no. 21 (December 1986).

Ohmann, Richard. "Where Did Mass Culture Come From?" *Berkshire Review,* 1981.

Olson, Lester C. "Portraits in Praise of a People: A Rhetoric Analysis of Norman Rockwell's Icons in Franklin D. Roosevelt's 'Four Freedoms' Campaign," *Quarterly Journal of Speech* 69 (February 1983).

Orvell, Miles. *The Real Thing: Imitation and Authenticity in American Culture, 1880–1940.* Chapel Hill: North Carolina University Press, 1989.

Park, Marlene. "Lynching and Anti-lynching: Art and Politics in the 1930s," *Prospects* 18 (1993).

Pells, Richard H. *Radical Visions and American Dreams.* New York: Harper and Row, 1973.

Perkins, David. *English Romantic Writers.* New York: Harcourt Trade Publishers, 1967.

Peters, Margot. *The House of Barrymore.* New York: Knopf, 1990.

Pitz, Henry C. *The Brandywine Tradition.* Boston: Houghton Mifflin, 1969.

Pope, Alfred, M.D. "Research at McLean Hospital: 1944–1989," *McLean Hospital Journal* 15 (Belmont, Mass.: McLean Hospital, 1990), 27–52.

Radway, Janice. "The Book-of-the-Month Club and the General Reader," in Cathy N. Davidson, ed., *Reading in America: Literature and Social History.* Baltimore: Johns Hopkins University Press, 1989.

Ratcliff, Carter. "Barnett Newman: Citizen of the Infinitely Large Small Republic," *Art In America* (September 1991).

Reed, Walt, and Roger Reed. *The Illustrator in America, 1880–1980: A Century of Illustration.* New York: Madison Square Press, 1984.

Reynolds, Joshua. *Discourses on Art.* Ed. Robert R. Wark. New Haven: Yale University Press, 1975.

Riding, Alan. "Mysteries in the Mirror of a Dutch Master's Soul," *New York Times,* July 21, 1999.

Ringenbach, Paul T. *Tramps and Reformers, 1873–1916: The Discovery of Unemployment in New York.* Westport, Conn.: Greenwood, 1973.

Robinson, David. *Chaplin: His Life and Art.* London: Collins, 1985.

Rockwell, Margaret. *Norman Rockwell's Chronicles of America.* New York: Michael Friedman Publishing, 1996.

Rockwell, Norman. *Rockwell on Rockwell: How I Make a Picture.* New York: Watson-Guptill, 1979.

Rockwell, Norman, as told to Tom Rockwell. *Norman Rockwell, My Adventures as an Illustrator.* New York: Harry N. Abrams, 1994.

Rockwell, Thomas. *The Best of Norman Rockwell.* Philadelphia: Courage Books, 1988.

Rosen, Charles, and Henri Zerner. "Scenes from the American Dream," *The New York Review of Books,* August 10, 2000.

Rosenblum, Robert. *On Modern American Art: Selected Essays.* New York: Abrams, 1999.

Rubin, Joan Shelly. "Between Culture and Consumption: The Mediations of the Middlebrow," in Richard Wightman Fox and T. J. Jackson Lears, eds., *The Power of Culture: Critical Essays in American History.* Chicago: University of Chicago Press, 1993.

Russell, John. *Matisse: Father and Son.* New York: Harry N. Abrams, 1999.

Said, Edward W. *Culture and Imperialism.* New York: Knopf, 1993.

Samuel F. B. Morse: Educator and Champion of the Arts. Exhibition catalog. New York: National Academy of Design, 1982.

Schama, Simon. *An Embarrassment of Riches: An Interpretation of Dutch Culture in the Golden Age.* New York: Knopf, 1987.

Scharf, J. Thomas. *History of Westchester County, New York, including Morrisania, New York City.* In two volumes, illustrated. Philadelphia: L. E. Preston and Co., 1986.

Schau, Michael. *J. C. Leyendecker.* New York: Watson-Guptill, 1974.

Schjeldahl, Peter. "Fanfares for the Common Man," *The New Yorker,* Nov. 22, 1999.

Schor, Naomi. *Reading in Detail: Aesthetics and the Feminine.* New York: Methuen, 1987.

Segal, Eric. "Norman Rockwell and the Fashioning of American Masculinity," *The Art Bulletin* 78 (December 1996).

Sklar, Martin J. *The Corporate Reconstruction of American Capitalism, 1890–1916.* New York: Cambridge University Press, 1988.

Sonder, Ben. *The Legacy of Norman Rockwell.* New York: Todtri Productions Limited, 1997.

Stack, Neil. *Some Phases of Dandyism.* New York: Girard Press, 1924.

Stegner, Wallace. "The Power of Homely Detail," *American Heritage* 36 (August/September 1985).

Steiner, Raymond J. *The Art Students League of New York: A History.* Saugerties, N.Y.: CSS Publications, 1999.

Stern, Robert A. M., Gregory Gilmartin, and John Massengale. *New York 1900: Metropolitan Architecture and Urbanism 1890–1915.* New York: Rizzoli, 1995.

Story, Margaret. *Individuality and Clothes.* New York: Funk & Wagnalls, 1930.

Susman, Warren, ed. *Culture and Commitment, 1929–1954.* New York: George Braziller, 1973.

Sutton, S. B. *Crossroads in Psychiatry: A History of the McLean Hospital.* Washington, D.C.: American Psychiatric Press, 1986.

Tebbel, John. *George Horace Lorimer and the Saturday Evening Post.* New York: Doubleday, 1948.

———, and Mary Ellen Zuckerman, eds. *The Magazine in America, 1741–1990.* Oxford: Oxford University Press, 1991.

Thorpe, Thomas Bangs. "New York Artists Life Fifty Years Ago," *Appleton's Journal* 7, May 25, 1872.

Truettner, William H., and Roger B. Stern, eds. *Picturing Old New England: Image and Memory.* Washington, D.C.: National Museum of American Art, Smithsonian Institution, 1999.

Updike, John. *Hugging the Shore: Essays and Criticism.* New York: Knopf, 1983.

———. *More Matter: Essays and Criticism.* New York: Knopf, 1999.

Wakefield, Dan. *New York in the Fifties.* New York: Houghton Mifflin, 1998.

Wallerstein, Immanuel. "Eurocentrism and Its Avatars: The Dilemmas of Social Science," *New Left Review* 226 (1997).

Walton, Donald. *A Rockwell Portrait.* Kansas City: Sheed Andrews and McMeel, 1978.

Washington, Ida H. *Dorothy Canfield Fisher: A Biography.* Shelburne, Vt.: New England Press, 1982.

Weithas, Art, ed. *Illustrators XXX.* New York: Madison Square Press, 1989.

Wilentz, Sean. *Chants Democratic: New York and the Rise of the American Working Class.* New York: Oxford University Press, 1984.

Wood, Paul, et al. *Modernism in Dispute: Art Since the Forties.* New Haven: Yale University Press in conjunction with the Open University, 1993.

Wright, Elizabeth. *Speaking Desires Can Be Dangerous: The Poetics of the Unconscious.* Oxford: Blackwell Publishers, 2000.

Yalom, Marilyn. *A History of the Breast*. New York: Knopf, 1977.

Yarnall, James L., and William H. Gerdts, eds. *Catalogues, from the Beginning Through the 1876 Centennial Year*. Boston: G. K. Hall, 1986.

Zukin, Sharon. *Landscapes of Power: From Detroit to Disney World*. Berkeley: University of California Press, 1991.

Notes

✦

Introduction and Acknowledgments

xviii with art critics scrambling In the past two years, articles reflecting the current range of opinion about Rockwell's artistic worth include Edgar Allen Beem, "A Rockwell Renaissance?," *ARTnews* 98, New York, Sept. 1999, 134–37; Michael Kimmelman, "Renaissance for a 'Lightweight,'" *New York Times,* Nov. 7, 1999, 1; David Maraniss, "American Beauty," *Washington Post Magazine,* May 21, 2000, 6; Peter Schjeldahl, "Fanfares for the Common Man," *New Yorker,* Nov. 22, 1999, 190–94; and Charles Rosen and Henri Zerner, "Scenes from the American Dream," *New York Review of Books,* Aug. 10, 2000, 16–20.

xviii The middle ground Deborah Solomon, "In Praise of Bad Art," *New York Times,* Jan. 22, 1999, 34.

xxi money, they scoffed Norman Rockwell (hereafter NR), as told to Tom Rockwell (hereafter TR), *Norman Rockwell, My Adventures as an Illustrator* (hereafter *MAI*), 59.

PART I: NEW YORK

1: Narrative Connections, the Heart of an Illustrator

3 "living out the cover" Jarvis Rockwell (hereafter JR) interview, Aug. 19, 1999.

4 "I never caught on" Ibid.

6 "Finally, my father changed" Ibid.

7 "It was very unpleasant" Ibid.

9 That crucial next stage This following description on developing a narrative line is based on *Rockwell on Rockwell,* 28–29.

10 "I think the painting" Peter Rockwell (hereafter PR) interview, June 20, 2000.

2: Family Ties That Bind

14 Given the option The following account of Norman Rockwell's genealogy is based on personal family archives, professional genealogists' research, church records, city directories, and old letters from family members.

16 But what Rockwell *MAI,* 20.

18 Howard's periodic tirades Ibid.

18 In between his forays The Alexander Smith carpet works was probably the largest carpet industry in the world, at least until the 1950s, when the plant moved from Yonkers to Mississippi. Providing carpets and rugs to wealthy collectors around the world—perhaps most famously, for the czars—as well as covering the floors of middle-class Americans, the industry experimented in the mid-twentieth century with hiring prominent artists such as Chagall and Matisse to create special designs for them.

19 "He was genial" "Necrology," "Opera Glass," *Westchester County Fair,* Aug. 17, 1886.

19 "Mr. Hill had resided" *Yonkers Statesman,* Aug. 17, 1886.

20 "enough people": Mary Amy Orpen (hereafter MAO) interview, Sept. 27, 2000.

21 "potboilers" TR interview, Sept. 15, 1999.

21 "an artistic painter" *Yonkers Statesman,* Mar. 7, 1888.

22 "Yes, she acted" MAO interview, Sept. 27, 2000.

22 "It's almost as if" Dale Heister letter to TR, July 1986.

23 "A people of" and "exceptionally literate" David Hackett Fischer, *Albion's Seed: Four British Folkways in America,* 87.

23 "whose Christian fidelity" J. Thomas Scharf, *History of Westchester County,* 113.

23–24 "fine country seat" and "to be considered" Rev. Charles Elmer Allison, *The History of Yonkers* (Harrison, N.Y., 1896, 1984), 383.

28 "Apparently she was considered" MAO interview, Sept. 27, 2000.

29 "She spoke" and "I didn't" Ibid.

30 The beauty of the ceremony *Gleaner,* July 22, 1891.

30 "agreeable fascination" and "the bride" Ibid.

3: City Boy, Born and Bred

33 "My mother" *MAI,* 21.

34 "darn near died" and "Mercy Percy" Ibid., 22.

34 "I had" and "in terror," Ibid., 23.

34 The crusty See, for instance, Eric Segal, "Norman Rockwell and the Fashioning of American Masculinity," 637–38.

34 "Norman and I" This account was repeated to me by several people who knew Nancy Hill or NR.

35 "I know" and "she saw" MAO interview, Sept. 27, 2000.

37 "lower middle-class" and "the tough slum" *MAI*, 22.

37 "Little Norman" Letter from Nancy to Jerry Rockwell, quoted from memory by Dick Rockwell (hereafter DR) to author, interview, July 11, 2000.

38 "I considered myself" and "I always felt" Jerry Rockwell, unpublished memoir.

38 "My father" DR letter to author, July 11, 2000.

38 "I have" Jerry Rockwell, unpublished memoir.

39 By the time John Tebbel and Mary Ellen Zuckerman, *The Magazine in America: 1741–1990*, 75.

40 Erik Erikson Erik Erikson, *Childhood and Society*, 314.

41 "language" Stephan F. Brumberg, *Going to America, Going to School*, 113.

42 "They left out" Ibid., 127.

43 "It was sort of" *MAI*, 37.

43 "I do recall" and "The Spanish-American War" Jerry Rockwell, unpublished memoir.

43 "My ability" *MAI*, 37.

44 "Whenever I think" Ibid., 27.

45 "I was never" Ibid.

46 dug holes "Norman Rockwell by Norman Rockwell," *Esquire*, Jan. 1962, 69.

46 "There was" *MAI*, 22.

46 "I was born" "Norman Rockwell by Norman Rockwell," *Esquire,* Jan. 1962, 69.

46 In the far Upper West Side *MAI*, 22–23.

46 "very dictatorial" Ibid., 20.

47 "I do remember" Jerry Rockwell, unpublished memoir.

47 "He was intensely loyal" *MAI*, 27.

48 private wedding "Love Costs Millions in a Woman's Case," *New York Times*, Nov. 27, 1901.

50 "The marriage" and "He says" and "If Mr. Palmer" Ibid.

51 "followed a request" Frank A. Crampton, *Deep Enough*, n.p.

4: A Dickensian Sensibility

53 "meaning of life" Benjamin Stolberg, quoted in Jan Cohn, *Creating America,* 117.

53 "even, colorless voice" *MAI*, 28.

53 "curing" Peter Rockwell first discussed this recollection of his father's in a talk he gave at the Berkshire County Museum, Nov. 12, 1999.

54 "art, or at least art that matters" "Comforting, Funny Outlandishness That Sticks to Its Own Logic," *New York Times*, Dec. 1, 2000, E33.

54 "I would . . . draw" and "So that" *MAI*, 28.

56 "to his own father" Harold Bloom, *Charles Dickens*, 6.

56–57 "had something aristocratic" and "My father's life" *MAI*, 27.

57 "I'd draw Mr. Micawber's" Ibid., 9.

57 Dickens's An astonishing amount of first-rate scholarship now exists on Charles Dickens, but one of the easiest, most informative places to start is Paul Davis, *Charles Dickens: A to Z* (New York, 1998).

58 "I sometimes think" and "Maybe as I grew" *MAI*, 35. Rockwell repeated this information for decades, with slight variations, whenever he was asked to explain his art.

59 "mock fireplace" *MAI*, 22.

60 "The central hall" Jerry Rockwell, unpublished memoir.

60 "Aunt Nancy" MAO interview, Sept. 27, 2000.

61 "I guessed" *MAI*, 28.

62 "we didn't visit" Ibid., 17.

62 The vivid recollection In the 1980s, the subject of Rockwell's anecdote would be (mis)identified as Anne Waring Paddock, whose husband, Walter Halsey Paddock, in fact didn't die until 1902, basically of old age, and whose son William died at age twenty, hardly a little boy.

62 the "wheels" and the "dump cart" *MAI*, 17.

63 "I remember" and "spreading our" and "always gray" Ibid., 29.

5: Urban Tensions, Pastoral Relief

64 "Unfairly, perhaps" *MAI*, 30.

65 "The other memory" Ibid.

65 "I forget how it ended" Ibid., 31.

66 "[F]rom the point of view" Barry Lewis interview, Jan. 12, 2001.

66 "The old neighborhood" Steven Millhauser, *Martin Dressler: The Tale of an American Dreamer*, 41.

66 "Those summers" Ibid., 31.

67 "hot heavy smell" Ibid., 33.

68 "negative space" Daisy Rockwell, letter to the author, Dec. 10, 2000.

68 "I sometimes wonder" Jerry Rockwell, unpublished memoir.

68 "I think" *MAI*, 34.

69 "I heard that" and "I liked her" MAO interview, Sept. 27, 2000.

70 As more than one critic See, for one particularly fine example of such explication, J. Hillis Miller, "The Dark World of Oliver Twist," in Harold Bloom, *Charles Dickens*, 68.

70 "sang . . . like angels" and "perched [on their stools]" *MAI*, 41.

71 "a typical Victorian" Robert Orpen, phone interview, Dec. 15, 2000.

72 "A slum" *MAI*, 41.

72 "he used to climb up" PR interview, June 26, 2000.

73 "[He] always" *MAI*, 38.

73 "My specialty" Jerry Rockwell, unpublished memoir.

73 "narrow shoulders" *MAI*, 38.

73 "crooked limp" Ibid., 39.

73 "some sort of a cripple" Ibid., 38.

74 "I put everything into" Ibid., 39.

74 "a lump" Ibid.

6: Mamaroneck: An Interlude

76 "We still had to go" Jerry Rockwell, unpublished memoir.

77 "of all things" *MAI,* 43.

78 When the choir boy's voice changed St. Thomas Episcopal Church records, Mamaroneck.

79 "Norman Percevel, you're late" *MAI,* 41.

79 "Norman Percevel *Rockwell,* you let go" Ibid., 41.

79 "I remember walking" Ibid., 39–40.

80 "Early into my adolescence" Dave Wood, *Washington Post,* Nov. 23, 2000, 24.

80 "Miss Genevieve Allen" and "trim" and "cloyingly" *MAI,* 42.

81 "I hated that coat" Ibid., 10.

83 "I imagined" Ibid., 45.

84 "I spent every Saturday" and "I went along" Linda Pero, "In Celebrated Company," exhibition, NR Museum, Stockbridge, May–Oct. '97.

84 "That must have been" Ibid.

7: Manifest Destiny

85 William Merritt Chase Gail Levin, *Edward Hopper: An Intimate Biography* (New York, 1995), 43.

86 "Dressed" Ibid.

86 "It'd be nice" Quoted in Jay Geltzler, *Westchester Home Life,* Aug. 3, 1932.

87 "flatness" T. J. Clark, *The Painting of Modern Life,* 12–13.

87 "high" and "broad" and limited Michele Bogart, *Artists, Advertising, and the Borders of Art,* 34.

88 Like Rockwell, Pyle For a good account of Howard Pyle's development, see Henry C. Pitz, *The Brandywine Tradition,* 38–40.

89 At *Harper's* Ibid., 52, 60.

89 "I had" "Who's Who," *Tattler,* Mar. 1914, 15.

89 Such a syndrome Thanks to Dr. Jennifer Naidich and Sue Erikson Bloland, both of whom discussed with me "agitated depression" and its manifestations in the lives of various cultural strong men, including NR.

91 "rather large" *MAI,* 50.

93 "an unusual" Pam Koob letter to author, Jan. 8, 2001.

94 "Artist, Illustrator" *MAI,* 73.

95 George Bridgman Ibid., 60.

95 "lovely compositions" and "you can't" Ibid., 60.

95 "as unfamiliar" "Bone and Muscle Man," *Time,* Sept. 14, 1942, 45.

96 "carrying around" Ibid., 34.

96 "dressed like artists" *MAI,* 60.

96 "Prim and meticulous" Ibid., 62.

96 The League Raymond Steiner, *The Art Students League of New York,* 87.

97 "heavy black line" *MAI,* 58.

97 "flop down" Ibid., 58.

99 the League occupied See Raymond Steiner, *The Art Students League of New York,* 67.

99 "there was not . . . Why don't you?" *MAI,* 56.

100 "He felt a sense" Henry C. Pitz, *The Brandywine Tradition,* 89–90.

100 "I really got" Audiotape, NR dictating his memoirs to TR, May 1959.

100 When he paused *MAI,* 56.

100 "Being somebody" Ibid., 53.

101 "jockey seat" Ibid., 63.

103 "He'd say" Ibid., 70.

103 The instructor occasionally ambled Ibid., 72.

104 "among people" Ibid., 80.

104 "Our objection" Thomas Gunn, *The Physiology of New York Boardinghouses,* 167.

105 "a comfort" Letter in the St. Thomas Episcopal Church archives, Mamaroneck, N.Y.

105 Tom Rockwell has suggested TR interview, May 2000.

105 A tell-all book Stella Carr, *Stella's Roomers,* table of contents.

106 "What was" and "I have" MAO interview, Nov. 6, 2000.

106 Shocking . . . earlier Marilyn Yalom, *A History of the Breast* (New York, 1997), 227–29.

8: Earning His Sea Legs

111 "You want to go" *MAI,* 86.

112 "Rembrandt or two" quoted in "An Artist's Interview," *Esquire,* Jan. 1962, 76.

114 "I'll write" *MAI,* 88.

115 "I was intensely ambitious" Ibid.

115 "as near" Ibid., 89.

9: A Cover Celebrity

118 "most courtly" Bob Patterson, "Newspaperman Arriving Here Finds a Famous Man Helpful," *New Rochelle Standard-Star,* Oct. 1, 1959.

119 Directly bordering F. A. Rellstab, *Facts About New Rochelle, "Queen City of the Sound"* (New Rochelle, N.Y., 1925).

119 "hasn't changed" Tom Hochtor interview, May 2000.

120 "Apart from" NR letter to Mark Augurt, Dec. 28, 1965.

122 "They knocked" *MAI,* 45.

123 The newspaper account "Squall Hits Local Dories," *New Rochelle Standard-Star,* summer 1913.

126 "I am working" "Who's Who," *Tatler,* Mar. 1914, 25.

126 "I know" Ibid., 25.

128 "Actually" DR interview, Sept. 1999.

128 a personal log JR, Sept. 1914.

129 "I expect" Ibid.

129 "Norman not" Letter from "Marian" to JR, Mar. 14, 1915.

130 "he and Norman" JR letter to Carol Cushman, Sept. 23, 1915.

130 "He just never" Mead Schaeffer, audio interview conducted by Susan E. Meyer, Sept. 30, 1980.

131 he resorted to painting *MAI*, 107.

132 "One might see" *New Rochelle Standard-Star*, Nov. 1918.

133 "Aunt Nancy" and "she had" MAO interview, Sept. 27, 2000.

133 "People used to say" *MAI*, 27.

133 Tom Rockwell believes TR interview, Sept. 15, 1999.

133 But the conventional pretty girl Irene Rockwell answered several letters on her husband's account as to why he painted so few girls; she explained that he just knew more about boys, but that he certainly liked girls as well.

136 "without class" Jan Cohn, *Creating America*, 25.

137 And he was proud *MAI*, 51.

137 When word reached Cohn, *Creating America*, 146–47.

137 The liberal assumptions Ibid., 148.

138 "specious sense of mastery" Ibid., 142.

138 as cultural historian Jan Cohn, *Covers of the Saturday Evening Post*, 49.

140 "in an outlandish" Quoted by Eric Segal, ibid., 635.

140 In an ad Ibid., 640.

140 "often energies spent" Sue Erikson Bloland interview, May 25, 2000.

141 "girls were" and "more polite" *MAI*, 67.

141 "make no mistake" I heard a variation of this statement from at least four people who knew him in Vermont or Stockbridge from the period 1940–78.

10: Becoming Somebody

142 "I was" DR letter to author, Oct. 12, 2000.

143 "When Norman" DR interview, May 1999.

143 "I didn't know" Audiotape, NR to TR, May 1959.

144 "I have the ability" *MAI*, 82.

145 "Canadian" Margaret McBurney interview, Nov. 7, 2000.

145 Following the ceremony "Miss O'Connor A Bride Weds Norman Rockwell, A Well Known Artist and Illustrator," *Courier Freeman*, July 5, 1916.

147 Theatregoers Linda Pero, "Hooray for Rockwell's Hollywood," NR Museum, Stockbridge, June–Oct. '99.

149 "resolved" *MAI*, 121.

149 His antics *MAI*, 121.

150 the disapproving accounts Jeannette Hochtor interview, May 2000.

151 Considered the most John Tebbel and Mary Ellen Zuckerman, eds., *The Magazine in America, 1741–1990* (Oxford, 1991), 63.

151 Only twenty-five years old Linda Pero, "In Rockwell We Trust," NR Museum, Stockbridge, March–Aug. 2000.

11: A Stab at Adulthood

154 "apart from" NR letter to Michael Smythe, Nov. 3, 1956.

155 "People used" Tom Wolfe, review of *America's Great Illustrators,* by Susan E. Meyer, *New York Times Book Review,* Nov. 24, 1978, 3.

155 "were too rich" Tom Hochtor interview, Apr. 2000.

156 "Pop knew" and "But in 1960" TR interview, Apr. 3, 2000.

157 "one of the best" Theodore Pratt, "Norman Rockwell," *New Rochelle Standard-Star,* July 27, 1919, 2.

158 "neither time nor expense" Clyde Forsythe, "Who's Who—and Why: Serious and Frivolous Facts About the Great and the Near Great," *Saturday Evening Post,* Dec. 18, 1926, 24.

158 "He cared about" Quoted in Susan E. Meyer, *Norman Rockwell's People,* 154.

159–160 "peculiar appeal" Harold J. Kline, "Making the Grade," *Globe,* May 29, 1923, 8.

160 "Norman Rockwell is not a Greenwich Village artist" Theodore Pratt, "Norman Rockwell," 2.

160 "arts people," anonymous, *New Rochelle Standard-Star,* July 1920, 5.

163 "a great technician" NR, "Rockwell on Parrish," *Berkshire Eagle,* Aug. 10, 1968.

164 "[It is as] if her thoughts" Brochure from the Rockwell Society of America, Kathleen Grant, 1983.

165 "a dominant force" Jan Cohn, *Creating America,* 177–78.

165 Although intellectuals Ibid., 177–78.

165 "a raucous affair" *MAI,* 24.

165 "everyone was drunk" Ibid.

166 "Norman would call" Connie Lewis Reitz letter to the Rockwell Society of America, July 8, 1984.

168 "I am always busy" Irene O'Connor Rockwell, *Watertown Daily Times,* reprinted from *Normal Magazine,* Nov. or Dec. 1921. Archival material from Massena Public Library "Rockwell File."

12: Building a Home on a Weak Foundation

171 "seven-year itch" Robert Berridge interview, Feb. 4, 2001.

172 "ran off" Margaret McBurney letter to Tracey Middlekauff, Jan. 13, 2001.

173 "You have sold" Louis Frohman, "Know Anybody in New Rochelle?" *International Studio,* Sept. 1923, 522.

173 "Mr. Rockwell went to Paris" Amy Forbes King, *New Rochelle Standard-Star,* July 1922, 4.

173 "Mothers are" and "Perhaps it was" Ibid., 3.

173 "Before leaving home" Louis Frohman, "Know Anybody in New Rochelle?" 522.

174 "inferiority" and "the fine thing" Clyde Forsythe, "Who's Who—and Why," *Saturday Evening Post,* Dec. 18, 1926, 34.

174 His canny modesty Jan Cohn, *Creating America,* 274.

178 "at the age of eleven" Harold Kline, "Making the Grade," *Globe,* May 29, 1923, 8.

178 "unlike the usual beginnings" Louis H. Frohman, "Know Anybody in New Rochelle?," 519.

178 "his feet" "Norman Rockwell," *New Rochelle Standard-Star,* Oct. 1923, 23.

179 "Even the suggestion" Frohman, "Know Anybody in New Rochelle?," 520.

179 "especially likes" Ibid., 519.

179 "success has not" Ibid.

179 Although most of his early endorsements Linda Pero, "In Rockwell We Trust," NR Museum, Stockbridge, March–Aug. 2000.

179 "the name of Norman Rockwell" Frohman, "Know Anybody in New Rochelle?," 520.

180 "modernist art strikes Rockwell" Ibid.

180 "Anyone seeing his work" Ibid., 522.

184 "huge, white, cold" *MAI,* 169.

185 "Pop also told me" TR interview, May 2000.

13: Cutting a Fine Figure

188 "wise cracks" Clyde Forsythe, "Who's Who—and Why," *Saturday Evening Post,* Dec. 18, 1926, 34.

189 "A strong histrionic strain" Henry C. Pitz, *The Brandywine Tradition,* 120.

189 "younger people" "Perfectly Equipped Golf and Country Clubs Border on New Rochelle," *New Rochelle Standard-Star,* Apr. 9, 1927, 24.

189 His son remembered TR interview, Apr. 3, 2000.

190 "arch-Americans" Benjamin Stolberg, quoted in Jan Cohn, *Creating America,* 171.

192 he and Irene bought "Studio, Once Occupied by Norman Rockwell, Moved," *Massena Observer,* Mar. 24, 1927.

193 "He studies . . . work, work, work" Clyde Forsythe, "Who's Who—and Why," 34.

193 "My father had probably had a bit" PR interview, July 2000.

194 "As an artist . . . consideration" "Art Association to Launch Memorial Exhibition for Coles Phillips at Library," *New Rochelle Standard-Star,* Jan. 11, 1927, 5.

194 "a woman came" PR interview, July 2000.

196 "outlying" Ruth Boyle, "A House with Real Charm," *Good Housekeeping,* July 1928, 45.

197 "I think my father" Betty Parmelee (Aaronson) interview, June 2000.

197 "My father loved" Ibid.

197 "I heard that" Ibid.

198 "Orienta Point" Ibid.

199 "I thought it kind of odd" Nick Rockwell interview, June 3, 2000.

199 "John and Dick entirely off" Carol Cushman Rockwell, "The Wall Street Crash," *Cosmopolitan,* Dec. 1930, 197–98.

200 "Baba" and "pretty, brunette" DR interview, Mar. 2000.

200 "the bidding" *The Little Acorn,* Nov. 1927.

201 "I often think" Ed Howe, quoted in Tebbel, *George Horace Lorimer and the Saturday Evening Post,* 161.

202 During his most productive years Michael Schau, *J. C. Leyendecker,* 25.

202 "I don't even have time" *Westchester County Fair,* Oct. 1927, 10.

202 "Howard Pyle said" Ibid.

203 "Billy . . . time" Armstrong Perry, "The Boy on the Cover," *American Boy,* Aug. 1928, 23.

203 "they were clambering" Ibid.

204 a young man Ibid.

204 "for having become," Quoted from *Judge,* in Perry, ibid., 23.

204 implied in the encomiums Françoise Mouly, "Covering *The New Yorker,*" *Cover Stories,* Supplement to *The New Yorker,* Feb. 2001, 22.

14: Losing His Way

206 "Mrs. Norman Rockwell" Earl Pattison, *Potsdam News,* Aug. 29, 1928, 4.

206 "I just don't think" PR interview, Aug. 22, 2000.

206–207 "my father bore" TR interview, Mar. 14, 2000.

207 The postcard shows Connie Lewis Reitz, letter to the Norman Rockwell Society of America, July 8, 1984.

208 "Norman was kind" "Reflections of Norman Rockwell: An Artist's Legacy," Ralynn Stadler, *New York Times,* Sept. 23, 1980, 23.

210 "The best artist's" Norman Rockwell, *Lehn and Fink Hour* radio speech, Jan. 10, 1929.

211 "a sextette" *Westchester Home Life,* Apr. 1929.

212 "she would never have bothered" Robert Berridge interview, Feb. 2001.

213 By the time Irene Psychotherapist Alice Miller, who has spent decades studying the lives of great achievers, believes it necessary to pause at the site of their origins in order to make sense of their later histories. Too often, she believes, biographies proceed as if the lives "of famous artists . . . began at puberty. Before that, we are told, they had a 'happy,' 'contented,' or 'untroubled' childhood, or one that was 'full of deprivation' or 'very stimulating.' But what a particular childhood was really like does not seem to interest these biographers—*as if the roots of a whole life were not hidden and entwined in its childhood*" (emphasis mine). Alice Miller, *The Drama of the Gifted Child,* 3–4.

214 "Jerry came home about five" Carol Cushman Rockwell, "The Wall Street Crash," *Cosmopolitan,* Dec. 1930, 198.

214 "[they] are no worse a strain" Ibid.

215 "When the 1929 panic" JR, "From Wall Street to Biddle Street," foreword to Holgate Toy Company yearly brochure, 1968.

216 "bums and drunkards" *MAI,* 256.

216 Twenty-five years later PR interview, Aug. 2000.

216–217 "[Rockwell] believes" Harold J. Kline, "Making the Grade," *Globe,* May 29, 1923, 19.

217 "The strangest thing" Ibid.

217 the Depression well may have triggered William Graebner, "Norman Rockwell
 and American Mass Culture," 325.

217 According to what Brad and Kay Hertzog interview, Sept. 28, 2000.

218 And even as this schism See Michele Bogart, *Artists, Advertising, and the Borders
 of Art,* 23.

220 "when Aunt Nancy spoke" MAO interview, Sept. 23, 2000.

221 "I thought I was seeing things" Mary Quinn interview, Jan. 2001.

 15: A New Beginning

223 "Everybody knew who she was" Nancy Barstow (Wynkoop) interview, Apr. 25,
 2000.

223 "He always reminded me" JR interview, Dec. 1999.

223 "an old codger" *MAI,* 263.

223 "rawboned" Ibid.

224 "the door of the studio" Ibid.

226 He encountered many associates Ibid., 295.

226 "You see" Mary Rockwell (hereafter MR), letter to her parents, Mar. 8, 1932.

227 "It was the oddest thing" MAO interview, Nov. 12, 2000.

227 "how sweet Mary was" DR interview, Apr. 3, 2000.

227 "There probably never has been" "Norman Rockwell of New Rochelle," *New
 Rochelle Standard-Star,* Feb. 4, 1931.

228 "tall, lean" Ibid.

228 "delighted that you are going" NR letter to Bessie Riddell, Feb. 10, 1931.

229 "Draw all day . . . sort of stuff" NR letter to Nancy Barstow (hereafter NB), July 20,
 1931.

229 "that vital necessity" N. C. Wyeth, quoted in Susan E. Meyer, *America's Great Il-
 lustrators,* 34.

229 "There's one thing" NR letter to NB, ibid.

230 "I am so sad" Nancy Rockwell letter to Harold and Ida Hill, Sept. 15, 1931.

230 "He bragged" Daisy Rockwell interview, Mar. 2000.

232 "after years of trying" Charles L. Mee, Jr., *Rembrandt's Portrait,* 187.

234 "It has a direct" MR letter to her parents, Mar. 8–Mar. 15, 1932.

234 "I am beginning really" Ibid.

234 "little villa" MR letter to her parents, Apr. 10–18, 1932.

234 "I love Paris" Ibid.

235 Mary grew up winning love Nancy Barstow (Wynkoop) interview, Jan. 1999.

235 "And now the best thing" MR letter to her parents, Apr. 10–18, 1932.

237 "For the first time" Ibid.

238 "has found the courage" MR letter to her parents, Apr. 26, 1932.

238 "[T]hat is his last thought" MR letter to her parents, Apr. 26, 1932.

239 ". . . the important thing" MR letter to her parents, May 3, 1932.

239 All that Mary's younger sister recalls Nancy Barstow (Wynkoop) interview, Jan.
 1999.

239 "Please do not be worried" MR letter to her parents, June 10, 1932.

240 "I have one big" MR letter to her parents, June 20, 1932.

240 "By the way" Ibid.

241 "my longing for familiar" MR letter to her parents, July 5, 1932.

241 "Norm has just sent off" MR letter to her parents, Aug. 10, 1932.

242 "Everything he does now" MR letter to her parents, Aug. 15, 1932.

242 "The difficulty is" MR letter to her parents, Aug. 18, 1932.

243 "He was always off working" Betty Parmelee (Aaronson) interview, June 20, 2000.

243 "I really do adore" MR letter to her parents, Aug. 18, 1932.

243 At the *Post* John Tebbel, *George Horace Lorimer and the Saturday Evening Post*, 199.

16: No Solution in Sight

247 "What was missing" William Graebner, "Norman Rockwell and American Mass Culture," 326.

247 But what else would we expect Ibid., 327.

248 "the surface of things" *MAI*, 355.

248 "She paced" DR interview, Feb. 2000.

248 "as I really feel Norman's" MR letter to her parents, Nov. 1933.

249 "everyone in Providence" MR letter to her parents, Nov. 28, 1933.

250 "I recall that I posed" Betty Parmelee (Aaronson) interview, June 5, 2000.

251 "[Provincetown] is an artists' colony" MR letter to her parents, spring 1934.

252 "blowing right in our faces" NR personal diary, Sept. 4–12, 1934, NRM archives, Stockbridge, Mass. All subsequent quotes concerning the camping trip come from this source.

254 "Recently admitted patients" S. B. Sutton, *Crossroads in Psychiatry: A History of the McLean Hospital*, 45.

255 "His assertions" TR interview, Sept. 1999.

256 "that pretty girl" Susan Merrill interview, Oct. 2000.

256 "For the first time unsure" John Tebbel, *George Horace Lorimer and the Saturday Evening Post*, 203.

256 "At the moment" MR letter to her parents, n.d.

17: Reconfiguring

257 "Just once" PR interview, July 2000.

257 "Although some may say" *The Heritage Sandglass*, Number 4D, 1938.

258 "He has excellent technique" George Grosz, quoted in *The New Yorker*, Mar. 24, 1945, 44.

258 "He told me that" NR, quoted in Arthur Guptill, *Norman Rockwell: Illustrator* (New York, 1946), 107.

259 "nothing but contempt" Edward Hopper, quoted in Gail Levin, *Edward Hopper: An Intimate Biography*, 95.

260 "Last year" F. T. Russell letter to NR, Jan. 10, 1939.

262 "You have" John Tebbel, *George Horace Lorimer and the Saturday Evening Post*, 116.

263 "For many years" Ibid., 293.

264 "He was a man" Ibid., 304–6.

264 One of the last editorial decisions Ibid., 160.

18: Plotting Escapes

266 it was a nightmare Jarvis, Tom, and Peter Rockwell have all repeated this story to me several times; the event was, they all believe, traumatic to the entire family.

267 "I recall random things" JR interview, June 2000.

267 One of Tom's TR interview, Sept. 1999.

268 "He was just bubbling" JR interview, June 2000.

268 "grappling in search" "Levine Boy Shot in Head, Squire Believes," *New Rochelle Standard-Star*, June 2, 1938, 1.

272 "as a group" Ibid.

272 "Somehow, at age seven" JR interview, Jan. 22, 2000.

272 "Dad's fame" Sue Erikson Bloland, "Fame: The Power and Cost of a Fantasy," 34.

272 Yes, responds JR interview, Feb. 2000.

273 "I wanted to connect" JR repeated this in various interviews and phone calls.

273 "even though . . . girls instead" MAO interview, Apr. 2, 2000.

274 "I beg you" George Macy letter to NR, Apr. 6, 1939.

275 "You should see the swimmin' hole" MR letter to NB, July 1939.

276 "We are not staying" MR letter to NB, Oct. 31, 1939.

276 "She thought nothing" JR interview, Jan. 22, 2000.

276 "Now I'm painting" NR letter to NB, fall 1939.

277 "democratic history painting" Dave Hickey, "The Kids Are All Right," in Maureen Hart-Hennessey and Anne Knutson, eds., *Pictures for the American People*, 125.

278 "win us back" Charles Dickens, *The Pickwick Papers*, 414–17 (first published as serial 1836–37).

PART II: NEW ENGLAND

19: New Roots in Old Vermont

282 The letter she wrote MR letter to NB, Jan. 25, 1940.

283 "I don't see how" Jack Atherton, quoted in Susan E. Meyer, *Norman Rockwell's People*, 89.

284 "For three months" JR interview, Jan. 4, 2000.

285 "full color reprint" Niblets corn advertisement, *Family Circle*, Mar. 22, 1940.

285 "I have tried to be pleasant" George Macy letter to NR, Apr. 1, 1940.

285 "Your changing" Ibid.

287 "Cruikshank, Abbey" "Norman Rockwell, Painter for America's Millions," *American Artist,* May 1940, 11.

288 "supplementary aids" Ibid., 12.

289 "girls in back" Mead Schaeffer audio interview conducted by Susan E. Meyer, Sept. 30, 1980.

20: Another War to Paint

292 "propaganda, sentimental trash" Susan E. Meyer, *America's Great Illustrators,* 89.

292 "A Will Rogers" Susan E. Meyer, *Norman Rockwell's People,* 76.

292–293 "although you've been acquainted" "He Paints the Town," *Family Circle,* Mar. 1941, 20–21.

293 "My father would suddenly" PR interview, June 2000.

293 "Rockwell's paintings" "He Paints the Town," *Family Circle,* 20–21.

295 During a summer Celia Mendelsohn, *American Artist,* Aug. 22, 1941.

297 "contents of your" Sidney Mendelsohn, editor of *American Artist,* letter to NR, Dec. 30, 1941.

297 "My grandfather" JR interview, Apr. 26, 2000.

297 "It was clear" PR interview, June 2000.

298 "And with her" JR interview, Apr. 26, 2000.

298 "He wasn't twenty" Stephen E. Ambrose, *Band of Brothers: E Company, 506th Regiment, 101st Airborne, from Normandy to Hitler's Eagle's Nest,* 239.

299 "about a Scotch boy" MR quoted in N. R. Howard, "The Editor's Column," *Cleveland News,* Nov. 20, 1946.

21: "The Big Ideas"

307 "Those 4F's" NR memo to self, Aug. 1942.

308 "I just cannot express" NR letter to Ben Hibbs and Jim Yates, Sept. 20, 1941.

308 "Time really is" Ben Hibbs letter to NR, Nov. 16, 1942.

310 "there is something" Arthur Danto letter to author, Dec. 6, 1999.

311 "He robs" Ibid.

312 its likely source Susan E. Meyer, *Norman Rockwell's World War II,* 88.

312 "is an extremely delicate" Ibid.

313 "I'm not interested" Todd Purdum, "Unsettling the Art World for a Living," *New York Times,* Sept. 4, 1999, B7.

313 "They were received" Rufus Jarman, "Profiles: U.S. Artists," *New Yorker,* Mar. 17, 1945, 34.

22: Square Dancing on the Village Green

319 "Farming is a hard life" Susan E. Meyer, *Norman Rockwell's People,* 106.

319 "One time" Buddy Edgerton interview, July 2000.

320 "giving his son a baseball lesson" "Norman Rockwell Sometimes Jumps," *Boston Sunday Globe,* May 30, 1943.

320 "Jerry was more of a loner" Buddy Edgerton interview, July 2000.

320 "That difference between us" JR interview, Apr. 2000.

320 "The boys would own" Buddy Edgerton interview, July 2000.

322 "I could no longer procrastinate" Pete Helck letter to NR, May 30, 1944.

322 Whatever lessons PR letter to author, Mar. 7, 2001.

322 "raised a small tempest" "Controversy," *Saturday Evening Post,* Sept. 7, 1940.

322 "no boy" Ibid.

324 In late July "The Arts Take a Holiday," *Boston Daily Globe,* July 28, 1943.

325 "The general attitude" JR interview, July 2000.

326 "sailed easily" MR letter to NB, n.d. but probably Nov. 26, 1944.

326 "white birches" MR letter to NB, Jan. 25, 1944.

327 "Rockwell defined" Neil Harris, "The View from the City," in Maureen Hart-Hennessey and Anne Knutson, eds., *Pictures for the American People,* 134.

328 "pull off any number" As Susan E. Meyer points out in *America's Great Illustrators,* 67.

328 "I'd get a call" Linda Pero, "Three Rockwell Photographers," NR Museum, Stockbridge, April–June '95.

329 "It was Christmas Day" Gene Pelham interview, Dec. 1999.

329 "If your models feel" Don Spaulding, audio interview conducted by Susan E. Meyer, Nov. 17, 1980.

329 He paid his models Ibid., 68.

330 "Aunt Nancy wasn't disturbed" MAO interview, Mar. 2000.

23: As High as He Could Fly

333 "melancholy brown eyes" Rufus Jarman, "Profiles: U.S. Artists," *New Yorker,* Mar. 16, 1945.

337 "We didn't even" JR interview, July 2000.

337 "Between fourth" PR interview, Nov. 1999.

339 "He loved costume parties" George Hughes on Susan E. Meyer's audiotaped interview, Sept. 1986.

340 "great pleasure" Letter from John R. Fisher, Dorothy Canfield Fisher, NR, MR, to President Millis, June 3, 1948.

340 Rockwell corresponded Stuart Murray and James McCabe, *Norman Rockwell's Four Freedoms: Images That Inspire a Nation,* 66.

341 "He purposefully makes" Dorothy Canfield Fisher, quoted in Arthur Guptill, *Norman Rockwell: Illustrator,* xi.

341 Rockwell's debt Ibid., vii.

342 "great genre painters" Vrest Orton, *Vermont Life,* Summer 1947, 20.

342 "the brilliant way" Michel Witmer interview, July 18, 1999.

343 "what a country boy" "The Editor's Corner," *Cleveland News,* Nov. 20, 1946.

344 "Any event was" Mary Schafer, quoted in Susan E. Meyer, *Norman Rockwell's People,* 116.

344 what did he most like? Ibid.

344 "My parents" PR interview, June 22, 1999.

345 "it was the boy thing" JR interview, Jan. 2000.

345 "way out beyond" PR letter to the author, May 14, 2001.

349 "I can't recall" JR interview, Oct. 2000.

349 "See, George likes" George Hughes, audio interview conducted by Susan E. Meyer, Nov. 17, 1980.

349 "Their presences made" Ibid.

350 "communist initiated" U.S. Department of Justice, Office of Information and Privacy, appeal no. 2305, July 24, 2000.

350 "teener" Norman Rockwell, "When I Was a Teener," *Newark Star-Ledger,* July 3, 1948, 11.

350 "a pose that" "People," *Time,* Sept. 6, 1948, 44.

350 "most exciting figure" NR, quoted in *Los Angeles Times,* Dec. 10, 1948.

24: Signs of Stress

352 "We'd never seen" JR interview, June 1999.

352 "My mother was sobbing" PR interview, June 2000.

352 "I remember going" Joy Edgerton interview, Sept. 2000.

353 Nancy Rockwell had started telling tales MAO interview, Dec. 1999.

354 "She was always" Gene Pelham interview, Nov. 1999.

354 "She wasn't" Ibid.

354 "I was twelve" PR interview, June 2000.

355 "It wasn't exactly" Ibid.

355 "she was insubstantial" JR interview, Nov. 1, 1999.

356 "I know that later doctors" Nancy Barstow (Wynkoop) interview, Mar. 1999.

359 "I remember my grandfather" PR interviews and letter to author, Mar. 5, 2001.

359 "I'm not sure" JR interview, Apr. 2001.

359 "I took some painting lessons" Ibid.

361 According to Diane Disney Miller interview, Jan. 2001.

363 "I've wanted always" MR, quoted by Mary Ann Callan, "Norman Rockwells Liked as Villagers," *Los Angeles Times,* Aug. 21, 1949, 8–9.

364 "He'd invite people" Quoted in Susan E. Meyer, *Norman Rockwell's People,* 70.

367 "My mother had always" Leah Schaeffer (Goodfellow) interview, Feb. 2000.

368 "yields nothing" As John Updike observes in "Art and Act," *Hugging the Shore: Essays and Criticism,* 770.

368 "eye for meticulously rendered" NR, quoted in Robert Taylor, "Norman Rockwell and the Spirit of '76," *Boston Sunday Globe,* Jan. 3, 1971.

369 "20th century genre painting" Ibid.

369 By 1950 Tom Wolfe, "America's Great Illustrators," in Art Weithas, ed., *Illustrators XXX.*

370 new schools Steven Heller, "Rebelling Against Rockwell," in Maureen Hart-Hennessey and Anne Knutson, eds., *Norman Rockwell: Pictures for the American People,* 178.

371 Just as Robert Frost Peter Davison commenting on and quoting from Frost in

"Farness and Depth: A Rumination on Robert Frost," *Atlantic Monthly*, 113–17 (this quote from 114).

371 "In this delightful setting" "This Week's Cover," *Saturday Evening Post*, Apr. 29, 1950, contents page.

25: Putting One Foot in Front of the Other

372 "swallowing Maalox" Bud Edgerton interview, Sept. 2000.

372 "I felt so bad" DR interview, Dec. 5, 1999.

373 "Germany's leading" Bill Pierce, "Will McBride," *Photography*, Sept. 1968.

373 "He never had to do a thing" Don Spaulding, audio interview conducted by Susan E. Meyer, Oct. 2, 1980.

374 "talking about" Ibid.

374 "Watching him paint" Ibid.

375 "They'd often share jokes" Don Spaulding, audio interview conducted by Susan E. Meyer, Oct. 2, 1980.

377 "All we knew was" JR interview, Jan. 2001.

377 "Pop just wasn't" TR interview, April 1999.

378 the biological factors for depression Dean Parmelee interview, Mar. 2000.

378 "found themselves" Quoted in Lawrence S. Kubie, *The Riggs Story: The Development of the Austen Riggs Center for the Study and Treatment of the Neuroses*, 82, 88.

380 Rockwell and Erikson shared Sue Erikson Bloland interview, Sept. 2000.

382 "PLEASE" NR notes for a letter to Ben Hibbs, n.d. but probably Sept. 1950.

382 influenced Hibbs's willingness Steve Pettigrew interview, Dec. 2000.

383 The championing See Dave Hickey, "America's Vermeer," *Vanity Fair*, Nov. 1999, 172–80.

387 "stick figure" JR interview, Nov. 16, 1999.

388 "as always" JR interview, Sept. 2000.

26: On the Road Again

390 "That man was like no other" Gene Pelham interview, Sept. 1999.

393 "He became the luminous" Sue Erikson Bloland, "Fame: The Power and Cost of a Fantasy," *Atlantic Monthly*, Nov. 1999.

394 "They really loved" JR interview, Nov. 16, 1999.

395 "I remember my mother" Jonathan Best letter to author, Nov. 16, 2000.

396 "all creeds" Letter to NR from "Nation-Wide Church Attendance Crusade," May 18, 1955.

397 "that he didn't like" Nancy Barstow (Wynkoop) interview, Apr. 9, 2000.

397–398 "rich uncle" Jarvis Waring Rockwell letter to NR, June 6, 1954.

398 "I think you know" NR letter to Bob Orpen, June 2, 1954.

401 "I was disgusted" JR interview, Nov. 16, 1999.

403 Erikson notes Erik Erikson letter to Robert Knight, Aug. 4, 1954.

404 "are doing nicely" MR letter to NB, Sept. 8, 1954.

405 "Dear Dr. Knight" NR letter to Robert Knight, Jan. 13, 1955.

407 "If I were starting" NR, quoted in Selwa Roosevelt, "Rockwell Exhibit Draws Hundreds," *Evening Star,* June 17, 1955, B1.

27: In for the Long Haul

408 "what people 'are'" S. B. Sutton, *Crossroads in Psychiatry: A History of the McLean Hospital,* 261, 263.

409 Although various media dramatizations Several well-informed reports have been published on ECT, including Daniel Smith's accessible and thoughtful "Shock and Disbelief," *Atlantic Monthly,* Feb. 2001, 79–90; institutional accounts available from McLean Hospital, Hartford Institute for Living, and the National Institutes for Mental Health, as well as medical journals, including the 1993 volume of the *New England Journal of Medicine,* also provide helpful summaries of ECT. Personal accounts of treatments also exist, such as William Styron's *Darkness Visible: A Memoir of Madness* (New York, 1990).

409 "psychiatry's job" Smith, "Shock and Disbelief," 81.

409 And even when it is not Ibid., 86.

410 "But oh how I miss" NR letter to Nancy Barstow (Wynkoop), July 12, 1955.

410 "on the side of the angels" Cinny Rockwell interview, June 2000.

410 "my darling Tom" MR letter to TR, July 14–28, 1955.

411 Reflecting on his father's indiscriminate PR talk to the National Press Club, June 2000.

411 "Why Hartford?" Peter Sudarsky, "Rockwell 'Limbers Up' by Sketching City Scenes," *Hartford Courant,* Sept. 4, 1955.

413 Erik Erikson noticed Erik Erikson letter to NR, n.d. but fall 1955.

413 several other illustrators Fred Taraba interview, Jan. 2000.

417 "A woman's life" MR letter to Nancy Wynkoop, May 25, 1957.

418 "For a few days" TR interview, March 14, 2001.

421 "You have to say something" NR audiotape, May 1959.

421 "I don't want" NR audiotape, May 18, 1959.

422 "deep moments" Arthur Danto letter to author, Dec. 1999.

422 "[The] myth of comforting superficiality" Michele Bogart, 76.

424 "I've been down . . . doesn't work" NR audiotape, June 1959.

425 "Good night, children" NR audiotape, June 26, 1959.

425 "I'm late today" NR audiotape, May 25, 1959.

426 "They seemed to be" JR interview, Aug. 1999.

428 "I could not write" Margaret Brenman Gibson letter to NR, Sept. 8, 1959.

28: Picking Up the Pieces

429 "We all loved Mary" NR letter to Peggy Best, Sept. 4, 1959.

431 "ironic self-consciousness" John Updike, *Hugging the Shore: Essays and Criticism,* 724.

431 "prophet of mindlessness" Benjamin DeMott, "When We Were Young and Poor," *The Nation*, Apr. 2, 1960, 299.

432 "you have to be" NR, "A Closeup Visit with Norman Rockwell," Mary Anne Guitar, *Design*, Sept./Oct. 1960.

433 "Dear Peggy" NR letter to Peggy Best, June 16, 1960.

433 "She hoped to marry him" Jonathan Best interview, Nov. 2000.

434 "Some of the other teachers" Shelley Getchell interview, Oct. 1999.

434 "cold and hard" Susan Merrill interview, Sept. 5, 2000.

434 "After she had retired" David Wood interview, Sept. 2, 2000.

435 "Why are we all" This account was recited to me by at least three of the couple's friends.

436 "I know it isn't correct" NR letter to Ida Hill Cahn, Oct. 18, 1960.

29: Another Schoolteacher

437 "You work too hard" NR letter to Peggy Best, Jan. 10, 1961.

437 "I got your letter" Ibid.

438 "Got your bright letter" NR letter to Peggy Best, Jan. 13, 1961.

438 "You're greatly missed" NR letter to Peggy Best, Aug. 22, 1961.

439 "Since we are such" NR letter to Peggy Best, n.d. but Sept. 1961.

440 "I didn't see how" Virginia Loveless interview, Sept. 2000.

441 "those of us" Lyn Austin interview, August 23, 2000.

442 "Norman was incapable" Bud Edgerton interview Sept. 2000.

443 "There was a tiny bit" Virginia Loveless interview, Sept. 2000.

443 "Everyone else was supposed" PR interview, Mar. 2000.

443 "Everyone else would be louder" Daisy Rockwell interview, Mar. 2000.

445 "old codger" Jan Cohn discusses Robinson's motif in *Covers of the Saturday Evening Post* (New York, 1998), 47.

446 As the cultural historian Wanda Korn explains Wanda Korn, "Ways of Seeing," in Maureen Hart-Hennessey and Anne Knutson, eds. *Pictures for an American People,* 90.

446 *Le Connoisseur* Ibid., 89.

446 One of the three printed letters Ibid., 85, taken from the letters to the editor in the February 17, 1962, edition of the *Post*.

446 "Often Pop would tell me" PR interview, Apr. 1999.

449 It expanded its foreign coverage John Tebbel, *George Horace Lorimer and the Saturday Evening Post*, 234–35.

450 "a remarkable cranium" NR quoted in Ed Wilcox, "Rockwell's America: It's Gone," *Chicago Tribune*, Aug. 2, 1970, 1.

453 "If only" *MAI*, 424.

454 "the American Nazi leader" *New York Times*, Feb. 24, 1965.

454 "Thrilled but" NR, calendar, Jan. 11, 1965.

454 "all excited" Ibid., Jan. 29, 1965.

454 "Big Day" Ibid., Feb. 4, 1965.

454 "JERRY HELPED" Ibid., Feb. 26, 1965.

455 "quite a change" Ibid., April 29, 1965.

455 "tried making" Ibid., April 1, 1965.

455 Reaction among Rockwell's admirers Linda Pero, "Three Rockwell Photographers," NR Museum, Stockbridge, April–June. '95.

456 "subject matter, composition" Dugald Stermer letter to NR, Aug. 25, 1965.

456 "As you expressed" NR letter to Dugald Stermer, Aug. 29, 1965.

456 "The proposal" "The One Hundred Best People in the World," *Esquire,* August 1965, 35–36.

30: A Rockwell Revival

459 "Give me contract" NR calendar, Aug. 24, 1966.

459 A letter Allen Hurlburt letter to NR, June 18, 1965.

460 "creative art direction" NR letter to Allen Hurlburt, Mar. 1, 1966.

460 "spurred on" Susan Merrill interview, Sept. 5, 2000.

460 "homemade wedding" Ibid.

461 "anyone can pass" Bradford Hertzog interview, Aug. 2000.

462 How much his wife's politics Linda Pero, "In Celebrated Company," NR Museum exhibition, Stockbridge, Mass., June 1997.

462 Henri Matisse John Russell, *Matisse: Father and Son,* 362.

462 "I had to really shake" PR interview, June 2000.

463 "It is no Rembrandt" NR letter to Allen Hurlburt, Nov. 26, 1968.

464 "I want to show" "Painter Andrew Wyeth," *Time,* Dec. 27, 1963, 52.

465 Christopher Niebuhr remembers from a story Christopher Niebuhr interview, Aug. 4, 2000.

466 "A picture without a frame" NR quoted in *The Christian Science Monitor,* Nov. 21, 1970.

466 Yet he had cannily invited Rita Reif, "Norman Rockwell's Home and Props," *International Herald Tribune,* Jan. 5, 1970.

468 "We should have great confidence" NR, quoted in Ed Wilcox, "Rockwell's America: It's Gone," *Chicago Tribune,* Aug. 2, 1970, 1.

469 "no longer" Ibid.

469 "I'm no artist" NR, quoted in Phil Casey, "Norman Rockwell Claims He's Not an Artist," *Sunday Oregonian,* Nov. 22, 1970.

469 "from exhaustion to exhaustion" Robert Taylor, "Norman Rockwell and the Spirit of '76," *Boston Sunday Globe,* Jan. 3, 1971, 3.

470 "The townspeople worried" Mary Quinn interview, Sept. 2000.

31: The Light Recedes

471 "I am very sorry" NR letter to correctional institution inmate, Aug. 24, 1971.

473 "I was just" Robert Coles interview, Nov. 2000.

473 "The reason I am writing" NR letter to Robert Coles, Oct. 12, 1968.

473 at the end of November NR letter to John Mack Carter, Nov. 29, 1971.

474 "fading fast" NR calendar, Jan. 18, 1972.

475 "It was a pleasure to shoulder" John Canaday, "Rockwell Retrospective in Brooklyn," *New York Times,* Mar. 23, 1972.

476 "I remember" Susan Merrill interview, Sept. 2000.

476 "fine arts man" NR, "Faces Behind the Figures," *Forbes,* June 1, 1972, 50.

477 illustration's place in American culture Stuart Little, "Are Illustrators Obsolete?" *Saturday Review,* July 10, 1971, 44.

478 "Jarvis died" NR calendar, May 9, 1973.

482 "Even that year" Virginia Loveless interview, Apr. 1999.

484 "splurge" and "dear" Mary Quinn interview, Sept. 2000.

484 "no" Brad and Kay Hertzog interview, Sept. 28, 2000.

485 "had a hell of a time" NR quoted in *People,* Feb. 23, 1976, 43.

485 "They would be pleasant" Virginia Loveless interview, Mar. 2000.

32: Rage Against Impotence

488 "I tried to reassure her" Mary Quinn interview, Mar. 2000.

489 "We all got so worried" Virginia Loveless interview, Mar. 2000.

489 "the help" Ibid.

490 "it made no sense" NR, quoted in Phil Casey, "Norman Rockwell Claims He's Not an Artist," *Sunday Oregonian,* Nov. 22, 1970.

491 "I always liked watching Jarvis" Mary Quinn interview, Mar. 2000.

491 "They were so close" Virginia Loveless and Mary Quinn interview, Sept. 2000.

491 "prejudices" NR, quoted in Lena Tabori Fried, "At Home with the Rockwells," *Good Housekeeping,* 217.

493 at least one major scholar The scholar is David Perkins, *English Romantic Writers,* 707.

494 "the world pays tribute" David Wood, remarks, St. Paul's Church funeral service for NR, Nov. 11, 1978.

Index

Illustration Credits

The author gratefully acknowledges the copyright permissions for art reproductions granted by the Norman Rockwell Family Trust and General Electric, and the loan of photographs by the Norman Rockwell Museum, Jarvis Rockwell, Thomas Rockwell, Peter Rockwell, Sally Hill Cooper, Mary Amy Orpen Cross, Judy Goffman Cutler, Virginia Loveless, and Richard Rockwell.

Illustrations copyright © 2001 The Norman Rockwell Family Trust, reproduced by permission of the Trust; photos courtesy of the Norman Rockwell Museum, Stockbridge, Massachusetts: *The End of the Road, Vinegar Bill, The Quarry Troop Life Guards, The Lucky Seventh, Boy with Baby Carriage, Checkers, Ichabod Crane, The First 4th, Bridge Game, Willie Gillis in Church, The Meeting, Freedom to Worship, Freedom of Speech, Freedom from Fear, Freedom from Want, Art Critic, Breaking Home Ties, Saying Grace, The Problem We All Live With, Murder in Mississippi, Triple Self-Portrait.*

Photos courtesy of the Norman Rockwell Museum, Stockbridge, Massachusetts: *Peach Crop;* NR and his brother Jarvis ("Jerry"), 1895; Jerry and NR catching frogs; NR, Jerry, Waring, and Nancy; summer boardinghouse, c. 1899; family portrait, December 1911; NR and buddies in the Navy, 1918; NR at work outside his New Rochelle studio, 1921; NR in his studio, 1922; NR painting *Let's Give Him Enough and On Time;* Jack Atherton critiquing NR.

Illustrations copyright © 2001 The Norman Rockwell Family Trust, reproduced by permission of the Trust; photos courtesy of Judy Goffman Cutler: *Love Ouanga, Strictly a Sharpshooter, The Connoisseur.*

ABOUT THE AUTHOR

Laura Claridge is the author of a biography of another twentieth-century painter, *Tamara de Lempicka: A Life of Deco and Decadence*, as well as a book on British Romantic poetry, *Romantic Potency: The Paradox of Desire*. She is also the co-editor of *Out of Bounds: Male Writers and Gender(ed) Criticism*, a collection of essays. A popular international lecturer, she was professor of English literature at the U.S. Naval Academy, Annapolis, for eleven years. She lives with her husband in Brooklyn, New York.

ABOUT THE TYPE

This book was set in Fairfield, the first typeface from the hand of the distinguished American artist and engraver Rudolph Ruzicka (1883–1978). In its structure Fairfield displays the sober and sane qualities of the master craftsman whose talent has long been dedicated to clarity. It is this trait that accounts for the trim grace and vigor, the spirited design and sensitive balance, of this original typeface.

Rudolph Ruzicka was born in Bohemia and came to America in 1894. He set up his own shop, devoted to wood engraving and printing, in New York in 1913 after a varied career working as a wood engraver, in photoengraving and banknote printing plants, and as an art director and freelance artist. He designed and illustrated many books, and was the creator of a considerable list of individual prints—wood engravings, line engravings on copper, and aquatints.